UNIVERSE

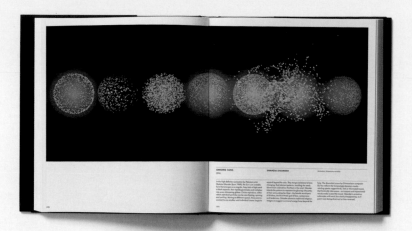

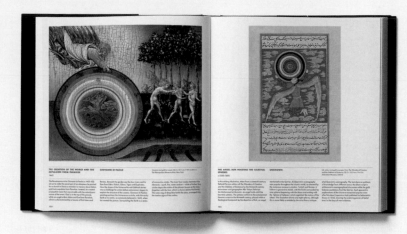

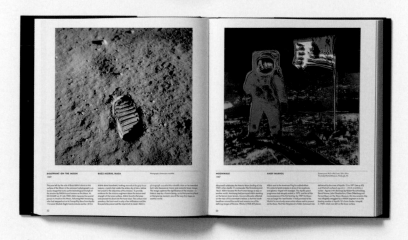

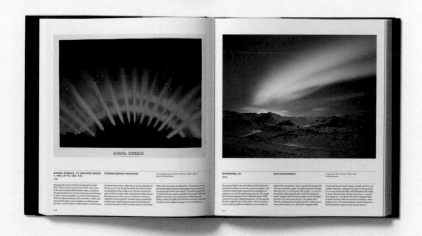

Explore man's journey to record and understand the Universe

-

300 inspiring images reveal the extraordinary beauty of the cosmos and its influence on our history and culture

Images span millennia, from ancient cave paintings and medieval manuscripts to contemporary art, photography and animation.

Carefully chosen by an international panel of experts and arranged to highlight thought-provoking contrasts and similarities.

Includes iconic works by a diverse range of globally renowned artists, photographers and astronomers, such as Buzz Aldrin, Nicolaus Copernicus, Olafur Eliasson, Galileo Galilei, Edwin Hubble, Yayoi Kusama, David Malin, Georgia O'Keeffe, Pablo Picasso and Wolfgang Tillmans.

UNIVERSE

EXPLORING
THE ASTRONOMICAL
WORLD

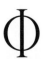

Phaidon Press Limited
Regent's Wharf
All Saints Street
London N1 9PA

Phaidon Press Inc.
65 Bleecker Street
New York, NY 10012
phaidon.com

First published 2017
© 2017 Phaidon Press Limited

ISBN 978 0 7148 7461 6

A CIP catalogue record for this book is
available from the British Library and the
Library of Congress.

Commissioning Editor: Victoria Clarke
Project Editor: Rosie Pickles
Production Controller: Adela Cory
Cover Design: Julia Hasting and Hans Stofregen
Design: Hans Stofregen
Layout: Rita Peres Pereira

Printed in Hong Kong

Editorial Note

Arrangement
The illustrations in this book have been arranged in
pairs to highlight interesting comparisons and contrasts
based loosely on their subject, age, purpose, origin
or appearance. This organizational system is not
definitive and many other arrangements would have
been possible. A chronological survey of astronomy
can be found in the timeline at the back.

Dimensions
Dimensions are listed by height then width. Digital
images have variable dimensions. Where differences
in dimensions exist between sources, measurements
listed refer to the illustrated version.

One warm summer's night, I stood outside my observatory in a glade in a forest in North America looking up to a display of the Northern Lights. Tall pillars and fiery glows of red and green marched and shot across the sky. Much closer, fireflies were sparking in the undergrowth all around, a flash from one triggering a response from another. The fireflies stimulated each other into a frenzy, their flashes becoming more and more frequent. To my great astonishment, I saw that the fireflies had started to respond to the aurora, a bright surge in the sky triggering the fireflies to flash back en masse. The fireflies were responding to the cosmos.

As with fireflies, so with humankind – much more so. We have the most intimate of relationships with the cosmos. The common chemical elements on Earth came into being through the creation and destruction of stars. The carbon and oxygen in our flesh, the iron in our blood and the phosphorus and sodium in our brain cells were all made in the generation of stars that preceded the birth of our Sun. Humans are literally and essentially star-stuff.

THE SKY OF STARS

Universe: Exploring the Astronomical World examines our response to the cosmos on all levels, from the spirit of scientific inquiry that has gradually revealed the underlying structure of the Universe to the religious mysticism that saw the heavens as the realm of a god or gods. The response ranged from the excitement that accompanied the technological achievements of the space race to the visceral, emotional reaction to the Universe and our place in it that has stimulated visual artists since at least 17,000 years ago, when prehistoric humans painted stars on the walls of the Lascaux caves in France (see p.12). Contemporary artists such as Katie Paterson and Sarah Sze find in space the stimulation to reconsider humanity's relationship with the Universe and time – and thus to reconsider what it means to be human. As scientific exploration reaches the limits of the detectable and comprehensible, so it too relies on the creativity and imagination of scientists to push boundaries, bringing scientific and artistic endeavours to interpret the Universe back into the kind of close relationship they shared throughout much of history.

Human responses to the Universe have varied widely, and *Universe: Exploring the Astronomical World* reflects this diversity, presenting works of art alongside the latest images from the Hubble Space Telescope and space probes and early astrological calendars alongside X-ray images of the nonvisible Universe. Rather than being arranged chronologically or thematically, the book pairs complementary or contrasting pairs of images to underline continuity, innovation and change. An iconic photograph of an astronaut's bootprint on the lunar surface is paired with Andy Warhol's Pop Art depiction of astronaut Buzz Aldrin on the Moon. A medieval Christian representation of the spheres of the cosmos faces a Muslim depiction of the same subject, a sixteenth-century drawing of the Universe contrasts with a twenty-first-century digital image of its underlying structure. Elsewhere, there are images of the same subject from different periods or from different cultures, and imagined depictions of the Universe paired with real images that are just as remarkable.

MAPPING STARS, RECKONING TIME

The oldest astronomical images are drawings, paintings and works in stone, metal and other materials that represent the appearance of part of the sky. These earliest representations reflect humans' deep impulse to impose patterns on what they could see, such as the arrangement of stars in constellations or asterisms (the Plough or, in the USA, the Big Dipper, is an asterism, or group of stars, within the constellation of the Great Bear). Although we know that the positioning of the stars is random, early hominids viewing the night sky perceived figures – animals, gods, mythical creatures – that both gave meaning to the stars and made them easier to locate in the sky.

Ethnographic evidence suggests that some constellations we currently recognize were already known in the Paleolithic age. The Great Bear was a constellation figure common to both native North Americans and northern Europeans, so it must predate the collapse of the Bering Land Bridge – the route by which people migrated into the Americas – about 11,000 years ago. This would make the constellations among the oldest – if not the oldest – cultural ideas still in common use.

The oldest image that unarguably represents the sky is the Nebra Sky Disk (see p.288), a bronze disc from 1600 BC that shows the Moon, Sun and stars. It is a simplified, abstract depiction that predates by a century or two the ancient Egyptian representations of the sky found in Pharaonic tombs. Both have in common their assumption that humans are at the centre of the Universe, because that's how the sky appears. This remained a firm belief until the late sixteenth or early seventeenth century.

One consequence of the anthropocentric cosmological view was the predominance for millennia in all societies of astrology: the belief that terrestrial events are caused by or foretold by cosmic events, in particular the apparent movements of the Sun, Moon and planets among the stars, expressed through the signs of the Zodiac, or celestial regions and constellations. The zodiacal signs were believed to connect with organs of the human body, a supposed direct link between humans and the cosmos (see p.90). Events such as eclipses, comets and meteors were regarded as both potent and portentous. The final concept persists in modern vocabulary: the word disaster means 'a bad thing from the stars'.

The map of classical Western constellations – in use from at least the fourth century BC – leaves an empty area in the south,

which is never visible from Mediterranean latitudes. The empty area is off-centre now because the tilt of the globe wobbles, but its location implies that the oldest constellations originated in the second millennium BC from just south of latitude 36°N: Babylon. Clay tablets from Mesopotamia in 3000 BC contain Sumerian names for stars that confirm the Babylonian origins of our constellations in, or even before, the Early Bronze Age.

From Mesopotamia, the constellations were transmitted to Hellenistic culture and, after the collapse of ancient Greece, were preserved in Arabic translations illustrated with figures drawn in Arabic style, such as in the star catalogue of the Persian astronomer al-Sufi (see p.304). From this Islamic heritage, the constellations were again transmitted to western Europe in the Renaissance. Printed star maps by European artists such the German engraver Albrecht Dürer (see pp.64–5) harked back directly to the Hellenistic tradition.

The earliest surviving evidence of Chinese constellations comes from the second-millennium BC practice of divination through oracle bones. Systematic astronomy in which astronomers measured and grouped stars into asterisms began in the Han period, and was combined into a single system by Chen Zhuo (third century AD). The Dunhuang Star Charts on paper (c.700 AD) and the Suzhou Star Chart on stone (12th century AD) carefully and accurately map asterisms according to his system (see pp.262 and 298).

From the earliest times, the study of the sky was closely connected not only with divination but also with the annual cycle. The passage of the Sun created day and night, and the Sun's height in the sky correlated with the passage of annual seasons. The phases of the Moon formed a calendar of months.

Calendars have agricultural significance, both defining the growing season and indicating the optimum times for planting and harvesting. The Anasazi people of New Mexico used solar observation to keep an accurate calendar to decide when to plant their staple crop, corn.

The heavens also tracked ritual calendars associated with religion. The lunar calendar that dictates the timing of Ramadan, Eid al-Fitr and other festivals encouraged the development of astronomy in medieval Islamic culture. Judaism and Christianity employed a complex calender that linked the – in fact, unlinked – phases of the Moon and the motion of the Sun. Astronomers working for Christian churches disagreed over the definition of Easter in relation to the full Moon and the spring equinox.

of the Universe as a nest of spheres, each carrying its planet in a near-circular orbit that in Christian cosmology reflected the perfection of the heavens (see p.104).

The motion of the planets proved to be more complicated. A series of systems was proposed to explain away apparent anomalies in circular motion by inventing 'epicycles' – circles whose centres themselves moved in circles – but a hierarchy of dozens of epicycles still did not explain the astronomical observations, even after the Polish cleric Nicholas Copernicus simplified the problem in 1543 by suggesting correctly that the planets, including the Earth, were all in motion around the Sun (see p.164). The breakthrough came from the German astronomer Johannes Kepler, who in 1605 showed that the orbits of Mars and, by extension, of all the planets, were neither circles nor epicycles, but ellipses.

Copernicus and Kepler had laid to rest the centuries' old idea of a heaven of divine (and circular) perfection. The idea was further undermined by the invention of the telescope by the Dutch spectacle-maker Hans Lippershey in 1608. The new device allowed astronomers, starting with the Italian Galileo Galilei, to view the surfaces of the planets and discover their moons, and to show that they were worlds more or less like our own – consistent with Copernicus' idea that the Earth, like the other planets, orbits the Sun. In 1687, Isaac Newton put forward the underlying explanation for planetary motion: gravity, with an inverse-square law of gravitational force across space from one body to another.

The work of Kepler and Newton made it possible to predict such planetary alignments, as that of Earth, Venus and the Sun that causes Venus to transit across the solar disc. Astronomers seized on the phenomenon as a means to use triangulation to determine the distance from the Earth to the Sun, giving the scale of the Solar System. International expeditions were sent to observe transits, particularly one in 1769 observed from Tahiti by Captain James Cook.

Meanwhile, the telescope not only magnified detail: it also gathered more light than the human eye, which brought completely new objects into view. This included faint smudges, called nebulae, listed in their thousands by the eighteenth-century astronomer William Herschel. In 1845 the Anglo-Irish aristocrat Lord Rosse used what was then the largest telescope in the world to make out the underlying structure of some of these clouds, beginning our understanding of galaxies (see p.30).

ASTRONOMICAL OBSERVATION

Until the invention of the telescope in 1608, all astronomical observation was by naked eye. That revealed five planets, named after Roman gods – Mercury, Venus, Mars, Jupiter and Saturn – plus the Sun and Moon, which were also classed as planets because, like the planets, they appeared to circle the Earth, as if on individual spheres. This inspired the idea

PAINTING AND PHOTOGRAPHY

The next technological advance, in the mid-nineteenth century, was the invention of photography. A camera can accumulate light over time, and so can record fainter stars than the eye and telescope alone, further increasing our depth of vision in space. The introduction of photography to astronomy revealed yet more detail about both our own Solar System and the deepest

reaches of the Universe. Coincidentally, the late nineteenth century saw the emergence of science fiction as a literary genre in the hands of Jules Verne and H. G. Wells, while the development of quantum physics and the efforts of scientists such as Albert Einstein in the early 1900s led to new ways to perceive the Universe. Whereas the Dutch artist Vincent van Gogh famously painted a starry sky as an expression of his own mental turbulence in 1889 (see p.114), in the hands of modernists such as Robert Delaunay in the 1910s (see p.92) space became both more futuristic and a more abstract idea – a forming ground for exercises in geometry and colour theory.

At the same time, a generation of 'space artists' – including Lucien Rudaux in France (see p.162) and Chesley Bonestell in the United States (see p.268) – began to ally astronomical information with realistic methods of painting to create likely depictions of other worlds. Their work was integral to the growth in popularity of science fiction novels, magazines and comic books in the 1950s and, especially, in the 1960s, when the race between US and Soviet engineers to place first satellites and then humans in space during the Cold War caught the imagination of people all around the world. The space race culminated in the visits of Apollo astronauts from 1969 to 1972 to the Moon – the only world other than Earth directly experienced by humans. The Moon was found to be a bleak place – one astronaut described the lunar surface as 'magnificent desolation'.

Since 1959, approximately 200 spacecraft have explored the Solar System. These probes have studied all the planets and their moons, and some twenty-five asteroids and comets. From orbit, they can study surface details at a scale as small as 10 metres across. Rovers have travelled for tens of kilometres across the surfaces of some planets – and again recorded in close up mainly 'magnificent desolation'.

Spacecraft and astronauts broke the physical limitations of the Earth by travelling into space in order to explore the Universe; so too the space age freed the gaze of astronomers from the constraints imposed by Earth's atmosphere. In 1990, NASA launched the Hubble Space Telescope (HST), which went into orbit 545 kilometres (340 miles) above Earth. The HST and subsequent space telescopes, together with ground-based detectors such as radio telescopes, extended our view of space even further. These detectors translate radio, infrared, ultraviolet and X-ray radiation into something we can see and open new windows on to the Universe. Through the radio window, astronomers saw what we now know are distant exploding galaxies, through the infrared one they saw newly forming planetary systems, and through the X-ray window they saw black holes. In the hands of contemporary artists such as Yayoi Kusama (see p.207) and Tomás Saraceno (see p.80), the revelation of deep space becomes the starting point of investigations of infinity, cosmic dynamics and the position of humans within an unimaginably vast Universe.

If there is an equivalent in contemporary astronomy to the excitement generated by the space race of the 1960s, it might be the search for planets orbiting stars beyond our Solar System. The distances to these extra-solar planets (exoplanets) are astounding, so the images that reach space or land-based telescopes show no detail: it is a significant technological feat simply to be able to say that they exist. Astronomers have identified about 3,000 exoplanets, and more are suspected. The search for further exoplanets focuses on finding those that are in the 'Goldilocks zone' – neither too hot nor too cold – because they may sustain liquid water and thus have the potential to support extraterrestrial life.

SHAPE OF THE UNIVERSE

As our ability to perceive objects in the Universe has changed, so has our understanding of the structure of the cosmos. The stars appear as if they are pinned to a sphere above us, and were represented in this way up to the sixteenth century. But with the growth of astronomy as a science, astronomers came to comprehend both that the distances to the stars are huge and that stars are distributed unevenly in space, with more occupying a slab in space that corresponds to the flat plane of our spiral galaxy, which we see as the Milky Way. Towards its centre we look out to vast, dense swarms of stars. Although many parts of the Galaxy are obscured by interstellar dust radio, infrared and X-ray telescopes can penetrate through the obscuration and reveal the supermassive black hole at the centre (see p.118–119).

The stars themselves are suns, masses of gas that accumulate through gravity into spheres. They heat to such temperatures that they sustain nuclear reactions and generate enormous amounts of energy. They form star clusters within galaxies, in the clouds (or 'nebulae') of hydrogen gas (and other chemical elements) that lie in interstellar space. Star colours are subtle, unsaturated pastels, almost white, because they are the result of a mixture of all of the primary colours of the spectrum, ranging from pale red through orange and yellow to pale blue. Blue stars are hotter and energize the atoms in the gas of interstellar nebulae, so that they emit light. False-colour photographs of nebulae are often beautiful, with deep, saturated colours (because they emit light in sparse combinations of a few primary colours). Their shapes vary from the intriguingly free-form to the geometrically structured.

Stars generate the radiation by which we see them from nuclear energy, but when its fuel runs out a really big star will eventually collapse under its own mass and explode as a supernova (see p.94), blasting material into space as a rapidly expanding shell that eventually dissipates in beautiful tracery (see p.286). The chemical elements released mix with hydrogen in the interstellar medium and will in the future condense into new stars with their associated planetary systems.

Supernovae generate not only a gaseous cloud but also a dense, compact stellar remnant that lasts essentially for ever, in the form of a neutron star or a black hole, the existence of both of which was predicted for decades by theoretical physics. Neutron stars were eventually discovered in 1967 in the form of pulsars – pulsating radio stars – regularly emitting pulses of radio waves that people at the time speculated might be from an extraterrestrial civilization. Evidence for black holes came at about the same time through the detection of X-rays generated by gaseous matter falling into them, but greater confidence about their reality came in 2015 with the discovery of a chirp of gravitational radiation emitted as two black holes in a binary system merged. Gravitational radiation had been predicted in Albert Einstein's Theory of General Relativity (1915) as ripples in space-time. The German-born physicist's idea was that space is not 'nothing', but a physical entity that interacts with matter. 'Matter tells space how to curve, space tells matter how to move,' Einstein wrote. The two fast-moving black holes caused curves in space that propagated like waves – and in 2015 the curves moved some components in a gravitational wave detector named LIGO. The concept would be hard to conceive did we not have artists to illustrate it (see pp.124–5).

GALAXIES

Once it was clear that the stars are scattered in space, the question was whether they extend indefinitely or whether they come to an end, perhaps with other star systems in existence beyond this boundary. The answer proved to be that the stars of our Milky Way form a galaxy that is indeed finite, with other galaxies out in the space beyond. The fuzzy patches glimpsed by William Herschel in the eighteenth century included many other galaxies like ours, millions or billions of light years away. Their forms are clear to modern instruments like the HST, but the further away galaxies are the smaller they appear. The HST spent days in 1995 staring at a portion of sky that appeared blank in order to record the faintest possible galaxies there. The picture that resulted is full of small, faint galaxies (see p.244). The furthest galaxy so far discovered by the HST is so far away that its light has taken 97 per cent of the age of the Universe – some 13.4 billion years – to reach Earth.

Astronomers have mapped the distribution of galaxies in an ever-wider exploration of the Universe. Galaxies congregate in small groups, pulling and tearing at each other (see p.31) and assemble into gigantic clusters. Recent surveys by robotic telescopes have mapped the millions of galaxies out to one billion light years and sampled their distribution ten times further out. Because the telescopes see the distant galaxies as they were in the past, it has been possible to infer how, over time, they have clustered together, attracting other galaxies nearby and opening up voids in space. In order to make everything fit the observations, astronomers have concluded that space contains 'dark matter', a hidden component that is five times more common than visible matter. The search is on to determine its nature.

A key property of galaxies is their speed. The American astronomer Edwin Hubble found in 1929 that galaxies were systematically moving away from us, a phenomenon explained by the Belgian Abbé Lemaitre on the basis of the Theory of General Relativity as being due to the explosion at the beginning of the Universe in what has come to be called the Big Bang. A remarkable recent discovery is that the resulting expansion is accelerating, contrary to the expectation that it should slow down with time. The possible cause of this phenomenon has been given the name of 'dark energy', by analogy with the term 'dark matter'. No one knows what dark energy is.

COSMOLOGY

The faintest galaxies detected by the HST represent a frontier in the exploration of the Universe by visible light. Because, in cosmology, distance relates to time in the past, it is a frontier in time as well as space. Beyond it lies the era during which stars and galaxies were forming, but the frontier has been crossed only by theory and simulation. It is very difficult to see what is there because newly born galaxies are full of dust that cloaks the light of stars inside. This region thus corresponds to a period in the life of the Universe that astronomers colloquially call the 'Dark Ages'. Beyond in distance and before in time lies the Big Bang.

Although visible light does not cross or come from that zone, microwave and infrared radiation do – and they bring an image almost of the Big Bang itself. This is the image of the Cosmic Microwave Background, the image in this book that originated before all the others (see p.301), just 400,000 years after the start of the Universe. The existence of the radiation was first discovered by radio astronomers in 1964, and its image was first recorded by the Cosmic Microwave Background Explorer (COBE) in 1992, having travelled across the Universe for nearly 14 billion years. Recorded by NASA's Wilkinson Microwave Antistrophy Probe (WMAP) in 2012, the image shows a blotchiness that represents the first development of structure in the Universe revealed by minute fluctuations in temperature. The blotches are almost but not quite without form, and grew into galaxies – they are thus linked to the birth of our own Galaxy and therefore our own origins as a species. Determining what happened in the Big Bang, including the nature of dark matter and dark energy, and the subsequent history of the Universe, including what happened in the Dark Ages, altogether constitutes the subject of cosmology. With the search for exoplanets, it is arguably one of the two most exciting subjects in astronomy today.

A VISUAL RECORD

Those two fields – cosmology and exoplanets – continue an exploration of humans' own place in the Universe that has lasted for at least 17,000 years. *Universe: Exploring the Astronomical World* reflects all aspects of that exploration, from the mystical and religious to the purely scientific, the aesthetic, the symbolic and even the psychological. It features works by both outstanding figures from the history of science and leading historic and contemporary artists. It also shows how astronomy has been part of everyday life for centuries, from medieval almanacs and calendars to nineteenth-century playing cards, board games and wall hangings. Although the images come from a wide range of sources, they are all in their own way records of the same quest: that of understanding the heavens and what they tell us about ourselves.

For the vast majority of history, humans had no view of space other than what they could see with the naked eye, and even the first telescopes probed only the neighbouring heavenly objects. Objects from the Solar System – the Sun, Moon, planets, asteroids and comets – therefore make up the bulk of the images in this book. Nevertheless, the larger galactic and cosmological scale is also well represented, particularly by the remarkable revelations from the last forty or so years of star formation and destruction in deep space. With their fundamentally real but dramatically exaggerated colourization, many images from the Hubble Space Telescope, such as the renowned Pillars of Creation (see p.18), are as visually striking and aesthetically beautiful as works of art.

Overall, indeed, the images collected in *Universe: Exploring the Astronomical World* strongly contradict the idea that there is a division between 'scientific' and 'artistic' depictions of space. Just as tomb paintings by ancient Egyptian artists included aesthetic details in a depiction of the night sky intended to illustrate the structure of their religious beliefs and medieval depictions of recorded portentous comets glow in dramatic tones of gold and red, so early and modern astronomical photographs are often as visually arresting as they are scientifically revealing. All the works included here succeed in making what is not always visible both visible and memorable – and yet while visual images can help to make astronomical ideas accessible, it is not always guaranteed that they will make them comprehensible. At heart, some of the ideas related to astronomy – the size, age, and sheer multiplicity of space – still lie at the limit or beyond the grasp of human understanding, just as did the apparent motion of the Sun and the shape of the stars for our ancestors millennia ago.

The fact that we understand more now than in the past is not simply the result of technological advances, although clearly developments in telescopes, spacecraft and astrophotography have been key. As these pages show, there has also been a change in humans' emotional response to the Universe. As we have learned more about it physically, we have also come to interpret it in different ways. For that reason, space has long fascinated scientists, astronomers and visual artists and it remains a recurring subject in our society and culture. Many of the images prove that, as astronomical research continues, the close relationship between the scientific and the artistic will remain as close as it has been for the last 17,000 years.

Paul Murdin
Institute of Astronomy, Cambridge

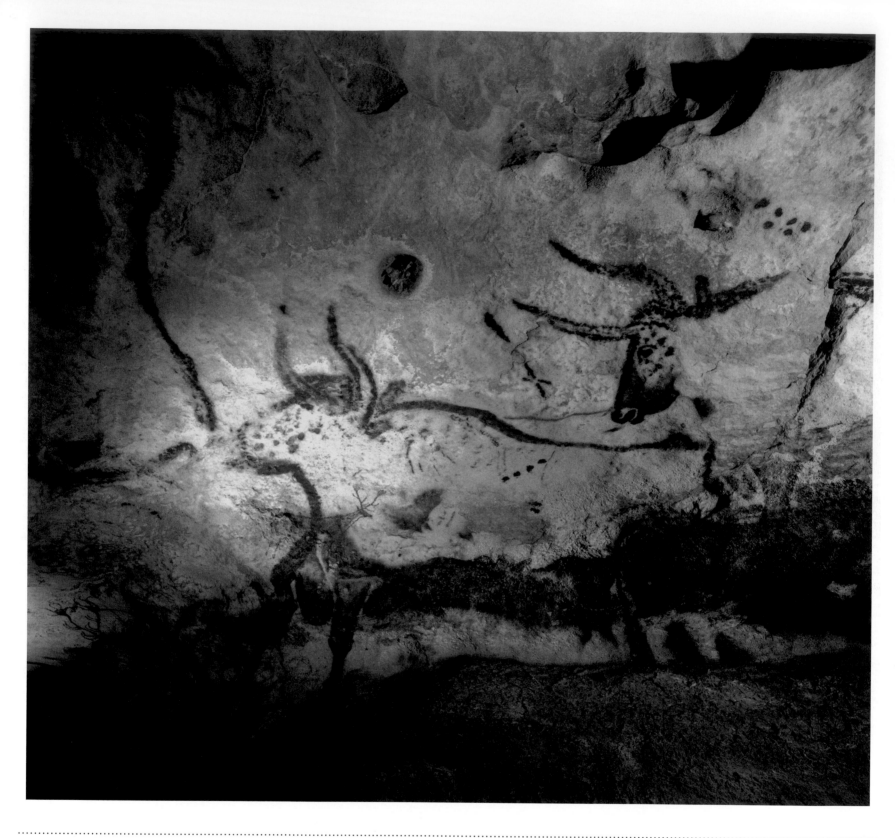

HALL OF BULLS, LASCAUX CAVES
*c.*15,000 BC

UNKNOWN

Pigments on rock, dimensions variable
Lascaux, France

The artists who painted these now-extinct wild cattle, called aurochs, on the wall of the Lascaux Caves in the Dordogne region of France around 17,000 years ago combined an expressive style with a purpose that was probably at least in part mystical and supernatural. Above one of the animals are six dots, arranged in a shape reminiscent of the stars known as the Pleiades (although in classical mythology there are seven

Pleiades, one star is less easily seen than the rest). The Pleiades are part of the constellation of Taurus, the Bull, and the coincidence that the six-star asterism is adjacent to the aurochs suggests that the animal may be seen as one of the constellation's forerunners. The aurochs' eye is surrounded by another cluster, this time of twelve dots. The arrangement is reminiscent of the star Aldebaran, positioned as the eye of Taurus and the Hyades star

cluster surrounding it. If so, the Lascaux Caves are home to one of the earliest celestial maps. These, and other cave paintings of animals, are thought to have been intended as an appeal to the gods to smile upon hunters. It appears that the Lascaux Caves may have astronomical significance – and provide evidence that Western mapping of the constellations is tens of thousands of years old, dating back into the ice ages.

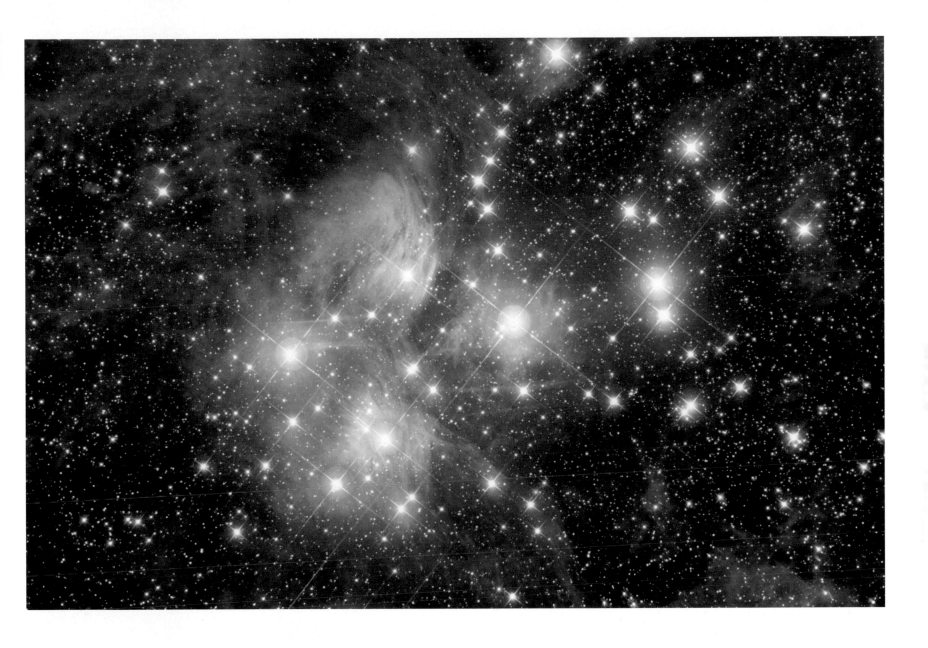

M45 (THE PLEIADES)
2012

EMIL IVANOV

Digital photograph, dimensions variable

The group of stars captured by the Italo-Bulgarian opera singer and astrophotographer Emil Ivanov shows one of the most familiar of all star clusters, the Pleiades or Seven Sisters. For classical civilizations around the Mediterranean, the constellation's near-dawn appearance from behind the Sun at the start of spring, called its heliacal rising, marked the beginning of agricultural and nautical activities. There are certainly seven sisters named in the Greek myth – Maia, Electra, Alcyone, Taygete, Sterope, Celaeno and Merope – but the number of stars visible in the Pleiades depends on eyesight, telescopic aids and the clearness of the sky. Six stars are clearly visible to the naked eye, but one seems to have grown fainter over the millennia. Keen-sighted people can see about a dozen stars, and in 1610 Galileo counted more than forty in his new telescope. Modern astronomers now count more than 1,000. Photographs show that the star cluster is embedded in blue nebulae formed of interstellar dust into which the Pleiades have strayed by chance. The nebulosity is caused by the starlight being deflected or scattered by the dust and it is blue for much the same reason that the sky is blue: dust scatters blue light more easily than red.

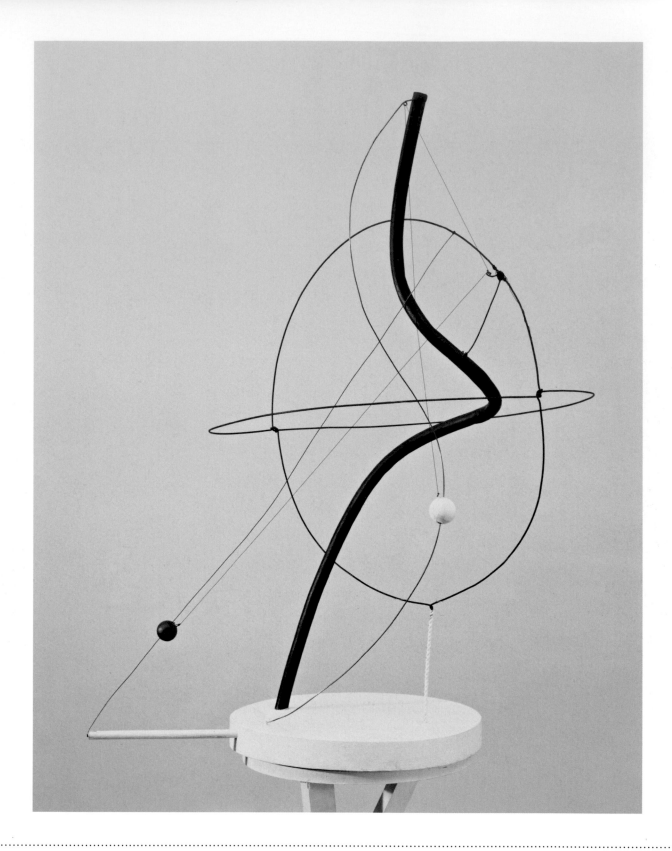

A UNIVERSE
1934

ALEXANDER CALDER

Painted iron pipe, steel wire, motor and wood with string
102.9 × 76.2 cm / 40½ × 30 in
Museum of Modern Art, New York

This sculpture by the renowned American artist Alexander Calder (1898–1976) was one of his first to move. A motor causes the two small red and white spheres to glide at different speeds along the undulating wires in a cycle that takes forty minutes to complete. *A Universe* recalls the dynamism of the cosmos, its abstract spheres, circles, lines and ellipses conjuring an impression of unifying forces. A black iron pipe provides a central axis that eventually curves as a helix, around which thinner lines arc. Calder was a pioneer of 'drawing' in three dimensions, using wire as a means of rendering line as volume in space, in addition to his famed experiments with the element of movement in his artworks. 'Just as one can compose colors, or forms,' wrote Calder, 'so one can compose motions.' While Calder was fascinated by the ever-changing, ever-expanding energies, the world science was equally fascinated by his interpretation of them. Albert Einstein was reportedly spellbound by *A Universe* when it was exhibited in Calder's 1943 retrospective at New York's Museum of Modern Art, standing and watching the two spheres moving for the whole forty-minute cycle.

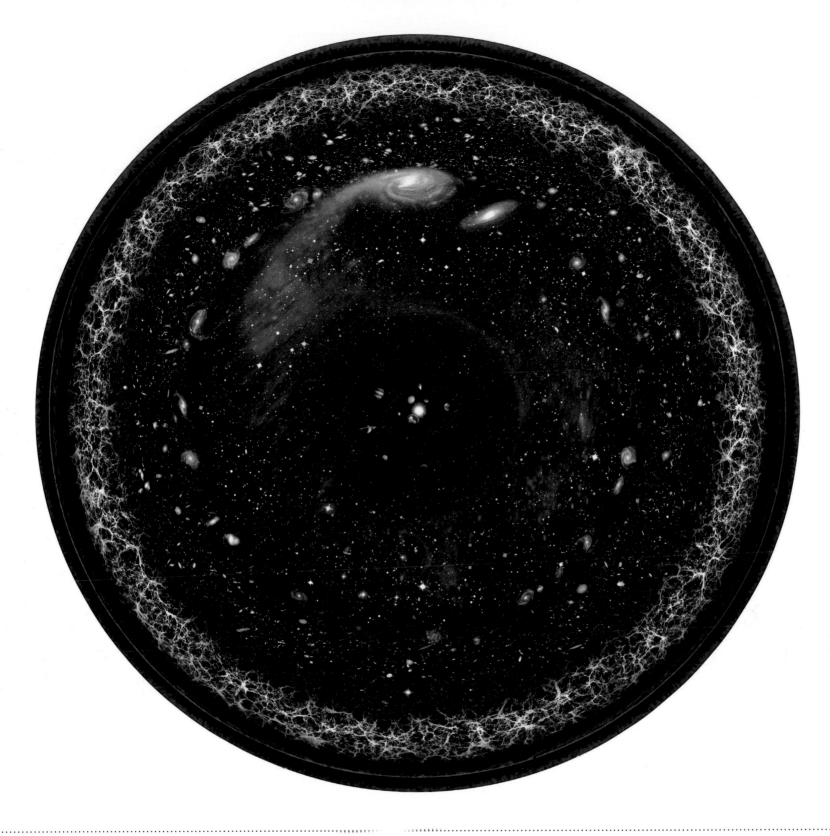

OBSERVABLE UNIVERSE
2012

PABLO CARLOS BUDASSI

Logarithmic illustration, dimensions variable

The idea to depict the entire Universe in a single image came to the Argentine artist Pablo Carlos Budassi while making hexaflexagons – paper polygons with a number of faces, often made by children. Budassi began sketching the central planets of the Solar System using a logarithmic approach: radiating from the centre, the scale increases by a factor of ten with each concentric section. He based his work on maps of the Universe produced at

Princeton University using data from the Sloan Digital Sky Survey (SDSS), and used Photoshop to combine images from NASA telescopes and probes. The Sun is at the centre, surrounded by the planets (we view Earth from the south), with Alpha Centauri at lower left in the haze of the Milky Way Galaxy. Most of the Milky Way is at top centre, among distant galaxies that merge into a network of filaments, the cosmic web – sheets and walls

of galaxies structured around voids at the edge of what we can see with visible light. The Universe is receding so fast that visible light is stretched into infrared radiation, and what we see is very old. At the red edge of the image is the cosmic microwave background, the echo of the Big Bang itself, which occurred about 13.8 billion years ago. It marks the edge of our understanding, as dictated by the travel time of light reaching us from the distant past.

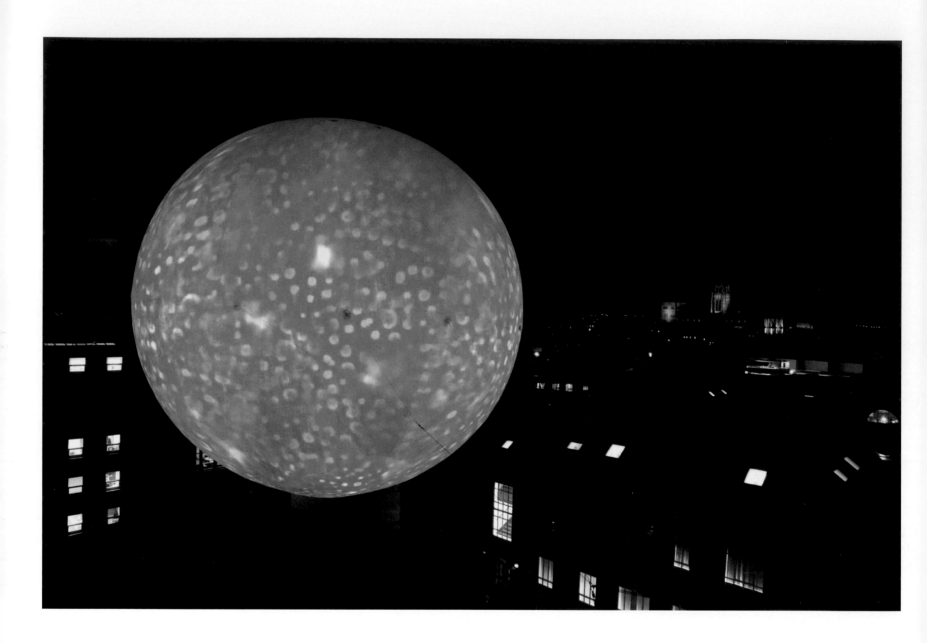

SOLAR EQUATION, RELATIONAL ARCHITECTURE 16

2013

RAFAEL LOZANO-HEMMER

Spherical captive balloon, helium, tethers and winches, 5 HD projectors, 7 computers with custom-made software, wifi network, iOS app
Installation view, Lumiere Festival, Durham

The mesmeric allure of this artificial Sun can outshine even the full Moon. For *Solar Equation*, Mexican-Canadian artist Rafael Lozano-Hemmer (born 1967) shrank the Earth's closest star by 100 million times and installed it in various public places as a large floating balloon (it was originally commissioned for Federation Square in Melbourne, Australia, a country in which high levels of ultraviolet radiation have caused many health problems, but it appears here in a later version in Durham in the north-east of England). The balloon's animated surface was rendered by five projectors, which beamed NASA's solar observatory images onto it. Illuminated with vibrant tones, the mottled exterior swirled as solar flares exploded, whirling flames licked and sparks flew. Lozano-Hemmer is known for his use of technology in works that often require viewer participation. Here, visitors were invited to download a free iOS application that allowed them to shape the projected images interactively. The work allowed the Sun's destructive power to be witnessed up close, but equally, its sublime beauty was intended to evoke the moods created by the poetry of William Blake and Johann Wolfgang von Goethe.

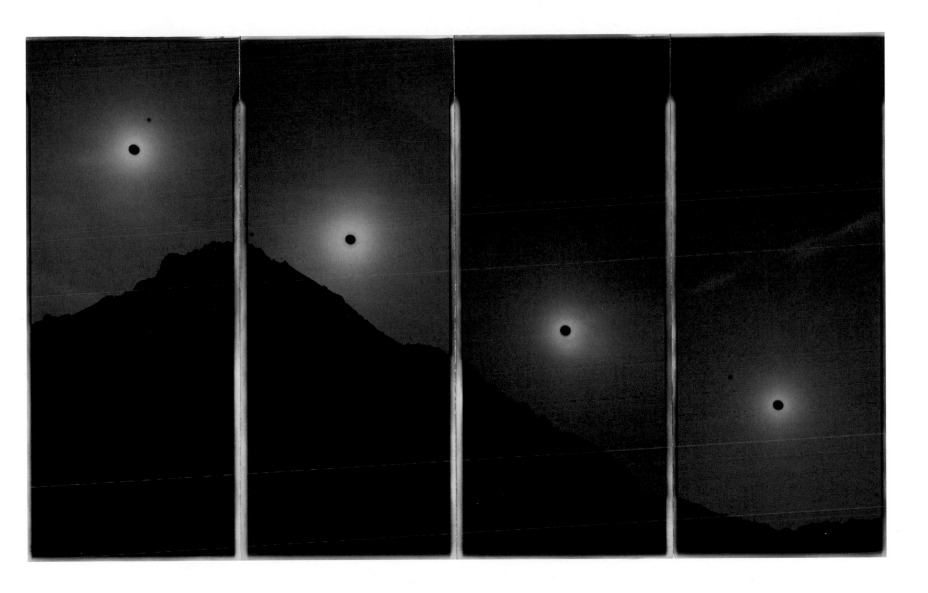

SUNBURNED GSP#839 (EVERY 30 MINUTES, ARCTIC CIRCLE, ALASKA)

CHRIS MCCAW

Unique gelatin silver paper negatives
Each: 25.4 × 10.1 cm / 10 × 4 in
Private collection

2015

The Sun moves in distinct steps down the slope of a North American peak in this series of images by American photographer Chris McCaw (born 1971). McCaw's work manifests the power of the Sun's intense light. By exposing photographic paper for long periods in a large-view camera of his own design, McCaw allows the sunlight to burn the film and leave behind blackened, sometimes charred photographic emulsion. The artist's experiments with this technique make different experiences of time visible, sometimes – such as here in *Sunburned GSP#839* – isolating the regular periods used to create each separate 'slice' and, by doing so, intensifying the experience of each. In others, a multi-hour exposure results in a single burn that tracks the Sun's movement across the sky, suggesting the ceaseless forward motion of time. He often photographs the Sun over favourite landscapes, such as the Pacific Ocean off the coast of his native California and the Arctic Circle, where the twenty-four hours of summer sunlight have inspired some of his most ambitious pieces. McCaw's focus on scenes devoid of human life aligns him with a long tradition of landscape photography, and calls to mind William Henry Fox Talbot's claim that the chemical nature of photography allowed nature to draw its own picture.

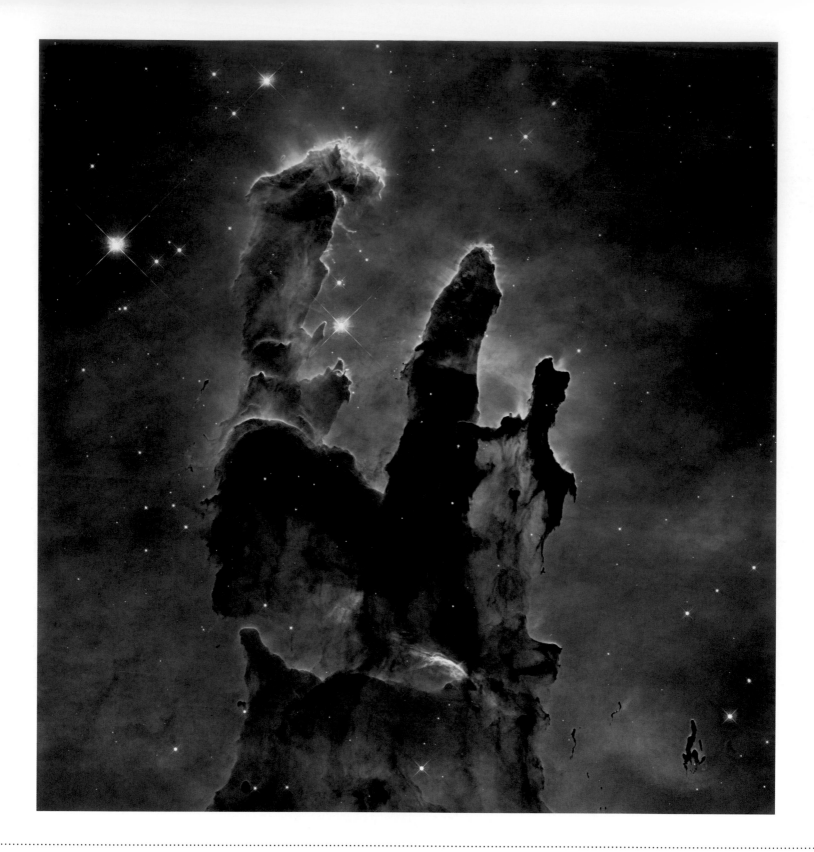

PILLARS OF CREATION IN THE EAGLE NEBULA

2014

NASA, ESA, HUBBLE HERITAGE TEAM (STSCI/AURA), J. HESTER, P. SCOWEN (ARIZONA STATE UNIVERSITY)

Composite digital image, dimensions variable

Three dramatic pillars of dust and gas, nearly 7,000 light years away in the Eagle Nebula in the constellation of Serpens, dominate one of the most famous images taken by the Hubble Space Telescope. Originally captured soon after Hubble's mirror was repaired in December 1993, the 'Pillars of Creation' redeemed the HST in the public eye after the anticlimax of its blurred initial images. The quasi-biblical name – a quote from the nineteenth-century Christian preacher Charles Spurgeon – helped to underline the spiritual quality in this image of stars being created at the tips of the columns. The pillars are vast star nurseries – each protusion is as large as our Solar System, and the dust hides globules that will give birth to new stars – but it is likely that the pillars were destroyed in a supernova explosion some 1,000 years ago (this image shows it as it was 7,000 years ago). In any case, the pillars are being eroded, albeit gradually, by photoevaporation caused by ultraviolet light from nearby stars. This image, taken with better cameras, is a recreation of the original, celebrating the 25th anniversary of the telescope. One of the jet-like structures at lower right had lengthened in 19 years by 60 billion miles. The colours identify the gas in the pillars: hydrogen (green), sulphur (red) and oxygen (blue).

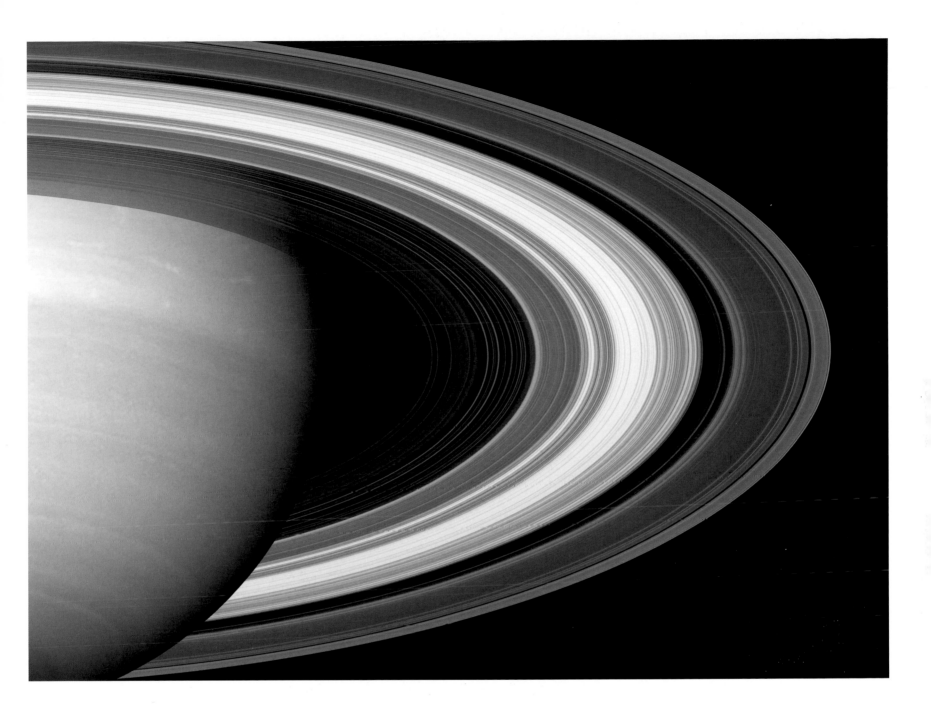

RADIO OCCULTATION: UNRAVELLING SATURN'S RINGS

2005

NASA, JPL

Digital simulated image, dimensions variable

The colours of this striking image lend a new elegance to one of the most intriguing features of the Solar System: the rings of Saturn. This false-colour simulation of the rings of orbiting particles that extend 282,000 kilometres (175,000 miles) into space around the equator of the planet is based on data from the Cassini spacecraft, which went into orbit around Saturn in 2004. Cassini passed behind the rings, then sent radio signals back through them to Earth, where they were used to create this colour-coded image of the particles in the rings. The colour purple indicates regions populated predominantly by particles larger than 5 centimetres (2 inches) in diameter and green indicates those regions with particles smaller than 1 centimetre (one-third of an inch). The white areas are high-density regions where it was too difficult to make a good determination and black areas indicate a paucity of particles, making the rings effectively transparent. Some particles in the rings are several metres across, whereas other are kilometres wide and deserve to be labelled 'moons'. Some of the individually identified moons (there are more than sixty) influence the orbits of the particles by shepherding them into groups with similar orbits. The image is at once an intriguing mixture of both simplicity and complexity, order and randomness.

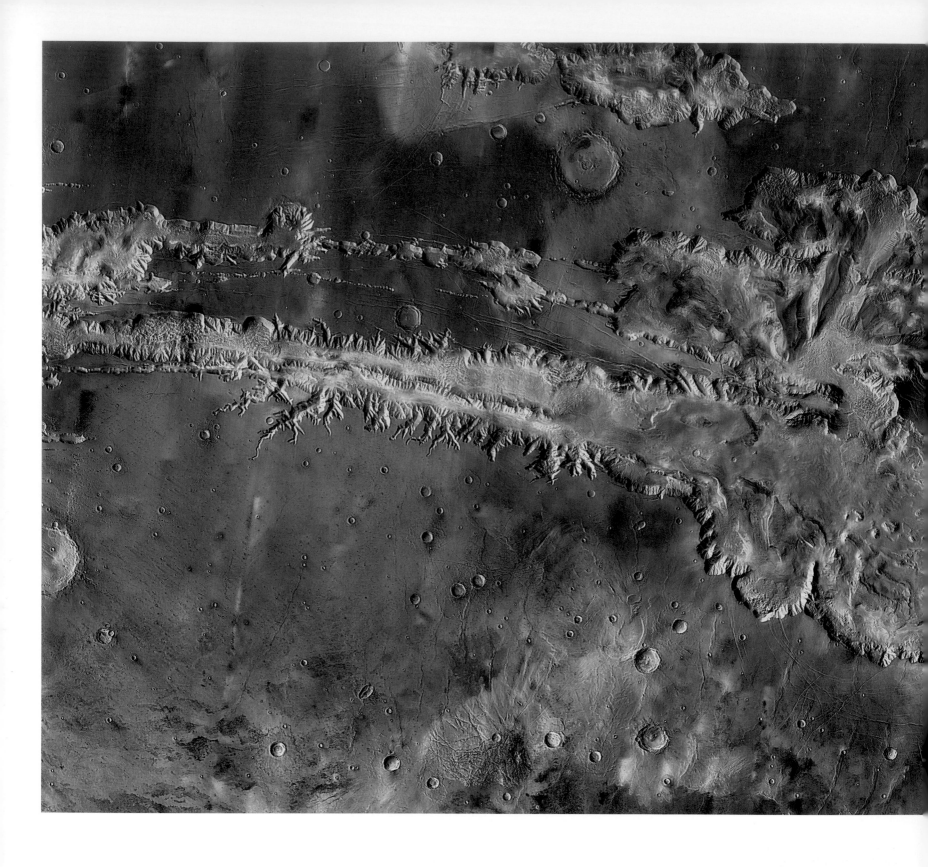

VALLES MARINERIS
2001

NASA, JPL-CALTECH, ARIZONA
STATE UNIVERSITY

Composite digital image, dimensions variable

Imagine the Grand Canyon. Lengthen it, so that instead of being the width of one state, Arizona, it is nearly the width of the USA. Widen it by five to ten times. Deepen it by five times. Move it to Mars. This is the scale of the Valles Marineris, the largest canyon known in the Solar System, discovered by the Mariner spacecraft in 1972 and named accordingly. At the centre of this image, taken by NASA's Mars Odyssey, is the region of the

Valley known as Melas Chasma, the floor of which lies 11 kilometres (6.8 miles) below the surrounding plain. Unlike the Grand Canyon, which was worn away by the Colorado River, the Valles Marineris is a rift valley, cracked in the surface of Mars by a volcanic upswelling from within the planet. It has been enlarged by landslides from its cliff sides – triggered either by volcanic activity or by meteor impacts – that cover parts of the Valley's

floor with hills of rubble. At some time in the distant past, when Mars was not the desert world that it is now, water cascaded down these cliffs. Now, what water there is seeps in trickles down the sides from damp springs, but at some time in the past rushing streams and winds have eroded gulleys into the cliffside. Parts of the canyon that would have been filled with water are now a flat-bottomed, dry lake.

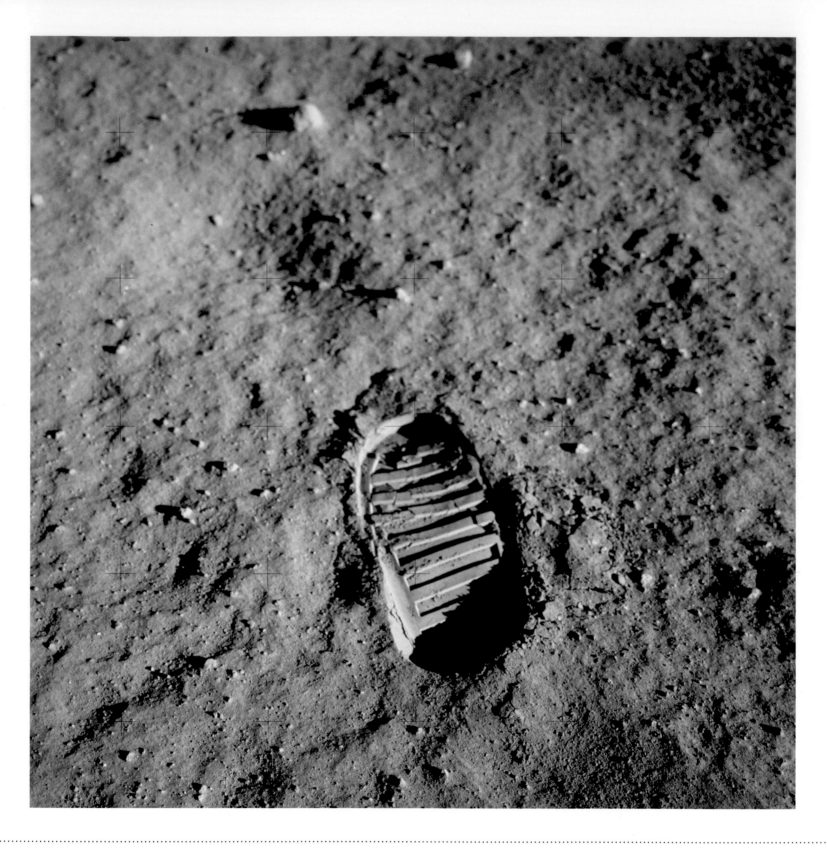

BOOTPRINT ON THE MOON
1969

BUZZ ALDRIN, NASA

Photograph, dimensions variable

The print left by the sole of Buzz Aldrin's boot on the surface of the Moon in the astronaut's photograph is an iconic image that sums up the technological triumph of the mission by NASA to put humans on the Moon. At 03:15 GMT on 21 July 1969, Aldrin became the second person to tread on the Moon, following Neil Armstrong, who had stepped out on to Tranquillity Base from Apollo 11's Lunar Module *Eagle* twenty minutes earlier. At first

Aldrin stood transfixed, looking around at the grey lunar scenery, crystal clear under the airless sky of stars, before he turned to the objectives of his mission. To provide evidence for the mission engineers about the texture and strength of the lunar surface, Aldrin found a flat area and pressed his boot into the lunar dust. The surface was powdery; the boot went in only a few millimetres and the fine particles preserved the imprint of its tread. Aldrin's

photograph recorded the scientific data as he intended, but it also became an iconic and romantic lunar image. The image captures the significance of the mission – a historic step by a human being, on to that precise place at that precise moment, one of the very first steps on another world.

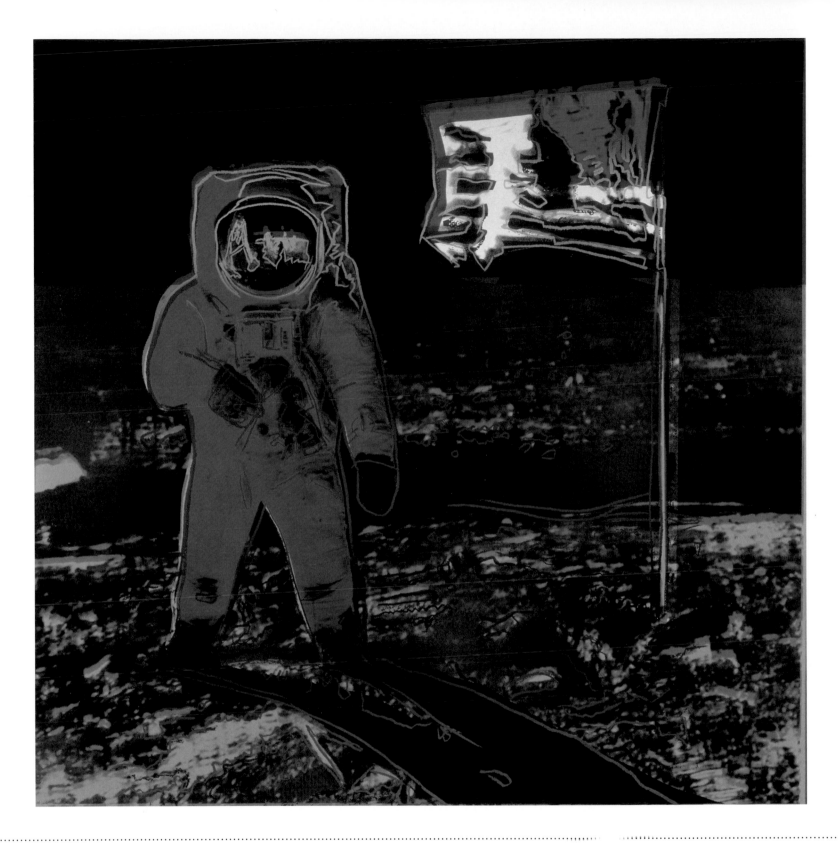

MOONWALK
1987

ANDY WARHOL

Screen print, 96.5 × 96.5 cm / 38 × 38 in
The Andy Warhol Museum, Pittsburgh, PA

Moonwalk celebrates the historic Moon landing of July 1969, when Apollo 11 commander Neil Armstrong and 'Buzz' Aldrin became the first human beings to step on another world. Armstrong had portrayed Aldrin standing on the barren lunar terrain, his own silhouette reflected on the visor of his crewmate's helmet, a shot that made headlines around the world and remains one of the defining images of the era. Warhol (1928–87) places

Aldrin next to the American Flag for added effect. His colourful print conjures a sense of lost euphoria and glamour tinged with nostalgia. The Apollo space programme had abruptly ended in 1972, and for all the momentousness of the first landing, by 1987 the Moon was no longer the 'next frontier' it had promised to be. Warhol is one of only seven artists whose work is present on the Moon. Paul Van Hoeydonck's *Fallen Astronaut* was

delivered by the crew of Apollo 15 in 1971 (see p.43) and Warhol's stylized signature – which resembles a rocket – figures with drawings by Robert Rauschenberg, David Novros, John Chamberlain, Claes Oldenburg and Forrest Myers on the *Moon Museum*; this tiny ceramic chip was allegedly smuggled by a NASA engineer on to the landing module of Apollo 12's lunar lander, Intrepid, in 1969, which was left on the lunar surface.

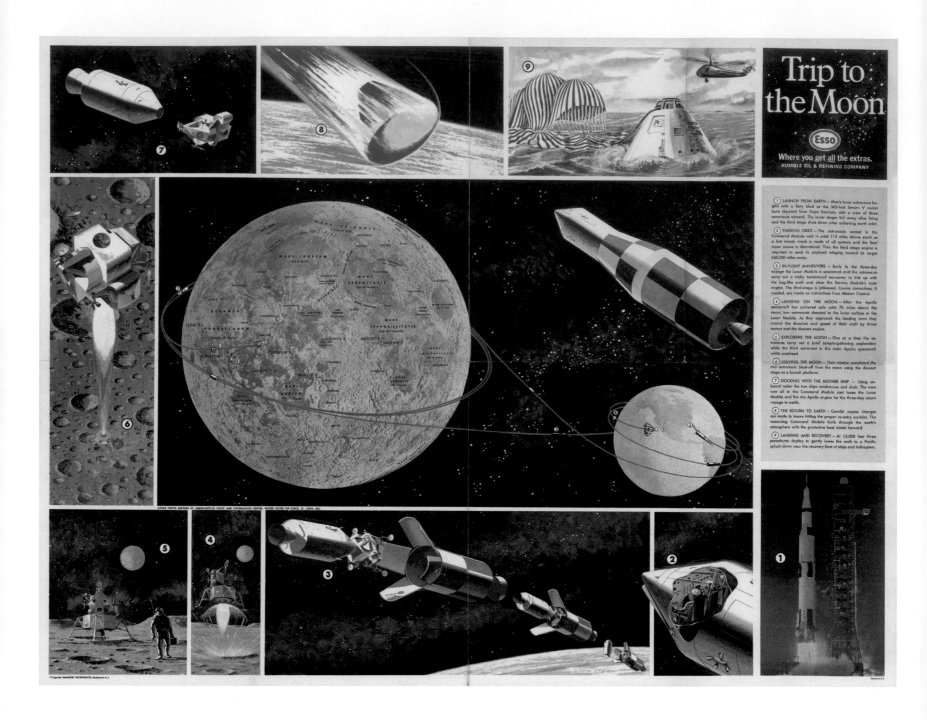

TRIP TO THE MOON
1969

HAMMOND INC., NASA

Printed paper, 47 × 62 cm / 18½ × 24½ in
David Rumsey Historical Map Collection, Stanford, CA

Founded in 1900, the American cartographic publisher C. S. Hammond & Co. was at its peak in the 1950s and 1960s, and its cartographers drew on decades of experience to produce this 1969 poster of the Apollo 11 moonshot, which was only weeks away. Around an accurate map of the Moon, a view of the spacecraft and lines indicating its course, the illustrations depict key stages of the mission (many already familiar from

previous Apollo missions): launch, entering orbit, in-flight manoeuvres, landing on the Moon, exploring, leaving, docking with the orbiting Command Module, re-rentry to Earth's atmosphere and splashdown. Placing the North American continent centre stage on the globe allows the map to highlight the launch from Cape Kennedy, Florida, and the Pacific Ocean landing site off California's coast. The Moon is enlarged to show labelled topographical

details; in reality, it is only about one-quarter the diameter of Earth. The detail is strikingly reliable: the poster was produced in association with NASA to educate a public keenly anticipating the mission to land men on the Moon for the first time. A number of versions were produced, some including photographs of Apollo astronauts. This version was given away as a promotional gift in US petrol stations by the oil company Esso.

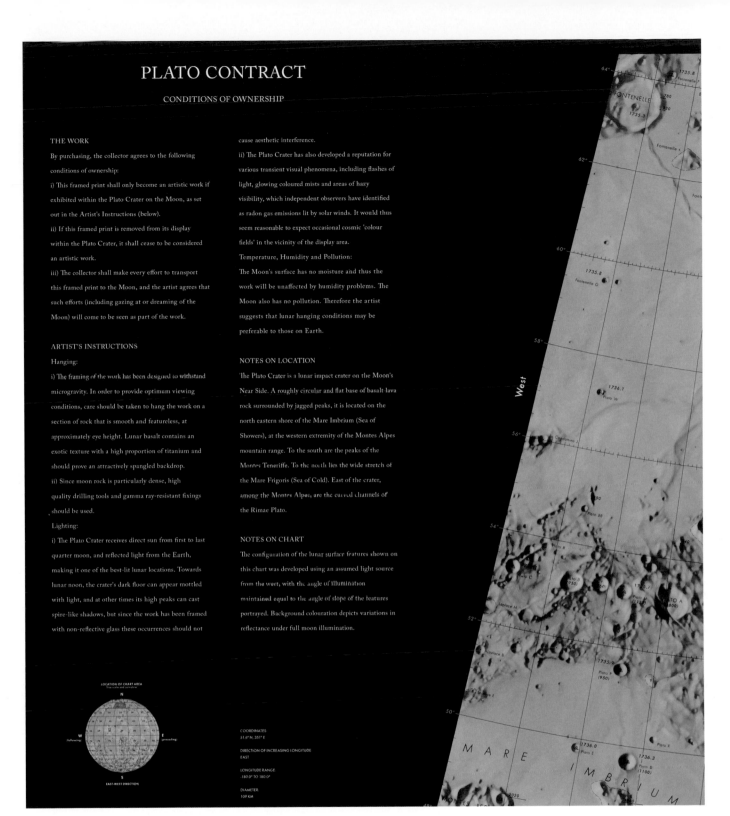

PLATO CONTRACT

CONDITIONS OF OWNERSHIP

THE WORK

By purchasing, the collector agrees to the following conditions of ownership:

i) This framed print shall only become an artistic work if exhibited within the Plato Crater on the Moon, as set out in the Artist's Instructions (below).

ii) If this framed print is removed from its display within the Plato Crater, it shall cease to be considered an artistic work.

iii) The collector shall make every effort to transport this framed print to the Moon, and the artist agrees that such efforts (including gazing at or dreaming of the Moon) will come to be seen as part of the work.

ARTIST'S INSTRUCTIONS

Hanging:

i) The framing of the work has been designed to withstand microgravity. In order to provide optimum viewing conditions, care should be taken to hang the work on a section of rock that is smooth and featureless, at approximately eye height. Lunar basalt contains an exotic texture with a high proportion of titanium and should prove an attractively spangled backdrop.

ii) Since moon rock is particularly dense, high quality drilling tools and gamma ray-resistant fixings should be used.

Lighting:

i) The Plato Crater receives direct sun from first to last quarter moon, and reflected light from the Earth, making it one of the best-lit lunar locations. Towards lunar noon, the crater's dark floor can appear mottled with light, and at other times its high peaks can cast spire-like shadows, but since the work has been framed with non-reflective glass these occurrences should not

cause aesthetic interference.

ii) The Plato Crater has also developed a reputation for various transient visual phenomena, including flashes of light, glowing coloured mists and areas of hazy visibility, which independent observers have identified as radon gas emissions lit by solar winds. It would thus seem reasonable to expect occasional cosmic 'colour fields' in the vicinity of the display area.

Temperature, Humidity and Pollution:

The Moon's surface has no moisture and thus the work will be unaffected by humidity problems. The Moon also has no pollution. Therefore the artist suggests that lunar hanging conditions may be preferable to those on Earth.

NOTES ON LOCATION

The Plato Crater is a lunar impact crater on the Moon's Near Side. A roughly circular and flat base of basalt lava rock surrounded by jagged peaks, it is located on the north eastern shore of the Mare Imbrium (Sea of Showers), at the western extremity of the Montes Alpes mountain range. To the south are the peaks of the Montes Teneriffe. To the north lies the wide stretch of the Mare Frigoris (Sea of Cold). East of the crater, among the Montes Alpes, are the curved channels of the Rimae Plato.

NOTES ON CHART

The configuration of the lunar surface features shown on this chart was developed using an assumed light source from the west, with the angle of illumination maintained equal to the angle of slope of the features portrayed. Background colouration depicts variations in reflectance under full moon illumination.

LOCATION OF CHART AREA
True scale and curvature

COORDINATES
51.6° N, 351° E

DIRECTION OF INCREASING LONGITUDE
EAST

LONGITUDE RANGE
-180.0° TO 180.0°

DIAMETER
109 KM

PLATO CONTRACT

2008

CAREY YOUNG

Detail of framed giclée print, 91 × 62 cm / 35¾ × 24¼ in
Private collection

According to the contract included as an integral part of this giclée print by London-based artist Carey Young (born 1970), this image must be installed on the Moon within the impact crater, Plato, in order to achieve its status as an artwork. Scientific in its appearance – it resembles a page from an encyclopaedia – a topographical map delineates a section of the Moon's surface where smaller pockmark depressions are

overshadowed by the giant impression left by Plato. Its exact location is marked on the north-eastern shore of the Moon's Mare Imbrium, beneath Mare Frigoris. On the left, the conditions of the artwork's ownership are listed, outlining a contractually binding agreement into which the collector enters when acquiring the work. The contract specifies hanging and lighting requirements, as well as the temperature and humidity conditions on the

Moon and the nature of the Plato crater itself. A collector is also asked about his or her personal dreams of the Moon – the subconscious wanderings of their mind over this dusty planet – as Platonic ideas of reality and illusion also come into play. The imagination thus injects wonder and fantasy into an otherwise ordered work, as we read about the crater's transient phenomena that include curious patterns, hazy visibility and flashes of light.

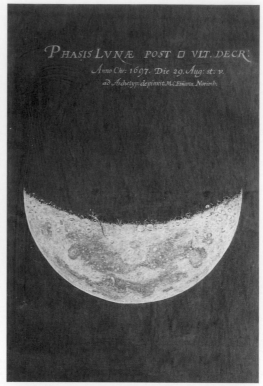

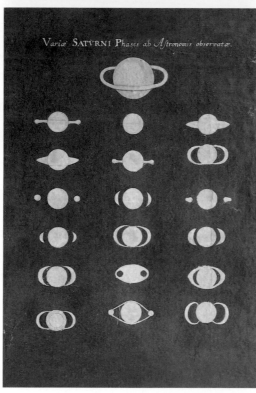

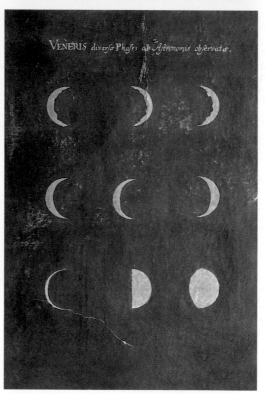

PHASES OF THE MOON AND ASPECTS OF THE PLANETS

Late 17th century

MARIA CLARA EIMMART

Pastel on blue cardboard, each 64 × 52 cm / 25 × 20 ½ in
Museo della Specola, Università di Bologna

These four images – of the Moon (top right), Venus (bottom right), Jupiter and its moons (top left), and Saturn (bottom left) – combine a beautiful simplicity with detail such as the delicate colour shading on the Moon's surface, a remarkably accurate depiction for the late seventeenth century when the plates were created. More remarkably, perhaps, the illustrations were produced by a young German woman, Maria Clara Eimmart (1676–1707), at a time when astronomy was dominated by men. Born in Nuremberg, Eimmart learned to paint as a student of her father, Georg Christoph Eimmart, director of the city's Academy of Art. She worked in her father's observatory, making exact sketches of the Sun and Moon: she is known to have made a sequence of 350 drawings of the phases of the Moon between 1693 and 1698 and two drawings of a total eclipse in 1706. Eimmart's plate of the phases of Venus is perhaps based on Galileo's drawings from 1610, while the images of Jupiter and its satellites are based on those by several distinguished astronomers, including Christiaan Huygens and Robert Hooke. The series of the rings of Saturn – at the time still an enigma – appears to be a copy of a 1696 drawing by the German monk and author Johann Zahn.

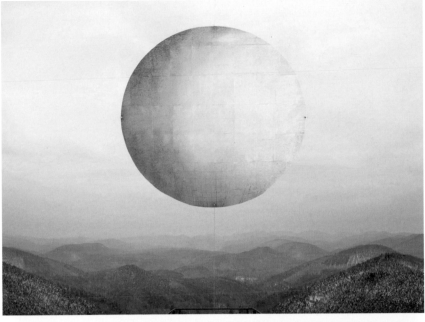

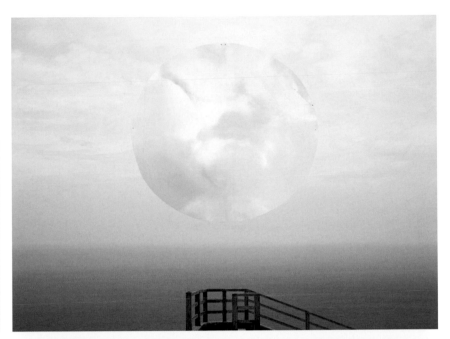

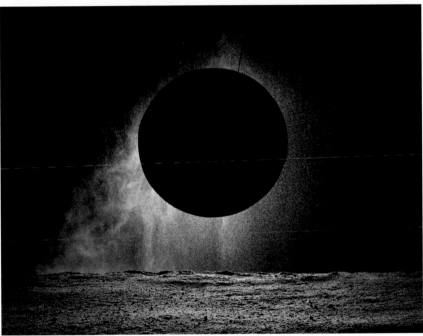

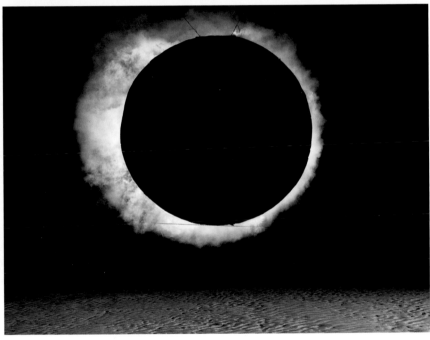

STATION II, STATION III, STATION V AND STATION VI

2015

NOÉMIE GOUDAL

Lightjet prints, top: 168 × 223 cm / 66 × 87¾ in
bottom: 168 × 214 cm / 66 × 84¼ in
Private collection

The large format images in Noémie Goudal's (born 1984) *Southern Light Stations* shift from the earthly orientation of her earlier works to focus on mankind's relationship with and desire to understand the heavens. The project intertwines research from antiquity to the middle ages, referencing astronomical theories of Copernicus and Galileo, whilst simultaneously drawing on pre-Enlightenment astronomy and 'fifth element'

philosophy. The images are the outcome of Goudal's most complex and monumental interventions within the landscape to date. Employing mirrors, dry ice and her signature photographic backdrops, Goudal constructs elaborate scenes which are in turn documented using the camera; her means of construction, however, are always intentionally left visible, forcing the viewer to participate in the illusion on which her artistic practice relies. Goudal

is interested in how photography straddles the line between truth and fiction and although her photographs are recognizably familiar, we are often not quite able to put our finger on what we are looking at. Throughout history, humans have investigated celestial space for both scientific and religious reasons; Goudal's works continue this search, with intangible results.

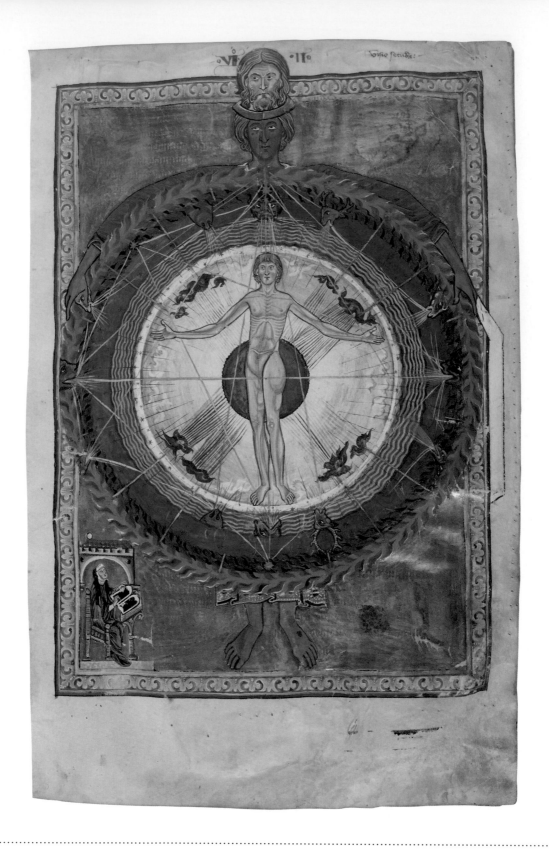

LIBER DIVINORUM OPERUM
13th century

HILDEGARD OF BINGEN

Manuscript on parchment, 22.5 × 20 cm / 8¾ × 7¾ in
Biblioteca Statale, Lucca

Hildegard of Bingen (1098–1179) was renowned in her day as a preacher, reformer and visionary, and has been widely celebrated since her death for her creative genius in subjects ranging through theology, music, medicine and the physical sciences. In this thirteenth-century copy of her most mystical work, the *Liber Divinorum Operum* (the *Book of Divine Works*), she is pictured observing how the Son of God orders the cosmos. In the centre of the image man, the microcosm, is shown to reflect the universe (macrocosm), which Hildegard likens to a wheel. Golden rays represent the influences of the planets and stars, as well as the four winds. With the east wind at the top of the image, these are represented as a leopard (east), a lion (south), a wolf (west) and a bear (north). This presents a mystical vision of the cosmos, but it had practical implications too: Hildegard's theories on the relationship between the four winds, the four elements and the four humours believed to govern human health had direct implications for her medicine, an important part of her work as a Benedictine abbess. The link between a divinely balanced cosmos and the delicate balance of human health was a core feature of the medieval sciences.

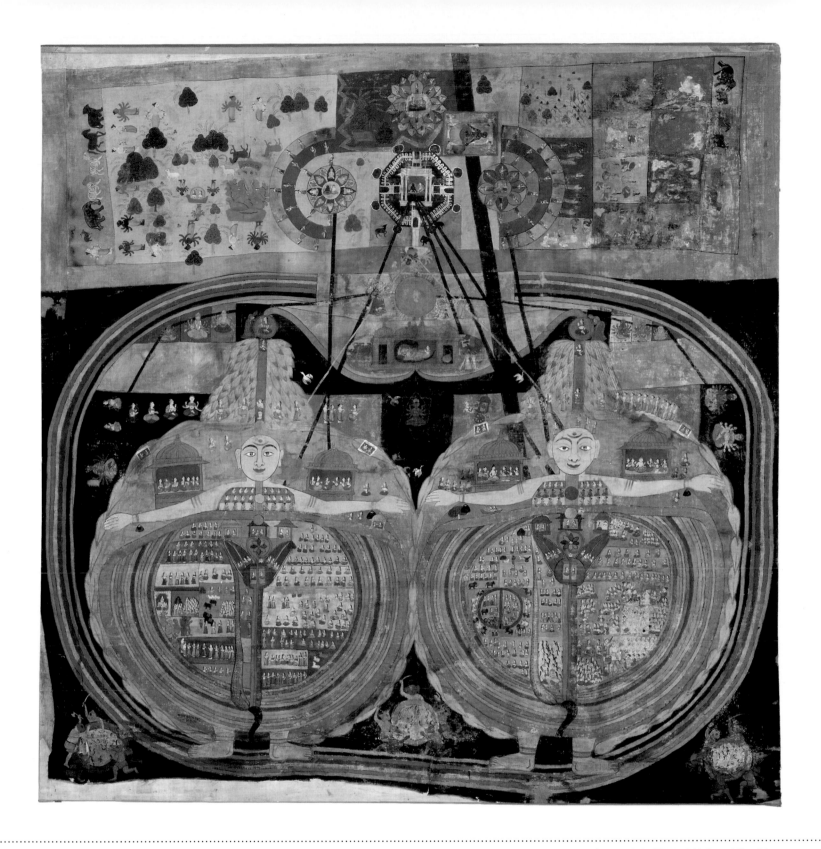

COSMOLOGICAL PAINTING

c.1750–1850

UNKNOWN

Watercolour on cloth, 231.1 × 228.3 cm / 91 × 90 in
Asian Art Museum of San Francisco, CA

Beyond the vibrancy of colour and the sheer weight of detail, perhaps the most striking thing about this Hindu cosmological diagram, painted in watercolour on cloth in Rajasthan in India between 1750 and 1850, is its size. It is well over the height of a person, at about 2.3 metres (7.5 feet). Even at such a large scale, it is so detailed that it is difficult to know where to look. Above the twin representation of the spheres of Earth is a depiction of

the Swarga Loka, or Good Kingdom, a home to Hindu holy figures and beatified mortals between stages of reincarnation. The spheres themselves – held by twin cosmic figures – show alternate views of Earth, with the same divisions of land and oceans, surrounded by the spheres of the oceans and continents and space itself. The representation of the planet as enclosed by a cosmic figure echoes early European cosmologies in which the

device illustrated both Christ's rule over the Earth and the close connections between the cosmic and human scales. Outer concentric circles depict the limits of the universe. Contained in the cosmic men's chests and watching from pavilions above their shoulders are characters from among the Hindu deities.

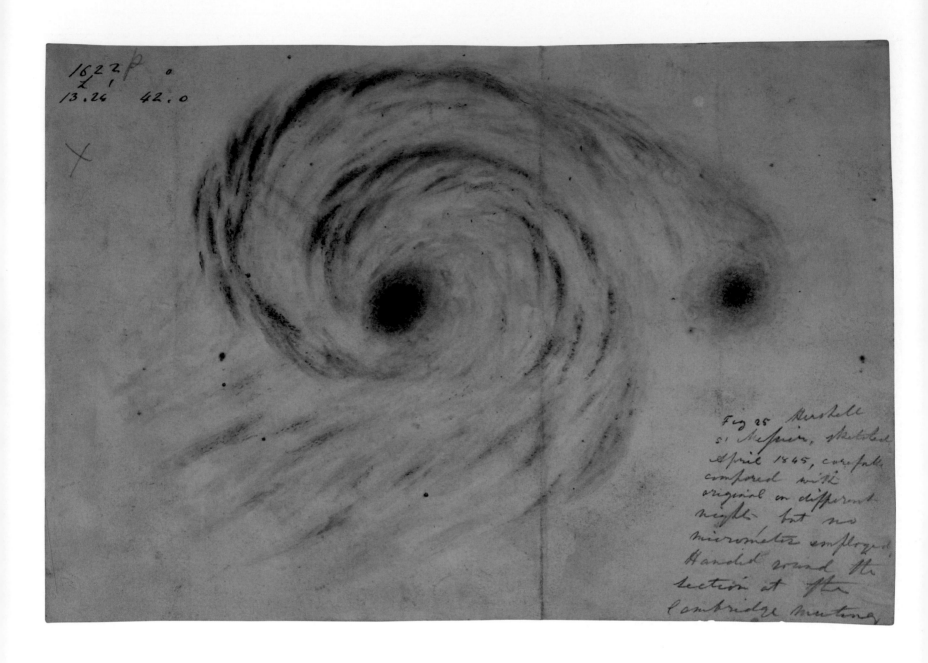

SPIRAL NEBULA M51
1845

WILLIAM PARSONS, EARL OF ROSSE

Ink on paper, 25 × 18.5 cm / 9¾ × 7¼ in
Birr Castle, Birr, County Offaly

This drawing was made by William Parsons, the third Earl of Rosse, and records the discovery of what we now call spiral galaxies. It was made in April 1845, using a telescope that Parsons had just built on his estate in Ireland. The so-called 'Leviathan of Parsonstown' was the largest telescope in the world, with a mirror 1.8 metres (72 inches) in diameter. Rosse and two astronomer friends, Dr Thomas Romney Robinson and Sir James South, deployed it to examine what were then called nebulae – small clouds of celestial light. The observers were stressed by the experience, being suspended 18 metres (60 feet) in the air at night on a platform, where the telescope's mounting meant that they could observe for only half an hour each day. Robinson and South were first to look at M51, the nebula numbered 51 by the French astronomer Charles Messier, and noted only two bright patches. Rosse observed it later and spotted the spiral structure, christening the nebula 'the Great Spiral'. When Rosse showed his drawing in July 1845 in Cambridge, the meeting's chairman, Sir John Herschel, expressed 'strong feelings and emotion' at seeing 'a new feature in the history of nebulae'. Two years later the drawing inspired the American astronomer Ormsby M. Mitchel to name M51 'the Whirlpool Nebula'.

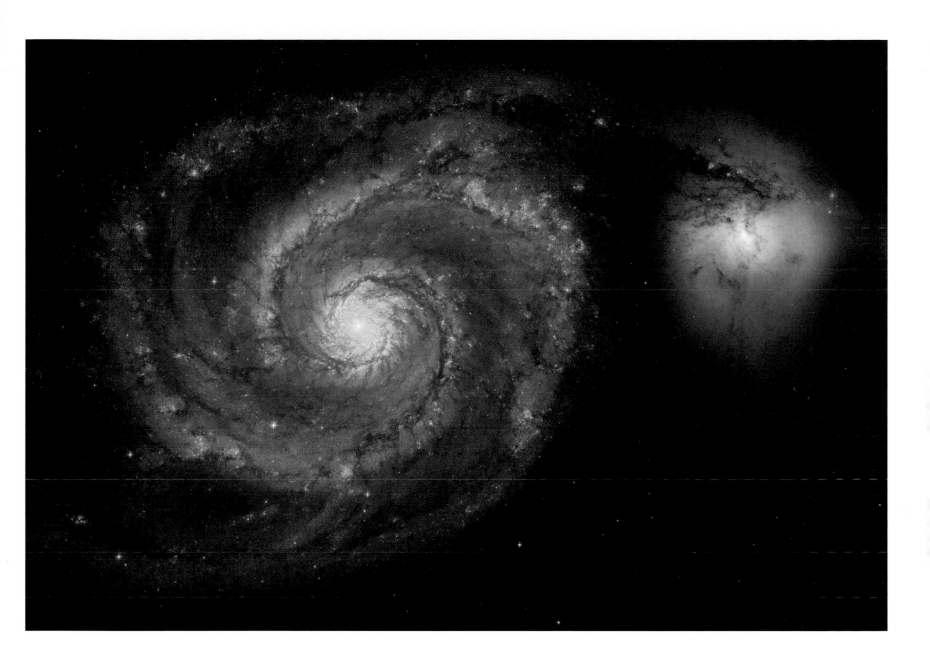

THE WHIRLPOOL GALAXY
2005

NASA, ESA, S. BECKWITH (STSCI), AND THE
HUBBLE HERITAGE TEAM (STSCI/AURA)

Composite digital image, dimensions variable

This image, released by NASA in 2005 to mark the fifteenth anniversary of the Hubble Space Telescope, is a classic face-on view of a spiral galaxy. Known as the Whirlpool Galaxy, or M51 in the Messier catalogue, it lies about 23 million light years from Earth in the constellation Canes Venatici. It has a particular power – or poignancy – because this might be something similar to what we would see looking back at our own Galaxy,

the Milky Way, from a comparable distance. In our Galaxy, the Sun is positioned on the inside edge of one of the spiral arms, the Orion Arm, about two-thirds of the way along from the central bulge; the great pathway of the Milky Way that fascinated ancient peoples is formed from stars in a cross-section of the Orion Arm and the central bulge of the Galaxy (the Milky Way might have anything from 100 billion to 400 billion stars). This image

is a mosaic put together from many Hubble exposures and enhanced using filters, so that the colours – blue spots of starbirth regions in the spiral arms, red older stars in the centre of the galaxy and reddish nebular gas on the interior edge of the arms – are stronger than they would be to the naked eye. One arm of M51 is being torn by a passing galaxy, NGC 5195, which silhouettes lanes of dust in the arm.

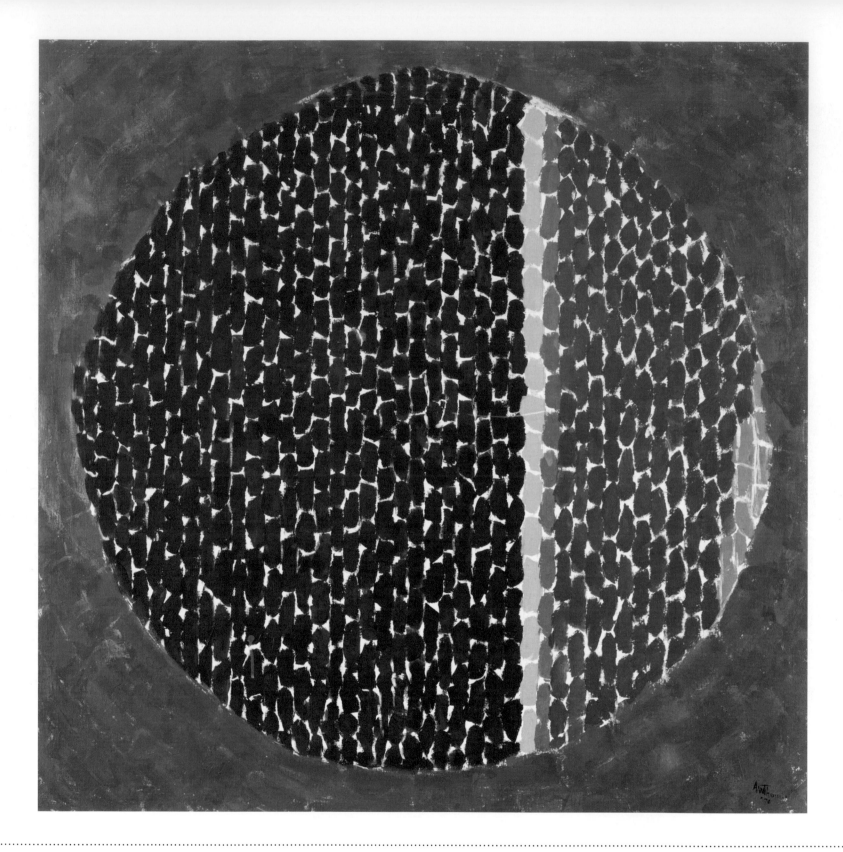

SNOOPY SEES EARTH WRAPPED IN SUNSET ALMA THOMAS
1970

Acrylic on canvas, 121.6 × 121.6 cm / 48 × 48 in
Smithsonian American Art Museum, Washington, DC

A single row of cadmium yellow brushstrokes divides the globe of the Sun in two. Rich vermilion scarlet fills the larger section, while the smaller is orange-hued. There are a number of ways to interpret the title of this vivid acrylic painting from late in the career of the African-American artist Alma Thomas (1891–1978). Snoopy was the call sign of the lunar module of Apollo 10, which orbited the Moon in May 1969, the year before Thomas painted the work.

Alone of all the Apollo lunar modules, Snoopy remains in orbit around the Sun – seeing the sunset wrapping Earth as a perpetual vertical line. But Snoopy is also the laid-back beagle from the *Peanuts* cartoon strip (Snoopy habitual position lying on top of his doghouse might also explain why the horizon runs vertically rather than horizontally). The setting Sun in Thomas's painting might itself be literal or metaphorical, a reference to a US society divided

by conflicts over civil rights and the war in Vietnam. The luminous circle pulsates with rows of single dabs of paint, suggestive of tesserae from a mosaic. A former teacher, Thomas studied colour theory after her retirement, and was attracted to the Colour Field painting of artists such as Mark Rothko. Thomas worked simply – her kitchen served as her studio – but her works achieved a singular depth of feeling.

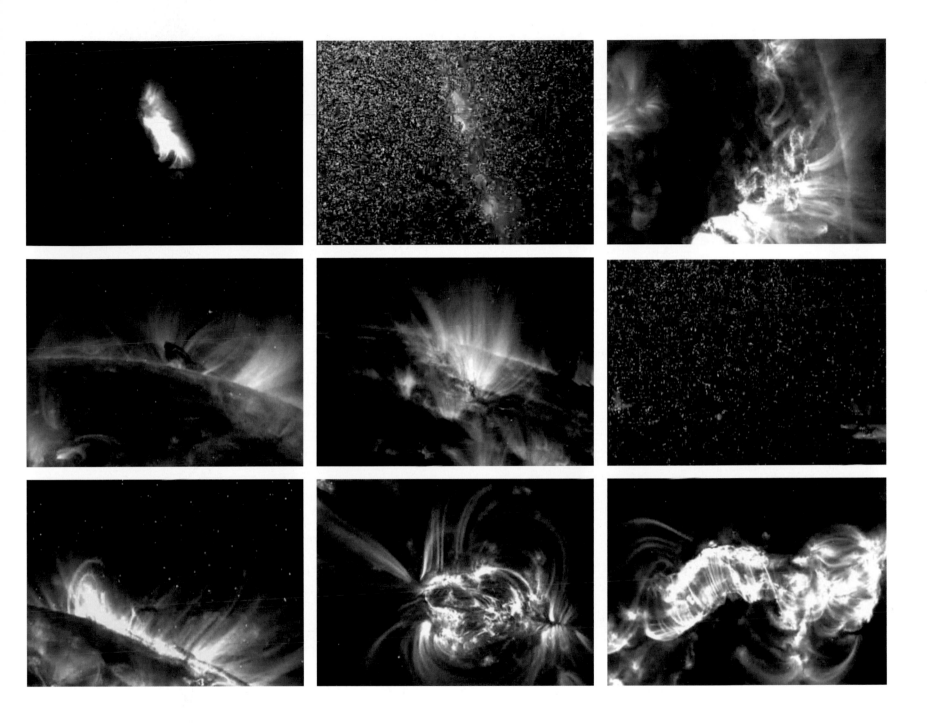

BRILLIANT NOISE

2006

RUTH JARMAN AND JOE GERHARDT

Video, dimensions variable

Nearly six minutes long, the black-and-white video *Brilliant Noise* presents a radically different view of the workings of the Sun. Its imagery progresses from a black orb emitting a white halo of beams to gaseous explosions swirling from the sun's surface, lava-like eruptions and blasts of fire illuminating amorphous forms and gentle flames whirling like tendrils of algae underwater. Grainy black and white dots flicker throughout the film. These are particles of the solar wind captured by observatories in time-lapse photograph sequences. Such effects are normally removed before the images are released to the public, but the British design duo Semiconductor (Ruth Jarman and Joe Gerhardt) searched thousands of data files from solar observatories to find just such grainy, unretouched effects during a 2006 residency at NASA's Space Sciences Laboratories in California. The video is scored with an ambient-noise soundtrack determined by areas of intensity within the image brightness. The Sun sounds intermittently like a jolting machine or a smooth radio wave; we hear high-pitched feedback loops or sudden spurts of noise that make for uncomfortable listening. In other works, Semiconductor capture the landscape of the Earth, with volcanoes smoking or pink flamingos sipping from the water's shore.

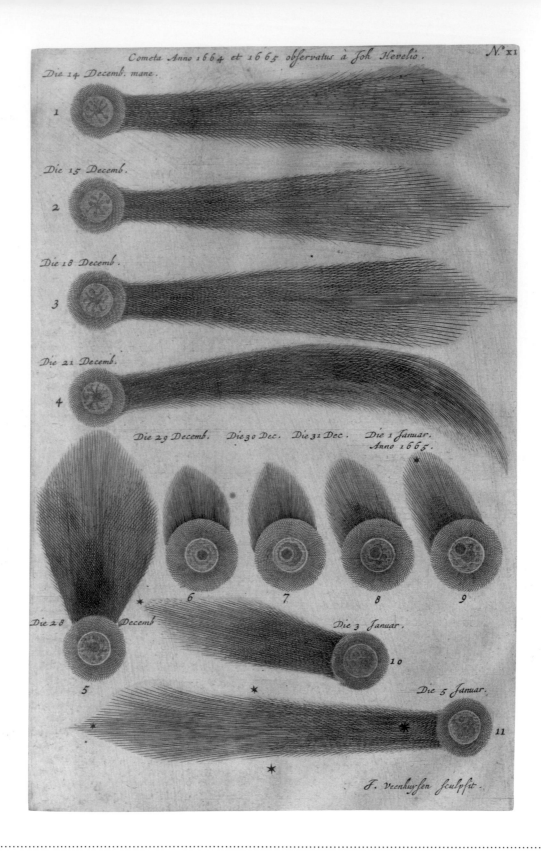

THEATRUM COMETICUM

1668

JOHANNES HEVELIUS

Hand-coloured engraving, 38.2 × 30.5 cm / 15 × 12 in
Bibliothèque nationale de France, Paris

This sheet of coloured engravings shows eleven naturalistic – though not particularly skilled – views of what is now known as Comet C/1664 W1 moving relative to the stars. It was contributed by the Danzig astronomer Johannes Hevelius to *Theatrum Cometicum*, published in 1668 by Stanisław Lubieniecki, a Polish astronomer and historian. Lubieniecki's book catalogued 415 comets in eighty or so plates, said to span the period from the Flood until 1665. In addition to Hevelius, the book included contributions from other eminent astronomers, such as Athanasius Kircher (see p.91) and Christiaan Huygens (see p.290). Lubieniecki wrote about the comets in a rational manner, placing them in a context that was 'mathematical, physical, historical, political, theological, economical and chronological'. It was one of the first attempts to record comets as astronomical phenomena rather than astrological portents of approaching doom. The 1664 comet stirred great interest. In December that year, the diarist Samuel Pepys recorded two illustrious observers of the comet, though he himself was disappointed: 'Mighty talke there is of this Comet that is seen a'nights; and the King and Queene did sit up last night to see it, and did, it seems. And tonight I thought to have done so too; but it is cloudy.'

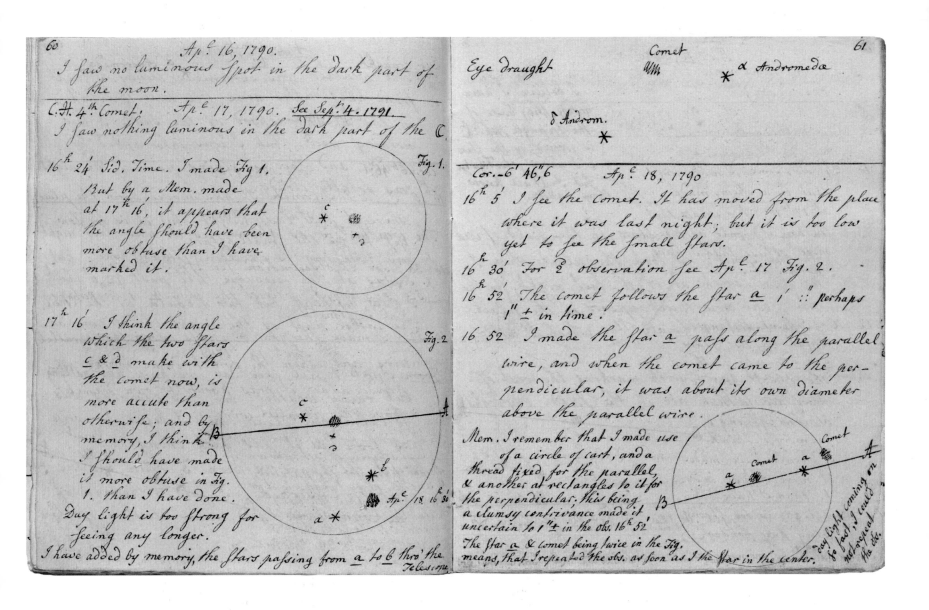

Ap.ͤ 16, 1790.

I saw no luminous spot in the dark part of the moon.

C.H. 4.ͭʰ Comet. Ap.ͤ 17, 1790. See Sep.ͭ 4. 1791.
I saw nothing luminous in the dark part of the ☾.

16.ͪ 24.ͥ Sid. Time. I made Fig 1.
But by a Mem. made
at 17.ͪ 16,ͥ it appears that
the angle should have been
more obtuse than I have
marked it.

17.ͪ 16.ͥ I think the angle
which the two stars
c & d make with
the comet now, is
more accute than
otherwise; and by
memory, I think
I should have made
it more obtuse in Fig.
1. than I have done.

Day light is too strong for
seeing any longer.

I have added by memory, the stars passing from a to b thro' the Telescope.

Fig. 1.

Fig. 2.

δ Androm.

Cor.–6ʹ 46ʺ,6 Ap.ͤ 18, 1790

16.ͪ 5.ͥ I see the comet. It has moved from the place
where it was last night; but it is too low
yet to see the small stars.

16.ͪ 30ʹ For ♀ observation see Ap.ͤ 17 Fig. 2.

16.ͪ 52ʹ The comet follows the star a 1ʹ ∷ perhaps
1ʺ ± in time.

16. 52 I made the star a pass along the parallel
wire, and when the comet came to the per-
pendicular, it was about its own diameter
above the parallel wire.

Mem. I remember that I made use
of a circle of cast, and a
thread fixed for the parallel,
& another at rectangles to it for
the perpendicular, this being
a clumsy contrivance made it
uncertain to 1ʺ± in the obs. 16.ͪ 52ʹ

The star a & comet being twice in the Fig.
means, that I repeated the obs. as soon as I the star in the center.

day light coming on so fast, I could not reveal the obs.

COMET DISCOVERY
1790

CAROLINE HERSCHEL

Ink on paper, 21.5 × 34 cm / 8¼ × 13¼ in
Observatory House, Slough

This page of notes and precise diagrams records the discovery of a comet by British astronomer Caroline Herschel on 17 April 1790. The comet – designated C/1790 H1 (Herschel) – was the fourth of the eight that Herschel eventually discovered, having found her first comet in 1786, the first known to have been discovered by a woman. Caroline's brother, William, was the British Royal Astronomer; the pair had moved from the city of Bath to a more remote house in the country near Windsor Castle to carry out their observations. William made telescopes for Caroline to use while his duties took him away from home. Caroline's first discovery attracted the attention of the president and secretary of the Royal Society, who visited specifically to see it through her telescope. William returned from a trip to Germany to find that his sister was famous. As the Royal Astronomer, it was William rather than Caroline who was summoned to Windsor Castle to show the royal family Caroline's first comet, which he called 'my sister's comet'. Although King George III dismissed the discovery as undistinguished, it gave pleasure to the ladies at court. Princess Augusta called her guests from the card table to view it. One, the author Fanny Burney, acclaimed it as the first 'lady's comet'.

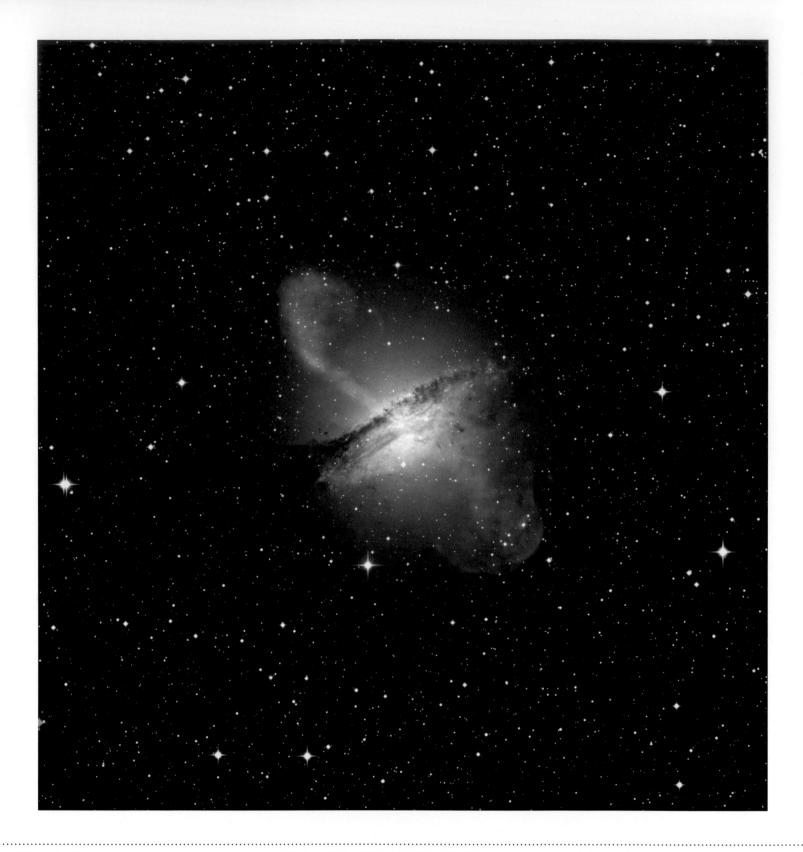

NGC 5128, CENTAURUS A
2009

OPTICAL: ESO, WFI; SUBMILLIMETRE: MPIFR, ESO, APEX, A. WEISS ET AL. X-RAY: NASA, CXC, CFA, R.KRAFT ET AL.

Digital photograph, dimensions variable

At the heart of this remarkable image of two galaxies in the process of merging is an unseen supermassive, spinning black hole with a mass equivalent to 55 million Suns. One of the merging galaxies is a dusty spiral, whose dark dust lane can still be seen, being absorbed into a giant elliptical galaxy. The drama is being played out 13 million light years away – very nearby as active galaxies go. This remarkable galaxy was discovered in 1826 by the Scottish-born astronomer James Dunlop, who called it 'a very singular double nebula', but only in 1949 was it found to be exceptional. It was one of the first radio galaxies to be identified – they emit high energy at radio wavelengths – and the first in the constellation of Centaurus (leading to its radio designation, Centaurus A). The initial discoveries were made by pioneering Australian astronomers, but more recently the galaxy's radio lobes have been traced over 10 degrees of the sky, the width of 20 full Moons. In this composite of visual and radio images, sub-millimeter radio wavelengths are seen as the inner lobes, coloured orange. At other wavelengths the galaxy also continues to surprise. Earth-orbiting satellites have found it to be a powerful source of X-rays, which emerge as jets and plumes, shown in blue, driven by matter falling onto the black hole.

ACCRETION: BLACK HOLE & QUASAR
2016

JANE GRISEWOOD

Ink on paper, each 40 × 50 cm / 15¾ × 19¾ in
Private collection

New Zealand born, London-based artist Jane Grisewood's cosmological work stems from the challenge of visualising gravity, relativity and time. This diptych merges this concern with her interest in the nature and intensity of blackness. A black hole is a region of spacetime where the gravitational field is so powerful that nothing – light, matter or radiation – can escape it. A quasar is a supermassive black hole, around which orbits a disk-shaped accretion of luminous gas. While a black hole is, by its nature, invisible as it pulls material in, its manifestation as a quasar can blaze with light that is brighter than a whole galaxy of stars. In this association of negative and positive, gaping void and orb teeming with light, Grisewood here expresses the paradox of an intensely luminous object, holding at its heart the ultimate darkness and absence. Against a pulsating network of shimmering lines, Grisewood's darkness seems blacker than black. Her work also displays a performative quality, expressed in painstakingly repetitive movements. An intricate mesh of lines, her drawing is as much about control as it is about chance, about gesture as it is about density. Grisewood's black hole and quasar do not only swallow matter and time, they also display intensely haptic qualities.

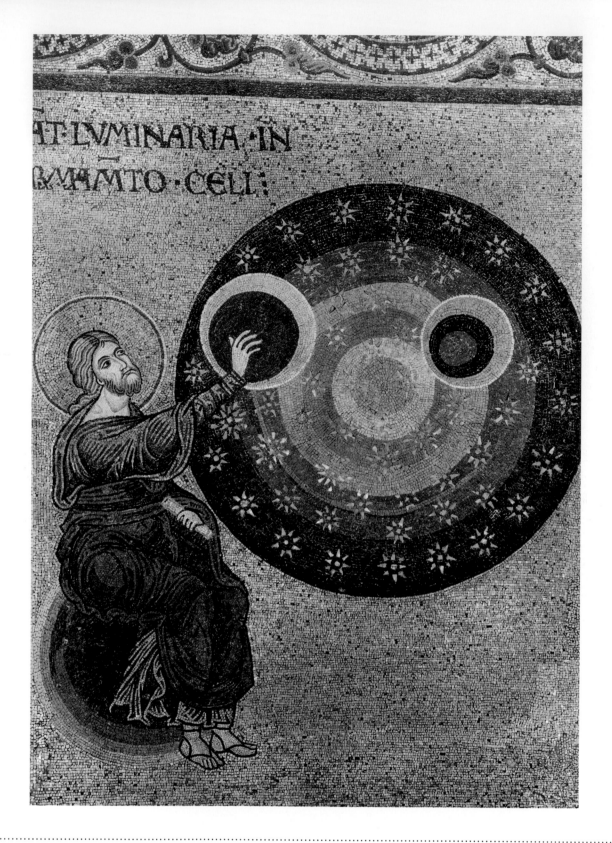

CREATION OF THE LIGHTS IN THE FIRMAMENT

c.1180

UNKNOWN

Mosaic, dimensions variable
Monreale Cathedral, Monreale

'Let there be light' is the famous quote from the Book of Genesis illustrated in this twelfth-century mosaic in which God extends his hand to place the Sun in the circular blue heavens, already filled with gold stars, above the blue Earth. This mosaic is part of a total of 6,500 square metres (70,000 square feet) of Byzantine mosaics that depict scenes from the Old Testament, Christ's life and miracles and the lives of Saints Peter and Paul on

the walls of the Romanesque cathedral in the town of Monreale (now a UNESCO World Heritage Site) near Palermo in Sicily. This mosaic, located on the north wall of the nave, is one of forty-two illustrating scenes from the Book of Genesis. Following the expulsion of the Arabs from Sicily in 1091, the Sicilian King William II began building a new church dedicated to the Virgin Mary in 1174. He brought skilled Arab and Byzantine craftsmen

to Monreale, many from Constantinople (now Istanbul), to create a cycle of mosaics using coloured glass and some 2,200 kilograms (4,850 pounds) of pure gold in less than ten years. As examples of Byzantine art, the Monreale mosaics are second only to those of the Hagia Sofia in Istanbul in size, but are much better preserved.

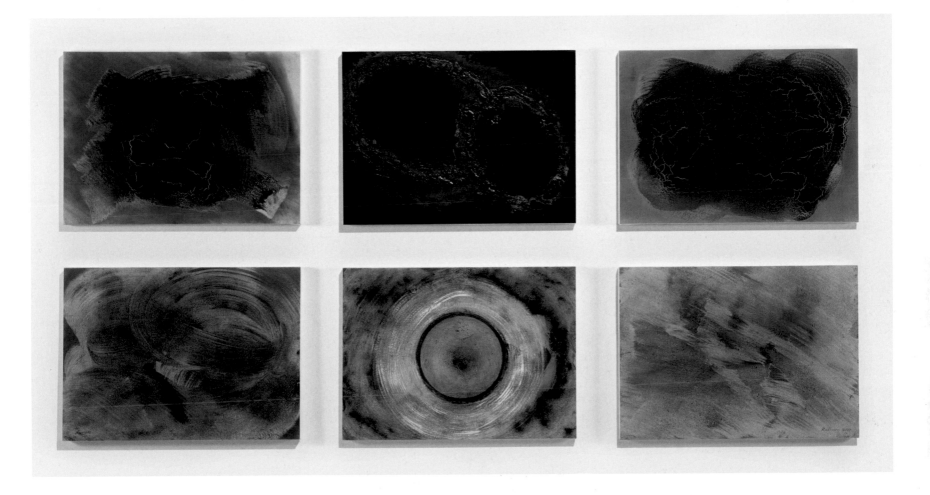

UNIVERSES
1994–9

DOROTHEA ROCKBURNE

Raw pigment, acrylic medium and charcoal on watercolour paper
mounted on linen, each 56 × 75.5 cm / 22 × 29¾ in
Collection of the Artist

By entitling her piece *Universes*, contemporary artist
Dorothea Rockburne (born 1932) encourages the viewer
to imagine our cosmos as a plurality. In six separate
panels, she explores form, colour and materials to present
different ways of imagining the Universe. Rockburne is a
careful student of mathematics, astronomy and art history,
and she draws from a range of interconnected sources
in her work. *Universes* invites multiple interpretations

from across different time periods and fields of study.
All six panels are studies in blues and grays, and the
colours recall the hues in Renaissance paintings, such
as Giovanni di Paolo's *The Creation of the World and
the Expulsion from Paradise* (1445). They also resemble
the vivid blues seen in digital images from the Hubble
Space Telescope, which first circulated widely in the mid-
1990s. Rockburne references the ancient theory of the

heavenly spheres in the bottom centre panel, whereas the
amorphous forms in the outer panels suggest contemporary
theories of an expanding or collapsing Universe. The
artist experiments with her materials, even heating some
panels after painting. This creates the crackle pattern on
their surfaces, reminding us of how paintings change over
time, as well as the changing, shifting features of
the cosmos.

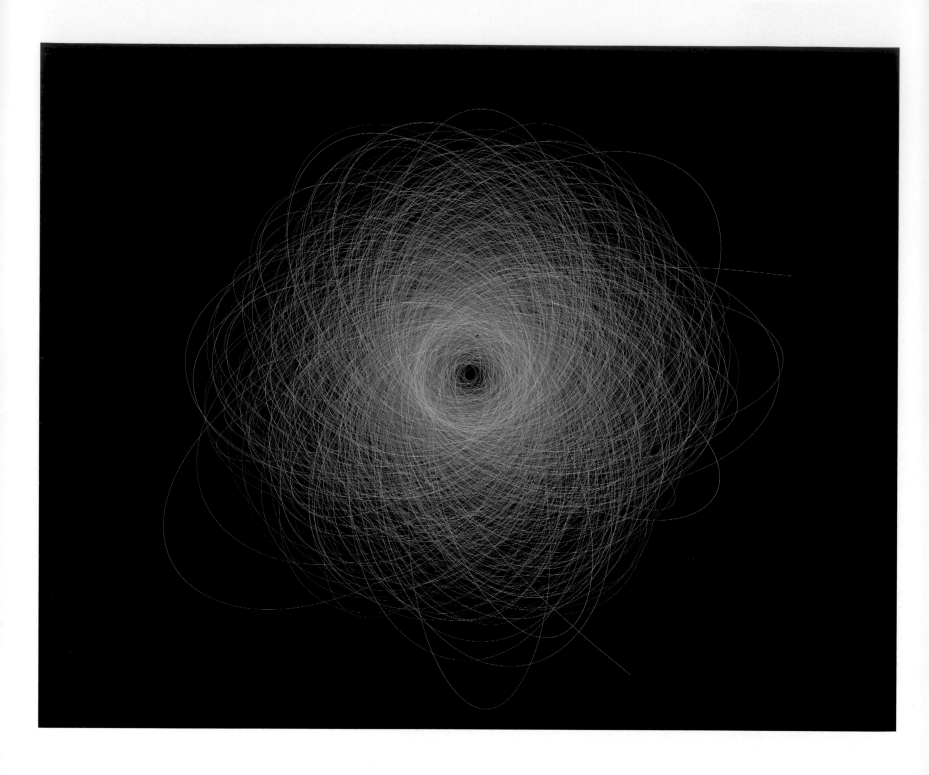

HAZARDOUS ASTEROIDS
2016

MICHAEL NAJJAR

Hybrid photography, 132 × 202 cm / 52 × 79.5 in
Wemhöner Collection, Herford

This tangle might appear random but in fact captures the elliptical paths of 1,600 asteroids between the Sun – represented by the black circle at the heart of the image – and the orbit of Jupiter, which defines its outer edge. The contemporary German artist Michael Najjar (born 1966) gathered information from NASA's Jet Propulsion Laboratory to show Earth's narrow escape from catastrophe. The planet appears as a dot just above and to the right of the Sun, in an orbit where the paths of the asteroids are at their most dense. Any one of what NASA terms Potentially Hazardous Asteroids (PHAs) could inflict catastrophic damage on the planet. PHAs are asteroids that are over 140 metres (460 feet) across that will at some time pass within 7.5 million kilometres (4.6 million miles) of Earth. Past collisions have changed the course of evolution, such as the asteroid impact thought to have destroyed the dinosaurs. The elliptical paths of PHAs among the inner planets are shaped by Kepler's laws, but not all PHAs have been charted. The bodies themselves are a small part of the asteroid belt, perhaps the rocky remains of what was once a planet or debris surviving from the formation of the Solar System 4.6 billion years ago. Najjar's interest in space goes beyond the conceptual: he is training as an astronaut.

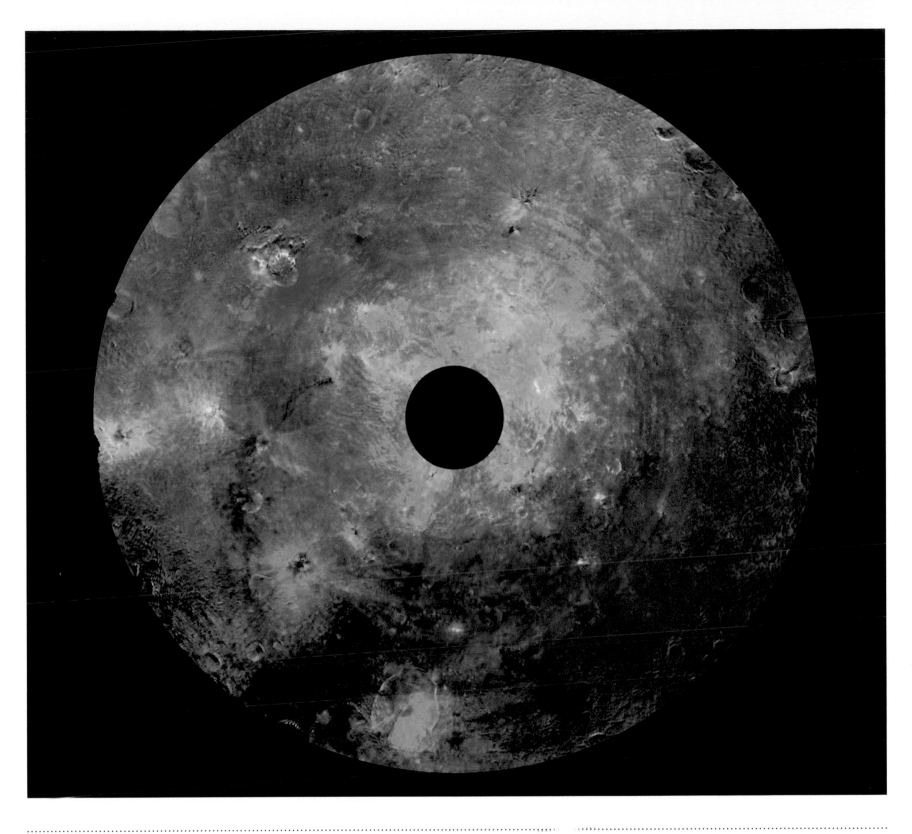

ASTEROID VESTA
2011

NASA, JPL-CALTECH, UCLA, MPS, DLR, IDA

Composite digital image, dimensions variable

This image, which resembles those once commonly projected on to the walls of discos, is, in fact, a highly functional, scientific representation of the southern hemisphere of Vesta, which, after Ceres, is the second largest object in the asteroid belt. The image is a 'mosaic' assembled from photographs taken as NASA's space probe Dawn, which was launched in 2007, approached Vesta in 2011. Dawn's hyper-efficient ion propulsion system enables it to orbit two different Solar System bodies, a first for any spacecraft. Reaching its targets would be impossible without this; in this mission, the spacecraft steps us back in Solar System time. The different colours result from the combination of two radiation wavelengths detected by the camera that show the range of rock types and the central black hole is caused by ommitted data due to the angle between the Sun, Vesta and the spacecraft. After confirming that Vesta is more closely related to terrestrial planets, including Earth, than to typical asteroids, Dawn moved into orbit around the dwarf planet Ceres in March 2015; it thus became the first spacecraft to orbit two different bodies in the Solar System. The data Dawn collected will increase our knowledge of the conditions and processes of similar protoplanets during the Solar System's earliest history.

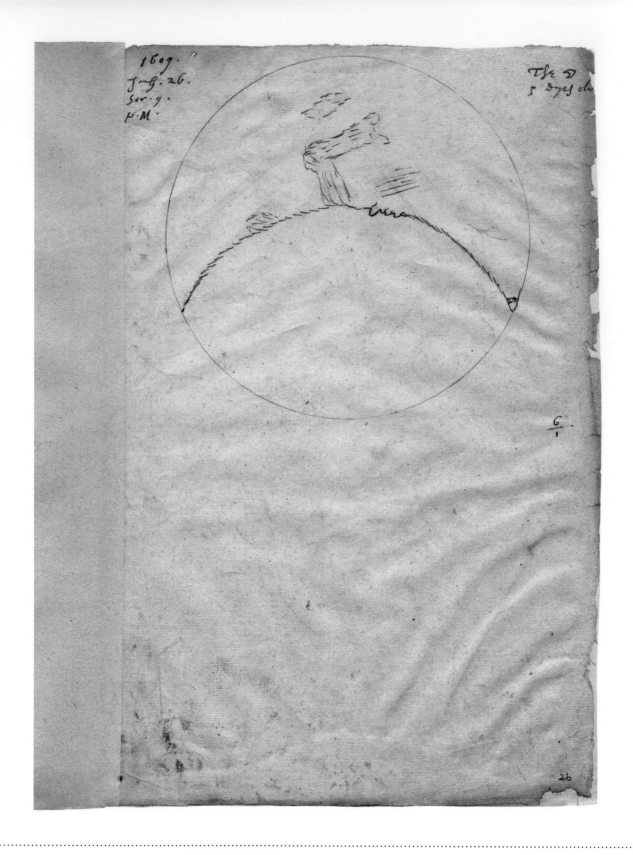

MOON
1609

THOMAS HARRIOT

Ink on paper, 24 × 32 cm / 9½ × 12½ in
Lord Egremont of Petworth House Collection, Petworth

There is an assumption that Galileo Galilei made the first known observation of the Moon through a telescope, yet this drawing proves otherwise. It was made by an under-recognized genius, the Englishman Thomas Harriot, who had bought what he called a 'Dutch trunke' (a telescope) a year after its invention. He made the observation on 5 August 1609 (Gregorian calendar), several months before Galileo's first Moon sighting. The drawing, which was made on the same day but dated 26 July 1609 according to the Julian calendar (upper left corner), shows the terminator of the Moon at five days old. (The terminator is the boundary between the half of the Moon illuminated by the Sun and the half shadowed in lunar night). Harriot drew a jagged boundary, the effect of the mountain ranges through which the terminator cuts; he also outlined some of the dark 'seas'. Harriot was a polymath. After being imprisoned in the Tower of London in 1605, he published nothing about his later achievements in mathematics and astronomy, including his observations of the Moon, to avoid drawing attention to himself. Harriot remained unnoticed for three centuries, during which time Galileo was rightly celebrated for making better celestial observations, recognizing their significance and disseminating them.

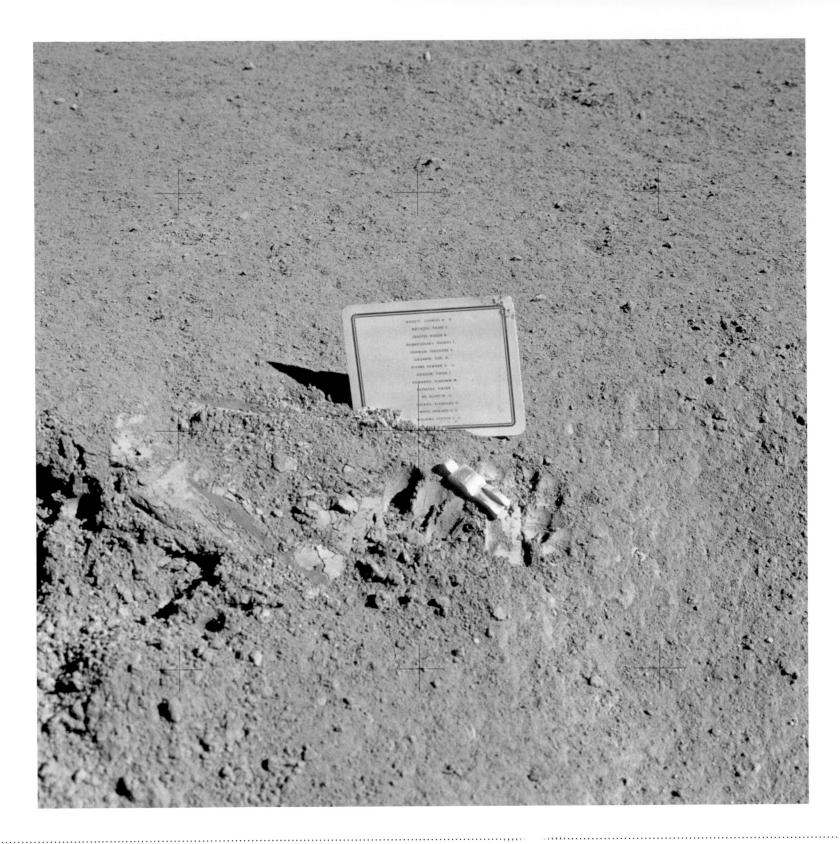

FALLEN ASTRONAUT
1971

PAUL VAN HOEYDONCK

Aluminium, h. 8.5 cm / 3⅔ in
Hadley Rille, the Moon

This tiny statue and plaque – the androgynous, race-less human figurine is only 8.5 centimetres (3⅔ inches) tall – is one of the only works of art on the Moon. It was left on the Hadley Rille in July 1971 by Apollo 15 commander Dave Scott, without the approval or knowledge of NASA. The idea of placing a sculpture commemorating the Space Race had come from the Belgian artist Paul Van Hoeydonck (born 1925) and his New York gallery; various behind-the-scenes manoeuvres led to a meeting between van Hoeydonck and the astronauts over dinner. Scott agreed to take into space the minimalistic generic human figure, created from aluminium in order to be light and to withstand radiation and extreme temperatures on the Moon. Scott also procured a memorial plaque inscribed with the names of the six Soviet cosmonauts and eight American astronauts who had died in the course of the Space Race, a reminder that the conquest of space came at a high cost. Scott secreted the statue and plaque in his pocket for the Apollo launch, and later left them on the lunar surface, taking this photograph. As there is no atmosphere on the Moon, the Fallen Astronaut will rest undisturbed for eternity on the Hadley Rille, staring into the unfathomable blackness of the Universe.

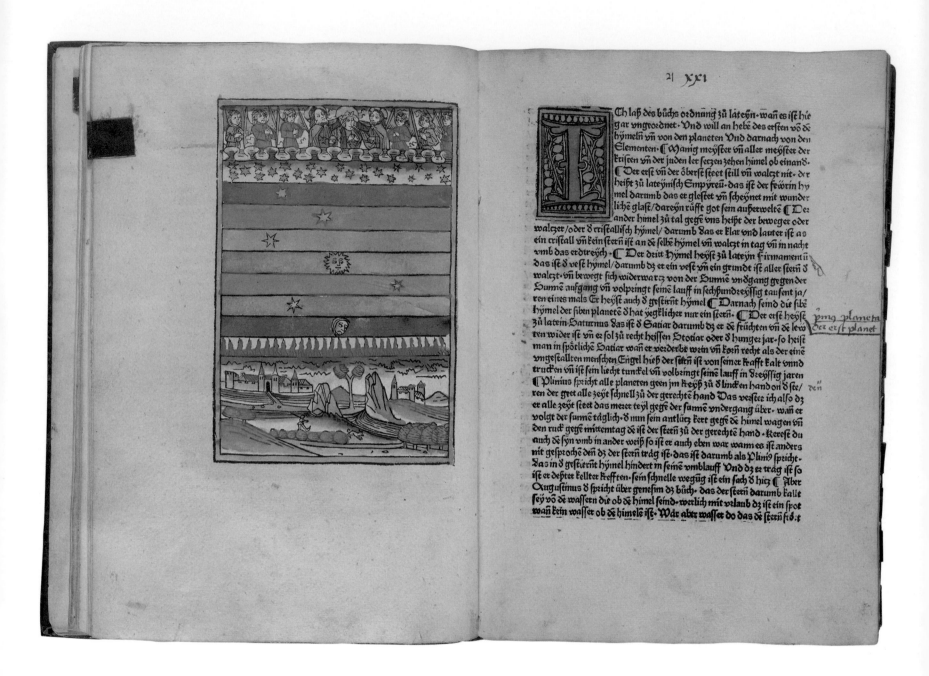

DAS BUCH DER NATUR
1475

KONRAD VON MEGENBERG

Woodcut print, 31 × 22 cm / 12¼ × 8¾ in
Library of Congress, Washington, DC

Sandwiched between the mundane earthly world beneath and the saints and angels in Heaven above, the orbits of the heavenly bodies are illustrated by the fourteenth-century German scholar and theologian Konrad von Megenberg (1309–74). The result is a highly unusual cross-section of the more common medieval cosmology in which Earth is surrounded by perfectly spherical concentric orbits of the Sun, Moon and planets.

In a prescient, if unintentional, gesture, von Megenberg places the Sun at the very centre of his diagram, long before the radical views of Nicolaus Copernicus placed it at the hub of the Solar System. Near the top of the print, just beneath heaven itself, is the thick band of stars of the Milky Way. Von Megenberg's *Das Buch der Natur* (*The Book of Nature*) was based on the thirteenth-century Latin text *Liber de Natura Rerum* by the Dominican priest

Thomas de Cantimpré, but with many revisions and additional observations from von Megenberg. This print comes from the second part of the work, which includes thirty-three chapters on heaven, the seven planets known at that time, astronomy and meteorology.

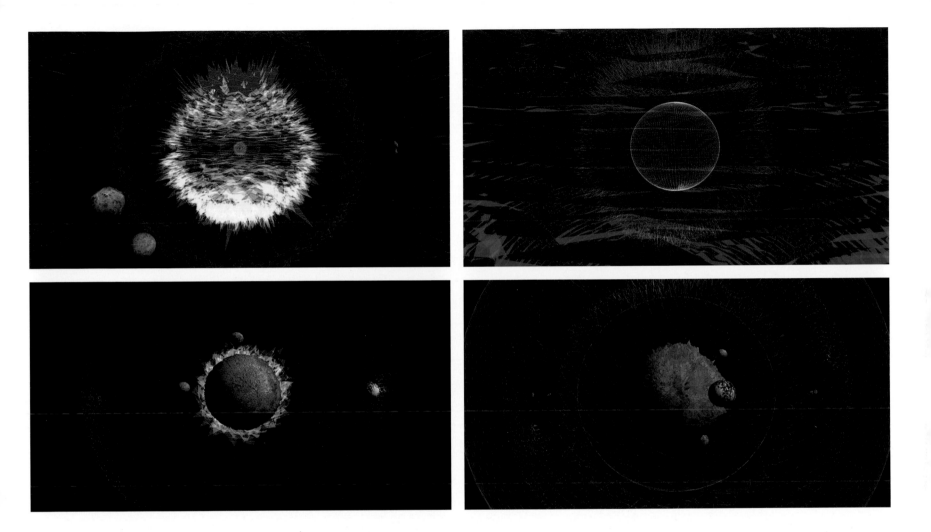

SO WHAT 2012
2005–12

MICHAEL JOAQUIN GREY

Computational cinema, dimensions variable

Stills can give only a partial impression of the immersive experience of *So What 2012,* a large-scale, unrecorded, generative film by the American artist Michael Joaquin Grey (born 1961). Grey's vision presents viewers with the sensation of travelling through space from a pixel at the centre of the Sun to the furthest reaches of the Solar System and back again, at ever-increasing speeds. The 'journey', which compresses time and space to perceptual limits, is shown on multiple screens in what is known as quaquaversal vision: it is projected outwards in all directions from a common centre so that it surrounds the viewer. The soundtrack resembles white noise, but at certain stages of the journey a selection of voices emerge, among them those of Miles Davis, Ella Fitzgerald, Werner Herzog, Steve Jobs and the Rolling Stones. Grey's unique and thought-provoking work can be seen, in one sense, as a contemporary digital orrery, an updated version of the mechanical models of the Solar System that demonstrate the motions of the planets and some of their satellites. Grey's echo of such devices reflects his belief that the purpose of all art is, at least in part, to educate.

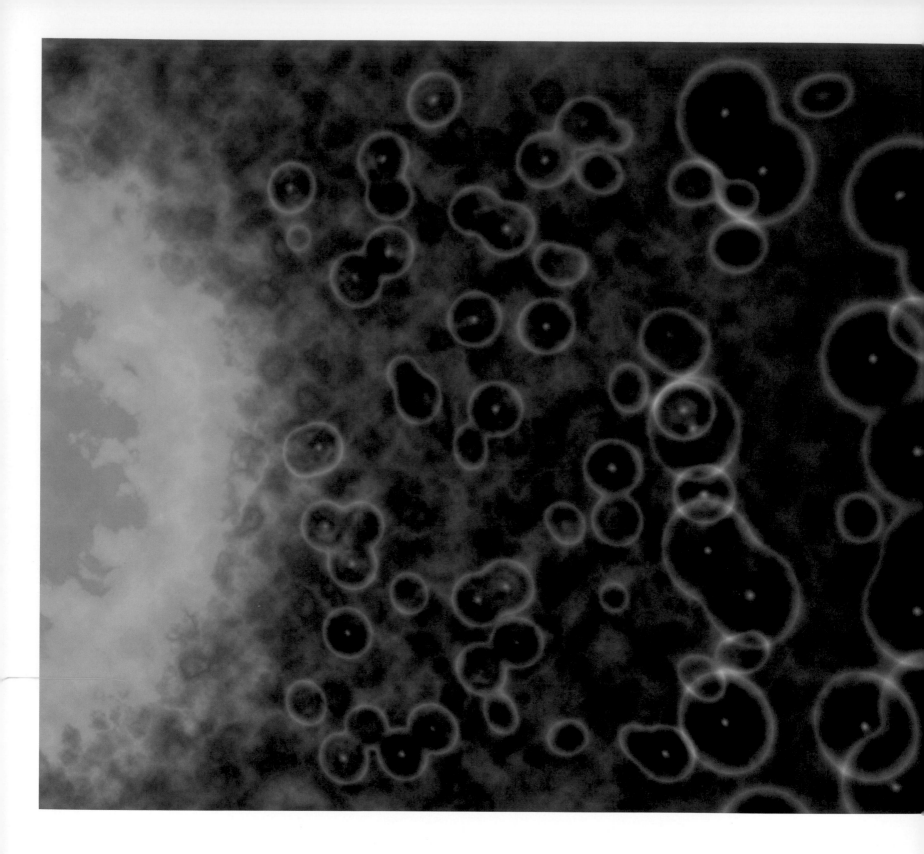

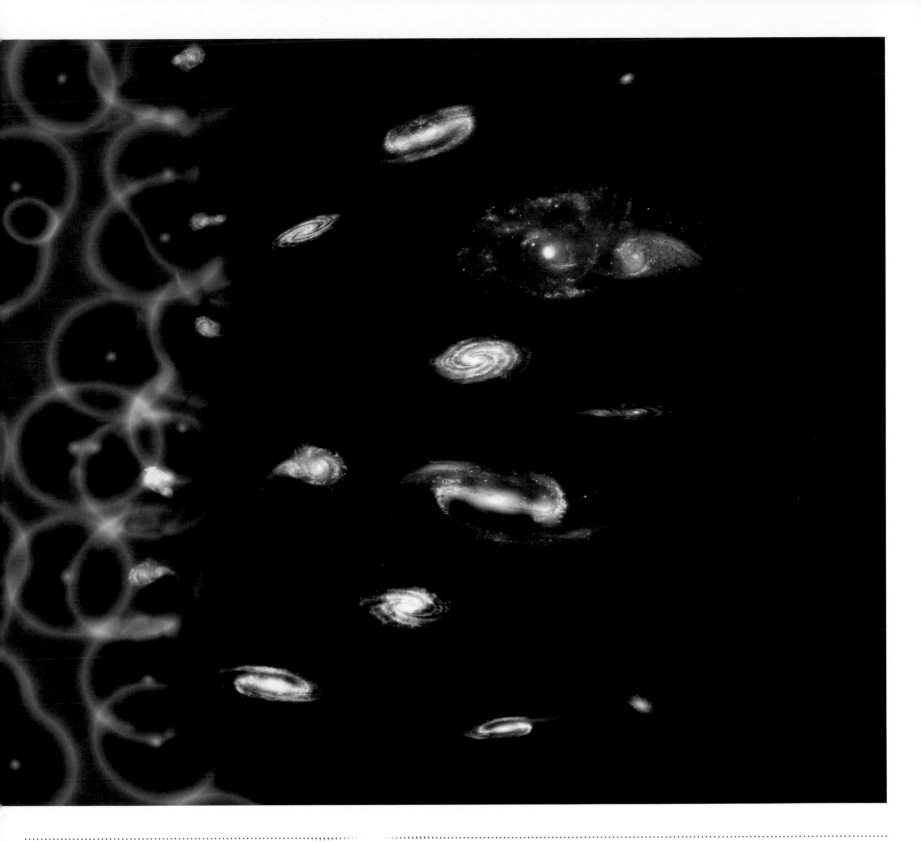

REIONIZATION
2011

M. WEISS

Digital Illustration, dimensions variable

This remarkable artist's impression shows the 'Epoch of Reionization', a visualization of the transition in which the fog of the Universe cleared to make the galaxies visible. From left to right the image covers the two billion years from the Big Bang through to the period when galaxies sprang into view. On the extreme left is the Big Bang of ultra-hot primordial plasma, which cooled to form 'everyday' matter, like hydrogen. The Universe first became transparent and, as it continued to expand and cool, the hydrogen became the first stars and galaxies. The stars made lots of dust which hid everything again: this was the period of the 'Dark Ages' of cosmic history, centred here on the fold between the left and right pages. The stars also radiated energy, as suggested by the expanding bubbles. The energy 'reionized' the hydrogen and eventually the ionized bubbles overlapped, so everywhere became transparent for a second time and galaxies emerged into view (right). For the last 11 billion years the Universe has been transparent and we are able with optical telescopes to follow the history of galaxies and the Universe back to the time represented by the right-hand quarter of this image. New telescopes are now looking back further, probing into and through the Dark Ages.

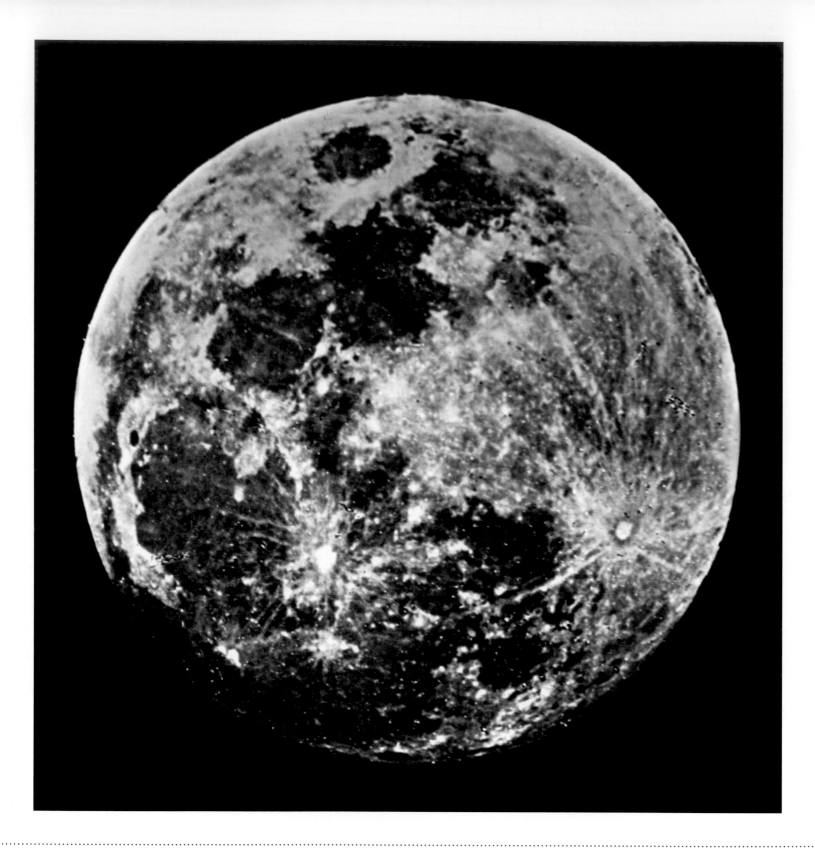

MOON
1840

JOHN WILLIAM DRAPER

Daguerreotype
New York University Archives, New York

Remarkable in its detail and clarity, this picture of the full Moon was taken in the very infancy of photography. As two disciplines whose essence concerns capturing light, astronomy and photography are inextricably linked. When he announced Louis Daguerre's revolutionary invention of the daguerreotype at the Académie des Sciences in Paris in 1839, the mathematician and astronomer François Arago immediately suggested its

application to lunar cartography and the mapping of the heavens. Daguerre himself had made a botched attempt at catching the features of the Moon, but its light remained too faint to photograph. Scientists, such as the astronomer John Herschel in England and the physician and chemist John William Draper (1811–82), across the Atlantic, set out to discover chemicals with higher photosensitivity to enable photographs to be taken more quickly. Through

experimentation with lens aperture and focal length, and by improving the sensitivity of the photographic plate, Draper reduced exposure times. After several attempts in 1839–40, Draper is credited with having produced the first detailed photograph of the Moon in March 1840. He is now considered the first astrophotographer. Very few of his daguerreotypes survive as most of them were destroyed in a fire in 1865.

SCREENSHOT 2015-11-07 18.34.11 / PINK FILTER

2015

PENELOPE UMBRICO

Pigment print, 101.6 × 101.6 cm / 40 × 40 in
Private collection

The colour of the Moon is a source of some debate. On the surface of the Moon, astronaut Alan Bean is recorded as saying, '... if you look cross-sun, the Moon appears one colour; if you look down-sun, it's another; if you look up-sun, it's another.' Taking a much wide view, the Lunar Reconnaissance Orbiter found the darker regions (Mares) slightly reddish and those that were darker still were very slightly blue, reflecting small differences in composition. These differences are also evident in Earth-based photographs that have had their colour-contrast enhanced. Overall however, while the Moon looks a neutral grey, the reflected sunlight of the full Moon is a little redder than direct sunlight. The work of American artist Penelope Umbrico (born 1957) is largely based on images taken from the internet, which provides her with a variety of interpretations. Most of the images of the Moon that appear on the Web have been photographed through the Earth's atmosphere, which has had a huge effect on its apparent colour, as revealed in her montage above. Umbrico has been quoted as saying, '... all images (artful, authored, pedestrian or unauthored) become unassignable and anonymous in this unlimited exchange of visual information, and function as a collective visual index of data that represent us ...'.

Printed for Henry Rhodes, next the swan Tavern in Fleet street

F. H. Van Hove sculp:

A RISING GLOBE BEING USED AS TRANSPORT TO THE MOON

1687

F. H. VAN HOVE

Copperplate engraving, from *The Comical History of the States and Empires of the Worlds of the Moon and Sun*
18.5 × 11.5 cm / 7¼ × 4½ in, British Library, London

This seventeenth-century illustration is a composite in an English translation of French author Cyrano de Bergerac's book, which describes how he used what he called 'machines' to visit the Moon and the Sun. Above, he has been put on trial by a parliament of birds and charged with the 'crime' of being human. The birds' questioning condemns the writer – and the rest of humanity. This exposure of human weakness, immorality and ignorance

lies at the heart of de Bergerac's stinging satire *The Comical History of the States and Empires of the Worlds of the Moon and Sun* (1687). The book (originally two separate works) is seen as a precursor to science fiction. One of his flying machines was supposedly powered by dew that evaporated in the sunlight, raising him up through the sky to the Moon. He also travels in a rocket powered by firecrackers – the first time that a rocket had been

identified as a vehicle for space travel. In the illustration he sits in a third machine – 'a large, very light Box' with a window of crystal shaped like an icosahedron. In sunlight, de Bergerac explains, 'the Vacuity that would happen in the Icosaedron, by reason of the Sun-beams, united by the concave Glasses, would, to fill up the space, attract a great abundance of Air, whereby my Box would be carried up'. The satire is more convincing than the science.

50

MOON SKY
2008

ERNESTO NETO

Pigment inkjet print, 50 × 73 cm / 19¾ × 28¾ in
Private collection

Looming charcoal tones edge in from the right-hand side of this monochrome inkjet print, giving the composition an ominous atmosphere that complements its otherworldly depiction of a conglomeration of orbs floating amid the clouds, the sky's mottled shades of grey pulled into the surface of these globes. Were it not for the multiplicity of globes, the scene might recall the occasions at the end of the day when the Sun and the Moon face each

other across the sky, the fading sunlight giving way to the Earth's illuminated satellite. In Brazilian artist Ernesto Neto's *Moon Sky*, the work's title gives us few clues: are these planets repeated, multiple suns or an alien spaceship? Or are the globes magnified specks of pollen? *Moon Sky* is part of a wider series of related prints titled *Pollen Sky* and *Pollen Bird* (both 2008), which recall powdery chains of scented pollen or even strings of

DNA. In Neto's work, the forms inside our bodies become connected to nature, and then extend into the cosmos. Neto (born 1964) is best known for installations in which spices hang in nylon fabric as amorphous round shapes. Evoking the cellular forms of the body's interior, they have a visceral appeal: walking through these large-scale forms elicits a sensual encounter as viewers touch their spongy, stretchy surfaces and inhale the rich aromas.

DIVINITIES OF THE PLANETS AND CONSTELLATIONS

16th century

ATTRIBUTED TO QIU YING

Ink and colour on paper, 19.2 × 402 cm / 7½ × 158¼ in
The Metropolitan Museum of Art, New York

The figures on this sixteenth-century scroll are both visually striking and shrouded in deep meaning. Each character is a Chinese deity who represents both a planet and one of the five elements of Chinese tradition (they may also correspond to the twenty-eight constellations of the Chinese zodiac, but the distinctions are unclear). At centre bottom, draped in flowing robes, the standing figure might represent Mercury and its element, water.

Next to Mercury is most likely Mars, shown sitting cross-legged atop a donkey while wielding a variety of weaponry and representing his element – fire. Next is Saturn, riding a bull and representing the element of earth. Beside Saturn is Venus, depicted on a beautifully-hued phoenix and representing her element, metal. Lastly comes Jupiter, astride a horse-like animal and representing the element of wood. This artwork may

not be the original version, but was probably copied by Qiu Ying (1494–1552), a Ming-dynasty artist renowned for his copies of earlier works. His signature appears in the far right-hand corner. The contents of this piece are likely taken from a painting originally by Liang Lingzan, of the Tang dynasty (which spanned the seventh to the tenth centuries). The original painting is now held in the collection of the Osaka Municipal Museum of Art, Japan.

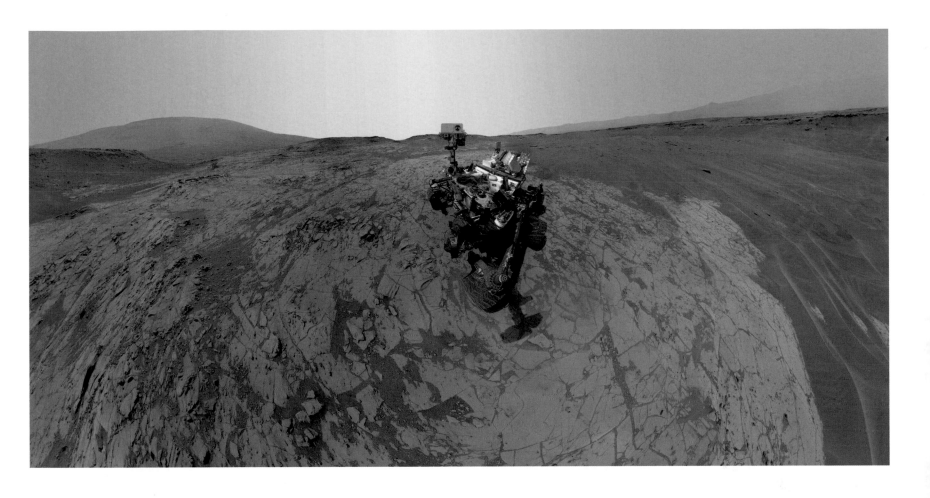

CURIOSITY'S MAHLI SELF PORTRAIT
2015

NASA, JPL-CALTECH, MSSS

Composite digital image, dimensions variable

To create this panoramic self-portrait, the Curiosity rover extended and rotated its robotic camera arm to take a series of seventy-two images that scientists stitched together as a collage. (Only the vertical section of the arm is visible in the final picture.) The camera that took the photos, the Mars Hand Lens Imager (MAHLI), is more generally used to scrutinize rocks and dust. In addition to the rover, the image also shows evidence of its activity on the Red Planet. Curiosity had recently drilled a hole and scooped up materials for testing, leaving behind newly exposed Martian dust, seen here as pale areas. Curiosity landed on Mars in 2012, and its mission built on the success of NASA's previous robotic explorations of the planet. The car-sized rover carries sophisticated instruments that allow scientists to analyze the planet's geology from a distance and determine whether it once sustained life. Mars continues to hold a unique position in our cultural imagination. Once envisioned as the site of alien civilizations, it is now proposed as a place for future human settlements. The endearing and easily anthropomorphized rover stands as our surrogate on its surface.

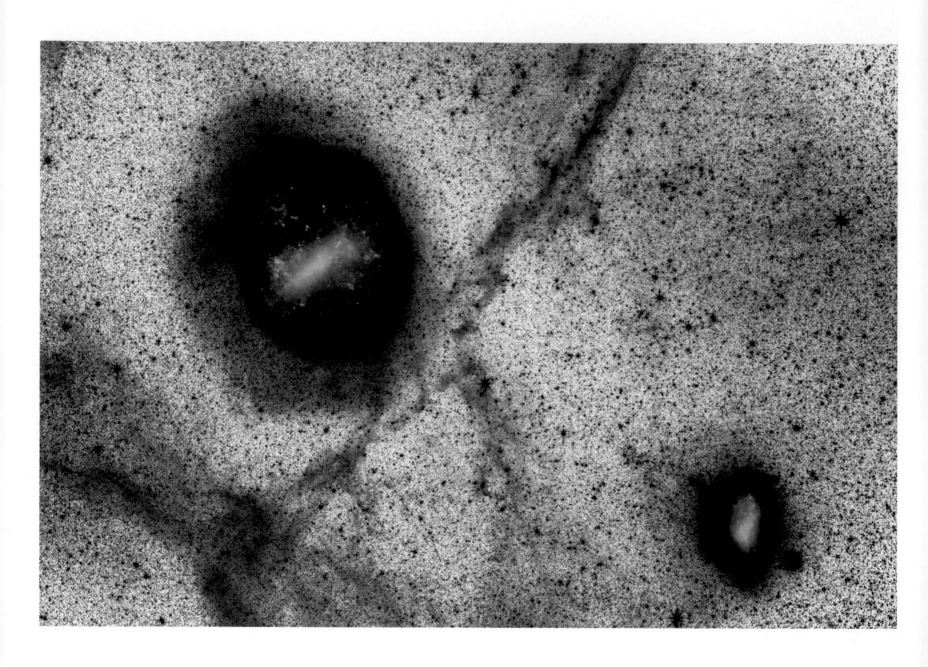

DEEP VIEW OF THE LARGE AND SMALL MAGELLANIC CLOUDS

2016

YURI BELETSKY AND DAVID MARTINEZ-DELGADO

Composite digital photograph, dimensions variable

Two small blooms of blue in a vast monochrome expanse (a negative version of space, in which black dots are stars) highlight two astronomical features named for Ferdinand Magellan, the Portuguese navigator. The crew of his 1519–22 expedition to circumnavigate the Earth saw them for the first time after his death. The Large Magellanic Cloud (LMC, top left) and the Small Magellanic Cloud (SMC, bottom right) are satellite galaxies of our own Milky Way. Both galaxies are easily visible with the naked eye – indeed, this image was made using only a powerful camera and a long exposure from one of the best sky-viewing places on Earth, La Silla Observatory in Chile. Most of the composite picture is in black and white and negative, because it is easier to reduce the background 'noise' of light interference from objects other than those being pictured. The Magellanic Clouds have been overlaid with images taken through a colour filter. Surrounding both the LMC and the SMC are faint haloes of stars, including a stream of stars that extends from one towards the other. It seems that the two galaxies recently collided, their mutual gravitational interaction drawing stars into intergalactic space. This is not unusual. Our own Galaxy is surrounded by streams of stars, the remnants of collisions of other small galaxies with ours.

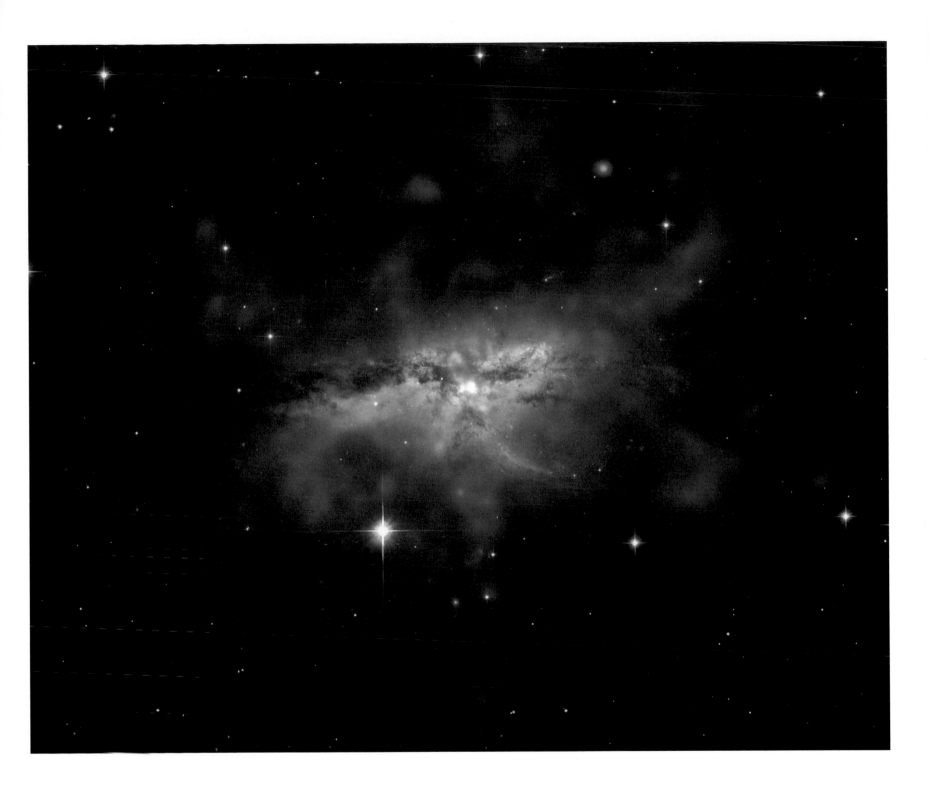

NGC 6240: HOT CLOUD AND SPIRAL GALAXIES

2013

X-RAY. NASA, CXC, SAO, E. NARDINI ET AL; OPTICAL: NASA, STSCI

Composite digital image, dimensions variable

The lightish smudges in the centre of this giant, gaseous purple cloud are two spiral galaxies violently colliding with one another. Although the Hubble Space Telescope has observed the galaxies, this image of the immense hot region enveloping them was created from observations made by a less famous, but equally important, orbiting telescope: the Chandra X-Ray Observatory. Carried into orbit by the Space Shuttle Columbia in 1999, the

x-ray observatory detects emissions from high-energy regions, such as black holes, exploded stars and clusters of galaxies. Because the Earth's atmosphere absorbs x-rays, orbiting telescopes are astronomers' only means of detecting and studying them. Chandra's images lack the sharp detail of many telescopic views: the glowing regions in x-ray images appear more diffuse. Because humans cannot see this wavelength of light, the images

cannot mirror our visual experience – astronomers must translate the invisible for us. The purple hue does not represent the cloud's appearance but its highly energetic qualities. As in this example, x-ray images are often shown combined with optical data. The more familiar images in the visible spectrum help to orient us – even as the ghostly appearance of the x-ray data reminds us of the cosmic mysteries that remain.

COLOURS OF DOUBLE STARS
1864

WILLIAM HENRY SMYTH

Chromolithograph, 25.2 × 15.9 cm / 10 × 6¼ in
Royal Society, London

This work might resemble a box of watercolour paints, but the Royal Navy admiral and amateur astronomer William Henry Smyth (1788–1865) had a serious scientific purpose when in 1864 he published *Sidereal Chromatics*, which presented a precise observation of the colours of double stars. Admiral Smyth wanted to ensure that astronomers used standard descriptions and drew this chart to provide, as far as contemporary printing techniques were able, a standard reference. Smyth had earlier classified by eye thousands of stars into a colour scheme of nearly forty shades, ranging from amethyst to the brown of vanilla beans. The initial list attracted criticism from his peers, who wondered how he could distinguish so many colours, so Smyth condensed it. His revised system contained eight basic colours, graded by intensity, although his chart omitted shades between white and pale yellow (the vast majority of stars) as being 'unfit for representation and lamplight reference'. Smyth's scheme is supported by modern measurements of the spectrum of the stars. Orange and red stars are easily distinguished from blue and green ones. The colours are, mostly, the result of the stars' surface temperature – blue stars measure tens or even hundreds of thousands of degrees, but red stars just a few thousand.

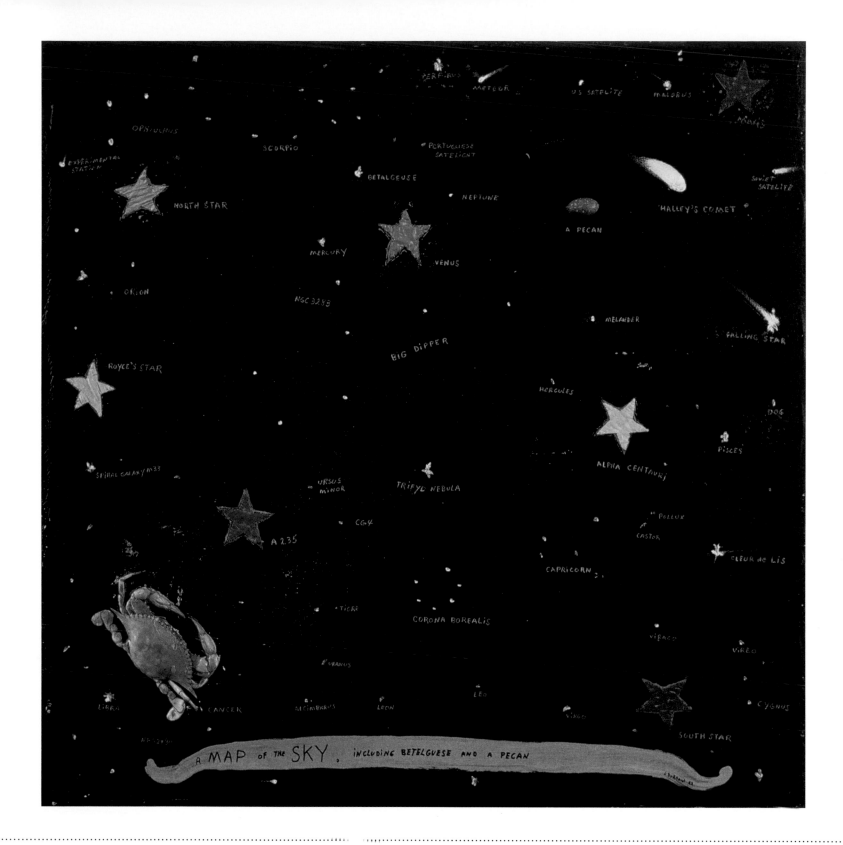

A MAP OF THE SKY INCLUDING BETELGUESE AND A PECAN

1993

JIMMIE DURHAM

Peçan, crab, fabric, cotton on wood, 91.5 × 92 cm / 36 × 36¼ in
Irish Museum of Modern Art, Dublin

There is a sense of delight and fun in the depthless arrangement of *A Map of the Sky*, which includes childish representations of five-pointed stars – including Venus, in its guise of the Morning Star, and Mars – depicted in lime green, lemon yellow, baby blue and scarlet red labelled with white upper-case writing. Other labels mark the position of constellations including Scorpio, with more or less accurate depictions of their stars, as well as Halley's Comet and a falling star. The American artist Jimmie Durham subverts the traditional medium of oil painting by including found objects: a crab to represent the constellation Cancer, and a pecan nut. The objects increase the work's cartoonish aesthetic, as the wonders of Durham's imagination mould a new vision of the Universe. Born in 1940, but leaving the United States in 1987 to live in Mexico and then Europe, Durham uses his work to question hierarchies, using sculptural assemblages, as well as found materials, to fuse materials that are both synthetic and natural. All are equal within his artworks: oil paint, crabs, nuts, driftwood and bones are all resources through which to express a feeling or idea. Durham is credited for helping to widen the art canon to include works by women and artists of colour.

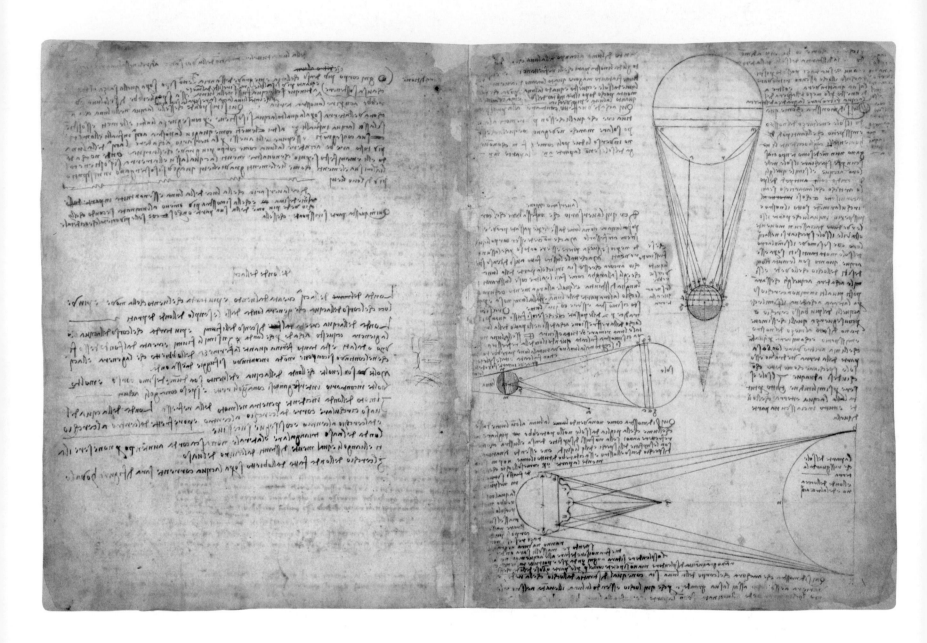

STUDIES OF THE ILLUMINATION
OF THE MOON

1508–12

LEONARDO DA VINCI

Sepia ink on linen paper, from *Codex Leicester*
29 × 22 cm / 11⅓ × 8⅔ in
Private collection

It is hardly surprising that Leonardo da Vinci should have turned his astoundingly fertile mind to problems in astronomy. His notebooks record his ideas, designs and field notes, revealing the incisive thinking of a man who was very much of his time, grappling with the same questions that concerned many of his contemporaries. On the 36 then-loose folios of what became the *Codex Leicester* (purchased by Bill Gates for $30.8m in 1994,

making it the world's most expensive book), Leonardo speculated in his customary mirror-writing on a range of subjects, mainly relating to water. The practical questions of water management that interested an engineer quickly flowed into other related topics. Here he discusses the luminosity of the Moon and, by considering the way sunlight is equally reflected from the seas on Earth, concludes that the Moon must be covered with water;

this implies that the Moon, like Earth, must have gravity. Later in the same notebook he speculates (correctly) that the dim light of the new Moon is light reflected from Earth's seas. His arguments are presented in scholastic dialogue, as he challenges the objections of an imagined interlocutor, and thinks through the logical implications of his ideas as well as their practical potential.

MEASUREMENT OF THE EARTH (ERATOSTHENES)

1966

CROCKETT JOHNSON

House paint on Masonite, 76.4 × 65 cm / 30 × 25½ in
Smithsonian American Art Museum, Washington, DC

Almost abstract, this painting by the American painter and illustrator Crockett Johnson (1906–75) shows a purple circle symbolizing the Earth illuminated by a beam of green sunlight. The two lines radiating from the centre of the circle represent the two rods used by the ancient Greek mathematician and librarian of Alexandria, Eratosthenes, in the third century BC to determine the size of the Earth. Eratosthenes had heard that, at noon on the summer solstice, the year's longest day, the Sun's rays pierced to the bottom of a deep well at Syene in Upper Egypt (present-day Aswan), a sign that the Sun was directly overhead. At noon on the solstice, Eratosthenes measured the length of the shadow cast by a vertical post at Alexandria and worked out that its angle to the Sun was one-fiftieth of a circle from the zenith. He determined the distance between Syene and Alexandria by driving a carriage between the two cities and counting the revolutions of the wheels (which must have been about 100,000!). Erathosthenes multiplied this distance – 5,000 stadia – by fifty to calculate the circumference of the Earth as 250,000 stadia. This is thought to be equivalent to about 45,000 kilometres (28,000 miles), remarkably close to the modern measurement of the Earth's diameter, which is 40,000 kilometres (25,000 miles).

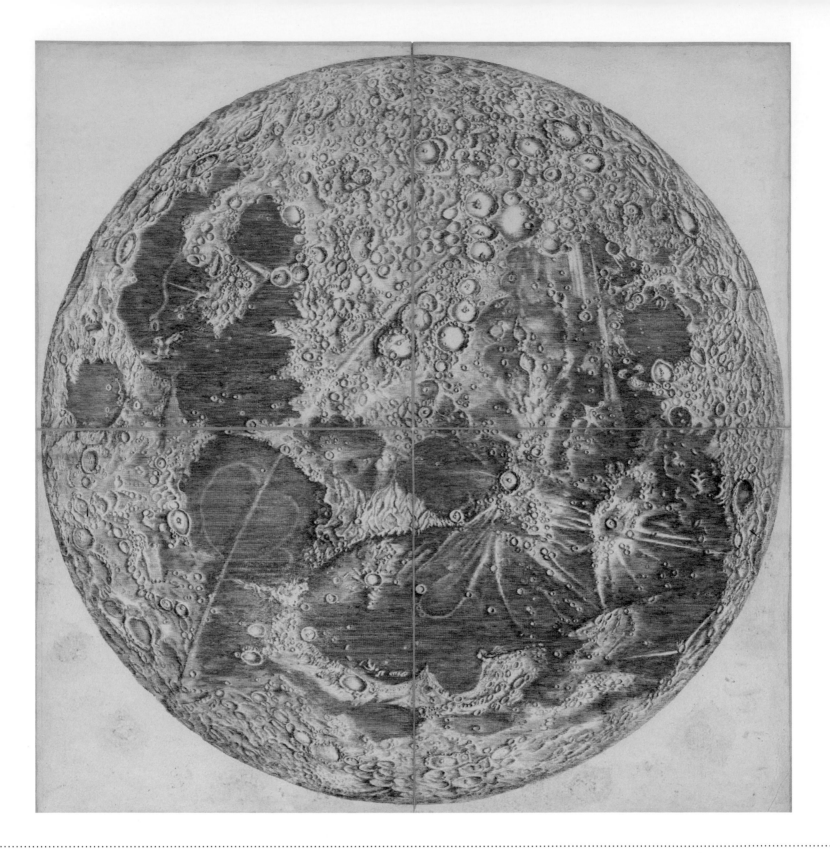

LARGE MAP OF THE MOON
1679

GIAN DOMENICO CASSINI AND JEAN PATIGNY

Copper engraving, 56 × 56 cm / 22 × 22 in
Observatoire de Paris, Paris

This 1679 engraving of the Moon – the first ever to show such detail – was compiled from about sixty drawings made by the astronomer Gian Domenico Cassini (1625–1712) during eight years spent observing the Moon from the Paris Observatory and working with two artist assistants. The map shows features as small as 15 kilometres (9.5 miles) across, and much of it has proved to be accurate, but some is less reliable – and it

also includes a completely fictional detail. In the lower right quadrant of the map, the Promontorium Heraclites (Heraclites' Promontory) is the end of a mountainous, broken crater wall that forms the edge of Sinus Iridum (the Bay of Rainbows), itself cutting into the black area of Mare Imbrium (the Sea of Rains) above. The promontory is depicted as the head of a woman, in profile, with her hair and neck merging into the rest of the mountain range.

It is not known who initiated the incorporation of the 'Moon Maiden' into the map, but it must have been either Cassini or his engraver, Jean Patigny. She may represent Cassini's wife, Geneviève De Laistre, whom he married in 1673, and of whom he commissioned a pen-and-ink portrait from Patigny's son, Jean Baptiste, in 1678. The map, measuring 53 centimetres (21 inches) across, was published the following year.

MOON DREAMING
1978

MICK NAMARARI TJAPALTJARRI

Synthetic polymer paint on composition board
60.9 × 44.9 cm / 24 × 1/ 4/3 in
National Gallery of Australia, Canberra

This painting from 1978 takes a viewpoint typical of aboriginal art, looking down on the Earth from such a remove that we are above the Moon, a golden globe from which gentle light washes over the ochre desert of the Australian landscape below, revealing the shadows of mysterious shapes. The shapes may mark the positions of buried axes or sacred artefacts or be simple hints of hollows and cracks in the desert soil. The story reflects an episode from the Dreaming, the period when Aboriginal Australians believe supernatural creatures walked the Earth while the Universe was created, represented largely in the ochres, whites and oranges and stippled technique of traditional Aboriginal art. Born in the remote Western Australian desert, the artist Mick Namarari Tjapaltjarri (1926–98) was one of the founders in 1971 of the Papunya Tula Art Movement, now based in Alice Springs. This remarkable group of artists developed innovative ways of telling Dreaming stories by linking the red land, blazing sun and dark beauty of Australia's night skies in complex and imaginative ways. The same colours appear in the simple and iconic Australian Aboriginal flag, which also dates from 1971.

SEARCHING FOR GOLDILOCKS
2012

ANGELA PALMER

Engraving on 18 sheets of Mirogard glass
210.4 × 99.8 × 76.8 cm / 82¾ × 39¼ × 30¼ in
Smithsonian Air and Space Museum, Washington, DC

The layered glass sculptures of British artist Angela Palmer (born 1957) usually represent introspective spaces, what is invisible within. With *Searching for Goldilocks*, Palmer went beyond the human, personal scale to map solar systems. She recreated a vast area of space using data from NASA's Kepler mission. The space-borne Kepler telescope is optimized to detect planets that fall within the so-called 'Goldilocks zone'.

This is the region at just the right distance from its parent star for a planet to be neither too hot nor too cold for liquid water to exist, and thus present the right conditions to sustain life – like our Earth. The telescope's 21 camera chips point at fixed locations in the sky giving, from the perspective of Earth, a cross-shaped grid encompassing 145,000 individual stars. Palmer de-projected this grid, by engraving the planetary systems on 18 staggered

sheets of glass, each slice representing 250 light years, to reveal a three-dimensional distribution of planet-bearing stars. Between its launch in 2009 and the completed piece, the telescope discovered 2,321 'planet candidates' (over 5,000 at the last count), here represented as clear circles. Of these, 40 were deemed capable of harbouring life – Palmer distinguished these by filling their outlines to make opaque circles.

RELATIVE SIZES OF KEPLER HABITABLE ZONE PLANETS

2015

NASA AMES, JPL CAITECH

Composite digital image, dimensions variable

For most people, only the right-hand planet in this image, Earth, will be familiar: the others are artists' impressions of five exoplanets, which are known only as (from left) Kepler-22b, Kepler-69c, Kepler-425b, Kepler-62f and Kepler-186f. They are scaled to reflect their sizes relative to Earth. The image was created from data gathered by the Kepler mission, the latest stage of a quest that has endured for centuries: the attempt to find other habitable planets. The Kepler Mission was launched in March 2009 to survey a region of our Milky Way Galaxy in order to discover other planets in or near the habitable zone – the region at the right distance from the star to be neither too hot nor too cold for life. The spacecraft's instruments also gather information to determine the proportion of the hundreds of billions of stars in Earth's Galaxy that might have such planets. In its first four years, Kepler monitored 150,000 stars, searching for tiny dips in their brightness that may be produced by a transiting planet, producing evidence for substantial numbers of exoplanets. The Kepler Mission's discoveries (including those of the K2 extension, approved by NASA in 2014 after damage to the reaction wheels of the Kepler observatory) are providing a huge amount of data and intensifying popular interest in the search for habitable planets.

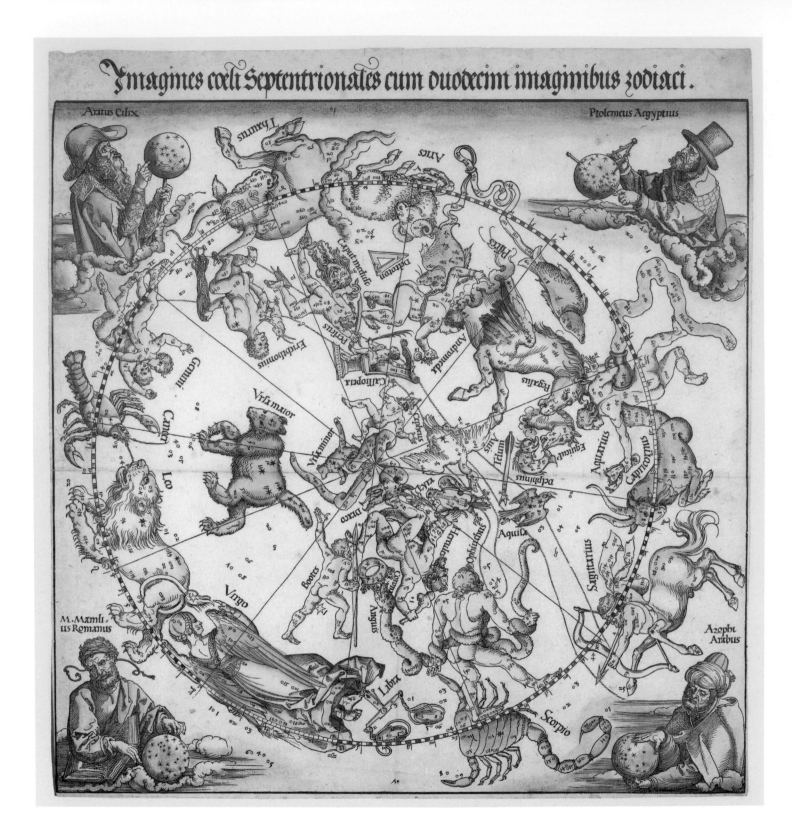

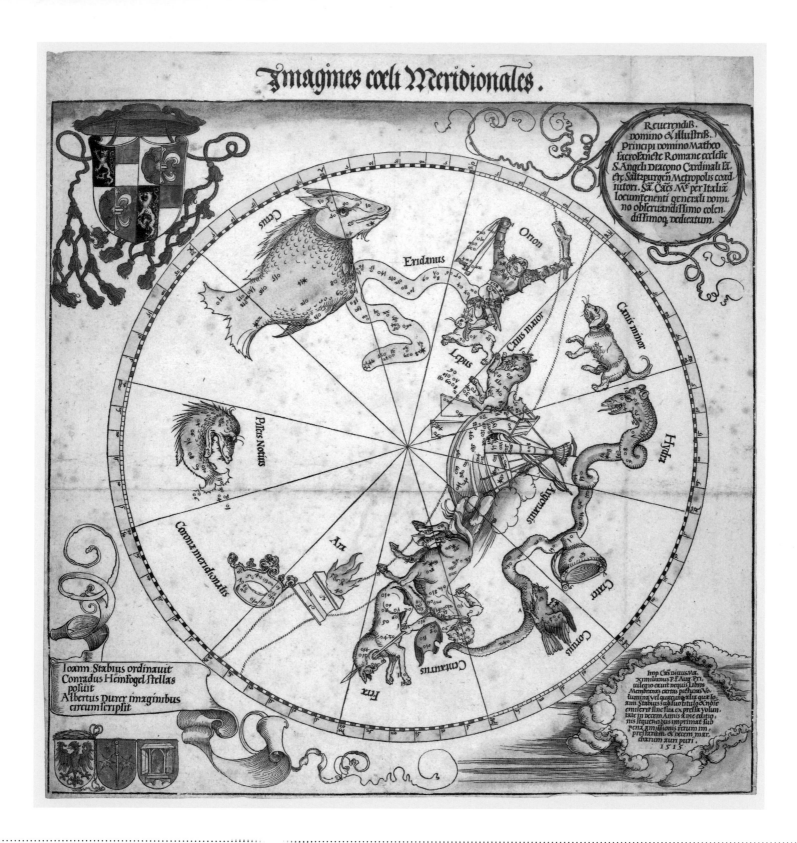

MAP OF THE NORTHERN SKY AND MAP OF THE SOUTHERN SKY

c.1515

ALBRECHT DÜRER

Hand-coloured woodcut prints, Northern Sky: 46.5 × 43.6 cm / 18⅓ × 17¼ in; Southern Sky: 46.2 × 43.8 cm / 18¼ × 17¼ in
Private collection

These woodcuts by the German artist Albrecht Dürer were the first printed celestial maps and their figures and animals remain iconic more than 500 years after he drew them. The stars and constellations are accurately placed as if they were on the inside of a sphere seen from the outside. The woodcut was based on work by the Austrian mathematician Johannes Stabius and the German astronomer Conrad Heinfogel. The map of the southern constellations shows the 'hole' in the south celestial region: the part of the sky never visible from the north, and where therefore no classical constellations were described. The hole is offset from the position of the south celestial pole because of the orientation of the Earth's rotation axis, which leans at an angle of 23.5 degrees to its orbital plane; however, with a period of 26,000 years the direction of the axis in space moves in a cone – the phenomenon of 'precession'. The amount the hole is offset, generated between the time the constellations took form and now, indicates where and when the constellations were named, which was probably in the second millennium BC by people who lived just south of latitude 36 degrees north – meaning the Babylonians and their Sumerian ancestors, who lived in Mesopotamia, located in modern-day Iraq.

DETAILED VIEW OF A SOLAR ECLIPSE CORONA

2008

MILOSLAV DRUCKMÜLLER

Digital photograph, dimensions variable

What seem almost like grey veils hanging in space are rare evidence of the corona formed by the violent solar wind that streams endlessly into space from the Sun, sweeping invisibly through the Solar System. The phenomenon becomes visible only during the brief minutes of a solar eclipse, when the Moon's disk blocks the Sun's light and the faint corona appears – although the rapid change from bright sunlight to near-darkness leaves the human eye little time to adjust in order to grasp the full extent of the solar corona. In 2008, the Czech academic and astrophotographer Miloslav Druckmüller travelled to Bor-Udzuur in Mongolia to photograph a solar eclipse. Druckmüller, who runs a project named Mathematical Methods of Visualization of Solar Corona (MMV), combined twenty-five separate images taken with his digital camera, using exposure times ranging from 1/4,000 to 8 seconds. Each image was treated using Druckmüller's maths-based processes to reveal detail, even the red fringe of solar prominences appearing above the grey disk of the Moon. The image created represents a true cross-section of the Sun's eastern limb, the loops capturing the effect of the Sun's magnetic field on the million-degree solar plasma, the streaks emphasizing the energy with which the plasma is ejected.

THE WEATHER PROJECT
2003–04

OLAFUR ELIASSON

Monofrequency lights, projection foil, haze machines, mirror foil, aluminium and scaffolding
26.7 × 22.3 × 155.4 m / 88 × 73 × 510 ft
Installation view, Turbine Hall, Tate Modern, London

High on one wall of a huge hall that once housed turbines for a power station in what is now Tate Modern in London, the Danish-Icelandic artist Olafur Eliasson (born 1967) hung a semi-circular screen that was backlit with 200 mono-frequency lights in yellow neon. Mirrors on the ceiling, completed the circle and created what looked like a giant sun. Eliasson had artificial mist pumped into the room to soften the light and the edges

of the screen, as well as to distinguish the conditions in the Turbine Hall from those in the rest of the gallery. Visitors came to sunbathe under the artificial light, gazing up at their reflections in the mirrored ceiling. With his 2003 installation, Eliasson brought the weather indoors, but although the project started from an interest in weather and how it shapes experience, the end result effectively focused attention on human interactions with the Sun.

Eliasson used a semi-circular screen, monofrequency light-bulbs, a ceiling of mirrors and artificial mist to create the illusion of the sun – half-light blubs and half-reflection. A visitor could bask in its light without fear of damaging rays or intense heat. The installation invited a reenactment of the long history of worshipping the Sun, the star that sustains life on the Earth.

DETAIL FROM THE BAYEUX TAPESTRY
1070–77

UNKNOWN

Embroidery on linen, 7,000 × 50 cm / 2,755 × 19⅔ in
Musée de la Tapisserie de Bayeux, Bayeux

Events in the heavens have often been taken as signs of divine will, and the Norman nobles gesturing towards the fiery-tailed comet in the sky are clearly wondering about its portent. They are captioned in Latin, 'ISTI MIRANT STELLA[M]' – 'These people are gazing at the star'. This is the thirty-second of the fifty-eight panels of the Bayeux Tapestry, a sequence of episodes measuring 70 metres (230 feet) long that illustrates the invasion of England by William, Duke of Normandy, in 1066. The comet is identifiable as Halley's Comet, which appeared in April 1066, soon after Harold's coronation. William believed that the former king of England, Edward the Confessor, had promised that William should succeed him, rather than Harold, and set out to rectify an injustice by seizing the throne. The tapestry, probably created between 1070 and 1077, illustrates several incidents that seem to justify the Normans' invaion. What could be more convincing than the appearance of a comet, showing that Harold's death was ordained and celestially endorsing William's claim? Shakespeare refers to the same astrological belief, writing about the death of Julius Caesar (Act II, scene ii): 'The heavens themselves blaze forth the death of princes.' The maker of the tapestry, which is in fact embroidered in wool on linen rather than woven, is unknown.

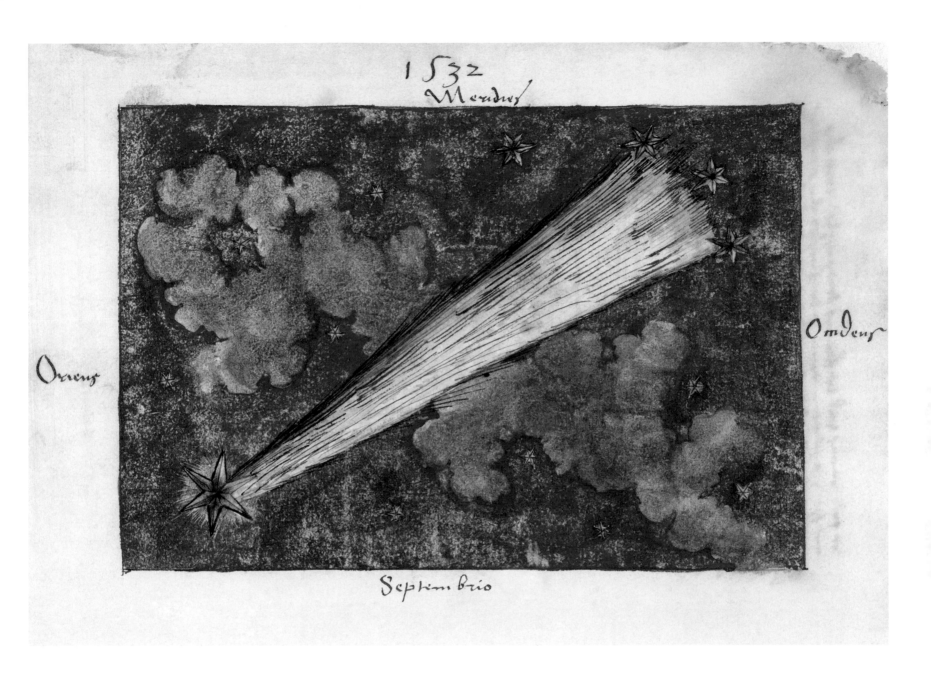

THE GREAT COMET OF 1532

16th century

UNKNOWN

Watercolour sketch, 15 × 22 cm / 6 × 8¾ in
Science Museum, London

When this watercolour was painted in a commonplace book in the sixteenth century, comets remained among the most mysterious of phenomena. The painter's naive depiction shows a straight-tailed comet in a blue sky that is partly cloudy and partly starry, presumably indicating twilight. The comet seems to be passing in front of the clouds, which is consistent with the then-prevailing view that comets were atmospheric phenomena, but it

also seems to be passing behind the stars. The painting depicts a specific event, as indicated by the margin date of 1532. The shape of the tail corresponds to that of the 'Comet of 1532' (now designated C/1532 R1), which moved along the morning horizon during the last quarter of the year. By analyzing this comet astronomers realized that its tail always pointed away from the Sun, a feature of comets' motion that suggested celestial rather than

atmospheric origins. Among those who studied the orbit was the English astronomer Edmond Halley, who noted that it moved similarly to a comet visible in 1661. He suggested they might be identical, but searches failed to find it again when it was predicted to reappear. It now seems that the two (and others since) might be pieces from the comet that gave rise to a twenty-first-century one, 153P/Ikeya–Zhang, discovered in 2002.

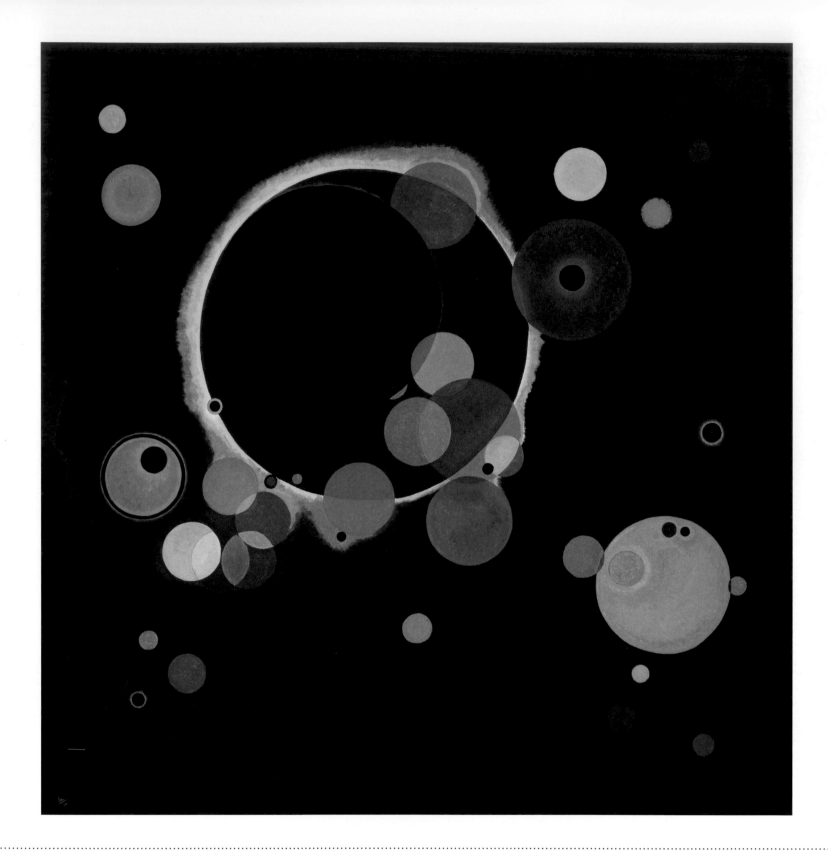

SEVERAL CIRCLES
1926

WASSILY KANDINSKY

Oil on canvas, 140.3 x 140.7 cm / 55¼ x 55½ in
Solomon R. Guggenheim Museum, New York

While composed as a purely abstract arrangement of various-sized circles, this canvas by the Russian artist Wassily Kandinsky (1866–1944) is full of suggestions of the cosmos. Within an atmosphere of black space that swirls with undulating patters of deepest blue-grey, his round forms float like planets and overlap, some with tiny black nuclei that stare out at the viewer. Carefully executed with delicate strokes of smooth brushwork, the circles shift in colour as they overlie one another: mint green becomes forest green as a light circle of ochre drifts over it also turning bubble-gum pink into a pale, dusty tone; cherry red fades into lemon yellow; lilac purple moves as lapis-lazuli blue. Kandinsky was associated with the expressionist group Der Blaue Reiter (The Blue Rider) in Munich but returned in 1914 to his native Russia, where his works began to reflect the geometry and flat colour planes of the Suprematist and Constructivist art movements. Inspired by an expressive rather than a rational approach, Kandinsky later joined the Bauhaus group in the German city of Weimar, under the influence of which he produced this work. Kandinsky uses colour, mass and pattern to convey a calm dynamic amid the uniformity of his circles, a shape that he felt opened up a fourth dimension – one of spirituality.

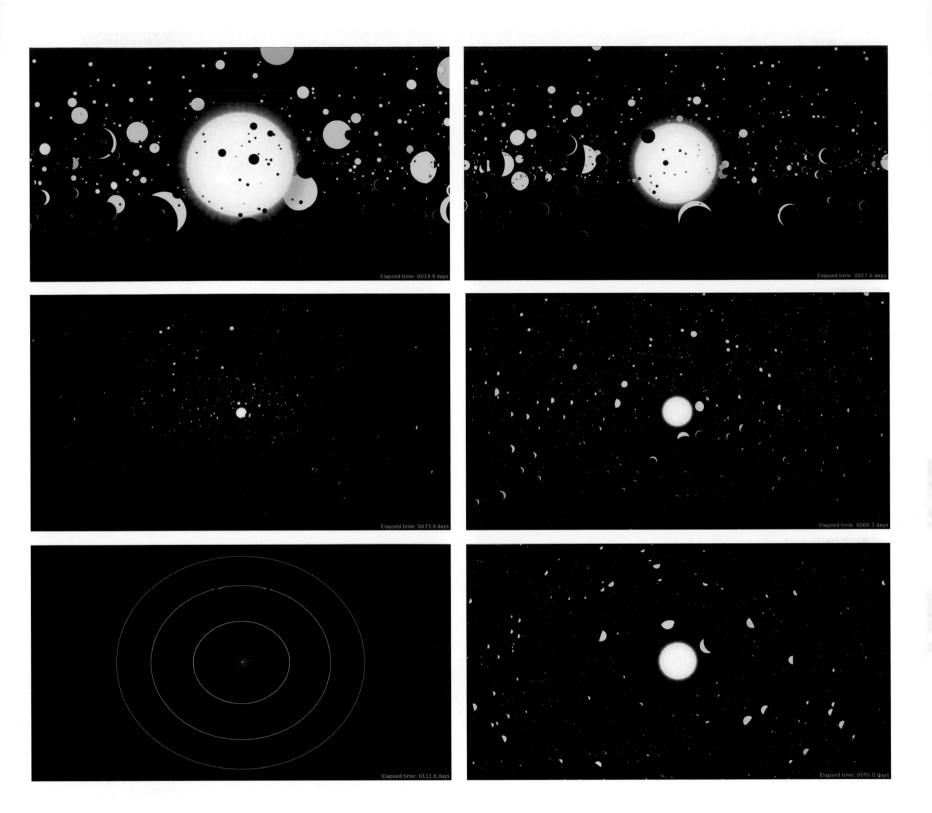

Elapsed time: 0019.9 days

Elapsed time: 0027.6 days

Elapsed time: 0073.9 days

Elapsed time: 0086.0 days

Elapsed time: 0111.6 days

Elapsed time: 0095.0 days

WORLDS: THE KEPLER PLANET CANDIDATES ALEX PARKER

2012

Animation, dimensions variable

In just under three-and-a-half minutes, University of California astronomer Alex Parker's animation *Worlds* depicts 2,299 possible planets orbiting a single star. What might seem like a fantasy exercise is nothing of the sort. The majority of these exoplanets (or extrasolar planets) have been detected by NASA's Kepler Space Telescope. Kepler monitors minute changes in a star's brightness to deduce information about possible planets crossing its disc. From the data generated by this dimming, Parker has constructed an animation that shows, to as precise a relative scale as possible, most of the currently known planets, their orbital distances and periods. The colours indicate a planet's estimated temperature, from red to blue. Imagining other worlds around other stars has preoccupied philosophers, scientists, science-fiction writers and others for centuries, at least since Copernicus proclaimed that the planets orbit the Sun. When Galileo's telescope revealed vast numbers of previously unseen stars, it seemed only a matter of time before exoplanets would be discovered. However, it was to be almost 400 years before solid evidence appeared in the early 1990s. By May 2017, more than 3,608 confirmed exoplanets had been detected circling more than 2,500 stars.

PLANET SET, TÊTE ETOILÉE
GIUDITTA PASTA (DÉDICACE)
1950

JOSEPH CORNELL

Glass, crystal, wood and paper
30.5 × 45.7 × 10.2 cm / 12 × 18 × 4 in
Tate, London

Twin maps of the northern and southern celestial hemispheres from a popular science book provide the background for this enigmatic box, which the American artist Joseph Cornell dedicated to Giuditta Pasta, the nineteenth-century opera star whose voice was said to evoke the beauty of the night sky. Cornell (1903–72), who is best known for the miniature, boxed dioramas that he assembled from found materials, had a long-standing interest in astronomy. He closely followed new scientific developments, as well as studying the history of astronomy, although the way Cornell used these elements was often more poetic. At the top of *Planet Set, Tête Etoilée, Giuditta Pasta (dédicace)*, the white balls balance on rods and roll along prescribed pathways, resembling planets in their orbits. The glasses at the bottom of the box might correspond to the six planets visible to naked-eye observers from Earth – or the blue marble may be a reference to Earth itself. But the juxtaposition of objects within Cornell's boxes remains idiosyncratic, and the title serves as a reminder of this. Stars of the screen and stage also fascinated the artist. Cornell brought his enthusiasms together by dedicating this box to a glamorous, largely forgotten star of the stage.

THE NIGHT CELL
2009/10

GARRY FABIAN MILLER

Water, light, lightjet C-print from dye destruction
152.1 × 182.6 cm / 60 × 72 in
Private collection

British artist Garry Fabian Miller's *Night Cell* speaks of the origins and essence of photography, the art of capturing light. Some of the earliest photographs were scientific records that revealed for the first time the infinitesimally small or the exceptionally large. Miller's indigo disk, speckled with shimmering dots on a deep blue field, recalls simultaneously colonies of bacteria in a Petri dish and a view of the night sky seen through a telescope. Working exclusively with 'camera-less' photography since 1984, Miller is known for his investigation of light as medium and subject. Directly capturing forms on to light-sensitive paper without using a lens or film, his work harks back to the foundations of photography, from the 'camera obscura' to early photographic experiments in the nineteenth century. Since the 1990s Miller (born 1967) has made abstract compositions in the darkroom, letting light seep through glass vessels or over cut paper shapes. He uses hours-long exposures, the concentrated expanse of light turning the invisible and imagined into luminous realities. Poignantly, Miller uses exclusively dye destruction paper or 'Cibachrome', which ceased to be manufactured in 2012. He has declared that when his supplies run out, his darkroom will close.

Photographie d'une portion de la Lyre (20 Juin 1887)

AR = 19ʰ 19ᵐ. — P = 37°.7'

Observatoire de Paris

Durée de la pose = 2 heures *Agrandissement = 2 fois*

par M.M. Henry.

A PORTION OF THE CONSTELLATION LYRA
1887

PAUL AND PROSPER HENRY

Albumen silver print, 31.4 × 24 cm / 12⅓ × 9½ in (image) on paper
49.2 × 32.1 cm / 19⅓ × 12⅔ in
Museum of Fine Arts, Houston

The stars in this photograph from 1887 of a tiny corner of the constellation Lyra may appear, frankly, rather underwhelming – yet the image contains many that had previously never been seen. More importantly, it also marked the launch of photography in professional astronomy. It was taken by the Henry brothers, Paul and Prosper, of the Paris Observatory, where in 1872 they had inherited a programme to map the entire sky by eye. Reaching the Milky Way in 1884, they found the stars too dense to map by eye, so they invented the first lens-type telescope, specifically designed for celestial photography. This inspired the project known as the *Carte du Ciel*, or Sky Map, for which this print was a prototype. The *Carte du Ciel* coordinated the work of eighteen observatories across a dozen countries, a forerunner of today's international space projects.

The observatories used telescopes built to the Henrys' model. Each observatory took between 1,000 and 1,500 photographs of its specific band of the sky, with exposures of up to two hours. The sky was to be photographed twice, for a catalogue of 5 million brighter stars and a map of fainter ones. The map was never completed, but the catalogue came to fruition after about seventy years.

CETTE OBSCURE CLARTÉ QUI TOMBE DES ÉTOILES
1999

ANSELM KIEFER

Acrylic paint, oil paint, shellac, earth, sand, wood, paper and glass on canvas, 4.7 × 4 m / 15 ft 5 in × 13 ft 1 ½ in
Tate, London, and National Galleries of Scotland, Edinburgh

White lines define what are apparently constellations, picked out against a background of labelled stars, but this apparent depiction of a cosmos is undermined by the work's French title, which translates as *The Dark Light that Falls from the Stars*. The German artist Anselm Kiefer (born 1945) created this image from a surface of cracked and fractured wood, pigment and straw, which he has combined with clay and a hard resin called shellac.

It is part of a sculpture based on a ruined bookshelf of manuscripts that are decaying before our eyes. The work is a reminder of the Nazis' book-burning in 1933, when books by Jewish writers were destroyed in a huge bonfire. The link between the bonfire and the stars is not clear in Kiefer's work, but the tones of smudged greys and blacks echo Kiefer's lifelong exploration of the darkness of Germany's twentieth-century history. The work's title

derives from *Le Cid*, a five-act tragicomedy by French dramatist Pierre Corneille, used to underline Kiefer's affiliation with France – he lives and works in Paris – and the sense of freedom that this has given him, allowing him to escape his German heritage in order more astutely to evaluate and portray it.

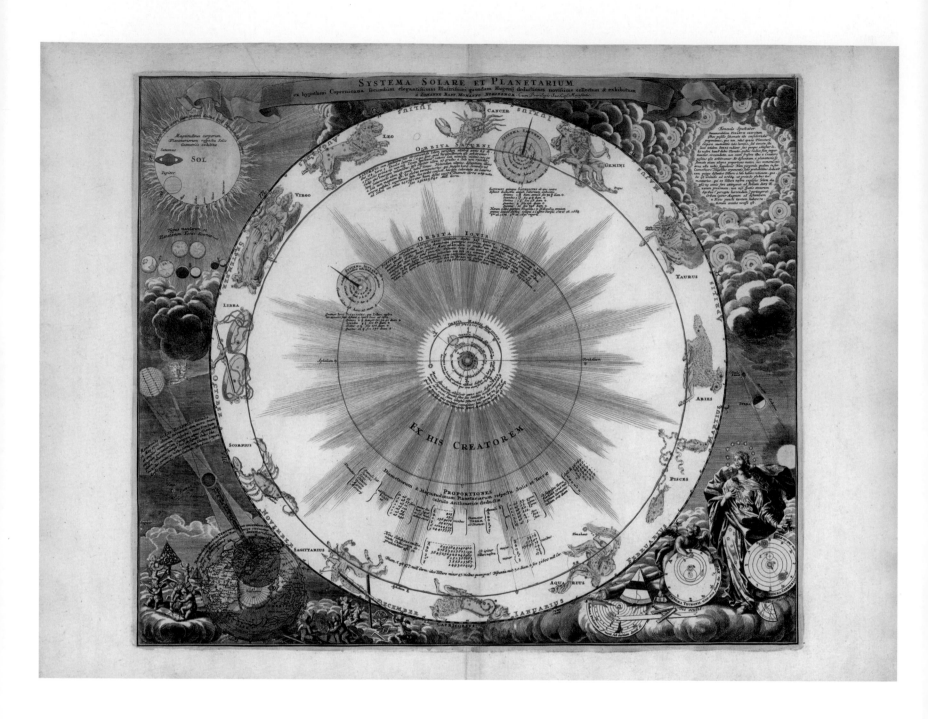

SYSTEMA SOLARE ET PLANETARIUM
1716

JOHANN BAPTIST HOMANN

Hand-coloured engraving, 51 × 60 cm / 20 × 23⅔ in
David Rumsey Historical Map Collection, Stanford, CA

This map of the Copernican Solar System, *Systema Solare et Planetarium*, which dates from 1716, was the work of the greatest cartographer of the day, Johann Baptist Homann (1664–1724). The map reflects the growing knowledge of astronomy and the Solar System, showing the planets to their relative scales, with suggested measurements for their diameters, along with the twelve constellations of the zodiac. In the lower left corner,

Homann details an eclipse of the Sun that occurred on 12 May 1706, while the lower right corner features Urania, the goddess of astronomy. Beneath Urania are three cosmological systems: that of Claudius Ptolemy (it is obscured by modern astronomical instruments, suggesting that it is obsolete); the Earth-centred system proposed by Tycho Brahe; and the heliocentric system of Nicolaus Copernicus, which Homann labels '*sic*

ratione' ('according to reason'). Homann's Nuremberg-based firm was known for its heavy detailed engraving, its vivid hand colouring and its elaborate allegorical cartouche work, all of which are evident here. Homann's firm was well established as the leading producer of maps thanks to enjoying 'privilege', an early type of copyright granted by the Holy Roman Emperor.

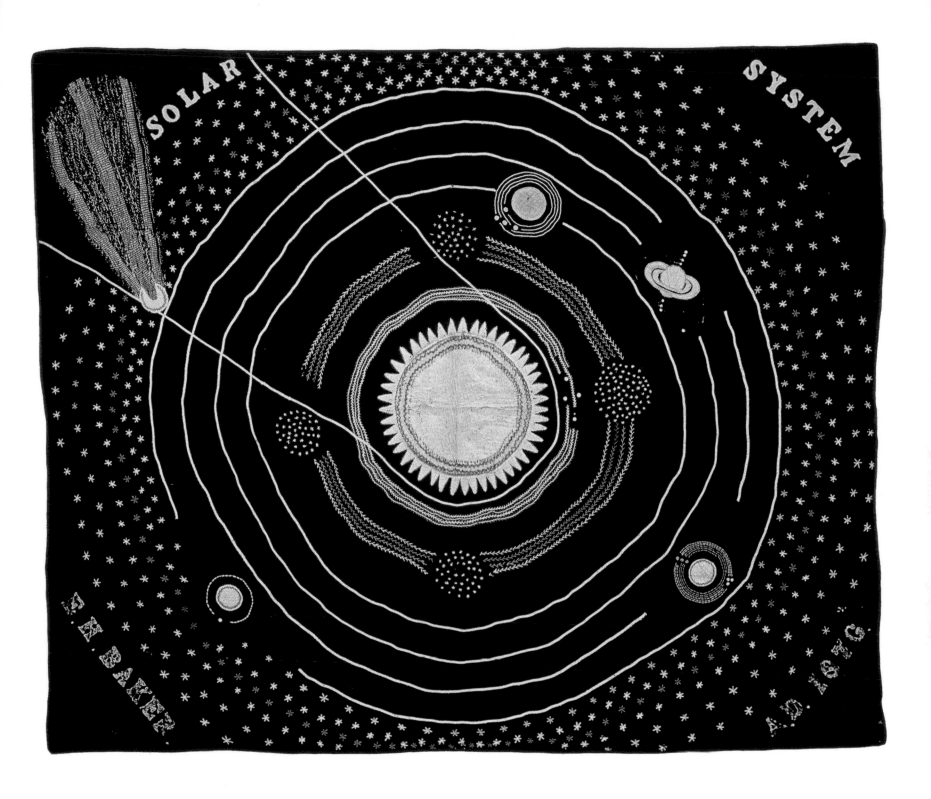

'SOLAR SYSTEM' QUILT
1876

ELLEN HARDING BAKER

Wool, cotton, silk, 225 × 269 cm / 89 × 106 in
National Museum of American History, Kenneth E. Behring Center,
Washington, DC

The concentric circles of this representation of the Solar System in a nineteenth-century quilt by Ellen Harding Baker (1847–86) are based closely on contemporary astronomy textbooks from the 1870s. With a combination of woollen appliqué, wool braid and silk embroidery, Baker shows the central Sun being looped by the path of a comet. The comet itself at top left only has one tail, as was believed at the time. We know now that comets have two tails: an ion tail that points away from the Sun and a more obvious dust tail that follows the comet's orbit. The four tightly grouped circles closest to the Sun mark the orbits of the four inner planets (Earth is accompanied by its Moon) inside the brightly coloured asteroid belt, with four groups of asteroids. Further out still lie the giant planets, floating in deep space: Jupiter and its four Galilean moons, then Saturn, Uranus and, finally, Neptune, discovered thirty years earlier. Outside the Solar System, Baker illustrates six rings of five-pointed stars with no sense of scale. Baker combined the popular American pastime of quilting with a characteristic contemporary enthusiasm for astronomy and used the quilt to illustrate lectures she gave to her neighbours in West Branch, Moscow and Lone Tree, Iowa, where she and her husband had a merchandizing business.

CHILDREN'S MAP OF THE MILKY WAY
2004

THE GENUINE COMPANY LIMITED

Printed paper, 137 × 97 cm / 54 × 38 in
Private collection

This large children's poster is intended as an entertaining introduction to the Milky Way, with a computer-generated image of our home spiral Galaxy and its billions of stars forming the background to 220 cartoon images randomly scattered across the poster – enough to mean that there is always something new to discover. The images range from rockets, satellites, supernovas and atoms to a traveller on a camel and Father Christmas and his

reindeer, each accompanied by a written caption that explains in bite-sized portions our current understanding of the Milky Way and life on Earth (most of the drawings feature children rather than grown-ups, although Father Christmas is suitably aged). From molecular clouds to globular star clusters, the colourful drawings teach users about stars, planets and cosmic phenomena in the Milky Way since the Big Bang. Each cartoon is carefully

sketched out, then drawn and coloured in before being added to the map. As well as describing astronomical events, the poster illustrates the different forays humans have made into space – all accompanied by facts about rockets and spaceflight.

MILKY WAY EXPLORER
2009

KEVIN JARDINE
Using images from various sources

Website, dimensions variable

The Galaxy Map website was launched in January 2009 with the goal of making an online atlas of the Milky Way – Earth's home galaxy. The project tracks on-going space programmes and related scientific research and, amongst other data and material, the site includes much information gathered by the Infrared Astronomical Satellite (IRAS) that started operating in 1983. A joint project of the US, UK and the Netherlands, this satellite successfully observed more than 96 per cent of the sky at four infrared frequencies and detected about 350,000 infrared sources. The site includes two sets of maps. First, Milky Way Explorer shows what our galaxy might look like from Earth if we could see at infrared, microwave and radio frequencies. The second, head-on, set of maps shows what the Milky Way might look like from an interstellar spacecraft, including the distances and positions of bright stars, star clusters, nebulae and molecular clouds. These maps also plot the positions of the images shown in Milky Way Explorer. Of the four images shown above, 1, 2 and 3 demonstrate the beauty that enhanced vision from spacecraft-borne cameras and radio-frequency data produces. Image 4 shows equally stunning effects achieved with a regular digital camera captured from two locations on Earth.

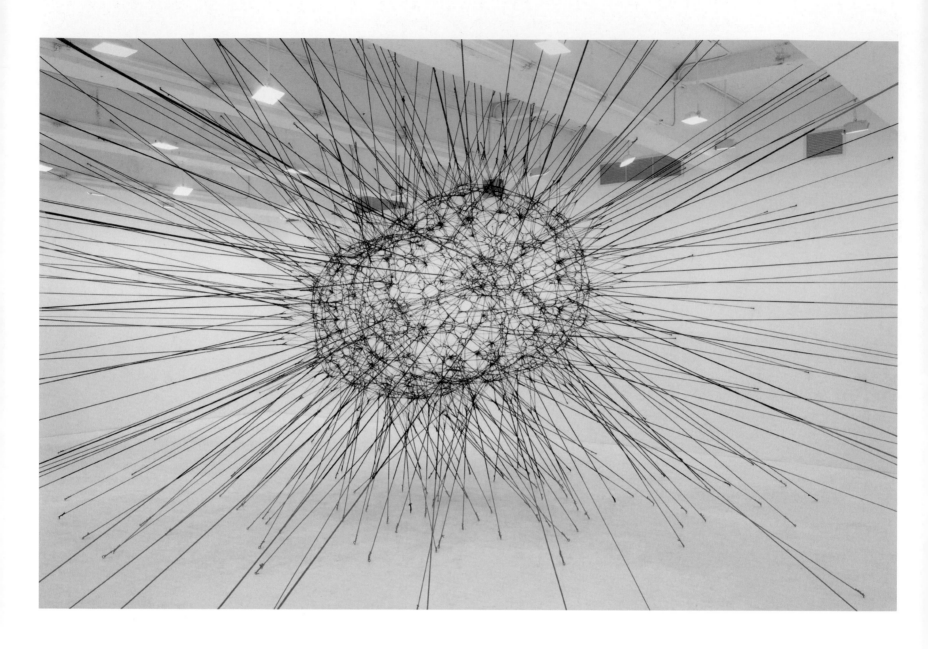

GALAXIES FORMING ALONG FILAMENTS
2008

TOMÁS SARACENO

Elastic cord, dimensions variable
Installation view, Tanya Bonakdar Gallery, New York

Visitors to this installation by Argentine artist Tomás Saraceno (born 1973) have to pick their way through black elastic ropes, passing beneath or climbing over them toward the centre, where they are woven into an amorphous, lacy bulb held in place by radiating ropes anchored to the walls, ceiling and floor. The artwork's porous quality reflects that of the early Universe as it developed through galaxies that materialized along slender filaments, different solar systems of moons, stars, asteroids and planets coming into being in clustered sponge-like regions, while most of the vastness of space remained virtually empty. Saraceno sees this as comparable to droplets of water on a spider's web, its intricate geometric form supporting vast weights. Originally created for the 2009 Venice Biennale, the work was adapted to other spaces, photographed here at the Tanya Bonakdar Gallery in New York. Saraceno's works are often architectural in their scope. Taking into account the world's diminishing resources and its increasing population, his practice investigates urban models that provide solutions to the overcrowding of the Earth's surface, elevating cities into the air and looking to the cosmos for structural solutions

A SLICE THROUGH A MAP OF OUR UNIVERSE

2016

DANIEL EISENSTEIN AND THE SDSS-III COLLABORATION

Digital image, dimensions variable

Each of the 48,741 dots in this picture indicates the position of a galaxy in a slab of the Universe that is 6 billion light years wide (covering five per cent of the sky) and 500 million light years thick and which is located 6 billion light years away. It was made by an automatic telescope and the data were compiled into a massive map called the Sloan Digital Sky Survey. The colour of each dot indicates its distance from the Earth, showing from yellow on the near side of the slice to purple on the far side. The galaxies are evidently not scattered uniformly. They are grouped together, with clusters connected by lanes of galaxies, and are surrounded by voids. This sponge-like structure has its origins in random fluctuations in the material of the Big Bang in the first fraction of a second of its life. The denser parts draw material from the more rarefied parts through the force of gravity. Astronomers attempt to calculate this process: they assess the success of their efforts by matching their results with the ensemble of the 1.25 million real galaxies in the entirety of this map.

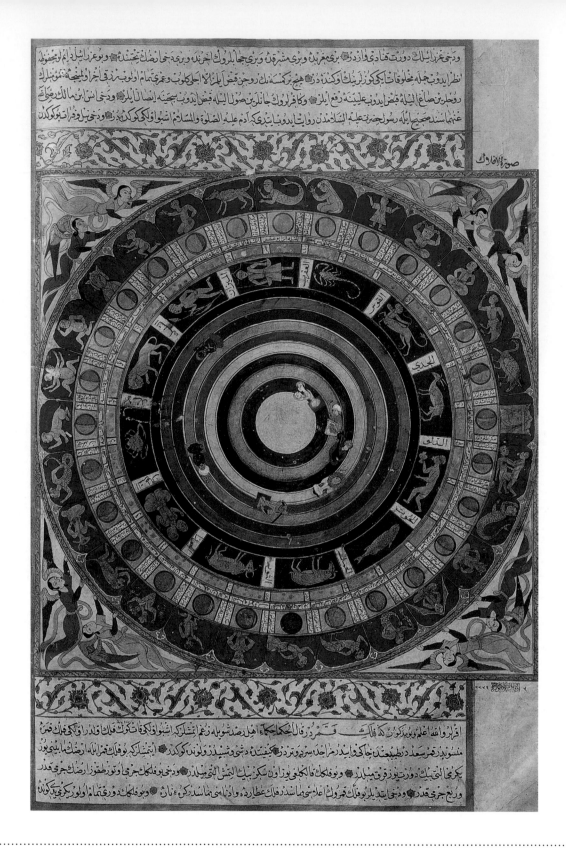

MAP OF THE UNIVERSE

1583

UNKNOWN

Hand-coloured woodcut, from *The Tales of the Luqman*
64.7 x 41.3 cm / 25½ x 16¼ in
Museum of Turkish and Islamic Arts, Sultanahmet

Islamic angels hold up the corners of the Universe in this sixteenth-century Arabic manuscript illustration, which accompanied a collection of popular fables, *The Tales of Luqman*, and illustrated the conventional Islamic view of the cosmos. Earth appears at the centre, surrounded by seven concentric spheres of sold colour marking the orbits of the Seven Saints or Luminaries, the name given to the visible objects that seemed to move through the heavens:

the Moon and the Sun, together with Mercury, Venus, Mars, Jupiter and Saturn. Beyond the concentric spheres another ring holds the twelve signs of the zodiac, picked out in gold, and another ring shows the successive phases of the Moon on the twenty-eight days of the lunar month, from the full Moon at the top. An outer circle contains representations of classical Islamic constellations. This miniature was one of a series that illustrated a 1583

edition of the tales, which have a similar moralistic purpose to the fables of Aesop in Western culture. Luqman was said to have lived in Ethiopia around 1100 BC, when Allah came to him in a dream and offered him the choice of temporal power or wisdom. Luqman chose wisdom, and learned moral lessons from studying the behavior of animals and the natural world.

*Ces Comettes apparoissent quand elle se rencontrent entre nôtre tourbillon et les tourbillons
Voisins I.K. ou alors elles sont repoussées plus proche du nostre.
Ces tourbillons I.K.L.V.X.Y.Z. sont Ceux des Etoilles Fixes.*

*M. Orbe de Saturne, N. Orbe de Jupiter, O. Orbe de Mars, P. Orbe de la Terre,
Q. La Lune, R. Orbe de Venus, T. Orbe de Mercure, S. Le Soleil.*

*Figure des Tourbillons Celestes. pour être mise entre les Pages 188. et 189.
A. Comette qui tourne sans cesse sur son Orbe A.B.C.D.
E. autre Comette qui tourne aussi sans cesse sur son Orbe E.F.G.H.*

FIGURE DES TOURBILLONS CÉLESTES
1699

NICHOLAS BION

Etching, from *L'Usage des Globes Célestes et Terrestres et des
Sphères Suivant les Différents Systèmes du Monde*
22.8 × 15.2 cm / 9 × 16 in
Bibliothèque nationale de France, Paris

By the time this etching was made to illustrate a series of
solar systems – ours is in the centre – contained in vast
swirling 'whirlpools' ('tourbillons') of an unseen substance
called plenum, the cosmological theory behind it was more
than fifty years old. The vortex theory of the Universe was
the creation of the French mathematician René Descartes
(1596–1650), who in 1644 proposed that the swirling
movement of the plenum carries the planets of the solar

system in orbit: here they are labelled M-R and T, and
orbit with their moons around the Sun, S. Two comets, A
and E, are also carried in the Sun's vortex. They travel in
more or less straight lines where vortices from adjacent
stars meet, but curve more sharply in the inner flow of the
vortex. This produces elongated, rectangular orbits (A-D
and E-H), similar to those of comets, although in reality
comets' orbits are mathematical ellipses, as described by

Isaac Newton's 1687 law of gravitation. This depiction
of the vortex theory appeared in a work by the French
author and instrument-maker Nicolas Bion (1652–1733)
that summed up competing views of the Universe. While
Descartes' theory was a mathematical failure, it did
attempt to address a problem brushed aside by Newton:
the puzzling way that the force of gravity acts across
empty space.

NEW EARTH
2002

DAVID A. HARDY

Acrylic paint, 40 × 26.2cm / 15¾ × 10¼ in
Private collection

New Earth, by the veteran British space artist David A. Hardy (born 1936), provokes the viewer into wondering how a small, blue, Earthlike planet could survive between the rocky, airless void of the artist's easel and the huge and presumably massive planet beyond. That there is a third planet in this crowded space and obviously a star – the source of the light in the image – complicates the dynamics further. For more than sixty years, Hardy

has allied imagination, astronomical knowledge and artistic talent to create beautiful depictions of other worlds. He represents a tradition of space illustration that includes artists such as Chesley Bonestell (see p.268). During the boom in space exploration in the 1950s and 1960s, the work of such artists was the only way for the public to get an impression of the possible conditions elsewhere in the Universe. This type of image is more

familiar now from science-fiction movies and books, but such paintings are a reminder of a period when deep space could be visualized only through imaginative extrapolation from photographs of the near Solar System. Even Hardy's imagination, however, falls short of more recently discovered features of the Solar System such as the craterless ice plains of Pluto and the deep expansion chasm around Charon's waist.

PLANET NINE
2016

CALTECH, ROBERT L. HURT (IPAC)

Digital image, dimensions variable

In this visualization by Robert L. Hurt, lightning storms light up the night side of a huge planet while our Sun is reduced to a distant star. Hurt works as a visualization scientist at the California Institute of Technology, combining artistic talent, astronomical training and advanced computer programs to generate simulations of other worlds. This one shows the hypothetical Planet Nine, a new planet far beyond what was originally thought to be the ninth planet

of the Solar System, Pluto. In the early twentieth century, the wealthy businessman Percival Lowell was devoted to finding a new planet beyond Neptune, calling his quarry Planet 'X'. The search was continued by Clyde Tombaugh, who in 1930 found Pluto – acclaimed as the ninth planet, despite being rather small. The label Planet X was shifted to hypothetical more distant planets, the extended search for which was rewarded in 1992 when Dave C. Jewitt and

Jane Luu discovered the first of a number of mostly small asteroid-like bodies, called Trans-Neptunian Objects (TNOs). Pluto proved to be a large TNO, but even TNOs might not be the outermost members of the Solar System. Disturbances in the orbits of some TNOs suggest that a real ninth planet lies way beyond Pluto. As large as Uranus or Neptune, it is sizeable enough to earn the label Planet Nine – assuming it exists.

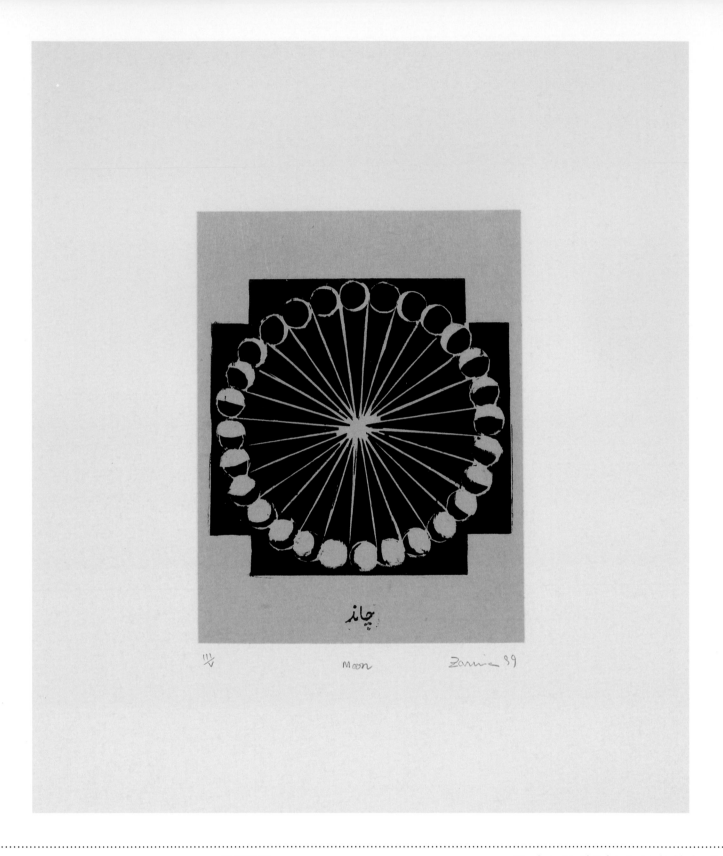

چاند

II/V Moon Zarina 89

MOON
1999

ZARINA

Woodcut print with Urdu text printed in black on Kozo paper
mounted on Somerset paper, from *Home is a Foreign Place* (portfolio
of 36 prints), sheet size: 40.6 × 33 cm / 16 × 13 in

This woodblock print uses a simple, old-fashioned technique
to illustrate an ancient concern of humankind: the waxing
and waning of the Moon in the night sky. For the artist Zarina
(born 1937), raised as a Muslim in India and later an exile in
New York City, the Moon is linked to a search for a sense
of belonging. This image comes from *Home Is a Foreign
Place*, a portfolio of thirty-six woodcuts that collectively
explore the idea of home and displacement, inspired by

Zarina's youthful experience of exclusion. This woodcut
depicts the phases of the Moon as it moves through its
stages of light and shadow. Yet, created from lines, points
and circles, the composition is ostensibly abstract. Another
print in the series, *Stars*, also looks to the heavens for
inspiration. Within the shape of a black cross that marks the
edge of the woodblock, angular linear patterns connect tiny
dots. At the bottom of each print, Zarina asked a Pakistani

calligrapher to write an Urdu word in traditional script,
called *nastaliq*. Each word details a memory the artist has
of her native home in her mother tongue, including the
phrases 'threshold', 'door' and 'border', spaces for transition
or movement. Having lived in cities from Bangkok to Paris,
Zarina's journeys across borders have led her to look not
just towards the changing physical matter of the Earth,
but also into the black space of the Universe beyond.

EARTH-MOON CONNEXIONS
1995

EL ANATSUI

Paint on wood, 90 × 84.4 cm / 35½ × 33¼ in
National Museum of African Art, Smithsonian Institution,
Washington, DC

Between landscape and skyscape, a representation of space and of time, this piece celebrates the relationship between humankind and Earth's closest cosmic companion, the Moon. Ghanaian artist El Anatsui (born 1944) uses found objects and materials from his surroundings – usually bottle tops and commercial packaging, here wood – to create visually striking pieces of symbolic significance that evoke a sense of place and African

identity. The earth-coloured wood conjures the quality of the landscape, while the grid pattern suggests astronomy's plotting of cosmic bodies, fixed stars and moving objects on celestial maps. The grid is marked by bold lines and colourful squares that evoke the journey and phases of the Moon across the sky. In doing so, Anatsui suggests the Moon's calendrical influence and effects on agricultural and ritual activities, key not just to

cultures in Africa, but the world over. The son and brother of *kente* weavers, Anatsui likens the composite metallic sheets he favours to 'cloths'. *Kente* is a traditional African silk or cotton cloth made by interweaving strips, here evoked by the grid pattern. In 2007 Anatsui explored lunar themes anew with *Sacred Moon*, an aluminium and copper wire wall piece, made to resemble the shimmering sky as celestial bodies rise and set.

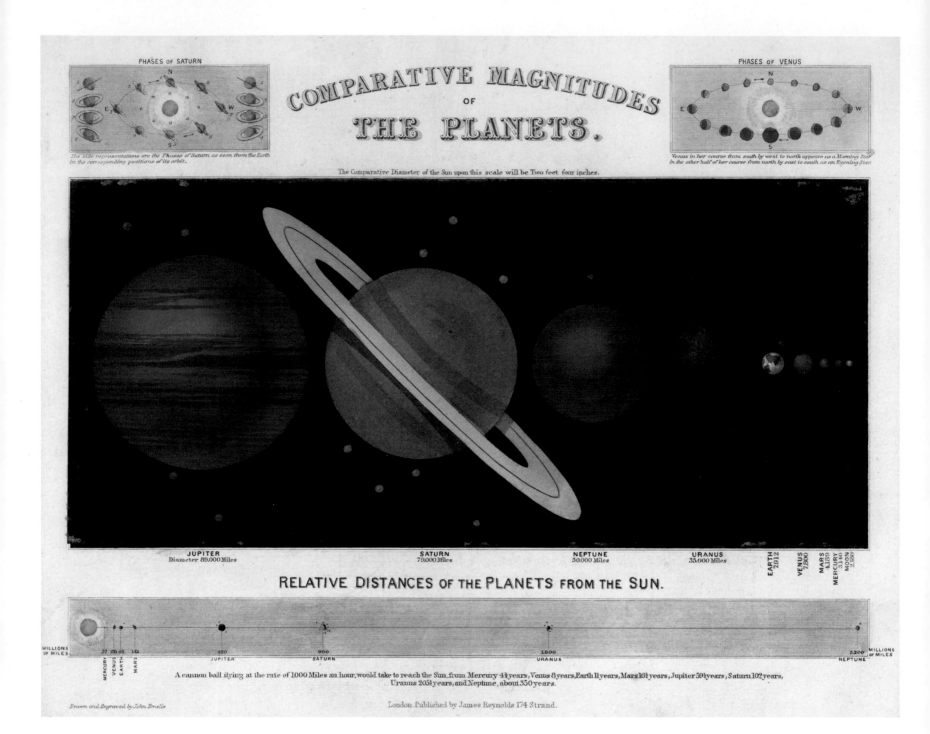

COMPARATIVE MAGNITUDES OF THE PLANETS

COMPARATIVE MAGNITUDES OF THE PLANETS

1851

JOHN EMSLIE

Engraving, 23 × 29 cm / 9 × 11½ in
David Rumsey Historical Map Collection, Stanford, CA

The indicator of the sheer size of the Solar System adopted by this engraving of the relative sizes of the planets – the length of time a cannon ball travelling at 1,000 miles (1,610 kilometres) per hour would take to reach each planet from the Sun – was probably no more helpful to contemporary users than it is today. Still, when this diagram appeared in London in 1851 the information portrayed was not widely available in an accessible visual form. Even today it is difficult to reconcile the vast distances between the planets, shown to scale on the lower panel, with the large range of their individual sizes in the main illustration. Small print gives the relative size of the Sun as 2 feet 4 inches (71 centimetres), or more than twice the width of the original page. Indeed, if the curve of the words 'Comparative Magnitudes' is imagined sitting on an arc at the top of a large circle, that circle would be an indication of the Sun's size relative to that of the planets. The two upper panels illustrate the changing appearance of Saturn's rings and the phases of Venus as the morning and evening star. As for the cannon ball fired from the Sun, it would take eleven years to reach Earth, almost sixty to reach Jupiter, and about 350 to reach Neptune.

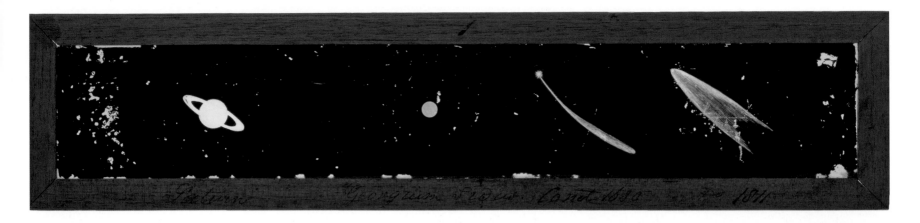

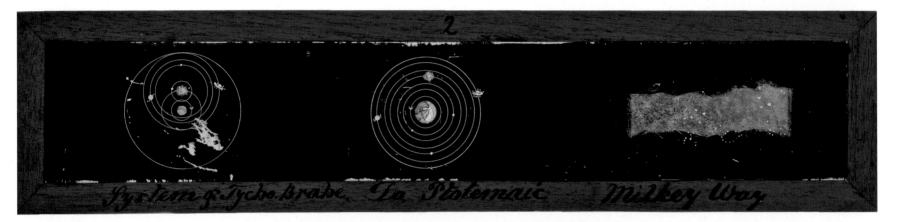

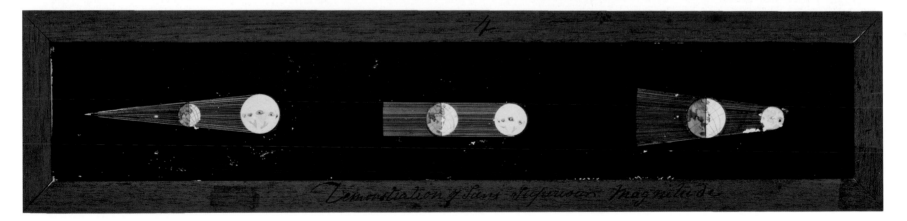

**MAGIC LANTERN SLIDES OF PLANETS
AND THE GREAT COMET OF 1811**

1811–25

UNKNOWN

Hand-painted glass slides in wooden frames
each slide 10 × 43.5 cm / 4 × 17 in
Science Museum, London

These hand-painted glass slides of planets, orbits and eclipses were once a lecturer's pride and joy – and an insight for his audience into the workings of the cosmos. During the early nineteenth century, travelling lecturers used magic lanterns in church halls and theatres to show the excited public the wonders of astronomy. Originally devised in the seventeenth century, these metal boxes contained a candle and lens that enabled them to magnify

and project slides like these on to walls. Often presented as a way of admiring God's creation, astronomy lectures were especially lucrative for comedians during Lent, when church disapproval of frivolity meant their usual shows were prohibited. Lecturers could purchase sets of notes and slides like these with the option to buy revised versions as new discoveries were made (the top slide here contains a topical element, with a depiction of

the recent Great Comet of 1811). Similarly, instrument makers used their technical ingenuity to produce complex mechanical slides that displayed the cycles of planetary orbits. Despite competition from other projection formats, magic lantern slides were produced throughout the twentieth century, including a set made by NASA in 1972 to illustrate their Space Shuttle design in a remarkable combination of old and new technology.

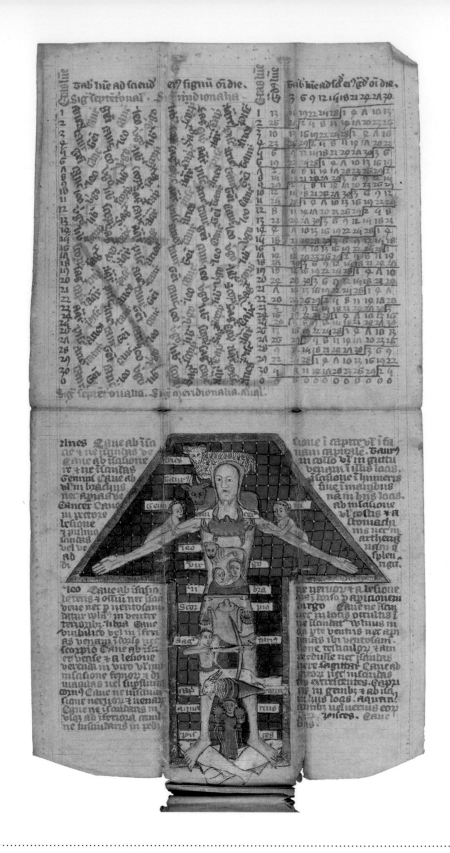

FOLDING MEDICAL ALMANAC

15th century

UNKNOWN

Ink on vellum, 23.8 × 11 cm / 9⅓ × 4⅓ in
Wellcome Collection, London

This diagram in an almanac that folds up for practical use is annotated with the signs of the zodiac that were thought to affect each part of the body. Such associations originated in Babylon in about 500 BC and influenced the understanding of medicine for well over 1,500 years. This approach – known as melothesia – was taken up by Greco-Roman astrologers and later by the Alexandrian astronomer Ptolemy and the second-century-AD doctor Galen. The head was linked to Aries, the throat to Taurus, the arms and hands to Gemini, the breast to Cancer, the heart and back to Leo, the stomach to Virgo, the kidneys to Libra, the genitals to Scorpio, the thighs to Sagittarius, the knees to Capricorn, the shins and ankles to Aquarius and the feet to Pisces. Astrological texts detailed the diseases and injuries to the various parts of the body that were covered by each sign, which could be countered with appropriate techniques, herbs and potions. Doctors also used melothesia to help diagnose and heal illness, casting astrological charts for the patient's date of birth or the onset of illness and seeking relationships between the horoscope and the affected parts of the body. In lieu of a complex calculation, simple aids like this almanac could form the basis for self-medication.

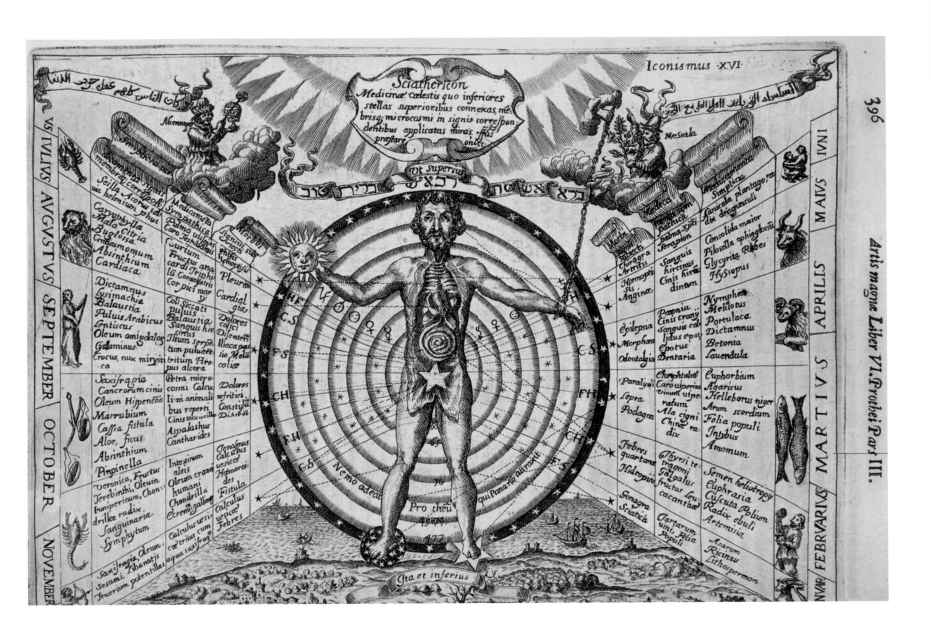

SCIATHERICON

1671

ATHANASIUS KIRCHER

Engraving, from *Ars Magna Lucis et Umbrae*
20 × 30.8 cm / 7¾ × 12 in
Dittrick Medical History Center, Cleveland, OH

This 1671 engraving links the human squarely with the cosmological, with its connecting lines showing the medical influence of the Sun and planets on the body as they move through the signs of the zodiac. The lines demonstrate the influence of the Sun's presence in certain zodiac signs on specific parts of the body, along with the associated lists of symptoms and remedies. The diagram represents the transition in astronomy from medieval, astrological perceptions of the Universe to the rational perspective that we know today. Based in Rome, the scholar Athanasius Kircher (1602–80) was a prolific writer who published more than forty works on such diverse topics as geography, archaeology and philosophy. This diagram first appeared in his book *Ars Magna Lucis et Umbrae* (*The Great Art of Light and Shadow*, 1646) and Kircher includes two historical figures at the top to assert his authority: the Arab astrologer Abenragel and the Persian Jewish astrologer Messahala. Despite this deference to ancient expertise, astrological medicine was already in decline by the time Kircher published his work, as scholars sought to develop a new version of medicine based on experimental science rather than the influence of the cosmos.

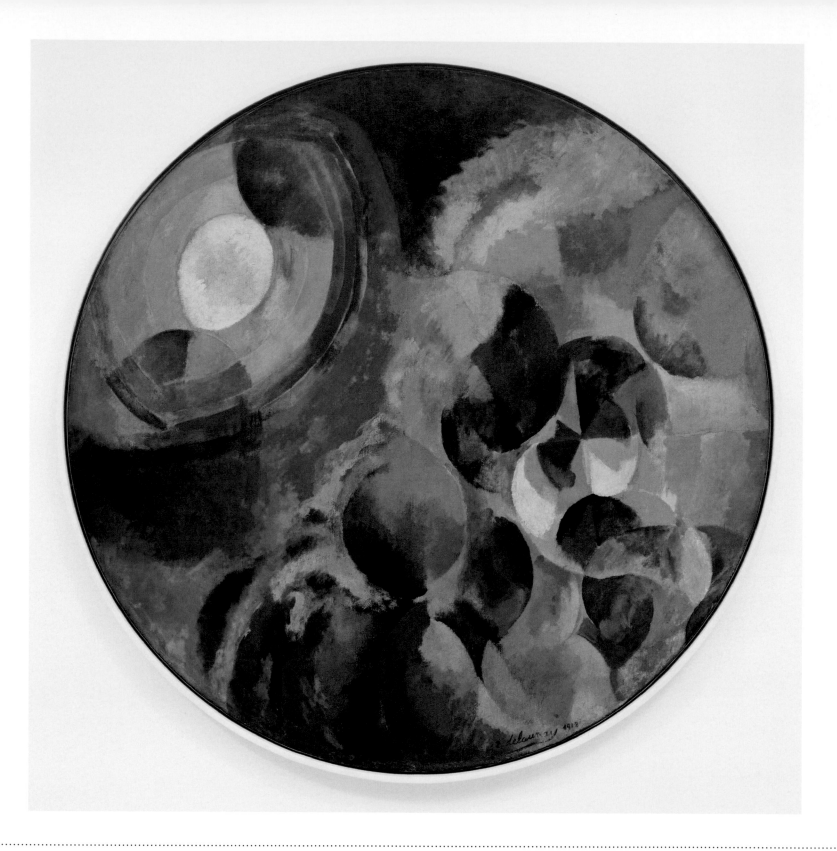

SIMULTANEOUS CONTRASTS: SUN AND MOON

1913

ROBERT DELAUNAY

Oil on canvas, diam. 134.5 cm / 53 in
Museum of Modern Art, New York

The circular forms of the Sun and the Moon are all-but indistinguishable from one another in this largely abstract oil painting by the French artist Robert Delaunay (1885–1941). Multiple orbs fill a circular canvas that represents the Universe, with concentric circles of colour emanating outwards from a series of spheres. Thick daubs of fresh lemon yellow rub up against rich deep ochre tones tinged with orange, while lapis lazuli blue feels cold next to the vibrant hues of cherry red. Together, the colours create a pattern that is suggestive of the Sun's pulsing rays and the cool light of the Moon as the Earth's rotation moves it through the warmth of day into the coolness of night. Based in Paris with his wife, the artist Sonia Delaunay, in the early twentieth century, Robert Delaunay helped found Orphism, a school of art influenced by the chemist Eugène Chevreul's classification of colours. Chevreul created chromatic diagrams to demonstrate his contention that the viewer's perception of colour is influenced by the tones that surround it, which interact to enhance or diminish each other. In *Simultaneous Contrasts: Sun and Moon*, Delaunay represents light as contrasting planes of pure colour, and yet with their feeling of rhythmic pulsation, they remain directly connected to the sensation of an endlessly moving cosmos.

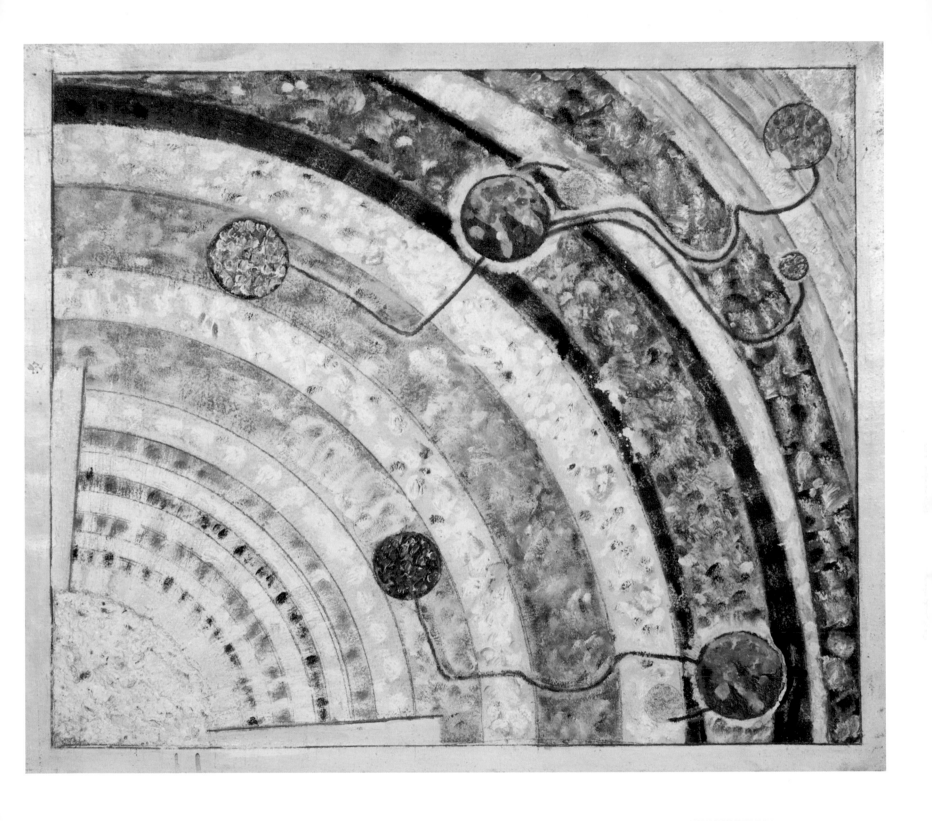

UNTITLED (ASTRONOMY WITH SUN LRC)
*c.*1950

PETER ATTIE BESHARO

Mixed media on canvas, 67 × 78.1 cm / 26½ × 30¾ in
Private collection

The Sun is a pale, nearly white ball in the corner of this segment of the Solar System, divided into concentric bands of pale blues and greens, the favoured palette of the Syrian-born American painter Peter Attie Besharo (1899–1960), for whom the colours recalled the Arabic tilework of his childhood. Earth and its Moon appear twice in their orbits, with the other inner planets dotted in a more-or-less random way, tethered to one another

by cords. The concentric circles echo medieval depictions of the cosmos. *Untitled (Astronomy with Sun LRC)* is one of more than seventy paintings created by the sign and house painter Besharo, who emigrated to the United States in 1912 and settled in the small, conservative town of Leechburg, Pennsylvania. Besharo's obsession with painting the Solar System, aliens and human interaction with space remained a secret until after his death in

1960, when the paintings were discovered in a garage he rented behind a hardware store. The paintings reflect Besharo's position as an Arab in America, and his concern with the fragility of the Earth and the potential of a future in space. Besharo's physician, Dr Fraley, observed, 'I always believed he was a man ahead of his time.'

SUPERNOVA REMNANT CASSIOPEIA A
2004

NASA, ESA AND THE HUBBLE HERITAGE (STSCI/AURA) ESA, HUBBLE COLLABORATION

Digital photograph, dimensions variable

Wispy fragments of a shattered star speed outwards in an explosion to form a shell in this ethereal image created using the Hubble Space Telescope. The wisps are colour-coded according to their chemical origin: bright green indicates filaments that are rich in oxygen, red and purple denote the presence of sulphur and blue reveals hydrogen and nitrogen. These delicate wisps could easily have been overlooked, but the supernova remnant was one of the first astronomical sources detected by radio telescopes, in 1948. The supernova remnant – 11,000 light years away – strongly radiates radio waves. The elements have been processed by a nuclear reaction from the hydrogen inside the star that exploded. At the time of the explosion – in about 1681 – the elements were concentrated in layers within the star, so the explosion reveals the inner working of the star, like the cogs and gears in a watch that has been smashed open. The wisps are still moving outwards from the explosion at a detectable rate, having begun their journey over 340 years ago. No contemporary observer noted the supernova that marked the star's destruction, but in 1680 the first British Astronomer Royal, John Flamsteed, had recorded the position of a star near this spot. The star no longer exists – so this presumably marks its remains.

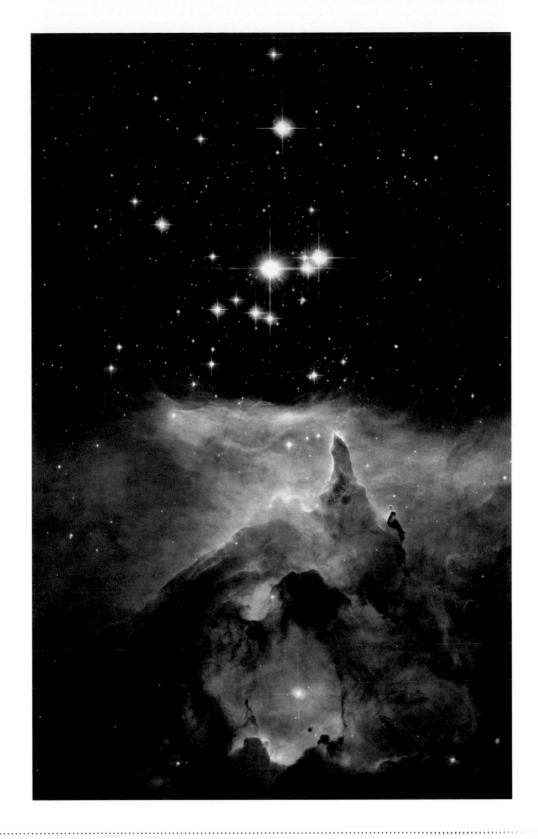

PISMIS 24 IN NGC 6357
2006

NASA, ESA AND JESÚS MAÍZ APELLÁNIZ
(IAA, SPAIN)

Digital photograph, dimensions variable

This dramatic image has the impression of a scene created in an artist's imagination – or on a computer – as the backdrop for a science-fiction film, perhaps with a spacecraft travelling over an eerie landscape beneath a cluster of stars. This image also exemplifies the dramatic qualities that have made Hubble Space Telescope pictures such widely admired representations of the cosmos. The lower part of the image captures part of a vast nebula, with clouds of gas and dust suggesting recession into space. Within it, brightly backlit pillars reach upward, drawing the viewer's eye toward the cluster of stars known as Pismis 24, some 6,500 light years from Earth. For astronomers, Pismis 24 is rather more interesting than the nebula (which is known as NGC 6357). Previous observations had suggested that Pismis 24 might contain a supermassive star – the heaviest star known, at 200 or even 300 times the mass of our own Sun. Such giant stars are surpassingly rare, however, and some astronomers doubt they can even exist. The high-resolution cameras aboard the Hubble Space Telescope solved the mystery and proved the scientific value of the observations by revealing the massive star to be two stars orbiting each other.

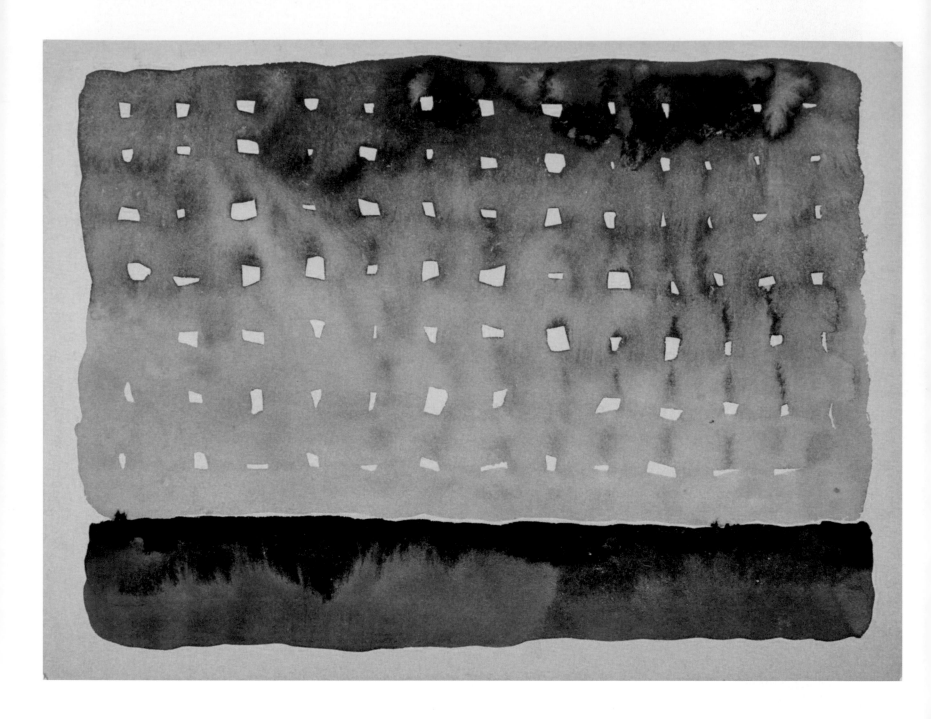

STARLIGHT NIGHT
1963

GEORGIA O'KEEFFE

Printed card, 14.8 × 21 cm / 5¾ × 8¼ in
Private collection

With this grid of irregular white shapes left amid a wash of watercolour that fades from a near-black to a pinky-violet, the American artist Georgia O'Keeffe (1887–1986) not only captured the vastness of the night sky but also suggested the human instinct to try to impose order and pattern on what we see when we look at the heavens. O'Keeffe painted *Starlight Night* in 1917 and reproduced it on her Christmas cards in 1963, nearly fifty years after

painting it. The painting – which features a strong, flat, deep blue horizon defined by the last vestiges of twilight, the pale blue of the night sky darkening up to the zenith, pierced by glittering stars – has echoes of the work of the Post-Impressionists, particularly Vincent van Gogh. O'Keeffe's artistic vision was increasingly inspired by the natural world – most famously by the landscapes of New Mexico, which she visited often and to where she

moved from New York to live permanently in 1949. In a letter to fellow artist Russell Vernon Hunter she offered the advice that she herself was putting into practice: 'Try to paint your world as though you are the first man looking at it – The wind … and the cold – The dust – and the vast starlit night.'

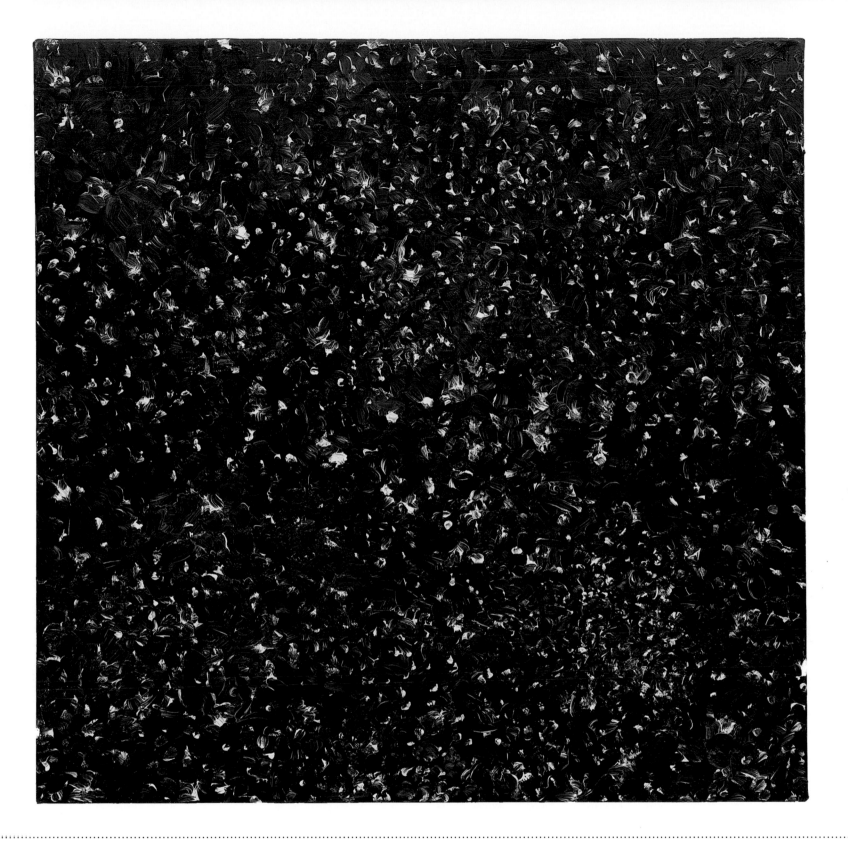

STERNBILD / CONSTELLATION
1969

GERHARD RICHTER

Oil on canvas, 92 × 92 cm / 36¼ × 36¼ in
Museum Frieder Burda, Baden-Baden

Stars appear to sparkle in a swirling night sky of tones ranging from near-grey to profound blackness in this oil painting by artist Gerhard Richter (born 1932). The image, which Richter created by dabbing white paint into wet, black colour, is intended both as a literal – if not accurate – depiction of a night sky and as an expression of the sensation of the thickly applied colour itself. In 1969, when Richter created this work

as part of a series of nine paintings entitled *Sternbild / Constellation*, the climax of the Space Race and the Apollo 11 Moon landing created huge public interest in all things astronomical. Richter had already produced artworks using photographs of rockets and the surface of the Moon before turning his attention to the sky itself. The series ranges from white-in-black patterns like this that reproduce the sensation of looking at the stars to

more abstract linear representations created by dragging objects across thickly painted surfaces. Richter often painted from photographs, remarking, 'When I paint from a photograph, conscious thinking is eliminated … it is absolute, and therefore autonomous, unconditional, devoid of style' or by the sensation of looking up at the night sky at a time when it seemed that technology was bringing space within humanity's grasp.

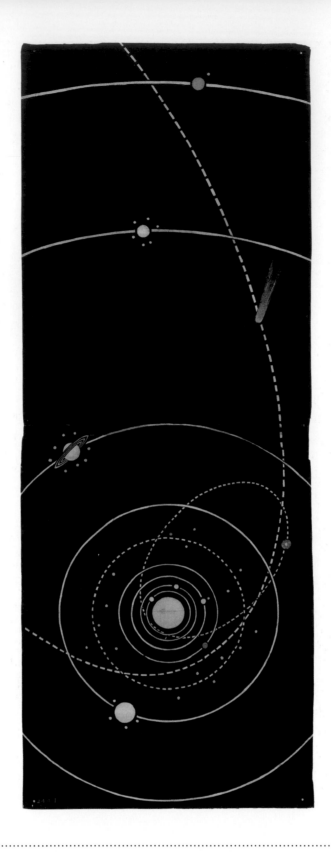

SOLAR SYSTEM
1850–55

WORKING MEN'S EDUCATIONAL UNION

Coloured cotton sheet, 240 × 91 cm / 94½ × 35¾ in
National Maritime Museum, London

Designed to be viewed at a distance by candle- or gaslight, this cotton wall hanging of the Solar System's objects and planetary orbits was used as a visual aid for lecturers to dazzle audiences at venues across Britain. Such wall hangings were devised by members of the Working Men's Educational Union, a philanthropic organization that promoted education for the working classes, as a cheap, portable way to illustrate lectures –

printed on cotton, they were exempt from the tax on paper. This hanging stretches over 8 feet (2.4 metres) tall to illustrate the enormous scale of the Solar System. Created in the early 1850s, it provides a glimpse of the astronomical knowledge of the day. Neptune, the newly discovered eighth planet from the Sun, along with its largest moon, Triton, is squeezed into the top section (Neptune's other moons were not discovered until the

twentieth century). Mars, the fourth planet from the Sun, appears alone, prior to the discovery of its moons in 1877. Subsequent astronomical hangings included topics such as telescope optics and the nebulae that astronomers of the time were beginning to resolve with larger and improved telescopes. The Working Men's Educational Union also commissioned other sets of hangings to illustrate topics such as geology, ancient Egypt and the lands of the Bible.

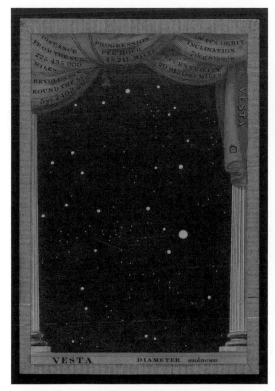

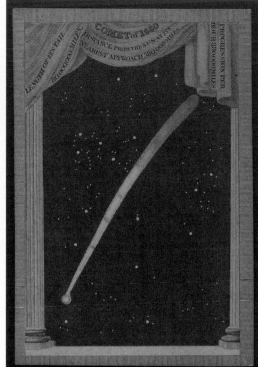

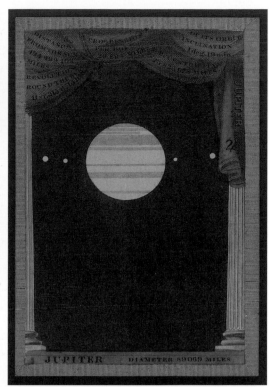

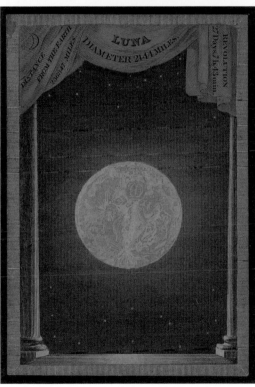

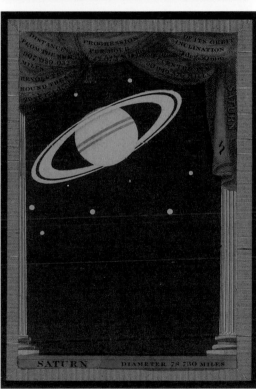

ASTRONOMIA

1829–31

HENRY CORBOULD

Hand-coloured engraving, each card 9.6 × 6.4 cm / 3¾ × 2½ in
Beinecke Rare Book and Manuscript Library, Yale University, New Haven, CT

These six delicate illustrations – showing from left to right (top) Vesta, a comet and Jupiter, then (bottom) the Moon, Pallas and Saturn – come from a set of fifty-two cards originally produced by Henry Corbould in 1829. At the time, astronomical educational games and toys were highly fashionable in middle-class families. Similar to a traditional set of playing cards, *Astronomia* is arranged in four suits: spring (blue), summer (red), autumn (yellow)

and winter (white). Each suit contains a repeating set of eleven cards with the names of the planets and asteroids, while the remaining two cards feature variables such as the relevant zodiac signs for each season. Drawing inspiration from the neo-classical trend of the day, each card is illustrated with a pair of temple columns draped in fabric to frame the view. For the planetary cards, these drapes are covered in numerical data to help players

appreciate the size and scale of the Solar System. Corbould ensured that the cards were up to date by including the new planet Uranus, discovered by William Herschel in 1781 and named here in his honour. Despite the excitement of this discovery, the formal tone of the accompanying booklet makes it clear that the game was intended for educational instruction rather than entertainment.

MILKY WAY

1989–90

PETER DOIG

Oil on canvas, 152 × 204 cm / 58¾ × 80¼ in
The artist's collection (on long-term loan to the National
Gallery of Scotland, Edinburgh)

The jewel-like effects of the Milky Way hanging in the inky blackness of a star-studded sky are reflected in the placid water of a lake, barely disturbed by a lone figure in a canoe paddling beneath the exuberantly shaped and startling green trees on the distant shore. The Scottish artist Peter Doig (born 1959) records how people actually see the Milky Way from Earth: not as billions of stars, but as a band of misty light, its irregular outlines and voids caused by clouds of cosmic dust blocking stars from our view. The horizontal bands give the painting a formal structure, while the vivid greens add a touch of hyperclarity that acts as a counterpoint to the eerie, stillness characteristic of Doig's magic realism. At a time when many of his contemporaries were drawn to cool aesthetics and a conceptual approach to painting, Doig boldly embraced figurative landscape and the textural possibilities of the medium. Despite the surreal atmosphere, his work is based on the real world, whether direct observation or from photographs. *Milky Way* fits into a long artistic tradition. Reflecting the night sky on a large expanse of water has been common in art since the first oil painting of the Milky Way known in Western art, *Adam Elsheimer's 1609 The Flight into Egypt*, right up to today's modern astrophotography.

AIRGLOW OVER ITALY
2012

TAMAS LADANYI

Digital photograph, dimensions variable

The Milky Way arches over a distinctive group of three upward-thrusting peaks – the Tre Cime di Lavaredo – in the Dolomites region of the Italian Alps in this remarkable 180-degree panoramic image of the view to the north, created in four exposures on 24 August 2012, by the Hungarian photographer Tamas Ladanyi (born 1972). The sky is suffused with a green light that resembles the aurorae but is in fact a more diffuse light known

as airglow. Unlike the aurorae, airglow is geographically widespread, being powered by the Sun's ultraviolet radiation rather than by charged particles in the solar wind, as are the aurorae. The light originates high in the atmosphere, on the edge of space, where the Sun's radiation separates electrons from atoms and molecules in the air during the daytime. At night the electrons recombine with the atoms and molecules, emitting

radiation. The process involves mainly oxygen atoms, but nitrogen is also important. So too is sodium, which originates in the 45,000 tonnes of meteors per year that break up on their entry into the atmosphere. The airglow is brighter in its total effect than starlight. The two together are the means by which nocturnal animals can see even on moonless nights. We can too provided our eyes are sensitized enough to the faint glow.

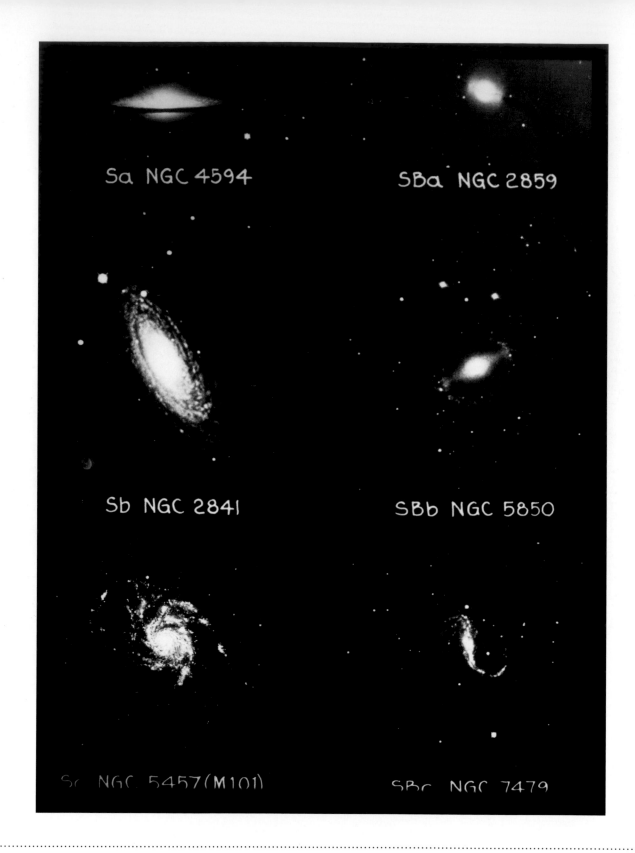

CLASSIFICATION OF EXTRAGALACTIC NEBULAE

1930

EDWIN HUBBLE

Photograph, 38.4 × 30.5 cm / 15 × 12 in
Science Museum, London

These photographic images from the 1930s show the classification into six common galactic systems developed by the US astronomer Edwin Hubble (1889–1953). Hubble labelled the galaxies with a simple code that is still used (with modifications) by astronomers today. The left column shows three types of spiral galaxy – Sa, Sb and Sc – and the right column three versions of spiral galaxies, each crossed by a prominent bar (SBa,

SBb and SBc). The so-called Hubble sequence also provides classes for two other broad types of galaxy: ellipticals and lenticulars. (Hubble was never comfortable with the term galaxy, and this plate comes from his popular 1936 book entitled *The Realm of the Nebulae*.) Hubble's contributions to astronomy were remarkable and he was a great believer in the power of astronomy to educate. In addition to classifying galaxies, he added

enormously to our knowledge of their nature and how distant they are. He was also the first astronomer to recognize clearly that the Universe was expanding ('Hubble's law'). Hubble first measured the apparent rate of expansion (now called 'the Hubble Constant'), but he was severely misled about the value of inaccurate estimates of the distance of the galaxies).

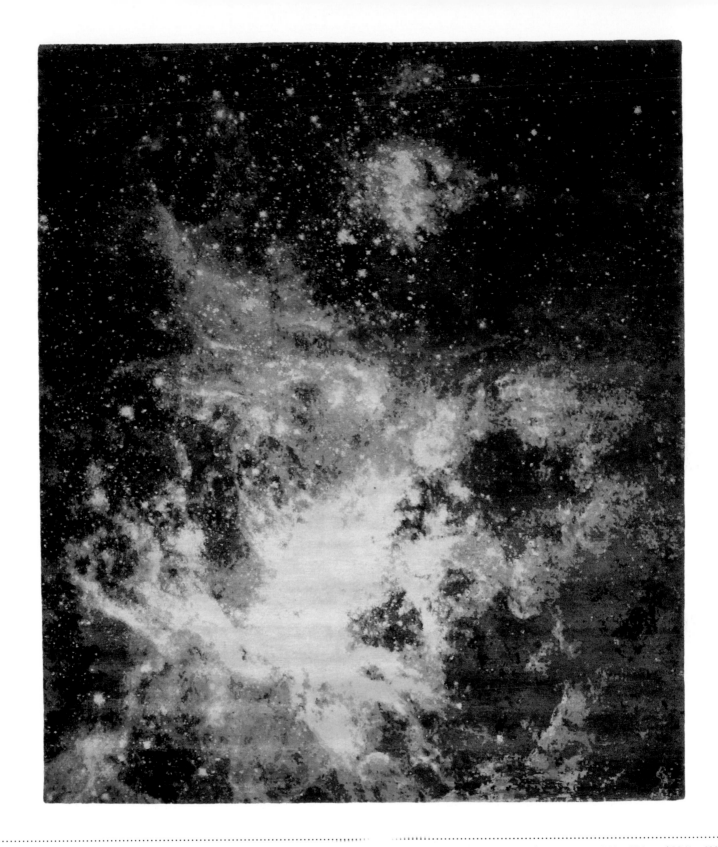

SPACE 3

2015

JAN KATH

Hand-woven carpet, 250 × 300 cm / 98 ½ × 118 in
Private collection

The full splendour of space is captured in this unique rug. Its creator, Jan Kath (born 1972), drew his inspiration from both his travels and images taken by the Hubble Space Telescope. In the Himalayas, he witnessed night-sky views of distant galaxies. Exceptionally clear skies occur at such high elevations because they are so far from the light pollution of the industrialized world. Images taken by Hubble and the infrared technology used opened his eyes to space's potential as a source of inspiration. *Space 3* is one of Kath's *Spacecrafted* collection, which realised one of his long held ambitions to use space imagery in his textile designs. The moment was right: he had years of experience and the huge pool of expertise required to realise the project. For this rug, space-age contemporary design and photorealistic images are combined with the classic hand-crafted methods of carpet weavers. We can only imagine the labour required to make this rug from strands of wool and silk. It is the human element that sets this image apart, and imbues it with a sense of warmth. This work demonstrates that the stellar spectacles and planetary movements of space have an aesthetic so remarkable that artists struggle to create a similar one – without such spectacular inspiration from the Universe.

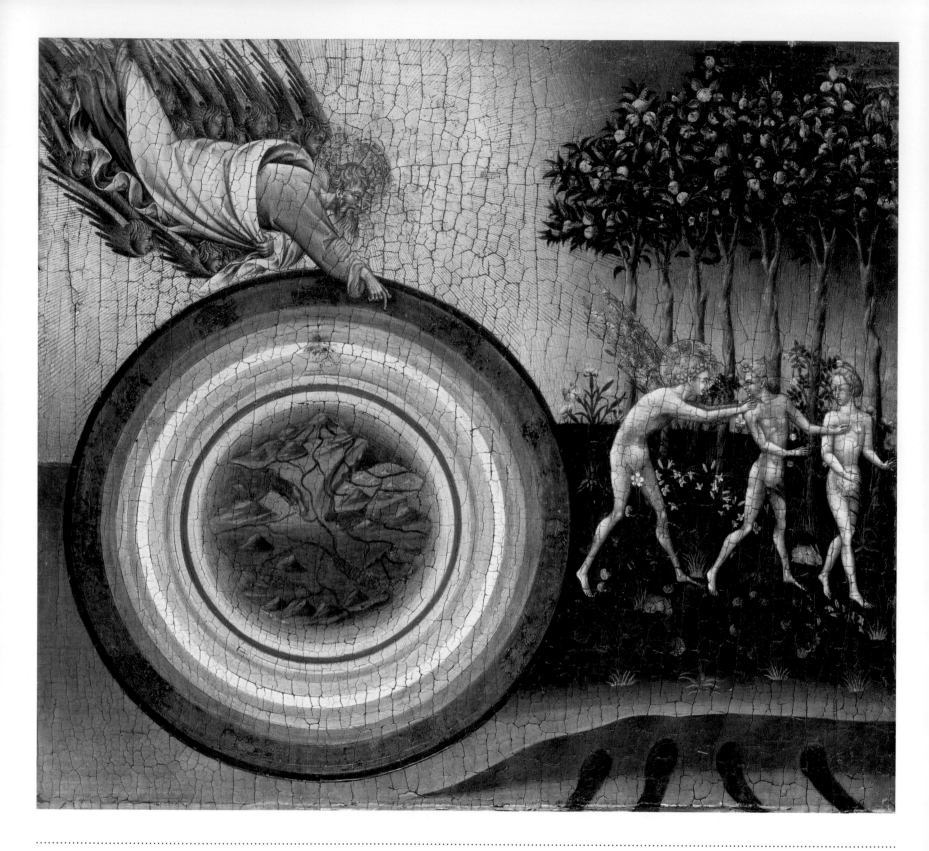

THE CREATION OF THE WORLD AND THE EXPULSION FROM PARADISE

1445

GIOVANNI DI PAOLO

Tempera and gold on wood, 46.4 × 52.1 cm / 18¼ × 20½ in
The Metropolitan Museum of Art, New York

The Renaissance artist Giovanni di Paolo (c.1403–82) set out to make this panel part of an altarpiece he painted for a church in Siena a reminder to viewers about Adam and Eve's expulsion from Paradise. Instead, he created a beautiful vision that was at odds with the cataclysmic nature of the event. God is at the top of the picture, while an angel orders Adam and Eve from Paradise, which is characterized by a bounty of fruit trees and flowers. Beneath the garden are the four rivers said to flow from Eden: Pishon, Gihon, Tigris and Euphrates. How the shape of the Universe fits with biblical stories was a challenge for artists before astronomers began to explain the structure of the cosmos. Giovanni di Paolo's painting portrays the Universe as a circle, with the rocky Earth at its centre, as commonly believed in 1445, when he created the picture. Surrounding the Earth is a series of concentric circles. The inner four circles represent the elements – earth, fire, water and air – while a further five circles depict the orbits of the planets known at the time (together with the Sun, which is shown above the Earth). The outer ring of deep blue holds the stars, arranged into the twelve signs of the zodiac.

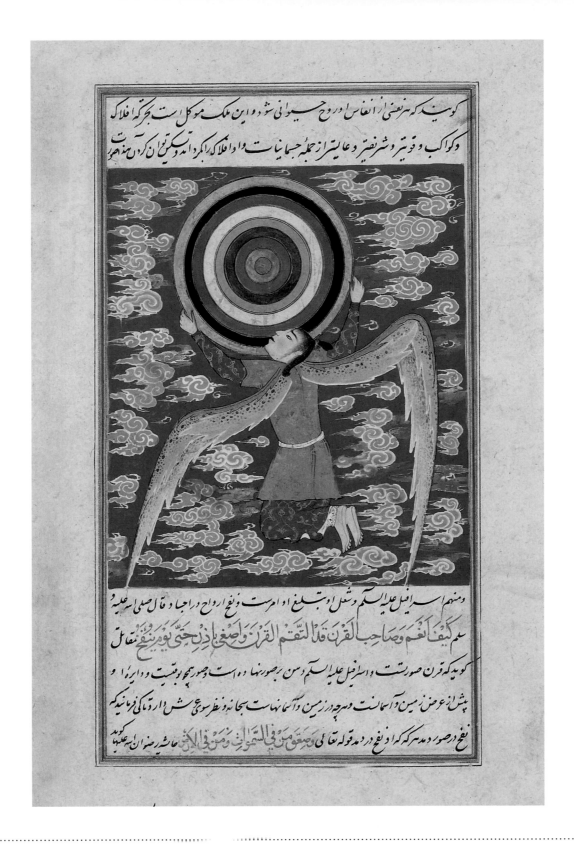

THE ANGEL RUH HOLDING THE CELESTIAL SPHERES

c.1550–1600

UNKNOWN

Ink, colour and gold on paper, from *The Wonders of Creation and the Oddities of Existence*, 22.5 × 12.5 cm / 9 × 5 in
Ashmolean Museum, Oxford

In this striking illustration, taken from a sixteenth-century Safavid Persian edition of *The Wonders of Creation and the Oddities of Existence* by the thirteenth-century astronomer and geographer Abu Yahya Zakariya ibn Muhammad al-Qazwini, an angel holds aloft the heavenly spheres. The spheres conform to the astronomical theories current in the thirteenth century, placed within a theological framework by the depiction of Ruh, an angel

mentioned in the Qur'an. Al-Qazwini's cosmography was popular throughout the Islamic world, as attested by the numerous versions in Arabic, Turkish and Persian. It follows a geocentric model, with the Earth surrounded by nine spheres beginning with the Moon and ending with the 'Sphere of Spheres', which regulated the motion of the others. This illustration shows only eight spheres, although this is more likely a mistake by the artist than a critique

of al-Qazwini's cosmography. The text shows a synthesis of knowledge from different areas: the black script is al-Qazwini's cosmographical discussion while the gold features quotations from the Qur'an. Such geocentric explanations of the Universe remained popular even after Nicolaus Copernicus had published his heliocentric theory in 1543, showing the enduring power of belief even in the face of new evidence.

UNTITLED
1990

GAVIN JANTJES

Ink on paper, 80.3 × 113.3 cm / 31¾ × 44¾ in
National Museum of African Art, Smithsonian Institution,
Washington, DC

Strange long-limbed figures are silhouetted against the concentric-circular grid of the night sky in this depiction of the southern constellation of Eridanus. Although the image is of the stars, it to is closely associated with water. Eridanus is also conceived as a river: it was identified by the second-century Greek astronomer Ptolemy – and its appearance coincided with the yearly flood of the River Nile. The deep-blue, green and purple ink creates a water-like texture on paper that has buckled as the wet ink dried; the edge of the colour bleeds into tiny rivulets. South-African-born artist Gavin Jantjes has created a bold diagonal figure holding a long, thin object; another to the far right climbs what appears to be a rope that passes a group of giraffe-like animals to reach a cross-legged being. A group of observers gazes upwards from within the skeleton of an arched hut. An enigmatic ritual appears to be taking place, probably connecting the emergence of the constellation with the successful harvest of staple foods. The image comes from Jantjes's series of works entitled *Zulu* – translating as 'the heavens' or 'the space above your head' – a collection of cosmological and mythological images in which figures often gaze towards the Moon and stars.

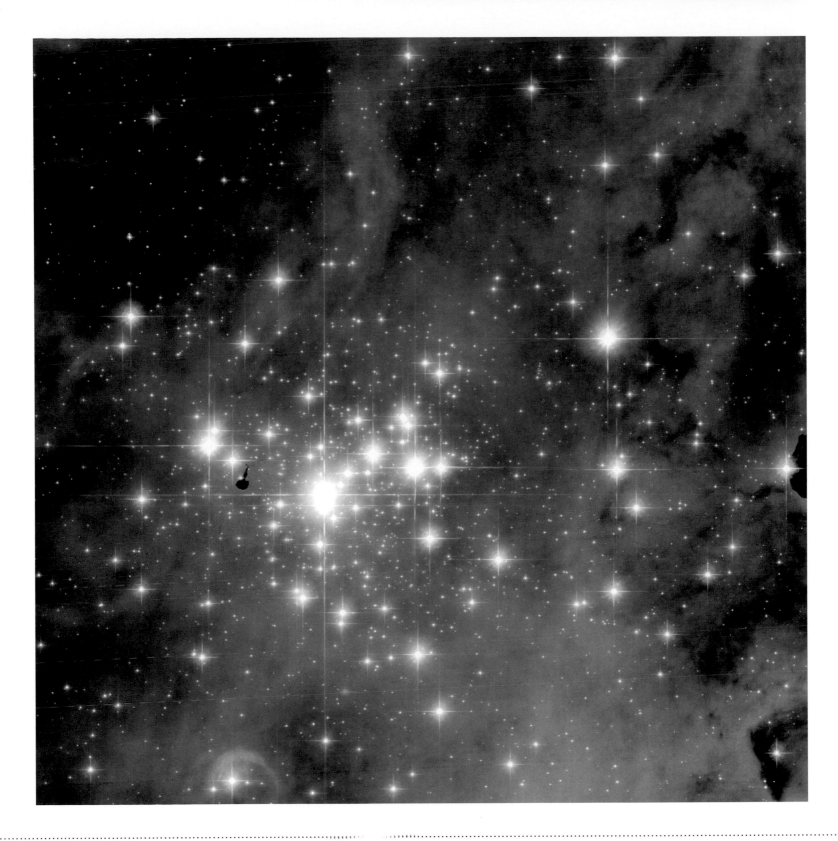

TRUMPLER 14

2016

NASA AND ESA, JESÚS MAÍZ APELLÁNIZ (CENTRO DE ASTROBIOLOGÍA, CSIC-INTA, SPAIN)

Digital photograph, dimensions variable

At first glance, this image of the star cluster Trumpler 14 taken by the Hubble Space Telescope seems to contain an obvious flaw – an odd, jet-black drop to the left of the brightest star in the photograph. Such black nebulae were first observed in the 1940s by Dutch-born US astronomer Bart Bok, after whom they were named. Bok globules are relatively small nebulae containing dense dust and gas that obscure any background light. Some contain a source of heat, thought to be a newly forming star. Bok himself likened the globules to insect cocoons. Trumpler 14 is one of the largest gatherings of hot, massive and bright stars in the Milky Way. It contains about 2,000 stars, including some of the most luminous stars in our entire Galaxy. It is one of the youngest known star clusters, being perhaps only one-third to half a million years old. Most of the light comes from the few brightest stars, but the fainter stars strewn around the brighter ones are much more numerous. The brighter stars are the most massive (several tens the mass of the Sun) and the slowest moving, so they tend to concentrate at the centre of the cluster. The fainter stars, by contrast, are only a few tenths the mass of the Sun and their higher speed takes them further away.

METEORITE MISSES WACO

2001

CORNELIA PARKER

Printed paper scorched with a meteorite
45 × 65 × 4 cm / 17¾ × 25½ × 1½ in

The idea behind this artwork by British artist Cornelia Parker (born 1956) is simple: a burnt hole in a road map marks the location of a fictional meteorite fall outside Waco, Texas. The image is one of six from *Meteorite Lands in the Middle of Nowhere: The American Series*, for which Parker heated pieces of a 400-year-old meteorite in order to scorch holes in maps, indicating craters at sites where meteorites hit or missed six towns

of the American South. Parker's locations were carefully selected for their resonance: Bagdad in Louisiana evokes contemporary conflict in the Middle East, while Bethlehem in North Carolina recalls both the Arab-Palestinian conflict and the birthplace of Jesus. Waco was the scene of a siege by state law enforcement officials and the US military in 1993, which ended when seventy-four members of a religious cult perished

in a blaze. By selecting locations that have a human or historical resonance, Parker draws attention to our tendency to look for significance in random or coincidental events. She invites us to reflect on humanity's propensity to cause harm to itself, rather than on the unavoidable threat of meteorites. Meteorites are a recurring theme in Parker's work and her aim is to one day release a meteorite into the 'wild', by sending it back into space.

METEORITES FROM VESTA
2012

HARRY MCSWEEN, UNIVERSITY OF TENNESSEE

Digital photograph, dimensions variable

The remarkable colours in the crystalline mineral structure of these thin slices of asteroid are visible only when polarized light is shone through them under a microscope. The colours reveal the structure and composition of minerals found in some meteorites found in Antarctica and North Carolina, USA. The meteorites originated on Vesta, the second largest object in the asteroid belt (see p.41), and the brightest member of

a family of much smaller asteroids that have similar orbits. The smaller asteroids seem to have originated when Vesta was struck by a large object. When the Dawn space probe visited Vesta in 2011–12, it imaged a large, relatively recent crater at one pole. It seems likely that the smaller asteroids originated in the impact that made the crater. It also created myriad tiny fragments of rock, some of which have fallen to Earth as meteorites.

They are made of the minerals eucrite and diogenite, which are common on Vesta, and a third mineral called howardite, which does not occur naturally on Earth. Howardite has some of the properties of the other two minerals and was presumably made when they became mixed on impact. These meteorites – known as HED meteorites from the initials of the three minerals – comprise about five per cent of all meteorite falls on Earth.

AURORA BOREALIS.

As observed March 1, 1872, at 9h. 25m. P.M.

AURORA BOREALIS. AS OBSERVED MARCH 1, 1872, AT 9H. 25M. P.M.

1881

ÉTIENNE LÉOPOLD TROUVELOT

Chromolithograph print, 72.4 × 97.2 cm / 28½ × 38¼ in
New York Public Library

Although the French artist Étienne Léopold Trouvelot (1827–95) provides a precise time for this observation of the Aurora Borealis (the Northern Lights, caused by charged particles from the Sun interacting with electrons in atoms in the atmosphere around the North Magnetic Pole), its radiant symmetry looks unrealistic. Unlike most astronomical sights, auroral displays are fleeting and dynamic, so this rendition is likely to be a visual memory of several observations, rather than a precise depiction of the sky at one time, though Trouvelot's star field is clearly recognizable as the northern sky. The hints of red and green reflect the colours often associated with the aurorae (the phenomenon also occurs in the South, where it is called the Aurora Australis). Trouvelot was a scientifically inclined artist noted for the astronomical illustrations he produced from about 1870 onwards, mainly in the United States. His illustrations are distinctive, with strong contrasts and clearly defined features that appear less pronounced on photographs of the same objects. Trouvelot argued that, 'A well-trained eye alone is capable of seizing the delicate details of structure and configuration of the heavenly bodies, which are liable to be affected, and even rendered invisible, by the slightest changes in our atmosphere.'

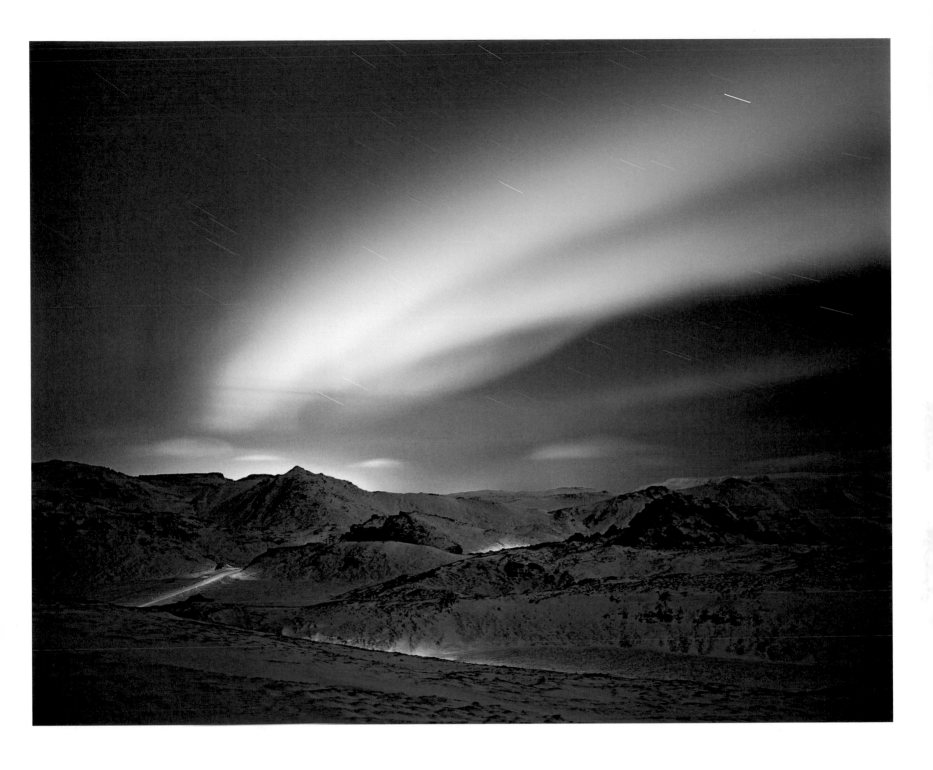

HYPERBOREA, 01
2006

DAN HOLDSWORTH

C-type print, 152 × 122 cm / 59¾ × 48 in
Private collection

The greenish light in the atmosphere bathes the barren Icelandic landscape in an eerie, supernatural glow, with a broken thread of gold caused by the headlights of vehicles on a road during the long exposure. This image by British photographer Dan Holdsworth (born 1974) comes from a series called *Hyperborea*. The title puts the Northern Lights firmly in their place – these inconstant, ever-wandering night-time displays occur towards the edge of the atmosphere, where it gradually merges with the vacuum of outer space. The glowing curtains of light drift along the ever-shifting boundary high in our planet's atmosphere, blown by the solar wind and shaped by Earth's magnetic field. The Sun's outflow carries charged particles: the more active the Sun, the greater their intensity, peaking around 'solar maximum', which occurs every eleven years or so. The Earth's magnetic field funnels the flux to discrete regions at high northern and southern latitudes, making the air glow as the particles lose energy above altitudes of 80 kilometres (50 miles) or more. Occasionally, intense solar storms – coronal mass ejections – can distort the Earth's magnetic field to make aurorae visible at much lower latitudes. These displays occur with similar intensity in both hemispheres, but the Southern Lights are less easy to observe.

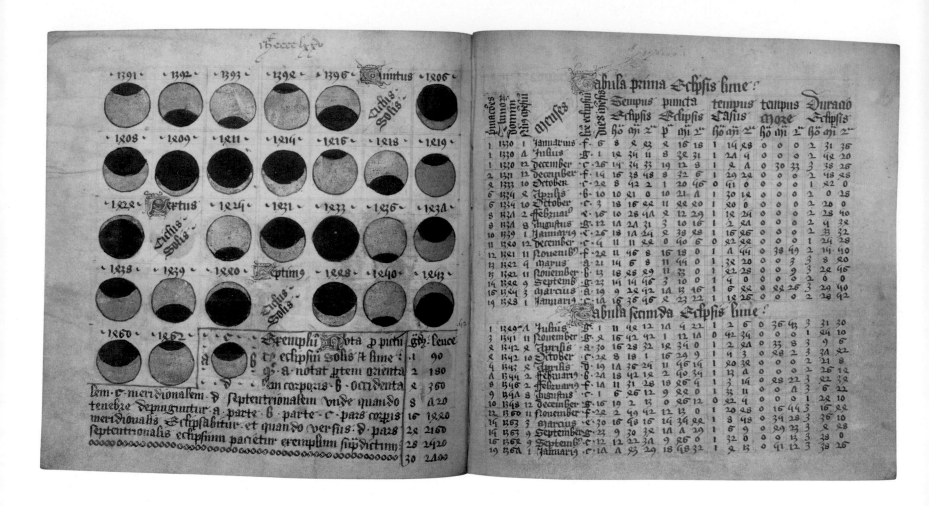

SHEPHERD'S CALENDAR

15th century

UNKNOWN

Ink on parchment, each page: 18.6 × 18.8 cm / 7¼ × 7½ in
University of Manchester

These pages from a late medieval manuscript illustrate twenty-eight solar eclipses that took place between 1391 and 1475. The careful drawing, the use of gold ink and the illuminated details suggest that, despite its title – *The Shepherd's Calendar* – this copy of the manuscript was created for someone far wealthier than a farm worker. The book was an almanac, communicating data about the calendar and astronomical observations that readers could use to identify the changing seasons and special days of the year, such as religious festivals, so they would know the right time for seagoing voyages, medical treatment and agricultural and social activities. Prior to 1457, almanacs were handwritten and therefore – unlike later, printed yearly almanacs – contained information that would be relevant to a longer period. This edition – there were many copies, made from a range of original sources – included tables of eclipses and other astronomical phenomena. It also contained paper devices, known as volvelles, which the reader could move to calculate planetary positions – a cheap form of such scientific instruments such as astrolabes. The almanac also illustrates the Labours of the Months, which were a standard medieval convention that illustrates the relevant agricultural actitivies for each month of the year.

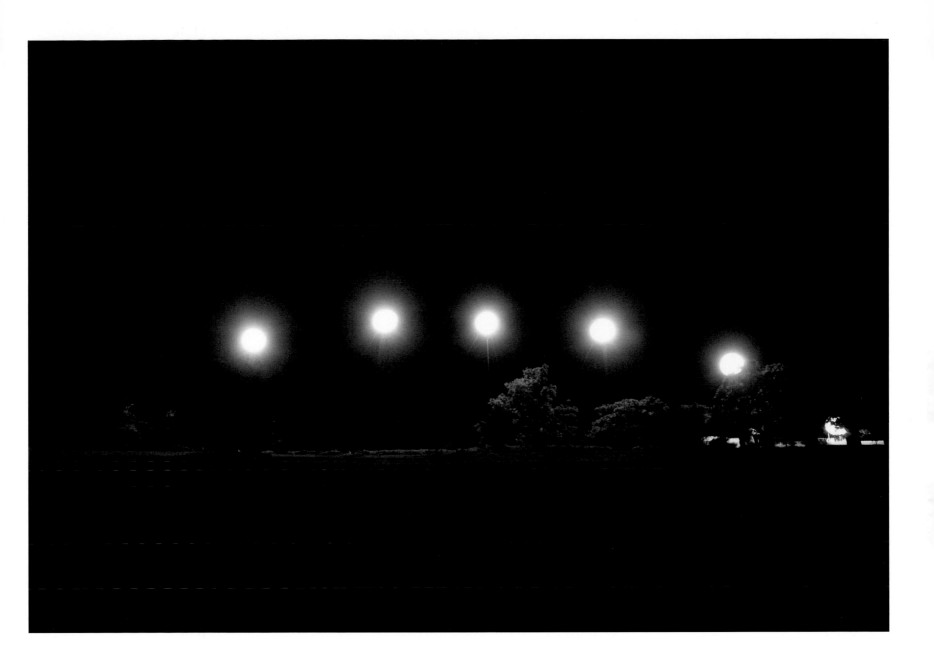

FAKE MOON (AS SEEN OVER 3 HOURS)
2010

SIMON FAITHFULL

Lights and helium balloon, dimensions variable

A counterfeit Moon rises above a field in the Herefordshire countryside, compellingly convincing. Created by British artist Simon Faithfull (born 1966), *Fake Moon* is a helium balloon, 3 metres (9.8 feet) in diameter, filled with powerful lights that make its skin glow as an unseen system of rope and pulleys moves it slowly across the sky. The illuminated sphere shines as a lunar apparition almost indistinguishable from the real thing – though brighter and bolder. The white orb gradually rises from behind the natural forms of trees. Over a period of three hours, the fake Moon mimics the movement of the real Moon in a simulacral homage to the original. Gazing up from the ground, viewers can observe long shadows cast by the glowing ball falling across vegetation. Faithfull has presented *Fake Moon* in the United Kingdom on three occasions: in Herefordshire at the Big Chill music festival in 2010, in Preston city centre that same year and in Bristol in 2013. Mesmeric in the way it harnesses the potential of the darkness, *Fake Moon* transports viewers into a surreal realm somewhere in between sleeping and waking.

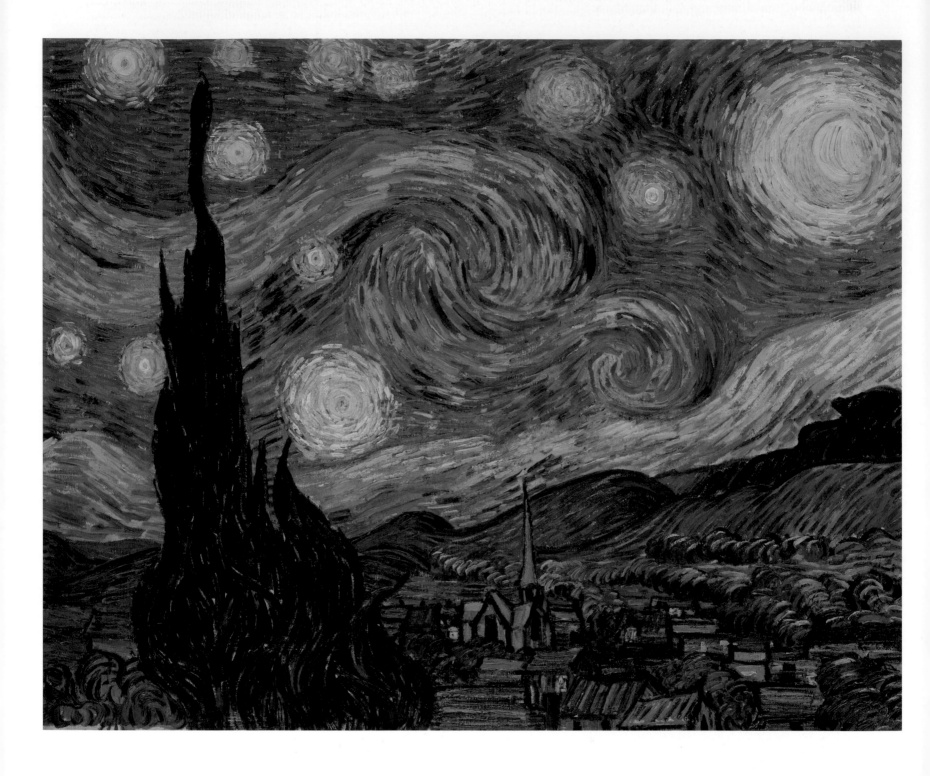

THE STARRY NIGHT
1889

VINCENT VAN GOGH

Oil on canvas, 73.7 × 92.1 cm / 29 × 36¼ in
Museum of Modern Art, New York

The Milky Way swirls across the night sky towards the crescent Moon, meandering among stars, one far brighter than the rest, like the planet Venus. Vincent van Gogh's swirling, dynamic painting is one of the most famous depictions of the night sky ever created. It is commonplace to observe that the restless energy of van Gogh's art reflected his troubled mind: this painting was one of a number he made at the psychiatric centre at the Monastery Saint-Paul de Mausole in Provence after suffering a mental breakdown. In this painting, the climax of the series, the rooftops of an imaginary, idealized village, with its church and its cypress trees, are spread out beneath a starlit sky, the night ending with the first light of dawn. Painted in mid-June 1889, as evidenced from van Gogh's letters to his brother, the painting reflects the nocturnal skyscape at that time – which did include Venus. Van Gogh (1853–90) altered the phase of the Moon from gibbous to cresent, to suit his composition. The swirls of the Milky Way are reminiscent of the shapes of the newly understood spiral galaxies, such as M51, the Whirlpool Galaxy. Van Gogh may have seen a reproduction in a popular science book of the first drawing by Lord Rosse of its spiral arms (see p.30).

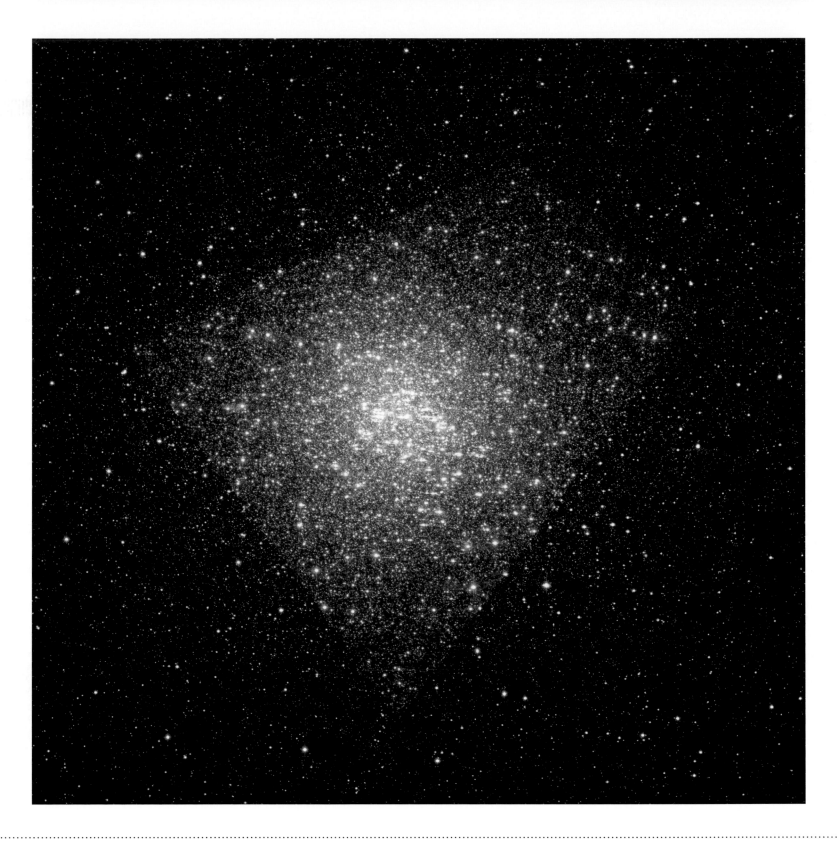

GOLDEN SOMA I

2015

SANAZ MAZINANI

Pigment print on archival paper with hand-applied 24-carat gold
38.1 × 38.1 cm / 15 × 15 in
Private collection

To create this striking representation of the cosmos, a pale blue form slopes away from us, reminiscent of a screen or cross-section diagram of the Galaxy embedded with glistening stars hand-panted with 24-carat gold. At its centre, a bright burst recalls a supernova, a dramatic explosion during the last stages of a star's evolution. For this print, the Iranian-born Canadian artist Sanaz Mazinani (born 1978) did not directly study the skies – instead she sourced imagery of the cosmos by searching through pictures on the Internet, then recreated them in pigment and gold. Interested in how digital manipulation can affect our perception of the world and the comprehension of the cosmos, Mazinani looks at the impact that representation has on us as viewers. This work is one in a series titled *Imminent Infinite* in which Mazinani contrasts the apparently 'all-knowing' World Wide Web with the ever-mysterious Universe, perhaps encouraging us to look inwards and consider more metaphysical questions about how the Universe began. At the same time, *Golden Soma 1* captures the overwhelming splendour and beauty of the experience of staring into a dark, star-studded sky.

HARE WITH PESTLE IN THE FULL MOON
*c.*1801–50

MATSUMURA GO SHUN

Woodblock print on paper, 38.4 × 52.4 cm / 15 × 20¾ in
British Museum, London

For as long as humans have existed, people have looked up at the Moon and studied the patterns of its surface to figure out who or what might live there. Europeans see a man on the Moon, while some African peoples see a frog. In Chinese and Japanese folklore the Moon is home to a rabbit or hare, as shown in this Japanese surimono print by Matsumura Go Shun (1752–1811). The white rabbit of the Moon clutches the pestle he uses to grind

rice to make rice cakes – a feature of the myth that plays on the similarity of the words for 'Full Moon' (*mochizuki*) and 'rice pounding' (*mochi-tsuki*). During celebrations of the Full Moon of the Harvest Festival, it is common to see prints and figurines of the Moon rabbit. Surimono prints were often commissioned by a particular group or circle of friends to be enjoyed during the festivities. Naturalistic images were surrounded by poems, or haiku, often

written especially for the occasion – this print includes seventeen different poems. The tradition of Moon-viewing (*tsukimi*) began in the ninth century and remains popular today. The lasting power of the folkloric motif is also evident in the names of the Chinese lunar rover *Yutu* ('jade rabbit'), which landed on the Moon in 2013, and the Japanese project *Hakuto* ('white rabbit'), created to explore the Moon in 2017.

MAN IN THE MOON
1902

GEORGES MÉLIÈS

Film still, from *A Trip to the Moon* (*Le Voyage dans le lune*)
Dimensions variable
Cinémathèque de Paris

This film still, showing a rocket landing in the eye of a disgruntled 'Man in the Moon', is of one of the most iconic scenes from the history of cinema. The first science-fiction movie, Georges Méliès's (1861–1938) silent film projects humankind's aspirations to reach another world. *A Trip to the Moon* was inspired by Jules Verne's *From the Earth to the Moon* (1865) and its sequel *Around the Moon* (1870), written a century before a man finally stepped on the Moon's surface. While Verne's novels showed early attempts to imagine scientific ways to travel to the moon with much flourish, theatricality and innovative special effects, the film itself concentrates on the whimsy and excitement of the astronomers led by Professor Barbenfouillis (played by Méliès). On the Moon, they encounter the hostility of the Selenites, before capturing one of their number, whom they parade to the crowds upon their triumphant return to Earth. *A Trip to the Moon* helped to fix the appearance of the Moon in popular imagery as a world with jagged, rocky terrains, as seen in later movies such as Irving Pichel's *Destination Moon* (1950) and Stanley Kubrick's *2001: A Space Odyssey* (1968). It was only with the Apollo 11 landing in July 1969 that the Moon would be revealed as a world with smooth dusty plains and rounded hills.

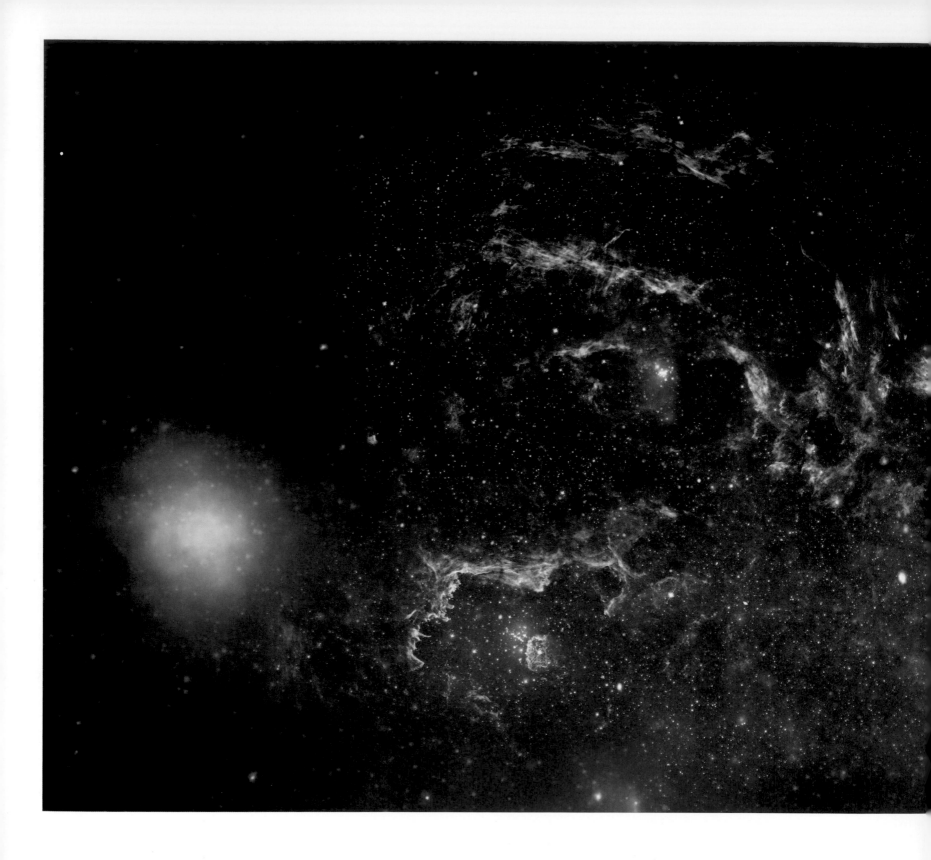

GREAT OBSERVATORIES' UNIQUE VIEWS OF THE MILKY WAY

2009

NASA, ESA, SSC, CXC, STSCI

Composite digital photograph, dimensions variable

This composite image of the central region of our galaxy contains a supermassive black hole, now named Sagittarius A*, around which our entire galaxy rotates. Its centre shows an area of extreme density, energy and activity that, combined with the gravitational effects of dark matter, holds enough mass to keep the galaxy from flinging itself apart. In November of 2009, NASA combined near-infrared, infrared and X-ray observations from their Hubble, Spitzer and Chandra telescopes to bring this view of unprecedented depth. The yellow arcs show near-infrared wavelengths and highlight regions of star birth, the pinkish-red corresponds to infrared wavelengths illuminating dust clouds around these star-birth regions and the blue-violet hues x-ray wavelengths from activity such as stellar explosions and material ejected from the black hole. The exact galactic centre is the white glow to the lower right of the middle of the image. The turquoise region on the left can be ascribed to a double star system, which may contain a body such as a neutron star or black hole. The volume of gas and dust between Earth and the galactic centre made it impossible to view this region before recent technological developments. Studying the galactic centre in such detail will give us clues into galaxy formation.

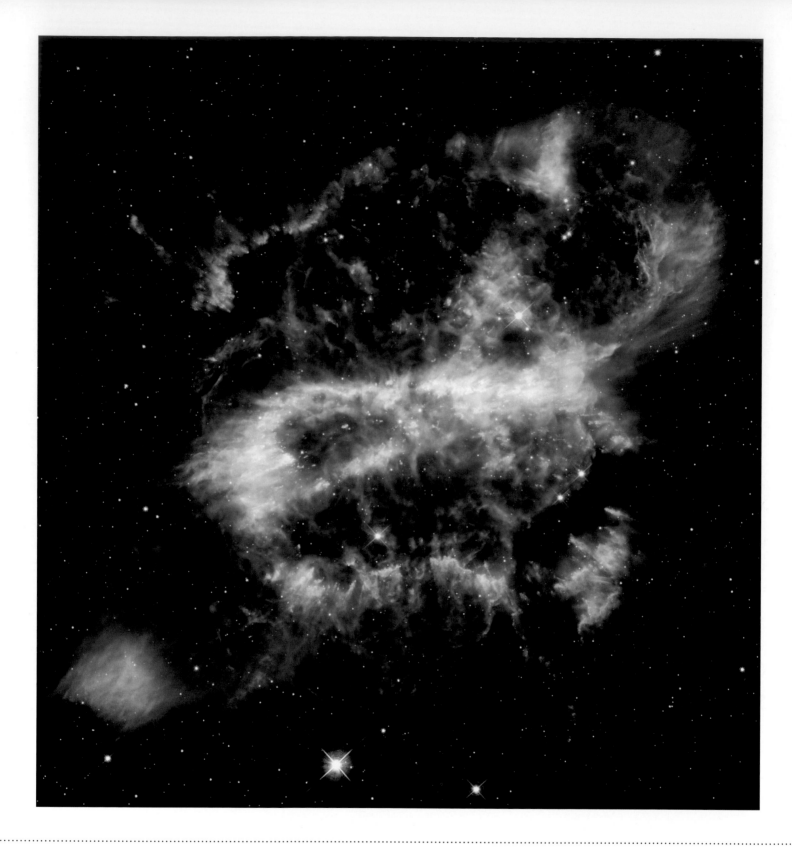

NGC 5189

2012

NASA, ESA AND THE HUBBLE HERITAGE TEAM (STSCI/AURA)

Digital photograph, dimensions variable

In the elegant words of astronomer David Stanley Evans, the planetary nebula NGC 5189 is 'a graceful affair of recurvant gaseous draperies'. Certainly, its chaotic structure, recorded in remarkable detail by the Hubble Space Telescope, is more like a twisting, spiralling ribbon than the simple shape of an archetypical planetary nebula. The nebula is formed from gas from a dying star; its intermittent structure, resembling the wakes of ships, indicates that the gas has been ejected in different directions in multiple episodes. Searching to explain this phenomenon, astronomers conjectured that the dying star was in a binary system, spinning and twisting in its orbit and periodically ejecting material. Hunting among the stars towards the centre of the nebula, at the focus of the streaky wakes, astronomers using the gigantic Southern African Large Telescope in 2015 found a binary star with a 4.04-day orbit. One of the pair is of a rare kind with a turbulent, excited atmosphere; the other is a white dwarf star. Which one is the star that was responsible for the gas? There are some reasons to think that both might be involved. That would certainly complicate the origin of the nebula and go at least some way towards explaining its intricate shape.

SNR 0509-67.5: A SUPERNOVA REMNANT
2010

X-RAY: NASA, CXC, SAO, J.HUGHES ET AL,
OPTICAL:NASA, ESA, HUBBLE HERITAGE
TEAM (STSCI/AURA)

Composite digital photograph, dimensions variable

This delicate, pink-edged bubble is a supernova remnant, the gaseous remains of a supernova explosion in our neighbouring galaxy, the Large Magellanic Cloud. The apparently hollow bubble, some 23 light years across, is the boundary of a region filled with expanding, heated material shocked by the explosion. The hot material, here coloured with soft blues and greens, emits X-rays. The image was made by combining images taken with light and X-rays using the Hubble Space Telescope and the Chandra X-ray observatory. The chemical composition of the exploding material shows that the supernova was caused by the collision of two white dwarf stars that had been spiralling around each other. The explosion occurred in a galaxy 160,000 light years from Earth, completely disintegrating the two stars, and it would have been visible by eye from the Southern Hemisphere in around 1600 – but the flash seems to have gone unremarked. Some faint traces of light from the flash have echoed off another nebula in the vicinity and are arriving on Earth only now, after a 400 light-year detour. This light echo has made it possible for astronomers to use the characteristics of the light to deduce the type of supernova and the explosion that occurred.

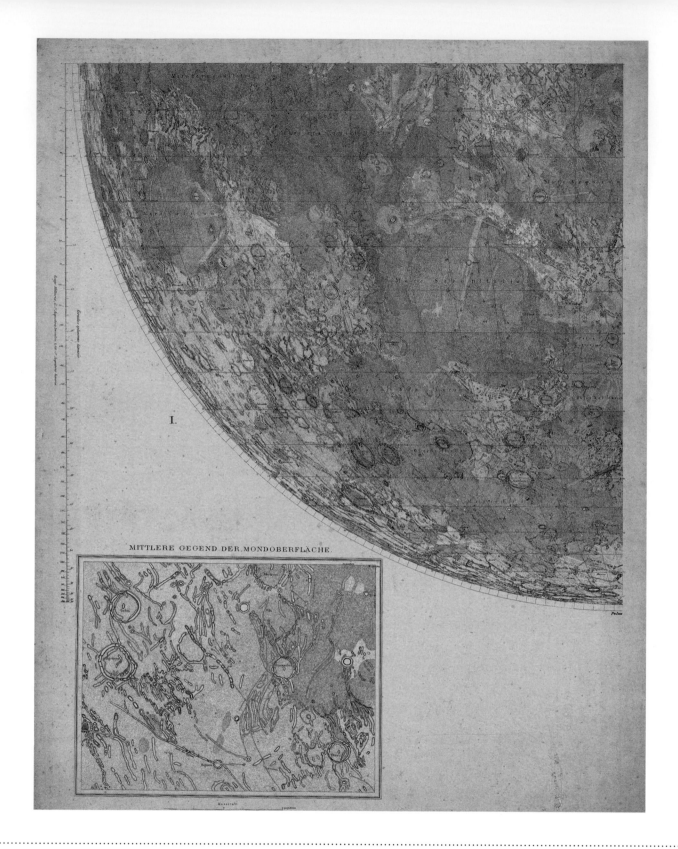

I.

MITTLERE GEGEND DER MONDOBERFLÄCHE.

MAPPA SELENOGRAPHICA
1834–6

WILHELM BEER AND JOHANN HEINRICH VON MÄDLER

Engraving, approx. 52.5 × 49.5 cm / 20½ × 19½ in
Barry Lawrence Ruderman Antique Maps, San Diego, CA

To those familiar with the Moon as seen with the naked eye, there is something amiss in this richly detailed engraving of our satellite (one of four parts of the map is shown here). The dark circular patch of Mare Crisium (Sea of Crises) appears in the upper right quadrant of the moon to naked-eye observers, but here it is in the lower left one. This is the result of a decision by the German Johann Heinrich von Mädler to replicate precisely

the view he saw through the telescope, an approach designed to minimize the number of lenses required and any subsequent distortion of the image. For the best part of 1831, von Mädler made multiple observations of each lunar crater using a 95-millimetre (3¾-inch) diameter refractor telescope at Wilhelm Beer's private observatory in Berlin. Thanks to their diligence, von Mädler and Beer were able to resolve and name more than 130 new

features on the Moon. The accompanying book *Der Mond* appeared a few years later in 1837 and provided astronomers with the technical drawings, mathematical principles, detailed descriptions and observational data used by von Mädler and Beer during their monumental project. This map remained the most detailed vision of the Moon's surface until the advent of lunar photography a few decades later.

LUNAR SURFACE. DAY 019, SURVEY W-F, SECTORS 1 5

1966–68

NASA SURVEYOR VII, JPL, USGS

Black and white photographs on paper
35.5 × 76.2 cm / 14 × 30 in
Private collection

This mosaic of 100 black-and-white photographs marks a key step in NASA's preparations for the successful first Moon landing of July 1969. It shows the lunar surface, close up, with the structure of the Surveyor spacecraft that supported the camera and, at the top, the Moon's horizon curving against the inky darkness of space. A grid in the background helped guide the assembly of the collage, with photographs lying over one another

like fish scales. The Surveyor programme was designed to gather data in preparation for manned landings and operated between 1966 and 1968. Of the seven spacecraft NASA launched, five robotic probes successfully landed on the Moon, the first US spacecraft to do so. The probes were important to demonstrate that it was technically possible to achieve a soft touch-down on the Moon – Surveyor had to fire retrorockets in order

to slow down from 9,656 to just 5 kilometres per hour (6,000 to 3 mph) – otherwise the whole crewed mission would be in jeopardy. Each Surveyor was equipped with a television camera, which was used to take images of the spacecraft's footpad, the lunar surface immediately surrounding it and the topography of the location. The resulting images revealed in close up what had until then only been seen from telescopes or orbiting spacecraft.

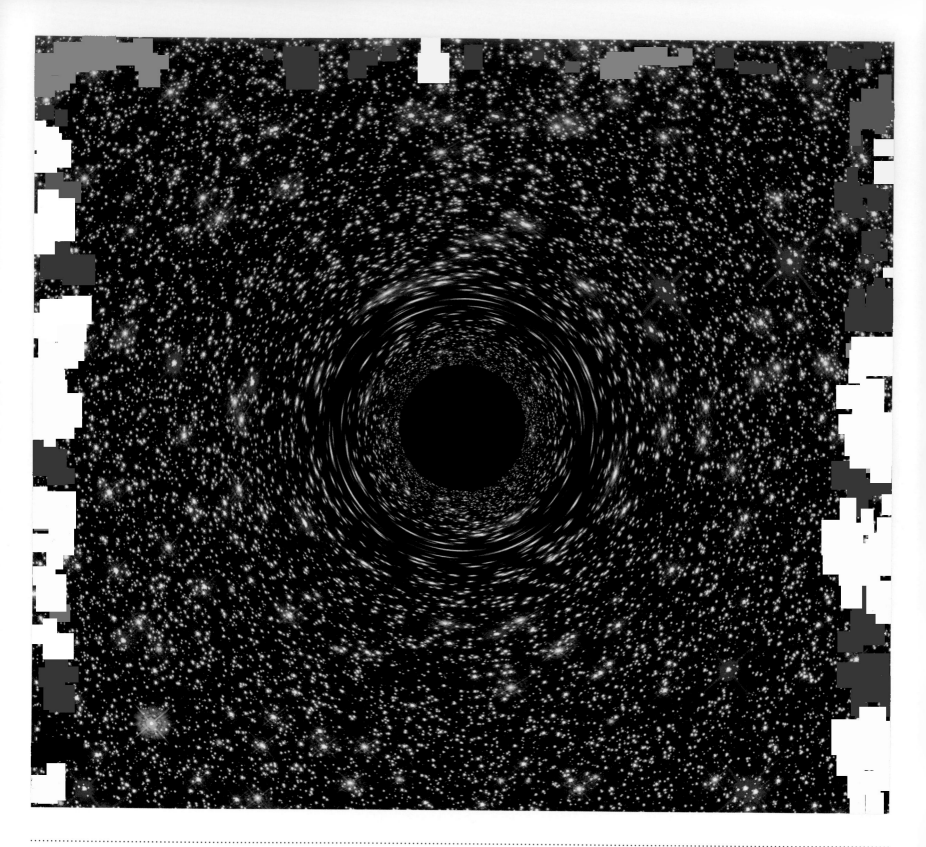

**COMPUTER-SIMULATED IMAGE OF
A SUPERMASSIVE BLACK HOLE**
2016

NASA, ESA, D. COE, J. ANDERSON AND R.
VAN DER MAREL (STSCI)

Digital simulation, dimensions variable

Blues and reds attract the eye in this computer simulation of a supermassive black hole, made using observations from the Gemini Telescope in Hawaii and the Hubble Space Telescope and. However, the real interest for astronomers lies in the central black circle, which represents the black hole's event horizon, from where no light can escape the object's strong gravitational pull. Such powerful gravity distorts space around it and light from background stars becomes stretched into a vast multicoloured spinning vortex as they swirl around the black hole. This simulation was inspired by the discovery of a supermassive black hole of near-record-breaking proportions, weighing the equivalent of 17 billion Suns, at the core of a galaxy in a thinly populated part of the Universe – a seemingly unlikely place. Large supermassive black holes, measuring roughly 10 billion times the mass of Earth's Sun, are usually found at the centres of large galaxies in areas of the Universe that are crowded with other galaxies. Scientists believe that the newly discovered black hole may indicate that giant black holes might be more common than previously thought. The data was captured using Hubble's Wide Field Camera 3 (WFC3), the HST's last and most technologically advanced instrument for taking images in the visible spectrum, installed in 2009.

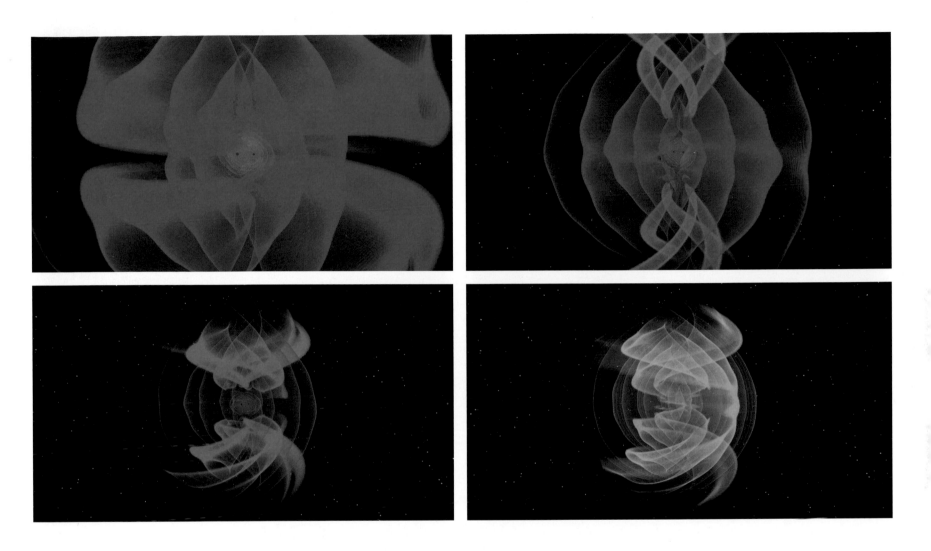

THE FIRST DETECTION OF BLACK HOLES
2015/2016

S. OSSOKINE, A. BUONANNO, W. BENGER
Digital visualization, dimensions variable

These sinuous lines might resemble the interlocking petals of exotic flowers, but they mark a huge moment in scientific history: the first evidence of black holes more than a billion light years from Earth merging and generating gravitational waves. Albert Einstein had predicted their existence in his Theory of General Relativity (1905), but thought their distance from Earth would prevent their detection. The waves were found by scientists firing lasers through long tunnels to try to detect ripples in the fabric of space-time caused by signals emanating from gravitational waves deep in the Universe. The discovery was the culmination of decades of research and international collaboration at facilities around the world. One of the leaders of the collaboration, Professor Karsten Danzmann of the Max Planck Institute, claimed that the detection of gravitational waves was one of the most important developments in science since the discovery of the Higgs boson. Danzmannn sees it as the astronomical equivalent of the discovery of the structure of DNA in biology. Astronomy now has the tools to study the darker depths of space, where there is neither light nor electromagnetic radiation – marking the start of a new era for astronomy, and in time potentially offering a view of the Big Bang itself.

SOLAR ECLIPSE
1919

ARTHUR EDDINGTON

Photograph
Royal Astronomical Society, London

This relatively ordinary photograph of a solar eclipse on 29 May, 1919 confirmed a revolution in science. The British astronomer Arthur Eddington took several photographs of the corona – he led an expedition to West Africa and sent another to Brazil – while the Moon obscured the Sun and recorded the deflection by the Sun's gravity of light coming from a star cluster known as the Hyades. Calculations based upon Eddington's photographs showed that the deflection caused by the Sun's gravity was 1.75 arcseconds – precisely as had been predicted by the young German scientist Albert Einstein in his Theory of General Relativity, published three years earlier. Einstein contended that light would be deflected by the warp in the space-time continuum created by a huge object. Specifically, light travelling past the edge of the Sun would be deflected by 1.75 arcseconds. The news that the Theory of General Relativity had been proved spread rapidly. 'Einstein's Theory Triumphs' proclaimed *The New York Times*, and 'Revolution in Science' said *The Times* in London. Einstein's position as a cultural icon was established and his theory 'proved', overturning the Newtonian view of the Universe.

TOTALITY
2016

KATIE PATERSON

Mixed media, 83 × 83 cm / 32¾ × 32¾ in
Arts Council Collection

A large mirrorball is inlaid with mirrored tiles reproducing almost every solar eclipse documented in human history – more than 10,000 images in total – from the earliest drawings to the most recent photographs. The mirrors reflect and scatter two beams of light into thousands of shimmering crescents that revolve over the walls, ceiling, floor and audience alike, replicating the gradual eclipsing of the Sun by the Moon. Scottish artist Katie

Paterson (born 1981) gathered images from observatories and picture libraries around the world to create *Totality*, an installation that is at once exhilarating and soothing. She collaborates with cosmologists and astrophysicists to bring together human and cosmic scales in works that make the ungraspable tangible by expressing the infinite times, expansive scale and unfathomable distances of the Universe. In Paterson's work, a confetti canon evokes

gamma-ray bursts in distant galaxies, condolence letters are sent to dead stars and a candle exudes the smells of the Universe. In these familiar forms, the mundane and the sublime are poetically combined to connect the brevity of human life to the unending vastness of the cosmos.

FIELD OF MARS
2016

JESSICA RANKIN

Embroidery on organdy, 131.5 × 172.3 cm / 51¾ × 67¾ in
Private collection

At first sight, the embroidered threads of *Field of Mars* appear almost as topographical markings mapping out an unknown mountain range. The intricate web in fact reflects the positions of the stars on the night New York-based Australian-born artist Jessica Rankin (born 1971) visited the grave of her mother for the first time, in a cemetery named 'Field of Mars' in a suburb of Sydney. This moment of personal significance for the artist, whose long-time interest in the natural world has led to a close study of astronomy, is placed within the wider context of the cosmos. Rankin embroidered yellow, blue and white threads on a dark surface of sheer organdy. The abstract patterns give form to a web of interconnected triangles and circles that appear to have been stitched with quite mathematical precision; these are framed by the words of the title spelled out in capital letters and scattered outside the composition, almost appearing as far-away planets. Rankin has described her needlework panels as a form of mental mapping, yet the aesthetic register of *Field of Mars* simultaneously recalls a star-studded cosmos or an astronomer's drawing of space. The threads of this work connect the mind to the landscape and the atmosphere beyond, holistically charting our Universe.

DUNES ON MARS
2014

HIRISE, MRO, LPL (U. ARIZONA), NASA

Digital image, dimensions variable

Crests of sand dunes catch the light as the Sun rises on a desert scene streaked with early winter frost and deep black shadows in the valleys between the dunes. This image captures a moment and location poised in diurnal and seasonal transition: from night to day, from summer to winter, from desert to ice-cap. Yet this is no earthly view: the Sun is rising on the desolate surface of Mars, as the autumn turns into the long, cold winter.

This picture was taken on 24 January 2014 by the HiRISE camera onboard the Mars Reconnaissance Orbiter, which circles the planet at an altitude of between 255 and 320 kilometres (160–200 miles). The image captures a 1.5-kilometre (0.9-mile) wide section of an unnamed crater that lies between the craters Proctor and Rabe. The temperature has barely risen above the night-time low of –100°C (–148°F). The slanting, dawn light brings into

relief the ripples of sand that cover the dunes, created by the prevailing westerly winds and highlighted by the overnight frost – a mixture of water and carbon dioxide – that has settled in the gullies between the ripple crests. At winter's peak, frost and snow settle permanently at the Martian south pole and the southern polar cap grows almost as far north as this location.

MOUN ROOM
2013–14

THOMAS HOUSEAGO

Tuf-Cal, hemp, iron rebar, 1391.9 × 1118.9 × 370.2 cm /
548 × 440½ × 175¾ in
Private collection

The Moon rises and falls across the walls of the installation *Moun Room* – the title is a pun on the name of the artist's girlfriend, Muna – waxing and waning in a series of raised shapes or apertures that follow its phases of new, crescent, quarter, gibbous and full. The British artist Thomas Houseago (born 1972) constructed three concentric rooms for the viewer to explore. What appear to be soft-pillowed white walls are in fact textured hemp and

Tuf-Cal plaster over a structure of iron re-bars. From the outside, the horizontal beams form a skeleton punctured by moon-shaped voids of negative space, some of which are large enough to walk through, while others are small portholes into the adjoining space; inside, the plaster is smooth and pearlescent, sculpted into reliefs of gently protruding, curved semicircular shapes. Although Houseago is better known for sculpting the figure, the

form of the Moon reappears throughout his work. The artist describes the journey through *Moun Room* as being 'about light and life'. With many astronauts defining their experience of space as one of profound spiritual impact, Houseago's work looks beyond our world into a more ethereal realm.

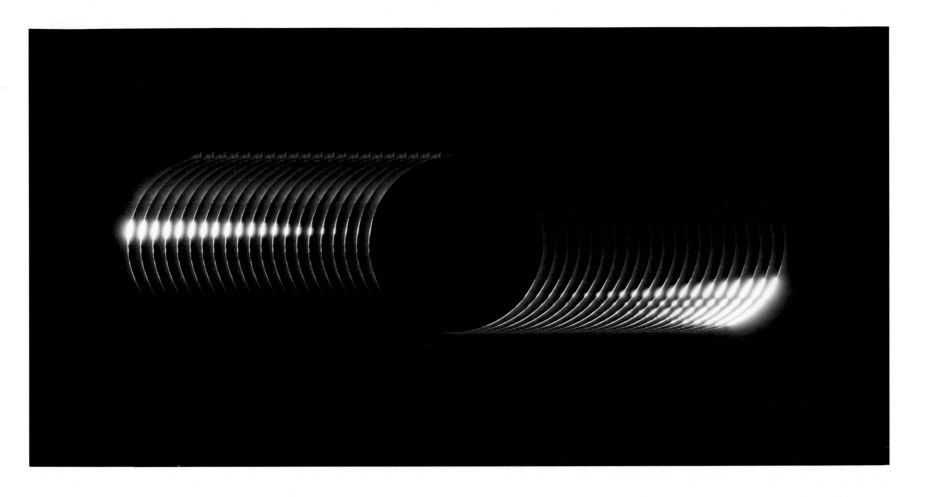

BAILY'S BEADS
2016

YU JUN

Digital photograph, dimensions variable

This remarkable multiple-exposure photograph of a solar eclipse by the Chinese astrophotographer Yu Jun defeated 4,000 other entries to win the 2016 Insight Astronomy Photographer of the Year award – but it came about largely by accident. Yu Jun, a seasoned observer of eclipses, travelled to Luwuk, Indonesia, to witness the solar eclipse of 9 March 2016, and hitched his camera to a laptop programmed to take a sequence of photographs

of the event. As it turned out, a glitch rendered most of the images unusable, leaving only a few images taken at the fleeting beginning and end of the eclipse. As the Sun disappears behind the Moon a red solar prominence blooms at top left before the star's brilliant edge reappears on the other side of the Moon, marking the end of the eclipse. It is seen as a very narrow, curved slit – but as the sunlight peeps through the mountains and

valleys of the Moon, the light is briefly broken into an apparent string of beads or jewels. The phenomenon is known as Baily's Beads, having been first noted by the English astronomer Francis Baily in 1836. To the dark-adapted eye, the last or first glimmer of sunlight to appear just before or just after the darkness of totality, can produce an especially brilliant impression, known as the 'diamond ring' effect.

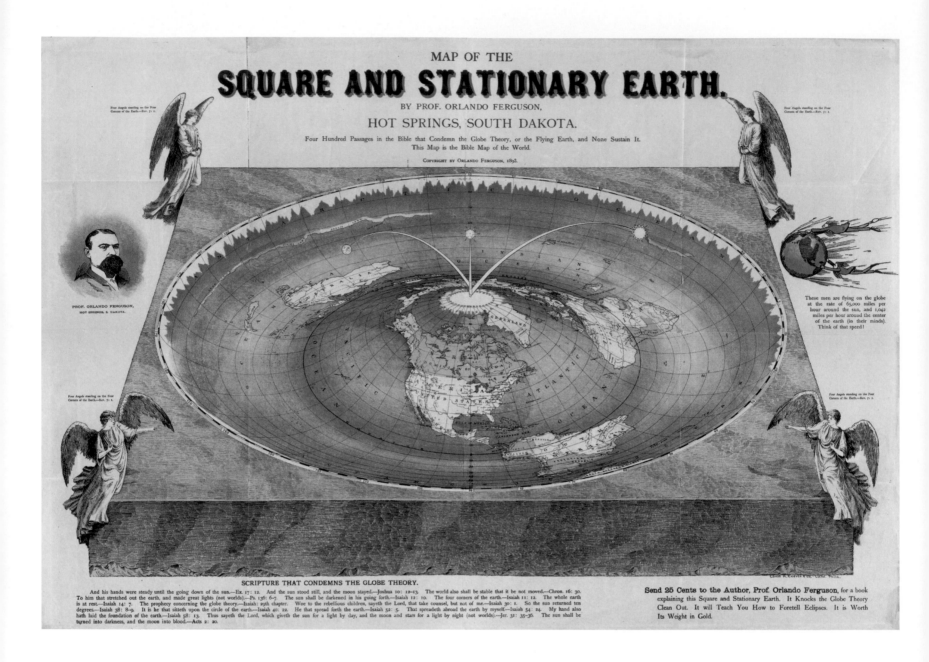

MAP OF THE SQUARE AND STATIONARY EARTH

1893

ORLANDO FERGUSON

Hand-coloured lithograph print, 82 × 57 cm / 32⅓ × 22½ in
Library of Congress, Washington, DC

This hand-coloured map is one of just two that still remain from 1893, when the self-styled 'Professor' Orlando Ferguson – actually a real-estate salesman from South Dakota – used it in a pamphlet illustrating his belief that the Earth was square and stationary. The Earth is pictured as a rectangular slab like a paving stone, imprinted with an inverse toroid. The shape would explain why, for example, a departing ship gradually seems to disappear below the horizon – but only for the northern hemisphere, the mound in the middle of the form. It is not clear why, following this logic, southern hemisphere lands would not be permanently underwater. The corners are supported by angels, a reference to the Bible's Book of Revelation. In a marginal illustration showing two men clinging to the Earth as it spins, Ferguson noted: 'These men are flying on the globe at a rate of 65,000 miles per hour around the sun, and 1,042 miles per hour around the center of the earth (in their minds). Think of the speed!' A footnote lists Bible verses condemning the theory of the Earth as a globe. Ferguson was not alone: a belief in a flat Earth became popular in the late nineteenth century and his lectures were apparently popular. He sold his pamphlets for 25 cents with the promise, 'It Knocks the Globe Theory Clean Out … It is Worth Its Weight in Gold.'

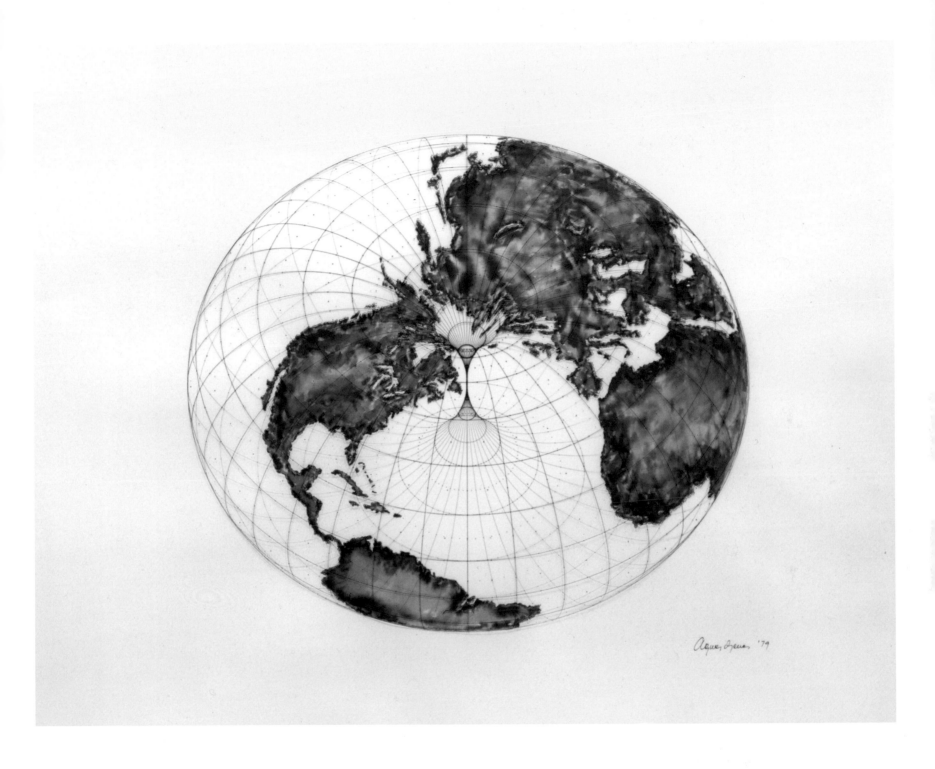

ISOMETRIC SYSTEMS IN ISOTROPIC SPACE MAP PROJECTIONS: THE DOUGHNUT
1979

AGNES DENES

Watercolour and graphite pencil on paper with screenprint on plastic overlay, 61 × 76.5 cm / 24 × 30 in
Whitney Museum of American Art, New York

The Universe is a place full of limitless possibilities for reimagining, as can be seen in this watercolour-and-pencil drawing of Earth by the Hungarian-born conceptual artist Agnes Denes (born 1938), who is based in New York. It is one of a series of similar isometric drawings she made from the late 1960s on as she experimented with ways to translate three-dimensional objects on to a flat sheet of paper, depicting Earth as a pyramid, a cube or a conch shell. Here she accurately renders Earth in a doughnut shape that creates a new, unexpected image of the planet. The North and South Poles meet in the hole of the doughnut, pulling the continents in with them. For Denes, whose predilection for fast food also extends to images of hot dogs, *The Doughnut* unravels the familiar lines of longitude and latitude that define how we look at Earth, allowing continents to drift into a new relationship and tampering with gravity. Denes began her career as a painter, but later adopted a wider variety of media that reflect an enduring interest in science and the way in which humankind perceives the Universe. She applies a deep understanding of time and space to her artistic work, ensuring that its presentation retains an aesthetic purity.

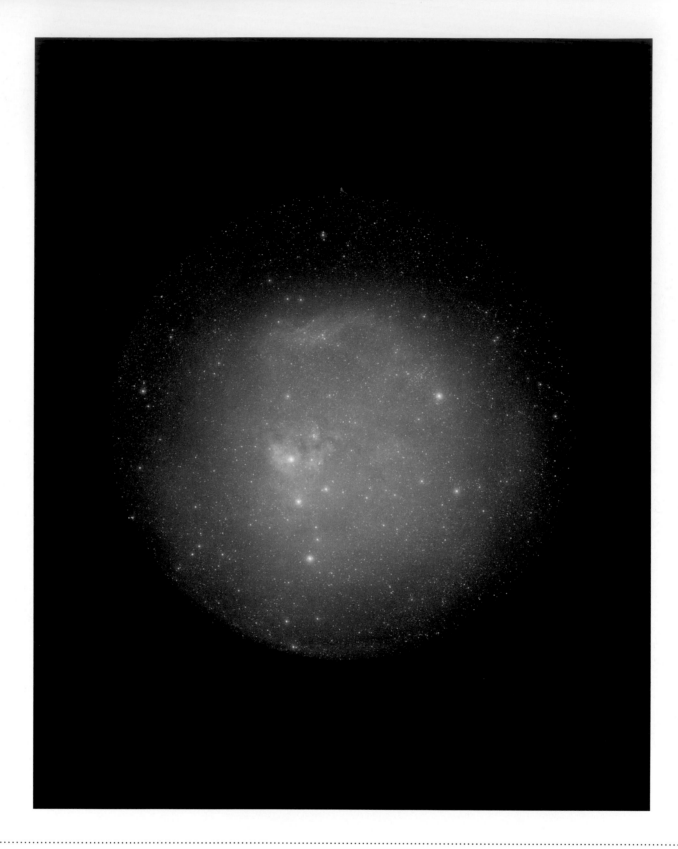

OBSERVATION 111
1991/2013

SOPHY RICKETT

Bromide print, 120 × 150 cm / 47¼ × 19½ in
Private collection

Observation 111 belongs to a body of work created by British artist Sophy Rickett (born 1970) during a residency at the Institute of Astronomy, University of Cambridge. There she met Dr Roderick Willstrop, now-retired astronomer and physicist, and inventor of the Three Mirror Telescope, a camera telescope which he used to record his astronomical observations. The use of three mirrors, rather than one or two, increased the detail and legibility of objects over a large field of view. In 1990–91 Willstrop produced 125 black-and-white film negatives, before the telescope was modified to record digitally. Rickett was attracted to the negatives for their materiality and the way in which they articulate our relationship to space at a point in time through the eyes of the astronomer and his telescope. In the darkroom, she reinterpreted Willstrop's photographic observations, at once rescuing them from oblivion and subverting their scientific intent with aesthetic concerns. The milky sheen of the night sky in *Observation 111* is eerie, poetic and compelling. But the scientific exactitude remains: each work is labelled with the coordinates of the patch of sky photographed, date, exposure time, camera and film used, the date of the original shot and that of Rickett's print.

SUN TUNNELS
1973–6

NANCY HOLT

Concrete, steel and earth, each tunnel 2.4 × 5.5 m / 9 × 18 ft
Great Basin Desert, UT

Sunlight shines through holes drilled in a large concrete tube carefully positioned in the remote Utah desert in an X-shape with three other tubes to frame the sunrise and sunset on the summer and winter solstices. The holes pierced into the the tubes echo the shapes of four well-known constellations: Draco, Perseus, Columba and Capricornus. *Sun Tunnels* was created by the American artist Nancy Holt (1938–2014) as a piece of Land Art

that engages with astronomical events. The piece employs industrially produced materials as a means to encourage renewed appreciation for natural cycles. The basic shapes and industrial materials share an affinity with minimalist art, but the grey tones of the concrete tunnels blend into the desert setting, making them seem part of the landscape so that the piece appears both manmade and natural. Holt made a film to document the work

and its construction, emphasizing the interplay between machine and nature. Nearly three-quarters of the film features the cement mixers, dump trucks and haulers used to build *Sun Tunnels*, but it concludes with a slow, meditative record of the completed work. It tracks the changing light inside the tunnels as the Sun moves across the sky, and then finally the Sun rising and setting against the mountains as viewed from within the tunnels.

COPERNICUS CRATER

Late 1850s

UNKNOWN

Salted paper print from a collodion negative
13 × 16.5 cm / 5 × 6 ½ in
The J. Paul Getty Museum, Los Angeles, CA

Tightly framed and impressively detailed, this photograph of a lunar crater from the middle of the nineteenth century looks almost too good to be true – and, in a sense, it is. From photography's introduction in 1839, astronomers were eager to use the new process to record and observe celestial objects. However, the photographic emulsions available at the time were not sensitive enough to register a close-up view of the surface of the Moon. Therefore,

this photograph shows not the Moon itself, but a scale model of its surface. At the time, both professional and amateur astronomers made plaster models of the Moon and its features, ensuring scientific accuracy by basing the models on lunar maps and drawings that astronomers had made through careful telescopic observations. John Herschel, one of the best-known astronomers of the era, owned this print and there is some suggestion he may

have taken the image himself. Whether his work or not, it reflects the intense interest in photographing the Moon. While the resulting print might initially deceive our eyes, no effort was made to hide that fact that it was a replica. The name of the crater – Copernicus – appears vertically on the lower right and distance scale along the upper left, both stamped into the model itself.

MONTES APENNINUS LM 41

1976

DEFENSE MAPPING AGENCY FOR NASA

Lithograph, 56 × 74 cm / 22 × 29 in
Lunar and Planetary Institute, Houston

On Earth, mountain ranges were raised over millions of years, as tectonic plates collided in slow motion. On the Moon, mountain ranges were raised in a few minutes from the walls of craters made by the impact of meteors and asteroids. This map, constructed in 1976 from photographs during the Lunar Orbiter satellite programme during its survey of possible landing sites for the Apollo missions, features a mountain range named the Montes Apenninus (named after the Apennines range in Italy). The mountains are part of the south-eastern crater wall of Mare Imbrium (the Sea of Rains), which was formed by the impact of a 250-kilometre-wide (155 miles) asteroid 3.9 billion years ago. The crater's interior later flooded with lava to form a flat, dusty plain. On the other side of the mountain range is Mare Serenitatis (the Sea of Serenity). After early astronomers made the error of identifying the Moon's dark patches as seas and named them *maria* (Latin for 'seas'), smaller plains were named for lakes (*lacus*), bays (*sinus*) or marshes (*palus*). This map includes Sinus Fidei (Bay of Faith), Lacus Felicitatis (Lake of Happiness) and Palus Putredinis (Marsh of Decay). At the eastern extremity of Palus Putredinis is the Rima Hadley (the Hadley Rille or channel), picked as the landing site for Apollo 15.

PIEDRA DEL SOL
1250–1521

UNKNOWN

Stone carving, diam. 358 cm / 141 in
Museo Nacional de Antropología, Mexico City

Probably carved between 1250 and the final collapse of the Aztec Empire in 1521 following the arrival of Hernán Cortés and the Spanish conquistadores in 1519, this huge basalt stone captures how the Aztecs saw the cosmos. At the centre of the round disc is the face of what is thought to be the sun god, Tonatiuh, holding human hearts in his claws and with a tongue shaped like a knife. The Aztecs believed that they had to offer their gods human sacrifices

to keep the Sun moving in the sky so that life would continue. Surrounding the sun god are depictions of the four eras of creation and destruction: the Aztecs who carved the stone believed they were living in the (final) Fifth Age. The concentric carved circles surrounding the centre describe the Aztec calendar system, a complex combination of a secular calendar that consisted of 365 days and a sacred calendar that had only 260 days. The

two calendars coincided just once every 18,980 days (52 years), on days with ritual significance. Remarkably, the disc was forgotten after the Spanish conquest until 1790, when it was rediscovered.

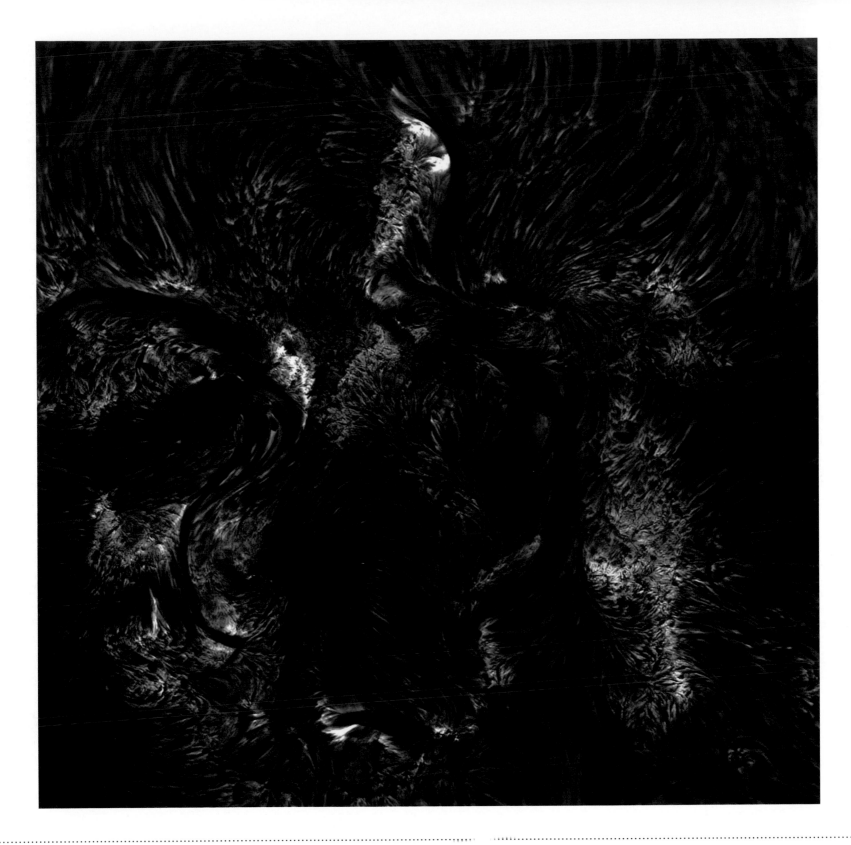

SOLAR ACTIVE REGION AR 10786
2003

DUTCH OPEN TELESCOPE

Composite digital image, dimensions variable

This false-colour image might appear abstract but is in fact a highly detailed depiction of activity on the surface of the Sun – in particular a tiny area named Solar Active Region AR 10786. The picture has been artificially coloured to highlight notable details, including the dark centres of sunspots and the many fibrils that emanate away from them. These fibrils outline magnetic connections between different areas, like filings around a magnet. The long, slender dark structures (filaments) mark regions of high solar activity. Ever since astronomers realized that the Sun was not a fixed entity but changed continually as it generated energy, astronomers have been seeking to understand solar activity. This 2005 image, taken by the Dutch Open Telescope (DOT) on La Palma in the Canary Islands, used adoptive optics (AO) to correct in real-time any distortion caused by the Earth's atmosphere. A process known as despeckling – which involves taking a hundred frames of the same object and then using computers to separate physical features from atmospheric effects – enables the creation of a more accurate image. Using such technology, a telescope on the ground is able to capture as detailed a picture as a telescope in space.

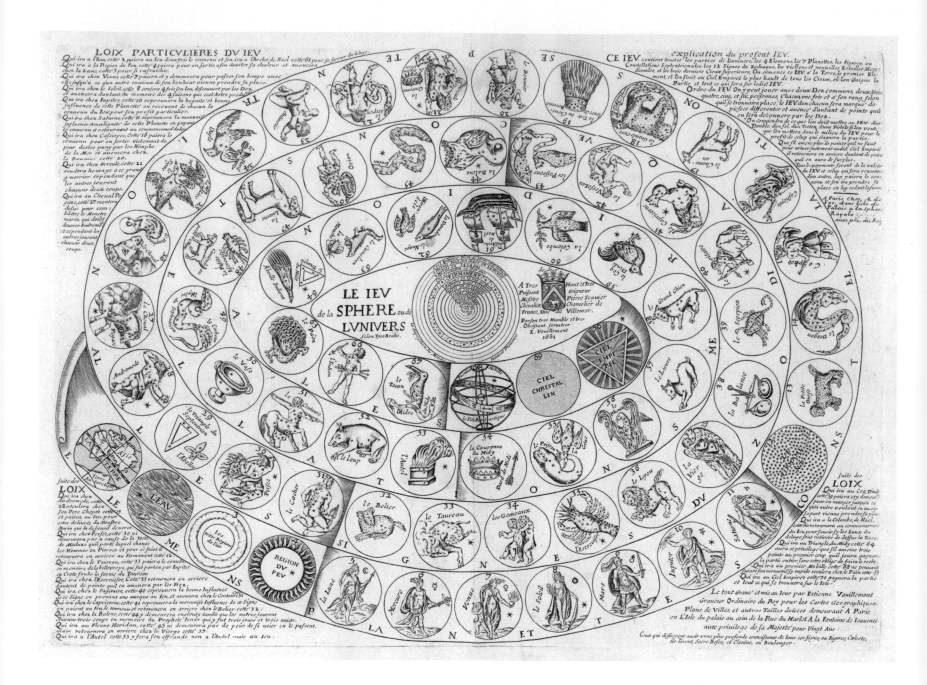

LE JEU DE LA SPHERE
OU DE L'UNIVERS SELON TYCHO BRAHE
1661

ESTIENNE VOUILLEMENT

Engraving, 38 × 53 cm / 12¼ × 15¾ in
National Library of Copenhagen

As printed board games became popular from the late sixteenth century, they quickly diversified to incorporate fashionable or educational themes. While the rules hardly changed, the subject matter could vary widely. In 1661 the French mapmaker Estienne Vouillemont devised a game in which the seventy spaces, arranged in a spiral, represented regions of the cosmos. The rules, printed around the playing area, explain that players are to agree the stakes

to be gambled, and to advance their counters from outside inwards according to throws of two dice. The spaces begin with the four elements, then the seven planets, and then an array of constellations climaxing in the Empyrean Heaven (marked with a triangle to represent the Trinity). Twenty-three of the seventy spaces had consequences for a player who landed on them: moving forward or back or increasing his stake. These provided an opportunity

for education: a player landing on the Sun moved four times the distance shown on the dice, representing the four seasons; while landing on Jupiter would win you one stake from each of your opponents in recognition of the planet's benign influence. The title of the game claimed it was a representation of the cosmological system of Tycho Brahe (1546–1601), but its contents adhere closely to ancient geocentric models.

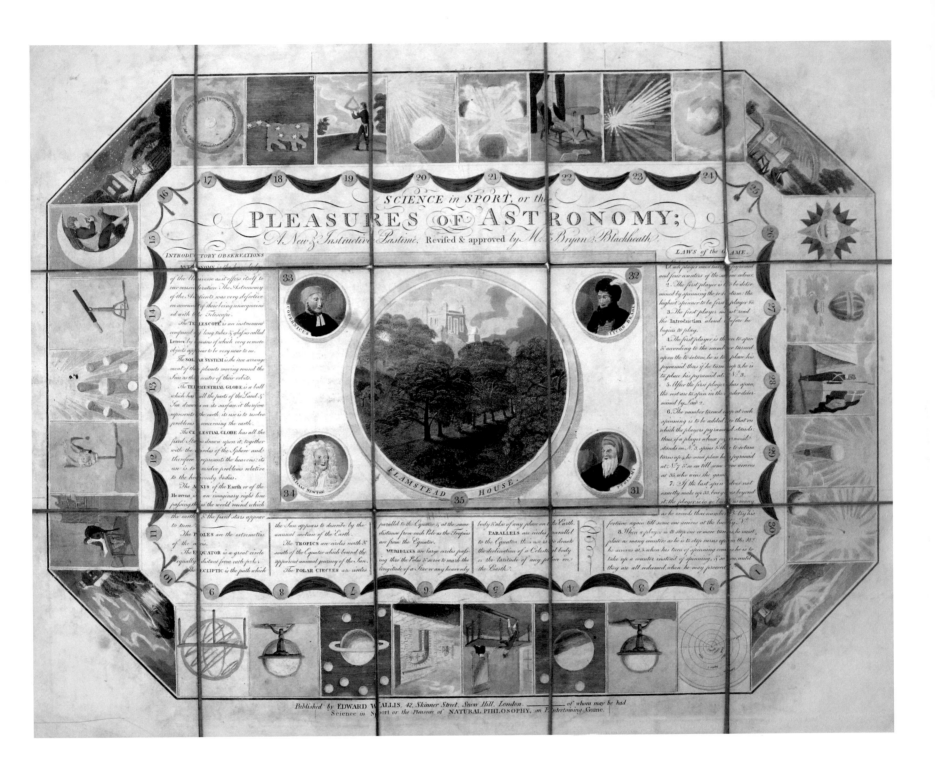

SCIENCE IN SPORT, OR THE PLEASURES OF ASTRONOMY

1815

JOHN WALLIS

Engraving on paper with linen backing
44.5 × 55.6 cm / 17½ × 21¾ in
Private collection

The drawing at the heart of this early nineteenth-century board game entitled *Science in Sport, or the Pleasures of Astronomy* shows Flamsteed House at the Royal Observatory in Greenwich, the traditional home of Britain's Astronomer Royal. That title is the reward of whichever player reaches the Royal Observatory first in this game, which was aimed at parents eager to enhance their children's understanding of astronomy (the game's educational quality was authenticated by the approval of Margaret Bryan, an author of popular science books who ran a girl's school in Blackheath, south London). As in the traditional version of *The Game of the Goose*, players spin a numbered top to move their token around the thirty-five squares, each of which is illustrated with either a planet or the portrait of a famous astronomer and mathematician, including Ptolemy, Nicolaus Copernicus and Isaac Newton. As they land on various squares, players have to complete a challenge detailed in an accompanying booklet, such as reading aloud information about the planets or explaining the principles and uses of the instruments illustrated around the board. The serious tone of the booklet reinforces the fact that education was the objective of the game, rather than entertainment.

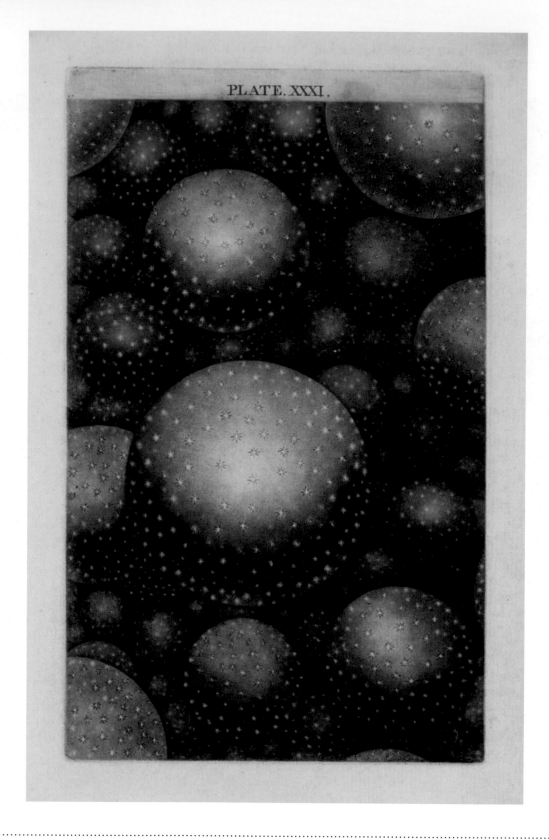

PLATE XXXI
1750

THOMAS WRIGHT

Lithograph and photographic collage on paper, from
An Original Theory or new Hypothesis of the Universe
28 × 22.5 cm / 11¼ × 9 in
Private collection

This Universe, crammed full of large spheres dotted with light stars, was the unique vision of the Durham astronomer, instrument-maker, mathematician and gardener Thomas Wright (1711–86). In Wright's view, the Milky Way was one of an infinite number of independent star systems that filled space: he referred to his illustration as 'a finite View of Infinity'. It seemed entirely feasible to Wright that this infinity would include many other inhabited worlds, but he did not find it difficult to reconcile such a view with the Christian idea of a Divine Creator. In other illustrations in his book *An Original Theory or New Hypothesis of the Universe* (1750), Wright indicates the Creator's presence as a disembodied eye. Wright's eccentric theories contained many accurate insights. He speculated presciently about the nature of 'The many cloudy Spots, just perceivable by us, as far without our starry Regions'. Wright observes that these 'luminous Spaces ... may be external Creation, bordering upon the known one, too remote for even our Telescopes to reach.' Today, we know that many of these light patches in the sky are indeed distant galaxies.

DARK MATTER DISTRIBUTION IN THE MILLENNIUM SIMULATION

2005

VOLKER SPRINGEL ET AL., VIRGO CONSORTIUM

Visualization from a digital simulation, dimensions variable

This is a still from the Millennium Simulation of 2005, which was the largest calculation carried out up to then to try to understand how the Universe developed. Its calculations took a month on a supercomputer located at the Max Planck Institute for Astrophysics in Garching, Germany. The Universe was represented by 10 billion particles, which, as they interacted with each other through the force of gravity, grouped themselves eventually into 20 million galaxies. The galaxies formed clusters surrounded by voids and connected by a web of threadlike filaments, as shown in this still. The calculations were matched to the way the Universe actually looks, and the basis of the calculations varied until it produced a good fit. One of the variations was the proportion of the 10 billion particles that are made of dark matter. The remarkably good match between the theoretical Universe of the Millennium Simulation and the real Universe is one of the reasons that astronomers are confident that there is five times more dark matter in the Universe than ordinary matter. The simulation has been re-run several times since 2005, on successively more sophisticated computers, with similar but more refined results – but although astronomers know how much dark matter exists, its nature still remains poorly understood.

EARTHRISE
1968

WILLIAM ANDERS

Photograph, dimensions variable
Johnson Space Center, Houston, TX

Seeming to hang above the arid lunar horizon, Earth appears small, isolated and vulnerable, suspended in space. Astronaut William 'Bill' Anders took this celebrated photograph 75 hours, 48 minutes and 41 seconds into the flight of Apollo 8, the first manned mission to orbit the Moon, at the end of 1968. The space capsule Anders shared with astronauts Frank Borman and Jim Lovell was beginning the fourth of its ten lunar orbits when Anders

noticed the view of Earth and exclaimed, 'Wow, is that pretty!' Anders used his Hasselblad camera to take a black-and-white photograph while Lovell looked for some colour film. The pair thought they had missed the shot, but the view reappeared in a different window and Anders took this image. He could have had little idea what impact it would have. It became one of the most reproduced photographs of all time. The first full-colour view of Earth

from outside the planet's atmosphere revealed a picture of beauty and fragility. It gave a new perspective to earthly divisions and conflicts and the whole-world view of the photograph has been credited with helping to spark the budding environmentalist movement. Apollo 8's mission was to photograph possible sites for a Moon landing, but Anders' image was perhaps its most important long-term legacy.

OUTER SPACE
1967

PETER MAX

Offset lithograph, 91.5 × 58.3 cm / 36 × 23 in
Smithsonian Design Museum, New York

Acclaimed US graphic artist Peter Max (born 1937) refers to his output around the time he produced this fluorescent poster as the 'Cosmic Sixties'. *Outer Space* perfectly caught the psychedelic mood of 1967 in its multicoloured representation of the cosmos. The image's perspective positions the viewer as if poised to land on the Moon, which sits as a colossal orb in the bottom half of the poster's vertical composition. The chiaroscuro

of its craters, marbled with tones of light and shade, is overshadowed by a bright coral pink that radiates from its surface, slowly graduating though hues of orange into electric yellow. Space itself is a vast, deep purple expanse with countless white stars. At the top of the poster, the Earth is represented as a small sphere in the distance, directly facing the Moon – the two seemingly in dialogue. The planet mirrors the satellite's vibrant yellow

accompanied by mottled shades of green, range and blue, lending it a sense of dynamism. Celebrated for his counter-cultural images, Max is renowned for his unique, expressive approach to colour, which was combined with his interest in astronomy to produce this striking poster.

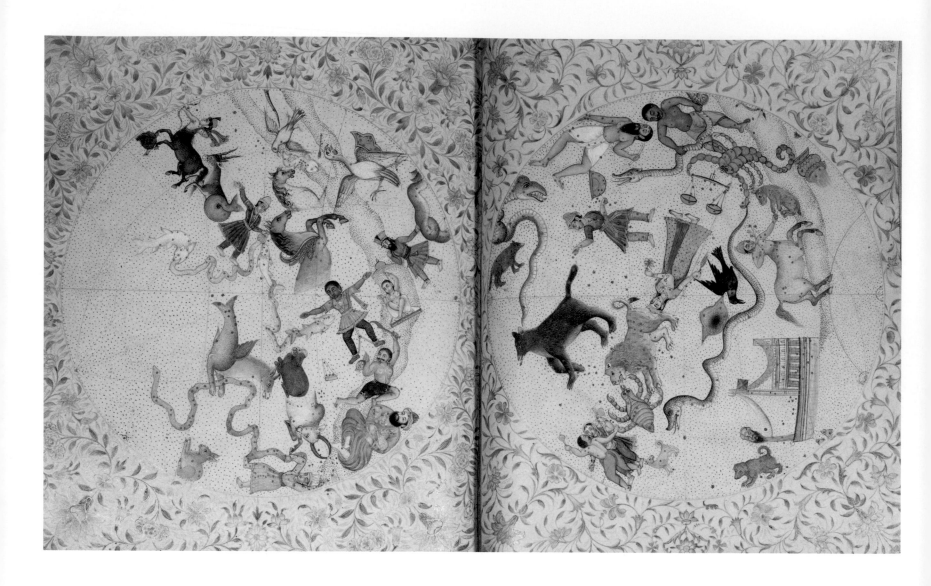

SIGNS OF THE ZODIAC

1840

UNKNOWN

Watercolour and ink on paper, 45.4 × 32.3 cm / 17¾ × 12¾ in
British Library, London

There is no certainty as to quite what is depicted in this illustration from an 1840 Sanskrit guide to astrology, but the most likely explanation is that it illustrates constellations from various astrological traditions plus some of the twelve signs of the zodiac. The circles within the floral borders of the left and right-hand pages represent the southern and northern celestial hemispheres, respectively. The illustration comes from

an Indian text entitled *Sarvasiddhantatattvacudaman*, which translates as '*The Jewel of the Essence of All Sciences*'. The book is a collection of astrological knowledge from the Hindu, Islamic and European traditions. Indian astrology and astronomy developed hand-in-hand from practices that dated back to roughly 2000 BC, around the time of the Indus Valley Civilization. The first record of Indian astrological documentation

comes from a distinguished text, the *Vedanga Jyotisha*, that dates back to between 1400 and 1200 BC. By the nineteeth century AD, Indian astrology had been infused with many other influences brought to the subcontinent by a series of conquerors and traders, and reflected Hellenistic, Chinese and Islamic traditions.

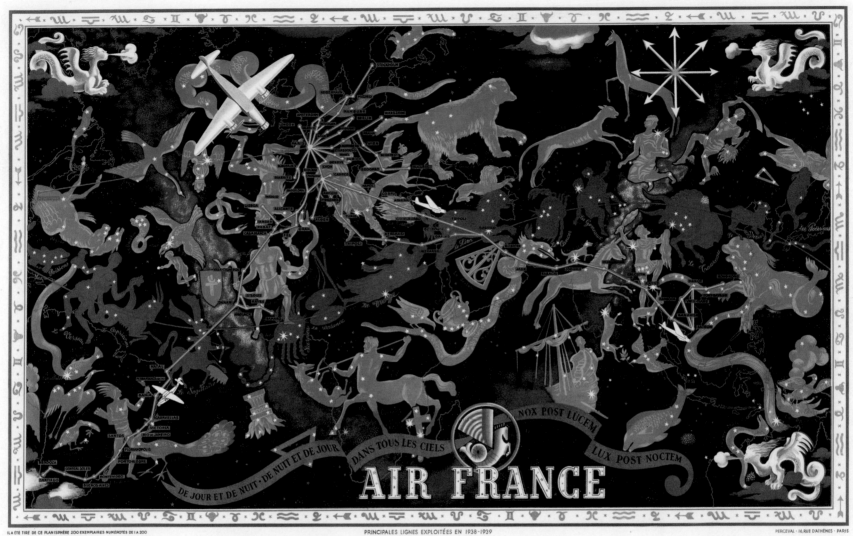

AIR FRANCE DE NUIT ET DE JOUR DANS
TOUS LES CIELS

1939

LUCIEN BOUCHER

Lithograph print, 61 × 96 cm / 24 × 37¾ in
David Rumsey Map Collection, Stanford University Library, CA

The orange lines that radiate across this striking poster originate from Paris, the headquarters of Air France, which commissioned the map from Lucien Boucher in 1938, shortly before the start of World War II (1939–45). The lines mark the principal Air France routes around the world (a world map is just visible beneath the detail of the constellations that also cover the image). Boucher was a graduate of the Sèvres School of Ceramics and

a former cartoonist, but is best known for the posters he designed for Air France between 1934 and 1962. A decade before Boucher drew this poster, the International Astronomical Union (IAU) had defined eighty-eight standard constellations across the sky, allowing astronomers around the globe to communicate consistently about the different regions of sky they studied. Boucher's celestial chart illustrates the larger

constellations in pale blue, while the zodiac constellations are picked out in a warmer tone. Three prevailing winds blow from the corners in a style reminiscent of Renaissance maps, while airliners 'signpost' the Air France network. Boucher saw his Air France posters as artworks that placed his clients at the centre of the emerging air travel industry – and collectors agreed.

ANDROMEDA GALAXY M31 AND ITS COMPANIONS

1959

WILLIAM C. MILLER

Digitally remastered photograph, dimensions variable

When astronomers view the Andromeda Galaxy – the closest large galaxy to our own Milky Way – through a telescope, appears white or pale green. The light is too faint for our eyes to register colour. So when William (Bill) C. Miller, a photographic engineer at Mount Wilson and Palomar Observatories, took this photograph of Andromeda in 1958, it was the first time anyone had seen it – or any other galaxy or nebula – in colour.

Although astronomers had used filters to record specific wavelengths, for example, observing and recording a picture of light in the green or blue wavelength range, they had not developed colour photographs from their monochrome negatives or successfully used early colour film to capture colour through long exposures. Through careful experimentation over a few years in the 1950s, Miller pioneered a painstaking method for using colour

film to capture the cosmos. At every step of the process, he worked to maximize the film's sensitivity and ensure the accuracy of the colour, often making corrections in the darkroom. The final results show the spiral galaxy with a glowing yellow centre and a halo of blue stars spread through its arms.

HUBBLE MOSAIC OF THE SOMBRERO GALAXY

2004

NASA, ESA AND THE HUBBLE HERITAGE TEAM (STSCI/AURA)

Composite digital photograph, dimensions variable

It is clear just how the Sombrero Galaxy got its name. It resembles the well-known Mexican hat, with a broad 'brim' formed by the flat disc of a spiral galaxy, inclined at just six degrees to the line of sight, and a high crown created by a large and extended bulge of billions of old stars at the galaxy's centre. This composite image comprises six pictures – taken using red, green and blue filters – to produce a natural colour. The brim is a dense, flat plane of dark lanes of dust that obscures the light of the stars beyond. The light of the bulge tails off as the density of stars drops away into space. The stars scattered across the picture are foreground stars our own Milky Way, but symmetrically distributed in the fainter regions of the bulge are small points of light that look like individual stars but are compact clusters formed of thousands of stars. The Sombrero Galaxy is unusual in the number of such clusters it contains: about two thousand, ten times more than our own Galaxy, even though the Sombrero is only about a third the size of the Milky Way. Its centre houses a large black hole, billions of time larger than the Sun, causing the stars nearby to circle faster in orbit around it. Although the galaxy is too far away – fifty million light years – to be seen by the naked eye, it has an apparent diameter that is nearly one-fifth that of the full Moon.

TAL QADI STONE

*c.*3000–2500 BC

UNKNOWN

Incised stone, approx. 29 × 24 cm / 11½ × 9½ in
National Museum of Archaeology, Valletta

This roughly shaped piece of limestone is incised with pointed stars and a D-shaped incision that appears to resemble a crescent Moon, with radiating diagonal lines that divide the stone into five segments. When this stone was discovered during excavations in 1927 at a temple dating back to the fourth millennium BC at Tal Qadi, near Salina Bay on the northern coast of the Mediterranean island of Malta, it was quickly identified as one of the earliest astrological maps. Recent studies suggest that the map might have a more practical purpose, as a Sumerian celestial navigation chart for use in the neighbouring Mediterranean and Black Seas. The true significance of the stone is still not fully understood. Was it once part of a much larger disk, on which the radiating lines represented the Sun's rays? If it was a navigational map, does it suggest that Malta was once at the centre of a trans-European trading route? The Mediterranean island is the site of some of the earliest known stone megalithic temples in the world, some of which might date back as far as 5000 BC. The temple at Tal Qadi was probably built between 3300 and 3000 BC.

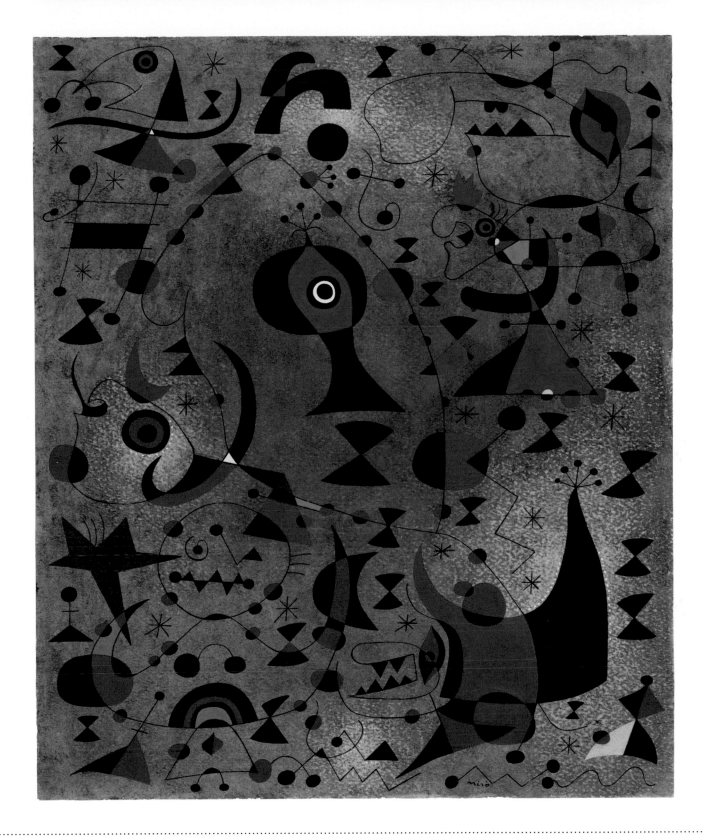

CONSTELLATION: TOWARD THE RAINBOW

1941

JOAN MIRÓ

Gouache and oil wash on paper, 45.7 × 38.1 cm / 18 × 15 in
The Metropolitan Museum of Art, New York

Some figures in this drawing are plausibly identifiable as constellations: the fish just above the centre of the painting echoes Pisces, while a horned head at lower left suggests Taurus. Other shapes – a bird, a dancer and man with his arms raised – do not seem to have any basis in the night sky. Nevertheless, the various geometric shapes and irregular forms, linked with free-flowing lines, are punctuated by simple four-line stars that place *Toward*

the Rainbow firmly in the night sky. It resembles a mobile of black-and-red celestial shapes lying flat on a luminous background. The whimsical quality of the work is at odds with the dark times in which it was created. It was the fifteenth in a series of twenty-three *Constellations* painted by Joan Miró between January 1940 and September 1941. When he began the series, he was living in Normandy and World War II had recently begun.

By the time he completed it, the German occupation of France had forced him to flee to Palma de Mallorca in neutral Spain. Miró, later said that his work took a new direction in 1939 and began to focus on different sources of inspiration: the night, music and the stars. In that way, the *Constellations* represented Miró's escape from the bounds of gravity and the brutality of the war into a unique map of an imaginary celestial realm.

A STORM WITHIN THE LARGE MAGELLANIC CLOUD

2016

ESA, HUBBLE AND NASA

Digital photograph, dimensions variable

Above and left of the central dark hole in this image of part of the Large Magellanic Cloud is a small nebula that might easily be missed were it not a startling white. This small, butterfly-shaped region, known as the Papillon Nebula ('*papillon*' is French for butterfly), contains a number of new-born massive stars – they are less than three million years old – that are energizing their own locality to create streams of outflowing gas. The two back-to-back streams fan out to create the shape of butterfly wings. The Papillon Nebula is a small part of the stellar nursery catalogued as N159, a 150-light-year-sized region of glowing gas in the Large Magellanic Cloud that is energized by the many hot, young stars that it contains. These stars both emit intense ultraviolet light, which causes the hydrogen gas they contain to glow, and pour out stellar winds, which carve the surrounding material into chaotic shapes. Stars have been forming in this nursery for at least a billion years and, as the Papillon Nebula shows, the process is continuing. The two Magellanic Clouds are among the nearest galaxies to our own Milky Way, and from Earth we can observe them from the outside looking in. As a result, it is often easier for astronomers to understand what is going on there than in our own Galaxy.

THE CONSTELLATION OF TAURUS
1655

JOHANN BAYER

Engraving, from *Uranometria*, 29 × 39 cm / 11½ × 15⅓ in
David Rumsey Historical Map Collection, Stanford, CA

This engraving shows a muscular bull, representing the constellation Taurus, charging along the ecliptic region (the grey horizontal strip, being the area of the sky in which the Sun, Moon and planets appear) and running into a lighter grey, cloudy upright band that represents the Milky Way. The Hyades star cluster forms the bull's muzzle, the star Aldebaran his eye. The size of each star shown represents its brightness. This plate is one

of fifty-one from *Uranometria*, a highly successful star atlas first published in 1603 by the German lawyer and astronomer Johann Bayer (1572-1625). Bayer's plates illustrate each of the forty-eight classical constellations, two planispheres and, on a single chart, the twelve constellations of the southern sky that had been invented by Europeans only years earlier based on recent observations and measurements. In all, the atlas plots

some 2,000 stars, indicating their brightness with a system of Greek letters or lower-case Roman letters. Although Bayer himself was somewhat inconsistent in applying these designations, the 'Bayer letters' are still used by astronomers today, reflecting the importance of the atlas in standardizing the depiction of constellations and magnitudes of stars.

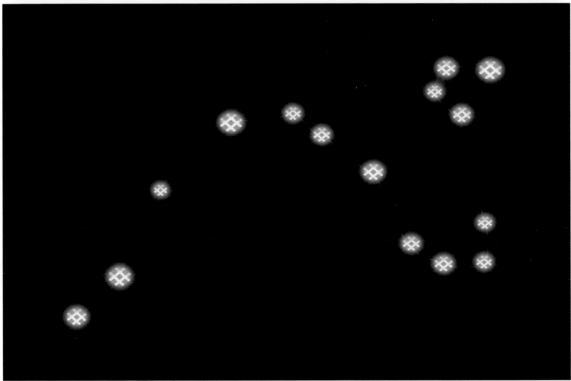

DRACO AND OURSA MAJOR
2015

ESMERALDA KOSMATOPOULOS

Neon, wires, transformer, 170 × 400 / 68 × 160 in
Private collection

These two wall-mounted light works – *Draco* and *Oursa Major*, or *Ursa Major* – bring constellations into the digital era. The Greek artist Esmeralda Kosmatopoulos (born 1981) has replaced the stars with hash tags of varying sizes that glow with a luminous white light, powered by electricity through the wire that defines the shape of each stellar configuration. In an era when people spend so much time staring at phone screens, the digital universe and the short-cut, punchy language of social media posts are more immediately recognizable to many than the constellations of the night sky. Our ancestors used the celestial starscape not only to orient themselves geographically but also to help define what the future held, today smart devices have replaced the cosmos as our guides through life. *Draco* (its name taken from the Latin for 'dragon', resembling a serpent's head with a coiled tail) and *Oursa Major* make up a series, which includes a third neon relief, *Oursa Minor*. Astronomy is the world's oldest form of science: it provided regular and predictable patterns by which people could navigate the Earth or sow and harvest the land. Interested in language and identity, Kosmatopoulos highlights our contemporary propensity for navigating life via the Internet, rather than looking into the sky for answers.

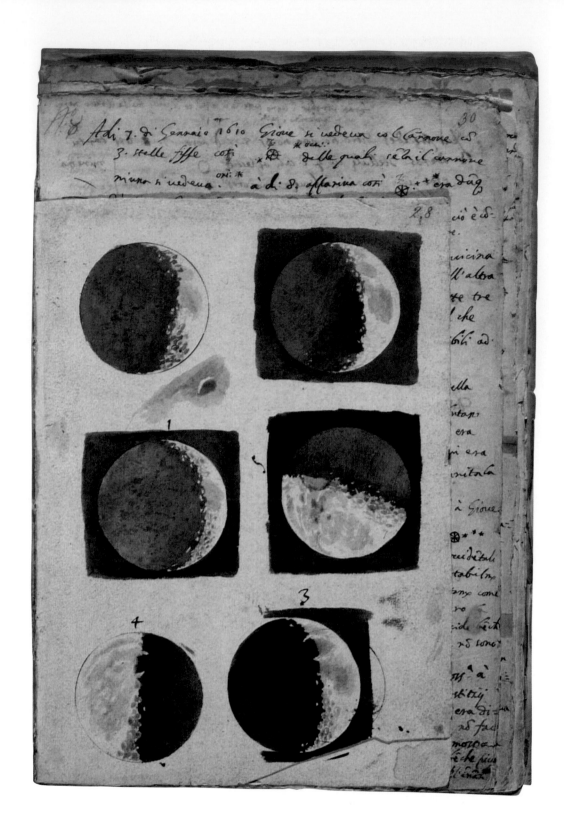

THE MOON
1609

GALILEO GALILEI

Watercolour, h. 28 cm / 11 in
Biblioteca Nazionale Centrale di Firenze

These simple drawings not only changed astronomy, they also launched an influential challenge to the accepted beliefs of the Roman Catholic Church. For several nights in November or December 1609, Galileo Galilei gazed at the Moon through a small telescope mounted on a rickety stand on a table at the top of the campanile of San Giorgio Maggiore in Venice. He sketched what he saw of the individual portions of the Moon's surface.

Later, he integrated his notes into sepia wash drawings that summarized how the complete disc of the waxing and waning Moon appeared. The images are the first recorded images of the surface of a world beyond the Earth. In his book, *Sidereus Nuncius* (*The Starry Messenger*, 1610), Galileo described what he saw: 'The surface of the Moon is not perfectly smooth, free from inequalities and exactly spherical … on the contrary, it

is uneven, full of hollows and protuberances, just like the surface of the Earth itself, which is varied everywhere by lofty mountains and deep valleys.' By recognizing that the Moon's surface mimicked that of Earth, Galileo disproved the belief that celestial bodies were perfect, in contrast to our imperfect terrestrial world. It followed, therefore, that both terrestrial and celestial bodies can be subject to the same scientific analysis.

THE MOON

*c.*1858

WARREN DE LA RUE

Stereograph glass positive, each 5.7 × 5.7 cm / 2¼ × 2¼ in
Victoria and Albert Museum, London

Here, two views of the Moon rest against a rectangular expanse of darkness – but if you view these through a stereograph, they seem to magically merge, gaining volume, depth and texture. The businessman, inventor and polymath Warren De La Rue (1815-89) was dubbed by his friend, engineer and astronomer James Nasmyth, the 'father of celestial photography'. While his working life was devoted to the family stationery business, in

his spare time De la Rue conducted scientific research. He gained his love of stargazing from Nasmyth, but what led him to astrophotography was seeing one of John Adams Whipple and George Phillips Bond's first daguerreotypes of the Moon at the Great Exhibition of 1851. De la Rue took his first photograph of the Moon in 1852. Instead of the daguerreotype, he used the new wet collodion process, which was more sensitive,

demanded shorter exposures and enabled reproduction. Six years later, De la Rue brought another innovation to lunar photography by producing stereoscopic views. The Moon rocks left to right in its orbit (libration) and shows at different angles. De la Rue paired pictures of the Moon at different libration angles, optically blending them in a stereographic viewer using the 3D effect to reveal the Moon's mountainous features

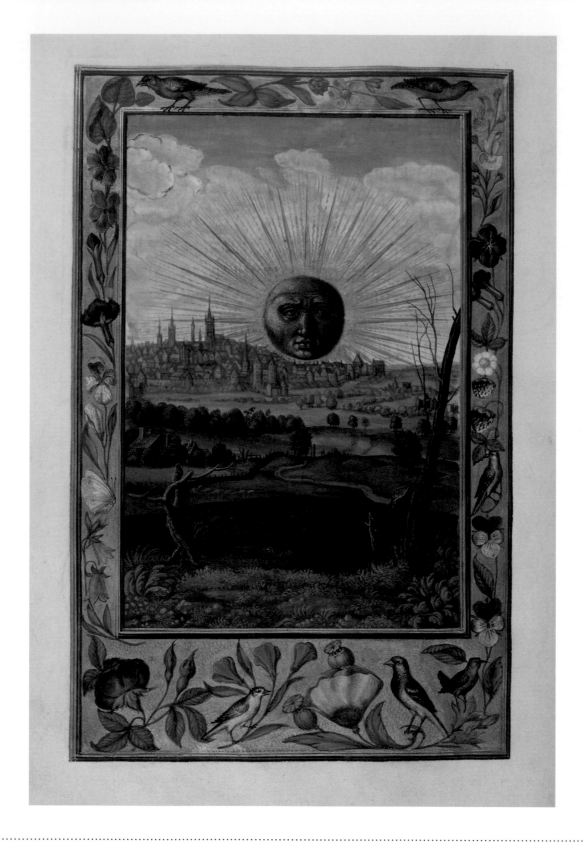

SUN WITH HUMAN FACE RISING, THE FIFTH TREATISE

1582

TRISMOSIN SALOMON

Watercolour and ink on vellum, from *Splendor Solis*
32 × 22 cm / 12⅔ × 8⅔ in
British Library, London

At the heart of alchemy lay a number of goals: the attempt to formulate the elixir of Life in order to bestow immortality; the search for the philosopher's stone so as to produce untarnishable gold and the provision of spiritual enlightenment – in short, to purify. To these ends, alchemy purported to harness the power of the Sun, not its radiation but its 'splendour': its magnificence, its glory. *Splendor Solis (Splendour of the Sun)* is a manuscript

book on vellum by a pseudonymous author, laying out a basis for this endeavour. It culminates with a depiction of the Sun, described in the text: '[It] exhibits the Sun just risen, golden red, serious, thoughtful and severe looking. The eyes seem so penetrating as if they would search into and question your inmost soul. The landscape has the sanctity of night over it and is of a blackish grey tint. A city is seen on the hill right underneath the chin

of the Sun. Yet it is seemingly wrapped in night. There is nothing like life stirring, all appears wrapped in night and sleep, and as if the Sun had stolen upon them unawares at very early morning, and was unable to give any light to the Earth or waken the people. A few blasted trees on foreground and middle distance alone show faint tinges of Gold.' This picture of the Sun is thus an allegory of the alchemists' endeavours in an ignorant world.

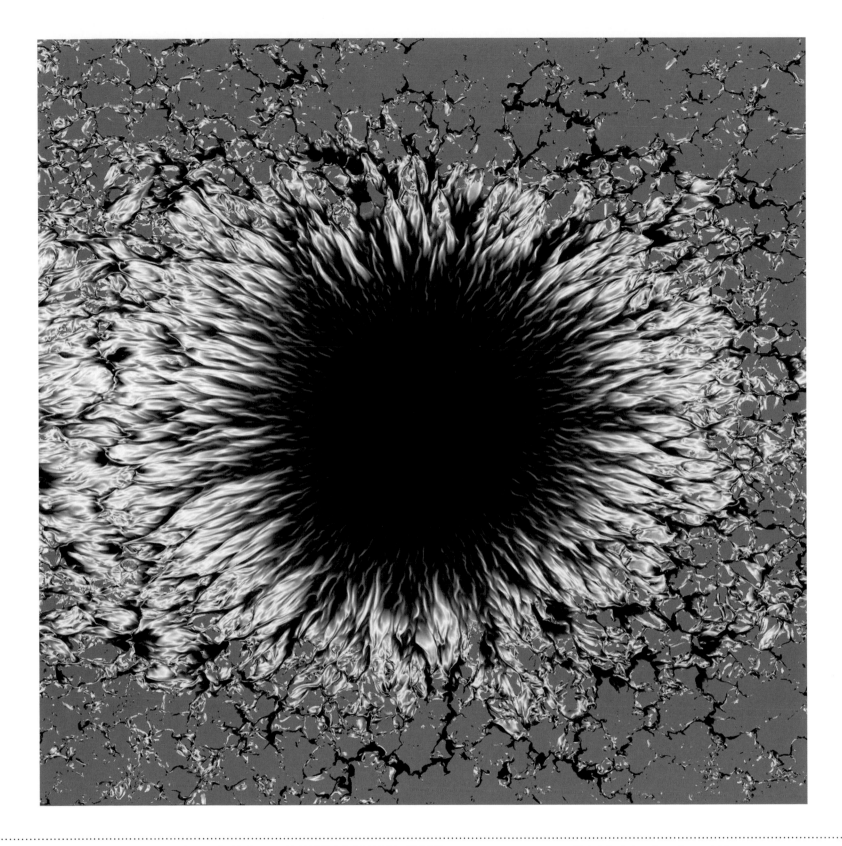

SIMULATION OF THE INTERFACE BETWEEN
A SUNSPOT'S UMBRA AND PENUMBRA
2009

MATTHIAS REMPEL, NCAR

Digital simulation, dimensions variable

This striking image represents the cutting edge of solar astronomy in its depiction of the theoretical structure of a sunspot, a phenomenon that has fascinated astronomers since the invention of the telescope. Matthias Rempel, a scientist at the High Altitude Observatory at the National Center for Atmospheric Research in the United States, created a three-dimensional computer model of the magnetic fields that create sunspots, by changing the flow of the Sun's plasma. Neither solid, liquid nor gas, plasma is ionized matter (mainly hydrogen) that is driven up from the heart of the Sun into its turbulent outer layers, where it is shaped by variations in the Sun's magnetic field – to create sunspots and other phenomena. The spots appear dark because they are cooler than the surrounding area. They can be up to 160,000 kilometres in diameter and last for a number of months. In Rempel's simulation viewing the sunspot from above, lighter colours represent a horizontal magnetic field, while darker colours are vertical field lines projecting toward and away from the viewer, revealing a complex interface between the dark central umbra and the lighter outer penumbra, where a structure of narrow, pale filaments is embedded in a darker background with a more vertical magnetic field.

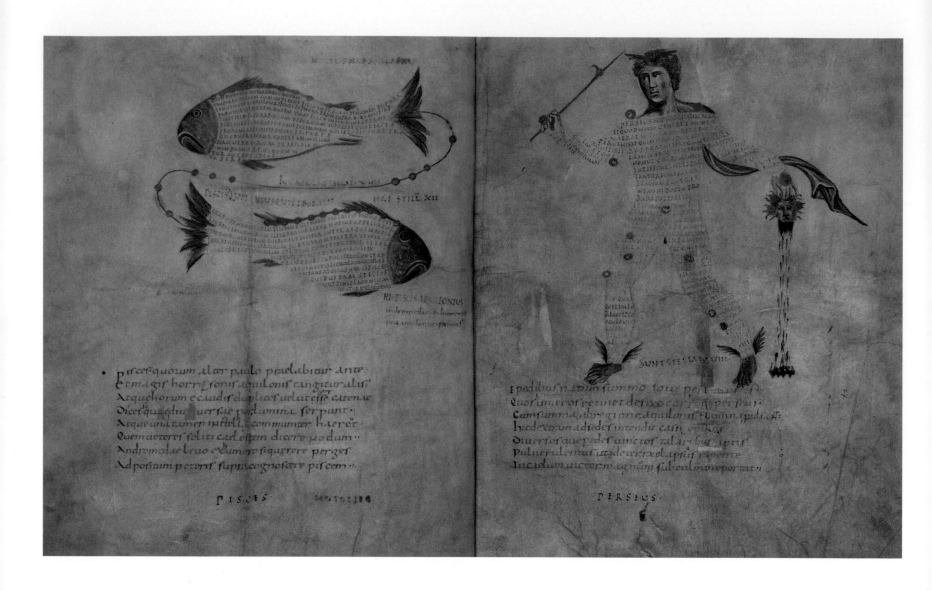

PISCES AND PERSEUS

c. AD 820–40

UNKNOWN

Ink and pigments on vellum, from *Phaenomena Aratea*
32 × 28 cm / 12½ × 11 in
British Library, London

The two constellations depicted in this medieval French manuscript are easily recognizable as Pisces, the fish, and Perseus, who carries in his hand the monstrous head of the Gorgon. The stars forming the constellations are picked out in orange – it may once have been a brighter red – while blue is used for detail. The bodies of the constellations are filled with Latin script, a device intended to separate later commentary, or 'scholia', from

the main text, which was a Latin translation of a Greek poem written in the early third century BC by Aratus, who in turn had versified a prose work by the fourth-century BC mathematician Eudoxos of Cnidus, a contemporary of Plato. Aratus' poem, the *Phaenomena* (*Appearances*) was highly influential in both its Greek and Latin versions, and despite its failings was the principal source of knowledge about the heavens for an educated Greek or Roman.

Cicero himself published a translation of the poem, most of which survives; this copy reproduces a late Roman version of Cicero's translation, *Phaenomena Aratea*. It describes the constellations, with details as to their rising and setting, but omits any discussion of the phases of the Moon or the orbits of the planets. The scholia corrected the numerous errors and inaccuracies in Aratus' poem, thus making it more scientifically reliable.

NIGHT SKY: AQUARIUS PEGASUS. 12
2012

ANGELA BULLOCH

LED-installation, felt, aluminium profiles, cables
267 × 200 cm / 105¼ × 78¾ in

This view of the heavens, while perfectly accurate, is completely artificial. It is made of black felt and twinkling LED lights that sequentially increase and decrease in intensity. The Canadian-born British artist Angela Bulloch (born 1966) created *Night Sky: Aquarius Pegasus. 12,* as one of a number of similar works that explore the Solar System in unfamiliar ways. Using a software programme named Celestia – a space-travel simulator that acts as a planetarium to produce a virtual reality based on factual input – Bulloch settled on a region of the sky that includes one or more well-known constellations and then extrapolated the view to a point far from Earth; we are looking at a real representation but from a wholly new viewpoint. This is our Solar System, but not as we know it. Some of Bulloch's installations feature Earth itself, so as viewers we find ourselves staring back into our own world. Originally associated with the Young British Artists (YBAs) of the 1990s, Angela Bulloch investigates patterns, systems and mathematics in relation to aesthetics and sees the Universe – governed by the mathematical equation of $E = mc^2$ – as the perfect space for artistic enquiry.

THE PLANET MARS AS SEEN FROM ONE OF ITS MOONS

c.1930

LUCIEN RUDAUX

Private collection

In this painting, created in the 1930s by one of the pioneers of modern space art, the French artist Lucien Rudaux (1874-1947), Mars appears a hundred times bigger from the rocky surface of one of its moons than the Earth does from our own Moon. Trained as a commercial illustrator, Rudaux was also an amateur astronomer who joined the French astronomical society in 1892, aged eighteen, and wrote regularly about his observations and discoveries in the society's journal for over twenty years. After World War I, Rudaux built his own observatory on the coast of Normandy in northern France, where he used a 4-inch reflecting telescope to photograph the Moon and the planets. He used his observations to create accurate paintings of celestial objects that appeared widely in books and magazines catering to the growing interest in other worlds in the late 1920s and 1930s, culminating in the production of his book *On Other Worlds* (1937), which included more than 400 illustrations. Among Rudaux's insights was the realization that the Moon's surface was likely to be far less jagged than portrayed by many of his contemporaries. Rudaux helped to pave the way for other so-called space artists, such as his younger contemporary Chesley Bonestell (see p.268) who helped to illustrate the golden age of science fiction.

COWBOY ON MARS
1951

DC COMICS, MANNY RUBIN, JIM MOONEY

Private collection

Watched by a crowd inside a glass bubble, cowboy Rick Nevins tries to tame a bucking bronco with birds' wings and the head and neck of a dinosaur in what the comic *Mystery in Space* boasts is 'the strangest competition ever imagined'. Written by Manny Rubin with artwork by Jim Mooney, *Cowboy on Mars* appeared in an early issue of *Mystery in Space,* a long-running anthology of science-fiction tales, published by DC Comics between 1951 and

1966. The series began at a time when the confidence of the post-war United States combined with a belief in the power of science inspired a golden age of science fiction in books, art and comic books. Comics such as *Mystery in Space* brought together a growing awareness of the Universe beyond Earth with melodramatic stories of alien beings, wars and heroes such as Rick Nevins, the Texan cowboy who was inexplicably transported to

Mars – where he continued to uphold traditional US values of self-reliance, integrity and fairness. Comics such as this fuelled the imagination of a generation who would see humans travel to space within a decade, at a time when anything seemed possible, and a future where humans would live on Mars seemed inevitable.

net, in quo terram cum orbe lunari tanquam epicyclo contineri
diximus. Quinto loco Venus nono menfe reducitur. Sextum
deniq; locum Mercurius tenet, octuaginta dierum fpacio circū
currens. In medio uero omnium refidet Sol. Quis enim in hoc

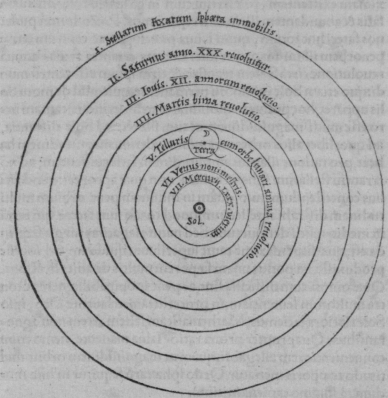

pulcherimo templo lampadem hanc in alio uel meliori loco po
neret, quàm unde totum fimul pofsit illuminare? Siquidem non
inepte quidam lucernam mundi, alij mentem, alij rectorem uo=
cant. Trimegiftus uifibilem Deum, Sophoclis Electra intuentē
omnia. Ita profecto tanquam in folio re gali Sol refidens circum
agentem gubernat Aftrorum familiam. Tellus quoq; minime
fraudatur lunari minifterio, fed ut Ariftoteles de animalibus
ait, maximā Luna cū terra cognationē habet. Concipit interea à
Sole terra, & impregnatur annuo partu. Inuenimus igitur fub
hac

SUN-CENTRED UNIVERSE
1543

NICOLAUS COPERNICUS

Ink on paper, from *De Revolutionibus Orbium Coelestium*
28 × 19 cm / 11¼ × 7½ in
Library of Congress, Washington, DC

This deceptively simple diagram appears near the beginning of *De Revolutionibus Orbium Coelestium* (*The Revolutions of the Heavenly Spheres*), published as Nicolaus Copernicus lay dying. He had decided many years earlier that the Earth orbits around the Sun; although not the first person to suggest this, as he himself was aware, he was the first to work out the mathematical details of this heliocentric system. The rest of *De Revolutionibus* explained the complex geometry, and it was hoped that 'most convenient Tables' would appeal to astrologers who needed planetary data for their practice. By setting the Earth in motion around the Sun, Copernicus simplified – and unified – the planetary models of Ptolemy, while adhering to the ancient principle that heavenly motion should be constant and circular. His system also established a connection between the size and speed of planets' orbits. But it remained complex: in order to reproduce the planets' uneven motions, he added circles (epicycles) to the model, just as Ptolemy had. His system was not universally accepted; many of his contemporaries published competing theories. Only after the publication of Kepler's laws of planetary motion (1609) did the idea of a heliocentric cosmos gain scientific consensus.

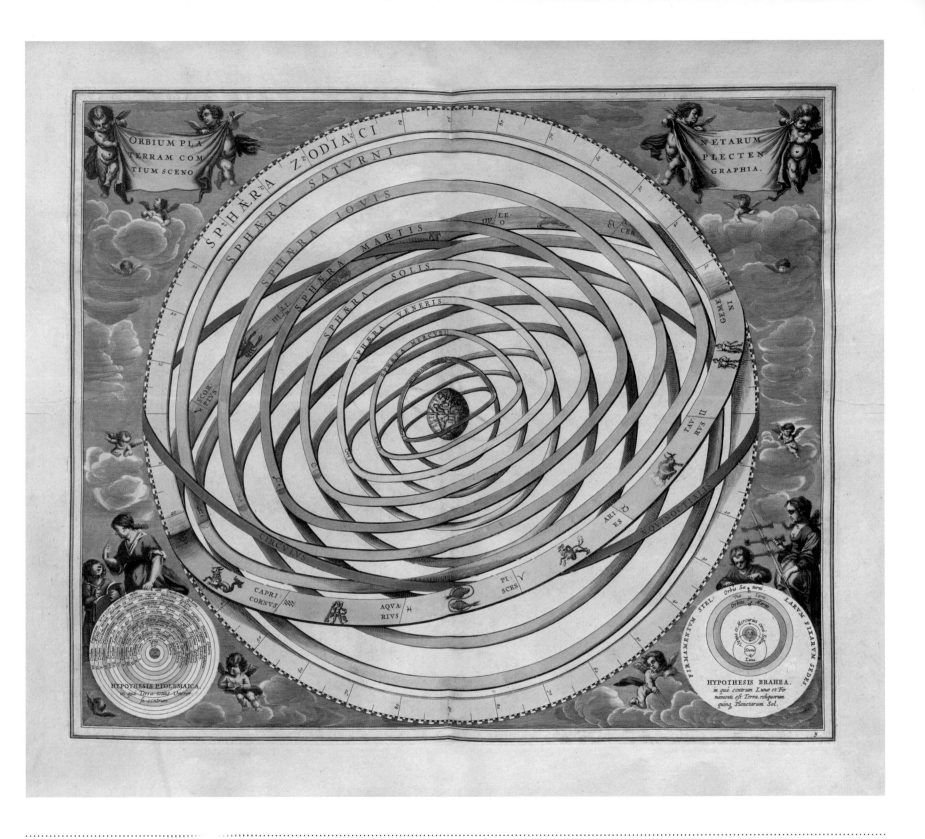

ORBIUM PLANETARUM TERRAM COMPLECTENTIUM SCENOGRAPHIA

1660

ANDREAS CELLARIUS

Hand-coloured engraving, from *Harmonia Macrocosmica*
32.2 × 51.2 cm / 12¾ × 20 in
Library of Congress, Washington, DC

The ornate inscription at the top of the Andreas Cellarius's coloured engraving proclaims it to be *Orbium Planetarum Terram Complectentium Scenographia* – a scenography of the planetary orbits encompassing the Earth. The coloured section of the plate gives a three-dimensional representation of the conventional Ptolemaic view of the Earth-centred Universe, with the known planets arrayed in divine order around the Earth. At lower left and lower right, respectively, are the more usual, flat depictions of Ptolemy's cosmos and Tycho Brahe's hybrid model, which was influenced by the ideas of Copernicus. Brahe retains the Earth at the centre, around which orbit the Sun, Moon and stars, but the other five planets go round around the Sun. Later pages in the *Harmonia Macrocosmica*, from which this engraving comes, show the fully fledged Keplerian model of the Universe, in which all the planets orbit the Sun. Of the twenty-nine plates of the remarkable *Harmonia*, twenty-one illustrate historical theories of the shape of the Universe, while the last eight are depictions of the celestial hemispheres and planispheres of the constellations. Little is known of the early life of Andreas Cellarius (1596–1665), but by the time his celebrated atlas appeared in 1660, he was working as rector of the Latin School in the small city of Hoorn in the Netherlands.

THE HELIX NEBULA
2004

NASA, ESA, C.R. O'DELL (VANDERBILT UNIVERSITY), M. MEIXNER AND P. MCCULLOUGH (STSCI)

Composite digital photograph, dimensions variable

This photograph (a composite of images from the Hubble Space Telescope and a ground-based telescope in Chile) shows clearly why the Helix Nebula is sometimes called 'the Eye of God'. It does little, however, to explain how the nebula got its original name in the early nineteenth century. About three light years in diameter, this nebula is envisioned as two circular discs at an angle to one another. Projected in three dimensions, this would imply a spiral pattern, or helix. Planetary nebulae are nothing to do with planets. When they were first discovered with small telescopes, many looked like the circular discs of planets. Larger telescopes have revealed that they are gaseous and have an array of colours created by spectral emissions from the gas. Planetary nebulae have complex shapes, but each is centred on the hot, exposed core of an aged star. The star excites the colours of the gas in the nebula, according to the strength of its radiation, causing the different colours. Radiation also generates a flow in the gas, which causes wakes around denser blobs pointing away from the centre. A nebula is made up of the outer layers lost from the aged star; the way those outer layers have spun off into space creates a nebula's complex shape, which, as here, is difficult to translate from the two-dimensional view we see into three dimensions.

**YANJIRLPIRRI OR NAPALJARRI-WARNU
JUKURRPA (SEVEN SISTERS DREAMING)**

2012

ALMA NUNGARRAYI GRANITES

Acrylic on linen, 122 × 122 cm / 48 × 48 in
Private collection

Concentric circles of bright blue mark the leading characters of *The Seven Sisters Dreaming*, a depiction by the modern Aboriginal Australian artist Alma Nungarrayi Granites (born 1955) of the story behind the Pleiades, a group of stars in the constellation Taurus. The story of the Seven Sisters is told widely among aboriginal communities across Australia. In this version, the Seven Sisters are the ancestral Napaljarri sisters. Two men are in love with them. One stalks the sisters, intent on seduction, but his attention is unwelcome because he belongs to a people whom the sisters are forbidden to marry. The sisters eventually escape into the Milky Way, where they become the stars of the Pleiades – followed across the sky by their stalker, his dark plans perpetually unfulfilled. The second suitor, Wardilyka, receives more tolerant treatment at the hands of the sisters, who carry him with them. In different versions one man or the other is a star in the belt of the adjacent constellation, Orion. Such map-like stories about the 'Dreaming' (Aboriginal creation-myths) traditionally relate mythical and spiritual events to real places. Nungarrayi Granites locates her version of the Seven Sisters story among the large round rocks of Yanjirlpirri country, a landscape where the sky meets the land.

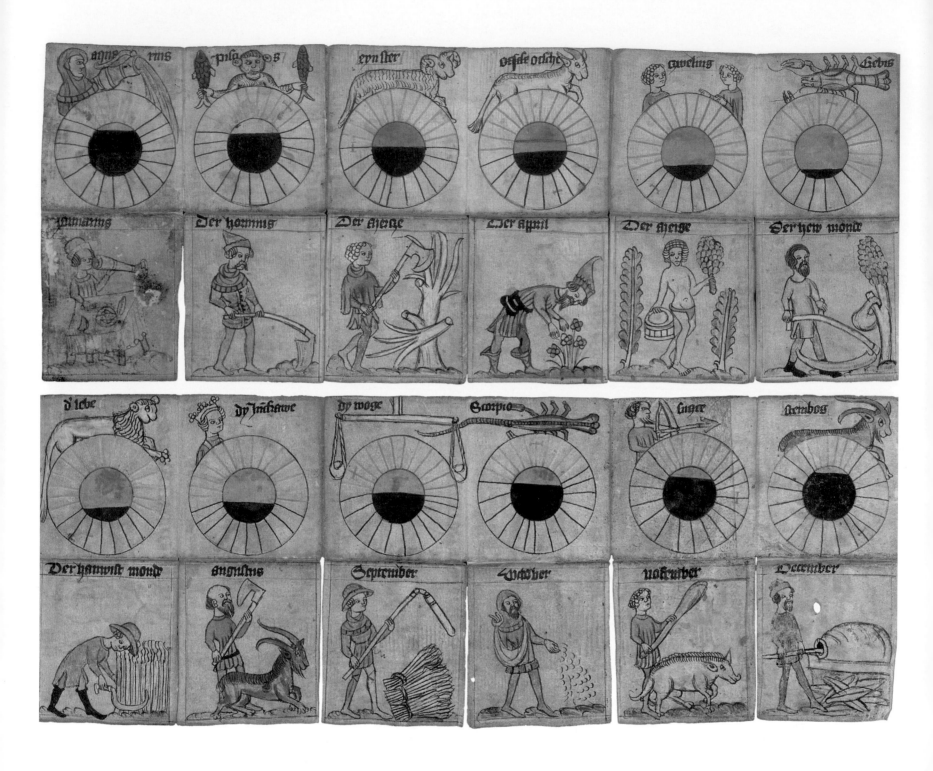

PERENNIAL CALENDAR

*c.*1400

UNKNOWN

Ink on concertina-folded parchment, 15 × 80.5 cm / 6 × 31⅔ in
Staatsbibliothek zu Berlin

This hand-drawn almanac dating from around 1400
combines a monthly calendar with informal drawings
that depict the appropriate agricultural tasks for that
particular month, be it tending to crops in April or
harvesting wheat in September. For each of the twelve
months, the illustration includes the corresponding zodiac
sign and an indication of the hours of daylight, displayed
by the simple method of using black to obscure more or

less of the solar disc. In the late Middle Ages, such visual
representations of the passing of the year were very
popular as a human-scale reflection on God's apparent
ordering of the Universe. Scenes of rural activities
and the signs of the zodiac were common themes of
medieval and early Renaissance art. Ever since the
ancient Babylonians, the zodiac had been understood
to represent twelve roughly equal divisions of a solar

year. Each zodiac sign represented one of the twelve
constellations the ancients linked to the Sun's movement
through the sky. For example, Aquarius (the Water
Bearer) was so named by the Babylonians, who noted
that the Sun passed through that constellation during the
rainy season.

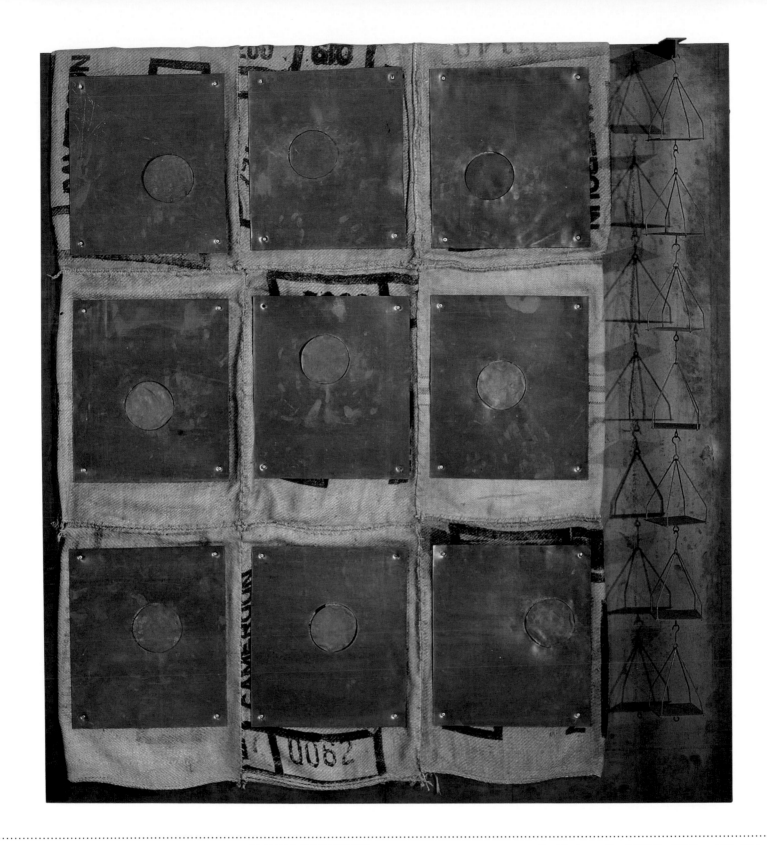

UNTITLED
1986

JANNIS KOUNELLIS

Steel, burlap and lead, 203.2 × 180.2 cm / 80 × 70 in
Private collection

The full Moon rises over and over again in this wall-mounted sculpture of nine sheets of lead fastened to a ground of burlap sacks by the Greek-Italian artist Jannis Kounellis (1936–2017), its phases rendered meaningless as if permanently illuminated by the Sun. Kounellis's Moon finds form as a single circle that reappears nine times on the soft, malleable metal from which the Moons have been cut out, with the artist's smudged fingerprints

still discernable on its surface. The lead's smoothness contrasts with the texture of the woven brown burlap, the printed text on which is still legible. To the right of the composition, interconnected steel forms hang like scales. The forms cast bold shadows on to the work's surface, signifying the Moon's own relationship with light and shade – although here, of course, the Moon has no shadow to speak of. Kounellis was associated with

the late-1960s Italian Arte Povera movement – literally translated as 'poor art' – that sought to merge art and life through the use of everyday materials. Horses, birds, fire, earth, coffee and coal, among other materials, appear throughout Kounellis's work. He delighted in the poetry and beauty of expressing the human condition through the combination of industrial and organic matter.

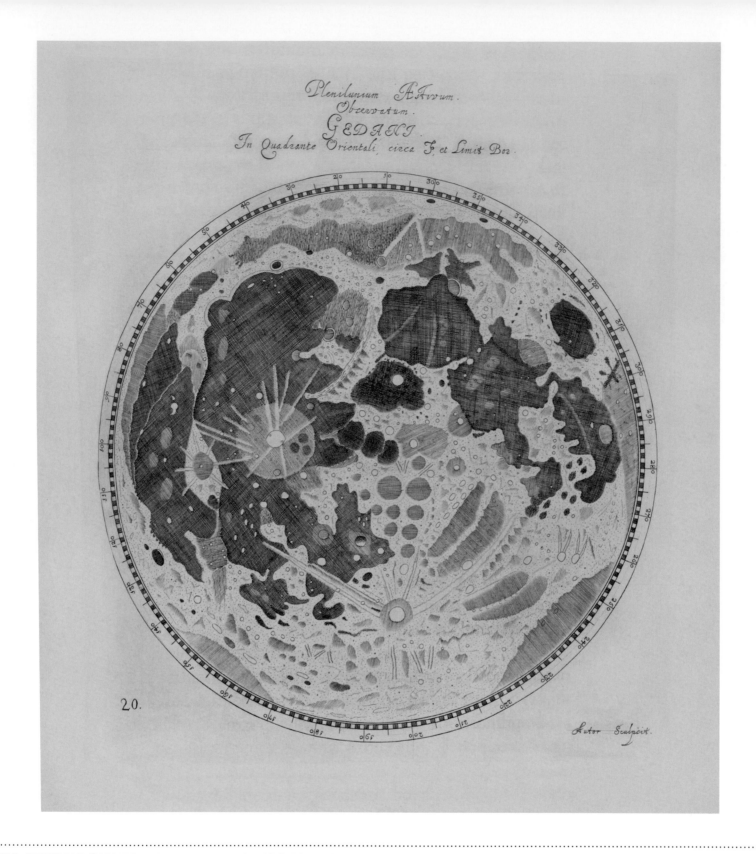

PLENILUNIO BRUMALE (WINTER FULL MOON)

1647

JOHANNES HEVELIUS

Copperplate engraving, from *Selenographia, Sive Lunae Descriptio*
34 × 22.5 cm / 13¼ × 8¾ in
University of Oklahoma Library, Norman, OK

This illustration of the Moon's surface, with cross-hatching shading the darker areas of the lunar planes, is actually a rotating disk, known as a volvelle. Using a string as a measure, this simple device enabled seventeenth-century astronomers to chart the Moon's changing appearance as it wobbled on its axis, an effect known as lunar libration. The Polish-Lithuanian astronomer Johannes Hevelius created the volvelle as one of forty plates in the weighty

Selenographia, a four-hundred-page guide to all aspects of the motion and changing appearance of the Moon and planets. It was the culmination of ten years' work in which Hevelius used the income generated by his family's brewing business to install and equip an observatory at his home in Gdansk. He produced three fold-out maps, one of which featured his new system of nomenclature for lunar features. Just two years earlier, Michael Florent van

Langren had created a Moon map with the features named after Catholic saints and royalty, but Hevelius rejected this scheme in favour of naming lunar features after equivalent locations on Earth. This cumbersome approach gained little support however, and Hevelius's nomenclature was superseded by Francesco Maria Grimaldi and Giovanni Battista Riccioli's Moon map in *Almagestum Novum* (1651), a reference standard that is still used today.

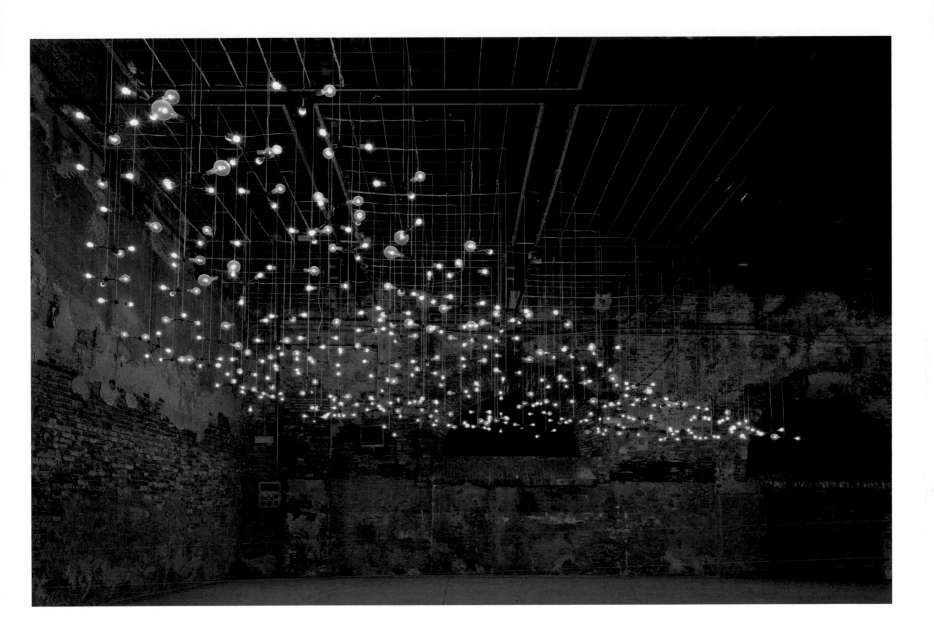

MOON DUST (APOLLO 17)
2009

SPENCER FINCH

150 light fixtures and 417 incandescent bulbs
1005.8 × 868.7 cm / 396 × 342 in
The Museum of Fine Arts, Houston, TX

In *Moon Dust (Apollo 17)* American artist Spencer Finch (born 1962) uses familiar and basic industrial materials to reference a culturally resonant substance and a historically significant event. Finch began from an analysis of the chemical composition of Moon dust collected by astronauts in 1972. He then chose light bulbs of various sizes to represent the atoms in the Moon dust; the smallest light bulb corresponds to oxygen and the larger ones to iron and chromium. Hung from the ceiling, the arrangement of the glowing bulbs suggests a plume of dust floating above the viewer's head. Apollo 17 was the last mission to carry humans to the Moon, and its passengers, like others before them, struggled with the dark, powdery, abrasive dust that blankets the Moon's surface and clings to objects. Yet the last man to walk on the moon, Eugene Cernan, wrote his daughter's initials in the dust as a poetic commemoration of the trip. The astronauts were among a small group of people to interact with the dust. Finch translates the scientific understanding of Moon dust, this substance touched by so few, back into light, the medium through which most of us see and experience the Moon.

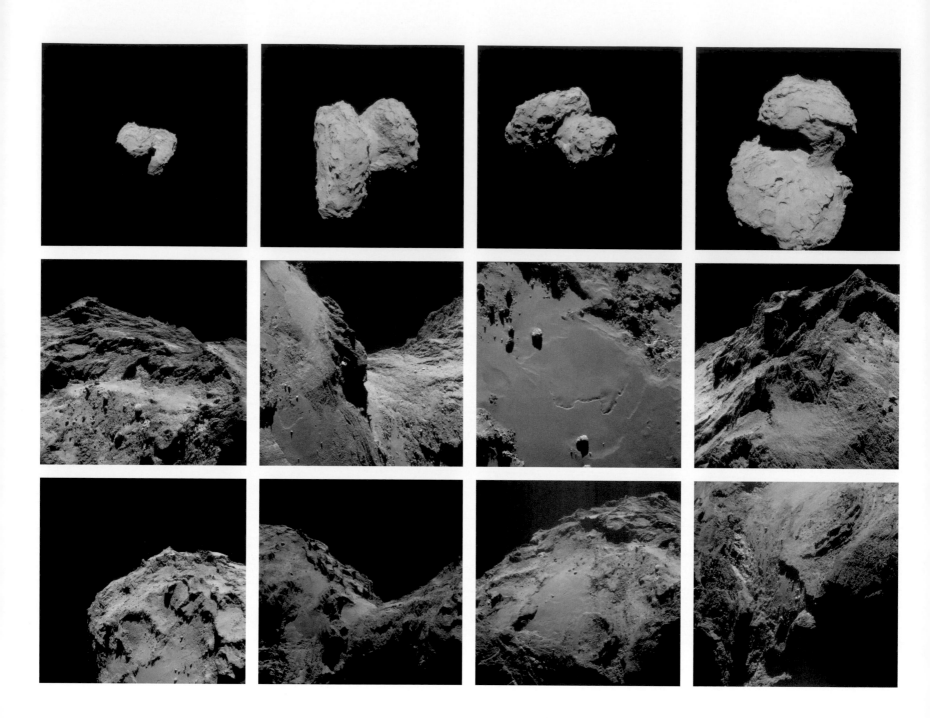

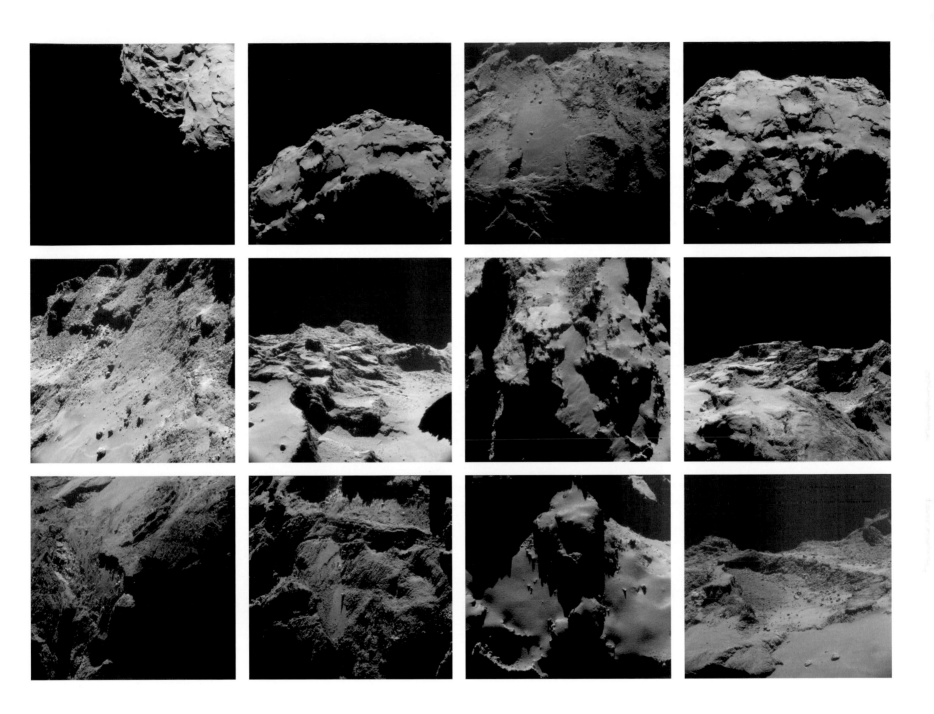

ROSETTA COMET LANDING SITE
2016

ESA, ROSETTA, MPS FOR OSIRIS TEAM MPS, UPD, LAM, IAA, SSO, INTA, UPM, DASP, IDA

Digital photographs, dimensions variable

This sequence of images from a navigation camera shows the view during the doomed final descent of the ESA Rosetta spacecraft to its landing site on Comet 67P/Churyumov-Gerasimenko on 30 September 2016. The images were among Rosetta's last communications: damaged during the landing, it fell permanently silent. Although the images resemble a brightly sunlit scene in a terrestrial desert, the comet's surface is as black and sticky as burned meat: the comet is covered in tarry dust, which has been carbonized by sunlight. Beneath the surface is a mixture of ice and rocks – left over from the interstellar material that gathered together to form the Sun and planets. Rosetta's images show scars and deep pits excavated out of the comet by fountains of outgassing volatile substances, like water, gasified by heat as the comet passed close to the Sun. There is no equivalent on the comet to the forces of wind and rain on Earth that relatively quickly smooth landscape features: recently broken crags retain jagged fractured edges, their shadows set in sharp profile by the unrelenting sunlight. Older areas are smoothly covered by dust – blown across the surface by the gaseous fountains – or sometimes littered with icy boulders.

TITAN
2006

DANIEL ZELLER

Ink and acrylic on paper, 43.2 × 53.3 / 17 × 21 in
NASA Art Program

In a complex pattern reminiscent of tiny cellular forms such as lichen, bright cadmium yellow is interspersed with mottled patches of white, subtly tinged with lines of pale purple. This drawing, created by the Californian artist Daniel Zeller (born 1965) as part of NASA's Art Program, is simultaneously an abstract plane of amorphous shapes and a topography mapping out the physical features of another world – Titan, the moon of Saturn. Zeller's image is based on data gathered by the Cassini spacecraft, which entered orbit around Saturn in July 2004 after a journey of seven years. At the time, little was known about Titan other than its nitrogen-rich, misty-orange atmosphere, but Cassini revealed vast lakes, liquid methane and ethane seas, hydrocarbon clouds and an internal ocean of water and ammonia. Using a visual language that draws from other scientific sources, including satellite imagery, maps and anatomical diagrams, Zeller's works chart territories of both land and body, reconfiguring the three-dimensional world into complex arrangements of shape, line and pigment.

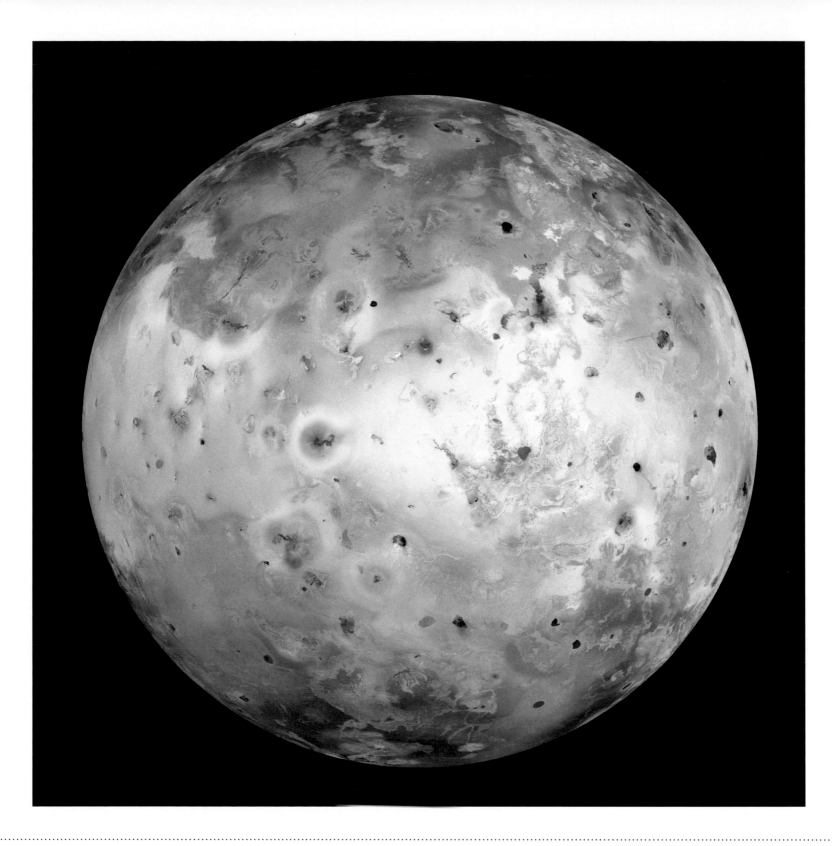

IO
1999

NASA, JPL, UNIVERSITY OF ARIZONA

Digital photograph, dimensions variable

The orange of Jupiter's moon Io is appropriate for what is the most geologically active body in the Solar System, with approximately 400 volcanoes, of which about 150 are currently active. The volcano Prometheus is the circular area at the centre of Io in this image, which is based on measurements of infrared heat energy by the space probe Galileo in 1995. Prometheus has a crater that is 30 kilometres (19 miles) wide, from which lava flows continuously. The pit is surrounded by ejected yellow sulphurous material. Below and to the left is another volcano, Culann Patera. Both volcanoes have been active since their discovery by Voyager 1 in 1979. The volcanoes produce both yellow sulphur patches and red-and-black coloured lava flows, while white patches elsewhere may be sulphur dioxide that has drifted like snow. Apart from around the volcanoes, Io's surface temperature is well below freezing. The constant volcanic eruptions are enough to renew Io's surface completely every million years or so, which is one reason why the surface has few impact craters as any that form are quickly covered up. Io's volcanic activity is caused by its eccentric orbit. Jupiter's gravity causes large tidal forces that raise and lower its surface by as much as 100 metres (330 feet) and the resulting heat causes volcanoes to form.

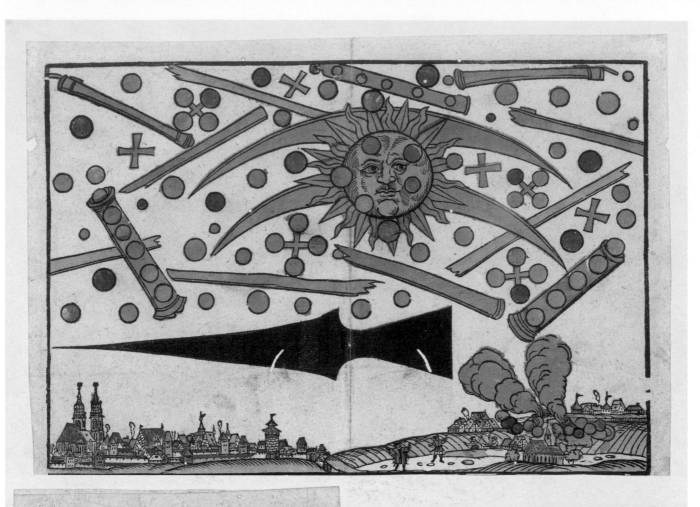

CELESTIAL PHENOMENON OVER NUREMBERG, 14 APRIL

1561

HANS GLASER

Hand-coloured woodcut, 26.2 × 38 cm / 10⅓ × 15 in
Zentralbibliothek Zürich

This broadsheet features a woodcut recording an aerial battle between orbs and globes of light around a bemused-looking Sun. The phenomenon was witnessed by hundreds of inhabitants of Nuremberg on 14 April 1561 and recorded by local printer and publisher Hans Glaser. According to witnesses, mysterious shapes and colours filled the sky, with blood-red strips, crosses and arcs appearing to fight around a larger black ball.

Glaser's broadsheet interpreted the phenomenon as a warning from God. The incident might have been forgotten had the broadsheet not featured in a 1958 book by the psychologist Carl Jung. Jung emphasized a psychoanalytical interpretation of the accounts: crosses have religious connotations, the colour was described as blood-red and so on. Through Jung's account, the incident entered the body of literature about Unidentified

Flying Objects (UFOs) as the story of a battle between flying saucers. A less speculative interpretation is that the phenomena were sundogs, or parhelia. These haloes, crosses, pillars, colours and bright patches are created by sunlight that is refracted and reflected in ice crystals in the atmosphere. The shape and orientation of the crystals create the various shapes, which may change dramatically as atmospheric conditions alter.

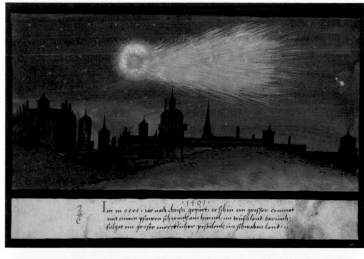

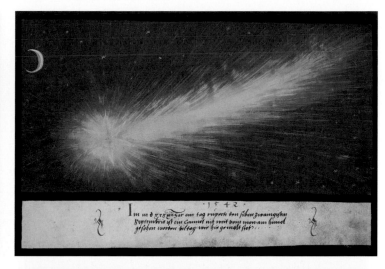

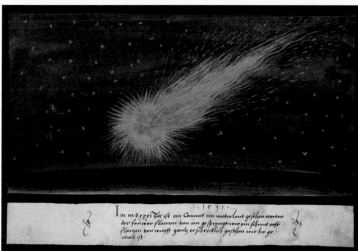

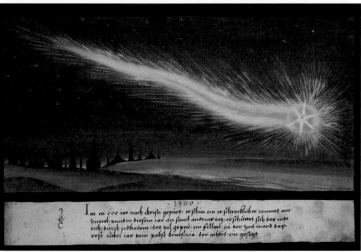

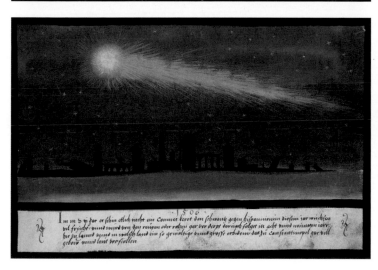

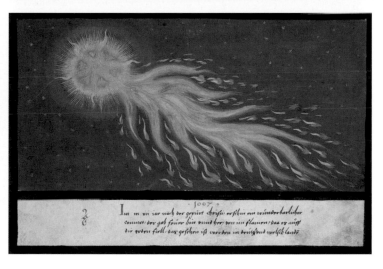

THE AUGSBURG BOOK OF MIRACLES (DAS AUGSBURGER WUNDERZEICHENBUCH)

*c.*1550

UNKNOWN

Gouache and watercolour inscribed on paper
14.9 × 29 cm / 5¾ × 11½ in
Cartin Collection, Hartford, CT

Six flaming comets blaze above darkened cities of domes and spires or the German countryside. Each illustration is accompanied by a brief explanation of the comet's influence on Earth. *The Augsburg Book of Miracles*, produced around 1550, portrays celestial phenomena as divine signs of approaching calamity: outbreaks of plague, flood or fire, warfare or famine. When the book was created, Protestantism was encouraging

people to read the Bible for themselves. Martin Luther's translation into German, which appeared in 1534, documented miracles and encouraged their literal interpretation. Throughout the Old Testament reported wonders, especially meteorological phenomena, are interpreted as divine penalties for past transgressions. In the New Testament, astronomical phenomena are presented as warnings about the punishment of future

sins. *The Augsburg Book of Miracles* reported extreme weather events such as summer snow and hailstorms, a rain of blood and a 'gruesome wind' that carried locusts. The portentous comets – each relates to an identifiable sighting – are strikingly beautiful, however, and richly coloured, their tails streaming out like Venus's hair in a painting by Botticelli (the word comet in fact derives from the Greek for 'long-haired').

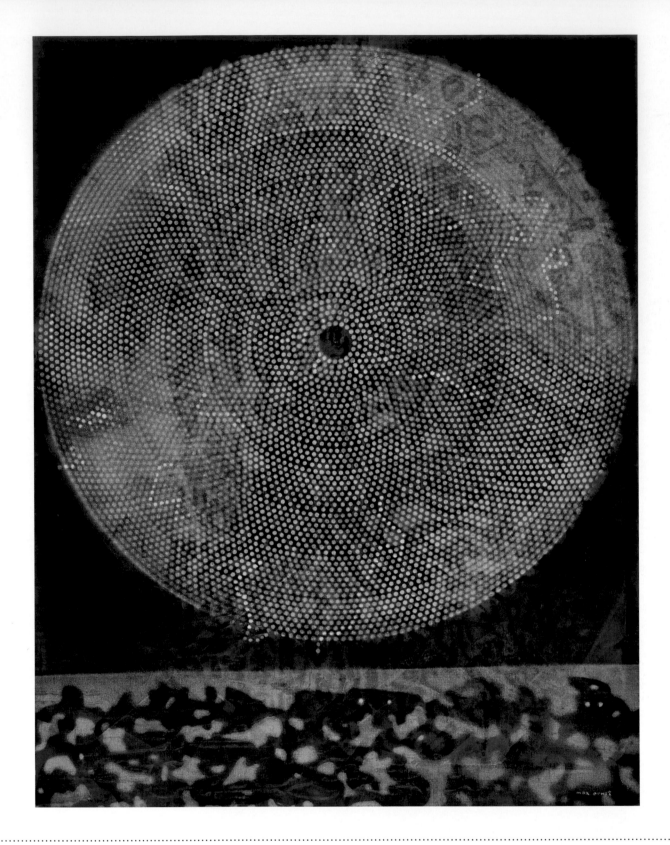

NAISSANCE D'UNE GALAXIE
1969

MAX ERNST

Oil on canvas, 92 × 73 cm / 36¼ × 28¾ in
Fondation Beyeler, Riehen/Basel, Beyeler Collection

This simple composition is a purely subconscious, imaginary depiction of the birth of a galaxy by the noted German Surrealist artist Max Ernst (1891–1976). A subdued background marbled with blue reflects the darkness of outer space and shows through the pale circular form, the central hole of which appears fathomless. Accentuated by the radial symmetry of the concentric circles of paint dabs surrounding it – the tightly packed dots and the amorphous blue and green shapes make the form appear to pulsate – this centre exerts a strong pull. The concentric pattern might recall the spiritual mandalas of Hinduism and Buddhism, or the circular coiling technique used in basket weaving by the Navajo people of the Southwest United States, where Ernst lived from 1946 to 1953. The curious shapes in the pale band at the foot of the image are reminiscent of Navajo glyphs – or are they aliens from the artist's subconscious? Ernst drew deeply on his subconscious – he was influenced by Freudian psychoanalysis – to create paintings and sculptures that depicted fantastic or nightmarish scenes and events that had their origins in childhood anxieties.

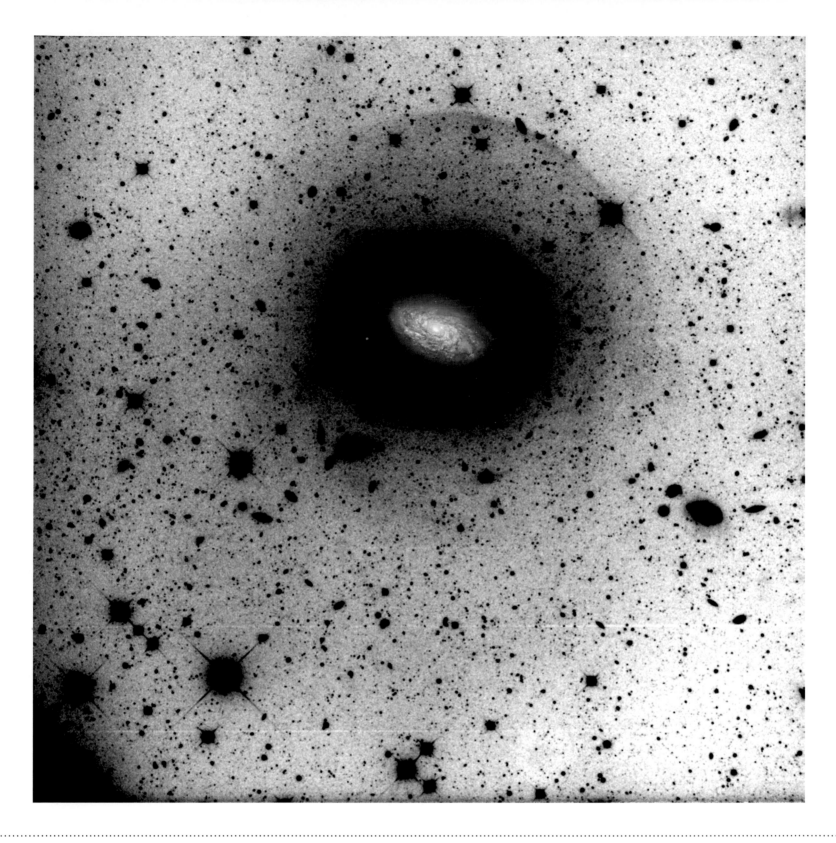

NGC 4414 STAR SHELL
2015

ADAM BLOCK

Digital photograph, dimensions variable

Around the small spiral galaxy that appears in colour at the heart of this image, the American astrophotographer Adam Block has used a negative exposure to reveal a faint shell of light that shows up as greys and blacks. Spiral and other galaxies are surrounded by faint halos that extend far out into intergalactic space. A high proportion of the galaxy's dark matter lies within the halo. Its mass, in combination with that of the stars orbiting in the outer reaches of the galaxy, is sufficient to exert control on the movement of the spiral galaxy within. Most galactic halos are structureless, but in some galaxies sharply defined shells can be made visible by enhancing the contrast of an image or creating a negative. These shells are fossil remnants of the process in which the halo was built up from other smaller galaxies that fell in and were absorbed. The motion of infall causes ripples of halo stars to pile up in shells. Some galaxies have up to a dozen shells, representing multiple incidents of galactic cannibalism. When astronomers attempt to simulate these events in computers, they find that dark matter in the halos is essential to make things work. This is one of several contributing reasons why astronomers are convinced that dark matter really exists – even though they cannot see it and do not yet know what it is.

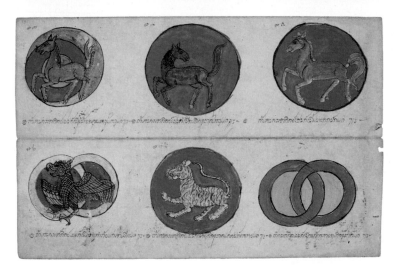
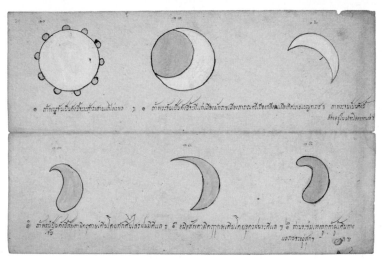

TAMRA PHICHAI SONGKHRAM
1800–80

UNKNOWN

Ink on paper, 36.7 × 12 cm / 14½ × 4¾ in
British Library, London

The bold illustrations of constellations and heavenly bodies on this colourful parchment originating in mid-nineteenth century Thailand might resemble children's drawings, but they have a deadly purpose. They come from a manuscript of war strategy, entitled the *Tamra Phichai Songkhram*, which uses divination – the art of forecasting the future using astronomical, astrological and intuitive methods – to predict propitious times for

conflict, an essential part of Thai war strategy. Divination dictated not only when to fight but also the choice of specific tactics on the battlefield. The practice played an important part in all realms of Thai political life, and it was common for a royal court to have one or more resident astrologers whose job it was to offer advice based on the interpretation of cosmological and earthly phenomena, such as the appearance of heavenly bodies,

planets and comets. The striking, bright colours were hand painted, and the whole manuscript crafted into an unbound, accordion-folded book, referred to in the Thai tradition as 'samut khoi' after the tree from which the paper is made. The delicate script is in Thai, and contains incantations known as mantras, amongst other information.

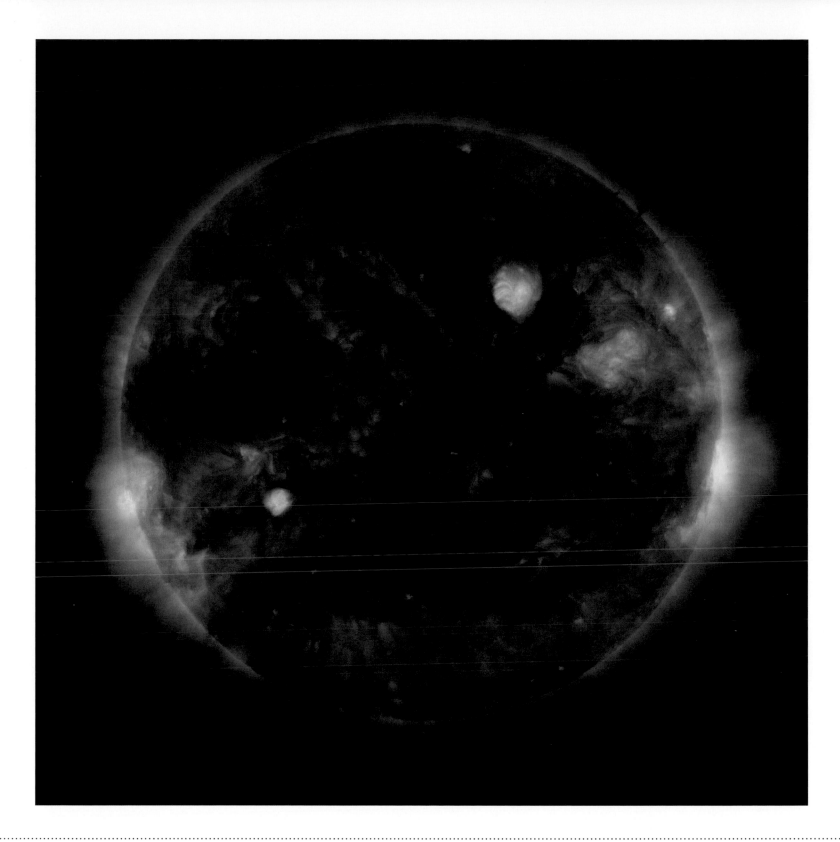

**THE HOT AND CLOUDY
ATMOSPHERE OF THE QUIET SUN**

2015

NASA, JPL-CALTECH, GSFC AND JAXA

Digital photograph, dimensions variable

Roiling clouds cover the surface of the Sun, interrupted by occasional flashes caused by sunspots and flares, in this X-ray image taken on 29 April 2015 – a day when amateur astronomers viewing the Sun conventionally would have seen an almost featureless disc, with just one tiny sunspot near the centre and another slipping out of sight around the back. In visible terms, solar activity was low, but a different view was revealed by the X-ray telescopes on NASA's satellite NuSTAR and the Japanese satellite Hinode. Above the two small sunspots – numerous other embryonic sunspots are also visible – areas of bright blue that represent hot gas in the Sun's atmosphere (its corona) heated to millions of degrees. These active areas are filled with flares, which can be giant eruptions that spew massive clouds of charged particles into the solar system or can take the form of smaller eruptions that happen all the time, as here. The material in the eruptions is guided by the magnetic field of the Sun into outflowing, fountain-like jets that arch above the sunspots, impinge on the corona and fall back. By contrast, coronal holes are dark, almost featureless, regions where the magnetic field of the Sun reaches right out into space, so outflowing material streams unhindered into space in a steady wind of charged solar particles.

Un missionnaire du moyen âge raconte qu'il avait trouvé le point
où le ciel et la Terre se touchent...

A MEDIEVAL MISSIONARY DISCOVERS THE POINT WHERE THE EARTH AND SKY MEET

1888

UNKNOWN

Wood engraving, from *L'Atmosphère: Météorologie Populaire*
British Library, London

A man in a long robe and carrying a staff pushes his head and arm through a gap between the Earth and the sky into a realm beyond, which is filled with clouds, fires and suns. When the prolific French writer Camille Flammarion, a noted popularizer of astronomy, published this wood engraving in *L'Atmosphère: Météorologie Populaire* (*The Atmosphere: Popular Meteorology*) in 1888, readers assumed that it was a medieval

illustration of a missionary's discovery of a place where the Earth and the sky were not joined together. The woodcut purports to be a contemporary pre-Copernican illustration of the cosmology of the Middle Ages, with a flat Earth under a dome of stars – but appearances are deceiving. The original engraving appears to have been made by a burin – a tool that only became available in the late eighteenth century – and the pattern in the frame

around the image clearly dates from later than the Middle Ages. Flammarion may have created the image himself, as he had once been apprenticed to an engraver in Paris. Certainly, he made no claims about its origins. It is often reproduced as an evocative metaphor for scientific exploration, and indeed, more widely, the human quest to discover the principles that govern our world – the mechanisms, gears and wheels of the Universe.

MOON STUDIES AND STAR SCRATCHES, NO. 5

2004

SHARON HARPER

Luminage print, 101.6 × 127 cm / 40 × 50 in
Fogg Museum, Cambridge, Massachusetts

Multiple Moons follow no clear path across the sky in this image by American photographer Sharon Harper (born 1966). Most astronomical observation stresses predictability; clocks and calendars follow the cycles of the Sun, Moon, planets and stars. Harper's photographs up-end this approach and present the cosmos as disordered and arbitrary. To create *Moon Studies and Star Scratches, No. 5* (one of a series that rely on the same method) Harper used a large-format camera and exposed a single negative on multiple occasions. Each time the camera recorded different conditions, preserving shifts in date, geographical location, atmospheric conditions or exposure time. Although using a careful, even methodical, process to create the images, Harper countered this sensibility by reorienting the camera with each exposure, shifting the Moon's placement in the frame. In the final print, Moons in all phases appear as if scattered randomly. Some are blurred and others sharp, some shine in brilliant white and others in yellow or orange, some have clouds streaking across them and others sit alone. Through its enigmatic appearance, the photo presents the Moon and stars as objects of wonder, and invites the viewer to marvel at the methods used to create such a picture.

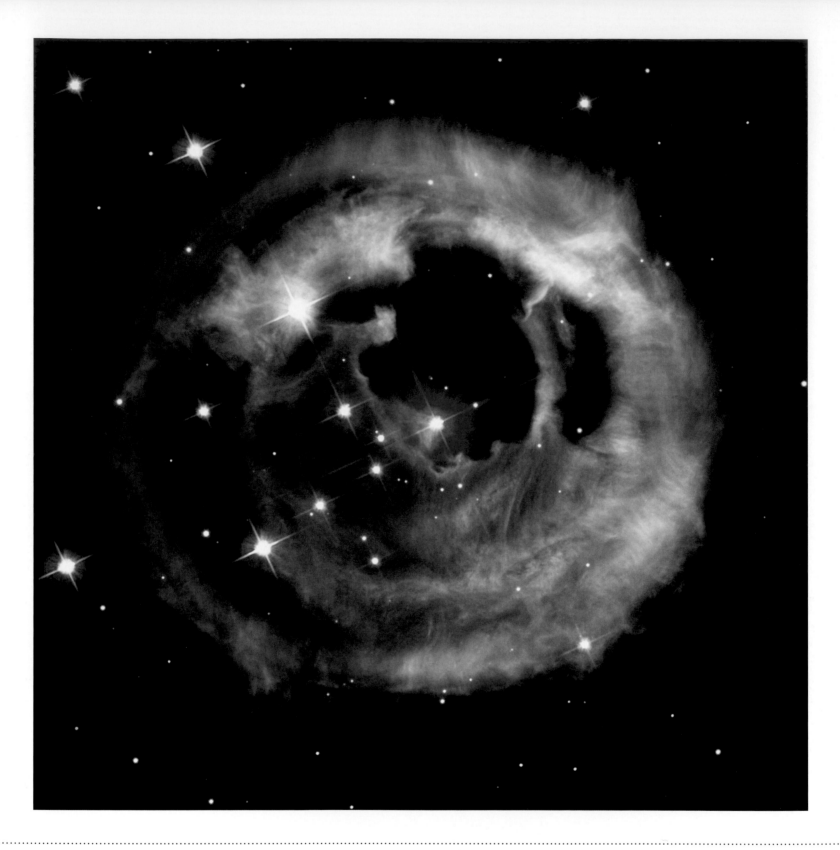

RED SUPERGIANT STAR V838 MONOCEROTIS

2002

NASA, ESA AND H.E. BOND (STSCI)

Digital photograph, dimensions variable

The burst of brilliant red at the heart of this photograph is a red supergiant star now known as V838 Monocerotis. The broken cloudy sphere is a dense nebula that lies behind the star like a concave backdrop. In early 2002 the hitherto unremarkable V838 Monocerotis suddenly – and for a reason that remains unexplained – became a million times brighter than the Sun, and perhaps the brightest star in the entire Milky Way galaxy. The starburst quickly faded, but the flash of light that travelled directly to the Earth drew astronomers' attention to the star and, over the following years, they observed the nebula that appeared to grow outwards from it. Superficially, the phenomenon resembled the explosion of a supernova: but this was not a supernova and the nebula was not created by the star. It was simply illuminated by it. The flash travelled outwards in all directions, including backwards to the clouds of dust and gas that lie light years behind the star. The flash was reflected back towards the Earth, where it arrived years after the initial flash had arrived by its more direct route. This phenomenon – known as a 'light echo' – has illuminated the sheet of the nebula behind the stroke of cosmic lightning. The nebula is about six light years in diameter and is perhaps twenty-thousand light years away.

THE END OF MODERNITY
2005

JOSIAH MCELHENY

Chrome-plated aluminium, electric lighting, hand-blown glass, steel cable and rigging, diam. 487 cm / 16 feet
Ohio State University, Ohio

A central orb of chromed aluminium radiates long poles of the same material that end in more than 1,000 glass globes and disks, especially blown by the American artist Josiah McElheny (born 1966). The anenome-like structure is made from more than 5,000 metal parts to create a solid representation of the Universe-forming gaseous explosion called the Big Bang. Its transparent but reflective glass forms glisten under the light, recalling galaxies of sparkling stars. *The End of Modernity* is suspended just above the floor, enabling the viewer to peer into the heart of the complex structure. Collaborating with cosmologist David Weinberg, McElheny produced the work for the Wexner Center for the Arts in Ohio. Along with the Big Bang, the artwork pays homage to the Lobmeyr chandeliers in New York's Metropolitan Opera House – similarly intricate designs that recall starbursts and the eternal expansion of matter. For the visitor who glimpses his or her own reflection in *The End of Modernity*, the sculpture highlights the place of human existence within the cosmos. The fact that we too are made of the carbon, nitrogen and oxygen atoms found in previous generations of stars reminds us that the cosmos is within us all.

UNTITLED (SUN STATE)
1974

JOSEPH BEUYS

Chalk and felt-tip pen on blackboard with wood frame,
120.7 × 180.7 cm / 47½ × 71 in
Museum of Modern Art, New York

Chalk drawings scrawled densely over a blackboard
in a frenzy of calculation or revelation have become
something of a symbol of genuis at work. The German
artist Joseph Beuys (1921–1986) drew what he called
this astrological chart during a public lecture in Chicago
in 1974 named 'Art into Society, Society into Art'. Beuys
set out to illustrate an ideal state in which the natural and
social orders are balanced. The 'Sun State' of the title

blazes at the base of the composition, creating energy
that radiates in looping white lines that alchemy turns
into a system of culture with three branches: religion, art
and science. At the centre of the image, an androgynous
human figure represents the Earth, accompanied by a
delicate stag that symbolizes humans' animalistic and
spiritualist nature. Further loops of chalk conect written
references to myth, the economy, socialism and astrology,

and balancing life force with the forces of death.
Ultimately, Beuys intended this to be a representation of
an ideal democratic state and system of culture, which
together could fuel human creativity. Interested in blurring
the lines between art and life, as well as fact and fiction,
Beuys was associated with the 1960s Fluxus movement,
which moved fluidly between literature, music and
visual art.

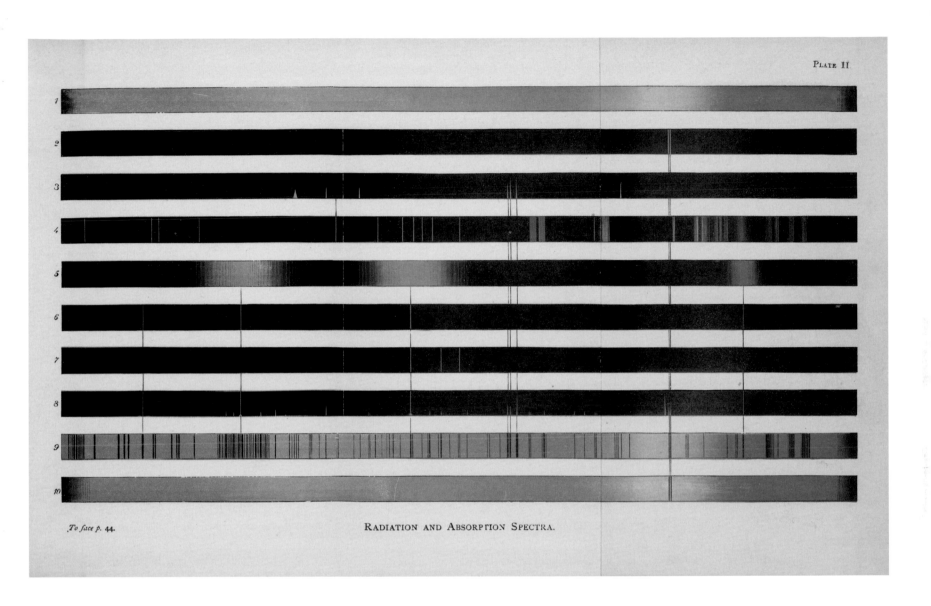

PLATE II

To face p. 44. RADIATION AND ABSORPTION SPECTRA.

SPECTRA
1878

NORMAN LOCKYER

Fold-out colour plate, from *Studies in Spectrum Analysis*
17.7 × 27.9 cm / 7 × 11 in
Huntington Library, San Marino, CA

In the late nineteenth century a gap opened between astronomy as the study of what we see in the sky and astronomy as the study of signals from space that are not necessarily visible at all. For centuries, astronomers had observed the stars as points of light in the night sky, tracking their positions, but as new technologies emerged, astronomers realized they could combine laboratory and photographic techniques to analyse starlight. In his book

Studies in Spectrum Analysis, the English astronomer Norman Lockyer (1836–1920) explained how a prism attached to the eyepiece of a telescope can be used to split starlight into a spectrum. Drawing on the work of other astronomers and chemists, Lockyer explained how each chemical element has a distinctive 'fingerprint' pattern of light (radiation) and dark (absorption) lines in its spectrum. In a full-colour plate, Lockyer illustrated how

the spectra obtained from gases heated in a laboratory (rows two to six of this image) match those obtained from gas clouds in space (row seven) and the sun (rows eight to nine), showing clearly how Earth-bound chemical analysis could be applied to astronomy. Part of the newly emerging discipline of astrophysics, the spectral analysis of starlight and galaxies would later transform our understanding of the evolution of stars and the Universe.

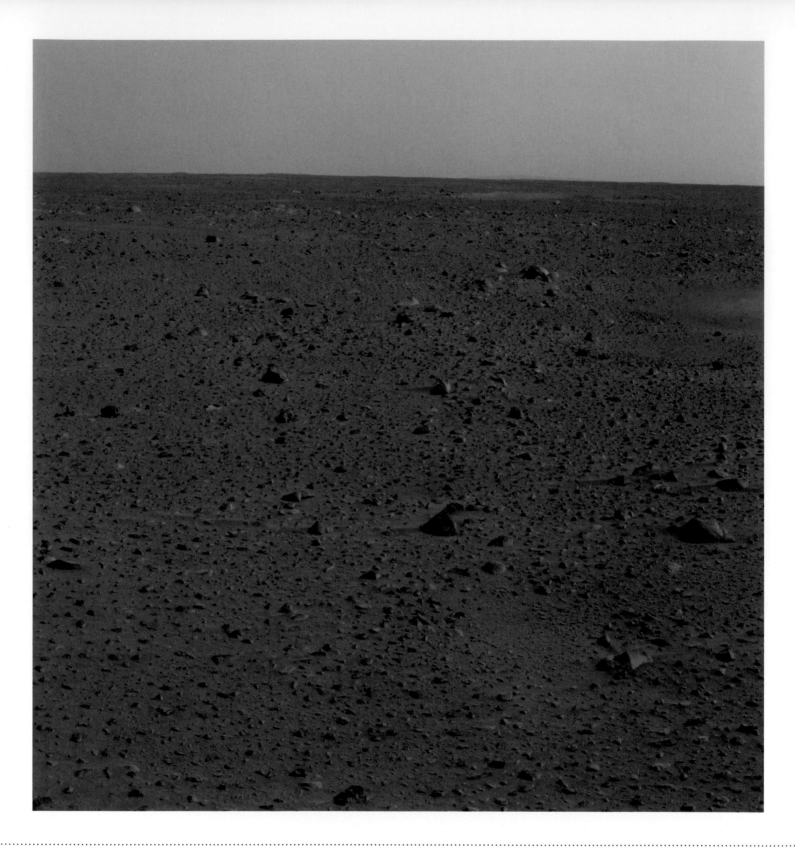

MISSION SUCCESS
2004

NASA, JPL, CORNELL

Digital photograph, dimensions variable

When the Mars Exploration Rover spacecraft, Spirit, landed on Mars near the Gusev Crater in 2004, it sent this view across its landing site as its first postcard home. The mission scientists had very conflicting feelings about what they saw. The first was elation at 'mission success': everything had worked. At the same time, there was a sense of anticlimax, considering the image itself. It shows a flat brown plain, littered with rocks with diminutive landscape features on the distant horizon. Despite the image's huge scientific importance, it also seemed – not to put too fine a point on it – boring. The reason is that events on Mars occur on a very small scale, things changing very little in three billion years. Some asteroids landed in distant regions of the planet over the horizon, throwing up rocks that fell on the plain. Some small meteorites have landed nearby to excavate white dust from beneath the surface. Long-lasting sandstorms have brought sand from elsewhere on the planet, and a few rocks have tails of sand that show the direction of the prevailing wind. At first, the scene looks like a terrestrial desert: but there are no dramatic canyons eroded by rivers, no mountains, no volcanoes. Above all there is no life: no cacti, no reptiles, no birds; no footprints, no contrails in the sky. This is Mars – the almost dead planet.

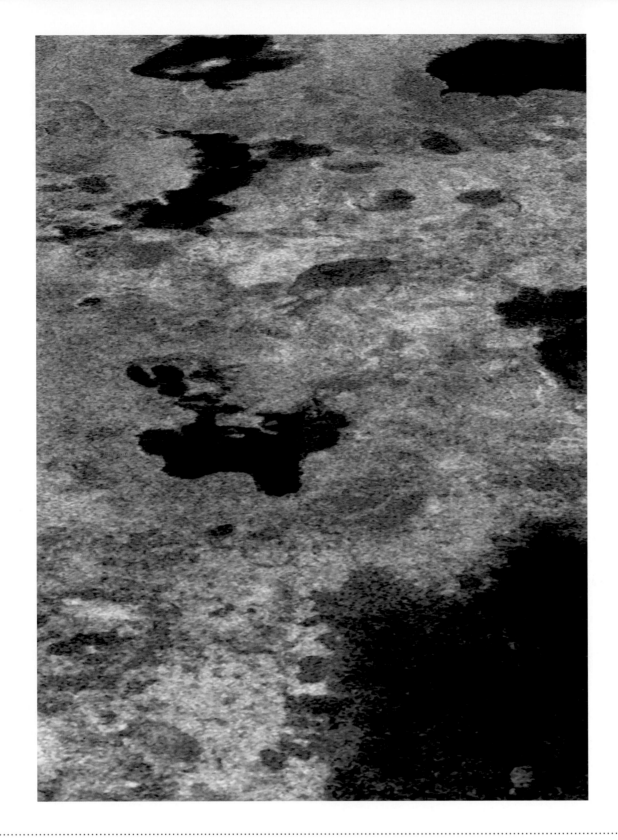

LAKES ON TITAN
2006

CASSINI RADAR MAPPER, JPL-CALTECH, ESA, NASA

Digital image, dimensions variable

The blue and black patches on this radar-generated, false-colour image of a 150-kilometre-wide (95 miles) slice of the surface of Saturn's largest moon, Titan, are flat lakes of liquid methane. That makes Titan remarkable. It is only the second body in the Solar System known to have liquid on its surface: we live on the other one. The Cassini spacecraft used radar to penetrate through the murky smog that surrounds Titan to reveal the roughness of the ground and the flat lakes (the methane does not reflect radar waves). The methane evaporates into Titan's nitrogen atmosphere, where it reacts with sunlight to create the moon's smog. When the methane condenses, it falls as methane rain, running off the hills in liquid methane rivers and draining back into the lake basins. Titan is a world in which humans could feel at home looking out of the window of a landing module at the landscape – provided we did not venture outside into the cold, choking atmosphere. This world is reminiscent of the Earth four billion years ago, before life began, fixing the methane into solid rock and suffusing the nitrogen air with oxygen. It is possible that Titan may be in a similar prebiotic state to that of the early Earth.

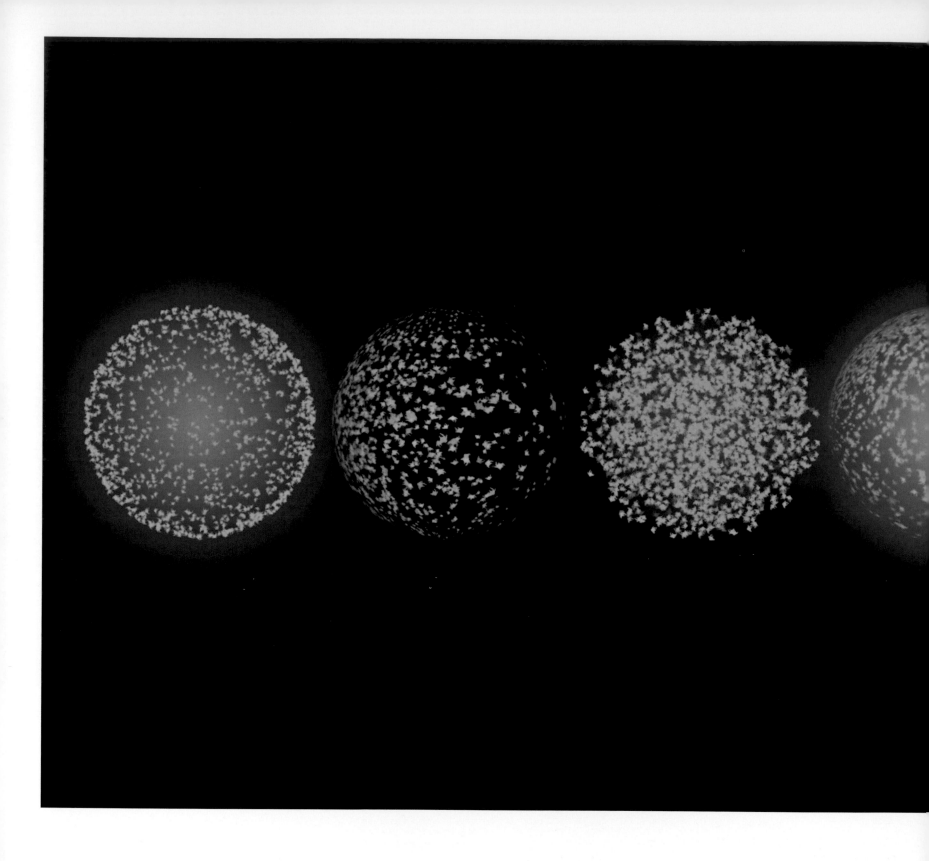

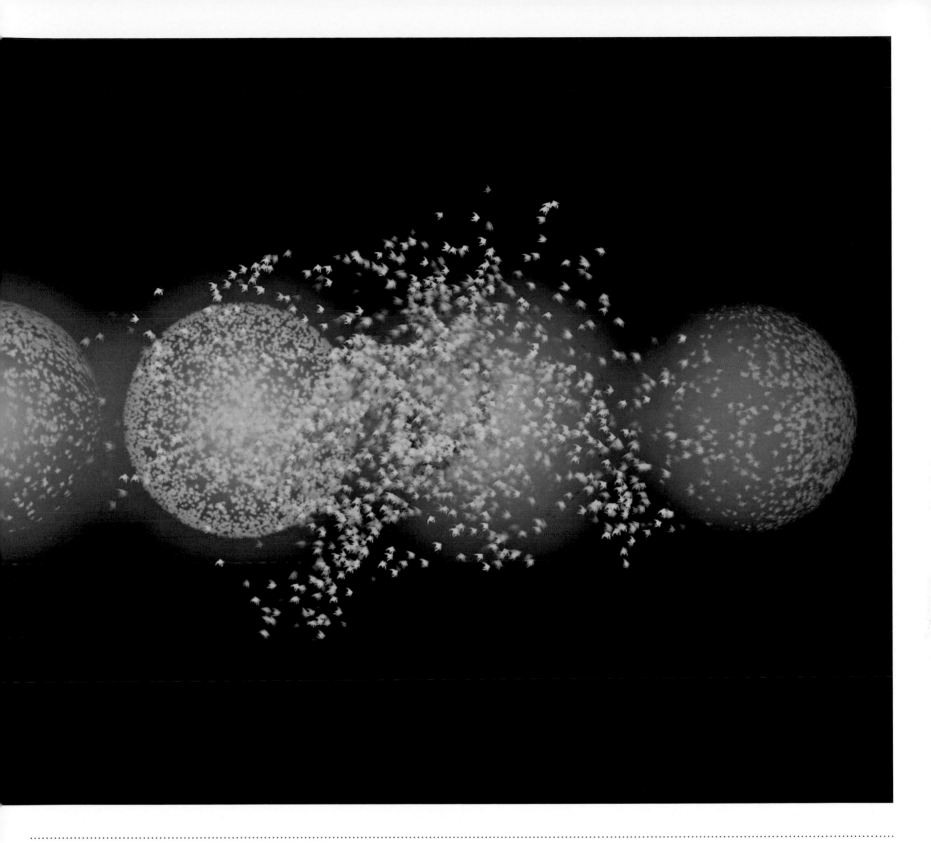

SINGING SUNS

2016

SHAHZIA SIKANDER

Animation, dimensions variable

In this high-definition animation by Pakistani artist Shahzia Sikander (born 1969), the Sun is an unstable form that emerges as a singular, hazy halo of light amid a black expanse, then rapidly germinates and multiplies into seven shimmering globes. Circles reproduce, within which individual particles can be seen floating, spinning and swirling. Moving at different speeds, these exist in contrast to one another until individual 'atoms' begin to

expand beyond the orbs. They merge and dance to form changing, fluid abstract patterns, recalling the seeds blown from a dandelion that float in the wind. Sikander intends the patterns to represent the glowing silhouettes of hair surrounding the *Gopi* – the female worshipers of Krishna, the blue Hindu god of love, compassion and tenderness. Sikander abstracts traditional religious imagery to suggest a universal energy force beyond the

holy. The discordant score by Chinese-born composer Du Yun reflects the increasingly dynamic visuals – whirling specks suggest birds, bats or illuminated insects that frantically interweave – as trumpets and impassioned vocals evoke a jazz-like mood. Sikander's animation culminates with each Sun slowly disappearing, as if paint were being dissolved or time reversed.

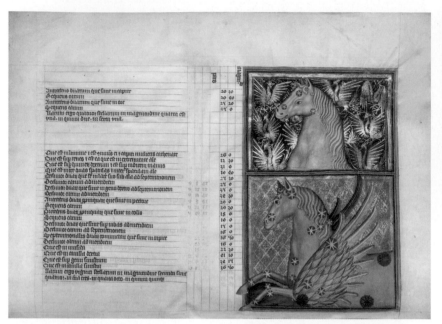

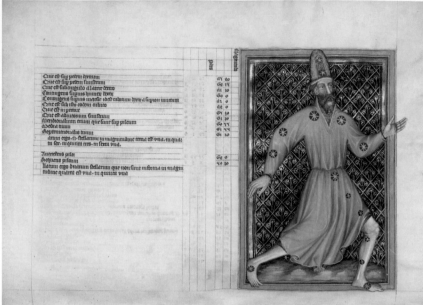

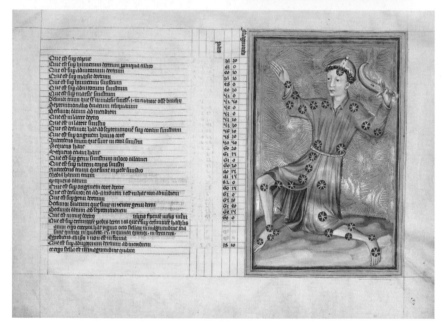

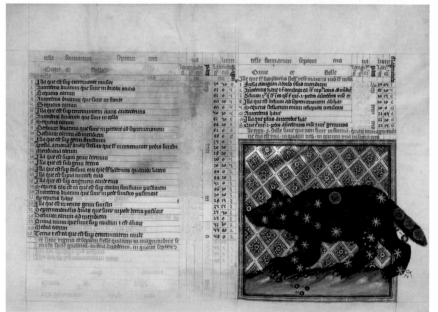

**ASTROLOGICAL MANUSCRIPT FOR
KING WENCESLAS IV OF BOHEMIA**

*c.*1400

UNKNOWN

Coloured ink and gold on parchment
46.7 × 34.6 cm / 18⅓ × 13⅔ in
Bavarian State Library, Munich

These beautiful manuscript paintings depict the constellations (clockwise from top left) Equuleus and Pegasus, Cepheus, Ursa Major and Hercules. The fact that Hercules is holding a curved scimitar rather than the more traditional club shows the influence of the tenth-century Persian astronomer Abd al-Rahman al-Sufi (see p.300): these illustrations form part of an incomplete series of the northern constellations recorded by al-Sufi.

The manuscript was created in Prague at the end of the fourteenth century for the Bohemian King Wenceslas IV, a rather unfortunate ruler who was imprisoned several times and deposed as King of the Romans in 1400. Wenceslas IV patronized to the production of lavish manuscripts, including this anthology of astronomical and astrological works, which made Prague an important seat of art and science. The accompanying text describes the stars, their positions and their magnitudes in Latin, with clear continuities in terms of style and format from al-Sufi's *Book of the Constellations of Fixed Stars*, itself based on a synthesis of the *Almagest* of Ptolemy and traditional Arabic astronomy. This manuscript is therefore a testament to the transmission and exchange of learning across cultures, which we perhaps do not always readily attribute to medieval Europe.

MESSIER 107
2012

ESA, HUBBLE AND NASA

Digital photograph, dimensions variable

This dense cluster of sparkling stars has been likened to thousands of flashbulbs in a darkened stadium – but for all its spectacular appearance, M107 is just one of 150 or so globular clusters that orbit in an extended halo about the Milky Way. These distinctive, gravitationally bound groups of stars exist in smaller numbers around lesser galaxies, while the giant galaxy M87 hosts more than 10,000. M107, which was discovered in 1782, contains about 100,000 stars, which makes it of modest size — the southern cluster 47 Tucanae contains about a million or so. What is remarkable about globular clusters in general is their age: M107 is over 13 billion years old, almost as old as the Universe itself. This collection of ancient stars existed long before the Milky Way took on its present form, and even longer before the Sun and its planets appeared. How globular clusters formed and what they looked like in their distant youth remains a mystery, but their creation must have been spectacular, especially if their stars all formed at around the same time. Astronomers now believe that many of their more wayward outlying stars have been stripped away during the course of numerous orbits close to massive galaxies. However, there is enough variety in the stars that remain to leave open many intriguing possibilities.

EXPLORERS ON THE MOON
1954

HERGÉ

Black ink and watercolour, 12 × 9.5 cm / 4¾ x 3¾ in
Studios Hergé

In this characteristic illustration from the Tintin adventure *Explorers on the Moon*, Tintin stands alongside his best friend, Captain Haddock, with Snowy the dog nearby. The renowned Belgian cartoonist Hergé (Georges Prosper Remi, 1907–83) shows all three wearing vibrant orange space suits with clear helmets that allow unimpeded views of the intrepid explorers (Tintin's trademark tufted hair style having survived space travel intact). In a nostalgic reminder of how humans in the 1950s imagined space travel would be, all three have radio antennae built into their spacesuits. An arc of torchlight – Earthly technology – illuminates a section of rock formations that we now know reflect Earthbound rather than lunar geology. Hergé first published storylines showing Tintin in space in weekly cartoons in 1950, before presenting them a few years later in the books *Destination Moon* and *Explorers on the Moon*. Hergé's style is instantly recognizable. His colour scheme suggests earthy tones and his explorers sniff around, exactly as if they had landed on one of Earth's exotic islands. When a page of the original black and white drawings for *Explorers on the Moon* came to auction in 2016, it set a record for a cartoon drawing, selling for 1.55 million euros.

PART OF SABINE D REGION OF THE MOON, SOUTHWEST MARE TRANQUILLITATIS

1972

NANCY GRAVES

Acrylic on canvas, 182.9 × 215.9 cm / 72 × 85 in
Museum of Contemporary Art, San Diego, CA

This acrylic painting of the Sabine D region of the Moon in the southwestern part of the Sea of Tranquillity is one of a series by the American artist Nancy Graves (1939–1995) based on maps produced by NASA during the preparations for the crewed Apollo missions that began in 1968. Graves requested copies of the maps, which arrived neatly folded in official manila envelopes accompanied by a description of each lunar region, complete with a colour-coded key for the various geological characteristics identified on the lunar surface. Graves recreated the colourful geological maps as abstract compositions, picking up patterns that dictated the mood of her compositions. In an interview conducted in New York City in the early 1990s, three years before her early death at the age of fifty-five, the Moon series prompted Graves to remark, 'What is the Moon? What is Abstraction? What are dots?' Completed at a time when the world was enthralled by the space race between the United States and the Soviet Union, and Americans were still ecstatic at the achievement of Apollo 11 – which put the first man on the Moon in 1969 – the works represented a completely novel idea of the Moon that merged scientific data, appropriation and artistic imagination.

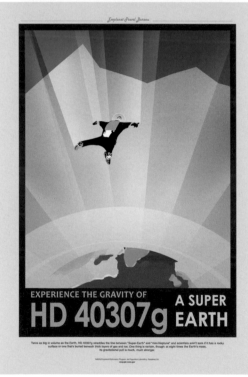

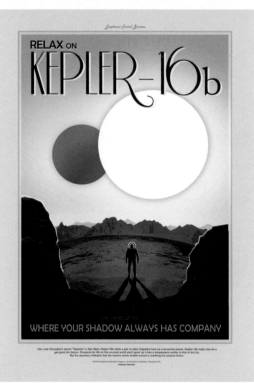

VISIONS OF THE FUTURE

2015

THE STUDIO, JPL

Digital, dimensions variable

These posters advocating futuristic space tourism come from a series of fourteen created by 'The Studio', a group of visual strategists at NASA's Jet Propulsion Laboratory (JPL). Those here illustrate (clockwise from top left) ballooning below the auroras of Jupiter; exploring beneath the frozen surface of Jupiter's moon, Europa; visiting a cloud city on Venus; admiring red vegetation on Kepler-186f; jet-packing on HD 40307g and experiencing the

light of two suns on Kepler-16b. The first posters were made to celebrate the recent growth in discoveries of exoplanets, planets that orbit stars outside our Solar System, and they present imagined scenes of travellers in conditions very different from those on earth. In the poster for Kepler-16b, a lone explorer looks toward majestic purple mountains as a pair of shadows stretch behind him. Another for Kepler-186f proposes how a sun with a different light spectrum

might result in plant life of a different hue. Later posters in this series – *The Grand Tour* and *Visit the Historic Sites of Mars* – commemorate the history of space exploration and project us to a time when we will look back nostalgically at the Voyager space mission's journey past the outer planets and the rovers' explorations of the Martian surface. All of them make use of mid-century modern design aesthetics, evoking travel posters from the 1930s.

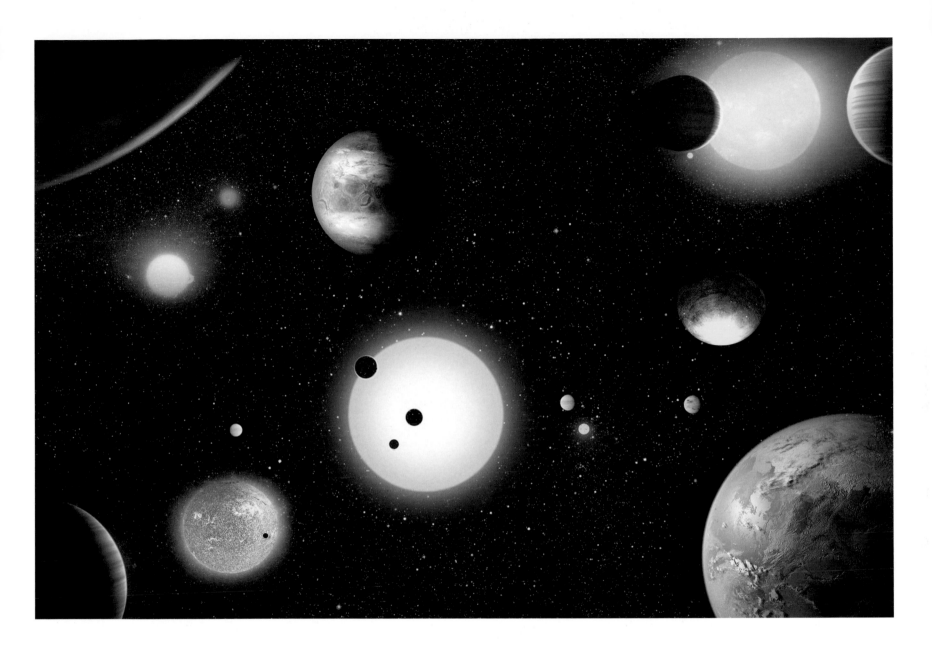

KEPLER PLANETARY DISCOVERIES
2016

WENDY STENZEL

Digital image, dimensions variable

This artist's concept shows a small selection of discoveries made by NASA's Kepler mission. A variety of sizes and types are given context by the Earth-like planets at upper mid-centre and bottom left (both of which look like they, too, could be habitable). As of May 2017, Kepler had discovered 2,483 new planets, the single largest finding of planets to date. The count of 2,483 is the number of objects found that have the characteristics of a planet with a probability of greater than 99 percent. The same analysis also verified more than 1,000 candidates previously suggested by other methods. Before this mission we did not know if exoplanets were common in our Galaxy. Now we know that there could be more planets than stars. This image was created after the end of the first phase of the Kepler mission, which ended when key parts of the spacecraft wore out. Partially disabled, the mission remained operational with more limited capability, continuing to add to its harvest of exoplanets. Kepler has succeeded in reaching its full potential, yielding a deeper understanding of the variety of exoplanetary systems including those that harbour potentially habitable, Earth-sized planets. Kepler has paved the way for us to find life on another planet like ours.

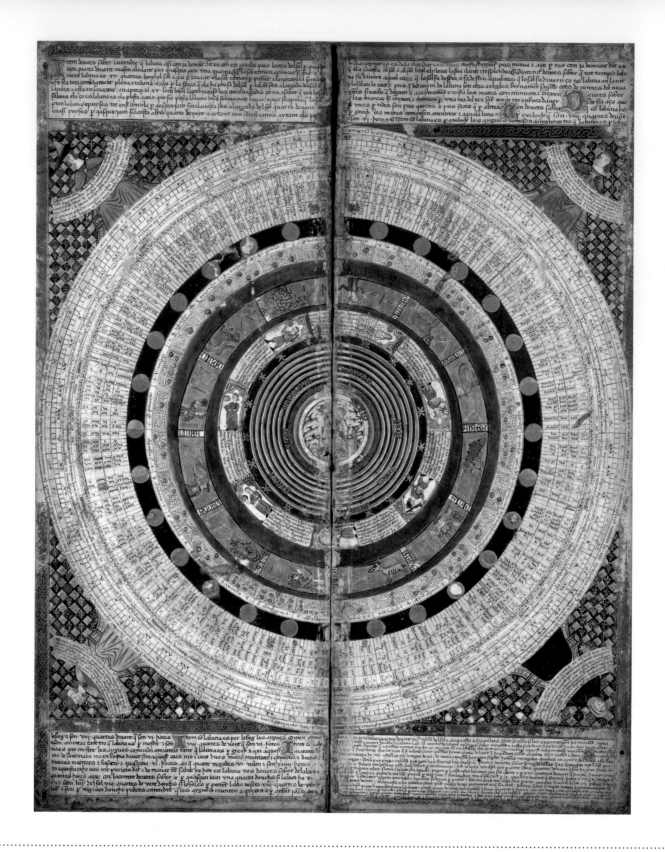

CALENDRIER ASTRONOMIQUE CIRCULAIRE
1375

ABRAHAM CRESQUES

Ink and gold leaf on parchment, from *the Catalan Atlas*
65 × 300 cm / 25½ × 118 in
Bibliothèque nationale de France, Paris

These two pages from the fourteenth century *Catalan Atlas* map the nested spheres of the cosmos, depicted at nearly 50 centimetres (19¾ inches) in diameter. At the centre is the Earth, on which stands an astronomer holding an astrolabe. The Earth is surrounded by bands representing the four elements, earth, air, water and fire. Outside these are the seven non-stellar heavenly bodies known at the time – in order of proximity to Earth, the

Moon, Mercury, Venus, the Sun, Mars, Jupiter and Saturn – contained within a sphere of stars. They feature again as personifications: male and female figures carrying planets and attributes (Venus is readily identifiable, wading out of the sea). The signs of the Zodiac are represented by their traditional figures – Leo as a lion, Cancer as a crab and so on – and by a crude depiction of their constellations. The outer portion of the chart provides calendrical

and lunar information. In the spaces at the corners are personifications of the seasons. The Jewish cartographer Abraham Cresques made maps and navigational instruments in Palma, Majorca. The *Catalan Atlas*, dated 1375 and said to have been a gift from King Pedro IV of Aragon to Charles V of France, is supplemented by material in Catalan, including astronomical, astrological, seafaring, calendrical and timekeeping information.

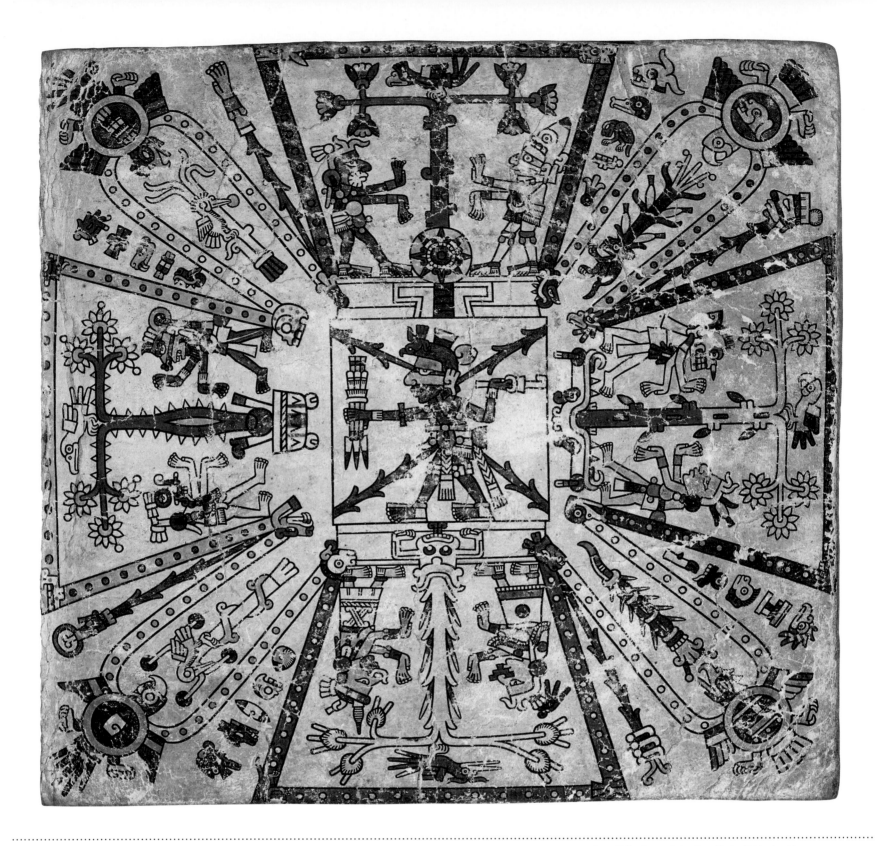

COSMOLOGICAL MAP

c.1400–1521

UNKNOWN

Deer Hide, Gesso, Paint, from Codex Fejérváry-Mayer
17.5 × 17.5 cm / 7 × 7 in
World Museum, Liverpool

This illustration, which opens a fifteenth-century Mayan codex, has been called the most important single page of native literature from anywhere in the Americas. At the centre of this depiction of the Mesoamerican cosmos stands the fire god, Xiuhtecuhlti, holding a bundle of spears. Around him in four cardinal directions (east at the top, north to the left) are T-shaped trees. In one Mayan legend the Earth was originally covered in a vast ocean.

The gods Quetzalcoatl and Tezcatlipoca (pictured at the west and the north respectively) destroyed the water monster, Tlalteotl, in order to lower the waters and create the sky and Earth. Five massive cosmic trees grew in the east, north, west and south and where the Earth, sky and underworld met at the heart of the world. The illustration also depicts in pictograms the calendar that played a central role in Mayan cosmology and daily life. Birds

bear one of four year signs, and there are five further calendrical motifs representing the twenty *trecena*, or thirteen-day periods, that compose the 260-day Mayan calendar called the *tonalpohualli*. The deerskin *Codex Fejérváry-Mayer* (so named after an Hungarian collector and an English antiquarian who owned the document in the nineteenth century) records histories, genealogies and relations between the Maya and their neighbours.

WINTER COUNT RECORDING EVENTS FROM 1800–70

1876

LONE DOG

Paint on buffalo hide, 259 × 207 cm / 102 × 81½ in
National Museum of the American Indian, Smithsonian Institution,
Washington, DC

About halfway between the centre and bottom edge of this re-creation of a winter count – a pictorial record kept by many Native American Plains peoples of key events in each year – is a pictograph of a crescent Moon surrounded by a blizzard of red dots. Lone Dog, the aged member of the Yanktonai band of the Dakota Sioux who is credited with creating this winter count in the 1870s, depicts a 'storm of stars' to represent the spectacular

Leonid meteor shower on the night of November 13, 1833. Other winter counts dubbed 1833 'Stars all fall down year', and noted, 'They feared the Great Spirit had lost control over Creation'. The meteor shower allowed experts to date the entries made each winter precisely: it begins to the right of centre in 1800–1 with tally lines recording the number of casualties in a battle, next to a spotted torso representing an outbreak of smallpox. The

sequence spirals out anticlockwise from the centre, with each image commemorating an important event of a year to serve as a reminder for the more detailed oral histories recalled by tribal elders. The star shower is the thirty-third entry in a sequence that continues to 1871. The original of Lone Dog's count, drawn on buffalo skin, is now lost but a number of copies survive. This copy was made in 1876 by a lieutenant in the First US Infantry.

THE GREAT COMET OF 1843, AS SEEN AT THE CAPE
OF GOOD HOPE, ON MARCH 4th, IN THE EVENING. (34 S. LAT

THE GREAT COMET OF 1843

1848

CHARLES PIAZZI SMYTH

Lithograph, 18 × 11.3 cm / 7½ × 4½ in
Royal Society, London.

British astonomer and traveller Charles Piazzi Smyth
(1819–1900) includes himself in his own lithograph of
the Great Comet of 1843, standing on rocks overlooking
the sea at the Cape of Good Hope in South Africa.
The comet was bright enough to be visible in daylight
and had an extremely long, double tail. The comet's
brightness is common to members of the Kreutz family
of comets, fragments of a comet that broke up in about

1106 as it passed close to the Sun, but its appearance in
1843 was taken as a symbol of bad fortune and sparked
an episode of mass hysteria. Some people took the
comet as a cosmic confirmation of a prediction made by
the US Baptist preacher William Miller that Jesus would
return to the Earth in the Second Coming on 22 October
1844. The abolitionist Moncure Daniel Conwayn noted,
'Apprehending the approach of Judgement Day, crowds

besieged the shop of Mr. Petty, our preaching tailor,
invoking his prayers. Methodism reaped a harvest from
the comet.' When 22 October 1844, came and went
without incident, those who had been awaiting the
Second Coming labelled it the Great Disappointment. In
1863, a reformulation of the basic concept of the Second
Coming became the founding belief of the Church of
Seventh Day Adventists.

STELLAR AXIS: ANTARCTICA
2006

LITA ALBUQUERQUE

Fibreglass spheres, dimensions correspond to the stars above
Installation photograph by Jean de Pomereu

Ninety-nine ultramarine-blue spheres are scattered across the snow of Antarctica, apparently placed at random. In fact, the arrangement of the spheres – some larger, some smaller – reflects precisely the brightness and position of the stars on the Summer Solstice in the Southern Hemisphere. The American artist Lita Albuquerque (born 1946) was the recipient of a grant from the National Science Foundation in 2006. Wanting to align the stars

above to the Earth's surface, she led a team of artists and scientists to Antarctica to lay out the pure blue spheres on the dazzling white snow. The spheres are stark against the frozen terrain, perfectly reflecting the colours of the crystal clear skies above and the mountains beyond. However, with Earth rotating at a speed of 1,610 kilometres per hour (1,000 mph), the artwork near the South Pole soon became misaligned with the

positions of the stars overhead; instead, the motion of our spinning world created an invisible spiral from the initial coordinates of the artwork. Albuquerque describes herself as an environmental artist and has undertaken other site-specific installations, sending her on her own spiral around the globe, from the Great Pyramids of Egypt to the Mojave Desert in the United States.

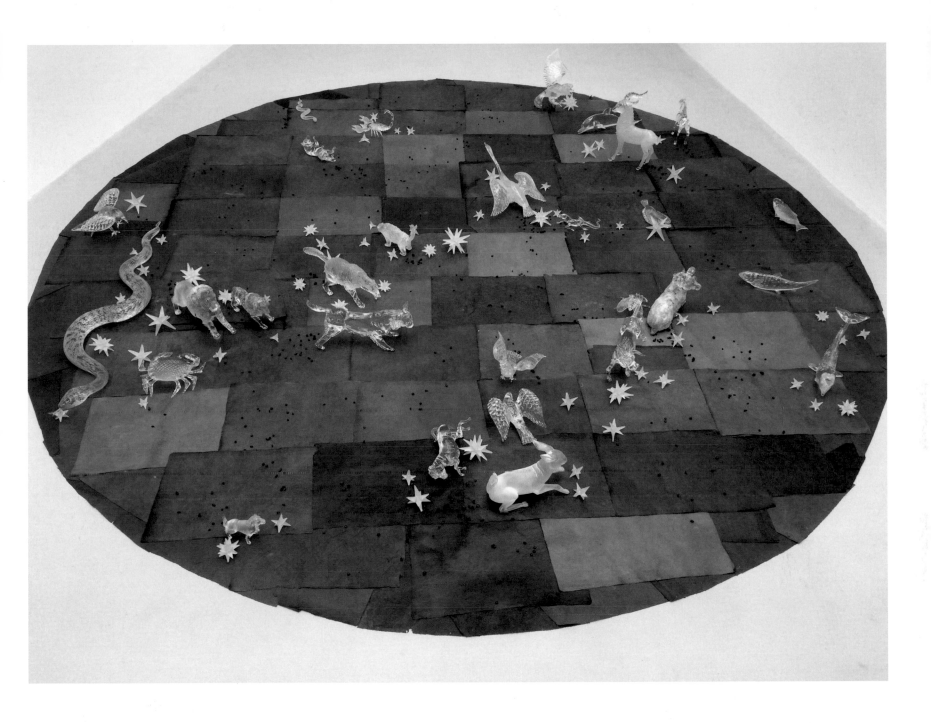

CONSTELLATION
1996

KIKI SMITH

Hot-sculpted glass and cast glass, cast bronze, handmade paper
Dimensions variable
Corning Museum of Glass, Corning, NY

You have to look down rather than up to see into the constellation, created by the German-born American artist Kiki Smith (born 1954). Sheets of handmade Nepal paper, in shades of blue from indigo to turquoise and teal, fill the room in the shape of a circle that provides a stage for twenty-nine animals made from glass. A snake slithers, a crab scampers, birds swoop and four-legged animals from goats to hares and a bull are poised to

charge. A whale glides along. Created by Smith with a Venetian master glassmaker named Pino Signoretto, the glass figures suggest the creatures that feature in the night sky's classical constellations and are offset by the cast crystal stars scattered all around the scene. The stars' sharp white points contrast with the smooth curves of tiny cast bronze pieces – representing trails of animal droppings – scattered over the paper. The animals are

semi-transparent, giving them a fleeting and mystical appearance. This bringing together of terrestrial materials and celestial vision reflects Smith's enduring interest in humans' link to nature and the cosmos. She remains most renowned, however, for her subtle and sensitive dealings with subject matters ranging from gender to race, sex and regeneration, as well as the 1980s HIV/AIDS crisis.

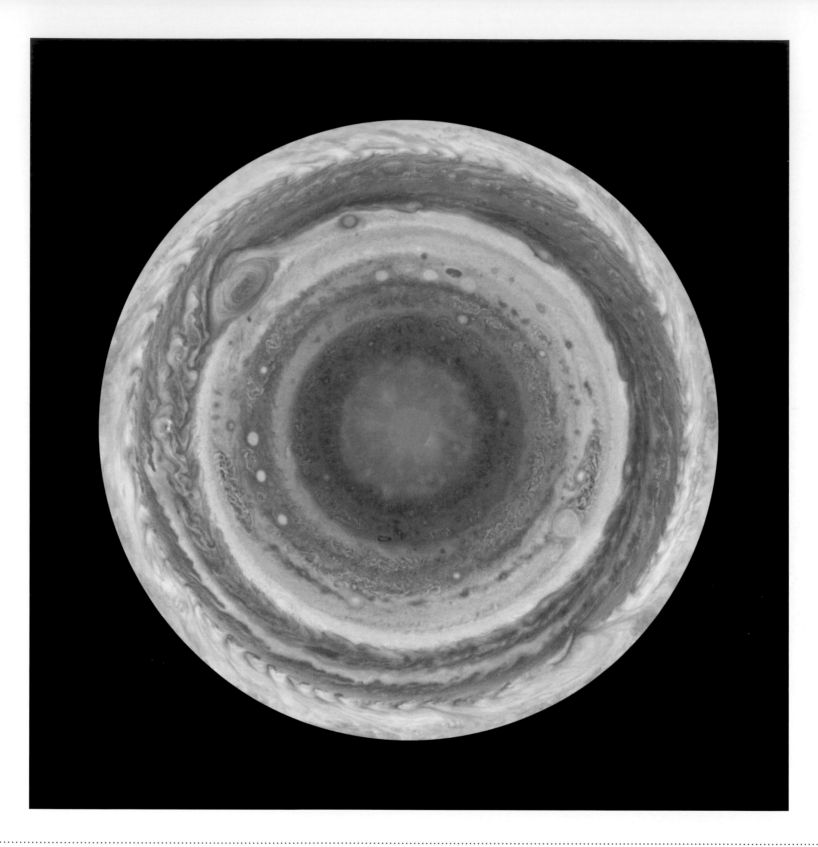

THE SOUTH POLE OF JUPITER
2000

NASA, JPL, SPACE SCIENCE INSTITUTE

Digital photograph, dimensions variable

This unfamiliar depiction of Jupiter from its South Pole – one of a pair providing the most detailed ever produced of the whole planet – was assembled from high-resolution images taken with a narrow-angle camera on board NASA's Cassini as it passed Jupiter on 11 and 12 December 2000, picking up a 'slingshot' from the huge planet's gravity en route to Saturn. The smallest details visible on this stereographic projection are about 120

kilometres (75 miles) across, and the colour balance approximates to what the eye might see. However, Cassini did not fly beneath the pole itself, where the sunlight was much fainter, resulting in a loss of detail. The planet's famous Great Red Spot is recognizable at upper left even at this unusual angle, with an extensive turbulent reddish region associated with it extending around most of the planet. Further south white ovals

appear among a different kind of turbulence, hinting at meteorology hidden far below the cloud tops. Launched in 1997, the Cassini mission was a huge success. It delivered a lander (Huygens) to Saturn's largest moon, Titan, and took thousands of informative images of Saturn, where it arrived in 2004. Cassini's mission ended around thirteen years later, when the spacecraft descended into the planet's atmosphere, never to be seen again.

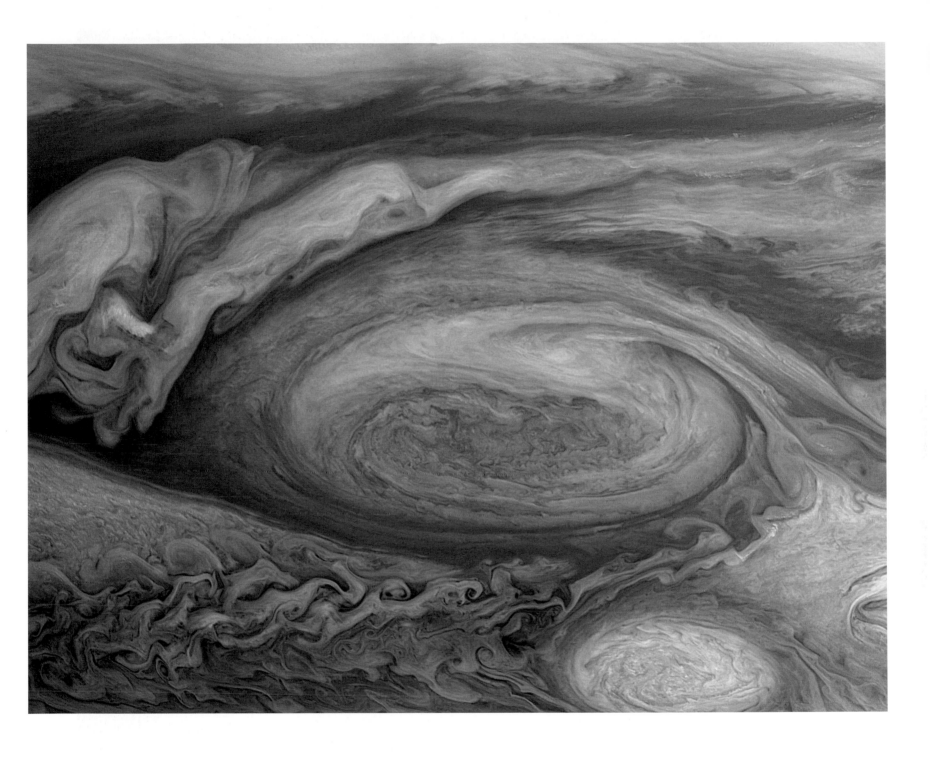

VOYAGER MOSAIC OF JUPITER'S GREAT RED SPOT

2010

NASA, JPL, DIGITAL PROCESSING BJÖRN JÓNSSON (IAAA)

Digital photograph, dimensions variable

This is one of the most detailed images of Jupiter's Great Red Spot (among the best known of all extraterrestrial planetary features) ever taken. In 2011, Icelandic software engineer Björn Jónsson used his own programs to process data gathered by Voyager 1 as it passed within 10 million kilometres (6 million miles) of Jupiter into a clear calibrated, carefully integrated, colour image. The Great Red Spot is evidence of a gigantic storm – the spot would

accommodate three planets the size of Earth – deep in Jupiter's atmosphere. Just south of Jupiter's equator, the Spot leaves a swirling wake and is surrounded by the eddies of other, lesser storms. It is highly unlikely that we will learn much more about the spot because the Jovian atmosphere is hostile, with bitterly cold temperatures, permanent clouds, winds blowing at up to 620 kilometres (385 miles) per hour and lightning storms visible from

space. The storm beneath the spot has been raging since at least the seventeenth century, when it was noted by Italian astronomer Giovanni Domenico Cassini, but some recent research suggests that it might eventually die out. Launched in 1977, Voyager 1 is now the most distant spacecraft from Earth and is still returning useful data. In 2012 it became the first probe to reach interstellar space, where the solar wind meets the interstellar medium.

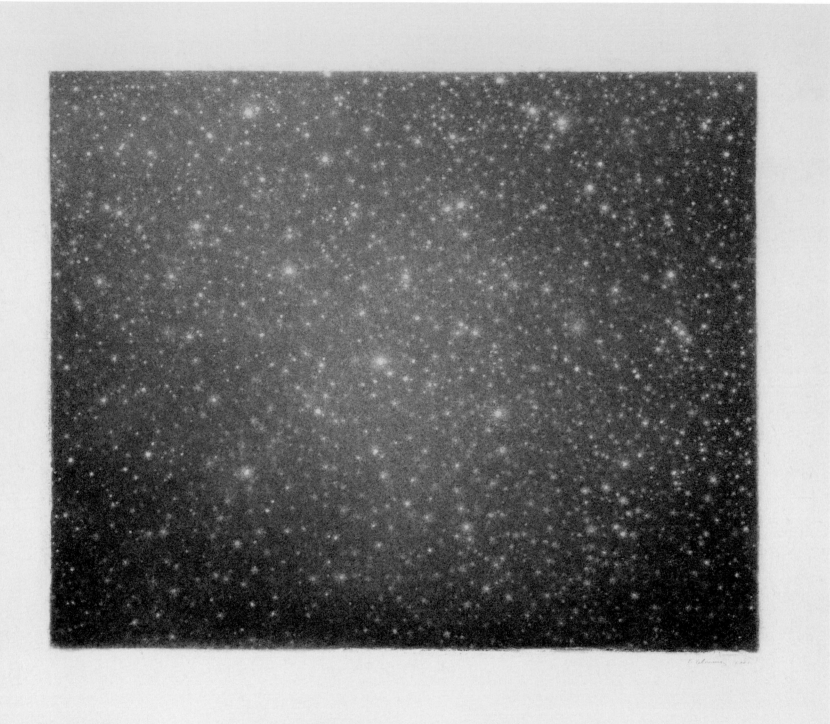

NIGHT SKY 3
2002

VIJA CELMINS

Aquatint with burnishing and drypoint, 51 × 55.9 cm / 20 × 23¾ in
The Metropolitan Museum, New York

Through this remarkable acquatint of a dense field of stars, Latvian-born American artist Vija Celmins (born 1938) makes a quiet statement about methods for observing and representing the heavens. For *Night Sky 3*, she began with a found photograph taken through a telescope (rarther than a direct observation of the night sky) and then meticulously reproduced the details of the machine-dependent image by hand on a copper plate.

Celmins has used the same method many times in her career, translating photographed scenes into pencil, paint or print. Although some of her astronomical images focus on easily identified celestial objects – the surface of the Moon or Saturn, for example – she often chooses instead photos of star fields that contain no clue of their location. The careful copying hides the presence of the artist, and Celmins presents the night sky with an air of

objectivity. She does not reinterpret observations of the stars, but preciselty replicates them. And yet, this and other similar works generate a rare intimacy as their almost photographic appearance invites close study.

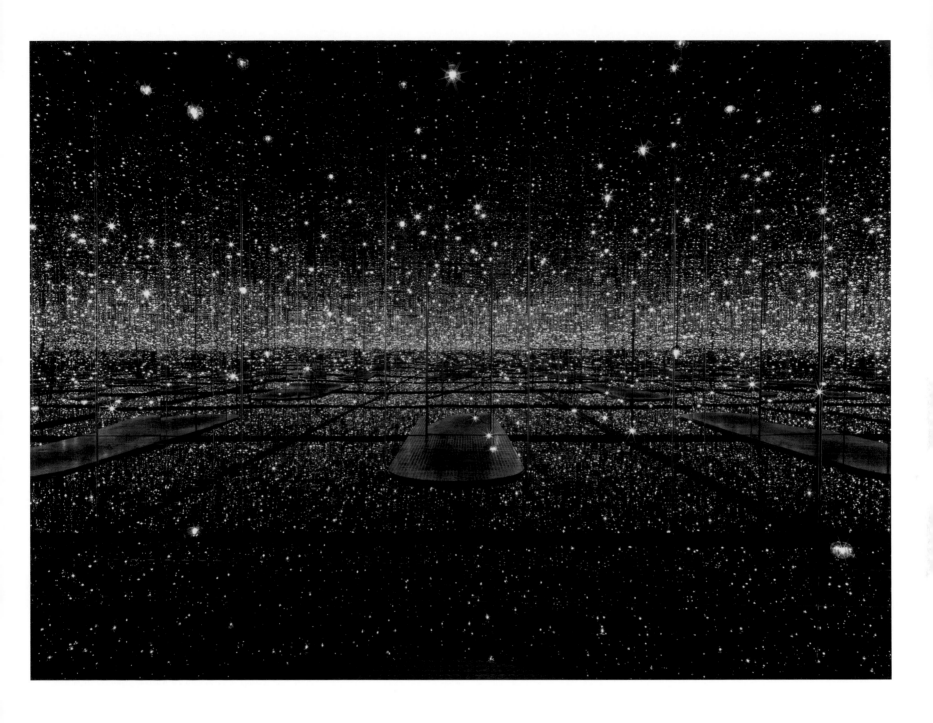

INFINITY MIRRORED ROOM – THE SOULS OF MILLIONS OF LIGHT YEARS AWAY

2013

YAYOI KUSAMA

Wood, metal, glass mirrors, plastic, acrylic panel, rubber, LED lighting system, acrylic balls and water
287.7 × 415.3 × 415.3 cm / 113¼ × 163½ × 163½ in
The Broad, Los Angeles, CA

To enter this 'mirrored room' made by the Japanese artist Yayoi Kusama (born 1929) is to enter a disorienting cosmos in which mirrors and LED lights combine to create a multitude that repeats itself to infinity: Kusama's inner universe becomes as expansive as the wider Universe, and viewers find themselves transported into an illusion of the immensity of the cosmos. The rich tones Kusama selected for the LED lights recall the palette of scientific imaging of deep space, notably the Hubble Deep Field (see p.244). Kusama's *Infinity Mirrored Room – The Souls of Millions of Light Years Away* is a tangible, three-dimensional expression of this paradigm-shifting moment of cosmic imagery. Yayoi Kusama's work is the expression of her mindscape, often inspired by hallucinatory experiences in childhood and early adulthood, when she saw herself in all-encompassing spaces covered in patterns. She first conjured these in the 1950s in her 'infinity nets', seemingly boundless and heavily worked abstract paintings punctuated by countless marks, polka dots or webs. With the *Infinity Mirrored Room* installations that she started in the 1960s, Kusama expanded her painting practice into an experiential environment, which itself becomes a spatial representation of her inner world.

INUIT MOON SPIRIT MASK

UNKNOWN

Wood and feathers, 34.3 × 33 cm / 13.5 × 13 in
Sheldon Jackson Museum, Sitka, AK

The Moon is central to Inuit mythology, and this enigmatic nineteenth-century carved wooden mask of the Inuit Moon Spirit, Taqqiq, was worn during shamanic rituals. The face is Taqqiq, while the pale painted board around it represents the air and the thin wooden hoops the different levels of the cosmos; the seven feathers represent named stars. In the Arctic regions of Canada, Greenland, Russia and the United States, where the Inuit live, the Sun does not rise for the four-and-a half-months of the winter night. The Moon, however, was often prominent during the long hours of darkness, particularly at the time of full Moon, and was thus seen by the Inuit, who believed that everything possesses a spirit, as a benevolent presence. The Inuit believed that Earth (*Nunarjuaq*) was a flat, stationary body around which the celestial beings orbited; their Moon was a flat disk made from ice and the Sun, with its summertime appearances, a ball of fire that was pulled down by the weight of the icy cold below the horizon. The arrival of the full Moon measures the passage of Inuit time; their year is a lunar calendar with thirteen months, and each Inuit band has a different start to the new year when the Sun appears over the horizon after the long dark winter, depending on the latitude of their village.

MOONS

2015

MARK LASCELLES THORNTON

Isograph pen on paper, 150 × 150 cm / 59 × 59 in
Private collection

The British artist Mark Lascelles Thornton's (born 1976) obsessive pen drawings hark back to the fathers of lunar draughtsmanship, Thomas Harriot and Galileo Galilei, as well as the work of the pastel portraitist John Russell. While Harriot wanted to map the features of the Moon, Galileo aimed to show its qualitative properties and Russell captured a sense of the skin of the lunar surface. Thornton's photo-realistic drawings synthetize all their approaches, using detailed spacecraft photography his forebears could only have dreamed of. As the number of known moons and their definition continues to evolve, Thornton's project, which engages directly with the evidential nature of project-based science, has the potential to be open-ended. For now, he has reproduced nineteen of the Solar System's moons on A1 paper. These were selected for being large enough to be considered dwarf planets if they were orbiting the Sun rather than a planet and having achieved hydrostatic equilibrium, that is a balance between pressure and gavity, resulting in a spheroidal shape. Using the type of Rotring pen traditionally used in technical drawings for its straight, cylindrical nib and the clarity of the resulting outlines, Thornton renders the cosmic darkness through a network of meticulously drawn lines of extraordinary precision.

Ink and watercolour on paper, *Codex Durán*
27.6 × 18.8 cm /11 × 7½ in
Biblioteca Nacional de España

HISTORIA DE LAS INDIAS DE NUEVA ESPAÑA E ISLAS DE LA TIERRA FIRME
1579

DIEGO DURÁN

The Aztec Emperor Moctezuma II looks on with some trepidation as a comet blazes above a desert dotted with prickly pear cacti and bathes the land in shades of yellow. Produced around 1579 by the Spanish Dominican friar Diego Durán (c.1537–88), the picture is full of dark portent. Moctezuma's concern was founded on several comets seen at this time. Hernán Cortés himself saw one in 1517, landing with his band of Spanish *conquistadores*

in Mexico two years later – and just two years later still the emperor was dead and the mighty Aztec Empire was in ruins. The sudden collapse of the mighty empire is one of history's most puzzling episodes, but one contributing factor might have been fatalism on the part of the Aztecs. Their priests interpreted the comets as a warning that the current age was about to come to an end (in Aztec myth, the world had ended in spectacular disaster four times

previously). The appearance of the comets coincided with the appearance of disease that killed thousands of Aztecs, and the priests argued that the comets, the disease and Cortés had been sent to punish the Aztec people. In fact, the disease was smallpox, brought by the Spaniards. This drawing appeared in Durán's history of the Aztec Empire, usually known as the *Codex Durán*, one of the main sources of information about the Aztecs.

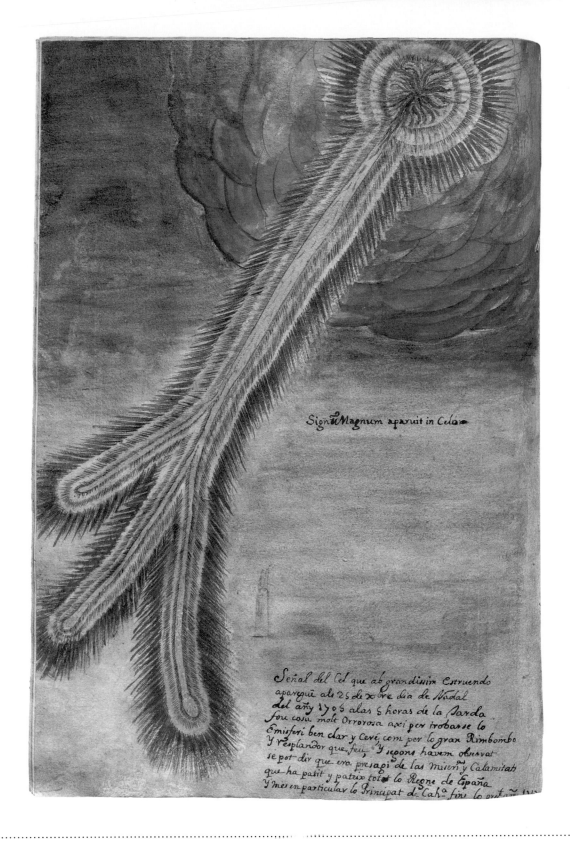

Señal del Cel que ab grandissim Estruendo aparegue als 25 de x.bre dia de Nadal del any 1705 alas 5 horas de la Barda fou cosa molt Orrorosa axi per trobarse lo Emisferi ben clar y Cerè, com per lo gran Rimbombo y resplandor que feu, Y segons havem observat se pot dir que era presagi de las miserias y Calamitats que ha patit y pateix tot lo Regne de España Y mes en particular lo Principat de Cah.ª fins lo ent.... ...

METEOR OVER CATALONIA

18th century

JOSEP BOLLÓ

Bound manuscript in colour, 35 × 25 cm / 13¾ × 9¾ in
Biblioteca de la Universitat de Barcelona

Leaving a tail that burns through the sky, a meteor splits into three flaming tongues as it falls over Catalonia on Christmas Day 1704, in this manuscript painting accompanied by a detailed description of the event. Very little is known of Josep Bolló, the artist who created this striking composition of golds and reds. A number of chondrites – stony meteorites – weighing about a kilogram were later recovered around the small town of Terrassa, inland from Barcelona. The remarkable phenomenon was widely noted in contemporary chronicles. This was partly because it occurred on such an auspicious day in the Christian calendar, but also because the political climate in Catalonia at the time was so tense that observers took the appearance of the comet as a bad omen. In the early stages of the War of the Spanish Succession (1701–14) – an attempt by Louis XIV to place his preferred candidate, the Bourbon prince Philip of Anjou, on the Spanish throne – the British and Dutch had landed troops in Barcelona in May 1704. They planned to encourage a Catalan uprising against Philip's rule in favour of Charles of Austria, but the revolt failed. A second landing in 1705 captured Barcelona from Bourbon rule: for the rest of the war, Catalonia supported Charles, before Philip's ultimate victory in 1715.

ASTRAL DANCE
1987

BANG HAI JA

Ink, oil, acrylic on paper marouflage on canvas
162 × 141 cm / 63¾ × 55½ in
Artist's collection

In this oil painting by Korean Bang Hai Ja (born 1937) forms resembling the stars are caught in the midst of a dynamic swirling dance of fire and light. At the base of the work, a sphere recalling the Sun shimmers with tones of gold, ochre and orange, a hazy mirage of heat emanating as an aura from its curved surface. Above, the cosmos is a mass of whirling, bursting colour: dark indigo, yellow, deep earthen red, pale creamy white,

sky blue and navy spill into one another in this marbled composition. Dappled with countless dots and delicate strokes of pigment, the textured atmosphere appears to be in a state of constant motion as gases drift in and out of one another. Often utilizing Korean paper, which comprises leaves and plants as well as the unwoven fabric of geotextiles, Bang Hai Ja paints both sides of the material so that it is saturated with mesmeric colour.

Moving in 1961 from her native Seoul to France – where she learned about Post-Impressionism, Expressionism and Cubism – Bang Hai Ja became interested in combining her knowledge of Eastern and Western art history, merging calligraphy with the avant-garde. Also looking within, she sought to reach deep inside herself to express emotion and feeling. By fusing this with her perception of the Universe, she portrays both inner and outer worlds.

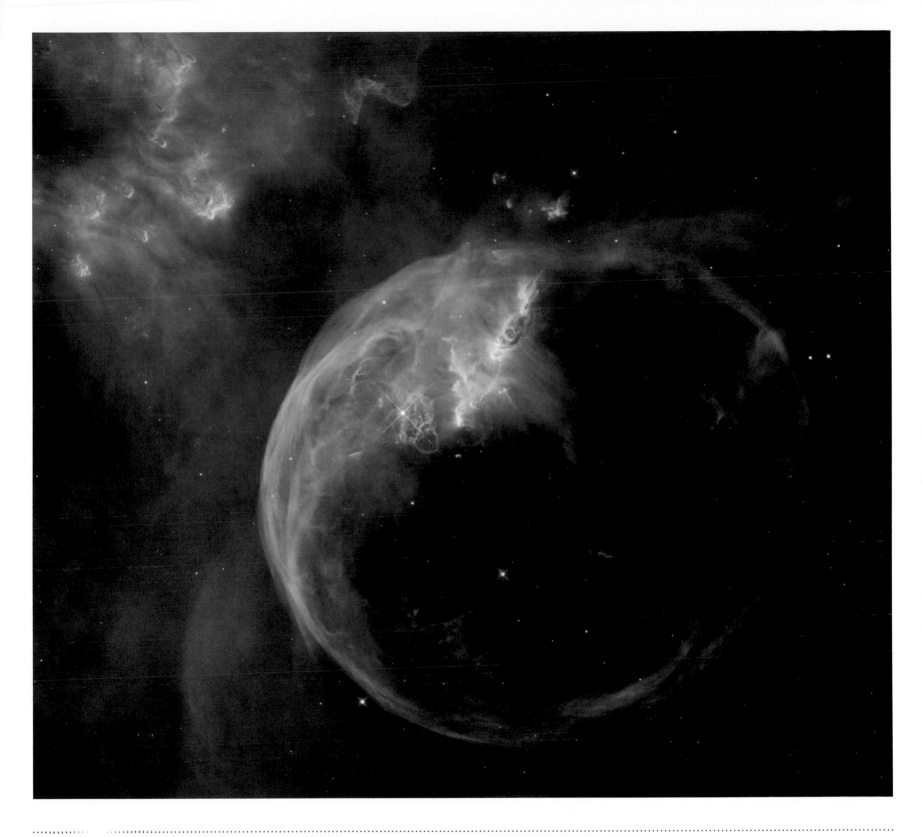

BUBBLE NEBULA (NGC 7635)
2016

NASA, ESA, HUBBLE HERITAGE TEAM
(STSCL/AURA)

Digital photograph, dimensions variable

At upper left inside the orb of cerulean blue from which the Bubble Nebula takes its name (NGC 7635) twinkles the purple star responsible for this energetic display. Located in the constellation Cassiopeia, about 7,100 light years from Earth, the Bubble Nebula is itself about 10 light years across. Although small in comparison to the nebula, the star in NGC 7635 is impressively large and hot compared to most stars: it is forty-five times the size of our Sun. Stars this massive live fast but die young. In order to maintain their size, they must burn fuel quickly and therefore they have a shorter life span than other stars. Such stars are consequently extremely hot, and escaping hot gas creates a stellar 'wind' blowing outward at four million miles per hour, forming an edge as it pushes cooler gas aside. The star is situated by the side of a dense region of cold gas, which slows the expansion of the bubble on that side, so the star appears off-centre in the bubble. The star's light causes its surrounding area to glow various colours, reflecting varying temperatures. Hottest, in bright blue, is oxygen and cooler in yellow and gold are hydrogen and nitrogen. This image was crafted in February 2016 from multiple photos taken by the Hubble Space Telescope's Wide Field Camera 3.

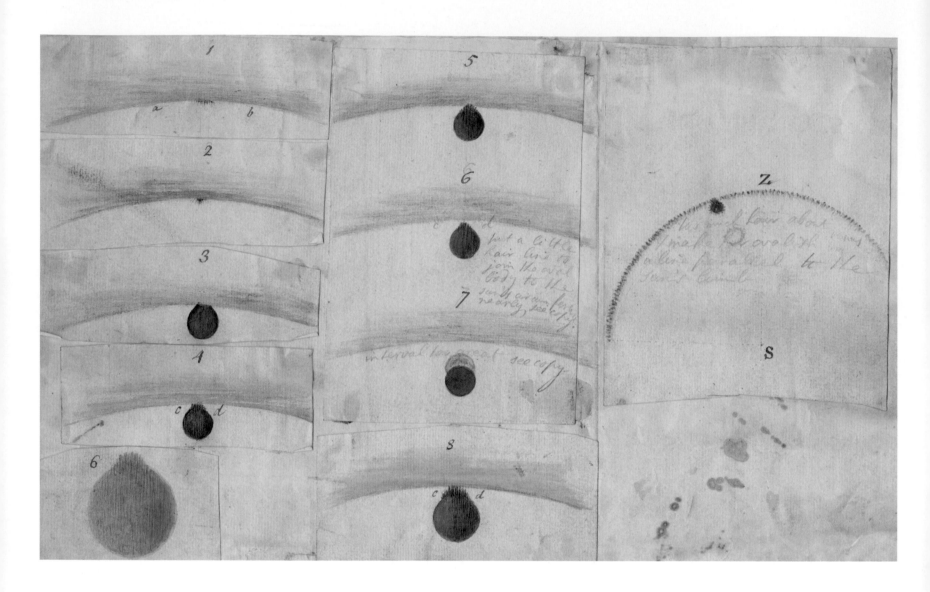

**INGRESS OF VENUS DURING THE
1769 SOLAR TRANSIT**

1769

WILLIAM HIRST

Ink on paper, 19.5 × 32.5 cm / 7⅔ × 12¾ in
Royal Society, London

When these eight sketches detailed the changing shape of the black disk of Venus across the face of the Sun on 12 June 1769, a transit of Venus was a major event. While William Hirst drew these sketches from the comfort of Greenwich in London, his fellow Royal Navy officer Captain James Cook had sailed to Tahiti in the South Pacific to observe the same phenomenon. The timings of the transits as observed around the world enabled experts to use triangulation to work out the distance of the planet from Earth and thus the size of the Solar System, which in turn made astronomical predictions and celestial navigation easier – and thus of great interest to the Royal Navy. The first sign of the transit, Hirst noted, was 'the sudden appearance of a violent corruscation, ebullition, or agitation of the upper edge of the Sun'. Over about twenty minutes, the disk of Venus became 'a black notch breaking in upon the Sun's limb'. Just before the planet moved entirely on to the Sun, the 'black drop' became visible. This black thread apparently connecting the dark disk of the planet to the outer edge of the Sun, as shown in Hirst's later sketches, was explained by the Russian polymath Mikhail Lomonosov as an effect of the atmosphere of Venus, but is now believed to be merely an optical illusion.

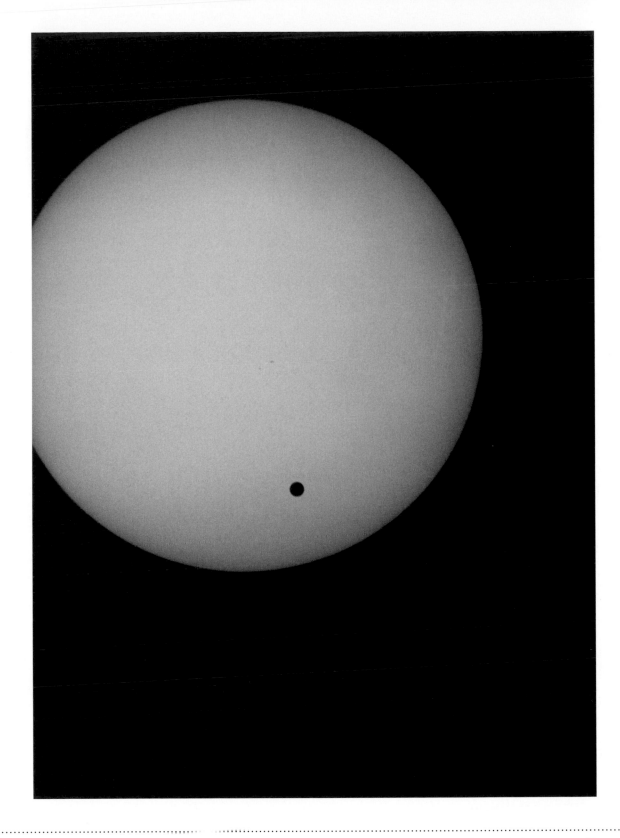

TRANSIT OF VENUS

2004

WOLFGANG TILLMANS

Photograph, dimensions variable

The black dot crossing the ball of the Sun is Venus. This photograph was taken by the renowned German artist Wolfgang Tillmans (born 1968) on 8 June 2004. No person alive at the time could have witnessed another transit of Venus – the previous one had occurred 122 years earlier, in December 1882. The phenomenon happens only when the Sun, Venus and Earth are in alignment. In Tillmans' image, this event takes on an abstract quality, juxtaposing the black void of space with the solid circular mass of the Sun and the off-centre bullet point of Venus itself. Tillmans made the image using the telescope he had as a teenager, when his interest in astronomy began, and swapped its eyepiece in and out several times with a camera adaptor for his 35mm SLR camera. For safety from the sunlight – eye protection is essential for viewing a transit – he reduced the exposure time to just a quarter of a second. Although the telescope's high magnification made it difficult to avoid camera shake, Tillmans took seven good pictures during the transit. The pink tint in this one derives from a Mylar solar filter. Tillmans refined the image in the darkroom as he printed it on light-sensitive photographic paper. This physical quality alone makes the print a rarity in this digital age.

THE MOON'S SURFACE WITH EARTH VISIBLE IN THE SKY

*c.*1963

LUDĚK PEŠEK

Acrylic on canvas
Private collection

The Earth hangs low over the horizon in this depiction of the lunar surface painted in 1963, before humans had even set foot on the Moon, but uncannily similar to the photographs taken by the Apollo astronauts after July 1969. The Czech illustrator and writer Luděk Pešek (1919–99) used the most up-to-date lunar landscape research to depict the Moon with smooth rocky outcrops and an impact crater. A 'sailing stone' has left a trail

in the dust as it moved across the lunar surface. This phenomenon – which also occurs on Earth in locations such as Death Valley in California – remains unexplained. The rocks may have moved because they are on a slope or due to lunar impacts, or may have been inched along by a sequence of ice formation and thawing. Brought up in a mining town in Czechoslovakia, Pešek became fascinated by both geology and astronomy. He attended

the Academy of Fine Arts in Prague and worked as an illustrator, but it was not until 1963 that he published his first book, *The Moon and Planets*, from which this painting comes. Pešek went on to depict Earth and the planets of the Solar System as well as imagined 'alien worlds'. His accurate painting style and attention to detail placed him in the tradition of space artists such as Lucien Rudaux (see p.162) and Chesley Bonestell (see p.268).

THE FIRST IMAGE OF EARTH FROM THE MOON

1966

NASA

Photograph
University College London

The scanning lines across this black-and-white image of the lunar surface with the Earth in the background, taken on 23 August 1966, may not be aesthetically pleasing but do not detract from its historical importance. This was the first photograph of an 'Earthrise', as the Earth hung in space above the surface of the Moon. It was taken by Lunar Orbiter 1, the first of a series of reconnaissance satellites launched by NASA as part of an urgent mission to identify possible landing sites for the first Moon landing, then only a few years away. Among other sensors, the orbiters carried photographic film cameras, a miniaturized photo-processing lab and a means of scanning the processed negatives to transmit the images of the lunar surface back to Earth via a NASA tracking station near Madrid, Spain. Showing objects a few metres across, the photographs were a great improvement on anything seen before, and enabled mission planners to select an appropriate landing site – *Mare Tranquillitatis* (the Sea of Tranquility). The analogue tapes of the transmitted data have recently been digitally enhanced by the Lunar Orbiter Image Recovery Project (LOIRP) team – but even in its original format the image was momentous enough for NASA to have it printed as a poster for distribution to the public.

CONSTELLATIONS
1924

PABLO PICASSO

Pen and India ink, 31.5 x 23.5 cm / 12½ x 9¼ in
Musée Picasso, Paris

These pen-and-ink constellations were inspired by gazing at the night sky. The sky charts depicted in what Spanish artist Pablo Picasso called his *Constellation Drawings* – sixteen pages from a 1924 notebook dotted with delicate, intricate shapes – are delineated like variations on a musical score. While ostensibly abstract – small black circles of ink connected with thin pen lines – we see glimmers of figurative moments amid the curving forms

and irregular patterns of the four groupings: at top right we can loosely discern an otherworldly square-headed being, with straightened arms and legs; at bottom right, the curvature of a planet is suggested, interrupted by intersecting geometric shapes such as triangles and rectangles. Other images in the series are indicative of a giant black Sun emitting rays of light; a guitar complete with neck, soundhole and frets; and strange

insects or flying machines, comprising concentric-circle thoraxes and angular antennae. One of the outstanding artists of the twentieth century, Picasso was associated with avant-garde movements including Cubism and Surrealism. His approach to style was developmental, if not eclectic, and these drawings sparkle like hidden stars, unknown compared to more famous paintings such as *Les Demoiselles d'Avignon* (1907) and *Guernica* (1937).

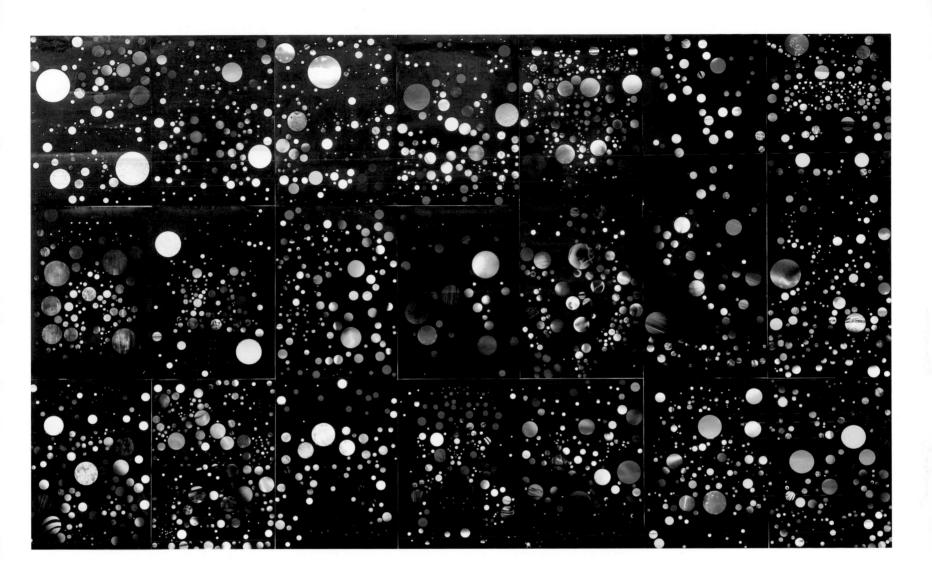

CONSTELLATION

2009

LEO FITZMAURICE

Permanent marker pen on film posters
180 × 294 cm / 70¾ × 115¾ in
Private collection

Depending on one's perspective, these constellations of rainbow-coloured circles created by British artist Leo Fitzmaurice (born 1963) could be clusters of planets, dark matter or stars or, alternatively, a purely abstract pattern. Fitzmaurice used permanent marker-pens to draw large and small circles on film posters, before filling in the space around these globes with a deep black; glimpses of the original posters remain, surrounded by

the equivalent of a dark night sky that absorbs the light around them. A turquoise-blue atmosphere with fluffy white clouds is discernible in one panel; while the other twenty sections of this stellar tapestry feature a dynamic spectrum of shades, ranging from canary yellow to royal blue, khaki green, cherry red, lilac, ochre and coral pink. Fitzmaurice harnesses his audience's potential for vis ual confusion and perceptual illusions, playfully using

found objects and reframing them as something new. By intervening with everyday matter, he gives objects new connotations, with past works utilizing cigarette packets that become football shirts, or rubbish bags that appear as rabbits. The artist creates his own universe of references, as the quotidian becomes extraordinary – or in the case of *Constellation*, extra-terrestrial.

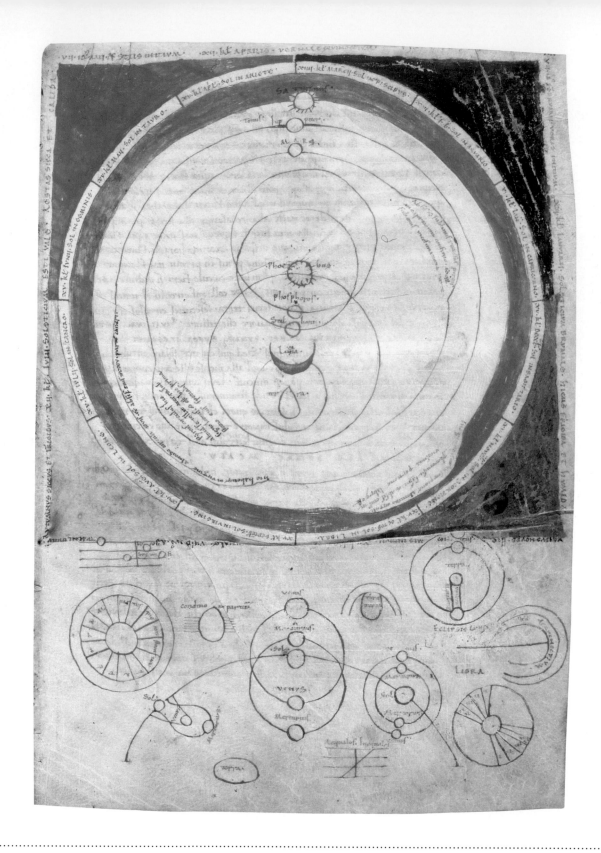

DE NUPTIIS PHILOLOGIAE ET MERCURII
11th century

MARTIANUS CAPELLA

Ink on parchment, 26.5 × 18.5 cm / 10½ × 7¼ in
Biblioteca Medicea Laurenziana, Florence

The fifth-century Latin writer Martianus Capella was an influential thinker throughout the middle ages. For the many scholars who read his allegorical work *On the Marriage of Philology and Mercury* in the thousand years after its composition, his most important contribution was to define the seven liberal arts of a classical education. Grammar, logic, rhetoric, geometry, arithmetic, astronomy and music were imagined as bridesmaids in the symbolic

courtship of learning (Philology) by intelligent pursuit (Mercury). The seven arts were to form the basis of the curriculum at the medieval universities, and this diagram was drawn in the century when the first universities were established. It presents Martianus's geo-heliocentric theory. The Sun, Mars, Jupiter and Saturn are presented with extremely off-centred orbits around the teardrop-shaped Earth, while Mercury and Venus orbit the Sun.

Bulges in the orbits of the outer planets remind the reader that they move closer to and further from the Earth. Martianus's system was praised by Copernicus, who used it as a stepping-stone in his argument that the outer planets also orbited the Sun. Some astronomers who rejected Copernicus' arguments continued to favour Martianus's scheme into the seventeenth century.

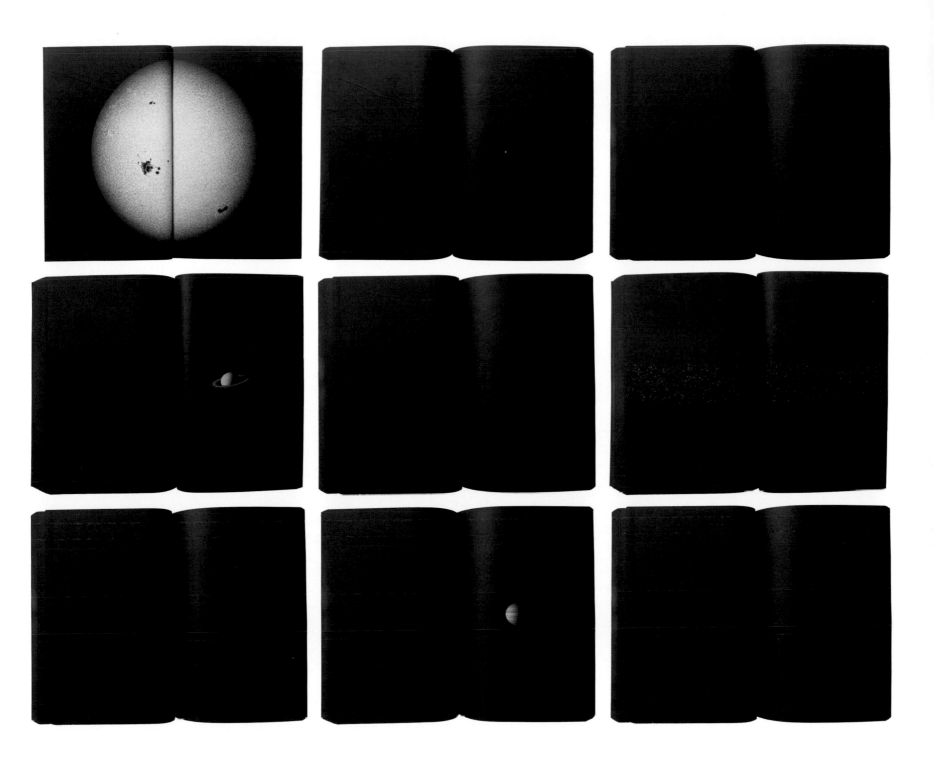

ASTRONOMICAL

2011

MISHKA HENNER

Twelve paperback volumes, each 13.97 × 21.59 cm / 5½ × 8½ in
Private collection

In the twelve volumes of *Astronomical*, each of which has 500 pages, the Belgian British-based artist Mishka Henner (born 1976) creates a scale model of the Solar System. The first volume begins with an image of the Sun. The last page of the last volume – page 6,000 – features an almost invisible dot representing Pluto. Virtually all of the pages between are unbroken black, as leafing through the books replicates the experience of travelling through space at a scale where one page equals one million kilometres (621,000 miles). Volume 1 covers the planets from the Sun to the asteroid belt – Mercury (another speck), Venus, Earth and Mars – building on the anticipation of encountering a planetary body. From the Sun, it takes 155 pages to reach the Earth, a pale dot, so small it could easily be missed. The remaining eleven volumes are broken only by the four gas giants – Jupiter, Saturn, Uranus and Neptune – before we reach Pluto (reclassified as a dwarf planet in 2006). By representing the void of interplanetary space within the familiar form of a book, Henner evokes the isolation of the Earth, lost within the immensity of the Universe. Much of Henner's work relies on mining Internet data to catalogue human activity (military bases, industrial farming, prostitution), but here he exposes the vacuum beyond our planet.

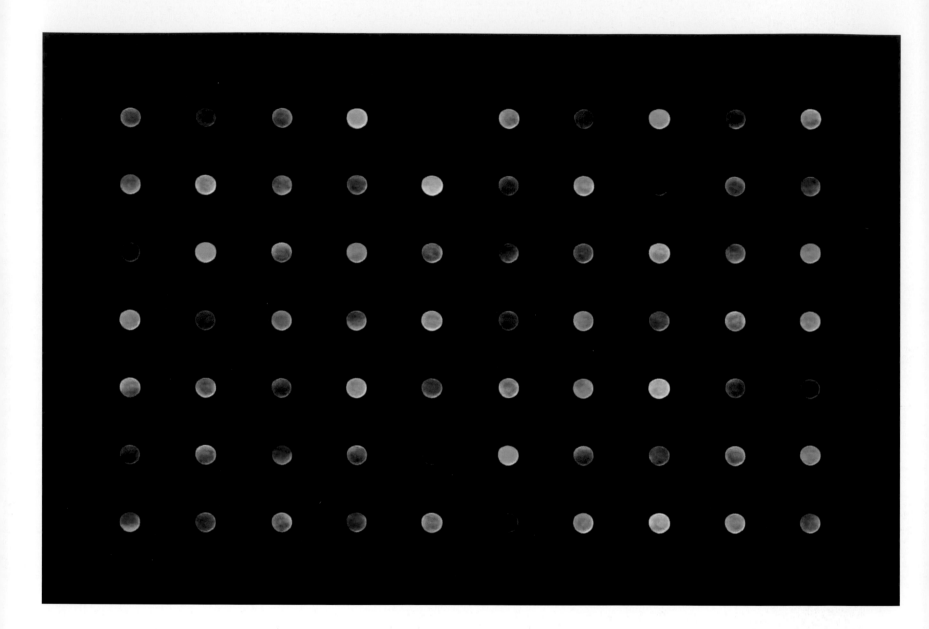

THE RAINBOW STAR
2016

STEVE BROWN

Composite digital photograph, dimensions variable

Seventy images of Sirius, the second brightest star in Earth's sky, present an apparently perfectly circular disk in a range of colours. Sirius – sometimes called the Dog Star because of its position in the constellation Canis Major – is in fact a binary star system known for millennia for its brightness, 'twinkling' and colour changes (the title of this work draws on another common name, the Rainbow Star). When British astrophotographer Steve Brown set out

to capture the rapid cycle of colour changes, he decided that video would be the best way to capture each flash of colour. Brown's observations of Sirius led him to break two rules of astrophotography. Although he positioned the star in the centre of the frame, it is intentionally out of focus; he also created the impression of a uniform disc. Brown shot his video when Sirius was low on the horizon, which creates poor viewing conditions, but provided exactly

what Brown wanted; the starlight passes through more of the atmosphere, resulting in a greater range of colour and twinkling spread over a larger area. Brown filmed Sirius in the hills close to his home in North Yorkshire before selecting 70 single frames to create this composite image. He was surprised by the sheer variety of colours revealed, with ranges of purples, pinks and oranges, and numerous shades of turquoise and indigo.

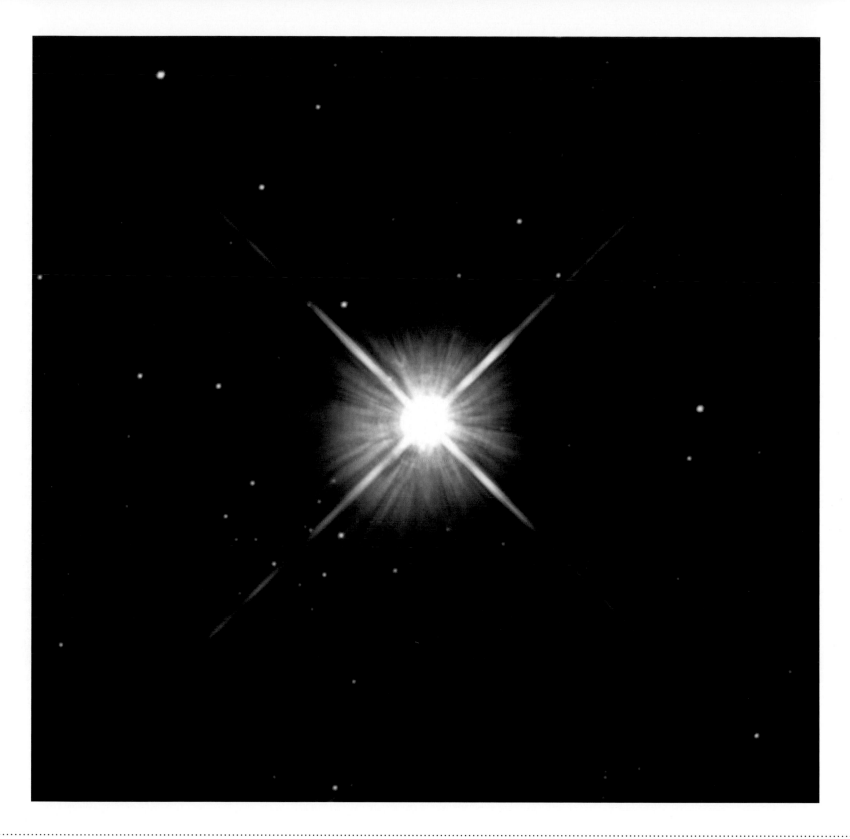

PROXIMA CENTAURI
2013

ESA, HUBBLE AND NASA

Digital photograph, dimensions variable

The classic 'pointed' shape of this 2013 Hubble Space Telescope photograph of Proxima Centauri, the closest star outside our own solar system (*proxima* is Latin for 'the nearest'), frequently occurs in depictions of stars made since the invention of the telescope. The points we commonly associate with stars are actually the result of the limitations of technology. The light from Proxima Centauri is so bright that it shows up the minute flaws and features of the Hubble telescope and its camera. The cross shape is formed by diffraction spikes, an image distortion common to telescopes that use a mirror rather than a lens to focus the light. The distortions are caused by cross-shaped struts supporting the telescope's secondary mirror. Any roughness and dust on the mirror forms a halo of scattered light around the sharp core of the star's image. The halo around Proxima Centauri shows up in delicate reds and blues – the result of merging two coloured pictures to form this composite image. Proxima lies in the constellation of Centaurus, and is 4.25 light-years from Earth. Apart from its proximity, the picture is beautiful to look at, except to a telescope optics manufacturer, for whom it is a nightmare, bringing into prominence limitations in his skill.

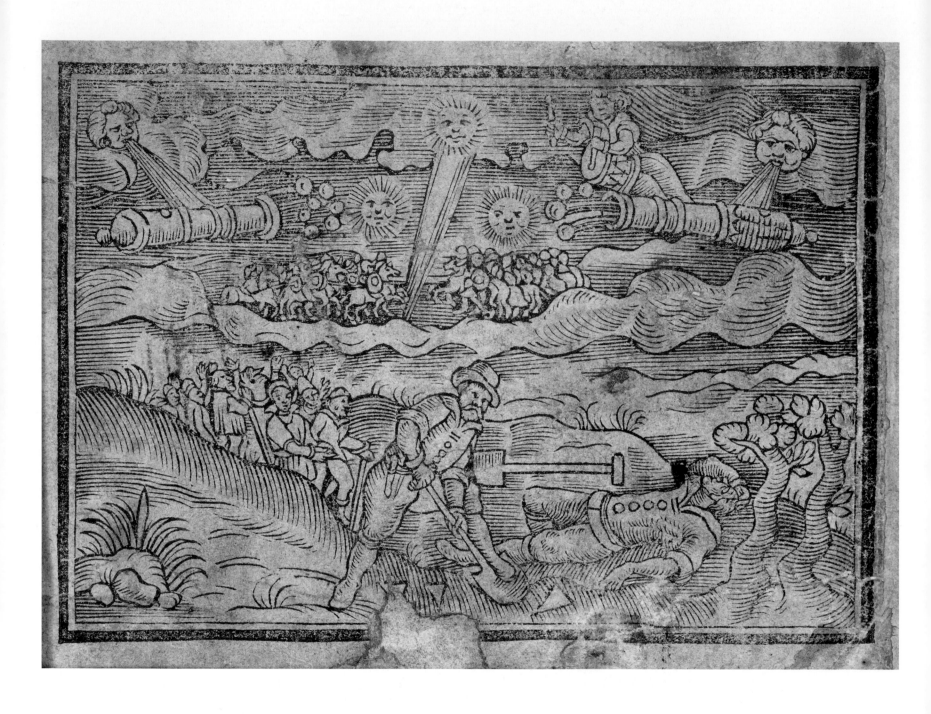

HATFORD METEORITE FALL
1628

THOMAS DEKKER

Woodcut, 30.5 × 19 cm / 12 × 7½ in
British Library, London

This woodcut print, sometimes attributed to Thomas Dekker, made in 1628 gives an impression of the consternation caused in the small village of Hatford in Berkshire, southern England, by a meteorite fall at about 5 p.m. on 9 April that year. The event was accompanied by such loud noise that local people reported hearing the sounds of battle in the sky, represented here by cannons and opposing armies, complete with a drummer boy. Modern astronomers suggest that the sound might be explained as a double sonic boom, caused when the meteoroid entered the Earth's atmosphere. For the contemporary artist, however, the phenomenon clearly indicated that something was awry with the world – hence a sky that features three Suns at the same time. The illustration also shows the episode's aftermath (depicting consecutive events as happening simultaneously was a common artistic device in broadsheet illustrations of the time) as two brave souls have ventured ahead of the other villagers in order to begin to dig up the brownish stones that have fallen from the sky. Coming into contact with these mysterious cosmic fragments proves too much for one man, however, and he faints. Today, scientists estimate that anything between 18,000 and 84,000 meteorites fall to the ground every year.

ESSAY ON THE ASTRONOMICAL AND
METEOROLOGICAL PRESAGES

c.1425

UNKNOWN

Ink on paper, 36 × 19 cm / 14 × 7½ in
Private collection

Comets and sunspots loom in the sky above rocky peaks and pine trees typical of Chinese landscape art of the Ming dynasty. This page from a book originally created in about 1425 shows just four of some 800 delicately painted images in what was essentially a handbook for astrologers in the court of the Ming ruler Renzong, known as the Hongxi Emperor. At the time, astrologers were key officials in the imperial bureaucracy, who studied celestial phenomena and other omens in order to advise the emperor on propitious periods for decisions or actions. The book depicts a range of celestial objects such as the planets and their movements, constellations and solar phenomena such as sunspots, as well as meteorological phenomena ranging from the familiar – clouds, rain, rainbows, parphelia (the display known as sundogs or mock suns) – to the fantastical, including meat falling from the sky, dragons and showers of coins. Each illustration is accompanied by an explanation of what the omen portends. Although astrology and prognostication have long been discredited in the West, astrological observations play an important role in our understanding of early astronomy. Early Chinese astrologers, for example, kept detailed and accurate records of comets over many centuries.

FIRST MOON FLIGHTS CLUB CARD
c.1968

PAN AMERICAN WORLD AIRWAYS INC.

Printed card, 9.25 × 13.3 cm / 3¾ × 5¼ in
PAHF Digital Collection

This slightly dog-eared, credit-card-sized piece of cardboard depicting two astronauts on the Moon was, briefly, what a ticket to lunar travel looked like. In 1968, the now-defunct Pan American World Airways (Pan Am) launched the 'First Moon Flights' Club for passengers to reserve a seat on the first commercial flight to the Moon – a year before Neil Armstrong and Buzz Aldrin made the first moonwalk in 1969. Enthusiasm for space travel was reaching a peak following the successful 1968 mission of Apollo 8 and in 1968 Stanley Kubrick's film *2001: A Space Odyssey* depicted a fictional Pan Am space-plane, the Orion III, positioning Pan Am as the go-to airline for future space travel (the reverse of the card lists other Pan Am 'firsts', implying that the airline would also be first to the Moon). By the time the reservations list closed in 1971, more than 93,000 'First Moon Flights' Club cards had been issued (joining the waiting list needed no down-payment, simply a phone call to a reservations clerk). As late as 1989, Pan Am was still suggesting that commercial spaceflights might become reality in the year 2000 – but that prospect, like Pan Am itself, has faded. Beyond a few super-rich space tourists, these slips of cardboard are all that remain of the heady days when commercial flights to the Moon seemed inevitable.

SPACE (TRIBUTE 21)
1994

ROBERT RAUSCHENBERG

Offset lithograph, 104.1 × 68.6 cm / 41 × 27 in
San Francisco Museum of Modern Art, CA

As the last in a series of twenty-one offset lithographs, *Space (Tribute 21)* depicts an astronaut floating in the zero gravity of space, beneath which the curvature of the Earth can be discerned, with its wispy clouds and blue seas. Commissioned by Felissimo – a Tokyo-based corporation that sought to progress social conditions – and printed at Universal Limited Art Editions (New York), each individual print celebrated a different humanitarian achievement to promote prosperity and peace at the end of the twentieth century. Using sustainable methods, the group used non-toxic printing dyes and water to transfer the images to paper, abstaining from the use of solvents in this process. *Space (Tribute 21)* comprises two sections, with its upper part depicting a vision of orange, blue and white planetary rings with a grainy, mottled texture where the ink has not fully adhered. Associated early on with the Pop Art movement, US artist Robert Rauschenberg (1925–2008) is celebrated for his Combines, which use found objects such as quilts and stuffed animals to foreground the connection between art and life. *Space (Tribute 21)* was not his first reference to the cosmos; after witnessing the 1969 launch of Apollo 11, Rauschenberg produced his *Stoned Moon* series, a group of lithographs based on NASA archival materials.

GALAXY CLUSTER ABELL S1063 AND BEYOND

2016

NASA, ESA, AND J. LOTZ (STSCI)

Digital photograph, dimensions variable

The yellowish blob that dominates this image – a massive elliptical galaxy in a galaxy cluster named Abell S1063 four billion light years away and imaged by the Hubble Space Telescope – is not its most interesting feature. The delicate bluish arcs centred on the main galaxy are faint galaxies that lie behind – and twice as far beyond – the galaxy cluster, made visible by a phenomenon known as gravitational lensing. The huge mass of Abell S1063 warps space-time around it, bending and magnifying light that passes through its gravitational field – and thus making the unseen visible. The effect, predicted by Albert Einstein's theory of general relativity some 100 years ago, offers astronomers a tantalizing glimpse back to the first generation of galaxies of the Universe. This photograph also illustrates another, unrelated, astronomical effect produced as the main galaxy engulfs the lesser ones around it, increasing its mass. This disturbs the otherwise smooth gradation in the density of stars in the outskirts of the galaxy, producing subtle shell-like variations in brightness. A few are just discernible, but they usually need special techniques to make them visible. Elliptical 'shell galaxies' have proved quite common since they were discovered by the astronomers David Malin and David Carter in 1980.

WESTERLUND 2

2015

NASA, ESA, THE HUBBLE HERITAGE TEAM (STSCI/AURA), A. NOTA (ESA/STSCI), AND THE WESTERLUND 2 SCIENCE TEAM

Digital photograph, dimensions variable

This view of the star cluster Westerlund 2, about 20,000 light years away in the constellation Carina, is impossible to see at visible wavelengths, as the star cluster is heavily obscured by dust. This false-colour image – released to mark the twenty-fifth anniversary of the Hubble Space Telescope in 2015 – uses data from observations at infrared wave lengths, which do penetrate dust. Westerlund 2 – it is one of three star clusters discovered by the Swedish astronomer Bengt Westerlund – has a dense concentration of massive, young stars, no more than a couple of millions of years old. The brightest star (below and right of the centre of the star cluster) is in fact a pair of stars called WR20a, each approaching 100 times the mass of the Sun. They are about as massive as stars get, and correspondingly rare: they will soon explode as supernovae. The fainter red dots sprinkled around the bright stars are new-born stars, still swaddled in cocoons of gas and dust that will eventually turn into planetary systems. Strong winds and radiation from the energetic massive stars have blown a hole in an adjacent gas cloud, pushing back its edge and sculpting it into pillars that point back to the central cluster. The blue area of the gas cloud is coloured by reflected light from the stars in the cluster.

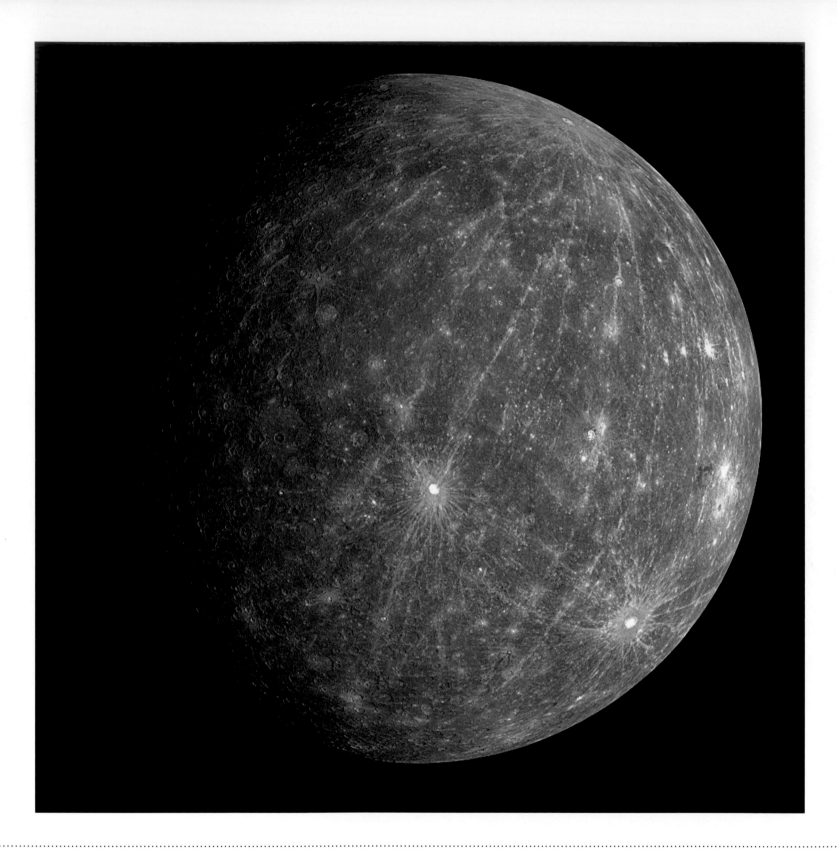

MERCURY
2011

MESSENGER TEAMS, JHU APL, NASA

Digital photograph, dimensions variable

This grey ball of rock with no visible atmosphere might at first glance resemble the Moon, but it is in fact Mercury, the closest planet to the Sun. The planet looks much like the Moon: it has a surface unprotected from the bombardment that in the distant past marked its surface with the craters of asteroids and meteoroids, which show as bright white dots. Notably, however, Mercury lacks any smooth plains of dusty magmatic rock similar to the Moon's dark maria. Mercury is often difficult to see in the bright sky-glow from the Sun when the star is just below the horizon, especially from places with a hazy atmosphere, but this remarkable image was among more than 277,000 photographs taken by the spacecraft Messenger, which orbited Mercury 4,105 times on a four-year mission before it was crashed into the planet in April 2015. The equatorial temperature of Mercury during the day is over 400°C (752°F), but at the poles the temperature never rises above -90°C (-130°F), because Mercury lacks the blanket of an atmosphere to transport heat from the sunlit regions and keep it in. Messenger detected the planet's frozen water-covered poles, and that it has an oddly off-centre magnetic field. Volcanic deposits on the surface are evidence that the planet had a geologically eruptive past.

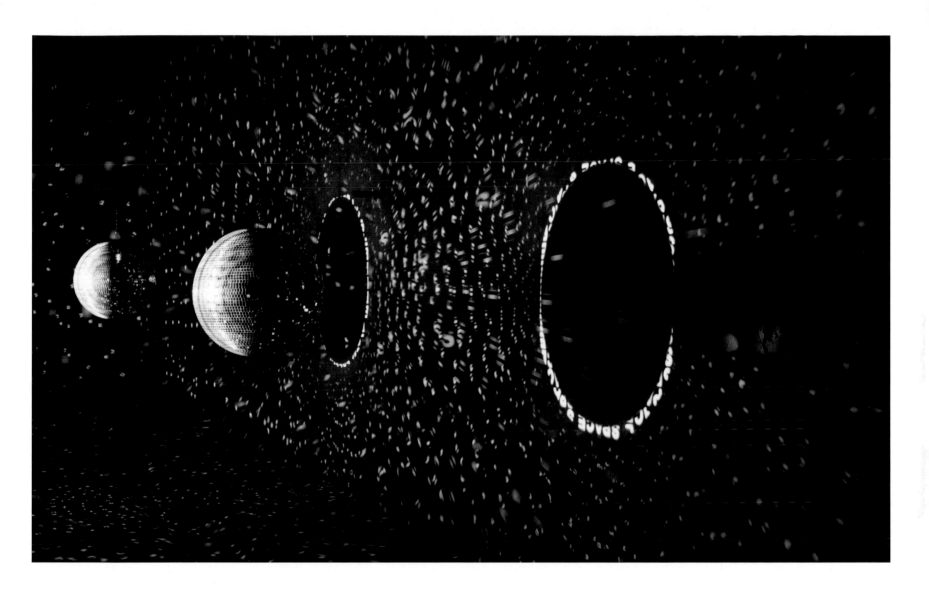

SPACE-SPEECH-SPEED
1998/2001

MISCHA KUBALL

3 mirrored balls, 3 projectors, 2 ceiling motors, 3 slides
Dimensions variable
Zentrum für Internationale Lichtkunst, Unna

A darkened room is punctuated by three mirrored disco balls, which hang and spin like planets or moons. Three corresponding projectors beam light onto the orbs through a circular disc containing multiple iterations of the eponymous, alliterative words 'space', 'speed' and 'speech'. Thousands of facets in the suspended globes break up and reflect the words in light patterns covering the walls, ceiling and floor of the installation – and the

skins and clothes of visitors – like swirling galaxies of shooting stars, reservoirs of gas and moving asteroids. The balls also create eclipse-like phenomena, black circles on the walls surrounded by coronas made from the three words, which here are legible: 'space', 'speed', 'speech'. The white outlines are reminiscent of the solar corona during an eclipse. This installation by the German artist Mischa Kuball (born 1959) brings to life

a mini universe within which the audience can wander amid refracted light particles. Kuball's work often uses light to encourage viewers to see and interact with our surroundings from a different perspective. A sensory experience, *Space-Speed-Speech* combines the sounds emanating from its projectors with dazzling shards of light that spin and swell in a dynamic dance: visitors explore the entire cosmos in the space of one room.

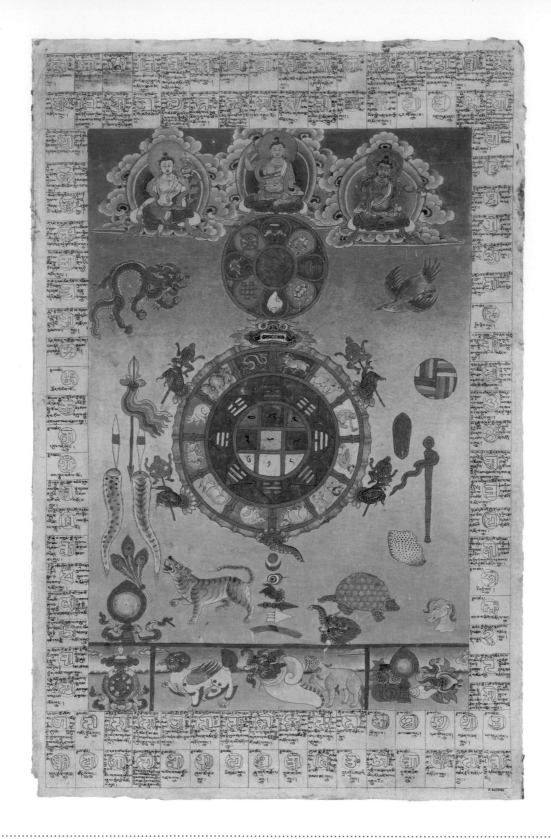

**CHART INDICATING GOOD AND
BAD BLOOD-LETTING DAYS**

1540

UNKNOWN

Watercolour and black ink on white linen
66 × 44.5 cm / 26 × 17 ½ in
Wellcome Library, London

This colourful manuscript illustration of the Tibetan cosmos shows three protector deities floating in clouds – Manjur…i, the White Tarsi and Vajrapani – presiding over a zodiacal wheel and depictions of various cosmic phenomena, which are further explained in the hand-written notes that surround the illustration. For all its aesthetic appeal, the chart had a practical –and potentially life-saving – purpose. In traditional Tibetan medicine, astrological omens dictated forms of treatment, and physicians used this chart to decide on the most and least auspicious days to perform blood-letting, which was usually carried out to remove an infection from the patient's body (or occasionally to release bad spirits that were thought to cause disease or mental illness). At the heart of the image is Rubal, the cosmic turtle, which carries on its back the *mewas*, a magical arrangement of numbers in nine squares, surrounded by eight *parkhas*, which represent the elements. Outside these is a ring containing the twelve animals of the Chinese zodiac, each representing a month of the year. Beneath the turtle's tail are symbols representing the Sun, Moon, Mars, Mercury, Jupiter, Venus, Saturn and the 'secret' planet, Rahu.

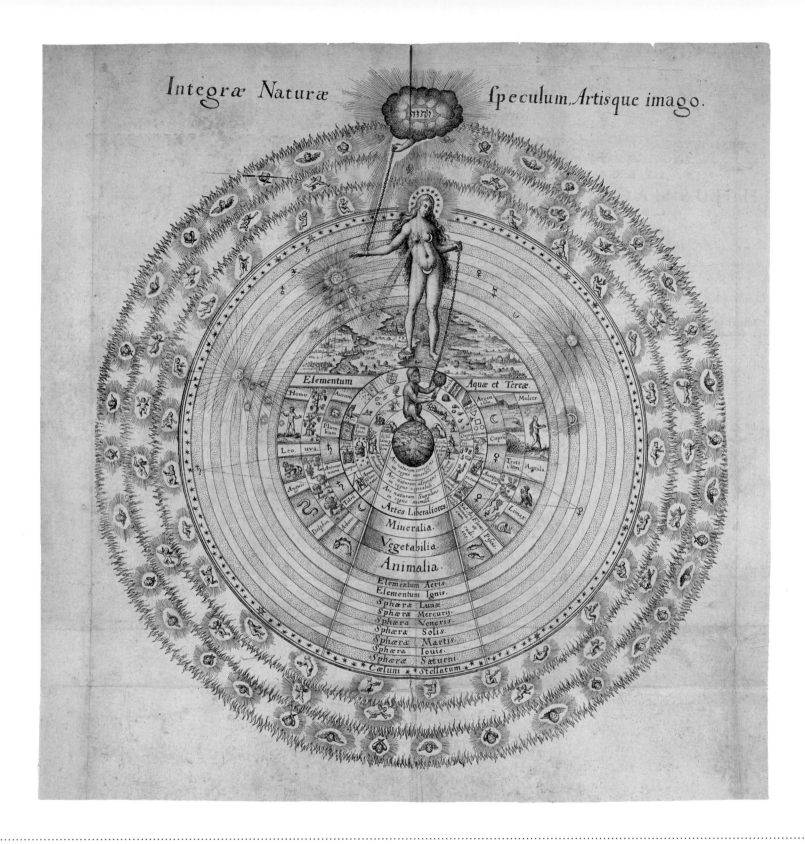

HISTORY OF THE TWO WORLDS
1617

ROBERT FLUDD

Copperplate engraving
British Library, London

The concentric circles of this early-seventeenth-century engraving designed by Robert Fludd (1574–1637) show the spheres of the cosmos, the Earth and their relationship with man. Fludd was an English physician, polymath and mystic who illustrated his theories with elaborate diagrams in his most famous work, the five-volume *History of the Two Worlds* (*Utriusque Cosmi … Historia*), in which this illustration appears. The engraving shows the 'Ape of Nature' at the centre of a universe made of concentric planetary orbits and the stars. The Ape, representing Man and the arts, sits on and plays with the material world of animal, vegetable and mineral things. God occupies the highest celestial regions, mostly hidden behind a cloud of ignorance, but his hand emerges from the cloud to hold Nature herself, who has stars in her hair so the viewer can tell her apart from pagan goddesses, on a chain. Nature in turn keeps the Ape on a chain. Influence radiates from her, and from the planets to Earth and its alchemical elements: sulphur, mercury, lead and so on. Fludd illustrates some liberal and practical arts including music, medicine, painting, bee-keeping and egg production. He has created a comprehensive diagram about the connections between our world and the Universe – and it is either profound or insignificant.

MOON TEMPLE
2017

JORGE MAÑES RUBIO

Inkjet print, 150 × 85cm / 59 × 33.5 in
Private collection

Moon Temple stands atop a massive staircase on the rim of Shackleton Crater, at the lunar South Pole, in this digital simulation. The structure's curved exterior is punctuated by arched doorways, with a hole in the ceiling and skylights extending horizontally. From here, the view of Earth is mesmerizing. This is a place for all human beings, beyond borders and territories – a spiritual space to come together as one. Undertaking

an artist's residency at the European Space Agency in 2016, artist Jorge Mañes Rubio (born 1984) looked at the potential of building an alternative world on the Moon, questioning what its colonization could look like and how the civilization's cultural parameters might develop. Rubio's structure is inspired by the Utopian spherical forms conceived by the eighteenth-century architects Étienne-Louis de Boullée and Claude-Nicolas

Ledoux, which could never be realized on Earth due to their enormous weight – the reduced gravity on the Moon brings new possibilities for architecture. The temple would be built using local materials – the lunar regolith's fine soil, combined with three-dimensional printing techniques – and with a depth of 4,200 metres (14,000 feet), some crevices of the crater may even hold water ice, securing the future of self-sufficient life on the Moon.

**ASTRONAUT BRUCE MCCANDLESS
ON UNTETHERED SPACEWALK**

1984

NASA

Digital photograph, dimensions variable

If any image captures the vulnerability of humans removed from the safety of Earth, it is this image of US astronaut Bruce McCandless floating alone in the vastness of space. The Earth curves below the small figure of the astronaut, the layers of protective atmosphere visible at the horizon. The coastlines of landmasses are dimly and reassuringly visible. Yet McCandless floats free against the deep blackness of space. Although few people will ever share the experience, the powerful photo taken by fellow astronaut Robert L. Gibson resonates strongly and brings to mind the drama of science-fiction films, from *2001: A Space Odyssey* to *Gravity*, when an astronaut disappears into the void, cut free from the tethers that both bind and sustain him. The photograph displays the thrill and terror of space exploration. On 7 February 1984, McCandless took the first untethered spacewalk in history, using a nitrogen-propelled backpack known as the Manned Maneuvering Unit (MMU) to move as far away as 98 metres (320 feet) from Space Shuttle *Challenger*. McCandless had helped to develop the MMU, and he was among the few astronauts to use the device. NASA discontinued it soon afterwards, deciding that the potential risks were simply not justifiable.

ASTRONOMICAL CEILING,
TEMPLE OF HATHOR

1st Century BC

UNKNOWN

Pigment on bas-relief, dimensions variable
Temple of Hathor, Dendera

Recently cleaned, the paintings on the ceiling high above the Temple of Hathor at Dendera in Egypt resemble their appearance when they were painted, probably in the first century BC, when Egypt came under Roman influence. Rows of Egyptian deities and zodiac figures, identified by the hieroglyphic cartouches that accompany them, are portrayed against a background of scattered stars. Hathor, who was usually portrayed carrying a sun disc on her head between the horns of a cow, had for more than 2,000 years been associated with the Milky Way: in some Egyptian interpretations, the sky was held up by the four legs of the cow goddess, with the stars and Sun carried on her belly. The bays of the ceiling – held up by tall columns – are decorated with depictions of the northern and southern halves of the night sky. Elsewhere in the temple, a circular diagram depicted the signs of the zodiac, which had been introduced to Egypt from Babylon by the Romans during the Ptolemaic period. The Egyptians placed great emphasis on astrology in creating their ritual calendar – the pyramids themselves were oriented to align with the North Star – and decorated the ceilings of pharaohs' tombs with star clocks, tables that would allow the spirit of the dead ruler to use the position of the stars to tell the time.

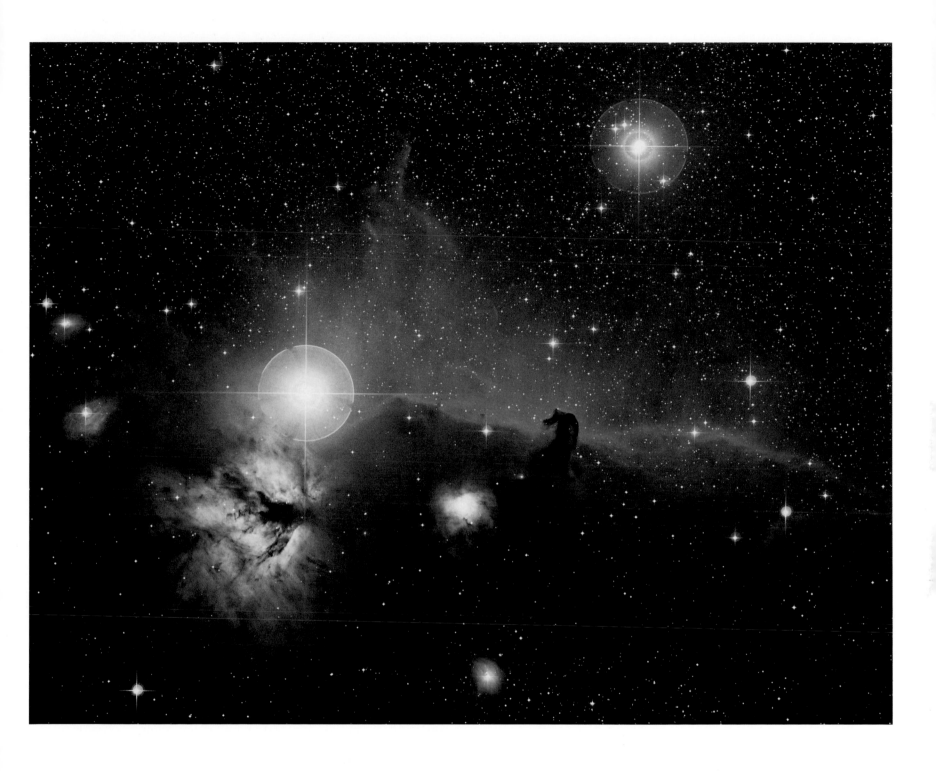

THE HORSEHEAD NEBULA IN ORION
1980

DAVID MALIN, AUSTRALIAN ASTRONOMICAL OBSERVATORY

Photograph, dimensions variable

Today it is common to see the cosmos depicted in vivid colours, but until the adoption of digital imaging at the end of the twentieth century, true-colour astronomical photographs were rare. The process for making them was time-consuming, and astronomers typically favoured black-and-white plates for scientific analysis. However, David Malin, a photographic-scientist astronomer at the Anglo-Australian Observatory, Siding Spring, from 1975–2001, demonstrated the aesthetic and scientific potential of seeing the Universe in colour. Trained as a chemist, Malin relied on his knowledge of photographic emulsions and his skill in the darkroom to create majestic shots such as this view of the Horsehead Nebula. First, he carefully chose photographic emulsions to maximize the sensitivity of the glass plate negatives, and made three separate exposures of the same region, one each for red, blue, and green wavelengths of light, using the UK Schmidt Telescope's wide field plates to frame large regions of the heavens. Malin then created a composite print from the three negatives in the darkroom, also employing photographic developing techniques to bring out the fine details throughout the nebula. The colour, sharp detail and expansiveness of the scene introduced new ways to see familiar celestial objects.

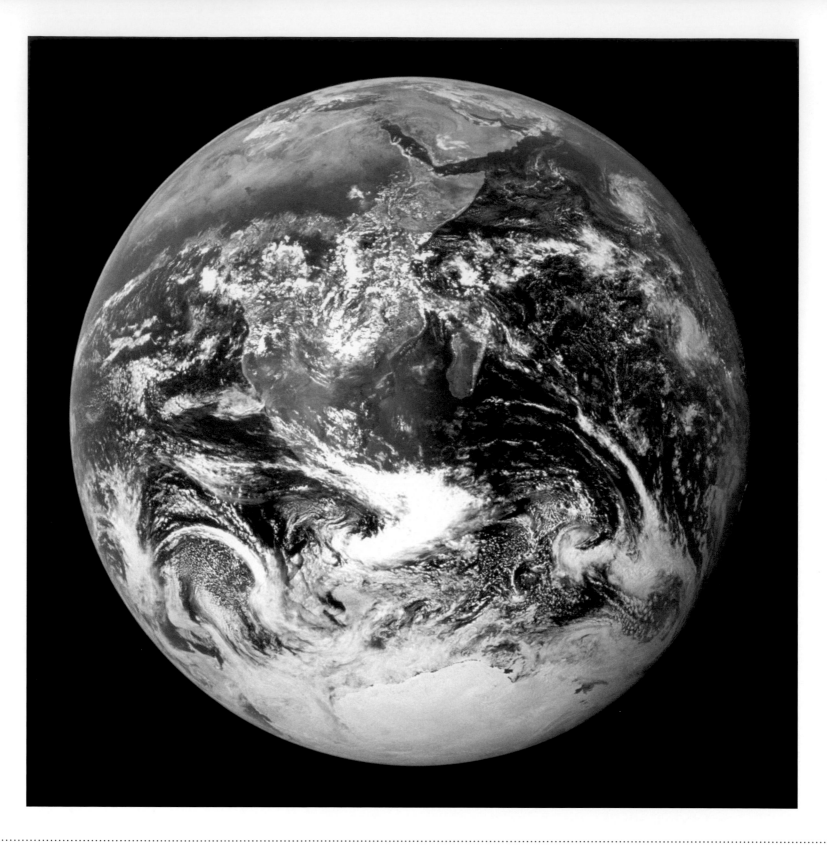

THE BLUE MARBLE
1972

NASA (EUGENE CERNAN, RONALD EVANS, HARRISON 'JACK' SCHMITT)

Photograph

This is one of the most famous and reproduced images of Earth ever taken. Known as the Blue Marble, it was taken by the astronauts aboard Apollo 17 at the start of what would prove to be NASA's final manned lunar mission to date. The globe is fully illuminated by the Sun, as brilliant white clouds swirl above the oceans and blend with the ice-cap that covers the South Pole. Africa and the Arabian Peninsula spread over the top of the globe,

and one can identify their different ecosystems from the shades of tan, brown and green. When seen from space, geopolitical boundaries and divisions disappear. Earth looks beautiful, fragile and unified. Apollo astronauts had taken photographs on previous trips and humanity had long imagined the experience of looking down at the globe – but this was the first clear photograph of the whole Earth. Of the thousands of pictures from the Apollo

missions, many consider this one to have had the most enduring influence. The Blue Marble is often credited with changing humanity's understanding and appreciation for our planet, as well as each other, and for encouraging the development of the environmental movement to protect its obvious fragility. Instead of a world divided, the image acts as a reminder of our common identity as earthlings and the need to preserve our shared home.

AMONG THE PLANETS
1965

HELEN LUNDEBERG

Oil and alkyd enamel on canvas, 152.4 × 152.4 cm / 60 × 60 in
Smithsonian Institution, Washington, DC

While ostensibly abstract in its composition of flat colour planes and geometric forms, the title of this painting – *Among the Planets* – invites the viewer to see it in a figurative way: we stare into the darkness of space sandwiched between the swirling biospheres of two planets, both with a halo of black and another sphere in the far distance. As if floating within this black sliver of zero gravity, we witness the imposing edge of the left-hand form, which blends hues of slate-grey and pale-purple, while on the right, more pastel tones of candy pink, sky blue and sherbet orange mark the contours of an undiscovered world. Although the American artist Helen Lundeberg (1908–1999) worked with geometric abstraction, her compositions often recall interiors, landscapes or other universal forms. Lundeberg referred to these works – neither entirely figurative nor entirely abstract – as enigmas. Her earlier paintings assumed a style that she defined as 'Subjective Classicism' or 'Post Surrealism', aiming to evoke states of mind, moods and emotions. In *The Red Planet* (1934), for example, an interior includes a bright orange doorknob that resembles a planetary globe, while a photograph shows a comet tearing through a star-studded universe.

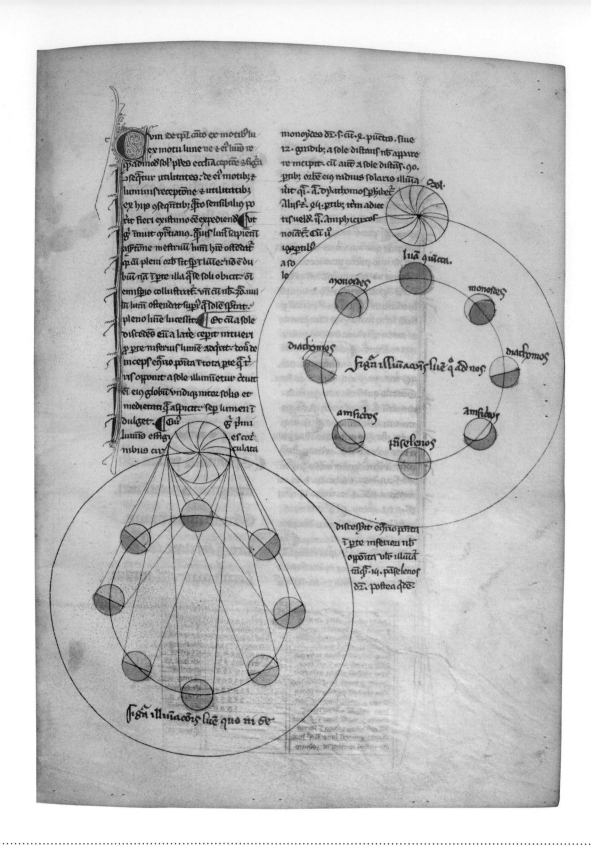

TRACTATUS DE SPHAERA
c.1300

JOHANNES DE SACROBOSCO

Ink on parchment, 25 × 18 cm / 10 × 7 in
British Library, London

These stylish diagrams were first drawn in the thirteenth century to explain two phenomena of the heavens as observed from Earth. The upper diagram shows the changing phases of the Moon during its 29.5-day orbit around the Earth and why it appears to progress from total darkness at new Moon (the green circle at the top) through to full Moon (yellow circle at the bottom) and back again. The lower diagram illustrates why we always see the same side of the Moon (highlighted in yellow), because it rotates once on its axis during one complete orbit (humans finally saw the far side of the Moon, shown here in green, for the first time in October 1959, thanks to images taken by the Soviet space probe Luna 3). Lavishly illustrated with many similar colourful diagrams, this early manuscript version of Johannes de Sacrobosco's *Tractatus De Sphaera* (*On the Sphere*) is a vivid reminder of the importance of astronomy in medieval scholarship. It became the standard textbook on the subject after it first appeared around 1230 and remained in print for centuries, appearing in many translations and editions. Astronomy was an essential part of university education during this period and *Tractatus De Sphaera* and similar textbooks were widely used and distributed.

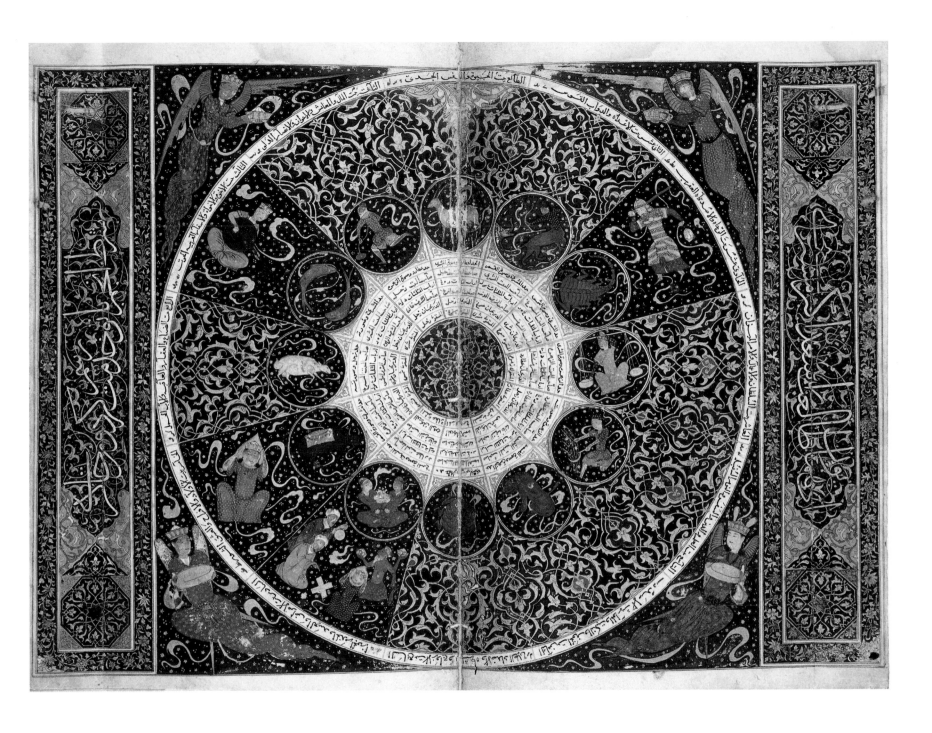

HOROSCOPE OF PRINCE ISKANDAR
1411

UNKNOWN

Red and blue ink with gold leaf on paper
26.5 × 17 cm / 10½ × 6⅝ in
Wellcome Collection, London

This remarkably ornate, hand-drawn horoscope from 1411 is the birth chart of Prince Iskandar, a fifteenth-century provincial ruler in Iran. The twelve zodiac signs appear in an inner ring of circles, including the sign of Taurus, the Bull, at lower left, along with a personification of the Sun. Above, at upper left, the sign of Pisces is accompanied by a personification of Venus playing the lute. A birth chart is a specific kind of horoscope that

records the positions of relevant heavenly bodies – the Sun, Moon and planets – at the moment of someone's birth. This mystical chart represents Iskandar's birth date, 25 April 1384. In 1411, during the second year of his reign and shortly before his death, Iskandar commissioned the chart as part of the creation of a book about his birth, with interpretation by a group of esteemed astrologers of the time, specifically Imad

ad-Din Mahmud al-Kashi. Produced by the royal publishing house, known as the 'kitabkhana', this horoscope was intricately and expertly crafted by a range of printing professionals, from paper-makers to calligraphers and gilders. It is a testament to the skill of the makers that this collaboration of many hands looks as though it were drawn and written by a single individual.

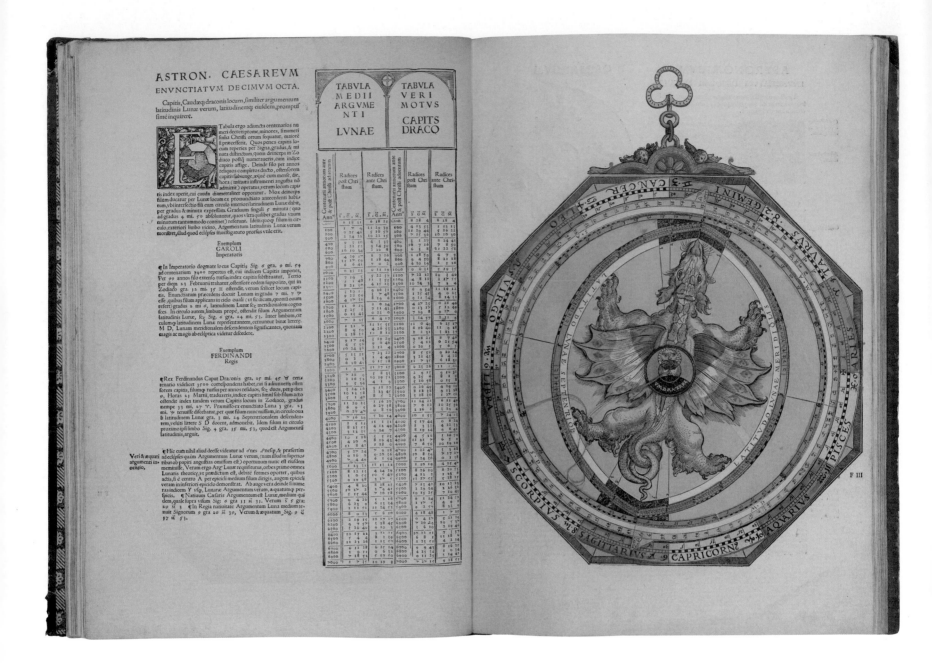

ASTRONOMICUM CAESAREUM
1540

PETRUS APIANUS

Hand-coloured woodcut print, 46 × 32 cm / 18 × 12¾ in
Universitätsbibliotek Wien, Vienna

The son of a Saxon shoemaker, Peter Bienewitz Latinized his name to Petrus Apianus (both names meaning 'bee') as part of the process of establishing himself as a Renaissance scholar in both Vienna and Bavaria. He became a printer, publishing works of theology as well as his own writings on astronomy, cosmography and mathematics. But it was his *Astronomy of the Caesars*, produced for the Holy Roman Emperor Charles V and his brother Ferdinand I,

that made Apianus's fortune. This hand-coloured work of art represented the most advanced astronomical science. The main contents are volvelles, complex movable layers of paper and thread. These could be used to find the positions of the planets more quickly than by mathematical calculation; as movable diagrams, they taught readers the Ptolemaic planetary theories. This instrument gives the latitude of the Moon; the lunar nodes, where the Moon's

path crossed that of the Sun and eclipses could take place, were known as the head and tail of the dragon. The latitude was found by laying out threads using data from the table on the facing page; Apianus provided worked examples of the process to find the lunar latitude at the birth-dates of Charles and Ferdinand. These patrons were certainly impressed: Apianus was made court mathematician and later an Imperial Count Palatine.

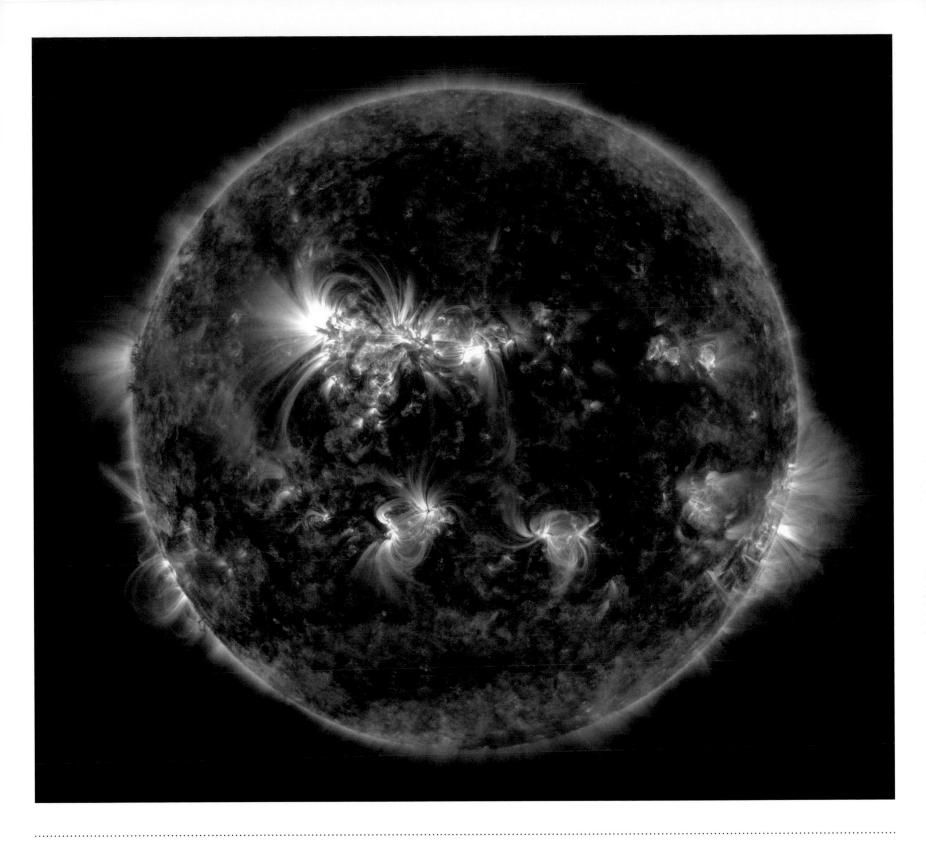

VENUS TRANSITING ACROSS THE FACE OF THE SUN

2012

NASA GODDARD SPACE FLIGHT CENTER, SDO, SVS

Digital photograph, dimensions variable

The black ball of Venus is dwarfed by solar flares in this frame from a timelapse sequence of the planet's transit of the Sun in June 2012, taken in ultraviolet light. Even though Venus passes between the Sun and the Earth regularly, seeing it so clearly against the disk of the Sun is rare. The Sun's disk is small when seen from the Earth, and the orbits of Earth and Venus around it are inclined several degrees to each other, which means that transits, though predictable, are infrequent. They occur in pairs about eight years apart, but separated by gaps of 122 and 105 years (the next transit is due in December 2117). The first accurately predicted transit required knowledge of Kepler's laws of planetary motion and was calculated by the English amateur astronomer Jeremiah Horrocks, who saw it in December 1639 from Much Hoole in Lancashire. By then it was realized that recording the timing of the same transit in widely spaced locations could provide the basis for calculating the accurate distance to the Sun, and thus a scale for the whole solar system. International scientific expeditions were organized for the 1761 and 1769 transits. One sent Captain James Cook to Tahiti, where he observed the transit before charting New Zealand and Australia's east coast.

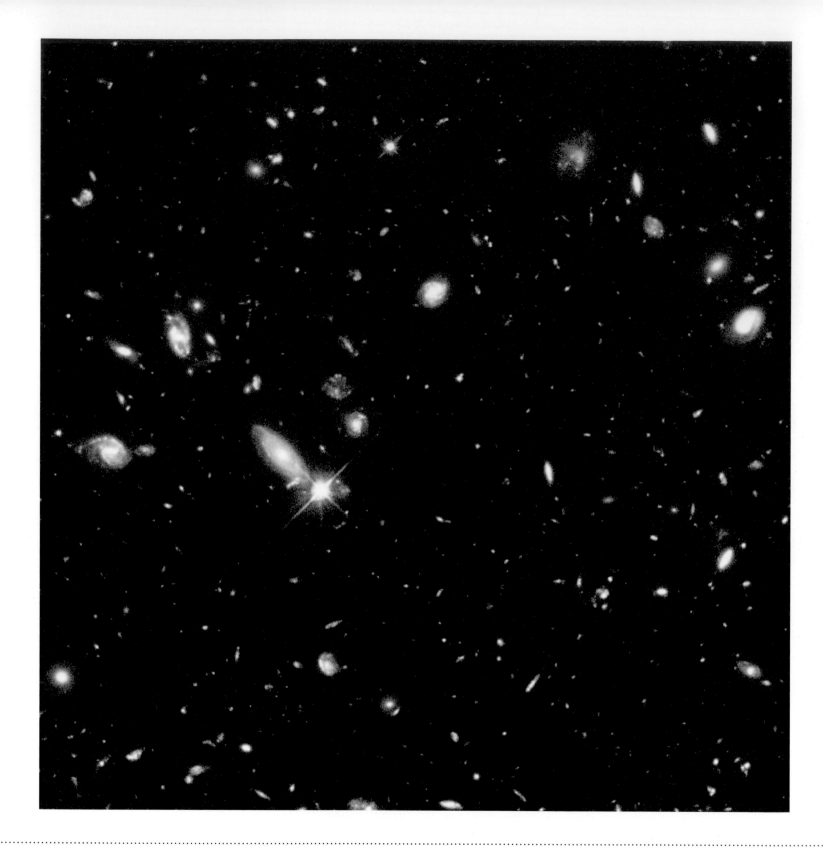

PART OF THE HUBBLE DEEP FIELD NORTH
1995

R. WILLIAMS (STSCI), NASA

Digital photograph, dimensions variable

Photographed in 1995, the Hubble Deep Field North – generally known as HDF-N – penetrates 12 billion light years deep into a speck of the sky, no larger than a small coin held about 25 metres (82 feet) away from the viewer. The area of sky in the constellation of Ursa Major was selected because it contained nothing special: no bright stars to dazzle the telescope, no giant galaxies to obscure what lies beyond. Yet of the approximately

3,000 deep-sky objects the Hubble Space Telescope (HST) recorded when it focused on the same patch of sky for ten consecutive days, only twenty are stars in our own Galaxy. Virtually all of the other objects are complete galaxies, spread along a narrow but deep 'pencil beam': the equivalent of a totally random sample of people in an opinion poll. The galaxies are typical of the Universe; the view is representative for every speck of sky we can see.

The HDF-N, an assemblage of 342 exposures, was the first of several images, repeated as the equipment on the HST was improved. The Hubble Deep Field South (HDF-S) of 1998 confirmed for the southern hemisphere what had been found in the northern, and that the Universe is essentially the same in all directions. The Hubble Ultra Deep Field (HUDF) of 2003–4 recorded an estimated 10,000 galaxies extending to 13 billion light years away.

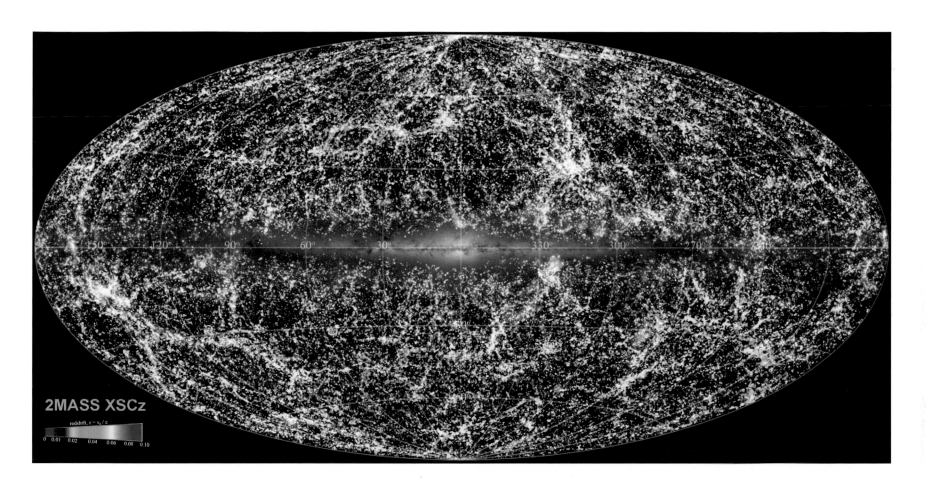

2MASS XSCz

redshift, $z = v_h / c$

0 0.01 0.02 0.04 0.06 0.08 0.10

LARGE SCALE STRUCTURE IN THE LOCAL UNIVERSE

2013

JOHN HUCHRA, THOMAS JARRETT 2MASS COLLABORATION, U. MASS., IPAC

Digital, dimensions variable

Each individual dot of the 50,000 dots in this picture is a galaxy, colour-coded from closest (blue) to farthest away (red). The central horizontal strip is the Milky Way, comprised of the light of 100 million stars and showing our Galaxy to be a spiral galaxy – viewed edge on from Earth – much like the Sombrero Galaxy (see p.149). At the top of the picture, purple and green dots indicate the massed galaxies in the Virgo and Coma clusters, at

relatively nearby distances of 54 and 320 million light years, respectively. Other green and yellow colour-coded galaxies form tangled filaments stretching across the sky, of which the Shapley Supercluster (above centre in this image) is the most prominent, lying at a distance of 650 million light years. Two automated telescopes, one in the USA, the other in Chile, scanned the sky to create this composite picture in what is known as the 2MASS survey.

The survey used 'redshift' – an increase in the wavelength of light as it moves away from the viewer – to map the web of galaxies that stretches all round us. The Milky Way exists inside a sponge-like structure of galaxies made of threads and walls that stretch out into the cosmos, as shown here, to depths of space up to 1 billion light years from Earth: an unimaginable distance, but still one that is 'local' to cosmologists.

LOOK BACK IN TIME
2006

RUSSELL CROTTY

Mixed media, dimensions variable
Installation view, San Jose ICA, CA

In his immersive installation piece *Look Back in Time*, the American artist Russell Crotty (born 1956) creates space-like environments by using spheres, drawings, sculpture and coarse panels of hanging fabric coated with bio-resin. Artefacts from the historical collection at the Lick Observatory in California are also integrated. The viewer walks through a maze of floor-to-ceiling patterns and globes that call to mind planets or particles floating in a celestial cosmos. Based on theories of the Big Bang and the subsequent development of the Universe, Crotty's work suggests both light's first creation and its never-ending journey. Light shapes how we see the world, perhaps most obviously through the creation of colour, and least obviously through the way in which it brings the past into the present. Astronomical observation is marked by an essential element called 'lookback time', which defines how light actually reveals the past by travelling great distances through space to reach the Earth in the contemporary moment. Having worked for over a two years with the University of California at Santa Cruz Institute of the Arts and Sciences, University of California Observatories and Lick Observatory Historical Collections Project, Crotty used his project to bring together an amalgam of art and science.

DRAWING ON SPACE
2011

MICHELLE STUART

Archival pigment prints, each 96.5 × 147 cm / 38 × 58 in
National Maritime Museum, London

This grid of twenty black-and-white photographs – some collected from archival sources, some taken by the New York artist, Michelle Stuart (born 1933) – mixes galaxies, star clusters and nebulae with earthly fireworks. Some of the grid's elements show antique lenses resting on images, inviting us to reflect on the importance of both the telescope and the camera in the development of astronomical knowledge. Stuart's first job was as a topographical drafter, and the compositional device of the grid recurs throughout her career; early on, in the use of maps, charts and the semantics of cartography, or later (as here) in photographic arrangements, with narrative structures evoking a journey or articulating connections. With its combination of both celestial and human-made lightshows, *Drawing on Space* links the cosmic to the human and reconciles forensic scrutiny with the wonders of space, suggestive of the contemplative and euphoric nature of stargazing. Stuart's work links nature and culture to challenge scientific rationalism and Western-centric, patriarchal narratives of exploration as a means of control. Cosmological themes have figured prominently in her works, from pieces produced in the 1960s as a response to the Space Race, to installations in which she reflects more broadly on humanity's place in the Universe.

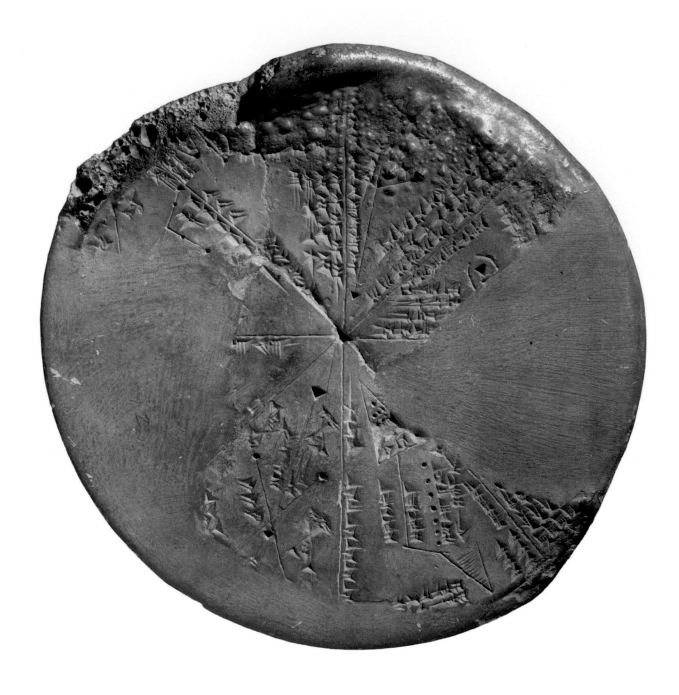

NEO-ASSYRIAN PLANISPHERE
*c.*650 BC

UNKNOWN

Clay, diam. 14.1 cm / 5½ in
British Museum, London

Since it was discovered in the ruins of ancient Nineveh in Iraq in the 1850s, the purpose of this clay disc inscribed with symbols and cuneiform script has been the subject of intense debate. Originally belonging to the Library of Ashurbanipal, the seventh-century-BC king of Assyria, the disc has been attributed with functions ranging from the calendrical and astronomical to astrological, magical and incantatory. In a widely accepted 1989 study, the

scholar Johannes Koch identified it as a star map, a stylized representation of the major constellations as seen from Nineveh on the night of 3–4 January 650 BC. The disc is divided into eight 45-degree sections (the number eight had considerable significance in ancient Mesopotamia). Within the six undamaged sectors are schematic diagrams of constellations accompanied by cuneiform symbols, rows of repeated syllables and

shapes and diagrams. Stars within the constellations appear as dots, connected by lines. A rectangle at the top has been identified as Gemini, with the Pleiades as ovals; two triangles at the bottom may represent the constellation of Pegasus. The repeated syllables may be mathematical calculations for astrological forecasting or magical incantations.

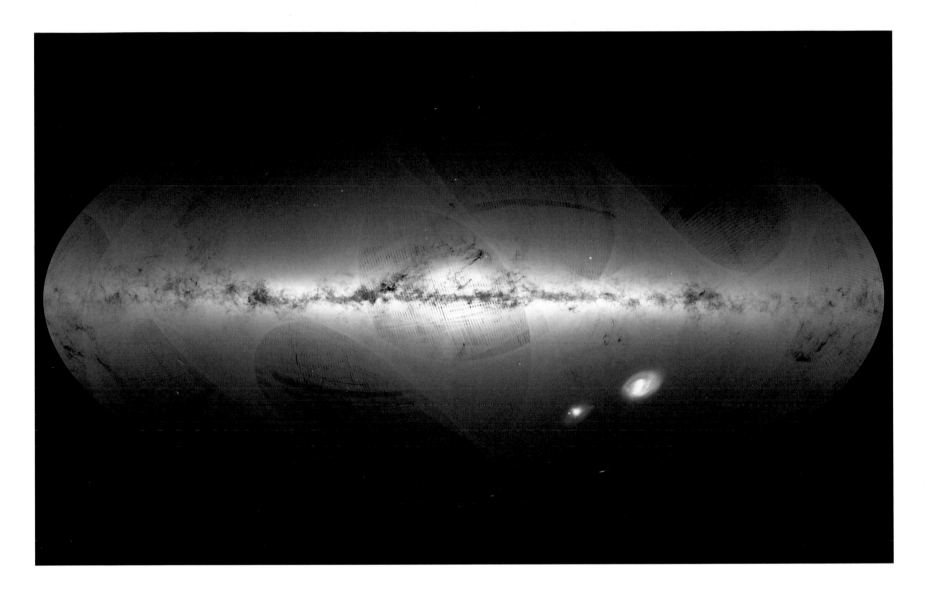

GAIA'S FIRST SKY MAP
2016

ESA, GAIA, DPAC

Composite digital image, dimensions variable

This first map published using data from the European Space Agency's satellite Gaia is a black-and-white, hree-dimensional image in which darker regions show the parts of the sky where there are fewer stars and brighter regions indicate denser concentrations of stars. Gaia carries the largest digital camera in the Solar System and orbits at a distance of more than 1.5 million kilometres (0.9 million miles) from Earth on a five and a half-year mission to create a precise three-dimensional map of our Galaxy by surveying everything that comes in its path – stars, exoplanets, asteroids, neighbouring galaxies (the Large and Small Magellanic Clouds can be seen as bright objects at lower right of the image) and other celestial bodies. Gaia's technology is able to locate precisely the position in the sky and the brightness of 1,142 million stars (although a billion stars account for less than one per cent of the Galaxy's stars). Between July 2014 and September 2015, the satellite captured images using two optical telescopes that use blue and red photometers and a radial velocity spectrometer to determine the location of stars and their velocities, and to split their light into spectra for analysis on Earth. To date, the European Space Agency has released data about the distances and motions of more than two million stars.

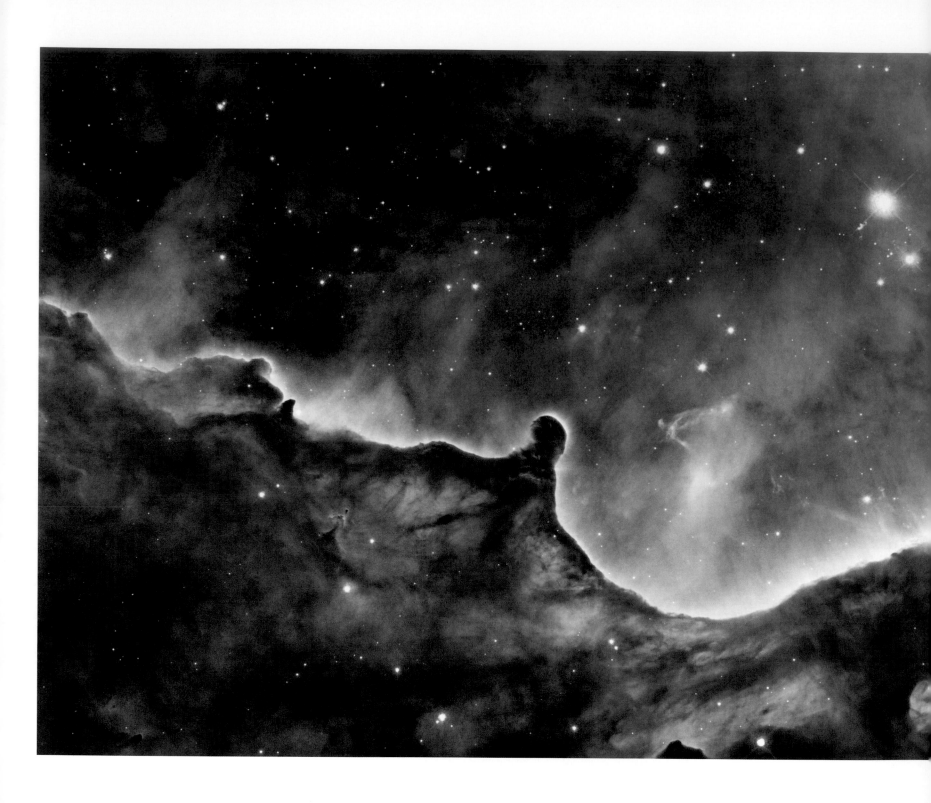

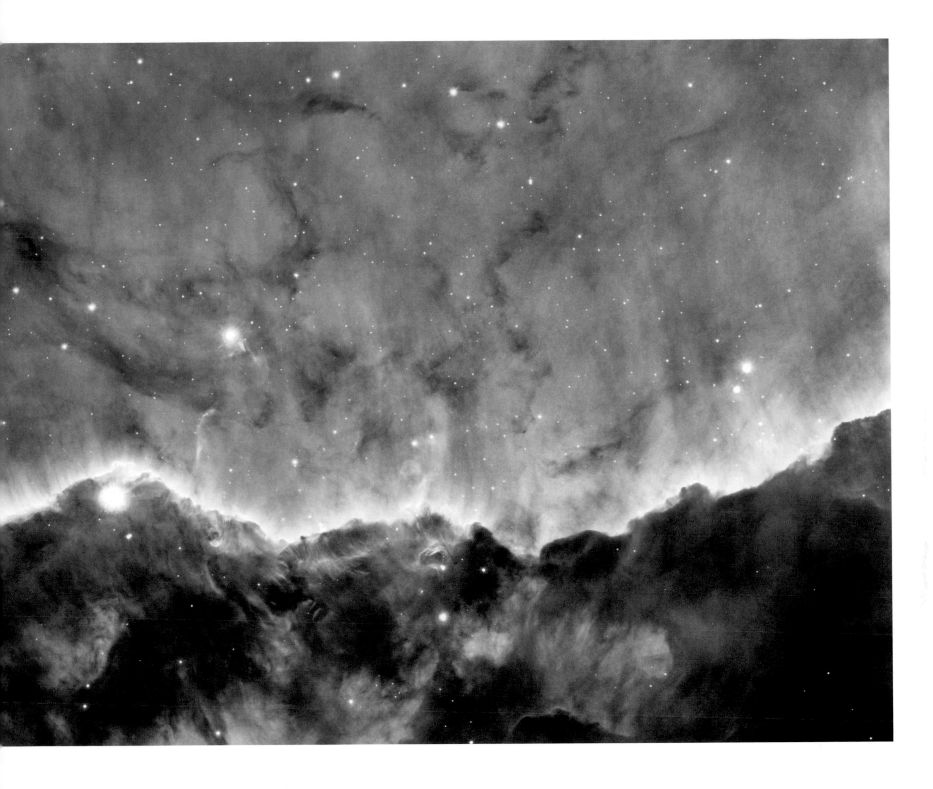

STAR-FORMING REGION NGC 3324 IN THE CARINA NEBULA

2008

NASA, ESA AND THE HUBBLE HERITAGE TEAM (STSCI/AURA)

Composite digital image, dimensions variable

Shortly after the Hubble Space Telescope's launch in 1990, NASA astronomers recognized that carefully crafted images developed from data gathered by the telescope had remarkable, widespread visual appeal. To ensure that the colour, detailed and well-composed pictures regularly reached an audience beyond the scientific community, a group of astronomers and image specialists formed the Hubble Heritage Project in 1998 and began producing and releasing a new Hubble image approximately every month. This view of a star-forming region, more than 7,000 light years away in the Carina Nebula, celebrated the project's tenth anniversary. It also epitomizes the group's efforts to balance aesthetic appeal with scientific validity. The colours indicate the presence of glowing gases at different wavelengths, thus conveying information about the nebula's physical properties. The colour scheme also transforms the gaseous clouds into a scene resembling a landscape of lush mountains against an azure sky. The telescope focused on a small section of a large circular cavity in the nebula, and its edges suggest a horizon that we might imagine crossing, even though the vast distance to the nebula means this kind of trip will remain – at least for now – a purely mental journey.

SOUTHERN LIGHTS
2005

NASA

Digital photograph, dimensions variable

Startling neon-green veining stands out amongst swirls of milky white in what at first glance resembles a giant marble or a mysterious dark opal. Looking closer, the green flare encircles the grey-white shape of Antarctica, with the distinctive outline of Australia visible at upper left. From Earth, the crowns of light (the auroras) around each of the poles are visible as the remarkable Northern and Southern Lights, but from space their near-circular structure is more evident. Scientists have long known that the aurorae are caused by the interaction of Earth's magnetic field with charged particles flowing from the Sun, but had no way of measuring them until NASA launched the Imager for Magnetopause-to-Aurora Global Exploration (IMAGE) satellite in 2000. Its mission was to collect data about the structure and dynamics of the Earth's powerful magnetic field, so scientists could analyse how it protects the planet from solar winds. This stunning image was captured on 11 September 2005, four days after a huge solar flare ejected a stream of plasma – ionized gas – towards the Earth. IMAGE pictured the resulting ring of light glowing green in the ultraviolet part of the spectrum. It was then overlaid onto another image from NASA's satellite-based Blue Marble to create the picture above.

URANUS
1986

NASA, JPL-CALTECH

Digital photograph, dimensions variable

This may appear to be a globe of blown glass, but it is actually Uranus, the seventh planet from the Sun. Taken by NASA's Voyager 2 probe in 1986, this image shows the exterior of a planet composed entirely of icy gases. Its smoothness can be attributed to haze that obscured any cloud features present at the time the photo was taken. Almost 98 per cent of Uranus is made up of hydrogen and helium; the remaining percentage – methane – creates the planet's colour, because methane absorbs red light. The photograph was taken during humankind's first and only visit to Uranus. After travelling for nearly nine years, Voyager 2's closest view of the planet (around 81,500 kilometres (50,600 miles) from the surface) lasted for only five and a half hours, but allowed the capture of this and other images of the planet's surface, rings and its moons. Thanks to advances in technology, NASA has since taken others showing details such as weather-related activity. This planet is the only one in our Solar System to rotate on its 'side', presumably thanks to a collision early in its history. Uranus rolls around the Sun rather than spinning like a top, as the seven other planets do. Its rings are oriented perpendicular to the Sun, unlike the rings of Saturn, which lie parallel to the solar disc. Uranus even rotates 'backwards', making the planet unique.

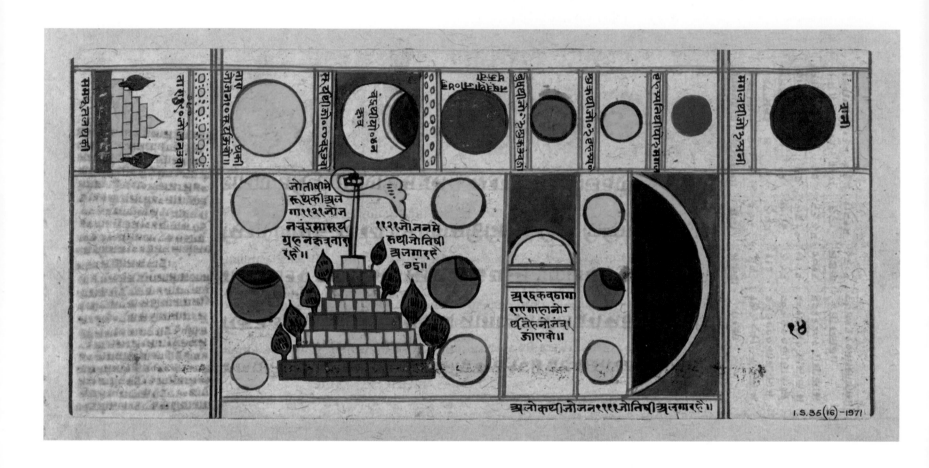

SANGRAHANISUTRA

18th century

UNKNOWN

Ink and watercolour on paper, 11.7 × 25.4 cm / 4¾ × 10 in
Victoria and Albert Museum, London

Although some of the globes in this Jain manuscript from western India might be recognizable as heavenly bodies, the cosmology to which they belong is unfamiliar. At the centre of the Jain perception of the Universe stands Mount Meru, seen here in a shape that resembles a stepped pyramid. The presence around it of two sets of identical celestial bodies reflects the Jain belief that, while one set is 'at work', the other set rests behind Mount Meru. In

addition to Mount Meru, the illustrations show the positions of the celestial bodies, including the known planets of the time: Saturn, Mars, Jupiter, Venus and Mercury. Much of Jain learning was committed to writing in about the twelfth century in a conscious effort to preserve it, and the texts were kept in *Jnana-Bhandaras*, or 'storehouses of knowledge'. This is a page from an illustrated manuscript of the *Sangrahanisutra*, first composed in Sanskrit by

Shrichandra Suri in 1136. This eighteenth-century edition reproduces the original text together with a Gujarati commentary by an unknown writer. The Jain approach to cosmology was highly mathematical, with precise distances specified between the individual elements of the Universe and illustrated with diagrams such as this one.

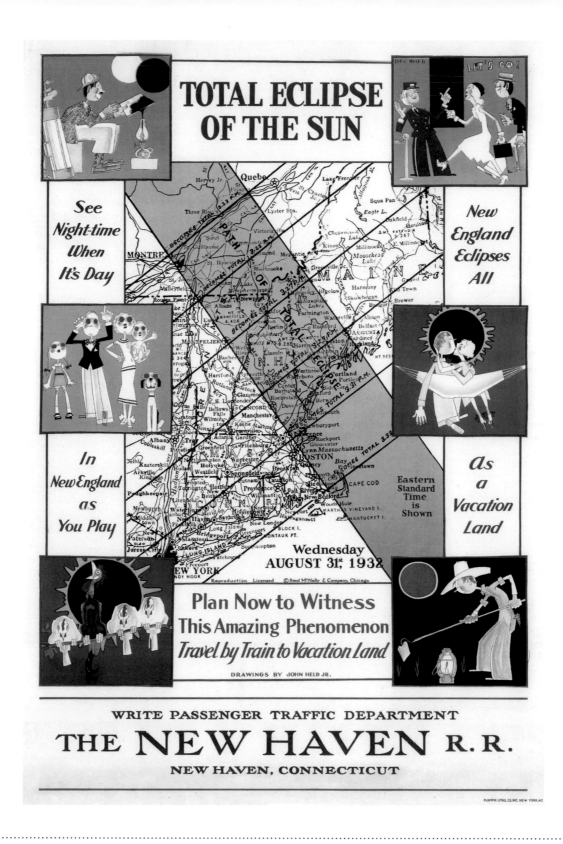

TOTAL ECLIPSE OF THE SUN
1932

JOHN HELD AND RAND MCNALLY & COMPANY

Paper map mounted on heavy paper on canvas
105 × 60 cm / 41¼ × 26¾ in
David Rumsey Historical Map Collection, Stanford, CA

Humorous cartoons and groan-inducing word play – 'New England Eclipses All' – decorate this cheery poster mapping the forthcoming total solar eclipse of 31 August 1932. Eager to encourage as many people as possible to travel by train to witness this spectacular event, the New Haven Railroad commissioned this poster as one of a series. Many of the posters, including this one, featured the work of John Held, Jr. (1889–1958), one of the most celebrated illustrators of his generation. Best known for his 1920s magazine illustrations, which helped to define the Jazz Age, Held created a series of images to suggest the glamour of train travel to see the eclipse. The poster includes a schedule for the path of the eclipse over New England – coloured blue – and gives the exact times it would cross various locations before it continued across the Atlantic Ocean. Of the four types of solar eclipse – total, annular, partial and hybrid – the most spectacular is the total eclipse, when the Sun appears to be briefly blotted out by the Moon, despite the Moon being 400 times smaller (coincidentally, the Moon is also about 400 times closer to Earth, thus the Sun and Moon appear to be the same size in the sky). The phenomenon occurs, on average, approximately once every eighteen months somewhere in the world.

COSMOLOGICAL MANDALA

14th century

UNKNOWN

Silk tapestry, 83.8 × 83.8 cm / 33 × 33 in
Metropolitan Museum of Art, New York

This remarkable silk tapestry, woven in China under the Yuan dynasty who ruled from 1271 to 1368, reflects the interplay of influences in South and East Asian culture in its representation of the Buddhist cosmic system. It is a mandala, a diagram of the structure of the Universe with the mythological five-peaked Mount Meru – in Buddhist, Hindu and Jain cosmology the physical and spiritual centre of the Universe – represented here by the central inverted pyramid. The pyramid is topped by a lotus, a Buddhist symbol of purity. At the base of the mountain are the Sun and the Moon, symbolized in Chinese culture by the three-legged bird and the rabbit, respectively. Outside the concentric squares marking what in Western depictions are the spheres of the Universe lie landscape vignettes representing the four continents of Indian mythology – here depicted according to the artistic conventions of 'blue-and-green' Chinese landscape painting. The tapestry reflects the influence of the Indo-Himalayan imagery that was introduced to China from India along with Esoteric Buddhism, carried by monks and traders moving along the Silk Road. The floral border reflects imagery used in Buddhist monasteries in central Tibet, which had close links with the Yuan court.

UNFOLD

2012

RYOICHI KUROKAWA

Stills from audio-visual installation, dimensions variable

Three huge projections fill the wall and a screen that juts out overhead to form a ceiling, so that the viewers are immersed in this audio-visual representation of the beginning of the Universe. Moving images show cycles of star formation, shifting from vast reservoirs of gas to the materialization of Sun-like stars. Its imagery portrays a shower of white light particles that rain down from an undulating mass of red; the outline of a white cube suddenly fills with an orange gas-like haze; and a swirling vortex of multi-coloured rays begins to vibrate. The screen glitches and jolts between pixels, finally knitting together an image of the Earth's swirling atmosphere, which then just as rapidly switches to the burning surface of the Sun. Made in consultation with astrophysicist Vincent Minier, this digital vision of the Universe combines observational, scientific and simulation data, which Ryoichi Kurokawa (born 1978), a Japanese-born artist based in Germany, deconstructed to create these startling moving images. Its soundtrack layers jittery static that pops into sharp flutters of ambient noise, merging into a smooth field of rhythmic base. As a synaesthetic experiment that seeks to stimulate new feelings for its audience, transducers send vibrations into the floor so that these sights and sounds can also be felt – the Universe humming within us.

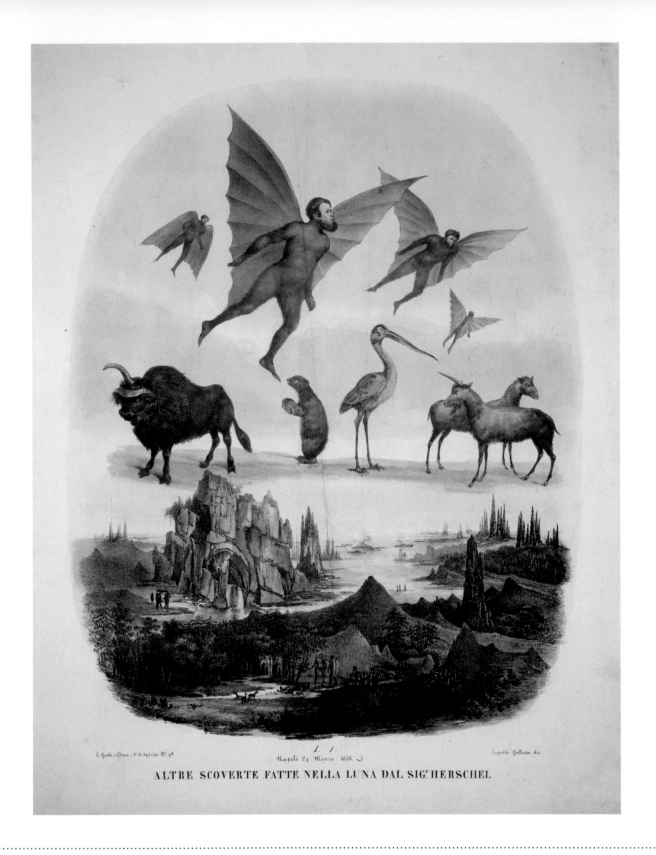

ALTRE SCOVERTE FATTE NELLA LUNA DAL SIG. HERSCHEL

ALTRE SCOVERTE FATTE NELLA LUNA DAL SIG. HERSCHEL

1836

LEOPOLDO GALLUZZO

Hand-coloured lithograph, 57 × 46 cm / 22½ × 18 in
National Air and Space Museum Library, Washington, DC

When the article that this Italian lithograph illustrates appeared in the *New York Sun* in August 1835, it was the first readers had heard of a discovery supposedly made from South Africa by the English astronomer Sir John Herschel using a telescope 7 metres (24 feet) long: the landscape and creatures of the Moon. The creatures – including a quadruped with a single curly horn, a one-horned goat, a beaver that walked on two legs, together with a furry, bat-like man and a woman with moth wings – are illustrated above a lunar landscape that closely resembles mountain scenery on Earth. The lithograph was probably made to illustrate an Italian version of six articles written by the reporter Richard Adams Locke, in a successful bid to boost circulation. Readers flocked to read about such lunar discoveries, and many believed them to be true – including the discovery of a sapphire temple with a gold roof supported by pillars 20 metres (70 feet) high. Herschel himself was still in South Africa where he could not deny the articles, whose content was entirely fake. The final article explained that the telescope's mirror had set itself on fire by concentrating the heat of the Sun. The incident – now known as the Great Moon Hoax – is a reminder of the way unscrupulous tabloid newspapers exploit public gullibility.

**VULCAN AND SISTER PLANET
AND ITS MOON**

1979

DAVID MORTON

Motion picture background from *Star Trek: The Motion Picture*, dimensions variable

Fiery sparks rise from two volcanoes, while craters of molten lava produce a reddish glow that bathes clear evidence of built structures: a flight of steps, the walls of a circular building that rises from the lava. In the foreground, a mysterious figure may be genuflecting towards a large pair of heads. This movie matte, or background, by David Morton of the Foundation Imaging studio depicts the Universe's most famous exoplanet: Vulcan. These are the

landscapes that would have been known to the young Mr Spock, the renowned Vulcan who went on to serve on the starship Enterprise in the long-running TV series *Star Trek*. The product of a Vulcan father and human mother from Earth, Spock is distinguished by his combination of devotion to pure logic with a consideration of emotion – he exhibits a definite emotional hinterland on occasions. Morton's depiction of Vulcan, produced for the 1979 film

Star Trek: The Motion Picture, reflects information revealed in the various TV series. Vulcan is a beautiful planet 16 light years from Earth, without moons – but with other planets nearby – with a hot, harsh climate. It possesses tourist attractions including active volcanoes, lava fields, ancient ruins and religious sites, including the Temple of Amonak, the Temple of T'Panit and the T'Karath Sanctuary.

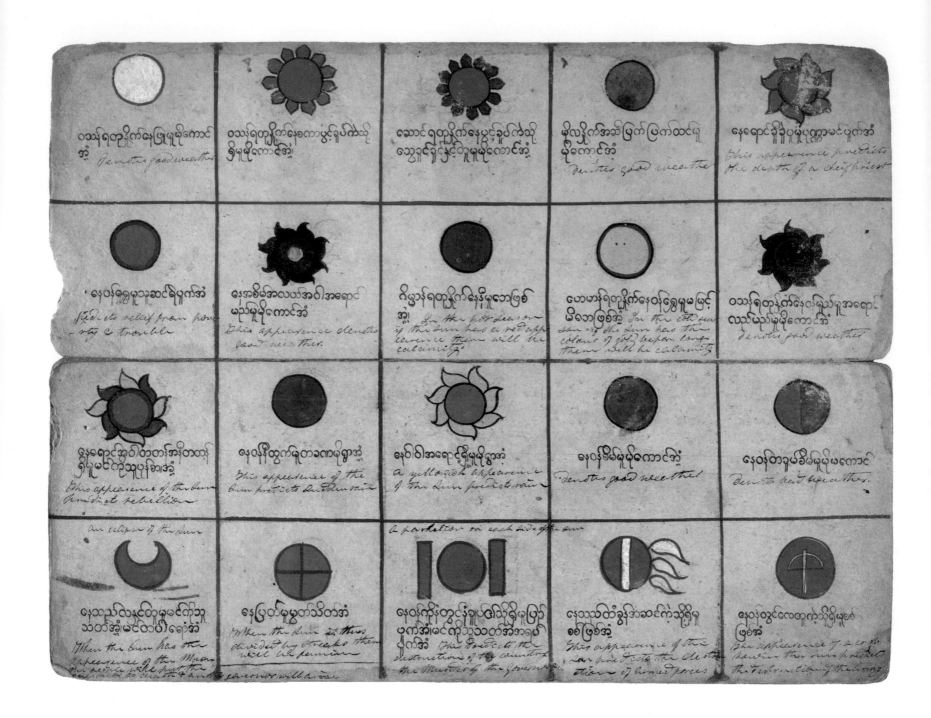

BURMESE ASTRONOMICAL-ASTROLOGICAL MANUSCRIPT

19th century

UNKNOWN

Gouache on handmade paper, 31 × 42 cm / 12¼ × 16½ in
Library of Congress, Washington, DC

These neatly ruled pages from a manuscript produced in Burma in the mid-nineteenth century show twenty possible faces of the Sun, ranging from a simple white disc to images that resemble flowers or tailed comets. This is a sample of a whole handbook intended to help astrologers divine the meaning of the Sun's aappearance in the sky for life on Earth. The Sun's different shapes, colours and markings all portend something different, according to the explanatory text underneath. Many of these omens are inauspicious and grave: some relate to warfare or ill fortune. Others are purely meteorological rather than astrological, and have far less import: one appearance of the Sun is simply labelled 'good weather'. Beneath the Burmese script in each square, an American missionary who once owned the manuscript began to add an English translation but it remains incomplete, because he notes that he ran out of time. The book is not bound but folded accordion-style into a traditional Burmese style called a *parabaik*, perhaps making it easier to transport and consult when needed. Even though divination is no longer scientifically accepted, the Sun remains an object of interest for its potential terrestrial influence. Scientists follow solar activity to determine its effect on Earth – aurora, magnetic storms, space weather.

SOLAR SPECTRUM
1984

N. A SHARP, NOAO, NSO, KITT PEAK FTS, AURA, NSF

Digital image, dimensions variable.

This spectrum is a breakdown of the Sun's light into a high resolution version of the rainbow effect discovered by Isaac Newton when he bent light through a glass prism, splitting it into colours from long wavelengths for red to short-wavelength blues and violets. For many astronomers, such diagrams – when the colours are stacked on top of one another like a ladder, the arrangement is called an echelle – are far more revealing than familiar visual depictions. Most of what has been learned of the Sun and the stars has come from studying their light in this way. As the detail increases, the span from blue to red becomes longer, so without the stacking this strip of colour would be a narrow rainbow, fifty times wider than the page. The apparently random dark lines are highly revealing. These absorption lines are created where parts of the spectrum are absorbed by the Sun's atmosphere, revealing its composition and physical state in detail. Every star has its own spectrum, like a unique barcode that allows astronomers to differentiate between the numerous types. Some lines are strong or weak, while others are broad and fuzzy or narrow and sharp. The pattern of lines identifies the elements involved, while the fuzziness points to the physical conditions in the Sun's atmosphere where the absorption occurred.

DUNHUANG STAR ATLAS

c.700

UNKNOWN

Ink on paper, 24.4 × 330 cm / 9¾ × 130 in
British Library, London

This paper scroll shows the Chinese constellations, with an atlas of cloud formations. When an unknown Chinese astronomer mathematically plotted the atlas in around 700 AD, he used colour-coding to denote which particular school of astronomy had measured the positions of the stars. The sources of the measurements go back to 400 AD. The atlas plots the positions of 1,345 stars in 257 constellations on an expensive scroll of mulberry

paper typical of that used by China's imperial court. Measuring 21 metres (69 feet) long, it was likely used as a reference for making forecasts. Notes describe when the constellations rise and set, and describe cloud formations. In about 1000 AD, the scroll was bricked up in a Buddhist temple in the Mogao Caves near Dunhuang in north-west China, along with 40,000 other scrolls, probably to preserve them from a marauding army. In

1900, a monk in the temple noticed that sand swept near a wall disappeared into a crack at its base. Breaking into the room behind the wall, he found the scrolls, and began selling them. The *Dunhuang Star Atlas* was brought to London with many others by Sir Aurel Stein, the British-Hungarian archaeologist.

STERNE 1H 55M – 30˚

1989

THOMAS RUFF

Chromogenic print, 257.8 × 186 cm / 101 × 73¼ in
Museu Coleção Berardo, Lisbon

Recollections of childhood experiences of observing the sky inspired German artist Thomas Ruff (born 1958) to create a series of photographs entitled *Sterne* (*Stars*), and these images seem carefully composed, almost Christmas-card views of the heavens. They derive, however, from carefully planned scientific observations used to carefully map the cosmos. For *Sterne*, Ruff purchased a set of 600 glass-plate negatives originally taken as part of a survey of the southern skies by the European Southern Observatory (ESO), a joint venture by sixteen countries that began in 1962. By methodically examining the negatives, astronomers carefully catalogued the precise locations of thousands of celestial bodies, many for the first time. Ruff's enlarged prints shift the viewer's engagement with the scientific plates, showing the stars as white dots and crosses. Several prints are often exhibited close together, suggesting the experience of becoming lost in a star-filled sky. Yet these starry views could never be experienced directly. Although they seem to promise a romantic communion with the heavens, they reflect not a lived experience, but depend on a view of the Universe mediated by telescopes and cameras.

THE RACE TO SPACE
1959

UNKNOWN

Printed paper, 68.6 × 104.1 cm / 27 × 41 in
Private collection

Despite the space race with the Soviet Union, the unknown designer of this poster for an American 1959 documentary film about the Redstone rocket project – the basis of the early US space programme – was happy to echo Soviet poster design from the 1920s and 1930s in the simple graphic representation of a Redstone. Along the bottom of the poster, four images give contrasting perceptions of the two countries' space programmes. The first two depict primates being sent into space to investigate the biological effects of space travel, and a US spacecraft landing in the ocean at the end of a mission. Missiles dominate the third image, showing a typical military display at Moscow's Red Square during the Cold War. These, and the huge Soviet rocket in the last image, add a sense of threat. *The Race to Space* was nominated for an Academy Award for Best Documentary Feature in 1959. David L. Wolper's film was based on interviews with two people fundamental to the Redstone project: Major General Holger Nelson Toftoy and Esther Goddard. Toftoy's contribution acknowledged the rocket's origins as a US Army missile bearer. Goddard was the widow of Dr Robert Goddard, who developed and integrated many of the basic systems of liquid-fuelled rocket engines.

SOVIET SPACE PROGRAMME POSTER
1963

UNKNOWN

Printed paper, 86.5 × 56 cm / 34 × 22 in
Private collection

'Soviet man, you can be proud – you opened the road to the stars from Earth' reads this poster produced in the Soviet Union in 1963 to celebrate what was at the time clear Russian superiority in the space race. Drawing on techniques of Soviet graphic design from the 1920s and 1930s, when posters were the main method for the communist government to encourage the loyalty of the population, the poster is both visually memorable and heavily symbolic. The giant hand points to the stars as it releases a Soviet rocket – both hand and rocket are in symbolic Commnunist red – bound for the cosmos of stars beyond. At the height of international tension between the Soviet Union and the United States (the world had come close to war a year earlier, with the Cuban Missile Crisis), the space race emerged as another front in the Cold War. Soviet achievements – the launch of Sputnik, the first satellite, in 1957, and the first man and woman in space (Yuri Gagarin in 1961 and Valentina Tereshkova in 1963, respectively) – had dismayed the West and given the Soviets real national pride. As the 1960s went on, however, it would be the United States, with its more prosperous economy, that would increasingly take the lead in space exploration, although the Soviet space programme remained impressive in its longevity.

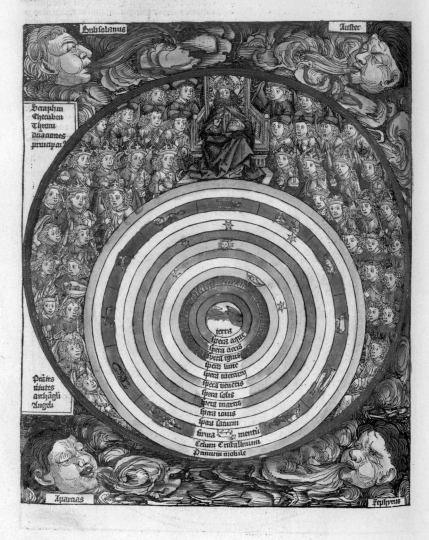

LIBER CHRONICARUM
1493

HANS PLEYDENWURFF AND MICHAEL WOLGEMUT

Hand-coloured woodcut print, 32.9 × 47.4 cm / 13 × 18¾ in
Bayerische Staatsbibliothek, Munich

The *Nuremberg Chronicle* is a hugely influential early printed book. The most extensively illustrated book of the fifteenth century, it was commissioned by two Nuremberg merchants and published simultaneously in both Latin and German; more than 1,000 copies of each edition survive, testament to its popularity. The text, written by the Nuremberg physician Hartmann Schedel, is a universal history of the Christian world from creation to the 1490s, drawing on medieval and Renaissance sources. It begins with a summary of the biblical account of creation, each day depicted by a more complex image of the cosmos, and culminating in the seventh day pictured here: the day of rest, when the Universe was complete. Following medieval cosmology, at the centre of the diagram are the four terrestrial elements (earth, water, air and fire) and outside them are the seven 'celestial bodies' from the Moon to Saturn. Beyond is the firmament, with the twelve zodiac signs, the crystalline heaven and the *primum mobile*, which produced the daily rotation of the heavens. Atop the spheres we see God the Father, surrounded by a heavenly choir, and the corners of the image are filled by the four cardinal winds. In this one image, the readers of the *Nuremberg Chronicle* could see the enormity – and order – of creation, and contemplate their place within it.

THE ANCIENT OF DAYS
1794

WILLIAM BLAKE

Relief etching, gold, red ink, and watercolour on paper, from
Europe a Prophecy, 23.4 × 16.9 cm / 9¼ × 6¾ in
Fitzwilliam Museum, Cambridge

A bearded figure crouching on an orb separates clouds and leans forward with open compasses as if in the act of measuring. There are two conflicting interpretations of the identity of this figure used by the English poet, artist and mystic William Blake (1757–1827) as the frontispiece of his long poem 'Europe a Prophecy'. In the traditional reading, the figure is God – the plate is known as the Ancient of Days – in his guise as the architect of the universe. More recent interpretations, however, suggest that the figure instead represents Urizen, a supernatural being who features in Blake's personal mythology as the embodiment of the tyranny of mathematical order and scientific thought – and of an oppressive church – in opposition to the mystical imagination that Blake believed led to the infinite. In this view, Urizen's compass is not for building but for constraining the human spirit. Blake was openly critical of the Enlightenment, particularly of the widely revered Isaac Newton, whom he also depicted as a nude figure stooping over his compasses, so engrossed in nature's laws that he looks down at his feet rather than up to heavens, and remains oblivious to the creative world. In such a picture of science, an understanding of the workings of the Universe does not free the spirit, but shackles it.

THE SURFACE OF MERCURY
1949

CHESLEY BONESTELL

Oil on artist's board, 51.3 × 41.3 cm / 20¼ × 16¼ in
Private collection

A cracked fissure runs between two prominent rocky outcrops and over a plain ringed by scarps, where shallow craters signal impact points, with visible streaks of ejected material. Above, the Sun shines through a light plume created by Mercury's movement around the star. This 1949 painting of the surface of Mercury by US artist Chesley Bonestell (1888–1986) was created a full twenty-five years before the first fly-by of the planet by a

space probe produced more reliable images. Bonestell modelled Mercury's topographical features in clay, then used photographic tricks and lighting effects to create the landscape he painted in his highly detailed style. Bonestell was one of the pioneers of astronomical art – along with others such as French artist Lucien Rudaux (see p.162) – who helped shape the public perception of space in the mid-twentieth century. Dropping out of

his training as an architect, Bonestell instead became an artistic renderer for more famous architects. Meanwhile, he had made his first astronomical painting in 1905, which began a life-long interest. In the late 1930s he worked as a special effects artist in Hollywood, creating matte paintings to act as the backdrop in films including the science fiction trio *Destination Moon* (1950), *War of the Worlds* (1953) and *Conquest of Space* (1955).

CALORIS BASIN

2014

NASA, JHU APL, ARIZONA STATE U., CIW

Digital photograph, dimensions variable

The false colours of this Messenger photograph lend a misleading beauty to Caloris Basin on Mercury which, at 1,500 kilometres (930 miles), is one of the largest craters in the Solar System. Discovered in 1974, it is ringed by mountains about 2 kilometres (1¼ miles) tall. The orange indicates ancient lava that has flooded the crater and overflowed into the valleys of the mountains. Meteor impacts that occurred before the flood show up as faint 'ghost craters', but those that occurred after the lava flood – the majority – excavated material from below (coloured blue in this image), giving a glimpse of the original floor 3 kilometres (nearly 2 miles) beneath the new surface. One, near the centre of Caloris basin, is the apparent focus of a system of cracks, called the Pantheon Fossae (so-called because they evoke patterns in the ceiling of the Pantheon in Rome). They are 'graben', troughs in which the base has dropped as a block to a lower level after the surface stretched. Caloris was named after the Latin for 'heat' because the crater faces the Sun when Mercury passes closest to it on its orbit. The impact that created the crater 3.85 billion years ago is believed to have had the energy of a trillion hydrogen bombs and the shockwaves it sent through the planet created a region of faults and cracks on the opposite side.

PLUTO

2015

ALEKSANDRA MIR

Fibre-tipped pen on synthetic canvas
203 × 1000 cm / 80 × 394 in
Private collection

Pluto was made in response to NASA space probe New Horizons' 'Pluto Fly-by' on 14 July 2015, which enjoyed considerable popular attention, played out globally as it was, on social media. Collaborative effort is key to Aleksandra Mir's work – be it to stage a Moon landing as a happening on a Dutch beach (1999) or create a 200m (650 feet)-long *Space Tapestry* (2015–17) as an immersive monochrome drawing. Here she invited eight practitioners to join her in producing a monumental 'cosmic strip' with 'Sharpie' marker pens. While the 'Sharpie' is, in her words, an unpretentious medium, its various tonalities at different stages of wet- or dryness and the gestural marks of a multiplicity of hands add vibrancy and depth to the act of drawing. The heart adorning Pluto evokes the public's delight in discovering this romantic shape on the terrains of another world. Mir plays with scale, granting as much space to the giant Saturn as to Pluto, the poor sibling in our Solar System, demoted from ninth planet to dwarf planet. 'And from here, it is you who look so small', a line from American rapper Eminem's song 'Fine Line', reminds us that significance is only ever a question of perspective. By combining fine art, popular culture and science, Mir invites us to reflect afresh on our place in the universe and the enduring romance of space exploration.

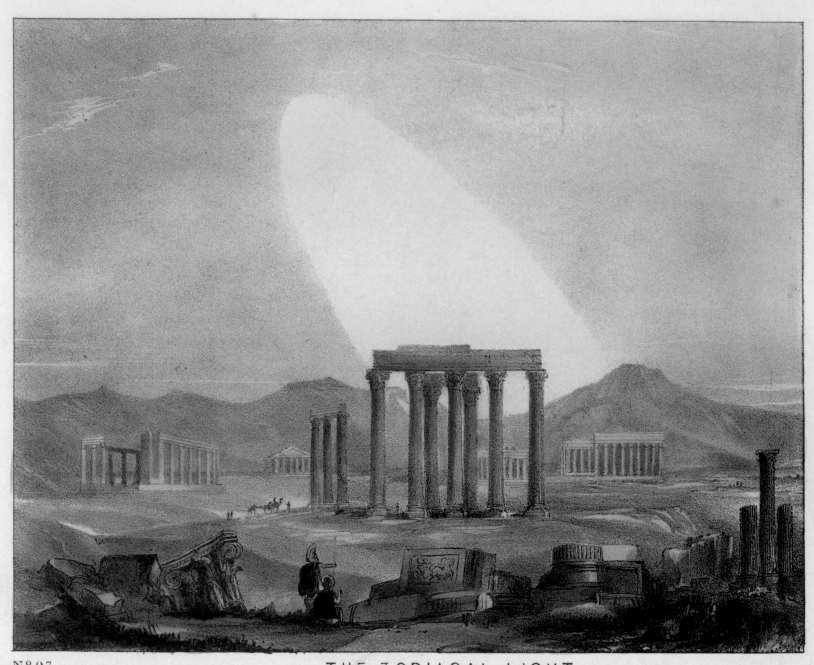

Nº 97. THE ZODIACAL LIGHT.

THE ZODIACAL LIGHT
1842

CHARLES F. BLUNT

Hand-coloured engraving, from *The Beauty of the Heavens*
18.2 × 15.5 cm / 7 × 6 in
British Library, London

In this delicate hand-coloured plate, the distinctive cone of the zodiacal light extends up into the sky behind this a Neoclassical scene of Roman soldiers and ruined ancient temples within a Mediterranean landscape, reflecting the architectural and travel fashions of the period when it was created in 1842. This seasonal phenomenon, which is usually seen just after sunset in the spring and before sunrise in the autumn, is caused by the effect of the Sun's illumination of dust particles left behind by comets, seen against the background of the zodiacal constellations. At the time the Englishman Charles F. Blunt produced the 100 plates for his book *The Beauty of the Heavens*, astronomers still believed that the zodiacal light was part of the Sun's outer atmosphere. Blunt's lavish book was designed as a teaching aid for parents wanting to instruct their children about astronomy from the comfort of their homes. In the introduction, Blunt explains that he has tried to provide explanations with little technical language but with enough detail to inspire the audience's appreciation for divine creation with much 'intellectual gratification'. The book covers topics such as the Earth's motion through space and the subsequent seasons, the phases of the Moon, telescopic views of the planets, the Milky Way and well-known constellations.

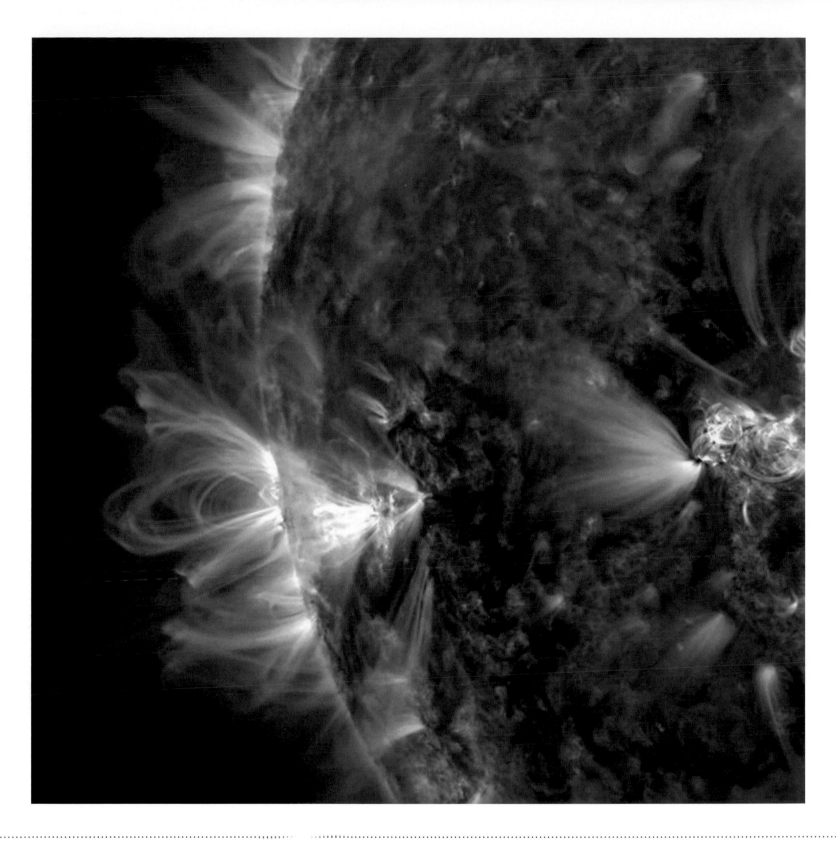

FESTOONING LOOPS
2014

NASA, SOLAR DYNAMICS OBSERVATORY

Digital photograph, dimensions variable

Coronal flares loop out from an active region of the Sun as it rotates into view during a two-day period from February 8–10, 2014, when this image was created by NASA's Solar Dynamics Observatory (SDO), designed to understand the causes of solar variability and their impact on Earth. SDO has a continuous view of the Sun at a range of extreme ultraviolet wavelengths, revealing solar features not visible from the ground, especially those associated with sunspots, prominences and other violent solar activity. Probably the most important solar outbursts to monitor are coronal mass ejection (CME) events, where giant loops of energetic particles are accelerated by the Sun's intense magnetic field and ejected into space with velocities up to 3,000 kilometres (2,000 miles) per second. Unlike sunlight, which takes about eight minutes to reach, CME particles take several days. The strongest flares profoundly alter the Earth's magnetic field and can damage satellites and terrestrial powerlines and disrupt radio transmission. All such events produce strong auroral effects and are most common at times of heightened solar activity, roughly every eleven years but everything about the behaviour of the Sun is notoriously unpredictable – hence the need for careful watching.

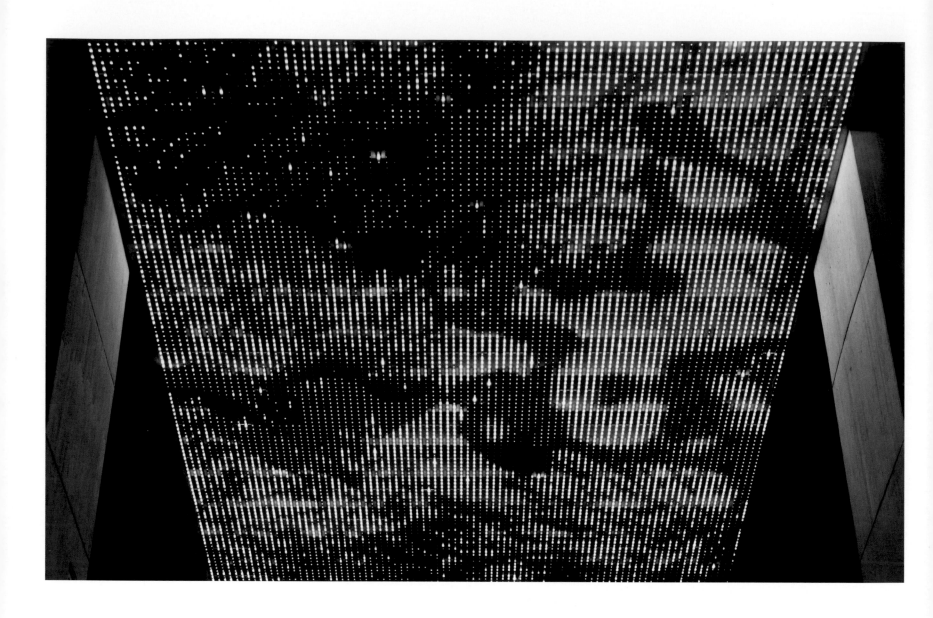

COSMOS

2012

LEO VILLAREAL

LEDs, custom software, electrical hardware
810 x 528 cm / 319 x 209 in
Installation view, Cornell University, Ithaca, NY

The Universe may be infinite, but what we can see is not only finite but measurable: the visible universe contains an estimated 10^{80} atoms, each atom containing many neutrons, electrons and protons. The US artist Leo Villareal (born 1967) visualizes these particles using a grid of 12,000 light emitting diodes (LEDs) on a metal armature below an outdoor ceiling. The flashing lights continually move with frenetic energy, reminiscent of minute atoms,

sparkling stars, swirling gasses, cloud patterns and even fireworks. Originally installed on the ceiling of Sherry and Joel Mallin Sculpture Court at the Herbert F. Johnson Museum of Art in Ithaca, New York, *Cosmos* is an homage to the late Cornell astronomy professor, Carl Sagan. Beneath the canopy of light viewers lie back on a long 'zero-gravity' bench to gaze at an artificial but mesmeric cosmos. Villareal is a pioneer of art that uses

lights and computer programs, with a particular interest in code: the lowest common denominators of systems and their underlying structures. He focuses on particles, pixels or zeros and ones of binary code, using them to build environments through a combination of programmed software and electrical hardware. The result is the visual manifestation of code *in* light, as unpredictable sequences play out through variations in speed and brightness.

BLANK II
2015

CAROLINE CORBASSON

Screenprint on telescope mirror blank, steel
150 × 40 cm / 59 × 15¾ in
Private collection

This translucent circle is the mirror blank of a telescope, and the marks projected upon it are a reminder of Earth's small, insignificant place within the Universe. The image belongs to the short series *Blanks*, in which the French artist Caroline Corbasson (born 1989) borrows from the Hubble Space Telescope's paradigm-shifting Deep Field images (see p.244). In 1995, the space-borne telescope changed our perception of the Universe by staring for ten days at a seemingly empty patch of the sky no bigger than a grain of sand held out at arm's length. Hubble's Wide Field and Planetary Camera 2 revealed the light of more than 3,000 galaxies, each containing hundreds of billions of stars. Nine years later, the telescope pointed its shutter for one million seconds of exposure to another empty region of the sky. The Hubble Ultra Deep Field revealed over 10,000 galaxies looking back in time some 13 billion years. While these galaxies are racing away from us in our constantly expanding Universe, by fixing the distant past within the boundaries of the mirror blank, Corbasson not only captures space but also domesticates immensity. She also goes beyond the colourized aesthetic of the Hubble palette to a more basic black on white, a negative image of space that reflects how astronomers study the Universe, without artifice or artefacts.

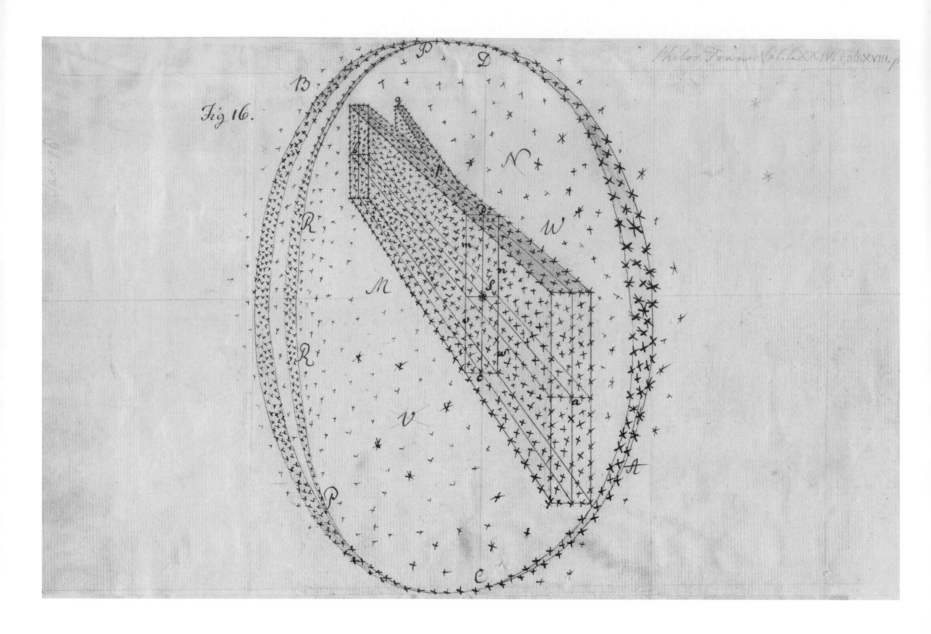

PROJECTION OF THE STARS IN THE MILKY WAY GALAXY

1784

WILLIAM HERSCHEL

Ink on paper, 22.4 × 32.7 cm / 8¾ × 12¾ in
Royal Society, London

Having built a new and larger telescope in 1784 that had more precise optics than any he had previously owned, the German-British astronomer William Herschel used it to scrutinize an area of the Milky Way Galaxy that hitherto he had seen only as a 'whitish appearance'. Through the new telescope, the view became a 'glorious multitude of stars of all possible sizes', a scene of 'dazzling brightness of glittering stars'. Herschel went on to interpret the 'great stratum' of the Milky Way as a slab of stars, which, seen from within in projection on to the celestial sphere, would look just like a complete circle, centred on the position of the Sun, 'lucid on account of the accumulation of the stars'. Herschel believed that the rest of the sky would be 'scattered over with constellations, more or less crowded'. He illustrated the idea in this diagram that he drew for the *Philosophical Transactions of the Royal Society*, showing the bifurcated slab projecting on to a split great circle. He looked forward to the day when 'we shall in time obtain some faint knowledge of, and perhaps partly to delineate, the Interior Construction of the Universe' (the Galaxy). The first president of the Royal Astronomical Society, Herschel was from a noted family of astronomers. His sister, Caroline Herschel, discovered several comets, while his son, John, named moons of Saturn and Jupiter.

TRIPLE POINT (PLANETARIUM)
2013

SARAH SZE

Mixed media including: wood, steel, plastic, stone, string, fans, and over-head projectors, 632.5 × 548.6 × 502.9 cm / 249 × 216 × 198 in
Installation view, US Pavilion, Venice Biennale

A compass rose on the floor echoes the traditional role of navigational stars in *Triple Point (Planetarium)*, a vast sculptural installation created from found materials by the American artist Sarah Sze for the 55th Venice Biennale in 2013. Utilizing the entire six spaces of the American Pavilion, Sze wove an intricate landscape throughout both the building's interior and exterior, incorporating within a matrix everyday detritus she had collected in Venice. Sze's disorienting, sprawling installation included an irregular sphere comprised two overlapping hoops of wood, while a universe of wooden and metallic struts and assembled matter protruded from this form. Included among many other objects were: lamps; photographs of mountain ranges; waterfalls and volcanoes; fans; a disco ball; screwdrivers; paint cans and a vice. In Sze's giant pseudo planetarium, these everyday found objects conjured a Solar System of stars, asteroids, planets and moons. The work's title contains the phrase 'triple point', connoting the combination of temperature and pressure at which point an element can exist as gas, liquid and solid exist in a thermodynamic equilibrium. In her wider practice, Sze creates idiosyncratic systems of order and balance, giving form to her personal universe within which the viewer can wander.

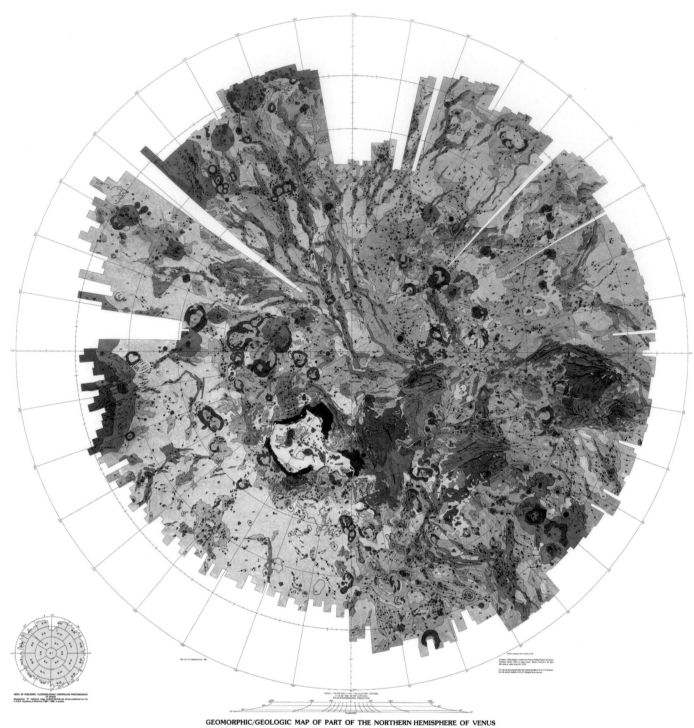

GEOMORPHIC/GEOLOGIC MAP OF THE NORTHERN HEMISPHERE OF VENUS
By
A.L. Sukhanov, A.A. Pronin, G.A. Burba, A.M. Nikishin, V.P. Kryuchkov, A.T. Basilevsky,
M.S. Markov, R.O. Kuzmin, N.N. Bobina, V.P. Shashkina, E.N. Slyuta, and I.M. Chernaya
V 15M 90/0 G
1989

GEOMORPHIC / GEOLOGIC MAP OF THE NORTHERN HEMISPHERE OF VENUS

1989

VERNADSKY INSTITUTE, MOSCOW (AND USGS)

Composite digital image, dimensions variable

The sun-burst shape of this geological map centred on the north pole of Venus, created by Soviet scientists at the Vernadsky Institute in Moscow in 1989 for NASA, results from combining radial radar strips of images taken of the planet by the identical space probes Venera 15 and Venera 16. The probes orbited the planet repeatedly from October 1983 to July 1984, when contact was lost. The map's striking colours are artificial, corresponding

to identifiable features of the planet's landscape. Reds and pinks indicate volcanoes that sit on lava plains of black scaly rocks, which on the map are coloured with yellows and greens. Broken terrain, such as mountain ranges, is coloured blue, as are recent lava flows, which have typically formed frozen, sinuous rivers. So intense is Venus's geological activity that volcanic features cover almost the entire map. It shows only a few purple

circles indicating meteor craters, including one cut into an incomplete horseshoe shape. The style of the map resembles that of a terrestrial geological map, but the colours make it more like abstract art. Its purpose was to plan the programme of the US Magellan space mission to Venus, but scientists had also produced the most striking image of the planet's surface available before Magellan itself arrived in orbit in 1990.

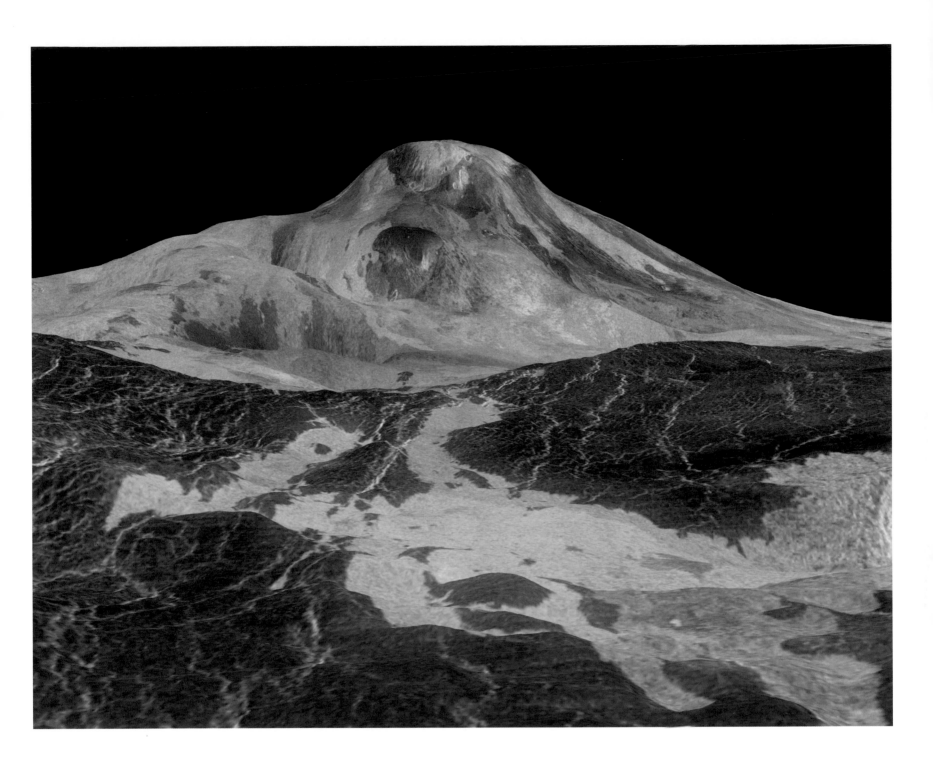

VIEW OF MAAT MONS, VENUS
1996

NASA, JPL

Digital photograph, dimensions variable

This glowing, golden volcano on Venus is the creation of computer mapping. Venus might be the most Earth-like planet in size, mass and distance from the Sun – at times it is the brightest object in the sky apart from the Sun and the Moon, appearing as the elusive and brilliant morning or evening star – but the planet's surface is little known, as it is obscured by an almost impenetrable veil created by a highly reflective cloud layer of droplets of sulphuric acid. The clouds float on a dense atmosphere of carbon dioxide (the atmospheric pressure at the surface is almost 100 times that on Earth) and the 'air' temperature can exceed the melting point of lead. The only spacecraft to land successfully on Venus were ten Soviet Venera landers between 1970 and 1982. The most successful of these sent back photographs for only two hours before succumbing to the harsh conditions. This image of Maat Mons was obtained by the NASA Magellan orbiter, also known as the Venus Radar Mapper, which orbited the planet from 1990 to 1994. The data have been processed to show the 8-kilometre (5-mile) high volcano as it might appear from about 1.7 kilometres (1 mile) above the surface, with colour information derived from the Venera images. It reveals extensive lava flows and fractured plains, yet more forbidding aspects of the planet's surface.

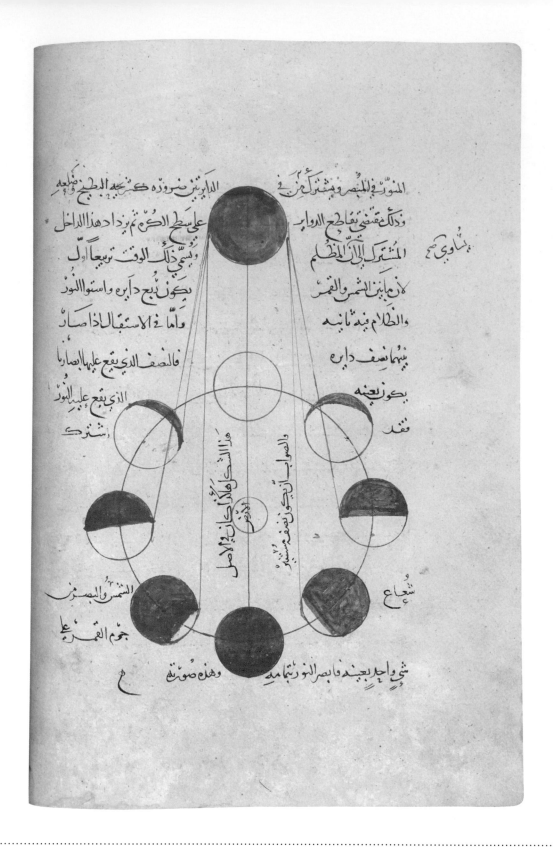

LUNAR ECLIPSE OR PHASES OF THE MOON
11th century

ABU AL-RAYHAN MUHAMMAD IBN AHMAD AL-BIRUNI

Ink on paper, 22.5 × 15cm / 8¾ × 6 in
British Library, London

This elegant eleventh-century diagram has been variously described as illustrating the mechanism of a lunar eclipse or as showing the phases of the Moon – it may well be that it can be seen as explaining both. If the precise purpose of the diagram is uncertain, the authority of its creator is not. Abu Rayhan Muhammad ibn Ahmad Al-Biruni (973–1084) was one of the greatest scholars of medieval Islam. He was born in what is now Uzbekistan

but spent much of his life in central Afghanistan. This diagram comes from al-Biruni's manuscript copy of his *Kitab al-Tafhim* (*Book of Instruction on the Principles of the Art of Astrology*) and contains his speculations about why moonlight is predictable in its brightening and dimming when stars are not. He goes on to suggest that 'the light of the stars is of their own', appearing correctly to distinguish starlight as being different from

the Sun's light reflected from the Moon or the planets. Al-Biruni's writings show him to be fluent in mathematics, astronomomy and physical and natural sciences; they suggest that he travelled widely, distinguishing himself as an objective and discerning historian and geographer. He was a true polymath, but his works did not reach Islamic Spain, so were never translated into Latin – and thus remained little known in the West.

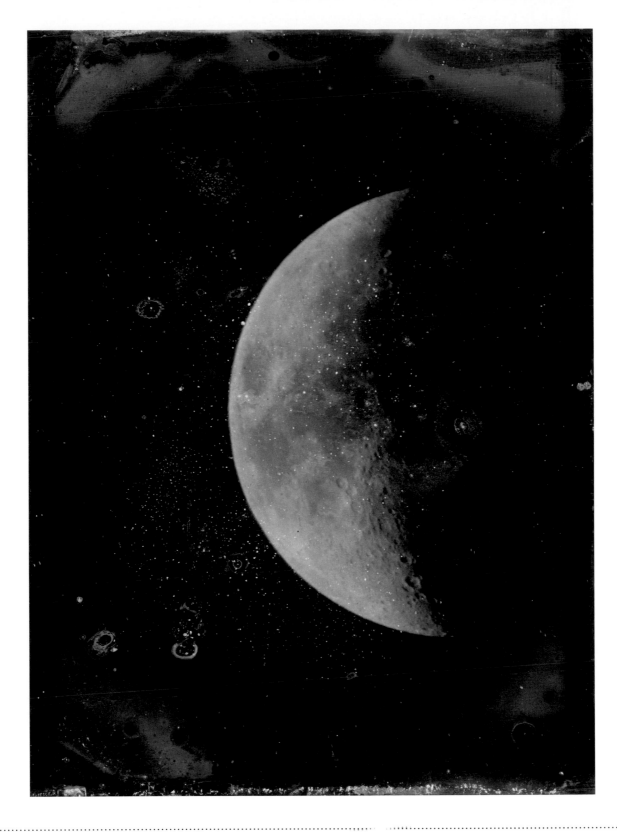

VIEW OF THE MOON

1852

JOHN ADAMS WHIPPLE

Daguerreotype, 8.3 × 10.8 cm / 3¼ × 4¼ in
Harvard University, Cambridge, MA

The round craters and dark plains clearly visible in this 1852 daguerreotype of the Moon are familiar today but until the earliest images of the Moon were created it was rare for astronomers to have a chance to study the lunar surface other than through a telescope. A similar daguerreotype by the same American photographer, John Adams Whipple, had won a prize at the renowned Great Exhibition held in London during 1851. Working with the father-and-son astronomers William Cranch Bond and George Phillips Bond, Whipple used the 15-inch Great Refractor telescope at Harvard College Observatory to capture these remarkable new images. Whipple was already well known as a portrait photographer in the Boston area and he was familiar with the daguerreotype, the main photographic technique of the day, invented in France in the 1830s. A silvered copper plate is exposed to the light in a camera before it is treated within a tray of mercury vapour and rinsed in a salt solution to fix the image. Whipple and the Bonds took more than seventy daguerrotypes of astronomical interest, including the first photograph of a star (Vega) on July 17, 1850 and of the cloud belts on Jupiter a year later. Whipple and the Bonds ceased to collaborate after a few years and the challenge to photograph the Moon was continued by others on both sides of the Atlantic.

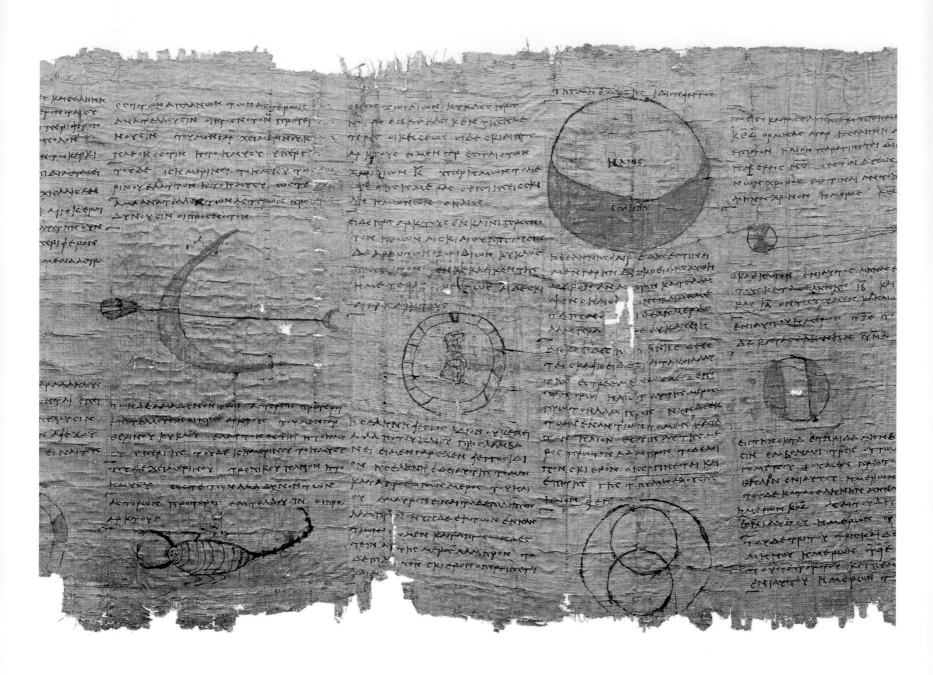

CELESTIAL TEACHING
190–160 BC

LEPTINES

Ink on papyrus (detail)
Musée du Louvre, Paris

Although this papyrus sheet of notes and diagrams about the motion of the Sun and the nature of eclipses is rather unremarkable, the document is notable as the oldest known illustrated text from ancient Greece. It appears to be the work of a student named Leptines drawing together notes from both a written source and a lecture. The back of the papyrus bears an acrostic of the name Eudoxus – but this is as likely to be idle doodling as a definite link

with Eudoxus of Cnidus (409–356 BC). Eudoxus is known both as a pupil of the philosopher Plato and as a tutor in turn to Aristotle, so any document linked with him would come from the period that saw the birth of the intellectual tradition of the West. While none of his writings survive, Eudoxus's ideas endured. He listed about half of today's eighty-eight formal constellations, and he was among the first thinkers to explain the complex motions of the planets

by developing the complex concept of concentric spheres centred on the Earth. This idea was further elaborated by Plato and survived in various forms, eventually as crystalline spheres that were shattered in the seventeenth century by the observational evidence and mathematics of Tycho Brahe, Johannes Kepler and Galileo Galilei.

STSS-1 AND TWO UNIDENTIFIED SPACECRAFT OVER CARSON CITY

2010

TREVOR PAGLEN

C-type print, 127 × 127 cm / 50 × 50 in
Smithsonian American Art Museum, Washington, DC

Trevor Paglen (born 1974), the American artist who took this long-exposure photograph of the night sky above Carson City, Nevada, in 2010, is less interested in the beauty of the star trails he captures than in the role of the two unidentified spacecraft inserted among them – a third is identified by Paglen as part of the Space Tracking and Surveillance System (STSS). Although all three are almost impossible for the uninitiated to find, they

cut across the concentric rings, two in a code of dots and dashes and one as an unbroken streak pointing towards the north celestial pole around which the stars appear to move. Paglen's technique – a long-exposure, wide-angle photograph of the night sky – is far from unique, but his fascination with surveillance of Earth from space gives additional meaning to his image. Many artificial satellites have scientific, meteorological or communications

functions, but the artist is more interested in those that have no stated public purpose. The circular motion of the stars is an illusion caused by the Earth spinning in space, with the camera pointing along its axis of rotation. The shortest, brightest star trail belongs to Polaris, the North Star – but the brilliant red sky is Paglen's own invention, suggestive more of a sinister atmosphere of surveillance than of anything to be seen in the night sky.

ZODIAC OF DENDERA
50 BC

UNKNOWN

Sandstone, 255 × 253 cm / 100¼ × 99¾ in
Musée du Louvre, Paris

This once brightly painted sky chart created in ancient Egypt can be precisely dated to between 15 June and 15 August, 50 BC. Such precision is possible because the chart illustrates a once-per-millennium configuration of the five planets known to the Egyptians, among which appear a lunar eclipse that took place on 25 September 52 BC and a solar eclipse that occurred on 7 March 51 BC. The disc represents the vault of the heavens, held up by four females and eight falcon-headed spirits; the circumference is occupied by thirty-six decans, each of them denoting ten days and making up the 360 days of the Egyptian year. Signs of the zodiac and the constellations occupy the inner rings of the disc. The solar eclipse itself is represented by Isis holding the baboon-god Thoth by the tail, and the lunar eclipse by the Eye of Horus within a circle. The chart originally decorated the ceiling of one of a pair of shrines to Osiris, god of the dead, located on the roof of the great temple of Hathor at Dendera, about 60 kilometres (37 miles) north of Luxor. In Egyptian mythology, Hathor was the wife of Horus, son of Osiris, but she was often also conflated with Isis, Osiris' faithful wife. Dendera was one of the many locations of Osiris' tomb, and the shrine would have hosted ceremonies to celebrate his death and resurrection.

ALTAR MAYOR, CORICANCHA TEMPLE OF THE SUN

1613

JUAN DE SANTA CRUZ PACHACUTI YAMQUI SALCAMAYGUA

Ink on vellum
Biblioteca Nacional de España, Madrid

The drawing in this Spanish chronicle by the Quecha Juan de Santa Cruza Pachacuti Yamqui Salcamaygua is a record of the altar wall in the Temple of the Sun in the Inca capital at Cuzco. The walls of the temple were covered with plates of beaten gold, which were pillaged by the Spanish some eighty years before this drawing was made. The arrangement is thought to be a stylized star map representing Inca cosmology. At the bottom,

a rectangle subdivided into squares is labelled *collca pata*, a reference to grain stores and agricultural terraces, the basis of Inca society. Above these stand male and female figures, the woman possibly pouring a libation from a vessel in a ritual act. Above the figures, four stars show the cardinal compass points below an oval representing a golden disc affixed to the wall in relation, according to Pachacuti Yamqui, to the positions

of 'the male and female figures, the morning and evening stars, the sun and moon, and the cross of the constellation of Orion'. Either side of the oval are the Sun and Moon, principal deities in Inca cosmology, along with Viracocha, the creator god. Above the oval, five stars represent the constellation Orion; the three vertical stars in it were believed to point to the most sacred spot in the sky.

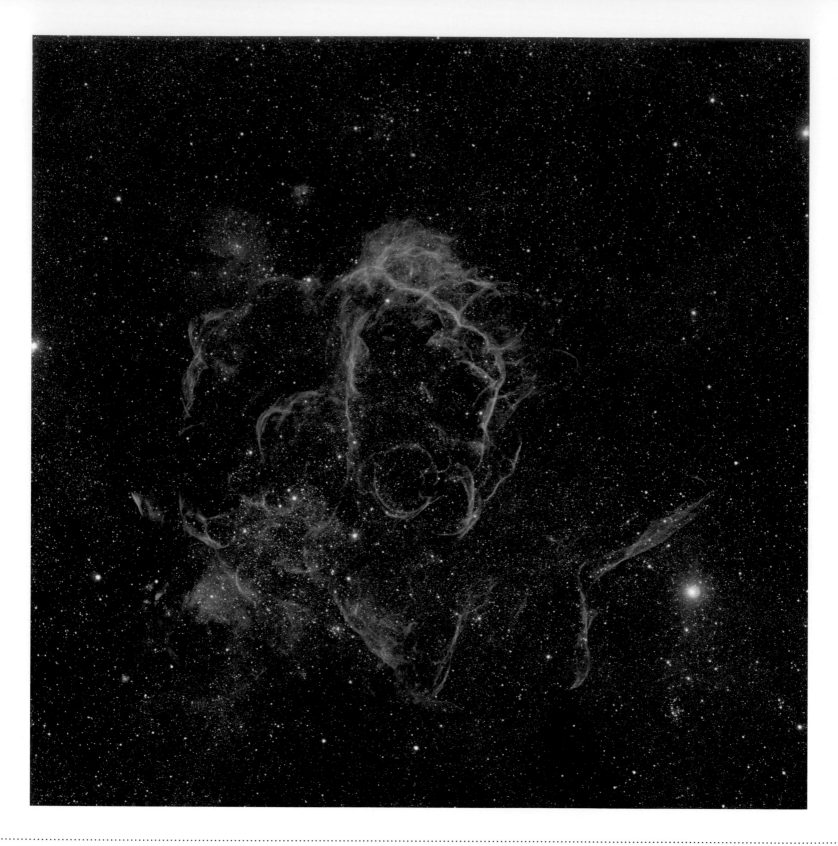

VELA SUPERNOVA REMNANT
2010

MARCO LORENZI (STAR ECHOES)

Digital photograph, dimensions variable

This image of the delicate blue filaments of a nearby exploded star against a background of the Milky Way gives a striking reminder that outstanding astronomical photography does not require access to space telescopes. Italian astrophotographer Marco Lorenzi (born 1970) photographs from his twelfth-floor terrace in Singapore using a small amateur telescope. The photo won the 2011 award in the Deep Space category of the Astronomy Photographer of the Year competition run by the Royal Observatory, Greenwich. The Vela Supernova Remnant is relatively old and nearby – the star exploded about 12,000 years ago, just 800 light years from Earth – and covers such a large area of the sky that Lorenzi had to combine four images into a mosaic to include it all. The tenuous filaments are gradually losing their identity and will disperse into interstellar space, when the chemical elements created by nuclear processes in the supernova explosion will enrich the interstellar material. When a subsequent generation of stars forms, these elements will make planets and any beings that inhabit them, just as humanbeings are made from chemicals from previous supernovae. At the centre of the supernova remnant is a pulsar, a spinning neutron star the rotation of which is slowing down: cold and dark, it will last forever.

PLANETS IN THE GALACTIC BULGE
2006

NASA, ESA AND K. SAHU (STSCI)

Composite digital image, dimensions variable

This image showing about 150,000 stars is the sum of 520 individual pictures taken during a week in 2004, when the Hubble Space Telescope was pointed toward the centre of our galaxy in a relatively clear window of sky in the constellation of Sagittarius. During the project – the Sagittarius Window Eclipsing Extrasolar Planet Search (SWEEPS) – astronomers examined the brightness of each star in each picture, identifying any that changed. Analysis identified sixteen stars that had a pattern of regular dips in brightness, probably caused by a planet repeatedly orbiting around them. Such stars are termed exoplanetary systems, each typically with a Jupiter-sized planet close near its sun. There must be far more exoplanetary systems hidden undetected in this picture, however: a reasonable average for this picture might be one planet per star. Each star in the image appears white where light is concentrated in the centre of its image, saturating the HST's detector, but the brighter stars have faint haloes caused by telescope imperfections (including a cross shape added by the structure of the telescope). The haloes do not saturate, so they reveal the colours of the stars. The very brightest blue stars are the nearest. The fainter, orange ones are farther away, their light reddened by interstellar dust.

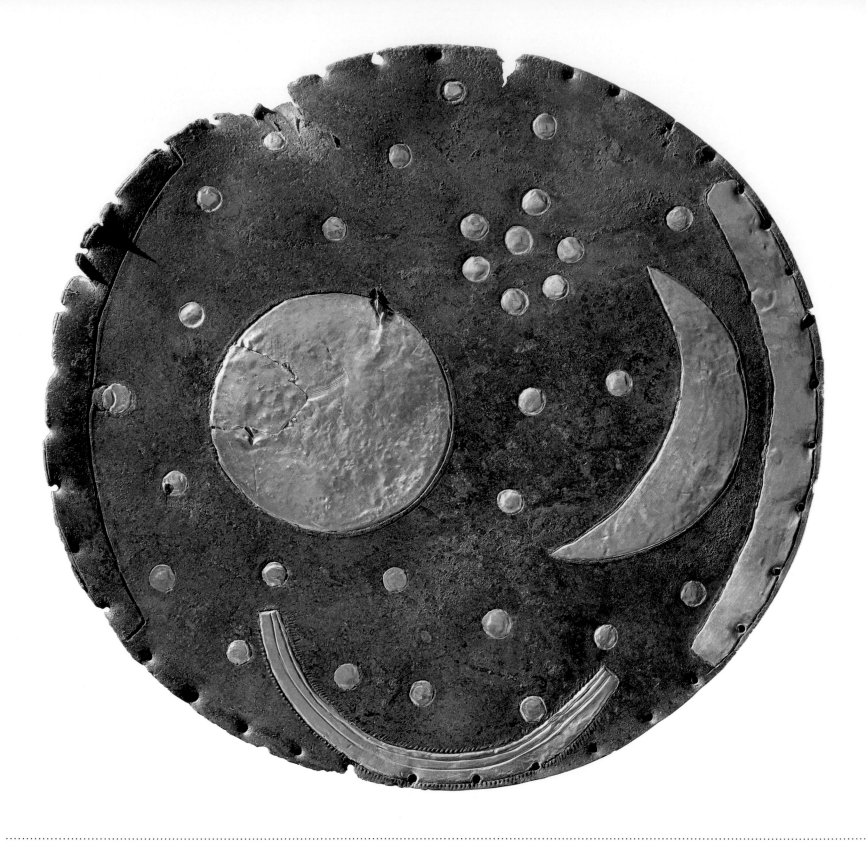

NEBRA SKY DISK
1600 BC

UNKNOWN

Bronze and gold, diam. 32 cm / 12¾ in
Landesmuseum für Vorgeschichte, Halle

This bronze disc inlaid with gold astronomical symbols gives us an insight into the astronomical understanding of Bronze Age Europeans in about 1600 BC. Named after the small German town near Leipzig where it was found, the Nebra Sky Disk is recognized by UNESCO as the oldest depiction of cosmic phenomena. The design depicts a crescent Moon and a circular Sun (there is some suggestion that this might instead be a full Moon). Thirty

smaller, circular dots representing stars are strewn across the disc, including seven stars of the Pleiades towards the centre: this cluster has been a seasonal marker for millennia. After its construction, artists added two arcs at its edges (one is now missing). These arcs mark an angle of 82 degrees to the horizon in central Germany, an accurate depiction of the angle between the positions of sunset at the summer and winter solstices. The meaning

of a third, short, thinner arc, decorated with strokes on its edges, is unclear: it may be the first representation in Western art of a sun boat journeying across the night sky. Made of Cornish gold and tin and Austrian copper, the disc was found in 1999 (along with other artefacts) by metal-detectorists. The illegal haul was seized in 2002 in Basel by archaeologist Dr Harald Meller, of the Halle Landesmuseum für Vorgeschichte, and the Swiss police.

 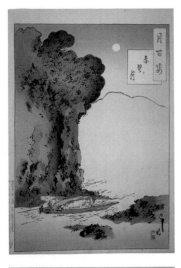 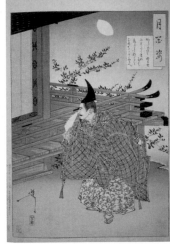

 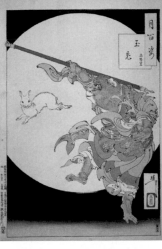 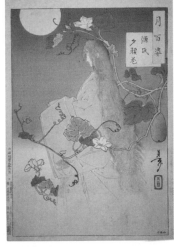 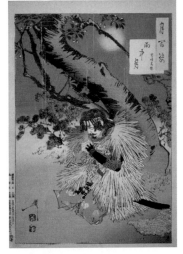

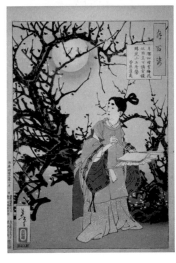 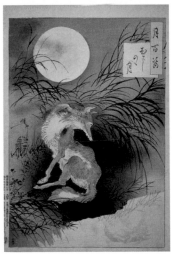

ONE HUNDRED ASPECTS OF THE MOON
1885–92

TSUKIOKA YOSHITOSHI

Woodblock prints, each 36 × 24.3 cm / 14¼ × 9½ in
National Diet Library, Tokyo

More or less prominent in the background of these traditional Japanese scenes (a selection from a total of a hundred produced by the artist Tsukioka Yoshitoshi (1839–92) between 1885 and 1892) hangs the Moon. Yoshitoshi's series *One Hundred Aspects of the Moon* is a celebration of the prominent role it plays in the mythology and cultural symbolism not just of Japan but also of much of East and South-east Asia. Its influence

over the tides and its predictable waxing and waning gave it a powerful influence over farming and fishing. The Moon also became central to Japanese ideas of beauty: gardens were built with ponds designed to reflect the Moon, with special platforms for viewing them. Moonlight was thought to purify the water with which it came into contact, giving it powers of rejuvenation. Yoshitoshi was the last great exponent of the *ukiyo-e* school of Japanese

art that originated in the hedonistic 'floating world' of early seventeenth-century Edo (now Tokyo) but would soon spread to encompass an artistic style of distinctive coloured woodblocks illustrating a broad range of natural subjects. By the time Yoshitoshi created this cycle, the great nineteenth-century masters Hokusai and Hiroshige had died and the art form was in decline – Yoshitoshi lived in near poverty while he persisted with his style.

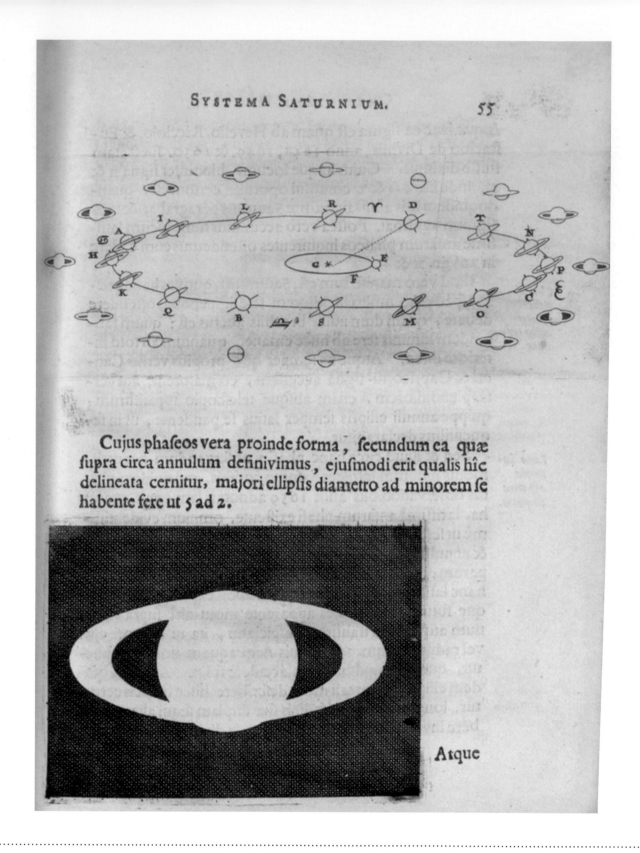

Cujus phaseos vera proinde forma, secundum ea quæ supra circa annulum definivimus, ejusmodi erit qualis hîc delineata cernitur, majori ellipsis diametro ad minorem se habente fere ut 5 ad 2.

Atque

SYSTEMA SATURNIUM
1659

CHRISTIAAN HUYGENS

Engraving, 20 × 15 cm / 8 × 6 in
Smithsonian Libraries, Washington, DC

In this page from his book *Systema Saturnium* (1659), the Dutch mathematician and scientific polymath Christiaan Huygens (1629–95) illustrated discoveries he made in 1655. The top diagram shows how Saturn's appearance changes due to the shifting relative positions of it and the Earth (E) and Saturn as they orbit the Sun (G). The lower diagram shows how Huygens saw that the rings were separate from the planet, as shown in his drawing.

Galileo discovered their existence first, but showed them attached to Saturn, like ears or handles. Huygens suggested that the rings do not touch the planet. Using a telescope he designed himself, he also discovered Saturn's largest moon, Titan (the first planetary moon to be identified, other than our own), and observed the Orion nebula. Among those involved in the scientific advances of the eighteenth century, Huygens stands out.

He invented the pendulum clock, formulated the first wave theory of light, published studies on games of chance, mechanics and optics. But it is for his work in astronomy that his name is remembered over 300 years after his death. He ground his own lenses for microscopes and astronomical telescopes and designed a two-element ocular eyepiece for telescopes, still known as a Huygenian eyepiece.

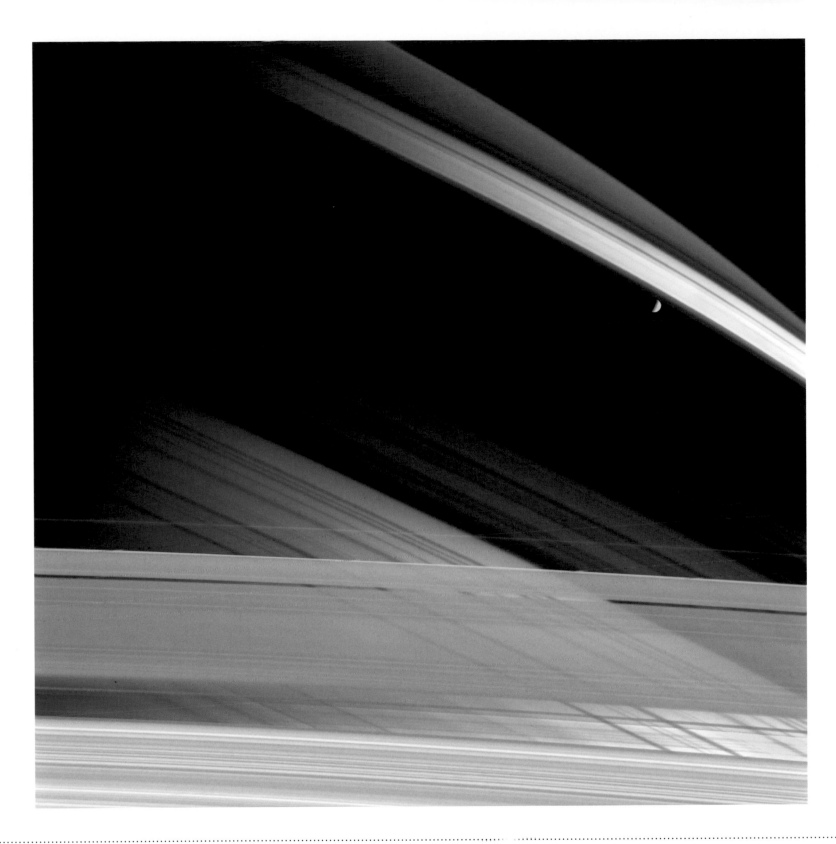

MIMAS OVER SATURN
2011

NASA, JPL–CALTECH, MICHAEL BENSON,
KINETIKON PICTURES

Composite digital photograph, dimensions variable

If the beauty and composition of this photograph of Saturn's moon Mimas against a background of the planet and its famed rings appears to reflect aesthetic rather than scientific priorities, it is because it was created by the US artist Michael Benson (born 1962). Achieving such an apparently simple image in 'true colour' takes hours of painstaking work as Benson searches the raw data of material gathered by various space probes, hopefully finding a minimum of two, but preferably three, individual photographs of a given subject that he can combine and manipulate. Here, in a composite of images from the spacecraft Cassini, Mimas appears in suspension as a tiny orb, half pale, half dark. The blue area in in the background is Saturn's northern winter hemisphere, an exciting Cassini discovery, with almost diagonally curving bands in a wide range of blue tones. Pale, semi-opaque southern rings fill the bottom of the image, creating a sense of movement against the dark background of space. Saturn's diaphanous halo of rings has fascinated astronomers, scientists and artists alike since Galileo first observed it through his telescope in 1610. Mimas is responsible for creating the Cassini Division, the gap between Saturn's two widest rings, by clearing material out of its orbit.

EUROPA'S SURFACE
2014

NASA, JPL–CALTECH, SETI INSTITUTE

Composite digital photograph, dimensions variable

The scarred half-dome of Europa peeks out of shadow in this image of Jupiter's sixth-closest moon, compiled in 2014 from photographs taken by the Solid-State Imaging Camera aboard NASA's Galileo spacecraft on two orbits, in 1995 and 1998. The blue regions, composed of water ice, form a canvas for a pattern of reddish brown cracks, ridges and patches, which are made up of non-ice materials such as mineral deposits. The icy surface cracks due to tidal forces caused by Jupiter's gravity and refreezes into intricate geometry, hinting at the activity that could lie beneath it. Europa, a moon slightly smaller than our own, is thought to contain an ocean of salty water beneath the comparatively thin ice crust and, in April 2017, NASA announced that it had gained evidence of vapour plumes erupting from Europa's surface, making the presence of water more likely still.

The presence of liquid is exciting because water is a fundamental requirement for life. Many origin theories hypothesize that life originated in Earth's oceans and, if we are to ever discover life beyond Earth, a giant liquid ocean would be an obvious first place to look. Future space missions will set out to land on Europa, confirm the presence of such an ocean and test it for signs of life – and for clues about our own origins.

PLUTO

2015

NASA, JHUAPL, SWRI

Digital photograph, dimensions variable

This intriguing image portrays Pluto, a world that has for decades been thought of by astronomers as rather dull. This high-resolution image was created from four images taken by the Long Range Reconnaissance Imager on board NASA's New Horizons spacecraft in July 2015. The images were combined with enhanced colour to bring out differences in surface composition. The light, heart-shaped region is known as Tombaugh Regio, named after the astronomer Clyde Tombaugh, who discovered Pluto in 1930 (New Horizons carries on board a portion of Tombaugh's ashes). This photograph was taken from a range of about 450,000 kilometres (279,617 miles), but is so clear that it shows individual features that are only around 2.2 kilometres (1 mile) across. From the varied textures revealed by the different colours, scientists have deduced that Pluto could be geologically active and that this activity is renewing the nitrogen in its atmosphere. When New Horizons was launched in January 2006, Pluto was still classified as the ninth planet. Today it is grouped with four other dwarf planets in the Solar System – and many more may exist. The flyby by New Horizons was the first time a spacecraft had visited Pluto, marking human reconnaissance of the former nine classical 'planets' in the Solar System.

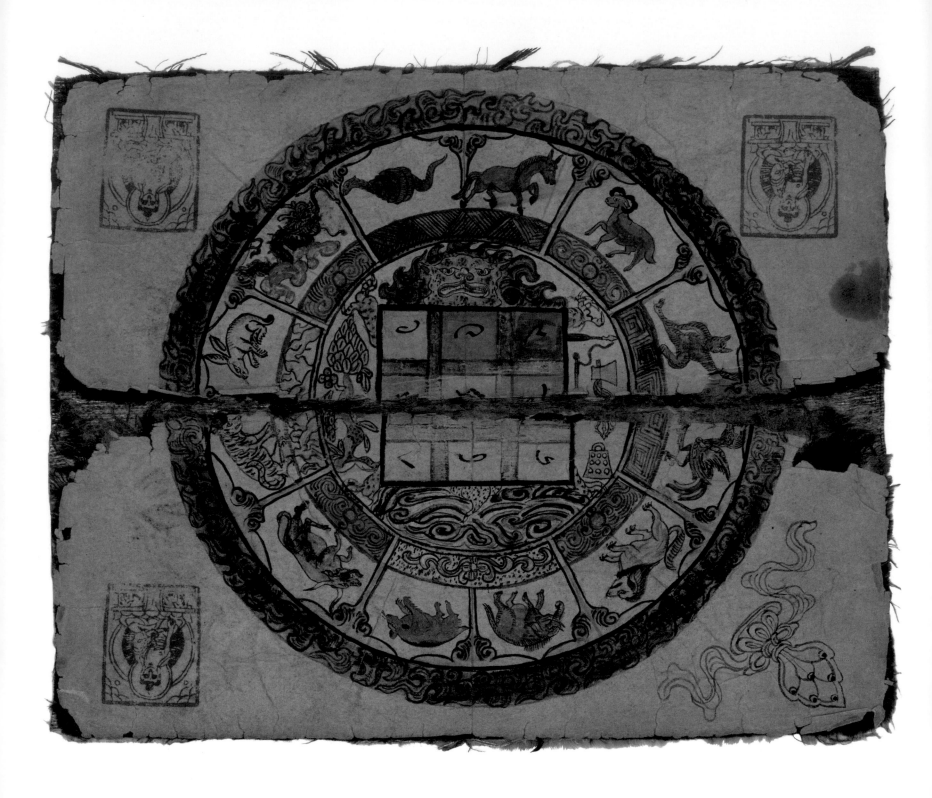

MONGOLIAN ASTROLOGICAL CHART
19th century

UNKNOWN

Ink and dye on paper, 11 × 35.5 cm / 4¼ × 14 in
National Library of Medicine, Bethesda, MD

This hand-drawn leaf of the Mongolian zodiac, exposing the indigo and red threaded innards that hint at its age, is a headlining page from a late nineteenth century Tibetan manual on divination – the art of forecasting the future using astronomical, astrological and intuitive means. Entitled *A Manual of Astrology and Divination*, the manuscript contains a collection of hand-drawn charts and texts that were primarily used by Tibetan

Buddhist monks to make calendars that foretold general astrological and climatic events, as well as highlighting auspicious days for specific activities, such as travelling or solving disputes. Although the pages are dated to the nineteenth century, the information within them is likely to be more ancient. In this particular image, we see animals representing the twelve signs of the Mongolian zodiac, similar to the Chinese zodiac, depicted along the

outside of a circle containing more astrological symbols within it. Pages such as this one are typical of traditional Tibetan manuscripts, made from leaves of paper that had most likely been imported. In contrast, local handmade inks and dyes would have been used to transcribe the information onto the pages, probably by a monk who acted as a professional scribe. The finished book would have been wrapped in silk and bound together with ties.

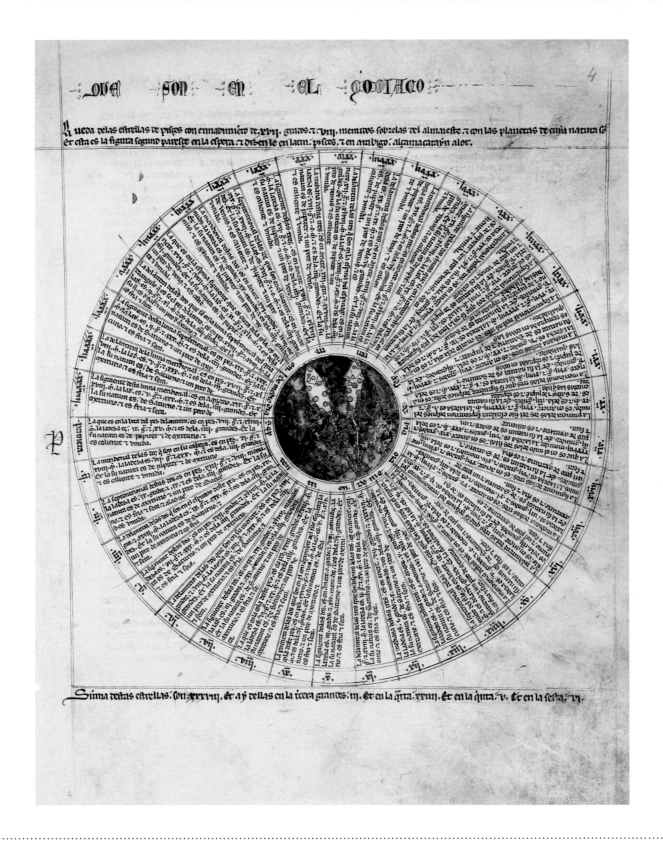

LIBROS DEL SABER DE ASTRONOMÍA DEL REY ALFONSO X DE CASTILLA

1276–9

YEHUDA BEN MOSHE HA-KOHEN AND ZAG DE SUJURMENZA

Ink on parchment, 47 × 31 cm / 18½ × 12¼ in
Biblioteca Histórica de la Universidad Complutense de Madrid

In the middle ages, Spain was a place where Christians, Jews and Muslims interacted extensively, albeit uneasily. This permitted transmission of knowledge and scholars travelled from across Europe to access philosophical and scientific works in Arabic. These included ancient Greek texts preserved in Arabic translation and developed by generations of Muslim and Jewish scholars. At the peak of this activity in the twelfth century translations were mainly made into Latin, but in the 1250s King Alfonso X of Castile began to promote translations into Castilian Spanish. Employing scholars of all three Abrahamic faiths, his support earned him the name 'Alfonso the Wise'. The most significant product of his scholars was the Alfonsine Tables, a complete and clear set of astronomical tables, which spread quickly across Europe and were used for centuries by astronomers including Copernicus. Alfonso's Books of the Wisdom of Astronomy described heavenly bodies and the instruments used to measure and model their motions. This diagram lists 38 stars in Pisces, based on Ptolemy's star catalogue. For each star, its celestial coordinates are given, together with its astrological relationship with the planets and its elemental qualities: hot or cold; wet or dry. This work stands as a monument to the complex cultures of astronomy.

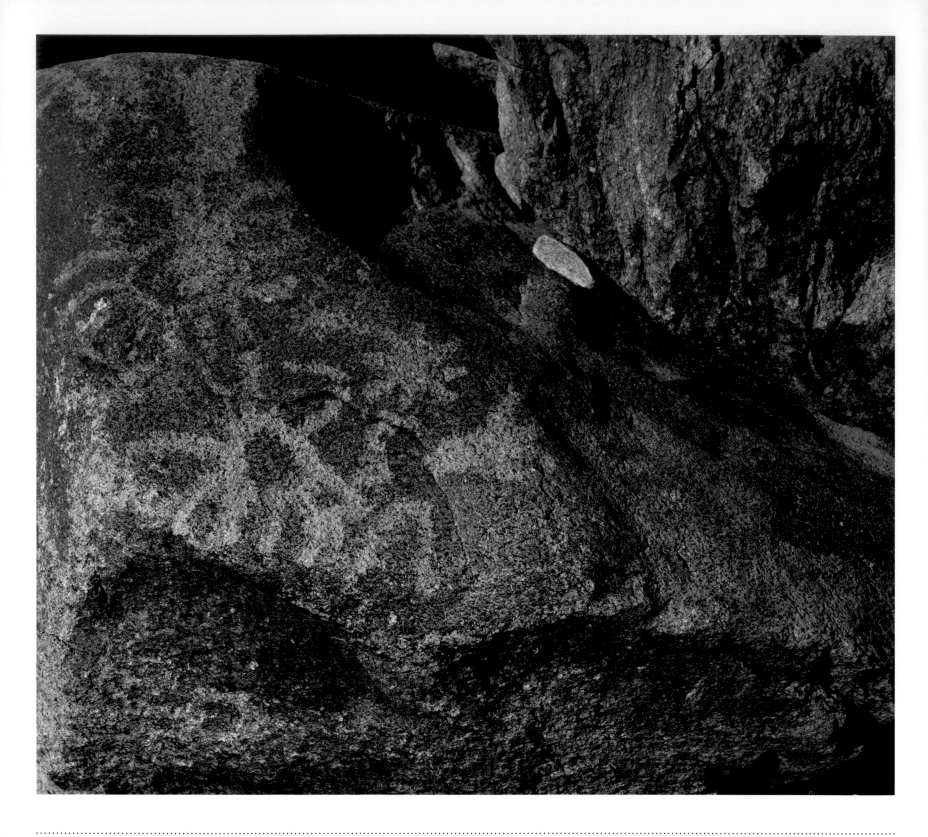

HOHOKAM PETROGLYPH OF SUPERNOVA

*c.*1006

UNKNOWN

Rock carving, dimensions variable
White Tank Mountain Regional Park, AZ

Barely discernible in this petroglyph, said to be around 1,000 years old, are a scorpion (above, left), a radiating star and other stars. The stone was found in the White Tank Mountain Regional Park outside Phoenix, Arizona, in 2006, home to the Hohokam people between about AD 500 and 1100. The patterns that the Hohokam created by hammering at the rock's surface appear to record an identifiable astronomical event. On the night of 30 April

and 1 May 1006, ancient astronomers noted what they believed was the birth of a new star in the constellation of Lupus, just south of Scorpius above the southern horizon of the night sky. In fact, the event was not the birth of a star but a supernova, the explosive destruction of a star some 7,000 light years away. Today, that supernova is almost invisible to the human eye, but in 1006 its light was so bright for months that it was said to make it

possible to read at midnight (astronomers believe it may be the brightest supernova known). The Hohokam carving matches the position of the supernova and Scorpius in 1006 – astronomers believe the Hohokam identified the same constellation as was known in the Old World – reflecting Native American awareness of astronomical events and the importance they placed upon them.

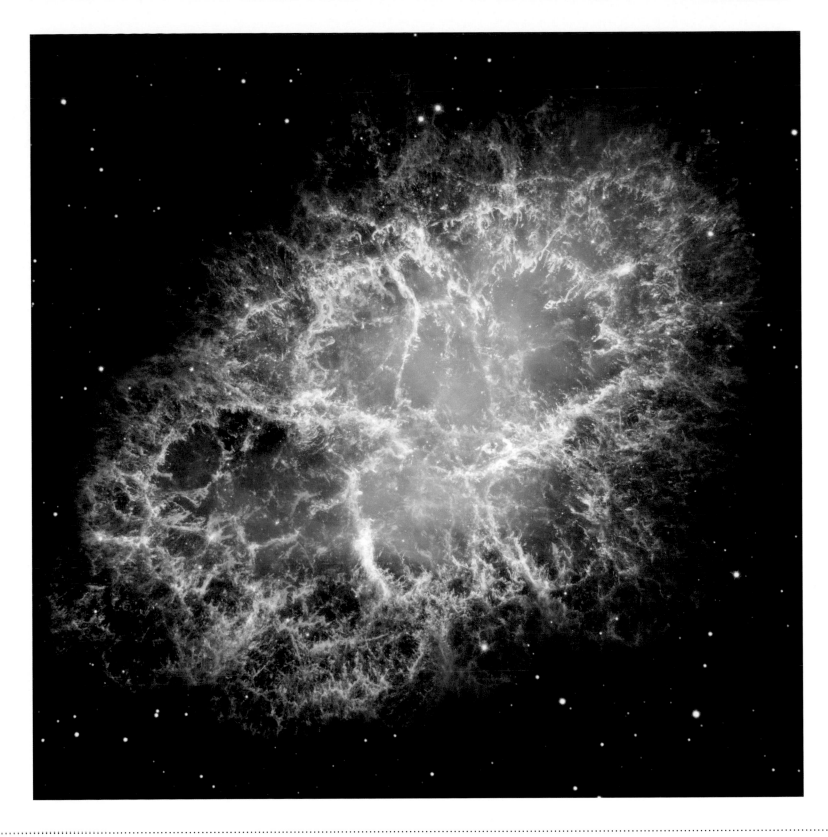

CRAB NEBULA
1999, 2000

NASA, ESA, J. HESTER, A. LOLL (ASU)

Composite digital image, dimensions variable

Located in the constellation of Taurus, the Crab Nebula (also known as M1 in the Messier catalogue) is a star being torn apart by a vast explosion seen as a supernova by astronomers of the Chinese court in 1054. Even now, after a millennium, it is still expanding at a speed of 1,500 kilometres (930 miles) per second. It appears as a network of rfilaments, which are the shredded remains of the star, arranged near the surface of an egg shape. The different coloured light of the filaments is produced by the different elements in the star: orange from hydrogen, blue and red from oxygen, green from sulphur. The diffuse blueish-white light is generated by high-energy electrons spun off a rapidly spinning neutron star by its magnetic fields. The stellar remnant of the supernova – the Crab Pulsar – is just visible if you know where to look as the lower right of two stars near the centre of the nebula, spinning thirty times per second (the other stars in the picture lie in front of or behind the Crab Nebula and are not connected with it). Apart from enhanced colours, the image is realistic, having been created from a mosaic of twenty-four separate images taken by the Hubble Space Telescope between October 1999 and December 2000.

SUZHOU STAR CHART

1247

UNKNOWN

Ink rubbing, 123 × 192 cm / 48 ½ x 75¾ in
Daniel Crouch Rare Books, London

This rubbing is a negative image of a star chart engraved on a stone tablet in China in the thirteenth century that depicts nearly 1,500 individual stars grouped into about 300 Chinese constellations. The irregular outline of the Milky Way winds across the chart, while geometric lines represent the ecliptic, the equator and a number of other coordinates. The stars are accurately positioned, based on observations made in the eleventh century. Originally drawn on paper by Huang Shang in about 1193, the chart was engraved on stone by Wang Zhiyuan in 1247 in order to preserve it forever. The sky rotates around the North Pole celestial at the centre of the chart, and the chart is accurate enough to show that the position of the North Pole has shifted in the millennium since the observations on which it was based were made. At the time of the chart, the North Pole was closest not to Polaris, as now, but to what the Chinese called the 'Pivot Star' (we know it today as HR 4893). The extensive text associated with the star chart describes how the stars, like humanity, separated from the original chaos at the beginning of the Universe and how celestial events are thus the counterparts of affairs on Earth – the underlying assumption of historical Chinese astronomy.

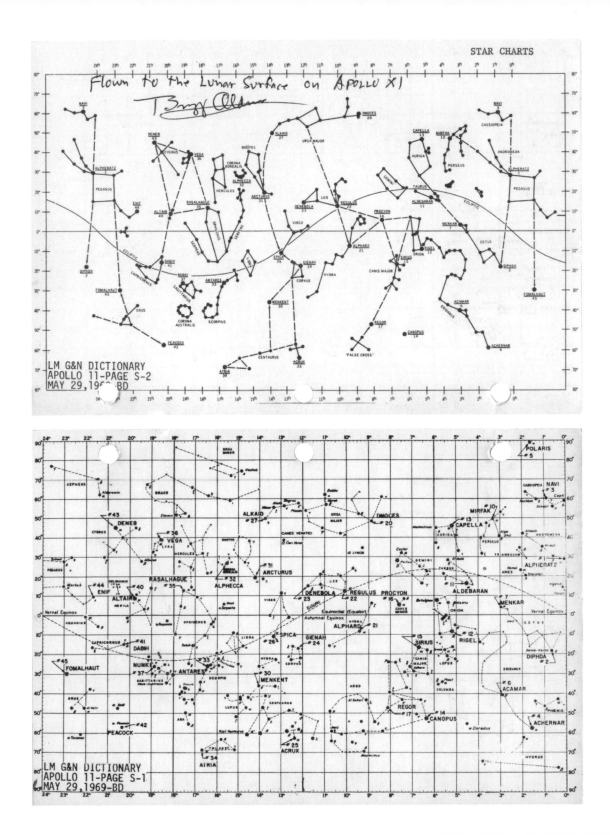

Flown to the Lunar Surface on APOLLO XI

Buzz Aldrin

LM G&N DICTIONARY
APOLLO 11-PAGE S-2
MAY 29, 1969-BD

LM G&N DICTIONARY
APOLLO 11-PAGE S-1
MAY 29, 1969-BD

APOLLO 11 FLOWN STAR CHART
1969

NASA

Printed card
Private collection

Astronauts stranded in space would have to rely on maps like these if their computers went down. This situation was similar to that of the ocean navigators of earlier centuries. These charts (printed back-to-back on a single punched card) display the constellations, with stars named and given a numerical code, while the curved dotted line of the ecliptic shows the apparent course of the Sun. They were carried on the Apollo 11 Lunar Module to help the pilot, Buzz Aldrin, to use star sightings for navigation during Trans Lunar Insertion (TLI), a propulsive movement to set the Lunar Module to arrive at the Moon, and Trans Earth Insertion (TEI), the manoeuvre that sent the spacecraft back to Earth. Aldrin used Apollo's Alignment Optical Telescope (AOT) to sight three stars, locate them on these charts and enter the grid coordinates into the Lunar Module's navigation system using the digital display and keyboard (DSKY). The information was processed by the onboard computer, and the best course determined. The chart contains a memorial to three astronauts who lost their lives on Apollo 1 in 1967. Stars 3 (Navi), 17 (Regor) and 20 (Dnoces) are named in honour of Gus Grissom, Roger Chaffee and Edward White II: Navi is Grissom's middle name, Ivan, backwards; Regor is Roger spelled backwards; and Dnoces is second backwards, for White.

ORIGINE DU MONDE (ORIGIN OF THE WORLD)

2004

ANISH KAPOOR

Concrete and pigment, 750 × 1200 × 600 cm / 295 × 472 × 236 in
21st Century Museum of Contemporary Art, Kanazawa

Inside a grey concrete room, on a wall that slopes up and away from the viewer, is a black oval. Despite being a simple geometric shape, it commands the attention of everyone who walks in the room, their faces turn upwards as though star-gazing, while their eyes try to locate something tangible on which to focus. But the hue is so dense and impenetrable that it is impossible to be sure whether the form is a flat surface, a deep

void or a window onto the depths of empty outer space. The title of this artwork by celebrated contemporary artist Anish Kapoor connects to scientific theories about the beginnings of the universe and the dark matter from which life on Earth was ultimately formed. It also references another well-known, though aesthetically very different, artwork with the same title, the 1866 painting by French artist Gustave Courbet. Kapoor rose to fame in

the 1980s for sculptures and installations that play with visual and spatial perception. In 2016 he started working with the material Vantablack®, a newly developed pigment, which Kapoor describes as the 'blackest material in the universe, after a black hole'.

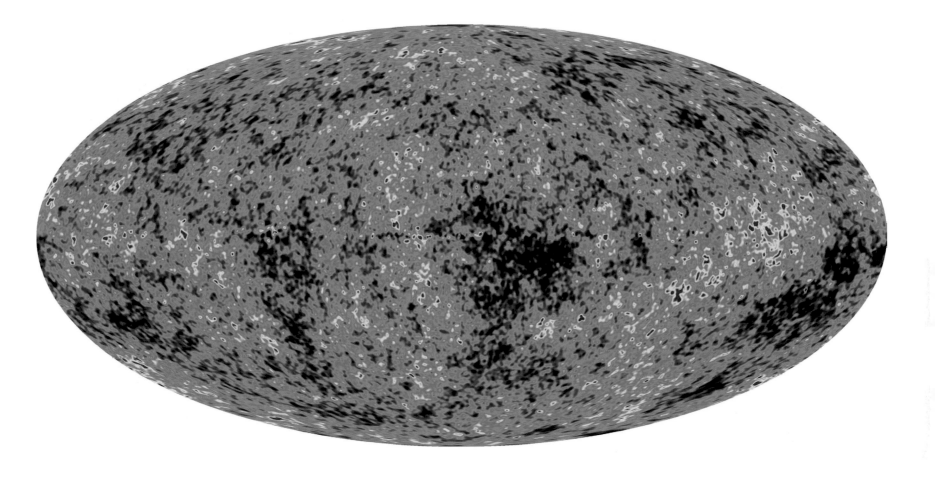

COSMIC MICROWAVE BACKGROUND RADIATION

2012

NASA, WMAP SCIENCE TEAM

Digital image, dimensions variable

In the 1940s cosmologists theorized that it should be possible to find the background radiation left over from the Big Bang and ensuing stages in the development of the young Universe, and in 1965 Arno Penzias and Robert Wilson of the Bell Telephone Laboratories detected it as an annoying hiss that interrupted telecommunications. It was found to have cooled to about 3 degrees above absolute zero, closely matching predictions, but further observations revealed that it is not uniform. In 1989, NASA launched the Cosmic Background Explorer, which spent seven years measuring fluctuations in the temperature of the radiation, which would indicate the Universe's structure just a few hundred thousand years after the Big Bang. The follow-up mission, the Wilkinson Microwave Antistrophy Probe (WMAP) was launched in 2001. This image is the result of nine years of observations and depicts the Universe as it was 13.77 billion years ago. The fluctuations are indicators of where matter was beginning to clump together into what would eventually become the earliest galaxies. Analysis of the results indicates that atoms make up only 4.6 per cent of the mass in the Universe, with the mysterious dark matter contributing 24 per cent and the even-less-understood dark energy 71.4 per cent.

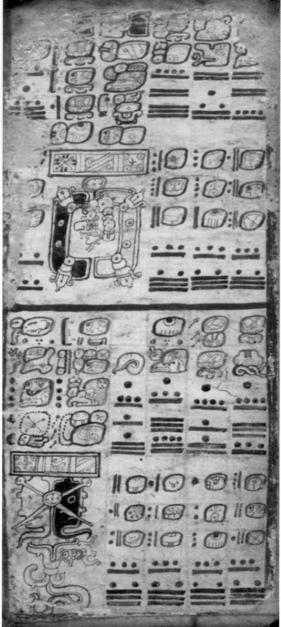

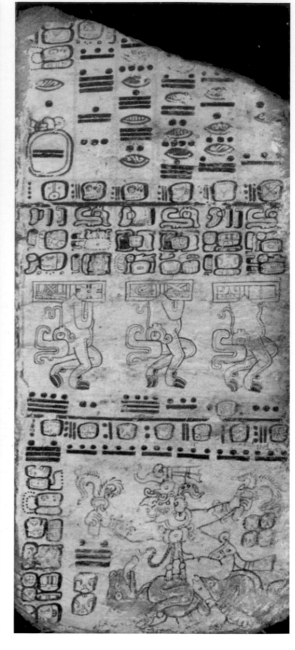

DRESDEN CODEX

*c.*1250– 1450

UNKNOWN

Amate and pigment, each page, 20.5 x 9 cm / 8 x 3½ in
Saxon State and University Library, Dresden

The *Dresden codex* is a collection of astronomical tables intended to enable priests and astrologers to forecast significant configurations of Venus, Mars and the Moon and the consequent behaviour of the planetary deities. It was painted on bark by Mayan scribes in the Yucatán peninsula of Mexico in the twelfth century and phonetic glyphs – symbol drawings – recount mythical events instigated by the planetary deities, with illustrations,

while tables of Mayan numerals (arrays of bars and dots) recording planetary movements enable astrologers to predict, and priests perhaps to to ameliorate, similar events in the future. The most important planet in Mayan astronomy was Venus, personified differently according to where it appeared in the sky. Here (central part of the left hand panel) Venus appears as the morning star – 'God L' – emerging from the darkness at a time

of floods that precedes a transition to peace. Eclipses signify times of chaos – the Maya saw the Moon and Sun as a quarrelling wife and husband – shown here as an open-mouthed snake devouring the Moon. Mars is enigmatically represented by an unidentified creature (a peccary?) known as the 'Mars Beast' (central part of right panel).

NIMBES

2014

JOANIE LEMERCIER AND JAMES GINZBURG Video installation, dimensions variable

In *Nimbes*, a remarkable fifteen-minute video installation, the French audio-visual artist Joanie Lemercier (born 1982) tackles the creation of the Universe and our unique responses to watching its unfolding. Working closely with British sound artist James Ginzburg, Lemercier uses laser scanning, CGI and projection mapping to create a Universe that moves from constellations to forests to urban centres. Fascinated by perception, Lemercier set himself the task of realizing how each person responds to the Universe in which we all live. The audience lies on the ground and watches the black-and-white images unfurl as they are projected on to a domed ceiling, accompanied by Ginzburg's soundtrack, placing the members of the audience, Lemercier says, 'at the centre of the space, and the Universe unfolds in front of their eyes'. Lemercier alters images of real forests, deserts, volcanoes and cathedrals using both three-dimensional modelling and two-dimensional photoscans so that the reworked images can then be projected on to the domed surface in a fantastical multilayered projection of constellations and stars, which in turn become mountains and landscapes as the viewer embarks on an exploration of consciousness, being and the relations between the physical, intellectual and emotional.

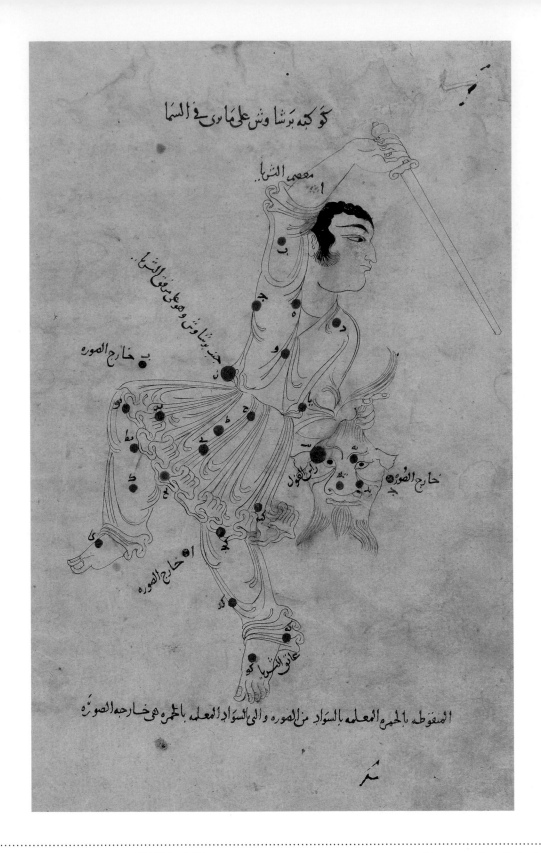

PERSEUS

1009–10

UNKNOWN

Ink on paper, from *The Book of the Constellations of the Fixed Stars*
26.5 × 18 cm / 10 ½ × 7 in
Bodleian Library, Oxford

In this early Persian map of the constellation Perseus, the hero holds not the severed head of the gorgon Medusa, as in the Greek myth, but that of a bearded, male demon. The change from the ancient original may derive from a misinterpretation of Greek representations of blood dripping from Medusa's neck. This illustration comes from *The Book of the Constellations of the Fixed Stars*, compiled around 964 by the Persian astronomer Abd al-Rahman

al-Sufi (known in a Latinized form as Azophi). The book presents charts of the constellations, tables of the positions of their principal stars, and supplementary information. The stars are shown and named in Arabic, together with constellation figures that are drawn in the Arab tradition but derive from Greek iconography. Each constellation chart appears twice, once as seen in the sky and once reflected as if on a celestial sphere, seen by God from

outside the Universe. The stars are not positioned precisely, but tables of accurate positions are given, with details of brightness ('magnitude') and colours. The data were updated from *Almagest*, the work of Claudius Ptolemy, a Greek astronomer who lived in Alexandria in the second century. The original of Al-Sufi's book is lost: almost 100 manuscript copies are known, including one held in the Bodleian Library, Oxford, from which this is taken.

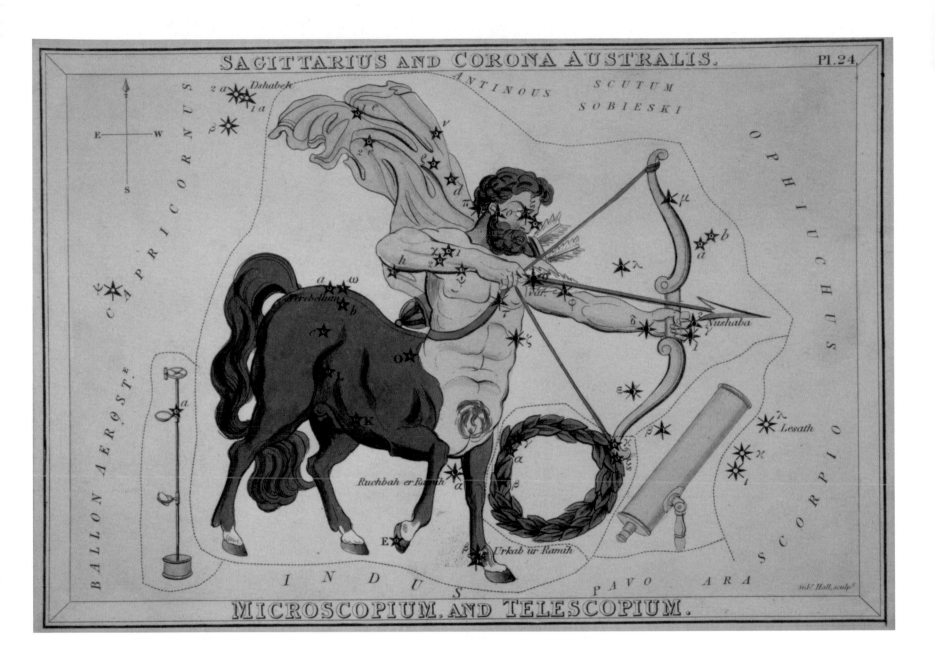

SAGITTARIUS AND CORONA AUSTRALIS, MICROSCOPIUM AND TELESCOPIUM

1825

SIDNEY HALL

Hand-coloured etching, 13.9 x 20.1 cm / 5½ x 7¾ in
Library of Congress, Washington, DC

The half-man, half-beast figure of Sagittarius is one of the oldest-known constellations, first devised by people looking up at the skies from Mesopotamia over 4,000 years ago. In contrast, the less familiar neighbouring constellations of Microscopium and Telescopium were only devised by the French astronomer Nicolas Louis de Lacaille in 1751–2, a few decades before this etching was made. Designed to be used by candlelight, constellation cards like this were a popular way for early-nineteenth-century families to learn about astronomy. Each card features pinprick holes that reveal the constellations when held up to the light. This set of cards first appeared in 1825, along with an explanatory booklet and a chart showing the stars as seen from the latitude of London. After establishing an observatory at the Cape of Good Hope, Lacaille set out to measure and map the stars as seen from the southern hemisphere. In an age of enlightenment and rational science, he broke with tradition and devised fourteen new constellations, based on scientific instruments rather than mythological creatures. They do not exercise the same hold over the imagination as the classical constellations, but as this card reminds us, different generations and civilizations have sought to interpret the night sky in their own ways.

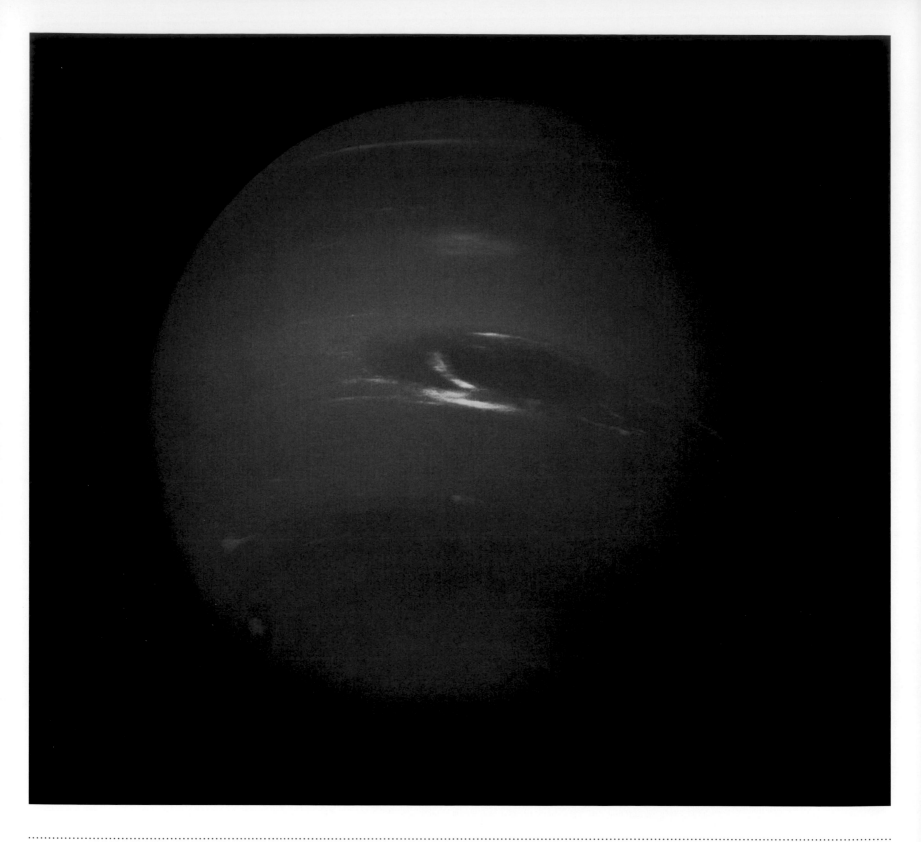

NEPTUNE'S GREAT DARK SPOT
1989

NASA, JPL-CALTECH

Digital photograph, dimensions variable

The last of the gas giants visited by Voyager 2 during its 'Grand Tour' of the Solar System was Neptune, which it reached 12 years after its launch. In Earth-based observations in visible light, the planet appears as a blank, bluish disc, but as Voyager 2 approached the planet some details began to emerge. In this image, the most obvious feature is the dark oval, edged with white clouds. Dubbed the 'Great Dark Spot', after Jupiter's

Great Red Spot, it appears to have been a storm. Unlike the Great Red Spot, however, it was not long-lived, as it was not seen in Hubble Space Telescope images from 1994. Neptune's atmosphere is primarily composed of methane and other hydrocarbons and appears blue because methane absorbs red light. By combining Voyager 2 observations of the cloud tops with Earth-based infrared studies, astronomers ascertained that

the top of the atmosphere has a rotation period of just under 18 hours. Radio emissions measured by Voyager indicated that the relatively tiny core rotates in marginally over 16 hours. Voyager 2 also imaged the planet's suspected ring system, discovered six new moons and found evidence that the largest one, Triton, had geysers at its south pole.

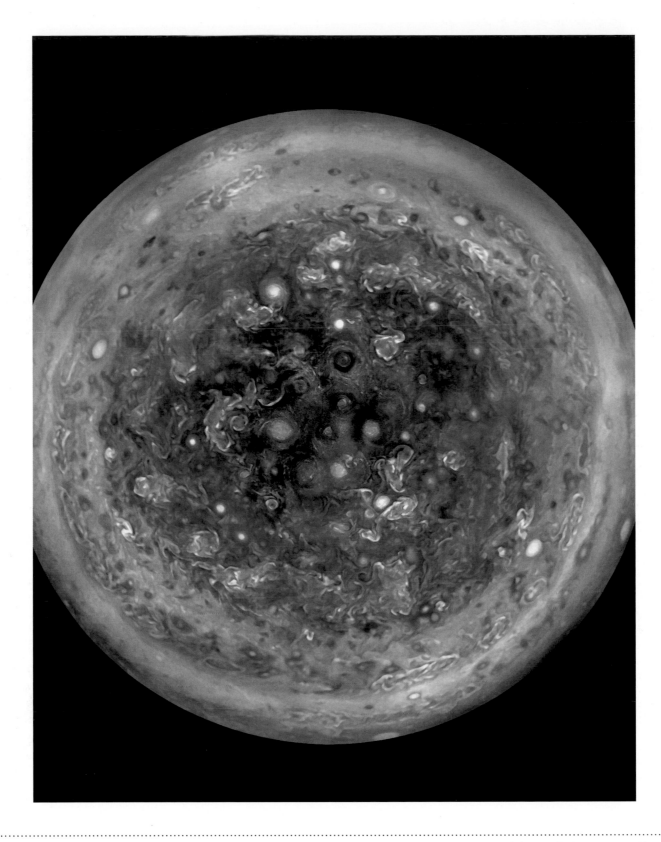

JUPITER'S SOUTH POLE

2017

NASA, JPL-CALTECH, SWRI, MSSS, B. A. HALL, G. ROBLES

Digital photograph, dimensions variable

NASA's Juno probe (named after Jupiter's wife in Roman mythology) arrived at the Solar System's largest planet on 4 July 2016, after a five-year journey, and entered an orbit that would take it close to the gas giant's as-yet barely glimpsed poles every 53 days. Among the first results released the following year was this stunning false-colour image of its unexpectedly chaotic south pole. Each of the close-packed rough ovals shown is an Earth-sized storm system; some of them extend deep into the planet's atmosphere. Astronomers had thought that the atmosphere at Jupiter's poles would be relatively stable, as it appears to be at lower latitudes. Other surprise findings from the early passes of the probe showed that atmosphere is layered, rather than mixed, and that the magnetic field is far stronger than thought, with a 'lumpy' structure that might indicate that it is formed in the atmosphere, perhaps in layers of 'metallic' hydrogen (under the high pressures there, hydrogen conducts electrical charge) rather than at the planet's core. The structure of the core itself appears not to conform to astronomers' expectations either, as early measurements seemed to show that it is diffuse, rather than solid.

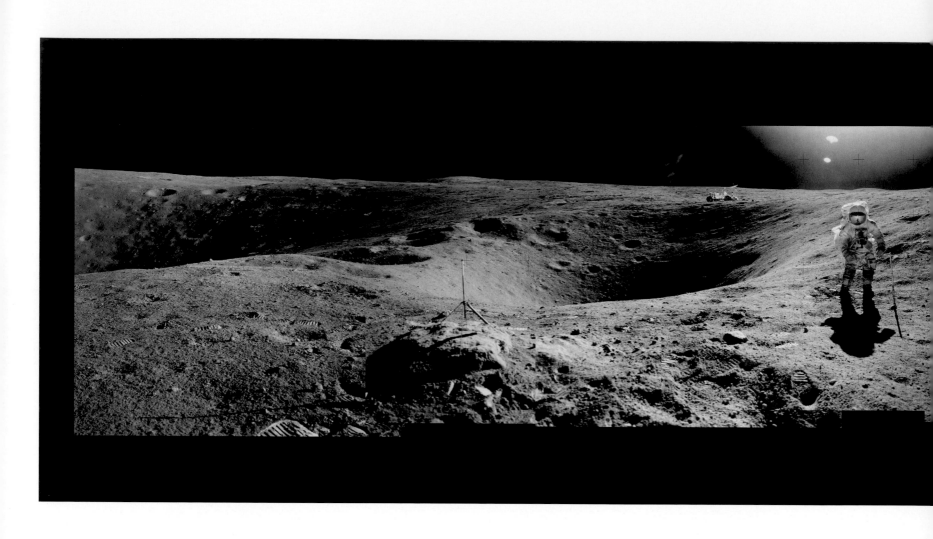

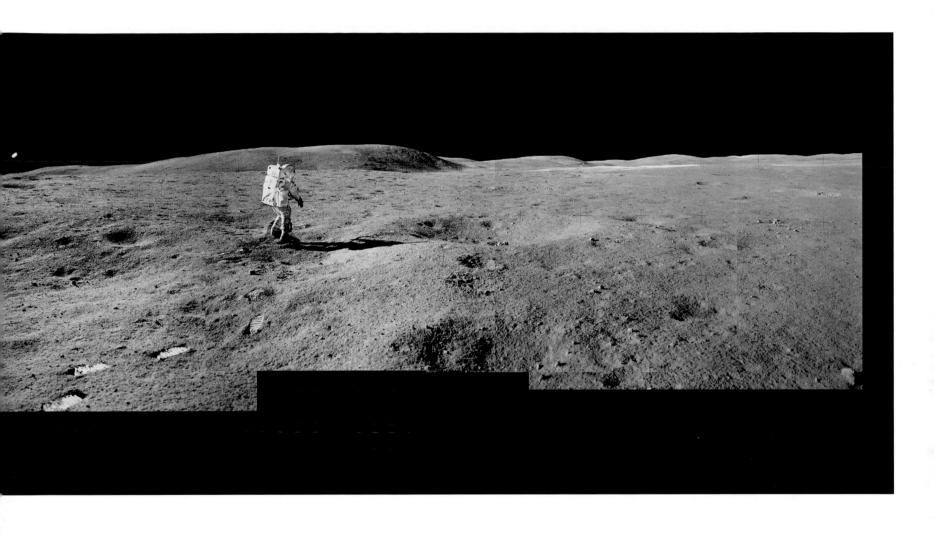

COMPOSITE OF CHARLES DUKE SEEN TWICE AT THE DESCARTES HIGHLANDS

1999

TRANSPARENCIES NASA, DIGITAL IMAGE MICHAEL LIGHT

Digital C-print from *Full Moon*, 121.9 × 487.7 cm / 48 × 192 in
Private collection

This composite panoramic photograph of the Descartes Highlands on the Moon, taken by astronaut John Young, commander of Apollo 16 in April 1972, includes two depictions of Young's colleague, Charles Duke, giving the image a narrative quality. Duke appears once looking straight at the camera and again moving away, leaving a trail of footprints in the lunar dust. In the background, left of centre, is the Lunar Rover the astronauts used to explore further afield on the lunar surface. Apollo 16 was the fifth of the six missions to land on the Moon, and the Descartes Highlands was chosen as a landing site because scientists suspected that the lunar material there was older than that in the flat lunar 'seas'. Apollo 16 was the second of what NASA designated 'J'-type missions, which saw the use of the Lunar Rover, increased scientific activity and an extended stay for astronauts on the lunar surface. Duke and Young spent three days and three nights on the Moon. They covered a distance of more than 26 kilometres (16 miles) and collected more than 95 kilograms (210 lb) of Moon rocks. Analysis showed that the highlands were not entirely formed by volcanic activity, as had previously been believed, but included fragments of rock created by the impacts of meteors on the Moon's surface.

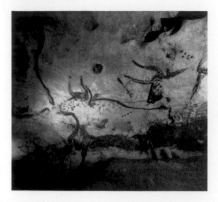

13.8 billion years ago
The Universe and everything in it bursts into existence in an event known as the 'Big Bang'.
........

Within the tiniest fragment of a second following the Big Bang the Universe 'inflates' into a 'soup' of energy, before fundamental atomic particles appear in the plasma. Some of these particles still exist today. Within minutes, hydrogen and helium nuclei had formed, providing the potential to make stars and galaxies.
........

Approximately 400,000 years after the Big Bang, atoms form, liberating energy particles (photons) to travel uninterrupted throughout the Universe. This becomes the cosmic microwave background, later discovered in 1964.

13.7 billion years ago
The Milky Way Galaxy forms.

4.567 billion years ago
Our Sun and the planets in the Solar System are born
........

Within 300,000 years, life begins on Earth, leaving behind the oldest fossils that exist today.

66 million years ago
A 10 km-wide asteroid impacts near the Yucatán Peninsula in Mexico, near Chicxulub and causes the change from the Cretaceous geological period to the Paleogene as a result of worldwide climate change. The event is credited with the extinction of the dinosaurs.

c.23,000 BC
Dating from the Upper Palaeolithic, a baboon fibula known as the Ishango bone is carved; it is now the earliest surviving lunar calendar. The bone is marked with three columns of asymmetrical notches.

c.16,500 BC
The earliest representations of stars appear in cave paintings in Cueva del Castillo in Spain and Lascaux in France (centre left, see p.12). The patterns depict recognizable parts of the constellations Pleiades, Corona Borealis and Summer Triangle.

c.15,000/14,000 BC
The constellation Ursa Major is imagined as a bear by people in both North America and Eurasia, suggesting that the constellation must have been recognized before the disappearance of the Bering Land Bridge linking Alaska and Siberia.

4000 BC
An arrangement of clam shells appears on a mural in a cave in Puyang, Henan Province, China, which represent the constellation we now call the Plough or the Big Dipper.

3500 BC
The Egyptians identify the twelve constellations of the Zodiac that we still recognize today.

c.3000 BC
The ancient Egyptians use observations of the star Sirius to calculate a calendar year.

c.3,000–2,000 BC
Stonehenge is constructed. Its true purpose is unknown but it is believed the stones were aligned with the heavens.

c.2500 BC
The Great Pyramid of Giza is built in Egypt. An internal shaft is aligned on the Pole Star as the path towards heaven. Solar alignments are also common in Pharaonic architecture: the temple of Amun-Re at Karnak in Egypt is aligned on the rising of the midwinter Sun.

c.2354 BC
Enheduanna is the first woman to hold the Sumerian title of 'En' or 'priest'. As High Priestess, her duties include tracking the movements of the Moon and making other astronomical observations, which she details in poems that survive today.

c.200 BC
Followers of the ancient Hindu Vedic philosophy in India hold the observation of the stars as a central pillar of their faith.

c.1600 BC
The Nebra Sky Disk believed to have been produced in the European Bronze Age, is discovered near Nebra in Saxony-Anhalt, Germany in the twentieth century. It is believed to be the earliest depiction of the cosmos (centre right, see p.288).

c.1000 BC
Indian and Babylonian astronomers calculate a year's length: 360 days. The Egyptians are later able to produce a more accurate calculation: 365.25 days.

650 BC
Astronomers in Assyria plot the stars within Gemini, the Pleiades and Pegasus on a clay disc (right, see p.248).

687 BC
Record-keepers of China's Zhou Dynasty note, 'in the middle of the night, stars fell like rain'. Not only is this the first documented record of a meteor shower, but also the first mention of the annual meteor display known as the Lyrids.

c.580 BC
Greek philosopher Anaximander creates a map of the world, which he envisages existing in space. This view is groundbreaking, showing Earth suspended in space without support.

c.500 BC
Pythagoras proposes that the Sun, Earth, Moon and planets are all spherical. His theory is later confirmed by Aristotle, who observed the shadow of the Earth during a lunar eclipse.

c.5th century BC
The zodiacal constellations emerge in Babylonian astronomy. This idea spread through Greece, Rome and India. There were originally six constellations, all named after animals, hence the word 'zodiac', meaning 'figured like animals' in Greek.

350 BC
Aristotle postulates that the dust lane in the Milky Way is a 'manufacturing fault' in the creation of the Universe; a split or a join in the fabric of space. This is due to its meandering, river-like shape.

280 BC
Greek astronomer Aristarchus disputes the notion that the Earth is at the centre of the Universe (the geocentric model), but his Sun-centred model fails to find acceptance.

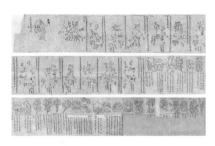

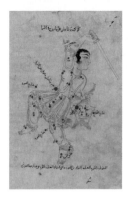

c.250 BC
In Egypt, scientific writer, astronomer and poet Eratosthenes successfully calculates the Earth's circumference to within five per cent accuracy.

239–40 BC
Chinese astronomers notice a new, 'broom star'. This is the first recorded sighting of Halley's Comet according to its regular cycle. The event is immortalized in the *Shiji* (*Records of the Grand Historian*).

164 BC
A probable sighting of Halley's Comet is recorded on fragments of two Babylonian tablets now in the British Museum, London.

c.190–120 BC
Greek astronomer Hipparchus devises a system organizing stars into orders of brightness. His system forms the basis of the star magnitude system still in use today.

150–100 BC
The Antikythera mechanism, perhaps the first analogue computer, is a device built according to the theories of Hipparchus. Its many bronze cogs allow the user to calculate the position of celestial bodies. Lost in antiquity, similar technology wasn't rediscovered until the fourteenth century.

104 BC
Emperor Wu of the Han dynasty introduces a new system of mathematical astronomy in China, used to calculate the civil calendar and predict conjunctions and solstices. The system also includes methods for predicting the motions of the planets and lunar eclipses.

45 BC
Julius Caesar introduces a new calendar, which includes a leap day every fourth year to stay in line with the solar year of just under 365.25 days. This calendar remains in use in much of Europe until Pope Gregory XIII reforms the calendar again in 1582.

c.AD 100
Chinese polymath Zhang Heng invents a water-powered armillary sphere; a system of interlocking rings the movement of which mimicked the celestial spheres and allowed for the production of more accurate star maps.

c.AD 147
Greco-Egyptian astrologer Claudius Ptolemy develops his theory of a geocentric model of the Universe in his treatise the *Almagest*.

AD 400
The Hindu text the *Surya Siddhanta* gives an average length of the sidereal year (the time it takes for Earth to orbit around the Sun) as 365.2563627 days. For a millennium this remains the most accurate estimate of the length of the sidereal year anywhere in the world and is very close to the modern value.

c.AD 400
Roman scholar Ambrosius Theodosius Macrobius publishes a commentary on Cicero's *Dream of Scipio*, which also contained a popular handbook on astronomy. Macrobius included the idea of a spherical Earth as well as the distinction between planets and stars thus ensuring the continuation of crucial concepts of Greek astronomy into the Middle Ages.

c.AD 500
The ancient Mayan city of Chichén Itzá is founded. A huge stepped pyramid is constructed with four sides of ninety-one steps each and a top platform, all of which add up to 365, the number of days in a solar year.

AD 628
Brahmagupta, the Indian mathematician-astronomer of the Indian Golden Age, composed *Brāhmasphuṭasiddhānta* (*The improved treatise of Brahma*), with chapters on astronomy and mathematics, including the calculation of solar and lunar eclipses and methods to determine the positions of heavenly bodies.

c.AD 700
The Dunhuang Star Atlas, one of the first known Chinese representations of the stars is created during the Tang Dynasty in China. The scroll was discovered with a collection of other documents the Mogao Caves in Dunhuang, Gansu Province by a Chinese Taoist Wang Yuan-lu in the early 1900s (centre left, see p.262).

AD 830
Persian mathematician and scholar Muhammad ibn Musa al-Khwarizmi publishes one of the first major works of Arabic astronomy, the *Zij al-Sindhind* (*Astronomical Tables of Sindh and Hind*), containing tables for the movements of the Sun, the Moon and the five planets known at the time.

c.AD 964
Astronomer Abd ul-Rahman al-Sufi updates the *Almagest* in his *Book of the Fixed Stars* and incorporates Arabic names for some heavenly bodies (centre right, see p304).

Late 10th century
Egyptian astronomer and mathematician Abd al-Rahman ibn Yunus composes a major astronomical work known as the *Hakimi Zij*. He is particularly renowned for his astronomical tables, and this book, about half of which survives, describes fourty planetary conjunctions and thirty lunar eclipses.

c.AD 980
Dating from the tenth century, the Barcelona astrolabe is the earliest example of this type of instrument made in Western Europe. Developed in ancient times, these complex instruments were introduced to Europe through Islamic Spain.

1030
Persian astronomer Abu al-Rayhan al Biruni proposes that the Earth turns daily on its own axis and travels annually around the Sun.

1054
A new star is recorded by Chinese, Korean, Japanese and Arab astronomers. It is visible in daylight for nearly three weeks and doesn't fully disappear for two years. The astronomers had witnessed the explosion that created of the Crab Nebula.

1066
The appearance of Halley's Comet is recorded in scene 32 of the Bayeux Tapestry. Comets were considered ill omens and this apparition seemed to bestow celestial approval on William the Conqueror's defeat of King Harold at the Battle of Hastings, England (right, see p.68).

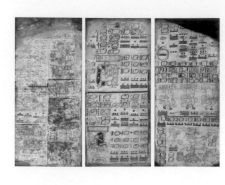
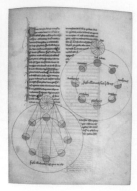
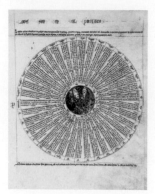
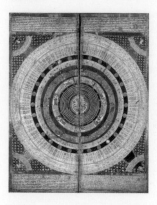

1085
Toledo falls to the Christians. Islam begins to recede from Spain, and scholars flock to the city to translate Islamic manuscripts.

1091–92
Prior Walcher of Malvern uses an astrolabe to observe a lunar eclipse in England. The astrolabe is Arabic and of a type developed in Toledo although it is thought Walcher acquired the instrument in England. This is the first recorded mention of the use of an astrolabe in western Europe and marks the arrival of Arabic learning into Europe.

1121
In the medieval work *Liber Floridus* (*Book of Flowers*), Canon Lambert of St Omer in France produces depictions of the Universe as it was then believed to be. In a diagram entitled 'The Order of the Seven Planets,' he shows the five known planets, the Sun and the Moon.

1126
The astronomical tables compiled by Persian astronomer and mathematician Muhammad ibn Musa al-Qazwini are translated into Latin. The original manuscript had been lost but it is believed English philosopher Adelard of Bath translated a version of the text copied by Spanish astronomer Maslamah Ibn Ahmad al-Majriti.

13th century
Dominican friar Thomas Aquinas synthesizes Christian theology with Aristotle's astronomical writings. In Aquinas's scheme, God is Aristotle's 'prime mover' while angels are charged with moving the celestial spheres.
........

Italian astronomer and mathematician Campanus of Novara, in keeping with the classical view of a finite Universe, suggests in his book *Theorica Planetarum* that the Universe extends around 70 million miles from Earth to the region of the fixed stars, with Earth at the centre.

c.1200
The Maya create a bark book, later to be known as the *Dresden Codex*, notable for its used of sophisticated mathematics in its recordings of the movements of Venus. It is the oldest surviving book from the Americas (left, see p.302).

1217
Scottish mathematician and scholar Michael Scot translates the work of al-Bitruji from Arabic into Latin. Al-Bitruji's manuscript was the culmination of efforts by Aristotelian philosophers to reconcile the Ptolemaic model of the Universe with that proposed by Aristotle.

c.1230
Johannes de Sacrobosco writes *De sphaera mundi* (*On the Sphere of the World*) which is used as a standard astronomical reference work in many of the newly emerging European universities (centre left, see p.240).

1247
In China, Wang Zhiyuan makes a stone engraving of the Suzhou star chart in China, originally drawn on paper in 1193, in order to preserve its transformation.

1276
The *Alfonsine Tables* are compiled in Toledo under the patronage of King Alfonso X of León and Castile enabling the calculation of eclipses and the positions of planets based on Ptolemaic theory. The tables remained influential until the work of Copernicus and Kepler superseded them three centuries later (centre right, see p.295).

1288
French-Jewish astronomer Jacob ben Machir ibn Tibbon (Profatius) designs the quadrans novus (new quadrant), an astronomical instrument that improved upon the existing quadrans vetus. His new quadrant combined features of the old one with some of the astrolabe so that the correct time of day could be determined from the altitude of the Sun.

1320
Richard of Wallingford, abbot of St Albans, builds a celebrated astronomical clock. It is a perfect evocation of medieval cosmology.

1342
French astronomer Levi ben Gershom (also known as Gersonides) describes using a cross-staff, also known as a Jacob's staff, to measure the distance between celestial bodies and the horizon.

c.1350
Arab astronomer Ibn al-Shatir proposes lunar, solar and planetary models based upon observation, avoiding many of the problems inherent in Ptolemaic theories. When his work was rediscovered in modern times it was noted that some of the geometrical devices he used were similar to those used later by Copernicus. Whether or not this is a coincidence is unknown.

1375
Majorcan cartographer and astronomer Abraham Cresques and his son create the *Catalan Atlas*, which provides detailed geographical knowledge, as well as information on the Moon, Sun and planets (right, see p.198).

c.late 1300s
Madhava of Sangamagrama, an astronomer of a Keralan school of astronomy and mathematics, publishes work containing calculations for the accurate determination of the positions of the planets and the Moon. He was known by later astronomers as Golavid (Master of Spherics).

1390s
English author and poet Geoffrey Chaucer writes his 'technical manual', *Treatise on the Astrolabe*. It is the first to describe, in English, the parts and uses of the instrument. The writing of the work implies the subject is no longer the preserve of those who speak Greek, Latin or Arabic. This book is second only to Chaucer's *The Canterbury Tales* in terms of the number of surviving manuscripts.

15th century
In the fifteenth century many publishers produce 'Ephemerides', which are texts that list information and events, usually of an astronomical nature. These texts would often be accompanied by illustrations demonstrating particular astronomical occurrences such as eclipses, as an aid to astrological predictions.

1420

1492

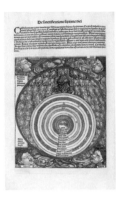

1515

1543

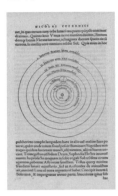

c.1420
Ulugh Beg (later the Timurid ruler) constructs an observatory at Samarkand. The principal instrument, a sextant with a radius of over 40 m (130 ft), swings in a deep trench outside.

1438–39
Ulugh Beg compiles the *Zij-i Sultani*, a catalogue of over 1000 stars, using his observatory at Samarkand. It is considered the most important star catalogue of the Middle Ages, surpassing previous examples.

1442
The Beijing Ancient Observatory is constructed in China. It is now one of the oldest observatories in the world.

1459
Austrian mathematician and astronomer Georg von Peuerbach compiles the *Tubulae eclipsium*, an influential table of eclipses based on the *Alfonsine Tables*.

c.1479
The Piedra del Sol is created, weighing around 24 tons and 3.7 m (12 ft) wide. The central image on this huge piece of basalt is believed to portray Tonatiuh, the Aztec Sun god. Thought to be a ritual item, its true purpose is unknown, a testament to the total destruction inflicted on the Aztec culture by the European conquistadores (left, see p.138).

1492
A triangular meteorite lands in a wheat field outside the town of Ensisheim in Alsace. A small boy witnesses the event. Emperor Maximilian deems the meteorite a good omen and has the meteorite, known as the 'Thunderstone of Ensisheim', preserved. It is still on display at the Regency Palace in Ensisheim.

1493
German physician and cartographer Hartmann Schedel publishes his *Liber chronicarum*, known as the *Nuremberg Chronicle*, in which he illustrates the Christian conception of the Aristotelian Universe. It describes a central Earth surrounded by concentric spheres containing the Moon, the planets and the Sun. The outermost sphere contains the fixed stars beyond which reside the angels (centre left, see p.266).

1500
Polish Renaissance astronomer and mathematician Nicolaus Copernicus observes a lunar eclipse whilst in Rome. He later uses his observations of this, and records of a similar eclipse made by Ptolemy, to make calculations of the motion of the Moon in his book *De Revolutionibus* of 1543.
........

German priest and astronomer Johannes Werner observes and records a comet for 24 days in June.

1501
Italian explorer Amerigo Vespucci, travelling in the southern latitudes, charts stars hitherto unknown to Europeans, recording Alpha and Beta Centauri and the stars of the constellation Crux.

c.1508
In Italy, artist Leonardo da Vinci uses his notebooks to record his observations of celestial phenomena such as the luminosty of the Moon, which he concludes is the result of oceans on the lunar surface.

c.1515
German artist Albrecht Dürer creates woodcuts of the constellations of the Northern and Southern skies, based on earlier German maps. They are the first printed celestial maps.

before 1521
The *Codex Fejérvéry Mayer*, a tonalamatl or 'book of days and destinies' is produced in central Mexico (centre right, see p.199).

1532
A bright comet is seen in the sky for four months, and at times is visible during the day. Spotted as the Spanish arrived in the New World, it was thought by some to augur the destruction of the Aztec empire.

1534
Flemish mathematician Gemma Frisius publishes his design for an astronomical ring, an instrument combining elements of an astrolabe and a armillary sphere.

1540
Petrus Apianus publishes *Astronomicum caesareum*. Printed and then hand-coloured, it is filled with beautifully fashioned 'volvelles' (movable paper devices used to calculate positions of cosmic objects).

Alessandro Piccolomini of Siena produces the first printed star atlas *De le stelle fisse* (*On the Fixed Stars*).

1543
Nicolaus Copernicus publishes his *De revolutionibus orbium coelestium* (*On the Revolutions of the Heavenly Spheres*) which contains his ideas of a heliocentric Universe. The book is printed in Nuremberg (right, see p.164).

1551
Spanish cosmographer Martín Cortés de Albacar describes an instrument known as the nocturnal. Used by both sailors and astronomers, it indicates the time by using the positions of the pole star Polaris and the pointer stars of Ursa Major. The pointers work as an hour hand of a 24-hour clock pivoting around the pole star.

1572
Danish nobleman Tycho Brahe is convinced the future of astronomy depends upon recording precise measurements of celestial objects. His observations of a supernova (in Cassiopeia) convince him that stars are not fixed a precise distance from Earth but are objects existing in 'space'.

1576
Mathematician Thomas Digges introduces a diagram of the Copernican model of the Universe to England in a new edition of his father's work *A Prognostication everlasting*, which, for the first time suggests stars extending to infinity.
........

Frederick II of Demark becomes patron to nobleman and astronomer Tycho Brahe and grants him the island of Hven, where he builds an observatory.

1577

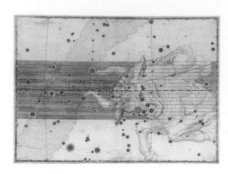

1608

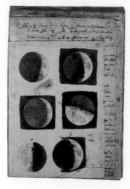

1611

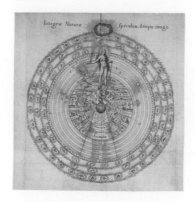

1645

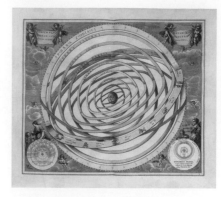

1577

An observatory built for the astronomer Taqi al-Din is completed in Istanbul in time to observe a bright comet, which is deemed a good omen for Sultan Murad III by the astronomer. A number of disasters immediately follow, which convinces religious leaders that prying into nature is unwise and the sultan has the observatory destroyed in 1580.

1580

Tycho Brahe builds the mural quadrant in Uranienborg, an enormous wall-mounted instrument used to measure the altitude of stars. At the time, it is the most accurate instrument of its kind.

1584

Giordano Bruno, a Dominican friar, publishes *De l'infinito universo e mondi* (*On the Infinite Universe and Worlds*) in which he suggests there could be life on planets other than Earth, among other radical views. Three years later, he is burned at the stake for heresy.

1595

The first Dutch expedition to the East Indies sets off and aboard the ship are two navigator-astronomers, Pieter Dirkszoon Keyser and Frederick de Houtman. Their observations of the southern sky form the basis for twelve new constellations.

1603

German lawyer and celestial cartographer astronomer Johann Bayer publishes *Uranometria*, the first star atlas to represent the complete celestial sphere. This work contains the twelve new southern hemisphere constellations described by Keyser and Houtman in 1595 These stars were largely unknown to Greek and Roman astronomers (left, see p.154).

1608

Dutch spectacle-maker Hans Lippershey of Middleburg in Zeeland invents the telescope and applies for a patent. His application is ultimately denied but word quickly spreads of his design.

1609

German astronomer Johannes Kepler publishes the influential *Astronomia Nova* (*New Astronomy*) in which he establishes that planetary orbits are neither circular nor epicyclic, but elliptical. The book is based on the planetary observations of Tycho Brahe and is the culmination of ten years of study.
........

Thomas Harriott buys a 'Dutch tube' (telescope) and observes sunspots, the moons of Jupiter, and makes the first sketches of the surface of the Moon but fails to publish anything.
........

Hearing of Lippershey's invention of the telescope, Galileo Galilei constructs his own superior versions for astronomical purposes, with a magnification of x30. His observations of the ever-changing moons of Jupiter and later the phases of Venus confirmed Copernicus's heliocentric model of the Solar System.

1610

Galileo publishes his early observations and his conclusions about the flaws of Aristolean cosmology in his book *Sidereus Nuncius* (*The Starry Messenger*) and is condemned by the Catholic Church, despite being widely read (centre left, see p.156).

1611

Simon Marius, a German astronomer, claims to have discovered Jupiter's moons at the same time as Galileo, causing life-long antagonism between the two men. While Galileo is credited with the discovery, Marius's names (Io, Europa, Ganymede and Callisto) catch on instead of Galileo's term 'Medicean moons', used to flatter his patrons the Medici family.

1617

English physician and cosmologist Robert Fludd in his book *Utriusque cosmi, maioris scilicet et minoris, metaphysica, physica, atque technica historia* (*The Metaphysical, Physical and Technical History of Two Worlds, the Macrocosm and the Microcosm*) creates a revolutionary image of infinity before the light of creation as a black square of nothingness (centre right, see p.233) .

1627

In his work *Coelum stellatum christianum* (*Christian Starry Heavens*), Julius Schiller replaces the pagan figures used in astronomy with biblical and early Christian characters. Even the Sun and planets of the Solar System are renamed. His system is not adopted.
........

Johannes Kepler publishes the *Rudolphine Tables*, a set of standard planetary tables and star catalogues based on the meticulous observations of Tycho Brahe. Kepler increases Brahe's star position tally from 777 to 1,005.

1645

A period of 70 years of drastically reduced Sunspot activity coincides with the coldest years of 'The Little Ice Age'. This period is later dubbed the 'Maunder Minimum'.
........

The first true lunar map, produced by Dutch astronomer and cartographer Michael Florent van Langren is published

1646

In Rome, scholar Anathasius Kircher publishes the first edition of *The Great Art of Light and Shadow*, which includes a 'sciathericon', illustrating the influence of the Sun and planets on the human body as they move through the zodiac.

1647

Astronomer and cartographer Johannes Hevelius publishes *Selenographia*. This was the first widely available lunar atlas and it's accuracy meant that it remained in use for more than a century.

1655

Reflecting the improvement in telescopes, the Dutch astronomer and mathematician Christiaan Huygens discovers Titan, the largest of Saturn's moons. A year later, in 1656, using a more powerful telescope built with his brother, Huygens realizes that Saturn is surrounded by rings, rather than 'handles' as previously thought .

1660

Dutch-German cosmographer and mathematician Andreas Cellarius produces his magnificent astronomical atlas the *Harmonia Macrocosmica* (right, see p.165).

1664

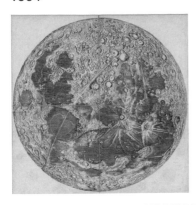

1676

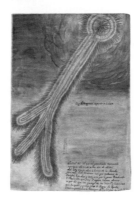

1696

1716

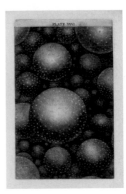

<u>**1664**</u>
English polymath Robert Hooke first sights Jupiter's Great Red Spot. We now know the spot is a storm in Jupiter's atmosphere although it is unclear whether the spot we see now is the same one recorded by Hooke.

<u>**1666**</u>
Giovanni Domenico Cassini, an Italian-French astronomer, is the first to observe polar caps on Mars and he posits they are formed of ice like those on Earth. Later, space probes confirm that they are indeed ice, 2–3 km thick.

<u>**1667**</u>
French astronomer Jean Picard contributes to greater precision in astronomical observations by adding telescopic sights to instruments such as the quadrant.

<u>**1671**</u>
Jean Richer observes on a voyage from France to Guyana that a clock that was accurate in France runs slow at the Equator. To achieve the correct time Richer has to reduce the length of the clock's 1 meter pendulum by 3 mm. Although a mystery at the time, this was the first tantalizing evidence that the Earth is not exactly spherical.

<u>**1672**</u>
Isaac Newton, modifying a design by Scottish mathematician James Gregory, builds the first successful reflecting telescope. This instrument eliminates chromatic aberration, a colour halo effect inherent in early, uncorrected lenses. The reflecting telescope was much more compact and could be made much bigger than the earlier refractors.

<u>**1675**</u>
In Britain, John Flamsteed is appointed to the newly created position of Astronomer Royal by Charles II.

<u>**1676**</u>
Danish scientist Ole Rømer makes the first quantitative measurements of the speed of light by studying Io, a moon of Jupiter.

<u>**1679**</u>
Giovanni Domenico Cassini, working with artists Jean Patigny and Sébastien Leclerc, produces an atlas of the Moon containing 50 detailed drawings. The work allowed Cassini to produce a large map of the Moon, which he presented to the French Academy of Sciences (left, see p.60).

<u>**1687**</u>
Johannes Hevelius names seven new constellations including Lacerta and Lynx.
........
Isaac Newton publishes his law of universal gravitation in *Philosophiæ Naturalis: Principia Mathematica* (*Mathematical Principles of Natural Philosopy*). The theory resolves the problem of why the planets follow fixed orbits without hurtling off into space.
........
Isaac Newton finds a solution to the problem Jean Richer observed in 1671 – the Earth is not a perfect sphere but instead is flattened at the poles and bulges at the equator. This distorted shape reduces gravity at the equator resulting in Richer's pendulum beating more slowly.
........
French author Cyrano de Bergerac publishes *The Comical History of the States and Empires of the Worlds of the Moon and Sun*, which imagines the author being transported to the Moon by the first rocket to appear anywhere as a possible means of transport into space (centre left, see p.50).

<u>**1696**</u>
English astronomer Edmond Halley asserts that the three comets of 1531, 1607 and 1682 were in fact, all the same object – he correctly predicts its return in 1758, however, Halley dies in 1742 and does not live to see his prediction fulfilled.

<u>**1698**</u>
Cosmotheoros, a work by Christiaan Huygens, is published after his death in 1695. The work speculates on the possibility of life existing on other planets.

<u>**1702**</u>
Scottish-born astronomer David Gregory publishes *Astronomiae physicae et geometricae elementa*, a popular account of Newton's principles of motion and theory of gravitation.

<u>**c.1704**</u>
English clockmakers George Graham and Thomas Tompion build the first modern orrery, an animated mechanical depiction of the Solar System. John Rowley, a celebrated maker of scientific instruments in London, is then commissioned to make a copy for Charles Boyle, 4th Earl of Orrery, his patron, from whom the device takes its name.
........
A meteor is recorded dividing into three tongues of fire in the sky over Catalonia in Spain on Christmas Day. The comet is widely seen as an inauspicious omen connected with the fighting taking place in the War of the Spanish Succession (centre right, see p.211).

<u>**1715**</u>
Edmond Halley predicts a solar eclipse to within four minutes, a first for Newton's theory of universal gravitation. This event, taking place in April (May in the Gregorian Calendar later adopted) becomes known as 'Halley's Eclipse'.

<u>**1716**</u>
Johann Baptist Homann, the greatest cartographer of the day, publishes *Systema Solare et Planetarium*, a diagram of the Copernican Solar System that reflects growing knowledge of astronomy.

<u>**1725**</u>
John Flamsteed's *Historia Coelestis Britannica* is published posthumously. The work is edited by his wife Margaret and it lists 2,935 stars to unprecedented accuracy.

<u>**1727–34**</u>
Maharaja Jai Singh II builds the Jantar Mantar observatory in Jaipur, India. The observatory's monumental sundial is capable of keeping time to within a few seconds.

<u>**1729**</u>
French scientist and Jesuit priest Nicolas Sarrabat discovers, without the aid of a telescope, the largest comet yet recorded.

<u>**1731**</u>
British mathematician John Hadley builds a device, the 'Doubly Reflecting Octant' to measure the altitude of the Sun or a star at sea, a notable advance.

<u>**1750**</u>
French astronomer Nicolas Louis de Lacaille sails to the Cape of Good Hope where he observes and catalogues nearly 10,000 southern stars and names fourteen new constellations, many after measuring instruments. *Coelum Australe Stelliferum*, published posthumously in 1763, was the most comprehensive catalogue of southern stars to date.
........
English astronomer Thomas Wright publishes *An Original Theory or New Hypothesis of the Universe* in which he explains why the faint, far-away stars of the Milky Way produce their 'milky' effect. (right, see p.142).

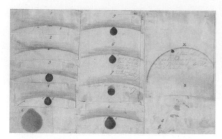
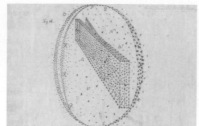
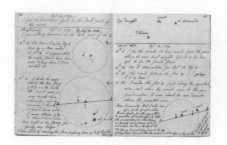
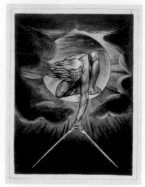

1761
Russian scientist Mikhail Lomonosov suggests Venus has an atmosphere.

1766
Johann Daniel Titius, a professor at the University of Wittenberg, devises an accurate formula for estimating the distances of the planets relative to the Sun. The formula, commonly known as Bode's law (having been popularized by German astronomer Johann Bode) appears to work because of the strangely regular spacing of the planets. However, it fails with the outer planets and has been discredited.

1769
A widely anticipated transit of Venus takes place. It is recorded in London by William Hirst. Meanwhile, Captain James Cook leads a naval expedition to Tahiti in the Pacific Ocean to observe the same transit. Information from the observations allowed the calculation of the Earth's distance from the Sun, and thus the size of the Solar System (left, see p.214).

1770
Lexell's Comet is spotted by French comet-hunter Charles Messier and is believed to be the closest to pass Earth. An encounter with Jupiter in 1779 is believed to have catapulted the comet out of the Solar System and it has never been seen again.
........

French astronomer Antoine Darquier de Pellepoix discovers the Ring Nebula in the constellation Lyra.

1781
Charles Messier publishes a catalogue of more than 100 'fixed' nebulae (diffuse objects) to distinguish them from comets, which were his main interest. This catalogue is still used by astronomers today when referring to prominent nebulae using a notation where the letter 'M' is followed by its Messier number.
........

William Herschel discovers the seventh planet Uranus and a year later is appointed Court Astronomer in England. Uranus is the first new planet discovered since antiquity. While Herschel suggests the new planet be called Georgium Sidus (after King George III, his patron), German astronomer Johann Bode's suggestion of Uranus catches on.

1783
John Michell, a professor of Geology at Cambridge University, speculates about black holes and the effect of gravity on light. He theorize that were our Sun 500 times larger, its resulting gravitational pull would be such that light would be unable to escape it. French astronomer Pierre-Simon Laplace considered the same concept in 1795, however their theories could not be correctly explored until 1910, when Albert Einstein put forward his Theory of General Relativity.

1784
William Herschel uses his new telescope to study the Milky Way and produces a cross-section of the galaxy showing a multitude of stars (centre left, see p.276).

1786
Caroline Herschel, William Herschel's sister, is the first woman to discover a comet. She eventually discovers a total of eight comets in her career (centre right, see p.35).

1789
William Herschel works on ways to gaze deeper into space. Instead of just increasing the focal length of his telescopes, as is the fashion, he experiments with larger mirrors and in 1789, built a telescope at Slough, England with a 1.25 m (4 ft) mirror.

1790
In December the enormous Piedra del Sol is discovered by workmen under the main square of Mexico City. The stone is heavily carved with depictions of the Aztec calendar and cosmological symbols. Some believe the stone was used in religious rites including human sacrifice. The stone now resides at National Museum of Anthropology, Mexico City.

1794
German physicist and musician Ernst Chladni studies a large iron meteorite in Siberia and notes its similarity to meteorites discovered all around the world, even in places possessing no naturally occurring iron deposits. He concluded meteorites must come from a single source that is capable of accessing all areas of the globe: space.
........

British artist William Blake draws an illustration of a divine figure – whom he calls the 'Ancient of Days' – who appears in the guise of the architect of the Universe (right, see p.267).

1799
Pierre-Simon, marquis de Laplace, an influential French scholar, begins publication of his five-volume *Méchanique céleste* (*Celestial Mechanics*). The series isn't completed until 1827.

1800
William Herschel discovers infrared radiation in Sunlight. By passing light through a glass prism the scientist is able to measure the heat emitted by each colour with the use of a thermometer. When Herschel placed a thermometer beyond red where there was no visible light, he witnessed an increase in temperature.
........

Hungarian baron and director of Seeberg Observatory in Germany, Franz Xaver von Zach, creates the 'Celestial Police', a group of 24 astronomers to locate a planet Bode's law tells him exists between Mars and Jupiter. The search for a planet is unsuccessful; the asteroid Ceres is discovered instead.

1801
The first asteroid, Ceres, is identified by Sicilian monk Father Giuseppe Piazzi through luck, not as part of the search initiated by Franz Xaver von Zach. The object Piazzi discovers is initially thought to be a planet because it occupies the space between Mars and Jupiter so neatly implied by Bode's law. Ceres is now classified as a dwarf planet, the only one in the Asteroid Belt.
........

French astronomer Jean-Louis Pons discovers his first comet (jointly with Charles Messier). By 1827 he has discovered 37 comets, more than anyone else before modern automated searches.

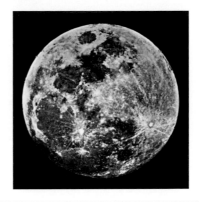

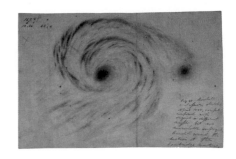

1802
On 28 March, German physician and astronomer Wilhelm Olbers discovers the asteroid Pallas. Wilhelm was a doctor by day and an amateur astronomer by night.

1807
Wilhelm Olbers discovers the second largest body in the asteroid belt. The honour of naming the new asteroid is given by Olbers to German mathematician Carl Friedrich Gauss, who names it Vesta after the goddess of the hearth.

1811
The 'Great Comet of 1811' is widely recorded and becomes the subject of numerous text books and posters used in educational lectures.

1815
John Wallis in London publishes *Science in Sport or the Pleasures of Astronomy*, a board game based on a race to become Britain's Astronomer Royal (left, see p.141).

1827
French mathematician Joseph Fourier first identifies the greenhouse effect in the Earth's atmosphere. The Earth absorbs most of the energy it receives, re-emitting it as infrared light, which is strongly absorbed in the atmosphere by greenhouse gases such as carbon dioxide and methane. The greenhouse effect keeps the Earth warmer than it otherwise would be, with a powerful influence on the climate.

1829
Henry Courland produces *Astronomia*, a set of playing cards based on planets and asteroids with scientific data, evidence of the popularity of astronomy in the first half of the nineteenth century (centre left, see p.99).

1833
Sioux tribes of North America record the Leonid meteor shower in their winter counts. They call the year 1833–4 'Stars Fall Down' in recognition of the shower which was particularly spectacular with a peak of 1000 meteors per minute.

1834
Germans astronomers Wilhelm Beer and Johann Heinrich von Mädler produce the first quadrant of their map of the Moon, *Mappa Selenographica*. Published in book form in 1837, their full Moon map names 130 new lunar features and remains the most detailed depiction of the lunar surface until the first photographic images of the Moon became available some decades later.

1835
The *New York Sun* publishes an elaborate (and popular) hoax claiming that a giant telescope has revealed life on the Moon, with illustrations of batlike men and mothlike women flying above a landscape reminiscent of alpine scenery on Earth.

1836
Belgian astronomer Adolphe Quetelet discovers the Perseid meteor shower, noting displays around 12–13th August each year.
........
While watching a solar eclipse, British astronomer Francis Bailey notices that the Sun's light appears to be temporarily broken into a string of separate beads of light. The phenomenon is now named Bailey's Beads.

1837
Edward Herrick, a bookseller in New Haven, Connecticut, notes several references to the Perseid meteor shower throughout history, revealing the Perseids had been known for centuries.

1838
German mathematician Friedrich Bessel at the observatory in Königsberg, Prussia (now Kaliningrad, Russia) is the first to accurately measure a stellar parallax, revealing that 61 Cygni had a parallax of 1/3 of an arc second. Knowing a star's parallax allows for the calculation of its distance from Earth, thus Bessel is credited with discovering the true distances of nearby stars.
........
The Cold Bokkeveld meteorite is found in Western Cape, South Africa. It is what is known as a 'stony chondrite', by far the most common type of meteorite found Consisting of silicate, metallic and suphide minerals, stony chondrites are thought to contain the materials from which the Earth was formed.

1839
In January, artist and inventor Louis Daguerre, using his daguerreotype technique, is believed to have produced the first photographic image of the Moon. The image is lost in March of the same year when Daguerre's studio burns down.

1840
British-born scientist, historian, chemist and philosopher John William Draper takes the first photograph of the full Moon in New York (centre right, see p.48).

1842
Austrian mathematician Christian Doppler proposes (wrongly) that the varying colours of stars can be explained by their movement towards or away from the Earth (blue shift and red shift). Star colours indicate their surface temperatures. Much higher velocities are required to produce Doppler's effect.

1843
Heinrich Schwabe, a German amateur astronomer, discovers sunspots occur periodically and he calculates a ten-year cycle. It is later discovered that the appearance of sunspots is linked to 'magnetic storms' that have a direct effect on compasses and power lines on Earth.
........
British astronomer Charles Piazzi Smyth records the Great Comet of 1843 in South Africa. The comet is associated with – unfulfilled – predictions of the Second Coming of Jesus Christ, and causes widespread panic and fear.

1845
William Parsons, 3rd Earl of Rosse completes the building of his 'Leviathan of Parsonstown' in Ireland, a huge telescope with a 1.8 m (6 ft) mirror which was the world's largest telescope until the early twentieth century. Using the Leviathan, Rosse becomes the first person to observe the spiral structure of the galaxy M51, which was soon nicknamed the Whirlpool Nebula (right, see p.30).

1846
Newtonian gravitational theory is simultaneously used by two scientists, Urbain Le Verrier of France and John Couch Adams of England, to predict positions for an undiscovered planet beyond Uranus. Their calculations both accurately indicated the position of the new planet making Neptune the first planet to be discovered by mathematics rather than direct observation.
........
Astronomers at the Berlin Observatory used Le Verrier's calculations to look for Neptune on 23 September 1846. It was discovered by Johann Gottfried Galle where Le Verrier had indicated.

1848

1860

1876

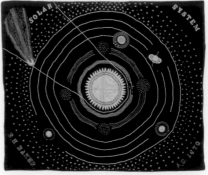

1888

1848
Édouard Roche explains the concept of the minimum distance to which a satellite can approach its primary body without its internal gravity being overcome. This concept, now called the Roche Limit, is crucial to our understanding of the nature of Saturn's rings.

1850
French scientist Jean-Bernard-Léon Foucault constructs a very long pendulum that demonstrates that the Earth rotates.
........
American photographer John Adams Whipple, working with the astronomers William Cranch Bond and George Philips Bond, takes the first-known photograph of a star, Vega.

1857
Scottish scientist James Clerk Maxwell demonstrates that the rings of Saturn cannot be solid but must be made up 'of unconnected particles, revolving around the planet with different velocities'. This was confirmed four decades later.

1858
Photographer Warren de la Rue creates stereoscopic views of the Moon by combining pairs of images taken with our satellite at different angles of libration (left, see p.157).

1859
Le Verrier discovers a discrepancy in the orbit of Mercury, which was thought to imply an unseen planet between Mercury and the Sun. The extra planet, which astronomers nicknamed Vulcan, does not exist, but the discrepancy was eventually explained by Einstein's theory of general relativity.

1860
French astronomer Emmanuel Lais suggests dark patches of variable colour on Mars could be vegetation.

1863
Italian Jesuit priest and Astrophysicist Pietro Angelo Secchi suggests that stars can be classified according to the details in their spectrum ('spectral type'). His conclusions formed the basis for the new Harvard classification system.

1864
British admiral and amateur astronomer William Henry Smyth produces a colour chart intended to standardize the cataloguing of the spectra of stars (centre left, see p.56).

1866
Italian astronomer Giovanni Schiaparelli of the Brera Observatory in Milan calculates the orbits of the Leonid and Perseid meteoroids.

1867
French astronomers Charles Wolf and Georges Rayet discover unusually hot stars. Over 300 of these 'Wolf-Rayet stars' have now been discovered.

1868
Astronomers Norman Lockyer and Jules Janssen notice a strong yellow line in a spectrum of the Sun. They regard it as being from an element not yet identified on Earth, and name it helium, for the Greek Sun god.

1860s
British astronomer William Huggins utilizes spectroscopy to discover that stars contain the same elements found on Earth.

1870
In September, American pioneer of astrophotography Henry Draper takes the first photograph of a nebula when he captures an image of the Orion Nebula.

1876
Amateur US astronomer Ellen Harding Baker embroiders a quilt of the structure of the Solar System that she uses to give lectures to her neighbours in rural Iowa, where astronomy is a popular subject for home study (centre right, see p.77).

1877
American astronomer Asaph Hall discovers the two Moons of Mars and names them Phobos and Deimos after the sons of the Greek god of war, Ares. He also calculates their orbits.
........
Giovanni Schiaparelli creates the first detailed map of Mars showing multiple 'canali' or channels linking what Schiaparelli termed continents or islands. Some of the names he gave to these features are still in use today, although the mention of the canali gave rise to speculation that Mars was inhabited by intelligent life.

1878
British astronomer Norman Lockyer publishes *Studies in Spectrum Analysis*, explaining that a prism attached to the eyepiece of a telescope splits light into a spectrum, and how the spectra of different stars vary (right, see p.187).

1883
Ainslee Common takes a long exposure photograph of the Orion nebula from Ealing in London, which shows stars too faint to be seen by eye with the same telescope. This marks the transition of photography from being a mere recording medium to a detector of the unseeable.

1887
A world-wide project to make a complete photographic star map is initiated by Amédée Mouchez in Paris involving 20 observatories in both hemispheres. It was never completed, but it led to the formation of the International Astronomical Union.

1888
Scottish-American astronomer Williamina Fleming discovers the Horsehead Nebula near to the Orion Nebula on a photographic plate. Fleming emigrated to the United States from Scotland in 1878 and worked as a maid for Edward Pickering, director of the Harvard College Observatory. Pickering eventually made her a clerk before promoting her to scientific assistant.
........
Lick Observatory, the world's first permanent mountaintop observatory, opens on Mount Hamilton, south of San Jose, CA.

1890
British astronomer Norman Lockyer publishes *Meteoritic Hypothesis: A Statement of the Results of a Spectroscopic Inquiry into the Origin of Cosmical Systems* considered to be a landmark in the development of astronomical spectroscopy.

1894
British Astronomer Edward Walter Maunder and his wife find that very few sunspots were recorded between 1645 and 1715. This period of time becomes known as the 'Maunder Minimum' and roughly coincides with a period known as the 'Little Ice Age'.

1897
At the University of Chicago, a 102-cm (40-inch) refractor is completed at the Yerkes Observatory.

1900
A monk at a Buddhist temple in Dunhuang, China, discovers a hidden cache of 40,000 ancient scrolls, including the *Dunhuang Star Atlas*, which was drawn in around AD 700.

1901

1910

1919

1924

1901

American astronomer Annie Jump Cannon devises the Harvard Classification Scheme of stars based on their spectral characteristics, linked to their temperatures. The International Astronomical Union officially adopts her system in 1922, and it is still used today.

1902

Georges Méliès makes the silent movie *Man in the Moon*, the first science-fiction film, which depicts an exhibition using a rocket to land on the Moon, where they capture a Moon-dwelling Selenite to take back to Earth (left, see p.117).

1904

A major development in international cooperation is instigated by American astronomer George Ellery Hale when the International Union for Cooperation in Solar Research is founded.

1905

Mass and energy are seen as different entities until Albert Einstein develops his Theory of Special Relativity and reveals they are interchangeable aspects of a single phenomenon. Einstein's theory contains the famous equation $E=mc^2$, which links energy, mass and the speed of light.

American architectural artist Chesley Bonestall paints his first astronomical picture, beginning a lifelong pursuit that later became his career.

1908

Henrietta Swan Leavitt's pioneering work on Cepheid variable stars results in the discovery of the period-luminosity relation. This discovery has enabled modern astronomers to measure the distance to galaxies and ultimately the size of the Universe.

Percival Lowell, with his own observatory in Arizona, suggests there is an unknown 'planet X' as he calls it – subtly affecting the orbit of Neptune. In 1930, Clyde Tombaugh showed this to be the dwarf planet Pluto.

1910

In May, the Earth passes through the tail of Halley's Comet; its spectrum reveals traces of the poisonous gas cyanogen (cyanide), leading to some panic. A photograph of the approaching comet is taken at the Yerkes Observatory at the University of Chicago.

1913

Danish chemist and astronomer Ejnar Hertzsprung is the first person to measure the distance to an object outside the Milky Way. By using variable stars called Cepheids, named after delta Cephei, he calculated the distance to the Small Magellanic Cloud.

........

French artist Robert Delaunay paints *Simultaneous Contrasts: Sun and Moon*, an abstract work based on colour theory (centre left, see p.92).

1915

Albert Einstein develops his Theory of General Relativity in which gravity is a geometric property of space and time or 'space-time'. Modern physics still adheres to this century-old theory.

1917

The Mount Wilson 2.5-m (100-inch) Hooker telescope in Los Angeles County, CA is completed. It remains the largest telescope in the world until 1949.

........

US artist Georgia O'Keeffe paints *Starlight Night*, one of her first works to deal with the vastness of the night sky above parts of the United States.

1919

The International Astronomical Union (IAU) is founded. The union institutes commissions to oversee various fields of astronomy, to encourage cooperation and to ensure standards of terminology.

........

British astronomer Arthur Eddington photographs the Sun's corona from West Africa during a solar eclipse and demonstrates that the Sun's gravity is deflecting light from stars beyond, confirming Einstein's Theory of General Relativity, which had predicted just such a deflection (centre right, see p.126).

1920

American astronomers Harlow Shapley and Heber Curtis take part in a public debate over the form and extent of the Universe. Shapley argues that there is only one big galaxy with a diameter of 300,000 light years. Curtis, on the other hand, proposes that there are numerous galaxies just like ours that are spread across the sky like islands.

........

The largest meteorite ever found is discovered at Grootfontein in Namibia. Named the Hoba West Meteorite, it was 66-ton mass consisting of 84 per cent iron and 16 per cent nickel. It probably arrived 80,000 years ago and rusting of its iron since then has seen its weight drop to about 60 tons.

1922

The International Astronomical Union (IAU), under the supervision of Belgian astronomer Eugène Delporte, standardizes the names and numbers and boundaries of the constellations into a modern scheme.

1924

Spanish artist Pablo Picasso fills sixteen pages of a notebook with what he calls his 'constellation drawings' – series of grids and lines joining dots that resemble stars in maps of the constellations.

1925

In her Harvard PhD thesis, British-born American astronomer Cecilia Payne-Gaposhkin hypothesizes that hydrogen is the most abundant element in the Sun. This was initially dismissed by influential Princeton astronomer Henry Norris Russell, but later proved to be correct. By mass, the Sun is in fact 71 per cent hydrogen, similar to the Universe itself.

1926

American engineer Robert Goddard suffers ridicule in his quest to prove rockets hold the potential for space travel. His idea of using liquid fuels proves successful with the launch of a 3-m rocket propelled by liquid oxygen and gasoline.

........

The Russian artist Wassily Kandinsky paints *Several Circles*, an abstract rendition of what might be interpreted as various-sized planets circling a large Sun (right, see p.70).

1927

In his book *Stars and Atoms,* British scientist Arthur Eddington speculates that the source of stellar energy could come from nuclear fusion.

........

Georges Lemaître, a Belgian priest and astronomer, formulates theories of an expanding Universe. This is a major breakthrough as Newton and Einstein had both realized that a static Universe would be inherently unstable.

........

Archaeologists discover an incised fragment of stone at a temple at Tal Qadi, on the nothern coast of the Mediterranean island of Malta. They conclude that it is one of the earliest astronomical maps, dating back to the fourth millennium BC.

1928

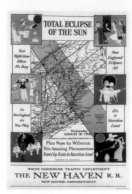

1932

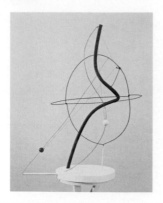

1936

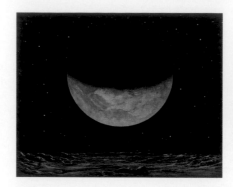

1944

1928
Radio engineer Karl Jansky is taken on by Bell Telephone Laboratories in New Jersey to investigate interference that might impact on transatlantic telephony. He builds an antenna and in the next four years discovers three types of 'static', one of which has its origin in space. This is the beginning of radio astronomy.

1929
Observing the 'redshift', where lines in a stellar spectrum appear to shift to longer (red) wavelengths, American astronomer Edwin Hubble concludes that the velocity of a receding galaxy is proportional to its distance from the observer. This becomes known as Hubble's law.

1930
Former amateur astronomer Clyde Tombaugh discovers Pluto while working at the Lowell Observatory in Arizona. After Percival Lowell's death in 1916, the search for a possible planet beyond Neptune was stalled until 1927. Tombaugh is taken on by the observatory in 1929 and the following year he makes his discovery.

1931
George Lemaître proposes the Universe began as a single entity, highly condensed. This is the birth of the Big Bang Theory.
........

American artist Joseph Cornell exhibited the first of his many collages and boxes inspired by astronomy at a New York City art gallery.

1932
The New Haven Railroad in Connecticut issues a poster to try to encourage Americans to take the train to the best venues in New England from which to experience a solar eclipse due to take place on 31 August (left, see p.255).

1933
Ukranian-born engineer and pioneer of the Russian space programme Sergei Pavlovich Korolev builds and launches the first Soviet liquid-fuelled rocket.
........
Fritz Zwicky, a Swiss-born scientist at the California Institute of Technology, realizes that a nearby galaxy cluster must have large amounts of mass unaccounted for. The missing mass, which still cannot be 'seen', is now termed 'dark matter'. Zwicky's idea is not confirmed until Vera Rubin's work on galaxy rotation in the 1980s.

1934
American sculptor Alexander Calder creates *A Universe*, a sculpture in which small planets follow courses along a series of wire orbits (centre left, see p.14).

1935
Subrahmanyan Chandrasekhar presents his work on white dwarfs and is publicly mocked by the leading British astronomer of the day Arthur Eddington, who calls the theory 'stellar buffoonery'. Chandrasekhar abandons his plan to work in Britain and moves to the United States. Eventually his work is vindicated with a Nobel Prize.

1936
US astronomer Edwin Hubble publishes *The Realm of the Nebulae*, a popular work in which he lays out the Hubble sequence, a simplified system for labelling types of galaxy according to their appearance.

1937
Grote Reber, an American radio engineer and a colleague of Karl Jansky takes up the latter's work on radio waves in his spare time and builds the first parabolic 'radio telescope' in his backyard in Wheaton, Illinois. In 1957 he moved to Tasmania, which offered radio-quiet skies.
........
French space artist Lucien Rudaux publishes *On Other Worlds*, which includes more than 400 illustrations of planets and other celestial bodies based on Rudaux's observations through a telescope at his own observatory (centre right, see p.162).

1939
French artist Lucien Boucher creates a poster for Air France that depicts the airline's routes as if seen through a glass sphere containing the constellations and the signs of the zodiac. Such posters make Boucher a widely collected artist (right, see p.147).

1940
Spanish artist Joan Miró starts painting a series of twenty-three paintings based loosely on the constellations, which to some extent represented his reaction to the outbreak of World War II.

1942
During World War II James S. Hey and his colleagues at the British Army Operational Research Group investigate what is believed to be a concerted German attempt to jam British radar, only to discover that the radio waves are being emitted by the Sun.

1944
The first man-made object enters space when the Nazis vertically launch a V-2 rocket that reaches an altitude of 174 km (108 miles). This is far above the Kármán Line, which is 99 km (62 miles) high, and is traditionally considered the border between Earth's atmosphere and space.

1945
Jodrell Bank radio observatory is established by Bernard Lovell near Manchester, initially to investigate meteor trails.
........
A seminal paper on the use of geostationary orbits for communication satellites is published by the renowned science fiction writer Arthur C. Clarke.
........
Jan Hendrik Oort, is made director of the Leiden Observatory in the Netherlands. He holds the position for 25 years and is best remembered for his notion that our Solar System is surrounded by a vast band of comets, now known as 'The Oort Cloud'.
........
Australian physicist Joseph Pawsey detects radio waves from the Sun, using a war-time radar antenna at Collaroy, near Sydney. He revealed that its corona had a temperature of a million degrees, thus initiating a new science, which he called 'radio astronomy'.

1947
Russian-born American cosmologist George Gamow, American physicist Robert Herman and Gamow's student Ralph Alpher predict the existence of the cosmic microwave background as part of their theory of the Big Bang.

1948	**1958**	**1960**	**1963**
	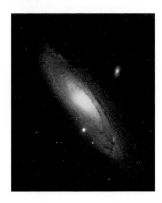		

1948
One of the first objects detected by radio telescopes is the supernova remnant Cassiopeia A.

1949
Chesley Bonestell paints *The Surface of Mercury*, twenty-five years before the first spacecraft were to send detailed images of the planet's appearance (left, see p.268).
........

The 508-cm (200-inch) Palomar telescope is completed in California. It is the world's largest optical telescope for more than forty years.

1954
The Belgian cartoonist Hergé publishes *Explorers on the Moon*, a volume in his celebrated comic-book series featuring Tintin and his friends.

1957
Margaret Burbidge, Geoffrey Burbidge, William Fowler and Fred Hoyle publish their seminal paper on the origins of the elements. The paper, known by astronomers as *B2FH* (formed from the initials of the scientists), provided a detailed scheme of how elements are formed in stars.
........

In October the Soviet Union announces the successful launch into orbit of a satellite, Sputnik 1, a small metal sphere with antennae and radio transmitter powered by batteries.
........

Just a month after the launch of Sputnik 1, the Russians launch Sputnik 2. It contains a live passenger, a dog named Laika.

1958
American satellites Explorer 1 and 3 are launched and discover solar particles trapped in the Earth's magnetic field. These layers of electrically charged particles are now known as Van Allen Belts after the scientist who built the scientific equipment carried by the satellites. This was the first major discovery of the so-called 'space age'.
........

The US government creates the National Aeronautics and Space Administration (NASA) '... to provide for research into the problems of flight within and outside the Earth's atmosphere'.
........

US photographic engineer William C. Miller takes the first ever colour photograph of a galaxy, Andromeda M31 (centre left, see p.148).

1959
British radioastronomer Martin Ryle uses his newly discovered technique 'aperture synthesis interferometry' to investigate radio galaxies and prove that an earlier, denser Universe existed. It takes several years to perfect the equipment and data handling to garner reliable results.
........

The Soviet space probe Luna 3 takes the first ever photographs of the 'dark side' of the Moon, which faces permanently away from Earth.
........

US filmmaker David L Wolper makes the documentary *The Race to Space*, about the US Redstone rocket programme, the precursor of the Saturn rockets of the 1960s (centre right, see p.264).

1960
The Ishango Bone is discovered by Belgian Jean de Heinzelin de Braucourt while exploring the Belgian Congo. The bone, covered in scratches with a piece of quartz affixed to one end, is interpreted by anthropologist Alexander Marshack to be a lunar calendar, perhaps 20,000 years old.
........

Frank Drake is the first director of SETI (the Search for Extraterrestrial Intelligence). SETI systematically searches for life in the Universe by analysing radio waves for signs of artificial messages.

1961
Yuri Gagarin becomes the first human being in space when his spacecraft Vostok 1 successfully orbits the Earth.

US President John F. Kennedy makes a shocking announcement: he promises the United States will land people on the Moon by the end of the decade. At this point the United States had yet to put an astronaut into orbit let alone propel one 400,000 km (250,000 miles) to the Moon.

1962
NASA's Mariner 2 carries out a 'flyby' of Venus thus becoming the first successful interplanetary spacecraft. Mariner 2 identifies the planet's searing temperature, high surface pressure and carbon dioxide atmosphere.
........

Suspecting that the Moon might produce x-rays from solar particles, Italian physicist Riccardo Giacconi and American scientist Herbert Gursky launch an X-ray detector on a rocket. Designed to scan in all directions, the detector successfully detects X-rays, but not from the Moon. Strong signals were received from the constellations of Scorpius and Cygnus. The signals from Scorpius are later found to be emanating from a blue neutron star, the remains of a supernova.
........

Sixteen European countries set up the European Southern Observatory (ESO)

1963
Czech artist Luděk Pešek publishes *The Moon and the Planets*, a collection of space art, including accurate predictions of the appearance of the lunar surface.
........

NASA Director James Webb initiated the Nasa Art Program, a decade long endeavour that led to the commissioning of work by more than 50 artists.

1964
Mariner 4 successfully conducts a 'flyby' of Mars and returns the first pictures taken of another planet's surface.

1965
Martin Ryle is finally able to refute publicly the Steady State theory of the Universe that has previously prevailed. His work provides valuable evidence for the reliability of the notion of a Big Bang. He makes his announcement at a press conference in front of astronomer Fred Hoyle who has been an outspoken proponent of the Steady State theory. Russian cosmonaut Alexei Leonov is the first person to walk in space. He spends 10 minutes outside his spacecraft.
........

American artist Helen Lundeberg paints Among the Planets (right, see p.239).
........

Astrophysicists Arno Penzias and Robert Wilson observe the Cosmic Microwave Background Radiation (CMB) for the first time. The CMB's existence had been predicted in 1947, and is the radiation remaining from the Big Bang.

1966

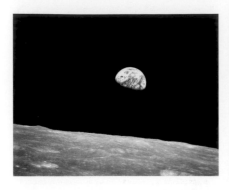

1969

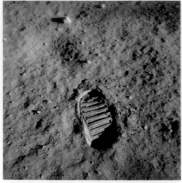

1971

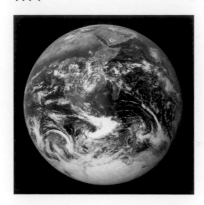

1972

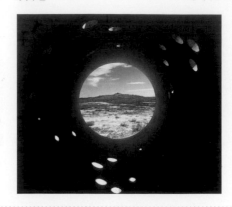

1966
The Soviet Luna 9 spacecraft becomes the first to land softly on another world, the Moon. It returned images of a dusty plain, the Oceanus Procellarum, the first from the surface of another world.
........

Soviet spacecraft Venera 3 reaches Venus and is believed to crash land. Although credited with being the first spacecraft to land on another planet, communication systems fail prior to Venera 3 reaching its destination so no data are returned.
........

NASA begins the Surveyor program, sending a series of seven probes to the Moon over the course of two years to photograph potential sites for a manned space landing.
........

NASA's Lunar Orbiter 1 sends back the first photograph of Earth – an 'earthrise' – taken from near the Moon (left, see p.144).

1967
PhD student Jocelyn Bell discovers 'a bit of scruff' while analysing data from a 4½ acre Radio Telescope in Cambridge. It transpires that she has discovered regular pulses from small rotating neutron stars, now known as pulsars.

1968
Apollo 8 astronaut Bill Anders takes a influential colour photograph of an earthrise said to have helped inspire the early ecological movement.
........

The airline Pan Am founds the First Moon Flights Club to allow passengers to reserve their seats on Pan Am's first commercial rocket flights to the Moon, whenever they inevitably come to pass.

1969
America's Apollo 11 is launched from Cape Kennedy (now Cape Canaveral) headed for the Moon. Four days later astronauts Neil Armstrong and Edwin 'Buzz' Aldrin land on the Moon in an area known as 'The Sea of Tranquility' and six hours later they walk on its surface. The two astronauts stay on the Moon's surface for twenty-one hours (centre left, see p.22).
........

Artist Vija Celmins begins making drawings based on photographs of the surface of the Moon and Mars from NASA's Jet Propulsion Laboratory. She goes on to make many drawings, prints and paintings based on astronomical photographs.

1970
The Apollo 13 mission to the Moon is aborted when an explosion occurs mid-flight. After rounding the Moon the astronauts manage to land back on Earth safely after a 143-hour journey fraught with danger.
........

Soviet spacecraft Venera 7 is launched and becomes the first spacecraft to return data to Earth from another planet when it successfully lands on Venus.

1971
NASA's Mariner 9 becomes the first spacecraft to enter into orbit around another planet, Mars. During a year in orbit around the planet, it returns images of a vast canyon system on Mars, which is named the Valles Marineris after the spacecraft.
........

Apollo 14 lands on the Moon in the Fra Mauro crater after the failed attempt by Apollo 13 the previous year. This is the only landing to include a two-wheeled 'lunar cart' to obtain samples. Later missions included a motorized Lunar Rover. This landing is also noted for its commander, Alan Shepard, hitting two golf balls on the Moon's surface.
........

Astronauts on the Apollo 15 mission bring a sample back from the Moon and it is named the Genesis Rock. This fragment of Moon rock is 4.5 billion years old.
........

Apollo 15 commander Dave Scott leaves *Fallen Astronaut* on the surface of the Moon. The artwork by Paul van Hoeydonck comprises a small model representing an astronaut with a plaque containing the names of the fourteen Americans and Soviets who died during the course of the Space Race. Scott commissions and leaves the piece without the permission of NASA, smuggling it onboard the spacecraft.

1972
United States space probe Pioneer 10 is the fastest manmade object to be launched into space when it leaves in March. It carries a metal plaque engraved with messages for extraterrestrial life. It passes the Moon in just 11 hours and by July is crossing the asteroid belt. It was the first spacecraft to visit Jupiter; it left all the planets behind it in 1983 and finally became uncontactable in 2003.
........

In December Harrison Schmitt becomes the first and only geologist to walk on the Moon during the Apollo 17 mission. A highlight of his visit is the discovery of orange glass inside lunar rock.
........

Astronauts on board Apollo 17 take a renowned photograph of Earth, the first taken from space to show the whole planet clearly. The image becomes known as *The Blue Marble* (centre right, see p.238).

1973
The United States launches Mariner 10, the seventh successful launch in the Mariner missions. It is the first spacecraft to use the gravitational pull of a planet (Venus) to reach another. It is also the first mission to visit two planets.
........

American artists Charles Ross and James Turrell begin large-scale Land Art projects and call attention to naked-eye observations of celestial events.
........

Mariner 10 returns close-up images of Venus and Mercury.
........

Pioneer 10 reaches Jupiter in December and becomes the first spacecraft to orbit the gas giant. While in orbit it obtains the first close-up images of Jupiter, records its extreme radiation belts, measures the planet's magnetic field and discovers that Jupiter is essentially composed of liquid.
........

American artist Nancy Holt creates her work *Sun Tunnels* in the Utah desert (right, see p.135).

1974

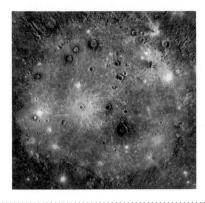

1976

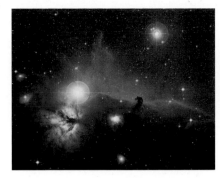

1984

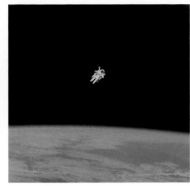

1989

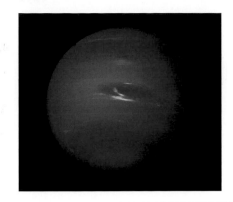

1974

Antony Hewish receives a share of the 1974 Nobel Prize in Physics for his 'decisive role in the discovery of pulsars'. Controversially, Jocelyn Bell, who made the discovery in 1967, is not recognized as she was a PhD student at the time.

........

Physicist Stephen Hawking theorizes how black holes (never to be able to radiate photons) can lose energy from photons created near the objects 'event horizon'. Hawking states that radiation causes black holes eventually to evaporate. This is the first successful integration of general relativity and quantum mechanics.

........

German artist Joseph Beuys creates *Untitled (Sun State)*, an astrological chart that serves as a diagram of a public lecture he gives in Chicago about the creation of an ideal society

........

The Caloris Basin is discovered on Mercury. It is one of the largest craters anywhere in the Solar System, at 1,500 km (930 miles) across (left, see p.269).

1975

Soviet spacecraft Venera 9 is the first to land on another planet when it settles on Venus. It transmits the first images of the surface of another planet and reveals a rocky, volcanic surface.

1976

Astrophysicist Vera Rubin and astronomer Kent Ford discover the discrepancy between the expected rotation of galaxies and the way they do rotate, attributed to dark matter, confirming the problem identified by Zwicky in 1933.

........

Viking 1 is the first spacecraft to land on Mars when it touches down in area known as Chryse Planitia (the Golden Plain). The device takes photographs, performs science experiments and also looks for signs of life on the planet. It is followed in quick succession by Viking 2.

1977

Five of the eleven rings of Uranus are discovered by chance by the Kuiper Airborne Observatory. The team had been hoping to measure the diameter of the planet while it was occulting a distant star, but the star appearing to blink before passing behind the planet revealed rings intermittently blocking the view.

1979

NASA spacecraft Pioneer 11 makes the first flyby of Saturn. This visit and later visits by Voyager spacecraft in the early 1980s establish that the planet has weather systems that appear similar to those of its neighbour Jupiter.

1980

In Australia, astrophotographer David Malin improves methods of taking colour photographs of the distant Universe, and creates a celebrated image of the Horsehead Nebula in Orion (centre left, see p.237).

1984

Bruce Gibson photographs fellow astronaut Bruce McCandless floating against a background of the immensity of space during the first untetherered space walk, from the Space Shuttle *Challenger* (centre right, see p.35).

1985

The European Space Agency (ESA) and NASA's joint initiative, the 'International Cometary Explorer (ICE), passes through the tail of Comet Giacobini-Zinner in September. It is the first craft to encounter a comet (centre right, see p.235).

1985–90

The existence of Pluto's moon Charon is confirmed. Charon is unusual in that it is almost the same size as the planet it orbits.

1986

Voyager 2 captures Images of the eleven rings of Uranus.

........

Voyager 2 passes within 32,000 km (19,900 miles) of the surface of Miranda, the innermost of the moons of Uranus, and photographs a bizarre, fractured world. Two theories are posited for its appearance, either the moon suffered a major collision sometime in its history which shattered it before it eventually reassembled, or alternatively the moon's creation was halted before it could be completed.

1987

Korean artist Bang Hai Ja creates *Astral Dance*, a mesmeric depiction of a whirling cosmos above a deep golden Sun.

1989

Voyager 2 returns thousands of images of Neptune to Earth and after passing the planet. NASA renames the craft the Voyager Interstellar Mission (VIM). The Voyager missions are notable for the discs that they carry, bearing images and sound recordings of the life and culture on Earth for the benefit of extraterrestrials who might find the spacecraft (right, see p.306).

........

Soviet scientists produce a striking map of the South Pole of Venus, based on data from the identical space probes Venera 15 and Venera 16.

1990

Joint USA- and Europe-funded mission, Ulysses, becomes the first craft to be sent into orbit over the Sun's poles to study solar winds and the Sun's magnetic field.

........

The Hubble Space Telescope is launched to observe the visible Universe above the interference of the Earth's atmosphere. Since its launch it has made over 1.3 million observations and many thousands of spectacular images and its data have been used in more than 14,000 papers, making it one of the most productive scientific instruments ever constructed.

1992

Using the Arecibo radio telescope, Alexander Wolsczan and Dail Frail report the first confirmed discovery of a system of terrestrial-mass planets, found around the millisecond pulsar PSR B1257+12, which lies 2,300 light years from the Sun.

........

The first object in the Kuiper Belt is found and catalogued by David Jewitt and Jane Luu after a five-year search. The Kuiper Belt is a band of material, asteroids and comets left over from the formation of our Solar System and lies beyond Neptune. It gets its name from American astronomer Gerard Kuiper who in 1951 discussed the theoretical existence of such a belt (but concluded it did not exist).

1993

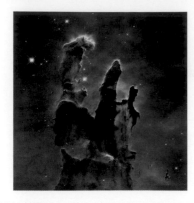

1996

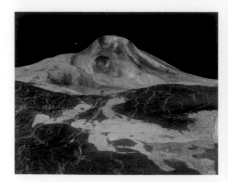

1999

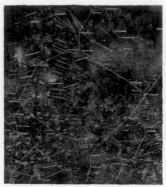

2003

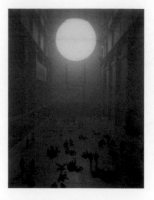

1993
ESA's Hipparcos satellite completes its mission after spending four years in space. It results in two catalogues. The *Hipparcos Catalogue* records over 118,000 stars, with data about brightness, position, motion and colour and the *Tycho Catalogue* records of 1,000,000 stars to a lesser degree of accuracy.

1994–95
Russian cosmonaut Valeri Poliakov spends 437 days aboard Mir, the longest duration in space of any astronaut.
........
Artist Robert Rauschenberg produces *Space (Tribute 21)*, a depiction of Saturn's rings and an astronaut floating in space.

1995
While working at the Observatoire de Haute-Provence in France, Swiss astronomers Michel Mayor and Didier Queloz discover the first planetary system similar to our Solar System.
........
The SOHO deep space probe is launched, its mission to study the interior and surface of the Sun. The mission is joint funded by the USA and Europe. SOHO stands for Solar and Heliospheric Observatory.
........
The repaired Hubble Space Telescope captures an iconic image of the 'Pillars of Creation', part of the Eagle Nebula, a star-forming region. These dark clouds are cold, dusty gas, many light years long, and are etched into shape by intense radiation from recently formed stars nearby (left, see p.18).

1996
Japanese astronomer Hyakutake Yuji spots Comet Hyakutake in January. The comet is one of the brightest witnessed in the twentieth century when it passes through Earth's orbit.
........
US scientists use computer mapping to turn data collected by the Venus Radar Mapper on the Magellan orbiter to produce a three-dimensional view of Maat Mons on Venus (centre left, see p.279).
........
Artist Kiki Smith uses specially blown glass figures to create a depiction of the constellations and stars in *Constellation*.

1997
In a joint enterprise, NASA, ESA and Italian space agency ASI launch the Cassini orbiter. Its main objectives are to orbit Saturn and deliver detailed studies of the planet, its rings and its satellites, as well as landing the ESA Huygens probe on the surface of Saturn's Moon Titan.
........
NASA's Mars Global Surveyor, orbiting at an altitude of 235 miles, maps the surface of the planet in minute detail.

1998
Construction begins in orbit of the International Space Station (ISS), a long term habitable orbiting laboratory. The United States, Europe, Russia, Japan and Canada are partners in the project.

1998–9
The Supernova Cosmology Project and High-z Supernova Search Team use the Hubble Space Telescope to measure the rate at which distant galaxies are receding. They are surprised to discover that the Universe is expanding more rapidly now than it used to. The phrase 'dark energy' is used to describe the mysterious force that is causing the acceleration.

1999
NASA launched the Chandra X-Ray Observatory to detect high energy emissions.

1999
German artist Anselm Keifer uses burned and cracked wood to create what are apparently depictions of the Universe but are in fact more abstract references to the destruction of books in Germany under the Nazis in the 1930s (centre right, see p.75).

2000
The first crew arrives at the International Space Station. Of the three astronauts, Commander William Shepherd is American and Sergei Krikalev and Yuri Gidzenko are Russian. They return to Earth in 2001.
........
NASA's Cassini spacecraft captures an unfamiliar image of Jupiter from the planet's South.

2001
NASA's Mars Odyssey maps the Valles Marineris, the largest canyon in the Solar System, on Mars. Over 11 kilometres (6.8 miles) deep, the canyon contains evidence that water once existed on Mars.

2002
The Hubble Space Telescope discovers the oldest white dwarfs in our galaxy. The discovery allows scientists to verify previous estimates of the age of the Universe at 13–14 billion years.

2003
The largest infrared telescope is launched in August. To take the infrared images, the Spitzer Telescope's instruments are kept at a constant temperature of near absolute zero and a solar shield protects the equipment from the heat of the Sun.
........
NASA's Galileo, the first craft to orbit Jupiter, ends its eight year mission by deliberately plunging into the planet's crushing atmosphere. It was the first craft to fly past an asteroid, to observe a moon orbiting an asteroid and to find evidence of an ocean beneath the icy crust on Jupiter's moon Europa. A surprise discovery was the extreme temperatures of the volcanoes on the moon Io.
........
Danish-Icelandic artist Olafur Eliasson installs *The Weather Project*, a huge neon-yellow Sun, in the Turbine Hall of Tate Modern in London (right, see p.67).

2004
NASA successfully lands two exploration rovers, Spirit and Opportunity, on opposite sides of Mars. Their mission is to study rocks and soil and to provide information about the geology of Mars. They find strong evidence for liquid water having existed in the distant past for a long time on the planet.
........
The Mars Express Orbiter discovers traces of methane in the planet's tenous atmosphere. Methane is emitted by volcanoes but none are known to exist on the planet.
........
The Rosetta mission is launched by the ESA with the intention of being the first mission to attempt a landing on a comet's nucleus in 2014.
........
NASA launches its Messenger spacecraft, its mission to orbit Mercury and return data on its surface composition and geological history.

2005

2008

2012

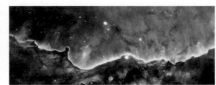

2016

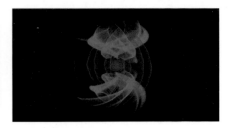

The Hubble Space Telescope takes a striking image of the Helix Nebula that makes clear why the nebula is also called, 'the Eye of God' (left, see p.166).
........
German artist Wolfgang Tillmans, an enthusiastic astronomer since childhood, photographs the first transit of Venus to occur for 122 years.

2005

Mike Brown and his team at Caltech discover a large body in the outer solar system, three times more distant than Pluto. It was named Eris and is more massive than Pluto though slightly smaller, at about a quarter the mass of Earth.
........
After a seven-year journey the Cassini spacecraft releases the Huygens probe to land safely on Saturn's largest moon Titan in January 2005. The data Huygens returns reveals that the moon has rain, rivers, lakes and seas (of methane not water) and its nitrogen-rich atmosphere is very like the conditions that once existed on Earth.
........
The Millennium Simulation generates a possible model for the formation of the Universe from 10 billion particles that grouped themselves through gravity into 20 million galaxies (centre left, see p.143).

2006

The International Astronomical Union contraversially re-categorizes Pluto as a dwarf planet.

NASA launches its New Horizons spacecraft, with the aim of capturing images of Pluto and its moon Charon and to continue to observe other objects in the Kuiper Belt.

2008

The Interstellar Boundary Explorer (IBEX) is launched. The spacecraft will observe the interactions between the solar wind and the interstellar medium, effectively delineating the boundaries of the Solar System.
........
To celebrate the tenth anniversary of the Hubble Heritage Project, NASA releases a striking image of a star-forming region in the Carina Nebula, 7,000 light years from Earth (centre right, see pp.250–1).

2009

The Kepler observatory is launched, designed to discover extrasolar planets by staring continuously at a field of stars in the constellation Cygnus to record the minute changes in brightness from planets in transit across their discs. By 2017 it had discovered 5,000 possible planets of which over 3,200 have been confirmed.
........
The Galaxy Map website is launched, with a goal of collecting comprehensive mapping data of the Milky Way, both as it is seen from Earth and as it would be seen head-on from space.

2010

The Japanese Space Agency (JAXA) launches its Akatsuki ('Dawn') mission to study the atmosphere of Venus from orbit. The attempt to insert the craft into Venus's orbit fails due to an engine fault. However, it entered an elliptical orbit and returned useful data.

2011

NASA's spacecraft Messenger begins orbiting Mercury and starts collecting data. The orbiter creates composition maps, topographic profiles of the northern hemisphere and measures the planet's gravitational field.

2012

Dragon, a spacecraft built by private company SpaceX, becomes the first commercial spacecraft to successfully deliver cargo to the ISS and return safely with cargo to Earth.

2013

The Chinese National Space Administration (CNSA) launches its lunar lander Chang'e 3. The craft examines the Moon from a static landing platform and also, briefly, with a rover.

2014

As Comet 67P/Churyumov–Gerasimenko approaches the Sun, ESA's Rosetta spacecraft becomes the first to orbit a comet. Released from about 30 kilometres away, the Philae probe lands on a dangerously rugged surface and bounces into a dark crevice where it quickly runs out of power. Despite this the probe is able to send the first images of the comet's surface and carry out some measurements, while Rosetta photographs and analyzes the comet in detail from orbit.

2015

JAXA's Akatsuki mission finally succeeds. After a five-year delay because of engine failure, the spacecraft is finally launched into its orbit of Venus.
........
The New Horizons spacecraft conducts its flyby of Pluto 6 billion km (3.7 billion miles) from Earth and transmits detailed images of the dwarf planet's icy surface. This is the most distant solid object visited by a spacecraft.
........

2016

The Laser Interferometer Gravitational-wave Observatory (LIGO) in the United States observes gravitational waves for the first time. The data gathered matches the predictions of the theory of general relativity first proposed by Albert Einstein a century ago (right, see p.125).

2016

Astronomers at the European Southern Observatory (ESO) discover a planet orbiting Proxima Centauri, the nearest star to Earth. 'Proxima b', appears to orbit its Sun at a 'habitable zone' distance and have a surface temperature suitable for of liquid water. If these estimates are true Proxima b could be the closest candidate for life beyond the Earth.
........
Mike Brown and Konstantin Batygin, propose the existence of a major planet about 10 times more massive than the Earth, based on observed discrepancies in the orbits of several trans-Neptunian objects. They speculate that it could be the mythical Planet Nine.

2017

The Trappist telescope in Chile and NASA's Spitzer space telescope discover seven Earth-sized planets orbiting a star in the constellation of Aquarius, three of which lie in the habitable zone of that star. This discovery has further raised the prospects of finding extra-terrestrial life.
........
Scientists release the first data from NASA's Juno probe, including spectacular photographs of the giant planet's south pole and unexpected findings about its internal structure, atmosphere and magnetic field.

David Malin
Astronomer/Photographer

THE HUMAN EYE

Of all the instruments and devices used in astronomy, the eye was the first and most influential, while the human mind and imagination remain the most powerful. The human eye evolved in response to survival needs. By day its central colour perception, 180-degree sweep, high acuity and three-dimensional spatial awareness are invaluable. However, under a dark night sky, away from artificial light, the eye quickly loses its sense of colour and ability to see fine detail, while at the same time becoming much more sensitive to faint light.

Until the early 1600s, the eye was the only tool we could use to observe the stars, so most nocturnal astronomy comprised studying the pattern of the stars (the constellations) and their movement. Of greater fascination were those few objects that appeared to move independently – the Sun, Moon and planets. Rare supernovae, comets and atmospheric manifestations such as meteors and the aurorae were also of interest. Day-time astronomy offered both the Sun and the Moon, with their occasional eclipses, and atmospheric phenomena such as rainbows and glories.

NON-OPTICAL INSTRUMENTS: SEEING THE LIGHT

From the earliest times, it was believed that the cycles of the Sun and Moon and the procession of the fixed stars were centred on the Earth and that the movements of heavenly bodies embodied a mechanism that combined clock, calendar and compass, linking the passage of time with a sense of direction on the Earth itself. No instruments were needed to recognize this, just an observation of the rising and setting points of the Sun and Moon against any distinctive features on the horizon throughout the year. However, to be useful (for example, the measurement of the seasons was vital in the development of agriculture), this had to be done from the same location, so the collection of such data implied a settled existence for the observer and enough time and motivation to record the gradual changes.

This perhaps explains the presence of many ancient stone monuments, such as Stonehenge, found at locations in both hemispheres that seem to embody this need for precise records of change over time. In fact, these may be the earliest recorded instruments for ascertaining the timing of celestial events such as solstices and equinoxes, defining the seasons, as well as potentially being used in religious or ceremonial rituals.

A fourth century BC example is the Chankillo astronomical site in Peru, which appears to be a solar observatory of 13 towers, constructed along a raised ridge, with observation points to the east and west. Though now degraded, it seems likely that the towers are designed to plot the position of the Sun at sunrise and sunset throughout the year, with the summer and winter solstice Sun appearing at the extreme ends of the ridge.

With more systematic and careful observations, much longer, more subtle celestial cycles were recognized. The search for more precise measurement is likely to have been connected to the wish for more accurate horoscopes and observation gradually involved the use of simple instruments such as the *gnomon* ('shadow stick'), a direct predecessor of the sundial. The earliest known example

is Chinese, dating from 2300 BC. Later ones from ancient Greece were perforated to project an image of the Sun that could be measured, or perhaps used as a means of calculating the altitude of planets.

A more portable sighting device was the cross-staff, which was used to ascertain the angle of a star or planet above the horizon. This device evolved into the quadrant and sextant, which were used for measuring the angles between stars. Larger versions that offered far greater precision were built on walls (mural quadrants) and the bigger and much later buildings of the Jantar Mantar in India seem to fulfil the same function.

Long before the quadrant and the sextant, complex calendars were already in use. Knowledge of geometry and mathematics was essential for every astrologer, though the establishment of astronomy as a science was long in the future. Instruments improved in sophistication and complexity. One, the armillary sphere, a model that represents the principal circles of the heavens, traces its origins to Greek antiquity (reaching maturity in Islamic times) and, although it is somewhat clunky, it allows astronomical calculations as well as measurements of the positions of the stars and planets. The more convenient and versatile planispheric astrolabe also incorporates features of the mariner's sextant.

Also dating from around the advent of the armillary sphere is an astronomical instrument that is of an entirely different level of sophistication, the so-called Antikythera mechanism, was discovered in an ancient shipwreck in 1901. This is not a mechanism for observing, but an astronomical clock and calculator that reveals that early instruments had been used to uncover many of the subtle cycles of the heavens.

By the sixteenth century it was becoming clear that there was something amiss with Ptolemy's model of the planets in orbit around the Earth beneath an unchanging Universe of stars. Much of this could be addressed in the simpler, heliocentric Universe promoted by Copernicus. But in 1572 a bright new star appeared in Cassiopeia; its position was measured with great precision for over a year by the astronomer Tycho Brahe, who demonstrated that it was motionless and thus in the sphere of the stars.

Tycho went on to build his own observatory on the Danish island of Hven, mounting his quadrant and sextant on rock and out of the wind, making meticulous observations of the planets with corrections for all known errors. As Tycho's assistant, the mathematician (and committed Copernican) Johannes Kepler inherited his data, ultimately producing what are known as Kepler's laws of planetary motion. Tycho's observations helped Kepler to transform the circles of Copernicus into ellipses, and these graceful curves traced the orbits of all the planets around the Sun, including the Earth. The scene was now set for an astronomical revolution, which came from an entirely unexpected direction.

THE TELESCOPE: COLLECTING THE LIGHT

The telescope was most likely invented in 1608 by Hans Lippershey, a German-Dutch spectacle-maker. It consisted of a simple convex lens at one end of an extendable tube (the objective) and a concave lens at the other as the eyepiece. Such telescopes produced an erect image, and their advantages were recognized immediately.

In Italy, Galileo Galilei heard of the telescope in June 1609 and quickly made a superior working copy, which

he demonstrated to the Doge of Venice. He soon turned his telescope to the night sky and began a remarkable series of discoveries that would upset the religious establishment and transform observational astronomy.

The main advantage of the telescope for military purposes is that, through magnification, it makes distant objects visible in more detail; in astronomy, its disctinctive feature is its light-gathering power, a power limited in the human eye by pupil diameter, which is only a few millimeters when fully dark adapted. Raise a telescope to the eye and its curved front lens becomes its 'pupil'. The focused light of the objective lens is collected by the eyepiece and enters the eye, enhancing the it's sensitivity in proportion to the diameter of the front lens. While the extra magnification offered by the telescope is a huge bonus, without the extra light it provides it would be useless for all but the brightest objects.

Galileo Galilei was both excited and surprised by the things he saw through his increasingly powerful telescopes and clearly understood their revolutionary implications. By March 1610 he had published *Sidereus Nuncius* (*Sidereal Messenger* or *Starry Messenger*), a short book of his early discoveries, which include the craters and mountains of the Moon, the moons of Jupiter and the multitudes of stars in the Milky Way. He apparently added four un-numbered pages of material late in the production of the book; these contain his drawings of Orion and the Pleiades, showing vast numbers of previously unseen stars. While not all reactions to the book were positive – some were downright hostile – it launched the use of the telescope as an accepted astronomical instrument.

Improvements in the design of refracting (lensed) telescopes followed rapidly, but a major limitation for many years was the difficulty that lay in making larger optics while retaining sharp images that had no colour fringes. This chromatic aberration problem was properly diagnosed in 1666 by Isaac Newton, who constructed the first functional reflecting telescope, which used a curved metal mirror 33 mm in diameter as a light collector. All major modern optical telescopes are reflectors, and the largest planned is the European Southern Observatory's E-ELT (European Extremely Large Telescope), whose 39-metre mirror will be composed of almost 800 hexagonal segments.

Though reflecting telescopes now dominate, after the problem of chromatic aberration had been solved in around 1760 by fabricating cemented compound lenses, refractors were used in professional observatories until the late nineteenth century, a period that had also marked another turning point in the history of astronomy – the displacement of the eye as the only detector of light.

PHOTOGRAPHY: CAPTURING THE LIGHT

Photography would eventually revolutionize astronomy, but its introduction was much slower and less dramatic than Galileo's sweeping success with his telescope. Photography became a practical proposition with the introduction of the daguerreotype between 1838 and 1840, though the process was suitable only for well-lit scenes and exposure times were long. Nonetheless, astronomers were aware of its possibilities and in 1839 in England, Sir John Herschel coined the term 'photography', together with the use of 'negative' and 'positive' in a photographic context. The first successful astronomical daguerreotype was made in New York by John Draper in 1840, with a 20-minute exposure resulting in an image of the Moon.

New systems of photography gradually appeared, each more sensitive than the last, but all of them were complicated and inconvenient to use. Progress was sporadic, and although images of the Sun and Moon appear occasionally, along with some eclipse pictures, the first photograph of the bright star Vega was not captured until 1851, with Jupiter and Saturn following in 1857. The spectrum of Vega was captured in 1872, but it was in 1881 and 1882 respectively that a nebula and a comet were photographed.

In 1871, Richard Maddox had invented a way of coating glass plates with a layer of gelatin containing light-sensitive grains of silver salts, which looked like an emulsion, but dried to a tough, thin layer. These light-sensitive plates could be made in bulk, stored and then transported to where they were needed. Once they had been exposed, development could be delayed until convenient. When a dry gelatin layer was coated on rolls of film in 1888 (by George Eastman, who also offered a processing service), photography was democratized, with the slogan 'You press the button, we do the rest!' Photographic astronomy was not quite as straightforward, but Maddox's invention had enabled the camera to replace the eye as the only detector of faint light.

In 1883, from his home in Ealing, London, and using a telescope he built himself, Andrew Ainslie Common took a dry-plate photograph of the Orion nebula and revealed stars that were too faint to be seen by the naked eye through the same telescope. This breakthrough would eventually displace the eye from professional telescopes. Astronomers recognized this achievement at once and, in 1884, Common received the Gold Medal of the Royal Astronomical Society, its highest award.

Photography empowered all traditional and embryonic branches of optical astronomy, especially photometry and astrometry (the measurement of the brightness, colour and position of stars) and spectroscopy (recording spectra). It also made possible many of the major discoveries of the twentieth century, such as the expanding Universe, the discovery of the redshift, the nature of the galaxies and countless others. Photography has since proved a superb means of communicating the beauty and mystery of the night sky. Surprisingly, most people are still unfamiliar with the shape of the Milky Way or even the phases of the Moon, but no-one can have missed pictures from the Hubble Space Telescope or spacecraft Cassini's journey around Saturn.

In some fields, photography gradually gave way to the electronic detection of light, beginning with photometry in the 1940s. Photography detects light very well, but light is notoriously difficult to quantify; in photometry, the electrical signal is proportional to brightness, which is ideal for studying the colours of stars. However, while voltage values are meaningful to the photometrist, they do not make interesting images.

Today, astronomical pictures appear in colour – this medium began to flourish only in the 1980s with the introduction of three-colour imaging, and increased in popularity when the optics of the Hubble Space Telescope were corrected in 1993. This development coincided with the gradual introduction of electronic CCDs (charge coupled devices) as the astronomical 'area detectors' of choice at large observatories, rendering conventional photography obsolete after almost a century of achievement. The output of a CCD was digital, and could be read out instantly, with no messy chemicals or analogue processing involved.

BEYOND THE VISIBLE, INTO SPACE, INVISIBLE LIGHT

The atmosphere shields the Earth from the temperature extremes of day and night and the radiation of space, but it also filters out most of the electromagnetic spectrum, of which visible light is a small part. Only the longer radio wavelengths penetrate unscathed and ground-based radio astronomy has flourished since the late 1940s, uncovering objects such as pulsars, quasars and the cosmic microwave background, an echo of the Big Bang.

The atmosphere is most effective as a filter at shorter wavelengths, absorbing cosmic rays, gamma rays, X-rays and ultraviolet light. Beyond the visible region, the infrared part of the spectrum is heavily obscured. To improve the quality of observation, since Sputnik 1 in 1957, numerous unmanned earth-orbiting satellites have followed, but the first images of the Earth from space came from a V2 rocket launched by the US in 1946. Sputnik 2 was launched by the USSR in November 1957, the first to be able to measure cosmic rays and ultraviolet and x-rays from the Sun. The US followed in January 1958 with Explorer 1; the 'space race' had begun. The US, USSR and other nations have gone on to launch astronomy-oriented satellites of ever-increasing sophistication and, as technology has advanced, the quantity and quality of available data from unseen wavelengths have improved dramatically.

In addition to satellites, numerous spacecraft have been launched to study the Sun, Moon and planets, the first being the USSR's Luna 1 in January 1959. It missed the Moon, its intended target, and entered into an orbit around the Sun, where it made the first observations of the solar wind. Also in 1959, Luna 2 became the first spacecraft to land on another celestial body, the Moon, and returned the first image of its hidden face. Many other lunar explorations followed and the Apollo landings of a decade later were to put the first man on the Moon.

Arguably the exploration of the planets has been more scientifically productive. All of them have been visited, many of them several times, and all have produced surprises. There are too many missions to list, but it was clear from Voyagers 1 and 2, launched in 1977, that there was still a lot to learn and many planets around distant stars to discover.

The most recent observational hurdle to be overcome was the detection of gravitational waves, the announcement of which in 2016 was was perhaps the most exciting discovery of recent times. Unlike light and most of the other phenomena mentioned above, gravitational waves are not the same thing as electromagnetic radiation – they are ripples in space-time, travelling at the speed of light. Predicted as a consequence of Einstein's Theory of General Relativity (first published in 1916), the first gravitational waves detected arose from a pair of merging black holes. From a brief and unexpected signal with a very distinctive signature, it can be deduced that the two fast-moving merging black holes had masses of about 36 and 29 times that of the Sun, and the power generated at the instant of the merger was greater than all of the light radiated by all the stars in the observable Universe.

ASTERISM

As viewed from the Earth, a configuration, typically a small group of brighter stars, perhaps part of a constellation. *see* CONSTELLATION

ASTEROID

A celestial object that orbits the Sun, primarily located in our Solar System's asteroid belt, usually composed of icy rock such as silicon, metals such as iron and nickel or a combination of rock and metal. A minor planet. Asteroids were formed from leftover planetary materials, or protoplanets that disrupted, during the Solar System's planetary formation period. *see* ASTEROID BELT

ASTEROID BELT

A specific region in our Solar System, located between the orbits of Mars and Jupiter and spanning roughly 140 million miles (225 million km) across, where the majority of asteroids in the Solar System can be found orbiting the Sun. *see* ASTEROID

ASTROLABE

A historical astronomical tool that allowed astronomers and navigators to determine key information about the sky and the heavens, such as how the sky looked at a specific place and time.

ASTRONOMICAL UNIT (AU)

A measurement that represents the average distance between the Earth and the Sun, roughly 93 million miles (150 million km), which astronomers use to measure distances within our Solar System.

ASTRONOMY/ASTRONOMER

The scientific study of the physical Universe that uses mathematics, physics and chemistry to observe, understand and explain the properties and processes of all it contains (i.e. planets, stars and galaxies). An ASTRONOMER is someone who studies astronomy.

ATMOSPHERE

Gases that encompass a celestial object such as a planet, moon or star and are held to the object by its gravity. Not all celestial objects have atmospheres.

AURORA

A natural phenomenon of light and colour, found at high latitudes near the poles of some celestial objects that have an atmosphere and their own magnetic field. Auroras are caused by the interaction between ionized particles from the solar wind (*see* SOLAR WIND) and the magnetic field of the celestial object.

AURORA BOREALIS/AURORA AUSTRALIS

see NORTHERN LIGHTS/SOUTHERN LIGHTS

BIG BANG

The colloquial name for the explosion that, according to the most prevalent cosmological theory of the origin of the Universe, started its expansion. As originally described, the Big Bang was a mathematical singularity, an infinitely hot and dense point that contained all of space-time within itself, and then rapidly expanded in an extremely short amount of time. Newer theories have been proposed in attempts to understand the physical nature of the Big Bang.

BINARY STAR

A pair of stars that orbit a common centre of gravity.

BLACK HOLE

The colloquial name for a region in space of high mass and density compacted into an infinitely small point, called a singularity. The subsequent gravity produced is so strong that no form of matter, or even energy such as light, can escape its pull. Because light that has fallen into the black hole cannot be reflected back to the viewing source, black holes are essentially 'invisible'. Black holes are made by nature in supernova explosions ('stellar black holes') and through the accumulation of matter in the centres of galaxies. *see* SUPERMASSIVE BLACK HOLES, SUPERNOVA

CELESTIAL/CELESTIAL BODY

Celestial, originally meaning 'heavenly', refers to something having the quality of existing outside or beyond the Earth and its atmosphere.
A celestial body is an object that exists beyond the Earth and its atmosphere.

COMET

A celestial object composed mostly of dusty, rocky ice that orbits the Sun, thought primarily to be found travelling in the outer regions of our Solar System in a zone referred to as the Oort Cloud (*see* OORT CLOUD). Disturbed from the Oort Cloud, comets can be seen closer to the Sun depending on their orbital path. When a comet passes close to the Sun, it heats and interacts with the solar wind (*see* SOLAR WIND), and can form the 'tail' features seen in most common depictions of comets.

CONSTELLATION

As viewed from Earth, a configuration of stars that, when connected together like a game of connect-the-dots, forms a commonly identifiable object, shape or pattern, associated with a specific character or archetype from mythology or antiquity. The constellations form a kind of map of the sky that astronomers use to refer conveniently to specific locations on the celestial sphere. The International Astronomical Union recognizes 88 constellations.

CORONA

The outermost layer of the Sun's atmosphere.

CORONAL MASS EJECTION

A burst of plasma and magnetic field energy from the Sun's 'surface', through its corona into space that often correlates with a solar flare and other phenomena. *see* SOLAR STORM

COSMIC MICROWAVE BACKGROUND (CMB)

Electromagnetic microwave radiation left over from the Big Bang, which permeates the entire known Universe. *see* BIG BANG

COSMOLOGY/COSMOLOGIST
The mostly theoretical, scientific study of the Universe as a whole. Cosmology uses the observations and data of astronomy (see ASTRONOMY/ASTRONOMER) and attempts to answer more fundamental questions about the Universe such as its overall structure, origins and future fate. A COSMOLOGIST studies cosmology.

COSMOS
A word stemming from the original Greek kosmos, meaning order, it refers to the whole Universe as a complete system.

CRATER
A hole in the surface of a solid celestial object, such as a planet or moon, caused by an impact from a meteorite, asteroid or comet or by a volcanic eruption.

DARK ENERGY
A label for whatever it is that explains why the expansion of the Universe appears to be accelerating. Dark energy is something that permeates the entire physical Universe, but has thus far not been directly observed. The force of gravity due to all the matter contained within the Universe should be slowing the expansion; dark energy is the name given to the phenomenon that counteracts this. Dark energy is thought to make up about 68 per cent of the Universe, the rest consisting of 27 per cent dark matter and a mere 5 per cent regular visible matter.

DARK MATTER
Dark matter is a theoretical matter that attempts to explain the amount of mass cosmologists believe to be 'missing' from the observable universe. Apart from having mass and therefore generating the force of gravity, its properties are unlike that of the regular matter that makes up the visible universe, (e.g. plants, animals, stars and galaxies), known as baryonic matter. Dark matter does not interact to any significant degree with baryonic matter except through gravity, therefore it has not been directly observed. see DARK ENERGY

DEEP-SKY OBJECT
A celestial object in distant regions that is visible from Earth, either by the naked eye or by telescope, with the exception of stars, planets and other distinct Solar System objects. A term that is usually used in amateur astronomy, these objects include star clusters, nebulae and galaxies.

DOUBLE STAR
A pair of stars that, as viewed from Earth, appear near to each other in the sky, whether by actual proximity or because they are visually adjacent in the field of view.

DWARF STAR
Any star that is smaller than a giant or supergiant star. The term refers to most 'normal' stars, including our own Sun, which is a yellow dwarf.

ELECTROMAGNETIC RADIATION/ ELECTROMAGNETIC SPECTRUM
Electromagnetic radiation is the propagation of electromagnetic waves – waves of energy, fundamentally of an electric and magnetic nature, released by stars into interstellar space. A trace amount of residual electromagnetic radiation from the Big Bang (see BIG BANG) also permeates all of space (see COSMIC MICROWAVE BACKGROUND). Electromagnetic waves have a range of frequencies that make up the electromagnetic spectrum, spanning radio waves, infrared radiation, visible light, ultraviolet radiation, x-rays and gamma rays.

EQUINOX
Either of two points during the year, around 20 March and 23 September, at which the Earth's equator is directly in line with the centre of the Sun, so day and night are of equal length.

EXOPLANET
Any planet located outside our own Solar System. see PLANET

GALACTIC TIDE
The tidal force experienced by objects subject to the gravitational field of a galaxy such as the Milky Way.

GALAXY
A collection of stars, gas, dust and dark matter that makes up a structure in space bound together by its own gravity. Galaxies come in varying forms, the most common of which are elliptical, distinguished by their elongated shape; spiral, characterized by having 'arms' forming the shape of a pinwheel and irregular, which fall into neither category.

GALILEAN MOONS
The four largest moons of Jupiter – Io, Europa, Ganymede, and Callisto – which were discovered by Galileo Galilei in 1610.

GAS GIANT PLANET
A classification of planet that is significantly more massive than a typical rocky planet, is composed mostly of gas, does not have a defined surface, and has a relatively small solid core. Our Solar System contains four gas giant planets: Jupiter, Saturn, Uranus and Neptune.

GLOBULAR CLUSTER
A densely packed, roughly spherical cluster of up to millions of very old stars. They are found in the haloes of galaxies.

GRAVITATIONAL LENSING
The bending of light due to gravity. The gravity of any particular celestial object warps the space-time around it, consequently bending the light travelling near it, causing the light to be refracted, such as with a lens, and refocused somewhere.

GRAVITY
One of the fundamental forces of the Universe, which causes anything that has mass to warp and curve the space-time around it. Bodies with a larger mass have stronger gravity. Two bodies of mass that are close together will move or 'fall' toward each other, each attracting the other.

HABITABLE ZONE
Often referred to as the Goldilocks zone, it is the area around a star that is just the right temperature for water to remain in its liquid state, giving any planets residing in this region a greater potential for harbouring life.

HELIOCENTRIC
Any model of the Solar System that places the Sun at the centre of the model. This model was first suggested by Nicolaus Copernicus in the mid-1500s as a challenge to the geocentric model, which placed the Earth at the centre.

INTERGALACTIC
Referring to the space between galaxies, and anything that resides there.

INTERSTELLAR
Referring to the space between stars, and anything that resides there.

KUIPER BELT
A specific disc-shaped region in our Solar System that lies just beyond the gas giant planets (see GAS GIANT PLANET). It encircles the entire Solar System and consists of many icy/rocky bodies of varying sizes referred to as trans-Neptunian objects, including Pluto.

LIBRATION
Usually referring to the Moon, the rocking or wobbling motion that allows for more than 50 per cent of the surface to be viewed from Earth over a period of time.

LIGHT YEAR (LY)
The distance that light travels in one year, which astronomers use to measure distances in space. It is equal to approximately 5.8×10^{12} miles or 5.8 trillion miles (9.5×10^{12} km or 9.5 trillion km).

LUMINOSITY
The total power produced by a celestial body such as a star.

LUNAR
Referring to the Moon, or something having a moon-like quality.

LUNAR ECLIPSE
A phenomenon in which the Earth is situated directly between the Sun and the Moon, blocking the Moon from the light of the Sun, which causes the Moon to appear dim and reddish.

LUNAR MARIA
Large, dark patches of basaltic deposits on the Moon's surface, caused by ancient volcanic activity.

LUNAR NODES

The two points in the Moon's orbit at which the Moon crosses the ecliptic, the apparent path of the Sun on the celestial sphere. Eclipses only happen when the Moon is near a lunar node.

MAGNETIC FIELD

The distribution of magnetic force throughout space. A magnetic field is produced when an electrical charge is in motion.

MATTER

Anything of physical existence that has mass.

METEOR

A (relatively) small celestial object made of rock and/ or metal debris from asteroids, comets or impacts that has entered the Earth's atmosphere at high speed and become significantly heated by friction. Meteors can sometimes be seen as bright lights streaking across the sky, which we refer to as shooting stars. Most meteors disintegrate completely due to friction before reaching the Earth, but once in a while an object will make it all the way to the surface, where it is then referred to as a meteorite.

METEOR SHOWER

As the Earth passes through pockets of meteoroids, typically left over from the trail of a comet, meteoroid material enters the Earth's atmosphere and heats to extreme temperatures producing numerous glowing streaks of light visible from Earth's surface.

METEORITE

see METEOR

MILKY WAY

The name given to the galaxy in which our Solar System resides.

MOON

A celestial object composed mostly of rock and solid material that orbits a planet or other celestial body, much like our own Moon, which orbits the Earth.

MULTIVERSE

A theory of cosmology with many variations that proposes that there are multiple universes, including our own, that exist simultaneously in some way, which differs depending on the theory. These other universes can be referred to as parallel universes.

NEBULA

A denser than usual collection of dust, gases and charged particles in space.

NEUTRON STAR

A celestial object made of neutrons, formed from the collapsed core of a giant star after it explodes in a supernova. see SUPERNOVA

NORTHERN LIGHTS

Also known as the Aurora Borealis, this specific auroral display is located around Earth's northernmost latitudes and centred near the magnetic North Pole (see AURORA). The Southern Lights (Aurora Australis) is the southern hemisphere equivalent. see SOUTHERN LIGHTS

OBSERVABLE UNIVERSE

Everything that exists, from matter and energy to space, that in principle, can be observed from Earth. There are parts of the Universe that cannot be observed from here because the light from those areas has not yet reached us. The boundary separating the observable and unobservable universe is called the cosmological horizon.

OBSERVATORY

A site that is equipped specifically for viewing and recording the motions of the sky and the natural phenomena of the observable universe, both earthly and cosmic.

OORT CLOUD

A region of our outer Solar System, named after the Dutch astronomer Jan Oort, that extends relatively far into space in comparison to the radius at which the planets orbit. Spherical in shape, it encircles the entire Solar System and was conjectured by Oort as the reservoir from which the comets come. As such, the region contains many solid objects composed mostly of ice. see COMET

ORBIT

The path of one celestial object around another, such as the path of a planet around its star, a moon around a planet or one star of a binary system around the other. The orbital period is the time it takes the celestial object to complete one orbit.

PLANET

A subsidiary object found orbiting a star, such as the Earth orbiting the Sun. To be called a planet, the object must be massive enough that its gravity is great enough to form the object into a spherical shape (more massive than a comet for example), but not so great that nuclear fusion occurs (when it would be called a star). To be categorized strictly as a planet, as distinct from a big asteroid for example, the object also has to have caused the clearing of its orbital path from debris and other smaller rocky objects, otherwise it is categorized as a 'dwarf planet'.

PLANETARIUM

An astronomical building or room, usually with a domed ceiling, in which projected images of the celestial sphere, as well as other images of space, can be viewed for educational purposes.

PLANETARY NEBULA

A nebula that in a small telescope looks like the disc of a planet, but which in reality is gas ejected from a red giant star as it turns into a white dwarf.

PLANETARY SYSTEM

A collection of celestial objects (planets, moons, asteroids, comets, etc) that orbit one or more stars.

PLANETESIMAL

A small planet of the sort that first forms in a planetary system and gathers with others into a protoplanet. The Solar System contains some asteroids, meteors and comets that are planetesimals that were left over from the formation of the planets. see PLANET, PROTOPLANET

PLANISPHERE

A type of astrolabe, it is a map of the sky that allows an astronomer to quickly reference which stars and constellations are visible above the horizon at their particular location on any given day of the year and time of day or night. see ASTROLABE

PLASMA

Ionized, or charged, gas particles. Plasma is one of the four states of matter – the other three being solid, liquid and gas.

PROTOPLANET

A planet in its embryonic stages, formed by the accumulation of planetesimals. see PLANET, PLANETESIMAL

PROTOSTAR

An early stage in the formation of a star, when it is condensing inside a cloud of interstellar dust and gas but nuclear reactions have not yet begun at its core.

PULSAR

A rotating neutron star. A pulsar emits two beams of radio waves and light, concentrated into two opposite directions, causing it as it rotates to appear to blink on and off as viewed from the Earth. see NEUTRON STAR

QUASAR

A galaxy that is extremely bright as the result of intensely hot radiation being emitted from near a supermassive black hole while it is accreting, or 'feeding', on surrounding material. The radiation from a quasar is so great that, for millions of years, it can far overpower the light of its parent galaxy. see BLACK HOLE, SUPERMASSIVE BLACK HOLE

RED GIANT STAR

One of the final stages of a star's life, in which it expands and cools and subsequently becomes red-orange in colour – the inevitable fate of the Sun before it turns into a white dwarf.

SATELLITE

A subsidiary body in orbit around another celestial object, usually a moon orbiting around a planet.

SOLAR ECLIPSE

A phenomenon in which the Moon is situated directly between the Earth and the Sun, temporarily blocking out the Sun as viewed from the Earth.

SOLAR FLARE

A solar event in which high energies of radiation are released in a burst from a localized region of the surface of the Sun.

SOLAR MAXIMUM

The period of peak solar activity in the solar cycle; the time of the greatest number of sunspots and solar storms, which occurs roughly every 11 years.

SOLAR PROMINENCE

A bright magnetic loop or arc of plasma extending from the 'surface' of the Sun that is bound to the surface by strong magnetic forces and can last up to several months.

SOLAR STORM

A period of energetic activity on the Sun comprising sunspots, solar flares, prominences, coronal mass ejections and other phenomena.

SOLAR SYSTEM

Our planetary system, which orbits the Sun and consists of eight planets and numerous dwarf planets, moons, asteroids, comets and other smaller solid objects. *see* PLANETARY SYSTEM

SOLAR WIND

Charged particles from the Sun that flow outward from the Sun's atmosphere in all directions at an extremely rapid rate, causing a kind of 'wind' effect.

SOLSTICE

One of two points in the year, either, around 21 June, when the Sun is at is at its most northerly point in the sky relative to the equator, and again around 22 December, when the Sun is at its most southerly point.

SOUTHERN LIGHTS

Also known as the Aurora Australis, this auroral display is located around Earth's southernmost latitudes and centred on the magnetic South Pole. *see* AURORA, NORTHERN LIGHTS

STAR

A celestial object that radiates intense heat and light; it is composed of very hot charged particles called plasma, and is held together in a spherical shape by its own gravity. Nuclear fusion inside the star's core generates the extreme heat, and also maintains the spherical shape of the star, keeping it from imploding from its own gravity.

SUNSPOT

A comparatively cool region on the surface of the Sun, which appears darker than its surrounding area because of the difference in temperature.

SUPERCLUSTER

A region of space in which large numbers of smaller groups of galaxies are found clustered together, forming some of the largest known structures in the Universe. About 9 per cent of all galaxies, including the Milky Way, are thought to reside in superclusters.

SUPERMASSIVE BLACK HOLE

The largest and most commonly identified size class of black holes that are thought to reside in the centre of most large galaxies, including our own. Energetic supermassive black holes are called 'quasars' (*see* QUASAR). They can contain anywhere from a million to a billion times the mass of a standard (or 'stellar') black hole. *see* BLACK HOLE

SUPERNOVA

The largest kind of celestial explosion that occurs as the final stage, or death, of a star. A star as massive as the Sun ends its life quietly as white dwarf (*see* WHITE DWARF). A star more than eight times the mass of the Sun ends explosively as a supernova, when it spews its contents into the surrounding interstellar space, seeding the area with elements for new stellar and planetary birth. The star may be disrupted entirely, or it may produce a neutron star or a stellar black hole. A supernova is so luminous that it can, for several days, outshine its parent galaxy. *see* BLACK HOLE, NEUTRON STAR

TELESCOPE

An instrument commonly used in astronomy for the purpose of viewing, observing and collecting information about the visible universe. Telescopes use curved lenses or mirrors to magnify the viewing source.

TERMINATOR

A moving line separating the 'day' and 'night' sides of a celestial object such as the Moon or the Earth illuminated by the Sun.

TERRESTRIAL PLANET

A planet that is composed mostly of rock and metals, has a metallic core and a solid surface, possibly an atmosphere and is significantly small in size compared to gas giant planets. Our Solar System contains four terrestrial planets: Mercury, Venus, Earth and Mars. *see* GAS GIANT PLANET

TRANSIT

The passage of one celestial object in front of another celestial object, such as the planet Venus in front of the Sun, as viewed from a particular vantage point, such as the Earth.

UNIVERSE

Everything that is known to exist, from matter and energy to space and time. The study of the Universe as a whole is called cosmology. *see* COSMOLOGY

VELOCITY

In astronomy and physics, velocity refers to the speed and direction of an object. As a function of time, it is the change in position of an object, divided by the time of travel.

WHITE DWARF STAR

A celestial object made of leftover stellar core material after a dwarf star has blown off all of its outer layers during its death – the inevitable fate of the Sun. This core is not dense enough to collapse into a neutron star or black hole. *see* BLACK HOLE, DWARF STAR, NEUTRON STAR

ZODIAC

The region of the sky that forms a band around the ecliptic, which is the path of the Sun through the sky over a year, as viewed from Earth against a backdrop of stars. The paths of the Moon and planets follow nearly the same path as the Sun, but can be up to 8 degrees either side, so the zodiac is the area of the sky in which the Sun, Moon and planets are always found. The zodiac is broken up into twelve equally sized regions, or 'signs', labelled after the constellations in which they occur. Over a year the Sun passes through the twelve signs of the zodiac in sequence. Starting at the Spring Equinox, the Western signs of the zodiac are: Aries, Taurus, Gemini, Cancer, Leo, Virgo, Libra, Scorpio, Sagittarius, Capricorn, Aquarius and Pisces.

ZAKARIYA IBN MUHAMMAD AL-QAZWINI
(Iran, 1203–83)

While living in Wasit in Iraq and working as a judge, in 1270 the Arab cosmographer and geographer Zakariya ibn Muhammad al-Qazwini compiled an illustrated treatise of the marvels of the Universe entitled *The Wonders of Creation and the Oddities of Existence*. The manuscript was widely read and copied across the Islamic world. Showing al-Qazwini's spiritual approach to astronomy, astrology, geography and natural history, the compilation is divided into two parts: the heavenly realm and the earthly realm.

ABD AL-RAHMAN AL-SUFI
(Iran, 903–86)

Al-Sufi, historically known in the West as Azophi, was a tenth-century Persian Islamic astronomer – a court astronomer in Isfahan. He published the culmination of his work as *The Book of the Constellations of Fixed Stars* (c.964), in which each constellation according to Ptolemy is laid out alongside al-Sufi's descriptions, amendments and observations, together with drawings of the corresponding zodiac figure. He also translated much of the Hellenistic astronomy into Arabic. The lunar crater Azophi and the minor planet 12621 Alsufi are named in his honour.

EL ANATSUI
(Ghana, 1944–)

Ghanaian artist El Anatsui has spent much of his career working and teaching in Nigeria, where he has become affiliated with the Nsukka group. Anatsui is well known for his large-scale sculptures made of recycled scrap metal or bottle tops sourced from local alcohol recycling centres, and woven together into a cloth-like assemblage with copper wire. Often installed on wall spaces, Anatsui's sculptures take different forms depending on how they are hung and draped. Through the materials and processes that he uses, his work can draw on narratives of colonial history, as well as create dialogues around the relationships between consumer, waste and the environment. In 2015 Anatsui was awarded the Golden Lion for Lifetime Achievement at the Venice Biennale.

WILLIAM ANDERS
(Hong Kong, 1933–)

American William ('Bill') Alison Anders was born in Hong Kong while his US Navy father was stationed in the region. He trained as an electrical engineer and a nuclear engineer before becoming a NASA astronaut. Together with Jim Lovell and Frank Borman, he was one of the three astronauts on the Apollo 8 mission, which, in 1968, was the first manned spaceflight to leave the Earth's orbit and to reach and orbit the Moon. Aboard Apollo 8, Anders took the famous colour photograph 'Earthrise'. After leaving NASA and the US Air Force in 1969, Anders continued to work in governmental advisory roles, and was the US ambassador to Norway, before moving into the private sector.

PETRUS APIANUS
(Germany, 1495–1552)

In 1524 geographer Petrus Apianus, also known as Peter Apian, created *Cosmographia*, the earliest and best known of his textbooks combining geography, astronomy and history. His book was so popular that it extended to sixteen editions. Apianus first studied mathematics, astronomy and cosmography in Leipzig and Vienna, before being appointed Professor of Mathematics at the University of Ingolstadt in 1527. As well as his interests in mathematics, cartography and astronomy, he designed mathematical instruments. He remained in Ingolstadt until his death in 1552.

JOHANN BAYER
(Germany, 1572–1625)

Johann Bayer studied philosophy and law at the University of Ingolstadt in 1592. He then moved to Augsburg to practise law. However, his curiosity about new developments in astronomy led him to publish *Uranometria* in 1603, which was a popular and highly influential star atlas – a guide to the constellations visible to the naked eye. He added twelve constellations to Ptolemy's star catalogue of forty-eight, and, based on the work of Tycho Brahe, assigned each visible star in a constellation with a Greek or Latin letter, developing a system of nomenclature that is still used today.

WILHELM BEER
(Germany, 1797–1850)

A banker by trade, Wilhelm Beer was an amateur astronomer. In 1834–6, together with Johann Heinrich von Mädler, he created the most complete map of the Moon to date, and the first lunar map to be divided into quadrants, entitled *Mappa Selenographica*. Continuing their work together, Beer and von Mädler later produced a map of Mars in 1840, which was the first to show the light and dark areas. Their *Mappa Selenographica* was only surpassed in detail in 1878, with J. F. Julius Schmidt's map.

MICHAEL BENSON
(Germany, 1962–)

Since 1997, American Michael Benson has based his art/science practice in foraging for raw data and partially processed images in archives of Solar System photographs. These images are taken by robotic interplanetary probes in space and Benson takes on the roles of editor and curator of the images. From this data, he creates large-format, intricately detailed composite images of planetary landscapes. He is also a filmmaker and worked with director Terrence Malick on the space sequences of the film *The Tree of Life*, and a contributor to print media including *The New Yorker*, *The New York Times* and *Rolling Stone*.

CHESLEY BONESTELL
(United States, 1888–1986)

Born in San Francisco, Chesley Bonestell combined his interests in astronomy and science fiction with a love of painting and illustrating from an early age. He initially studied architecture at Columbia University but left

before graduating and then worked as an architect and architectural illustrator for twenty-eight years, working on projects including the Chrysler Building in New York. He then became a matte artist creating backdrops for Hollywood films including *Citizen Kane* (1941). However, it was after *Life* magazine published several paintings by Bonestell of Saturn, as seen from its moons, that he became a professional space artist. His work featured in magazines, books and films from the late 1940s to the 1970s, firing the growing public interest in spaceflight.

ANGELA BULLOCH
(Canada, 1966–)

Graduating in 1988 from Goldsmiths' College, London, Angela Bulloch is part of the generation known as the Young British Artists. Her diverse range of work is rooted in her interest in systems, patterns and codes – ultimately in the intersection between mathematics and aesthetics. She is best known for her 'pixel boxes', which are stacking cubes with a screen of gently pulsing coloured light. She also creates 'drawing machines' in which machines are programmed to respond to external stimuli that direct their plotted course to draw lines on gallery walls. Most recently she has worked on a series of night-sky simulations in which she uses information on constellations as viewed from Earth, and recreates projections as they would be seen from alternative viewpoints far from Earth.

ALEXANDER CALDER
(United States, 1898–1976)

Born into a family of artists in Pennsylvania, Alexander Calder studied engineering at university, before going to the Art Students League in New York. Interested in kinetics, he is best known for his abstract sculptural works called 'mobiles' – sculptures suspended in space, either free-moving or mechanized. He also made stationary constructions referred to as 'stabiles', as well as paintings. A personal fascination with the Solar System and its mechanisms informed his art-making throughout his career. During his lifetime, he was the subject of major retrospective exhibitions at both the Guggenheim Museum and the Whitney Museum of American Art in New York.

ANDREAS CELLARIUS
(Germany, c.1596–1665)

Mathematician and cartographer Andreas Cellarius was born in Neuhausen and moved to Heidelberg for his education. In 1660 he published the *Harmonia Macrocosmica*, an atlas of richly illustrated celestial maps depicting the world systems of Claudius Ptolemy, Nicolaus Copernicus and Tycho Brahe. Little is known about Cellarius's life, but the minor planet 12618 Cellarius is named after him.

VIJA CELMINS
(Latvia, 1938–)

Based in New York, Latvian-American artist Vija Celmins was born in Riga in 1938 and emigrated to the United States with her family in the late 1940s. She studied painting and printmaking at the John Herron School of Art in Indiana and completed a master's degree at UCLA.

Her paintings, drawings and prints create photorealistic scenes of nature – waves in the sea, the desert floor, rocks and constellations. Earlier work focused on pop sculptures and monochromatic representational paintings. Celmins has had major retrospective exhibitions at many international museums including the Museum of Modern Art and the Whitney Museum of American Art in New York and the Centre Pompidou in Paris.

NICOLAUS COPERNICUS
(Poland, 1473–1543)

The Renaissance mathematician and astronomer Nicolaus Copernicus proposed that the Sun was the fixed point around which the planets orbited, rather than the Earth, and that the Earth turned once daily on its own axis during its orbit of the Sun. His theories were not widely accepted until after his death, but they had wide influence on the scientific revolution and the work of Galileo, Descartes and Newton, among others. Copernicus was a polymath, who also made notable contributions to economics with a quantity theory of money, and a principle later known as Gresham's law. He died in Royal Prussia, the region where he was born, in the Kingdom of Poland at the age of seventy.

JOSEPH CORNELL
(United States, 1903–72)

Born in Nyack, New York, American artist and filmmaker Joseph Cornell is best known for developing a form of sculpture called 'assemblage', in which seemingly random objects are grouped together in compositions. Being an avid collector of memorabilia and having been exposed to the work of the Surrealists, Cornell's work often took the form of 'shadow boxes', within the confines of which he used found objects to compose imaginary worlds and journeys, despite having never travelled much further than New York State. His boxes and later collage works reflect his wide-ranging fascination with the fields of astronomy, ornithology and literature, among others.

LEONARDO DA VINCI
(Italy, 1452–1519)

Artist, inventor, scientist and engineer, among other titles, Leonardo was a polymath for whom the term 'Renaissance man' was coined. Born in Tuscany, he was apprenticed to the artist Verrocchio in Florence. He worked for seventeen years in Milan for Duke Ludovico Sforza, before moving to Venice and then back to Florence, where he worked for Cesare Borgia; later he worked in Rome for Pope Leo X before moving to France at the invitation of King Francis I. His oeuvre includes such masterpieces as *The Last Supper* and *Mona Lisa*. He is widely renowned for his closely observed sketches of human anatomy and military and mechanical designs, but his fascination with vision and optics also drew him to astronomy – particularly in relation to observations about the Sun and the Moon.

AGNES DENES
(Hungary, 1931–)

Born in Hungary, raised in Sweden and educated in the United States, Agnes Denes was a leading member of the concept-based artists of the 1960s and 1970s. Her art uses a range of media to investigate science, philosophy, psychology, history and other subjects. Based in New York, she has a reputation as a pioneer, creating important early environmental artworks, using non-traditional materials for delicate drawings and prints, and for applying alternative mapping strategies to overturn assumed systems of knowledge.

JOHANNES DE SACROBOSCO
(c.1195–c.1256)

Also known as John of Holywood or Ioannis de Sacro Bosco, Johannes de Sacrobosco was a monk, scholar and astronomer. Few details of his life are known, but it has been suggested that he was born in England, educated at Oxford University, then joined the Order of St Augustine at the monastery of Holywood in Nithsdale. It is, however, known that he taught at the University of Paris and was the author of a widely read introductory textbook to astronomy in four chapters, *Tractatus De Sphaera* (1220), which outlines the idea of the Earth within a spherical Universe and an introduction to the Ptolemaic system.

PETER DOIG
(Britain, 1959–)

Scottish artist Peter Doig spent some of his childhood years in Canada and some in Trinidad, where he returned to live and work in 2002. His paintings – often landscapes – are figurative, yet have elements of abstraction, or, as he describes, they create 'abstractions of memories'. He regularly uses found photographs as source material but his style is far from photorealistic; instead, the moments he captures represent both personal and collective experiences and convey mysterious, multilayered narratives. Doig was nominated for the Turner Prize in 1994 and named the 2017 Whitechapel Gallery Art Icon.

ALBRECHT DÜRER
(Germany, 1471–1528)

Albrecht Dürer was one of the most celebrated German artists of the Renaissance, best known for highly skilled woodcuts and engravings, altarpieces, other religious works and portraits. He worked mainly in his native Nuremberg, although he travelled as far as Italy to study art and corresponded with such contemporary artists as Leonardo da Vinci. Dürer was also renowned for his printmaking, through which his influence spread across Europe, and he created the first printed map of constellations in Europe.

JIMMIE DURHAM
(United States, 1940–)

An artist, activist, poet and essayist, Jimmie Durham has been making iconoclastic works that tackle the colonizing systems of Western culture for over fifty years. Defying categorization, his practice is

multifaceted, including sculpture, performances, wall-based collages and ersatz ethnographic displays. After studying art in Geneva, Durham worked for the American Indian Movement, with which he remained affiliated until 1980. His Cherokee heritage and his understanding of the history and marginalization of the American Indians form a key subject matter for his art. After living in Mexico for several years, Durham moved to Europe in 1994.

MARIE CLARA EIMMART
(Germany, 1676–1707)

Born and raised in Nuremberg, the astronomer, engraver and designer Marie Clara Eimmart was the daughter of the painter, engraver and amateur astronomer Georg Christoph Eimmart, the younger. He built a private observatory in Nuremberg in 1678, and it was through her work with her father that Marie Clara trained as an apprentice astronomer. She specialized in astronomical and botanical illustrations, and gained a reputation for her exactness. Between 1693 and 1698, Eimmart made over 350 illustrations of the Moon, charting its different phases, drawn from observations through a telescope.

OLAFUR ELIASSON
(Denmark, 1967–)

The Icelandic-Danish artist Olafur Eliasson studied in Denmark before establishing Studio Olafur Eliasson in Berlin in 1995, which has a team of ninety craftsmen, technicians, architects, archivists, administrators, art historians, programmers, and cooks – all contributing to his interdisciplinary social practice. His exploration of perception, movement and experience covers a wide range of media, including sculpture, painting, photography and film. Eliasson is also accomplished in creating art for public spaces, and his public art installations have appeared in New York, London and Reykjavik, among other cities.

MAX ERNST
(Germany, 1891–1976)

One of the foremost avant-garde artists of the early twentieth century, Max Ernst was involved in the Dada art movement in Cologne before moving to Paris and becoming a founding member of the Surrealists in the early 1920s with Paul Éluard and André Breton. He pioneered forms of art originating from the unconscious, or automatism. In order to stimulate imagery from the unconscious mind, Ernst used techniques such as frottage (pencil rubbings over different materials) and decalcomania (pressing together and pulling apart two canvases with liquid paint between them) in order to create chance images, which would then induce an instinctive response. Ernst fled to the United States in 1941, and married Peggy Guggenheim a year later. After divorcing from Guggenheim, he married Dorothea Tanning and relocated to France in 1954.

CAMILLE FLAMMARION
(France, 1842–1925)

The French astronomer and author Camille Flammarion was an early writer and popularizer of science fiction. The brother of the founder of the Flammarion Group publishing house, Ernest Flammarion, he was a prolific author, whose popular science and astronomy works included *Imaginary Worlds* and *Real Worlds* in 1864, which included some of the earliest representations of otherworldly beings, or aliens. Flammarion was also a founder and the first president of Société Astronomique de France, and was involved in scientific approaches to researching spirituality and psychic forces. A crater on the Moon, a crater on Mars and an asteroid are named after him.

GALILEO GALILEI
(Italy, 1564–1642)

Born in Pisa, Galileo Galilei was a natural philosopher, astronomer, mathematician and physicist, whose research and theories made huge contributions to the fields of astronomy, motion and the strength of materials, and to the development of scientific method. His observations through the use of the telescope revolutionized astronomy – he confirmed the phases of Venus and discovered the four largest satellites of Jupiter – and led him to champion the Copernican heliocentric system of the Universe, which held that the planets orbited the Sun. This advocacy, however, resulted in an Inquisition process that found him suspected of heresy and forced to recant.

EDMOND HALLEY
(England, 1656–1742)

Edmond Halley was the English astronomer and mathematician who first calculated the orbit of the famous comet that is named after him. Born in East London, he was educated at St Paul's School and then The Queen's College, Oxford, where he met and was heavily influenced by John Flamsteed, the first Astronomer Royal at the Royal Greenwich Observatory. Halley, following Flamsteed's influence, compiled a catalogue of the stars in the southern hemisphere. Then, with Robert Hooke, Sir Christopher Wren and Sir Isaac Newton, he tried to develop a mechanical explanation for planetary motion, the answer to which Newton would publish in 1687 as *Philosophiae Naturalis Principia Mathematica*. Halley eventually succeeded Flamsteed to the position of Astronomer Royal in 1720.

THOMAS HARRIOT
(England, c.1560–1621)

Little is known of the early life of English mathematician and astronomer Thomas Harriot, but he received a degree from the University of Oxford in 1580. Following this, he was under the patronage of both Sir Walter Raleigh and Henry Percy, the ninth Earl of Northumberland. He travelled to the Americas to found Raleigh's colony on Roanoke Island and is likely to have visited Virginia. On his return to England, he continued his scientific work under Percy's patronage and was endowed with houses in Durham and on the Syon estate in west London. He researched the refraction of light, was one of the first to apply algebra, and used the telescope to observe and record charts of the Moon, the paths of the moons of Jupiter, sunspots and comets.

CAROLINE HERSCHEL
(Germany, 1750–1848)

Caroline Herschel was a German-born British astronomer who worked with her brother, astronomer William Herschel, throughout her life. She started her working life managing her family's household, before moving to Bath with her brother and performing as a singer. When William was made court astronomer to King George III in 1782, she undertook many of the laborious calculations that were important contributions to his astronomical research. During this time, she also discovered three nebulae and eight comets. After William's death in 1822, she returned to Hanover and completed the catalogue of 2,500 nebulae and many star clusters that subsequently formed part of the *New General Catalogue*. She was awarded a Gold Medal by the Royal Astronomical Society in 1828.

WILLIAM HERSCHEL
(Germany, 1738–1822)

William Herschel, born Friedrich Wilhelm Herschel in Hanover, was a British astronomer and brother to fellow astronomer Caroline Herschel, with whom he worked throughout his career. Originally following his father's footsteps as a musician, Herschel developed an interest in astronomy and began making his own ever-more powerful mirrors to build telescopes that would allow him to view celestial bodies outside the Solar System. In 1781 Herschel discovered the planet Uranus, following which he was awarded the Copley Medal by the Royal Society of London, and made court astronomer to King George III. Other notable astronomical contributions were his proposal that nebulae are composed of stars and a theory of stellar evolution.

JOHANNES HEVELIUS
(Poland, 1611–87)

The astronomer Johannes Hevelius was a Gdansk city councillor and a brewer. Fulfilling a fascination with astronomy, he built an observatory at the top of his house in Gdansk and constructed his own fine astronomical instruments. While he did use telescopes, he preferred measuring the distance of stars without the use of lenses. He compiled an atlas of the Moon (*Selenographia*, 1647), which included maps of the Moon's surface and names (such as 'the Alps', which is still used today) for many of its features. A lunar crater is named after him. He also compiled a catalogue of 1,564 stars and a celestial atlas of constellations, both of which were published posthumously.

HILDEGARD OF BINGEN
(Germany, 1098–1179)

Also known as Saint Hildegard, Hildegard von Bingen or the Sybil of the Rhine, Hildegard of Bingen was a German visionary mystic, a Benedictine abbess and a composer, who was formally canonized in 2012. She became a nun at the age of fifteen and was made Prioress of Disibodenberg in 1136. Throughout her life, she experienced visions, which were to become the basis of her written work, starting with *Scivias* (1141–52), which recorded twenty-six of her visions of the relationships between God, man, the Church and redemption. She

also founded the monasteries of Rupertsberg (1150) and Eibingen (1165), and continued to make prophecies and record her visions in writing, as well as in poetry and music.

NANCY HOLT
(United States, 1938–2014)

Known for her large-scale site-specific outdoor works, American artist Nancy Holt was very influential in the 1960s Land Art movement. Holt graduated from Tufts University, Massachusetts, with a degree in biology. She then moved to New York where she met and collaborated with such other artists as Robert Smithson, Carl Andre, Eva Hesse and Richard Serra. She later married Smithson. Beginning to work in video and photography, she explored nature through her art, working in locations in the west and south-west of the US. She later moved to a much larger sculptural scale to explore the relationship between the Earth and the sky above, and used the movements of the Sun itself as a medium to explore the vastness of the surrounding land, notably in her most well-known works Sun Tunnels (1973–6) and Dark Star Park (1979–84).

EDWIN HUBBLE
(United States, 1889–1953)

One of the most influential astronomers in history, Edwin Hubble made discoveries that fundamentally changed our understanding of the Universe and our place within it. He discovered that what were previously thought to be nebulae within the Milky Way were in fact galaxies far beyond its borders, and therefore concluded that the Universe consisted of many galaxies. In the theory known as 'Hubble's law', he provided evidence that the further away galaxies were from each other, the faster they moved away from each other, thus implying that the Universe was expanding. NASA's Hubble Space Telescope, which was put in a low Earth orbit in 1990, was named in his honour.

CHRISTIAAN HUYGENS
(Netherlands, 1629–95)

A prominent Dutch scientist and mathematician, Christiaan Huygens made several notable contributions to science and technology, including the discovery of the true shape of Saturn's rings and of its moon Titan; his wave theory of light as established in his Treatise on Light; and the invention of the pendulum clock following his findings on time-keeping published in his Horologium (1658). From a wealthy middle-class family, Huygens excelled at school and was well connected as his father's friends included Galileo Galilei and René Descartes. He attended the University of Leiden (1645–7) followed by the College of Orange at Breda. In 1666 Huygens became one of the founders of the French Academy of Sciences.

GAVIN JANTJES
(South Africa, 1948–)

Born in Cape Town, Gavin Jantjes studied art during his childhood at the Children's Art Centre in District Six. He attended Cape Town's Michaelis School of Fine Art (BA, 1969) followed by a move to Hamburg, Germany,

to attend the University of Fine Arts (MA, 1972). In Hamburg, he became a founding member of the German anti-apartheid movement, and was a consultant for the UN High Commissioner for Refugees. His work in printmaking and painting regularly comments on the political situation in South Africa, as well as addressing wider issues of cultural identity and forgotten collective experience.

WASSILY KANDINSKY
(Russia, 1866–1944)

The Russian-born artist Wassily Kandinsky was one of the first proponents of pure abstraction in painting. Kandinsky founded the avant-garde Munich group Der Blaue Reiter (The Blue Rider), which lasted from 1911 to 1914, and coincided with his move to total abstraction and his most spontaneous paintings that drew heavily on music. He went back to Moscow in 1914 after the outbreak of World War I, but returned to Germany in 1921. He taught at the Bauhaus school of art and architecture from 1922 until it was closed by the Nazis in 1933 and his work developed in a more geometrical direction. He then moved to France and the last phase of his life saw prolific output with an emphasis on a more organic visual language.

JOHANNES KEPLER
(Germany, 1571–1630)

Born in Baden-Württemberg, Johannes Kepler was a German astronomer who discovered three major laws of planetary motion: that the planets in the Solar System revolve in elliptical orbits around the Sun; that the time to cross any orbital arc is proportional to the area of the space between the planetary body and the arc, known as the 'area law' and that there is an exact relationship between the squares of the planets' periodic times and the cubes of the radii of their orbits, known as the 'harmonic law'. These theories provided the basis for Isaac Newton's theory of universal gravitation.

ANSELM KIEFER
(Germany, 1945–)

One of the most prominent artists in the Neo-Expressionist movement of the late twentieth century, Anselm Kiefer uses his art to consider a diverse range of subject matter including modern German history and cultural identity, a Teutonic mythology, alchemy, the nature of belief, life, death and the cosmos. His raw, monumental, textural, canvases and sculptures are often composed of organic materials such as straw, dirt, wood, sand and lead, combined with oil paint. Kiefer started studying law at the University of Freiburg, but left to study art at art academies in Freiburg, Karlsruhe and Düsseldorf; at the last of these he studied under Joseph Beuys.

ATHANASIUS KIRCHER
(Germany, c.1601–80)

Athanasius Kircher was a Jesuit priest and scholar. He used his knowledge of Greek and Hebrew as well as his education in science and humanities to allow him to disseminate knowledge through his prolific writing. Although not a theorist himself, he wrote approximately

forty books as well as thousands of manuscripts and letters, 2,000 of which still survive. Sometimes known as the 'last Renaissance man', he conducted research in such areas as geography, astronomy, mathematics, language, medicine and music.

YAYOI KUSAMA
(Japan, 1929–)

The Japanese contemporary artist Yayoi Kusama now works predominantly with installations, which are at once representational and abstract. Prone to hallucinations from an early age, Kusama transforms these experiences – how she sees the world – into her art. Repetitive patterns, often polka dots, are obsessively mirrored and extended into infinite spaces that envelope the viewer into their world. Her early work comprised paintings, referred to as 'infinity nets', of obsessively repeated tiny marks across large canvases, as well as performance.

DAVID MALIN
(Britain, 1941–)

A photographic scientist-astronomer and professor of scientific photography, David Malin began his career as a chemist, specializing in optical and electron microscopy, X-ray diffraction and other microscopic techniques. After moving to Australia in 1975 for a job at the Anglo-Australian Observatory, he developed techniques for extracting faint and low-contrast detail from photographic plates. He is best known for his three-colour, wide-field images of deep-sky objects using telescopes. In 1986 he discovered a giant spiral galaxy that was named Malin 1. He now teaches at RMIT University in Melbourne.

GARRY FABIAN MILLER
(Britain, 1957–)

A progressive fine-art photographer, Garry Fabian Miller started photographing in the documentary tradition, but since the mid-1980s he has been borrowing techniques of the early pioneers in photography of the 1830s and 1840s of using light and objects on light-sensitive paper to make 'camera-less' photographs. Working in the dark room, he shines lights through glass vessels and paper cuts to create shapes directly on to photographic paper. His photographs with circular forms evoke planetary and cosmic forms.

ALEKSANDRA MIR
(Poland, 1967–)

Aleksandra Mir attended the Schillerska/Gothenburg University (1986–7), the School of Visual Arts, New York (graduating with a BFA in 1992), and the New School for Social Research, New York (1994–6). Her work often challenges social conventions, inviting friends and passersby to participate in the works with her. She has made several works that traverse the 'art world' and the 'space world', including First Woman on the Moon (1999), Pluto (2015) and Space Tapestry (2017).

JOAN MIRÓ
(Germany, 1676–1707)

Joan Miró was a Catalan painter who infused his Surrealist, abstract work with rich symbolism. He also made lithographic prints, murals, tapestries and sculptures. The son of a goldsmith and watchmaker, Miró grew up in the Catalonian landscape and was introduced to art at a young age. He initially worked in Spain, experimenting with the Fauvist style, but began spending more time in Paris from 1919 onwards, where, under the influence of the Dadaists, Surrealists and Paul Klee, he increasingly created Surrealist dreamscapes and scenes of the imagination. Following World War II, he returned to Spain and his work was increasingly driven by escapism through music and nature, coinciding with the establishment of his reputation internationally. Works such as the series *Constellations* were an outlet for him to explore the night, stars and music.

MICHAEL NAJJAR
(Germany, 1966–)

Born in Landau, Michael Najjar is a photographer, videographer and astronaut-in-training. He has lived in Berlin since 1988, where he attended the Bildo Academy for Arts. His art practice combines the fields of photography, technology and science – investigating how developments in science and technology impact on our social structures. His most recent work has focused on the future of space travel and his ambition to become the first artist to journey into space. With the backing of three art collectors, he will be a Pioneer Astronaut on the first Virgin Galactic voyage to space. He is training as an astronaut at the Yuri Gagarin Training Centre and the German Aerospace Centre – and documenting this process in his series *Outer Space*.

GEORGIA O'KEEFFE
(United States, 1887–1986)

One of the leading American artists of the twentieth century, Georgia O'Keeffe had a conventional training before turning her back on realism in her twenties to experiment with abstraction. Her work was first exhibited in 1916 by the photographer and gallery owner Alfred Stieglitz, whom she later married in 1924. Among her favourite subjects were flowers, of which she made huge, close-up paintings into which some critics read a sexual significance. She moved to Canyon, Texas, in 1916 and her paintings – particularly her watercolours – began to explore the vast landscapes and skies around her. From 1929 O'Keeffe spent much of her time painting landscapes and animal bones in New Mexico, to where she moved permanently in 1949, three years after Stieglitz died.

CORNELIA PARKER
(Britain, 1956–)

The British sculptor and installation artist Cornelia Parker is best known for her 1991 installation at the Chisenhale Gallery, London, entitled *Cold Dark Matter: An Exploded View*, for which she blew up a garden shed and its contents and then reassembled the rubble around a single light bulb to create a cartoon-like interpretation of the original explosion. Since then, her work has varied in subject matter and medium, from flattening a collection of silver-plated objects with a steamroller and suspending them in space (*Thirty Pieces of Silver*, 1988–9) to building an installation with a vitrine within which actor Tilda Swinton lay, apparently asleep (*The Maybe*, 1995) and commissioning a hand-embroidered tapestry of Wikipedia page for the *Magna Carta* (2015).

WILLIAM PARSONS, THIRD EARL OF ROSSE
(Ireland, 1800–67)

Also known as Lord Rosse, William Parsons was an Anglo-Irish astronomer, who built the largest reflecting telescope of the nineteenth century, called 'the Leviathan of Parsonstown', at his home in Birr Castle (now in County Offaly), Ireland. Parsons was elected to the House of Commons in 1821 but resigned his seat in 1834. In 1841 he inherited his title from his father and joined the House of Lords. He dedicated much of his time to his obsession of constructing a large telescope and the mirrors for it. The resulting 72-inch (1.8-metre) aperture telescope, the Leviathan, led him to discover the spiral shape of many 'nebulae'.

KATIE PATERSON
(Britain, 1981–)

A multidisciplinary artist whose conceptual body of work draws widely from the fields of astronomy, ecology and geology, Katie Paterson often engages and collaborates with scientists and researchers to make her work, including astronomers, astrophysicists, geologists, nanotechnologists, geneticists and even jewellers. The resulting installations, which often focus on landscapes and spacescapes, are both thought provoking and playful. Born in Glasgow, Paterson studied at Edinburgh College of Art (2000–04) followed by an MA at the Slade School of Fine Art, London (2005–07); she lives and works in Berlin, Germany.

LUDĚK PEŠEK
(Czech Republic, 1919–99)

The space artist and illustrator Luděk Pešek grew up in the mining town of Ostrava and developed interests in art, geology and astronomy at an early age. He began painting at the age of fifteen and later attended the Academy of Fine Arts in Prague. Influenced by Lucien Rudaux's book *Sur les Autres Mondes* (*On the Other Worlds*, 1937), his artworks included representations of cosmic and terrestrial subjects with technical precision but also more surreal and poetic works. He was commissioned by *National Geographic* magazine to do a series on Mars, and also wrote science-fiction novels including *Log of a Moon Expedition* (1967) and *The Earth is Near* (1971).

QIU YING
(China, c.1494–1552)

Qiu Ying was a Chinese ink and brush painter who specialized in the delicate gongbi style, which he used to create intricately detailed figurative, architectural and floral paintings. He lived in the Suzhou region in the south of China, also the home to the Wu school of painting and therefore a hub for artists, including Tang Yin and Zhou Chen, who may have been Qiu's teacher. Qiu is known to be one of the group known as the Four Masters of the Ming dynasty.

ROBERT RAUSCHENBERG
(United States, 1925–2008)

One of the most influential American artists of the twentieth century, Robert Rauschenberg was an early forerunner to the Pop Art movement, borrowing visual content and print reproduction methods from the print media and consumer brands. He made several radical innovations in the cross-pollination of the media of painting and sculpture with his 'combine paintings', which incorporated objects into canvases of paint and collage. He was also a serial collaborator, working with other avant-garde artists in music, dance, performance and printmaking.

GERHARD RICHTER
(Germany, 1932–)

A prominent painter of the post-war period, Gerhard Richter has encompassed multiple styles of painting, from photorealist to the highly abstract. Often using photographs as source material, he explores a diverse range of subjects, ranging from the socio-political experience of living through the evolution of post-war Germany to abstract evocations of collective memory and loss. Born in Dresden, a year before Hitler came to power, Richter trained in the Social Realist tradition at the Dresden Academy of Fine Arts (then part of East Germany) before escaping to Düsseldorf in West Germany in 1961, where he met artists including Sigmar Polke and Blinky Palermo at the Düsseldorf Academy of Fine Arts.

LUCIEN RUDAUX
(France, 1874–1947)

An astronomer and director of the observatory at Donville, Normandy, Lucien Rudaux was also one of the earliest pioneers of space art. His highly detailed paintings of the Moon showed lunar mountains with rounded and eroded peaks – much like the later Apollo photographs would reveal them to be – that he had observed from his telescope far earlier than man landed on the Moon. Rudaux wrote and illustrated his own books, including his most well-known title *Sur les Autres Mondes* (*On the Other Worlds*, 1937). The Rudaux crater on Mars is named after him, as well as the asteroid 3574 Rudaux.

THOMAS RUFF
(Germany, 1958–)

Based in Düsseldorf, contemporary photographer Thomas Ruff explores the possibilities of his medium through experimenting with a range of themes and photographic methods. He uses both digital and analogue photography as well as computer-generated and scientific archival imagery and pictures appropriated from print media and the Internet. Along with challenging traditional themes such as portraits, nudes and architectural photography, he has also made a series of astronomical images using images from NASA and the European Southern Observatory in Chile as source material, from which he extracts, enlarges and manipulates details.

TOMÁS SARACENO
(Argentina, 1973–)

In the intersection between art, astrophysics, architecture, natural science, and engineering, Tomás Saraceno's interactive installations, community projects and floating sculptures investigate new sustainable ways of interpreting and inhabiting our environment. Research into scientific exploration informs Saraceno's practice, which he combines with social engagement and a desire for a Utopian future. In pursuit of this goal, he has collaborated with scientific institutions including London's Natural History Museum, the Massachusetts Institute of Technology and the Nanyang Technological University in Singapore.

KIKI SMITH
(Germany, 1954–)

The American artist Kiki Smith was born in Nuremberg, then part of West Germany, and her family returned to the United States in 1955, after which she grew up in South Orange, New Jersey. A sculptor, installation artist and printmaker, she works in the figurative and expressionist traditions to address themes including the human body and its organs and fluids, AIDS, gender, sex, race, birth and regeneration. Using the body as a metaphor for the experience of human existence, she uses a range of sculptural materials including bronze, cloth, paper, ceramics and beeswax. Smith lives and works in New York.

SARAH SZE
(United States, 1969–)

Contemporary artist Sarah Sze was born in Boston, Massachusetts. She attended Yale University (BA, 1991) followed by the School of Visual Arts, New York (MFA, 1997). Sze's work redefines the boundaries of sculpture by combining found and made objects and often suspending them in complex site-specific installations that relate to, challenge or open up the architectural spaces they exist within. Her references are often found in scientific instruments used to analyse and quantify the Universe, thus Sze's interpretation of them also acts as a system of reorganizing personal universes. Sze represented the United States at the Venice Biennale in 2013. She lives and works in New York.

WOLFGANG TILLMANS
(Germany, 1968–)

Wolfgang Tillmans is an artist and photographer who, from the early 1990s onwards, became known for his intimate photographs of his friends and other young people in their social environment – clubs, gay pride parades and warehouse parties. In 2000, he was the first photographer and first non-British artist to win the Turner Prize. Around that time, his work turned increasingly towards an investigation of the nature of photography itself, exploring abstraction, grids and photographic sculpture. His practice has continued to expand, incorporating video, installation and music to his body of work. Tillmans also founded and maintains the non-profit exhibition space Between Bridges, originally located in his studio in London (2006–11) and relocated to Berlin in 2014.

ÉTIENNE LÉOPOLD TROUVELOT
(France, 1827–95)

The astronomer and artist Étienne Léopold Trouvelot was born in Aisne, France, but moved with his family to the United States after a *coup d'état* by Louis-Napoléon in 1852. A keen amateur entomologist, Trouvelot unwittingly released gypsy moth larvae into the wild in the United States, thus introducing the foliage-eating pest to the country. Shortly after, his interest turned to astronomy, and he began illustrating his observations. His skill as an astronomical illustrator led him to a position at the Harvard College Observatory, and fifteen of his pastel illustrations were published in 1881. He was elected a fellow of the American Academy of Arts and Sciences in 1877. In 1882, Trouvelot returned to France to work at the Meudon Observatory, where he began to use photography.

VINCENT VAN GOGH
(Netherlands, 1853–90)

A leading Post-Impressionist painter, Vincent van Gogh was known for his striking use of bold colour, textural brushwork and emotional sense of spontaneity. Van Gogh's early work in the Netherlands mainly comprised still lifes and studies of peasants. These were followed by formative years in Paris, where he met artists including Paul Gauguin, who had a tremendous impact on his style. He finally moved to Arles in the south of France, where he created some of his most recognized paintings of the local landscape – of cypress trees, wheat fields and sunflowers. Van Gogh's short life was marred by his mental health. He suffered from psychotic episodes and delusions, and he famously cut off part of his left ear. His depression, charted in his extensive correspondence with his brother Theo, continued until his suicide at the age of thirty-seven.

LEO VILLAREAL
(United States, 1967–)

Leo Villareal is a contemporary artist who creates complex LED light installations. He graduated from Yale University with a degree in sculpture and from NYU Tisch School of the Arts with a postgraduate degree from the Interactive Telecommunications Program (1994). Villareal is fascinated with the rules and structures of systems, and his art breaks these down to their most fundamental points – pixels or binary codes – and builds them up again using coding to control the brightness, patterns and rhythms of his lightworks.

JOHN ADAMS WHIPPLE
(United States, 1822–91)

One of the early practitioners of photography, John Adams Whipple experimented with the photographic process, trying his first daguerreotype in 1840. He set up a photographic studio with his partner James Wallace Black for portrait photography, but also photographed architecture in and around his local Boston area. In 1849, Whipple took his first photograph of the Moon using the telescope at the Harvard College Observatory in Cambridge to make a daguerreotype, which was one of the earliest lunar photographs and notably the most detailed at that time.

TSUKIOKA YOSHITOSHI
(Japan, 1839–92)

Yoshitoshi was an artist who upheld the Japanese woodblock printing tradition of ukiyo-e despite the challenges to traditional art practices offered by technology and mass reproduction techniques during the modernization period in Japan following the Meiji Restoration. He is known as the last great master of ukiyo-e, who maintained traditional methods but also incorporated new innovations from both the West and his own ideas. His later years were characterized by prolific production, including two of his best-known series, *One Hundred Aspects of the Moon* (1885–92) and *New Forms of Thirty-Six Ghosts* (1889–92). His latter years were also marked by mental health problems, and he died from a cerebral haemorrhage in 1892, at only fifty-three years of age.

CAREY YOUNG
(Zambia, 1970–)

Carey Young's art explores the contemporary condition of both private and public life being increasingly subsumed by commercialism through various media including video, photography, text, performance and installation. Born in Zambia, Young studied in the UK at Manchester Polytechnic, the University of Brighton and the Royal College of Art, London. Having exhibited internationally, including at the Hayward Gallery and the Institute of Contemporary Arts in London and the Brooklyn Museum of Art, she also teaches at the Slade School of Art, London.

FURTHER READING

Michael Benson
Cosmigraphics: Picturing Space Through Time. New York: Abrams, 2014

Jerry T. Bonnell
Astronomy: 365 Days. New York: Abrams, 2006

Jean Claire et al.
Cosmos: From Romanticism to the Avant-garde, 1801–2001. London: Prestel, 1999

James Dean and Bertram Ulrich
NASA/Art: 50 years of exploration. New York: Abrams, 2008

David H. DeVorkin
Hubble: Imaging Space and Time. Washington: National Geographic, 2008

David H. DeVorkin
The Hubble Cosmos: 25 Years of New Vistas in Space. Washington: National Geographic, 2015

Jemima Dunne et al. (eds.)
Space. From Earth to the Edge of the Universe. London: Dorling Kindersley, 2010

James Geach
Galaxy. Mapping the Cosmos. London: Reaktion Books, 2014

George Greenstein
Understanding the Universe: An Inquiry Approach to Astronomy and the Nature of Scientific Research. Cambridge: Cambridge University Press, 2013

Michael Hoskin (ed.)
The Cambirdge Illustrated History of Astronomy. Cambridge: Cambridge University Press, 1997

Nick Kanas
Star Maps. History, Ancestry, and Cartography. New York, Heidelberg, Dordrecht and London: Springer, 2009 (second edition)

Elizabeth A Kessler
Picturing the Cosmos. Hubble Space Telescope Inages and the Astronomical Sublime. Minneapolis: University of Minnesota Press, 2012

Kristen Lippincott
Astronomy (Eyewitness Guides). London: DK ELT/Schools, 1998.

David Malin
Heaven and Earth. Unseen by the Naked Eye. London and New York: Phaidon Press, 2002

David Malin
Ancient Light: A Portrait of the Universe. London and New York: Phaidon Press, 2009

Ron Miller
The Art of Space. The history of space art, from the earliest visions to the graphics of the Modern era. Minneapolis: Zenith Press, 2014

Paul Murdin and David Allen
Catalogue of the Universe. Cambridge: Cambridge University Press, 1979

Paul Murdin
Secrets of the Universe. How We Discovered the Cosmos. London: Thames and Hudson, 2009

Paul Murdin
Mapping the Universe. The Interactive History of Astronomy. London: Carlton Books, 2011

Nirmala Nataraj
Earth and space: photographs from the archives of NASA. San Francisco: Chronicle Books, 2015

Michael J. Neufeld (ed.)
Milestones of Space: Eleven Iconic Objects from the Smithsonian National Air and Space Museum. Minneapolis: Zenith Press, 2014

Martin Rees (ed.)
Universe. The Definitive Visual Guide. London: Dorling Kindersley, 2005

Martin Rees (ed.)
Illustrated Encyclopedia of the Universe. London: Dorling Kindersley, 2009

Italicized page numbers
refer to illustrations

PICTURE CREDITS

Every reasonable attempt has been made to identify owners of copyright. Errors and ommissions notified to the Publisher will be corrected in subsequent editions.

A. Buonanno, S. Ossokine (Max Planck Institute for Gravitational Physics), Simulating eXtreme Spacetimes project, W. Benger (Airborne Hydro Mapping GmbH): 125, 325(r); Granger Historical Picture Archive/Alamy Stock Photo: 68, 311(r); Heritage Image Partnership Ltd/Alamy Stock Photo. © 2017 The Andy Warhol Foundation for the Visual Arts, Inc./Artists Rights Society (ARS), New York and DACS, London: 23; Photo Researchers, Inc/Alamy Stock Photo: 208; World History Archive/Alamy Stock Photo: 265; Photo by Antimodular Research. © DACS/VEGAP 2017: 16; Courtesy of the Artist: 17, 40, 111, 131, 174, 196, 221, 247; Photo James Ewing, courtesy of the artist: 274; David Pace/Courtesy of the Artist: 246; Courtesy of the artist/© Sophy Rickett. All Rights Reserved, DACS 2017: 134; Photo © Asian Art Museum of San Francisco: 29; © Noemie Goudal, courtesy Edel Assanti: 27; David A. Hardy/astroart.org: 84; Astronomy Library of the Vienna University: 243; © Australian Astronomical Observatory/David Malin: 237(cl); Biblioteca de la Universitat de Barcelona: 211(cr); Fondation Beyeler, Riehen/Basel, Beyeler Collection/Photo: Robert Bayer © ADAGP, Paris and DACS, London 2017: 178; Bayerische Staatsbibliothek München: 192, 266, 313(cl); NASA, JPL/Michael Benson, Kinetikon Pictures: 291; Courtesy the artist and Galerie Laurence Bernard: 275; Courtesy of Museu Coleção Berardo, Lisbon, Portugal, © Thomas Ruff und ESO/DACS 2017: 263; Beinecke Rare Book and Manuscript Library, Yale University: 99, 317(l); Bibliothèque nationale de France: 34, 83; Bodleian Library, University of Oxford, MS. Marsh 144, page 111: 304, 311(c); Courtesy of Bonestell LLC.: 268, 321(l); Ashmolean Museum, University of Oxford, UK/Bridgeman Images: 105; Photo © Boltin Picture Library/Bridgeman Images: 58; Courtesy the artist and Tanya Bonakdar Gallery, New York: 51; bpk/andschriftenabteilung, Staatsbibliothek zu Berlin - Preußischer Kulturbesitz: 168; British Library, London, UK/© British Library Board. All Rights Reserved/Bridgeman Images: 158, 160; Museum of Fine Arts, Houston, Texas, USA/The Manfred Heiting Collection/Bridgeman Images: 74; National Gallery of Australia, Canberra/Bridgeman Images: 61; © 2017 Trustees of the British Museum: 116, 248; Steve Brown: 222; Courtesy of Stephen Bulger Gallery: 115, Caltech/R. Hurt (IPAC). 85, Gunter Lepkowski. Courtesy the artist and carlier | gebauer: 128; Courtesy of the artist and Carroll/Fletcher, London: 45; Courtesy The Cartin Collection: 177; Chetham's Library: 112; Biblioteca Histórica de la Universidad Complutense de Madrid: 295, 312(cr); Courtesy of artist and Paula Cooper Gallery: 25; Christie's Images, London/Scala, Florence/© DACS 2017: 169; Image courtesy of Daniel Crouch Rare Books/crouchrarebooks.com: 298; DEA Picture Library/Contributor: 199, 313(cr); © Peter Doig. All Rights Reserved, DACS 2017: 100; Miloslav Druckmüller, Martin Dietzel, Peter Aniol, Vojtech Rušin, image precssing by Miloslav Druckmüller: 66; Dutch Open Telescope: 139; Collection Gad Edery: 123; Daniel Eisenstein and the Sloan Digital Sky Survey III collab.: 81; ESA/Gaia/DPAC: 249; ESA/Rosetta/NAVCAM – CC BY-SA IGO 3.0: 172, 173; Gilbert A. Esquerdo: 296; Mary Evans Picture Library: 162, 272, 320(cr); Dimo Feldmann: 103; Photo by Claire Iltis/Courtesy Fleisher/Ollman Gallery: 93; Courtesy the artist and Frith Street Gallery, London: 108; From the Galaxy Map website, created using IRIS reprocessing of the original IRAS data, as described in: Miville-Deschênes, Marc-Antoine, and Guilaine Lagache. IRIS: A New generation of IRAS maps. The Astrophysical Journal Supplement Series 157.2 (2005), 302: 79; Bettmann/Getty Images: 117, 319(l); Sisse Brimberg & Cotton Coulson, Keenpress/Getty Images: 12, 310(cl); DEA/G. DAGLI ORTI/Getty Images: 82; Getty Images: 150; Photo by J. W. Draper/London Stereoscopic Company/Getty Images: 48, 317(cr); Science & Society Picture Library/Getty Images: 69; Photo by Lucio Ghilardi. Courtesy Biblitoteca Statale di Lucca: 28; Jane Grisewood: 37; © Garry Fabian Miller/Courtesy HackelBury Fine Art, London: 73; Photo Hyonjin BAK © banghaija.com: 212; Sharon Harper: 183; Harvard College Observatory: 281; © Thomas Houseago. Courtesy the artist and Hauser & Wirth © ADAGP, Paris and DACS, London 2017: 130; Heritage Auctions, HA.com: 264, 321(cr); Jonathan A. Hill: 225; Hirshhorn Museum and Sculpture Garden Smithsonian Institution The Joseph H. Hirshhorn Bequest, 1981. Photo by Cathy Carver: 239, 321(l); © Estate of Nancy Holt/

DACS, London/VAGA, New York 2017: 135, 322(l); Richard Holttum: 62; RB 490308, The Huntington Library, San Marino, California: 187, 318(r); Archivo Digital de las Colecciones del Museo Nacional de Antropología.INAH-CANON: 138, 313(cl); Photo Katie Paterson. Image courtesy the Artist/ The Lowry, Manchester/Ingleby, Edinburgh: 127; Emil Ivanov: 13; © Alma Nungarrayi Granites and Warlukurlangu Artists of Yuendumu. Image courtesy of Japingka Gallery, Fremantle, Australia: 167; Image courtesy of Dr. T.H. Jarrett (Caltech/UCT): 245; © Anish Kapoor. All Rights Reserved, DACS 2017: 300; Dino Kalogjera www.dinosmaps.com: 78; www.gerhardkassner.de: 171; Tim Knowles: 113; Esmeralda Kosmatopoulos: 155; Photo: Werner J. Hannappel, Essen and Zentrum für Internationale Lichtkunst, Unna © Archiv Mischa Kuball, Düsseldorf/VG Bild-Kunst, Bonn 2017: 231; © Ryoichi Kurokawa. All rights reserved: 257; © Yayoi Kusama. Courtesy David Zwirner, New York; Ota Fine Arts, Tokyo/Singapore; Victoria Miro, London; Yayoi Kusama Inc: 207; Tamás Ladányi: 101; Juraj Lipták/Landesamt für Denkmalpflege und Archäologie Sachsen-Anhalt: 288, 310(c); Artist production: Juliette Bibasse/co-produced by SAT Montréal © Studio Joanie Lemercier/ © Photos Sébastien Roy: 303; Library of Congress: 44, 132, 164, 260, 305, 313(r); Transparencies NASA; digital images © 1999 Michael Light: 308–9; Marco Lorenzi: 286; © Zarina; Courtesy of the artist and Luhring Augustine, New York: 86; Adam Block and David Martinez-Delgado/Extra Galactic Stellar Tidal Stream Survey: 179; Yuri Beletsky (Carnegie Las Campanas Observatory, TWAN) & David Martinez-Delgado (U. Heidelberg): 54; Firenze, Biblioteca Medicea Laurenziana, Ms. San Marco 190, c.102r Su concessione del MiBACT: 220; The Metropolitan Museum of Art, New York: 52; © 2000–02, Malin/Caltech, Photo by Bill Miller: 148, 321(cl); Photo Pablo Mason © Nancy Graves Foundation, Inc. Courtesy Mitchell-Innes & Nash, NY. © Nancy Graves Foundation/VAGA, NY/DACS, London 2017: 195; From On a marché sur la Lune © Hergé/Moulinsart 2017: 194; ESA/Hubble & NASA: 153, 193, 223; ESO/WFI (Optical); MPIfR/ESO/APEX/A. Weiss et al. (Submillimetre); NASA/CXC/CfA/R.Kraft et al. (X-ray): 36; HiRISE, MRO, LPL (U. Arizona), NASA: 129; NASA: 22, 124, 144, 196, 197, 235, 238, 252, 299, 306, 322(l), 322(cl), 322(cr), 323(r); NASA/Ames/JPL-Caltech: 63; NASA/JPL: 19; NASA/JPL-Caltech/Arizona State University: 21; NASA/JPL-Caltech/SwRI/MSSS/Betsy Asher Hall/Gervasio Roble: 307; NASA/JPL-Caltech/USGS: 189; NASA/CXC/M.Weiss: 46; NASA/CXC/SAO/J.Hughes et al (X-ray) and NASA/ESA/Hubble Heritage Team STScI/AURA (optical): 121; NASA/CXC/SAO/ E.Nardini et al (X-ray) and NASA/STScI (optical): 55; NASA & ESA, Jesús Maíz Apellániz (Centro de Astrobiología, CSIC-INTA, Spain): 107; NASA, ESA and Jesús Maíz Apellániz (Instituto de Astrofísica de Andalucía, Spain), Davide De Martin (ESA/Hubble): 95; NASA, ESA, S. Beckwith (STScI), and The Hubble Heritage Team (STScI/AURA): 31; NASA, ESA, J. Hester and A. Loll (Arizona State University): 297; NASA, ESA, and the Hubble Heritage Team (STScI/AURA): 18, 120,149, 213, 324(l); NASA, ESA, and the Hubble Heritage (STScI/AURA)-ESA/Hubble Collaboration. Ackn.: R. Fesen (Dartmouth College) and J. Long (ESA/Hubble): 94; NASA, ESA, Hubble Heritage (STScI/AURA), Ackn.: N. Smith et al. (JHU): 250, 325(cr); NASA, ESA, the Hubble Heritage Team (STScI/AURA), A. Nota (ESA/STScI), and the Westerlund 2 Science Team: 229, NASA, ESA, and J. Lotz (STScI): 228; NASA, ESA, C.R. O'Dell (Vanderbilt University), M. Meixner and P. McCullough (STScI): 166, 325(l); NASA/JHUAPL/SwRI: 293; NASA/Johns Hopkins University Applied Physics Laboratory/Carnegie Institution of Washington: 230, 269, 323(l); NASA/JPL: 279, 324(cl); NASA/JPL-Caltech: 253; NASA /JPL-Caltech/ESA/CXC/STScI: 110; NASA/JPL-Caltech/GSFC/JAXA: 181; NASA/JPL-Caltech/SETI Institute: 292; NASA/JPL/Cornell: 188; NASA/JPL/Björn Jónsson: 205; NASA/JPL/Space Science Institute: 204; NASA/JPL/University of Arizona: 175; NASA, ESA, and K. Sahu (STScI): 287; NASA/Science Photo Library: 41; 244; NASA/SDO/AIA: 243; NASA/UCL Faculty of Mathematical and Physical Sciences: 217; NASA/WMAP Science Team: 301; Solar Dynamics Observatory/NASA: 273; National Diet Library: 289; National Library of Spain: 210; © National Maritime Museum, Greenwich, London: 98; N.A.Sharp, NOAO/NSO/Kitt Peak FTS/AURA/NSF: 261; Observatoire de Paris: 60, 315(l); © Georgia O'Keeffe Museum /DACS 2017: 96; Courtesy History of Science Collections, University of Oklahoma Libraries: 170; Photo The Corning Museum of Glass, Corning, New York © Kiki Smith, courtesy Pace Gallery: 203; Trevor Paglen; Metro Pictures, New York; Altman Siegel, San Francisco:

283; © Wolfgang Tillmans, courtesy Maureen Paley, London: 215; Pan Am Historical Foundation: 226; Alex H. Parker: 71; Lord Egremont of Petworth House: 42; © Robert Rauschenberg Foundation /Licensed by VAGA, New York, NY; published by Felissimo/© Robert Rauschenberg Foundation/DACS, London/VAGA, New York 2017: 227; © 2017 Gerhard Richter: 97; Photo © BnF, Dist. RMN-Grand Palais/image BnF: 198, 312(cr); Photo © Musée du Louvre, Dist. RMN-Grand Palais/Christian Decamps: 284; Photo © RMN-Grand Palais (musée du Louvre)/Hervé Lewandowski: 282; Photo © RMN- Grand Palais (Musée Picasso de Paris)/Béatrice Hatala. © Succession Picasso/DACS, London 2017: 218; Photo © The Solomon R. Guggenheim Foundation/Art Resource, NY, Dist. RMN-Grand Palais/The Solomon R. Guggenheim Foundation/Art Resource, NY: 70, 319(l); © 2016 Dorothea Rockburne/Artists Rights Society (ARS), New York/© ARS, NY and DACS, London 2017: 39; © Josiah McElheny Courtesy Andrea Rosen Gallery, New York: 185; Courtesy of the Earl and Countess of Rosse, Birr Castle: 30, 317(l); The Royal Library, Copenhagen: 140; © The Royal Society: 56, 201, 214, 276, 316(l), 316(cl), 318(cl); Jorge Mañes Rubio/Ditishoe: 234; David Rumsey Map Collection, www.davidrumsey.com: 24, 76, 88, 147, 320(l), 147(r), 154, 255, 314(l), 320(l); Courtesy the Artist; Tanya Bonakdar Gallery, New York and Miami Art Museum. Photo © Fabian Birgfeld, PhotoTECTONICS and Studio Tomás Saraceno, 2008: 80; © 2017. The British Library Board/Scala, Florence: 50, 146, 180, 182, 224, 233, 240, 280, 312(cl), 314(r), 315(cl); Cooper-Hewitt, Smithsonian Design Museum/Art Resource, NY/Scala, Florence: 145; The Fitzwilliam Museum, Cambridge/Scala, Florence: 267, 316(r); The Metropolitan Museum of Art/Art Resource/Scala, Florence: 52, 104; The Metropolitan Museum of Art/Art Resource/Scala, Florence/© Successió Miró/ADAGP, Paris and DACS London 2017: 151; Digital image, The Museum of Modern Art, New York/Scala, Florence: 92, 114, 319(cl); Digital image, The Museum of Modern Art, New York/Scala, Florence. © 2017 Calder Foundation, New York/DACS London: 14, 320(cl); Digital image, The Museum of Modern Art, New York/Scala, Florence. © Vija Celmins, Courtesy Matthew Marks Gallery: 206; The Museum of Modern Art, New York/Scala, Florence/© DACS 2017: 186; © 2017. Photo Scala, Florence: 38; © 2017. Photo Smithsonian American Art Museum/Art Resource/Scala, Florence: 32; British Library/Science Photo Library: 262, 311(cl); Luděk Pešek/Science Photo Library: 216; Royal Astronomical Society/Science Photo Library: 35, 126, 316(cr), 319(cr), 323(cl); Science Photo Library: 53; Science, Industry and Business Library/New York Public Library. Science Photo Library: 89, 110; © Science Museum/Science & Society Picture Library All Rights Reserved: 102; Semiconductor: Ruth Jarman and Joe Gerhardt: 33; Image Courtesy Sikander Studio: 190; Courtesy the artist and Bruce Silverstein Gallery, NY: 49; © Angela Bulloch. Courtesy of the artist and Simon Lee Gallery, London/Hong Kong: 161; Hirshhorn Museum and Sculpture Garden Smithsonian Institution The Joseph H. Hirshhorn Bequest, 1981. Photo by Cathy Carver: 239; Photo by Franko Khoury. National Museum of African Art Smithsonian Institution: 87; Gift of Ruth Krauss in memory of Crockett Johnson, Division of Medicine & Science, National Museum of American History, Smithsonian Institution: 59; National Museum of the American Indian, Smithsonian Institution. Photo by NMAI Photo Services: 200; Textile Collection, National Museum of American History, Smithsonian Institution: 77, 318(cl); Purchased with funds provided by the Smithsonian Collections Acquisition Program: 106; Courtesy of Smithsonian Libraries, Washington, DC: 258; Photo courtesy of Sotheby's, Inc. © 2011: 64, 65; Alma Mater Studiourum Università di Bologna, Sistema Museale di Ateneo – Specola Museum of Astronomy: 26; Volker Springel & The Virgo Consortium: 143, 325(cl); Photo Tom Powel. Courtesy of the Artist © Sarah Sze: 277; Tate London/© The Joseph and Robert Cornell Memorial Foundation/VAGA, NY/DACS, London 2017: 72; © Olafur Eliasson/Galerie Neugerriemschneider (Berlin)/ © Tate: 67, 324(r); Photo © Tate, London 2015 © Anselm Kiefer: 75, 324(cr); University of Tennessee: 109; Mark Lascelles Thornton: 209; © Agnes Denes, courtesy Leslie Tonkonow Artworks + Projects, NY: 133; Adapted from M. Rempel, M. Schüssler, R. H. Cameron, and M. Knölker, Penumbral Structure and Outflows in Simulated Sunspots, Science, Vol. 325, Issue 5937, 10 July 2009. © UCAR: 159; U.S. Geological Survey: 278; Paul Van Hoeydonck BVBA: 43; © Victoria and Albert Museum, London 2017: 157, 254, 318(r); Wellcome Library, London: 232, 241; Wikipedia: 15, 90; Zentralbibliothek Zürich: 176.

PUBLISHER'S ACKNOWLEDGMENTS

A project of this size requires the commitment, advice and expertise of many people. We are particularly indebted to our consultant editor Paul Murdin for his vital contribution to the shaping of this book and his exhaustive astronomical knowledge, and to David Malin and Elizabeth Kessler for their editorial input and guidance during the development of the project.

Special thanks are also due to our international advisory panel for their knowledge, passion and advice in the selection of works for inclusion: Louise Beer, Jerry Bonnell, David DeVorkin, Louise Devoy, Seb Falk, George Greenstein, Elizabeth Kessler, Michael Light, Kristen Lippincott, Mary-Kay Lombino, David Malin, Paul Murdin, Liba Taub and Melanie Vandenbrouck.

We are also grateful to Sarah Bell and Annalaura Palma for their picture research, and to Emma Barton, William Booth-Clibborn, Tim Cooke, Ellen Christie, Daniel Goode, Phoebe Heseltine, Cathy Lowne, João Mota, Michela Parkin, Caroline Rayner, Tracey Smith, Sarah Scott, Gary Urton, Kaitlin Villano and Anne-Marie Weijmans for their invaluable assistance.

Finally we would like to thank all the artists, illustrators, photographers, collectors, libraries, institutions and museums who have given us permission to include their images.